THE SOCIETY OF
PUBLICATION DESIGNERS
42ND PUBLICATION
DESIGN ANNUAL

HAVERING COLLEGE

LEARNING
RESOURCES
CENTRE

CONTENTS

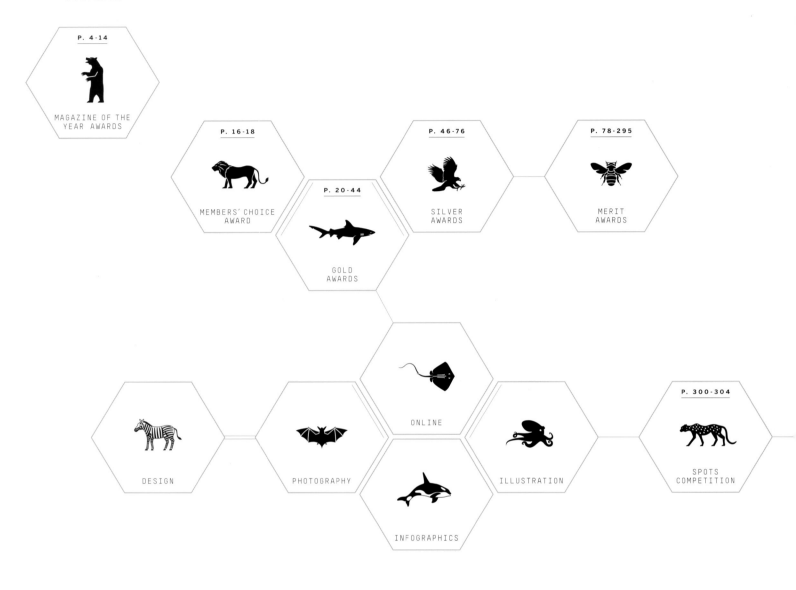

P. 4-14
MAGAZINE OF THE YEAR AWARDS

P. 16-18
MEMBERS' CHOICE AWARD

P. 20-44
GOLD AWARDS

P. 46-76
SILVER AWARDS

P. 78-295
MERIT AWARDS

DESIGN

PHOTOGRAPHY

ONLINE

INFOGRAPHICS

ILLUSTRATION

P. 300-304
SPOTS COMPETITION

THIS YEAR'S COMPETITION WAS CHAIRED BY
GEORGE KARABOTSOS, FIONA McDONAGH AND MITCH SHOSTAK

COVER

ENTIRE ISSUE

ENTIRE STORY

SPREAD/SINGLE PAGE

P. 305-307
STUDENT WINNERS

P. 296-299
THE JUDGES

THE MAGAZINES OF THE YEAR

COVER

JACKET CREATIVE DIRECTION: **JILL GREENBERG** AND **ROBERT PRIEST**
COVER PHOTOGRAPH: **JILL GREENBERG** PROPS: **ETHAN TOBMAN**

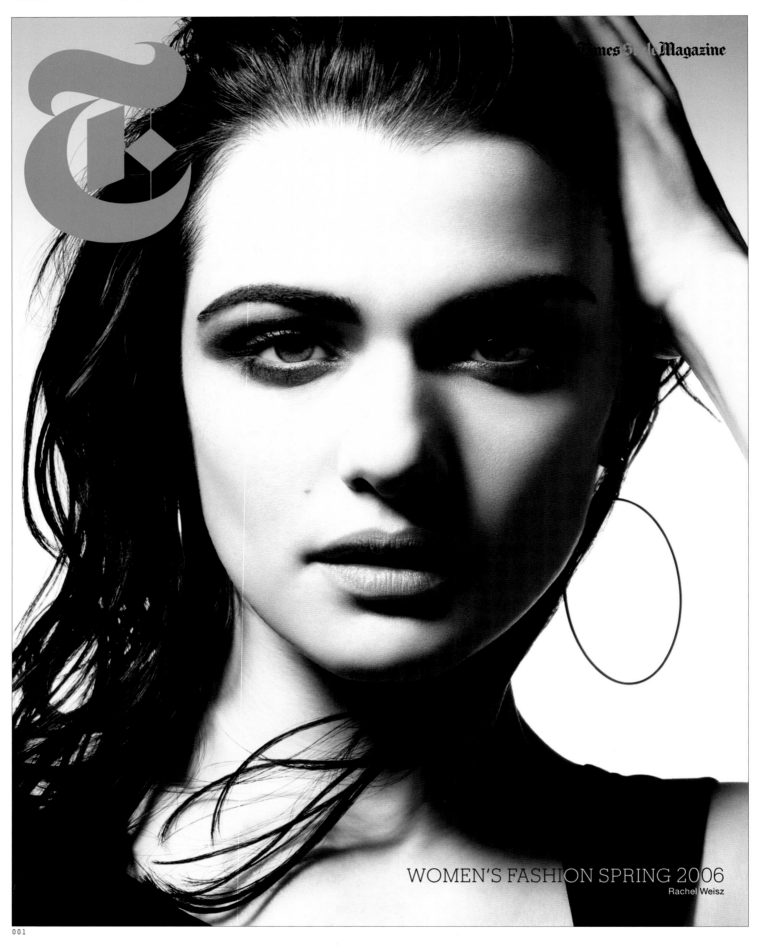

Times Style Magazine

T

WOMEN'S FASHION SPRING 2006

Rachel Weisz

001

4

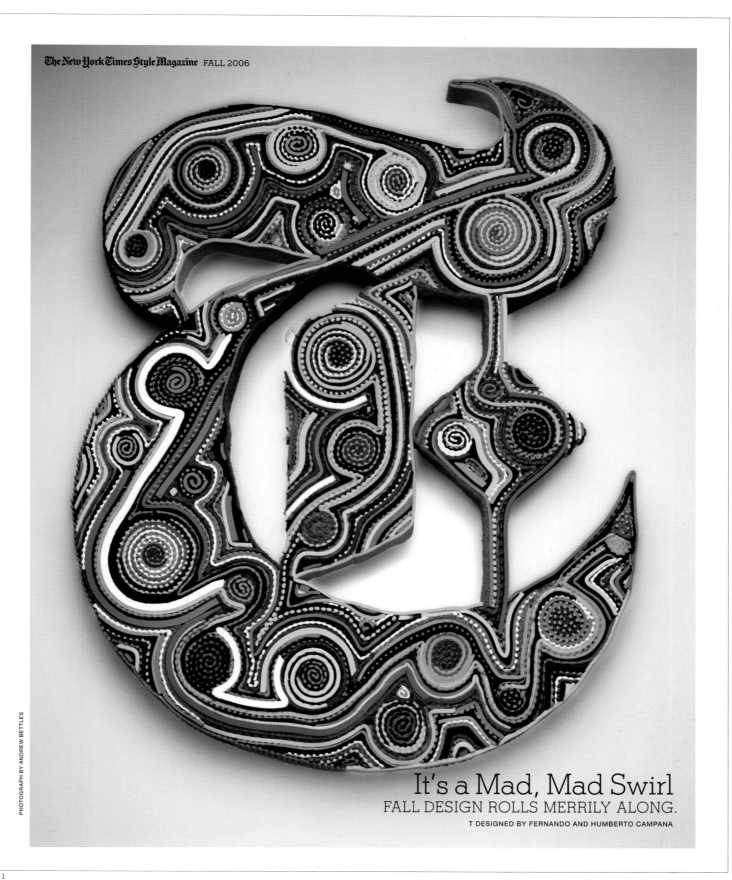

It's a Mad, Mad Swirl
FALL DESIGN ROLLS MERRILY ALONG.

T DESIGNED BY FERNANDO AND HUMBERTO CAMPANA

001

001. **T. THE NY TIMES STYLE MAGAZINE**

creative director. Janet Froelich. senior art director. David Sebbah. art director. Christopher Martinez. designers. Janet Froelich, David Sebbah, Christopher Martinez, Elizabeth Spiridakis, Jody Churchfield. director of photography. Kathy Ryan. senior photo editor. Judith Puckett-Rinella photo editors. Scott Hall, Jennifer Pastore. photographers. Raymond Meier, Jean-Baptiste Mondino, Paolo Roversi, Ilan Rubin. editor-in-chief. Stefano Tonchi publisher. The New York Times. issue. February 26, 2006, September 17, 2006, October 8, 2006. category. Design: Magazine of the Year (+1 million circulation)

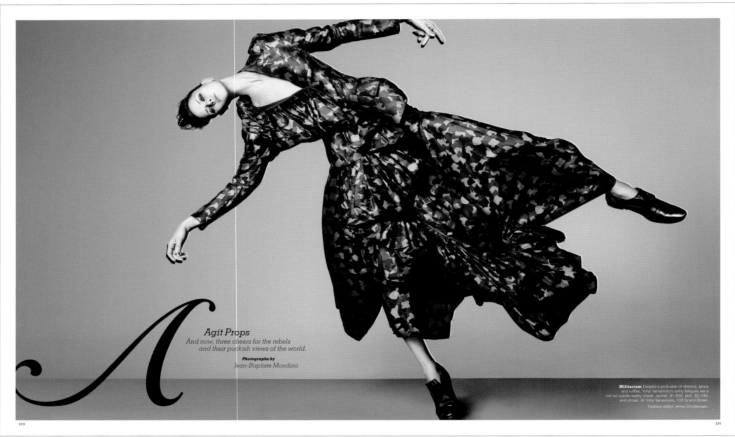

A

Agit Props
And now, three cheers for the rebels
and their puckish views of the world.

Photographs by
Jean-Baptiste Mondino

Militarism Despite a profusion of ribbons, bows and ruffles, Yohji Yamamoto's army fatigues are a not-so-subtle reality check. Jacket, $1,820, skirt, $2,430, and shoes. At Yohji Yamamoto, 103 Grand Street. Fashion editor: Anne Christensen.

001. **T, THE NY TIMES STYLE MAGAZINE**

creative director. Janet Froelich. senior art director. David Sebbah. art director. Christopher Martinez. designers. Janet Froelich, David Sebbah, Christopher Martinez, Elizabeth Spiridakis, Jody Churchfield. director of photography. Kathy Ryan. senior photo editor. Judith Puckett-Rinella photo editors. Scott Hall, Jennifer Pastore. photographers. Raymond Meier, Jean-Baptiste Mondino, Paolo Roversi, Ilan Rubin. editor-in-chief. Stefano Tonchi publisher. The New York Times. issue. February 26, 2006, September 17, 2006, October 8, 2006. category. Design: Magazine of the Year (+1 million circulation)

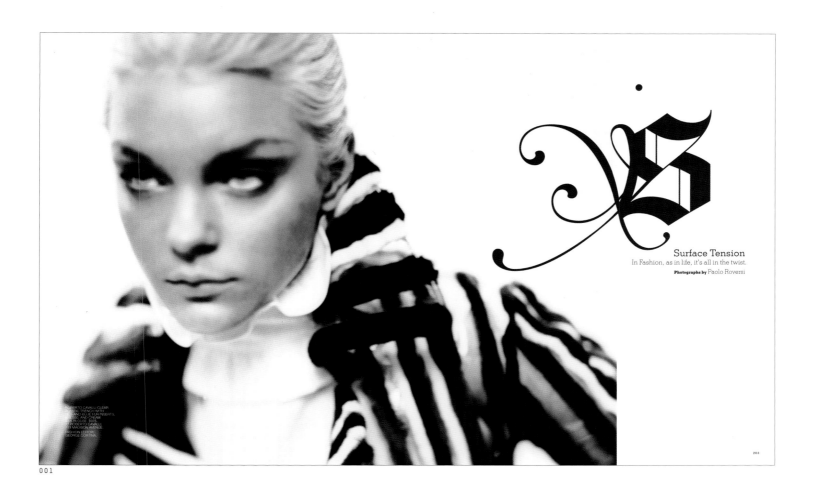

S

Surface Tension

In Fashion, as in life, it's all in the twist.

Photographs by Paolo Roversi

203

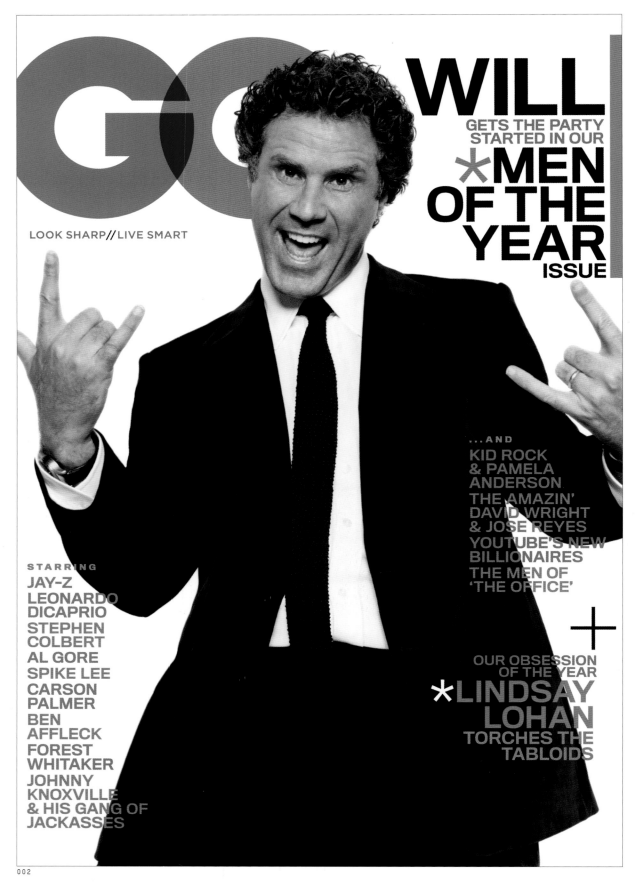

GQ

LOOK SHARP//LIVE SMART

WILL
GETS THE PARTY
STARTED IN OUR
*MEN
OF THE
YEAR
ISSUE

...AND
KID ROCK
& PAMELA
ANDERSON
THE AMAZIN'
DAVID WRIGHT
& JOSE REYES
YOUTUBE'S NEW
BILLIONAIRES
THE MEN OF
'THE OFFICE'

+

OUR OBSESSION
OF THE YEAR
*LINDSAY
LOHAN
TORCHES THE
TABLOIDS

STARRING
JAY-Z
LEONARDO
DICAPRIO
STEPHEN
COLBERT
AL GORE
SPIKE LEE
CARSON
PALMER
BEN
AFFLECK
FOREST
WHITAKER
JOHNNY
KNOXVILLE
& HIS GANG OF
JACKASSES

002

002. **GQ**

design director. Fred Woodward. art director. Ken DeLago. designers. Anton Ioukhnovets, Thomas Alberty, Michael Pangilinan, Drue Wagner, Eve Binder, Delgis Canahuate. director of photography. Dora Somosi. senior photo editor. Krista Prestek photo editors. Justin O'Neill, Jolanta Bielat, Jesse Lee . editor-in-chief. Jim Nelson. publisher. Condé Nast Publications Inc. issue. March 2006, April 2006, November 2006. category. Design: Magazine of the Year (500,000 — 1 million circulation)

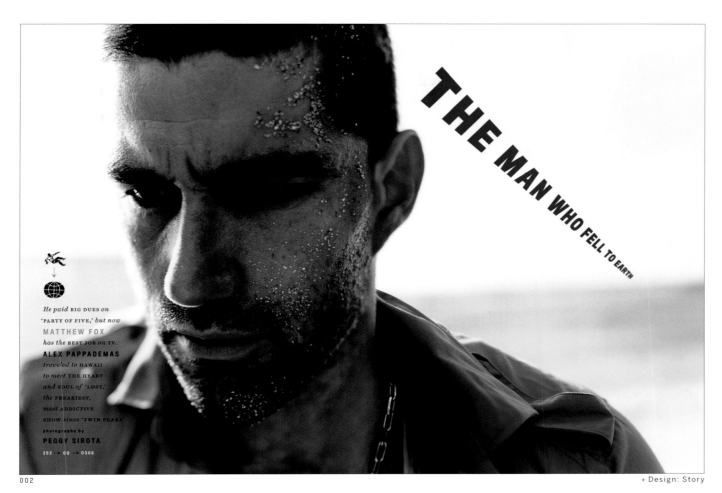

THE MAN WHO FELL TO EARTH

He paid BIG DUES on
'PARTY OF FIVE,' but now
MATTHEW FOX
has the BEST JOB on TV.
ALEX PAPPADEMAS
traveled to HAWAII
to meet THE HEART
and SOUL of 'LOST,'
the FREAKIEST,
most ADDICTIVE
SHOW since 'TWIN PEAKS'
photographs by
PEGGY SIROTA

252 → GQ → 0306

232.GQ **YOUNG LOVE** 04.06

BY KATRINA HERON

HE'S NOT RICH, HE'S NOT
POWERFUL, AND HE'S HALF
MY AGE. BUT HERE'S WHAT
MY YOUNGER MAN DOES
FOR ME THAT AN OLDER MAN
CAN'T. LISTEN AND LEARN

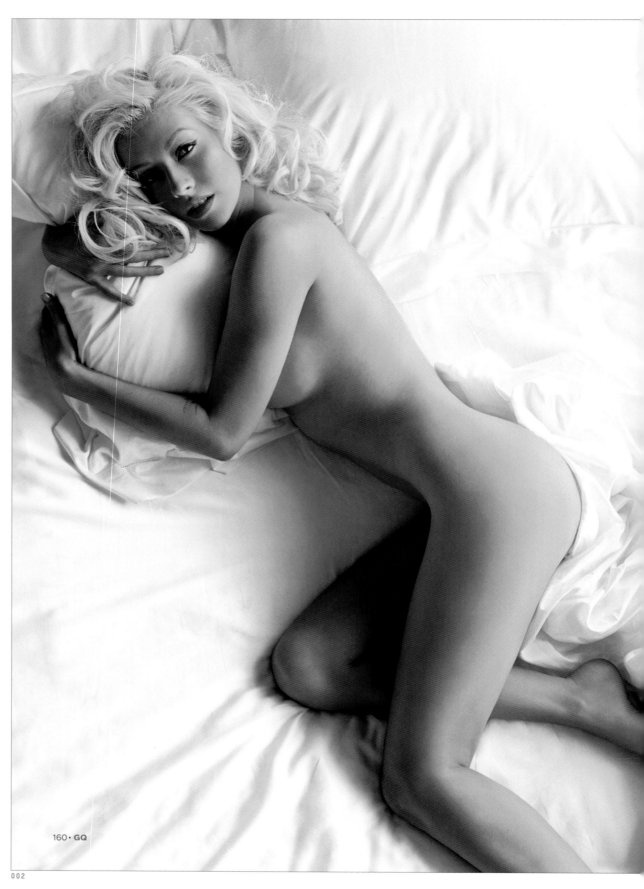

160 · **GQ**

002

002. **GQ**

design director. Fred Woodward. art director. Ken DeLago. designers. Anton Ioukhnovets, Thomas Alberty, Michael Pangilinan, Drue Wagner, Eve Binder, Delgis Canahuate. director of photography. Dora Somosi. senior photo editor. Krista Prestek photo editors. Justin O'Neill, Jolanta Bielat, Jesse Lee . editor-in-chief. Jim Nelson. publisher. Condé Nast Publications Inc. issue. March 2006, April 2006, November 2006. category. Design: Magazine of the Year + Design Spread (500,000 — 1 million circulation)

QUEEN CHRISTINA

IN A POP LANDSCAPE LITTERED WITH MACHINE-MADE POSEURS, CRAZY-PIPED **Christina Aguilera** IS THE REAL DEAL. BUT WILL MARRIED LIFE AND A STIRRING NEW ALBUM SOFTEN HER GLORIOUSLY RAUNCHY IMAGE? · BY **Chris Norris** · PHOTOGRAPHS BY **Michael Thompson**

THE SUMMER ISSUE

NEW YORK

JULY 3–10, 2006

Scarlett ♥ Woody
(page 44)

247 Ways to Have A Brilliant Summer, For Water-Nuts, Landlubbers, Hyper Kids, Jocks, Slackers, Cinéastes…

PLUS Hillary, the Principled Hawk ▸ Graffiti, an Oral History
▸ The Lemmings of Long Beach Island ▸ The Cult of Amy Sedaris, and more

$3.99 (CANADA $4.99)

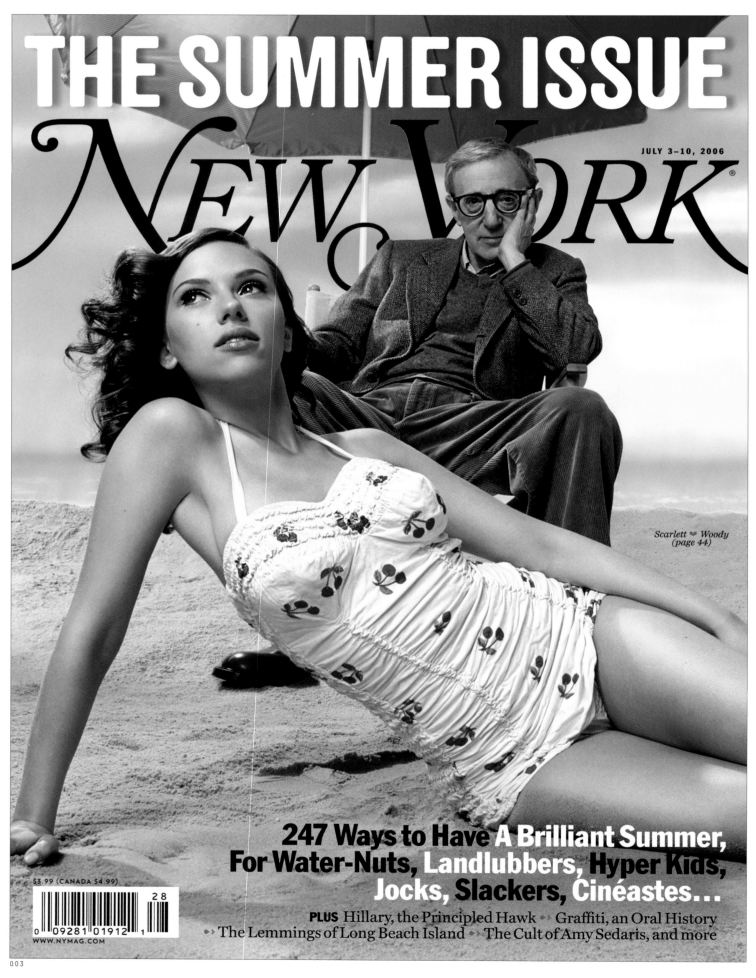

WWW.NYMAG.COM

003

12

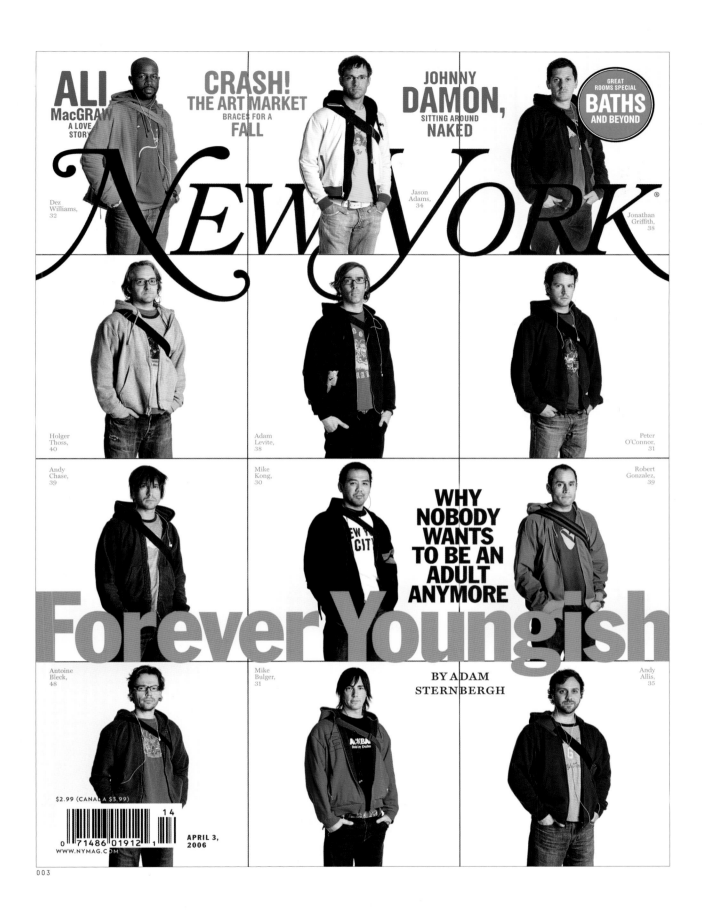

ALI
MacGRAW
A LOVE
STORY

CRASH!
THE ART MARKET
BRACES FOR A
FALL

JOHNNY
DAMON,
SITTING AROUND
NAKED

GREAT
ROOMS SPECIAL
BATHS
AND BEYOND

NewYork

Dez
Williams,
32

Jason
Adams,
34

Jonathan
Griffith,
38

Holger
Thoss,
40

Adam
Levite,
38

Peter
O'Connor,
31

Andy
Chase,
39

Mike
Kong,
30

Robert
Gonzalez,
39

WHY
NOBODY
WANTS
TO BE AN
ADULT
ANYMORE

Forever Youngish

Antoine
Bleck,
48

Mike
Bulger,
31

Andy
Allis,
35

BY ADAM
STERNBERGH

$2.99 (CANADA $3.99)

APRIL 3,
2006

0 71486 01912 1

14

WWW.NYMAG.COM

003

003. **NEW YORK**

design director. Luke Hayman. art director. Chris Dixon. designers. Kate Elazegui, Randy Minor, John Sheppard, Emily Anton
illustrators. Joe Darrow, James Taylor, John Burgoyne, Charles Wilkin, Sean McCabe, Cook Design, Karen Caldicott, Jason Lee, Wes Duvall, Ben Fry,
Christopher Sleboda, Demetrios Psillos, Rebeca Méndez. director of photography. Jody Quon. photo editors. Amy Hoppy, Leana Alagia, Lea Golis,
Ilana Diamond, Lisa Corson, Alexandra Pollack. photographers. Cass Bird, Ari Verslius & Ellie Uyttenbroek, Jeffrey Lamont Brown,
Christoph Morlinghaus, David Allee, Brad Paris, Jake Chessum, Jeremy Liebman, Brigitte Lacombe, Alison Jackson, Todd Selby, Michal Chelbin,
Noah Shelley, Mark Heithoff, Michael Edwards, Mitchell Feinberg, Davies & Starr, Mark Peterson, Carlos Serrao, Vincent Laforet, Andrew Eccles,
Reuben Cox, Jeff Mermelstein, Matthias Clamer, Robert Maxwell, Amy Arbus. editor-in-chief. Adam Moss. publisher. New York Magazine Holdings,
LLC. issue. April 3, 2006, April 17, 2006, July 3-10, 2006. category. Design: Magazine of the Year (under 500,000 circulation)

He owns *eleven pairs of sneakers,* hasn't worn anything but *jeans* in a year, and won't shut up about *the latest Death Cab for Cutie CD.* But he is no kid. He is among the ascendant breed of grown-up who has *redefined adulthood* as we once knew it and *killed off the generation gap.*

Up With Grups *

BY ADAM STERNBERGH
Photographs by Ari Versluis & Ellie Uyttenbroek

* Also known as **yupster** (yuppie + hipster), **yindie** (yuppie + indie), and **alterna-yuppie.** Our preferred term, **grup,** is taken from an episode of *Star Trek* (keep reading) in which Captain Kirk et al. land on a planet of children who rule the world, with no adults in sight. The kids call Kirk and the crew "**grups,**" which they eventually figure out is a contraction of "**grown-ups.**" It turns out that all the grown-ups had died from a virus that greatly slows the aging process and kills anybody who grows up.

24

New York

NOT SINCE JESUS

While humanity awaits the arrival of the *BRANGELINA BABY,* the paparazzi scheme and scramble for a shot at the biggest score of all time.

By Jason Zengerle

Disclaimer #2. As on the cover, these people are not Brad Pitt and Angelina Jolie or any of their children. Sorry. But at least there's no digital manipulation here! These are models photographed by Alison Jackson, who specializes in staging fictitious scenes involving celebrity look-alikes.

32 *Photographs by Alison Jackson*

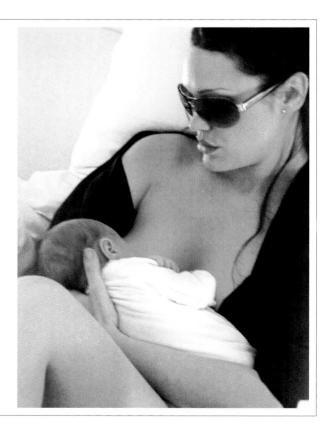

003. **NEW YORK**

design director. Luke Hayman. art director. Chris Dixon. designers. Kate Elazegui, Randy Minor, John Sheppard, Emily Anton illustrators. Joe Darrow, James Taylor, John Burgoyne, Charles Wilkin, Sean McCabe, Cook Design, Karen Caldicott, Jason Lee, Wes Duvall, Ben Fry, Christopher Sleboda, Demetrios Psillos, Rebeca Méndez. director of photography. Jody Quon. photo editors. Amy Hoppy, Leana Alagia, Lea Golis, Ilana Diamond, Lisa Corson, Alexandra Pollack. photographers. Cass Bird, Ari Versluis & Ellie Uyttenbroek, Jeffrey Lamont Brown, Christoph Morlinghaus, David Allee, Brad Paris, Jake Chessum, Jeremy Liebman, Brigitte Lacombe, Alison Jackson, Michal Chelbin, Noah Shelley, Mark Heithoff, Michael Edwards, Mitchell Feinberg, Davies & Starr, Mark Peterson, Carlos Serrao, Vincent Laforet, Andrew Eccles, Reuben Cox, Jeff Mermelstein, Matthias Clamer, Robert Maxwell, Amy Arbus. editor-in-chief. Adam Moss. publisher. New York Magazine Holdings, LLC. issue. April 3, 2006, April 17, 2006, July 3-10, 2006. category. Design: Magazine of the Year (under 500,000 circulation)

THE MEMBERS' CHOICE AWARD

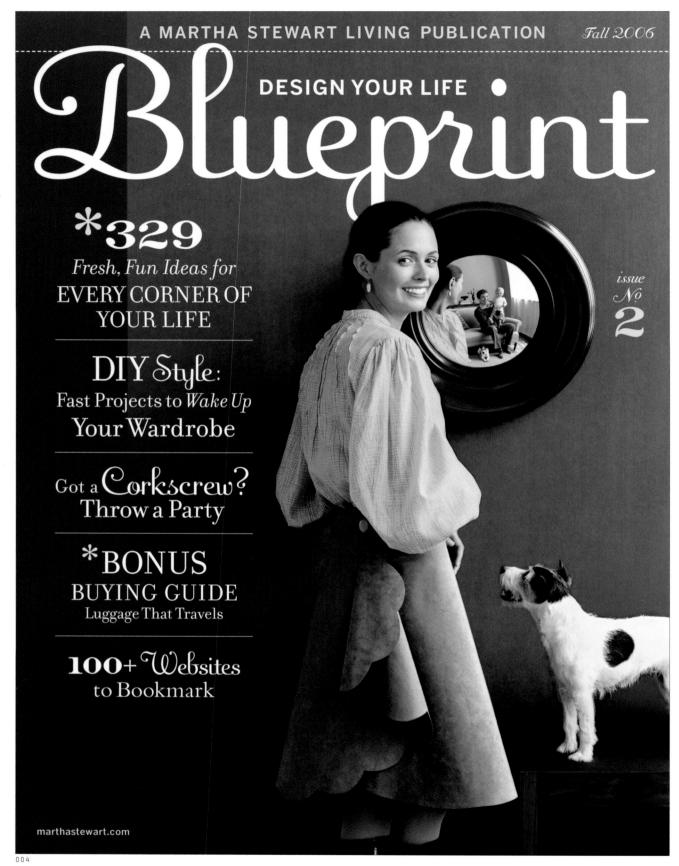

A MARTHA STEWART LIVING PUBLICATION · *Fall 2006*

DESIGN YOUR LIFE

Blueprint

issue Nº 2

***329**
Fresh, Fun Ideas for
EVERY CORNER OF
YOUR LIFE

DIY *Style:*
Fast Projects to *Wake Up*
Your Wardrobe

Got a *Corkscrew?*
Throw a Party

***BONUS**
BUYING GUIDE
Luggage That Travels

100+ *Websites*
to Bookmark

marthastewart.com

004

004. **BLUEPRINT**

creative director. Eric A. Pike. design director. Deb Bishop. designers. Cybele Grandjean, Jennifer Merrill. illustrators. Natasha Tibbott.
Mark Watkinson, Melinda Beck. director of photography. Heloise Goodman. photo editors. Sara McOsker, Mary Cahill
photographers. Jens Mortensen, Karl Juengel, William Waldron, Gentl & Hyers, Roland Bello, Craig Cutler, Mikkel Vang, David Meredith
stylists. Page Marchese Norman, Shane Powers, Rebecca Robertson, Kendra Smoot, Katie Hatch, Jennifer Aaronson
editor-in-chief. Sarah Humphreys. publisher. Martha Stewart Living Omnimedia. issue. Fall 2006. category. Members' Choice

HOW Suede IT IS

9

easy projects

a sexy no-sew skirt, a simple sash,
a cool hair band,
PLUS PILLOWS, ELBOW PATCHES &
ipod cases
that add warmth
AND WIT
to every corner of your life

PHOTOGRAPHS BY GENTL & HYERS

Text by Rory Evans

An Easy Little Number
"If you can sew a button, you can make this skirt," says Blueprint fashion editor Katie Hatch. All the projects on these pages are made of cut-and-go microfiber suede (the best known: Ultrasuede). For the scalloped edge, Katie traced an oatmeal canister. "Yes, it's that unscientific," she says. How-tos for all projects, page 114. Ultrasuede Soft in Executive Grey, $40 per yard, fieldsfabrics.com; Maria Bonita Extra Blouse, $248, Mick Margo, 212-463-0515; "Janell" boots, $360, Cole Haan, 800-201-8001; DKNY tights, $12.50, eluxury.com for stores

106 *Blueprint* FALL 2006

004

+ Design: Spread

129 — PLUCKY CHARMS
43 — ROOM-BY-ROOM REDOS
Blueprint MAY 2006
8 — ANYTIME DRESSES
69 — PARTY FOODS, DRINKS, TUNES & TIPS
30 — NICE NOTE CARDS
19 — OVERNIGHT BEAUTY BALMS
3 — INSTANT HANDBAGS

97

004

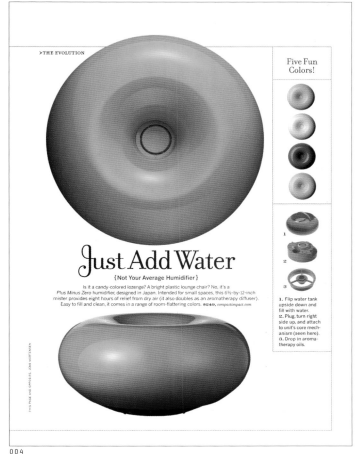

>THE EVOLUTION

Five Fun
Colors!

Just Add Water

{ Not Your Average Humidifier }

Is it a candy-colored lozenge? A bright plastic lounge chair? No, it's a Plus Minus Zero humidifier, designed in Japan. Intended for small spaces, this 6½-by-12-inch mister provides eight hours of relief from dry air (it also doubles as an aromatherapy diffuser). Easy to fill and clean, it comes in a range of room-flattering colors. $249, compactimpact.com

1. Flip water tank upside down and fill with water. 2. Plug, turn right side up, and attach to unit's core mechanism (seen here). 3. Drop in aromatherapy oils.

004

17

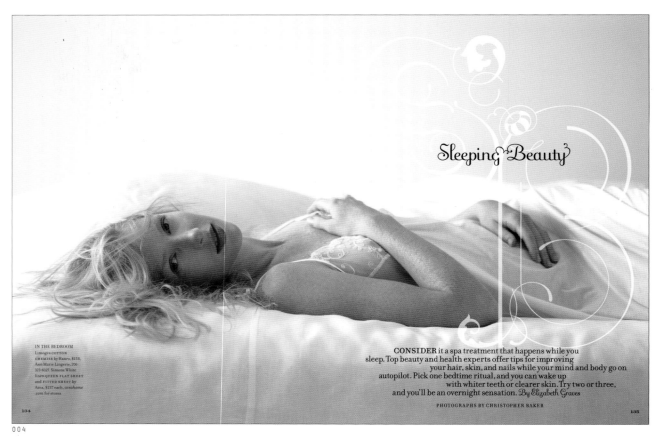

Sleeping Beauty

IN THE BEDROOM
Limoges COTTON
CHEMISE by Hanro, $158,
Ann Marie Lingerie, 206-
323-6627. Simone White
linen QUEEN FLAT SHEET
and FITTED SHEET by
Area, $237 each, areahome
.com for stores

134

CONSIDER it a spa treatment that happens while you
sleep. Top beauty and health experts offer tips for improving
your hair, skin, and nails while your mind and body go on
autopilot. Pick one bedtime ritual, and you can wake up
with whiter teeth or clearer skin. Try two or three,
and you'll be an overnight sensation. *By Elizabeth Graves*

PHOTOGRAPHS BY CHRISTOPHER BAKER

135

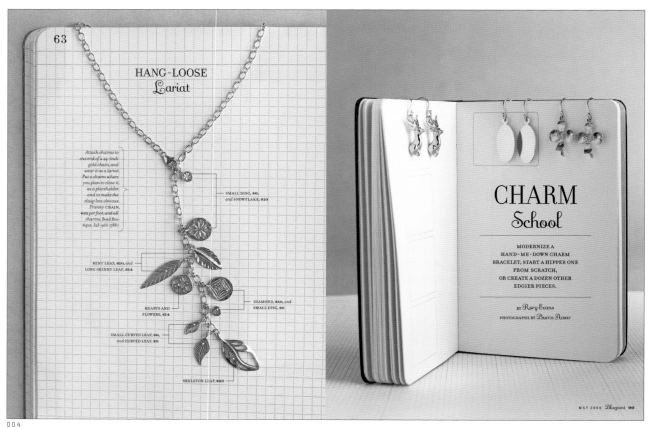

63

HANG-LOOSE
Lariat

Attach charms to
one end of a 24-inch
gold chain, and
wear it as a lariat.
Put a charm where
you plan to close it,
as a placeholder,
and to make the
clasp less obvious.
*Franky CHAIN,
$2a per foot, and all
charms, Bead Bou-
tique, 323-966-5880*

SMALL DISC, $6,
and SNOWFLAKE, $10

BENT LEAF, $10, and
LONG SKINNY LEAF, $14

HEARTS AND
FLOWERS, $14

DIAMOND, $10, and
SMALL DISC, $6

SMALL CURVED LEAF, $6,
and CURVED LEAF, $8

SKELETON LEAF, $20

CHARM
School

MODERNIZE A
HAND-ME-DOWN CHARM
BRACELET, START A HIPPER ONE
FROM SCRATCH,
OR CREATE A DOZEN OTHER
EDGIER PIECES.

By Rory Evans

PHOTOGRAPHS BY *Burcu Avsar*

MAY 2006 *Blueprint* 99

004. **BLUEPRINT**

creative director. Eric A. Pike. design director. Deb Bishop. designers. Cybele Grandjean, Jennifer Merrill. illustrators. Natasha Tibbott,
Mark Watkinson, Melinda Beck. director of photography. Heloise Goodman. photo editors. Sara McOsker, Mary Cahill
photographers. Jens Mortensen, Karl Juengel, William Waldron, Gentl & Hyers, Roland Bello, Craig Cutler, Mikkel Vang, David Meredith
stylists. Page Marchese Norman, Shane Powers, Rebecca Robertson, Kendra Smoot, Katie Hatch, Jennifer Aaronson
editor-in-chief. Sarah Humphreys. publisher. Martha Stewart Living Omnimedia. issue. Fall 2006. category. Members' Choice

THE GOLD AWARDS

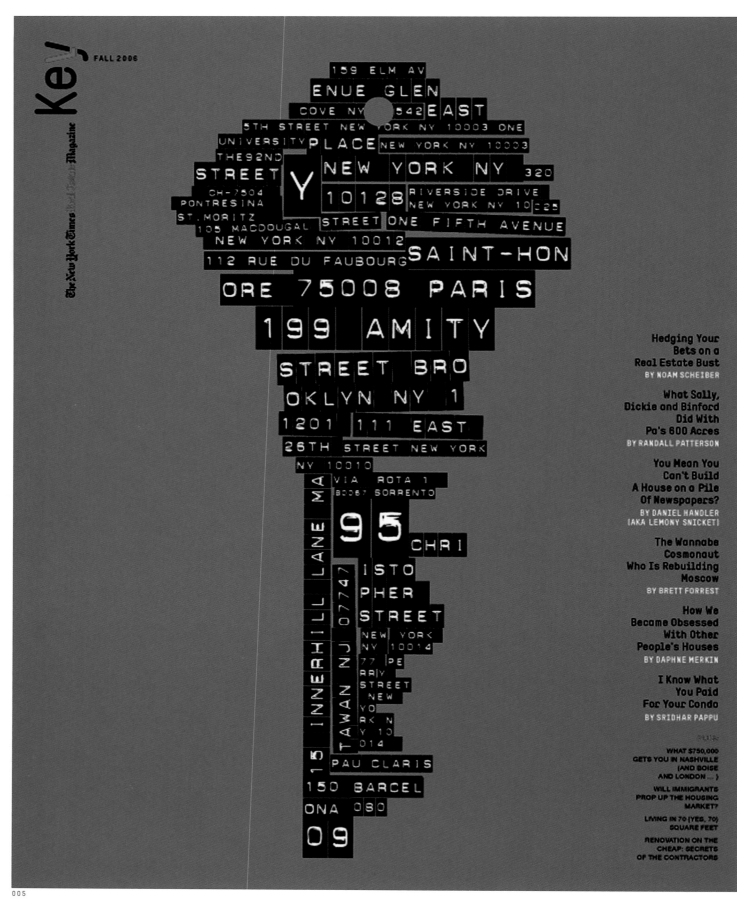

005. **KEY, THE NY TIMES REAL ESTATE MAGAZINE**

creative director. Janet Froelich. art directors. Arem Duplessis, Dirk Barnett. designer. Dirk Barnett. illustrator. Carin Goldberg
publisher. The New York Times. issue. Fall 2006. category. Design: Cover

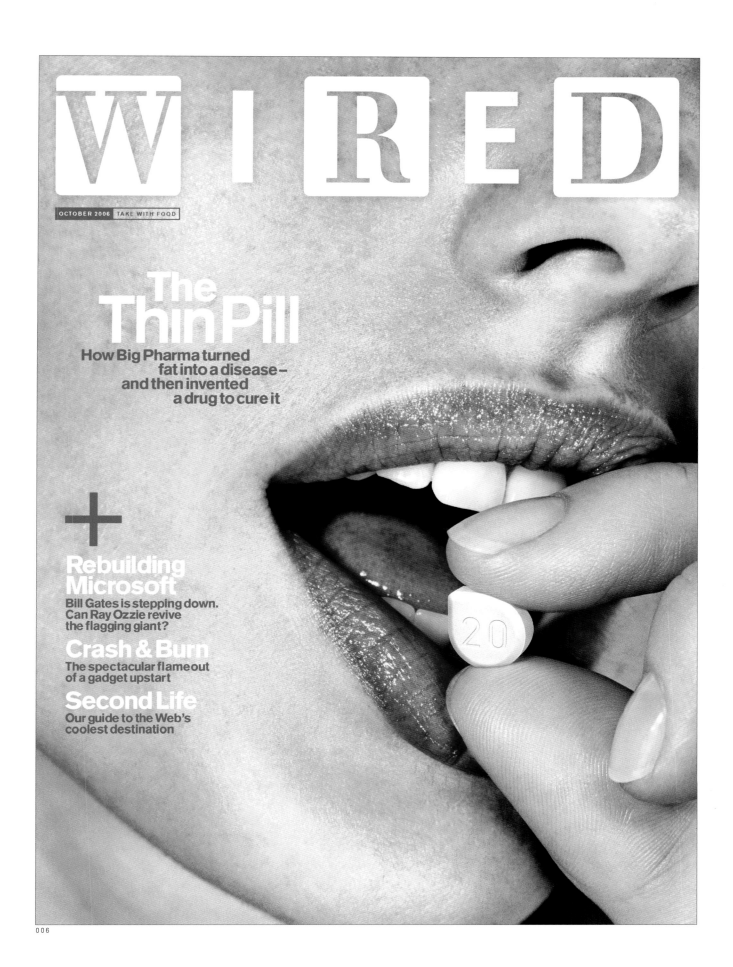

WIRED

OCTOBER 2006 TAKE WITH FOOD

The Thin Pill

How Big Pharma turned
fat into a disease –
and then invented
a drug to cure it

+

Rebuilding Microsoft
Bill Gates is stepping down.
Can Ray Ozzie revive
the flagging giant?

Crash & Burn
The spectacular flameout
of a gadget upstart

Second Life
Our guide to the Web's
coolest destination

006

006. **WIRED**

creative director. Scott Dadich. designer. Scott Dadich. director of photography. Matt Mowat. photo editor. Carolyn Rauch
photographer. Olaf Blecker. publisher. Condé Nast Publications, Inc. issue. October 2006. category. Design: Cover + Design: Entire Issue

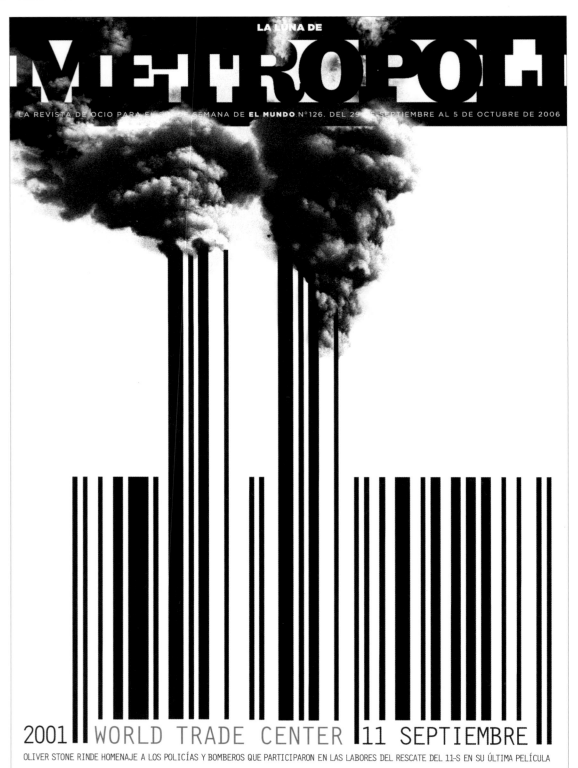

007. **LA LUNA DE METROPOLI**

design director. Carmelo Caderot
art director. Rodrigo Sanchez
designer. Rodrigo Sanchez
illustrator. Raúl Arias
publisher. Unidad Editorial S.A.
issue. September 29, 2006
category. Design: Cover

008. **GQ**

design director. Fred Woodward
designers. Anton Ioukhnovets, Thomas Alberty,
Michael Pangilinan, Drue Wagner, Eve Binder,
Delgis Canahuate
director of photography. Dora Somosi
photo editors. Justin O'Neill, Jolanta Bielat,
Jesse Lee. photographer. Terry Richardson
senior photo editor. Krista Prestek
editor-in-chief. Jim Nelson
publisher. Condé Nast Publications Inc.
issue. December 2006
category. Design: Entire Issue

009. **NATIONAL GEOGRAPHIC ADVENTURE**

design director. Julie Curtis
director of photography. Sabine Meyer
photographer. Paul Taggart / WPN
publisher. National Geographic Society
issue. May 2006
category. Photo: Spread

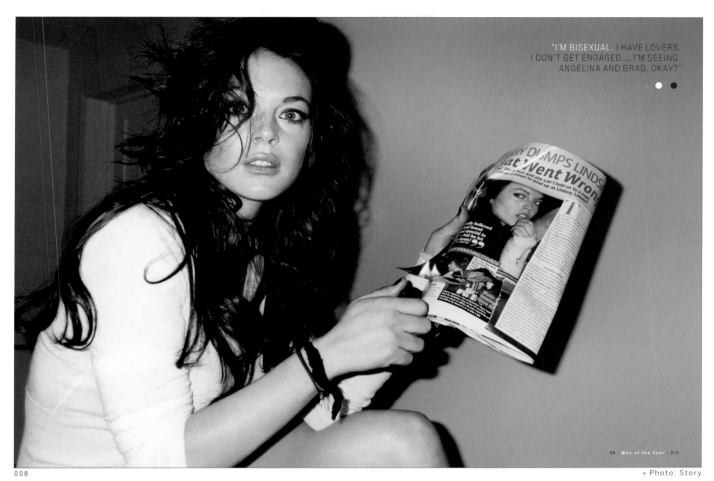

06 | Men of the Year | 315

008

+ Photo: Story

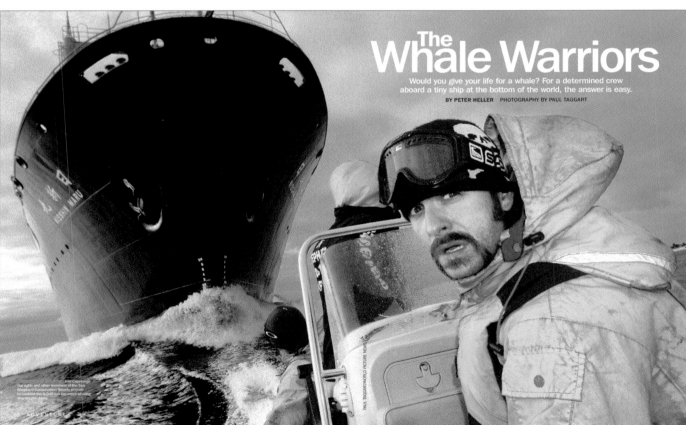

The
Whale Warriors

Would you give your life for a whale? For a determined crew
aboard a tiny ship at the bottom of the world, the answer is easy.

BY PETER HELLER PHOTOGRAPHY BY PAUL TAGGART

009

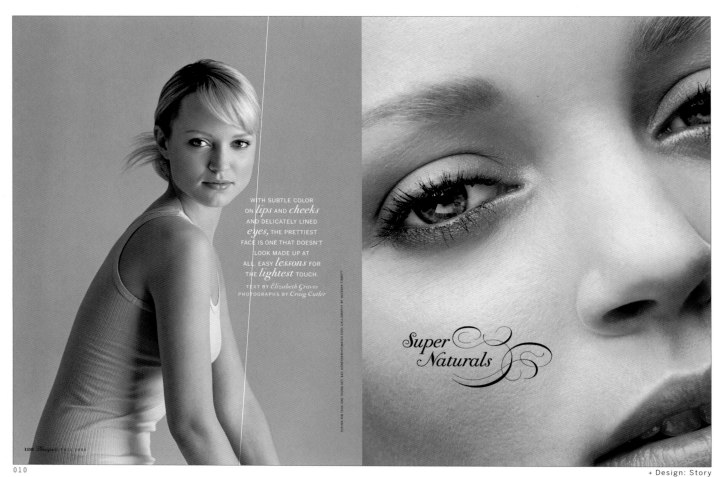

+ Design: Story

010

010. **BLUEPRINT**

creative director. Eric A. Pike. design director. Deb Bishop. designers. Cybele Grandjean, Jennifer Merrill. illustrators. Natasha Tibbott, Mark Watkinson. Melinda Beck. director of photography. Heloise Goodman. photo editors. Sara McOsker, Mary Cahill. photographers. Jens Mortensen, Karl Juengel, William Waldron, Gentl & Hyers, Roland Bello, Craig Cutler, Mikkel Vang, David Meredith. stylists. Page Marchese Norman, Shane Powers, Rebecca Robertson, Kendra Smoot, Katie Hatch, Jennifer Aaronson. editor-in-chief. Sarah Humphreys. publisher. Martha Stewart Living Omnimedia. issue. Fall 2006. category. Design: Entire Issue

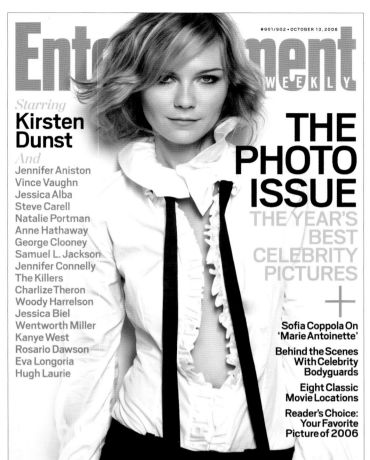

011

011

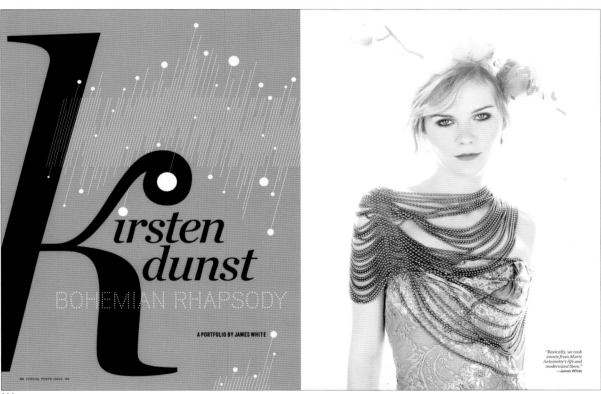

011

011. **ENTERTAINMENT WEEKLY**

design director. Geraldine Hessler. art director. Brian Anstey. director of photography. Fiona McDonagh. photo editors. Richard Maltz, Audrey Landreth, Michelle Romero, Carrie Levitt, Freyda Tavin, Michael Kochman, Suzanne Regan, Kristine Chin, Rachael Lieberman, Samantha Xu. photographers. Eric Ogden, Bruce Gilden, Jeff Riedel, Patrick Hoelck, Emily Shur, James Dimmock, James White, Henrik Knudsen, Brian Bower Smith, Guy Aroch, Martin Schoeller, Gavin Bond, Jeff Minton, Platon. managing editor. Rick Tetzeli. publisher. Time Inc. issue. October 13, 2006. category. Design: Entire Issue

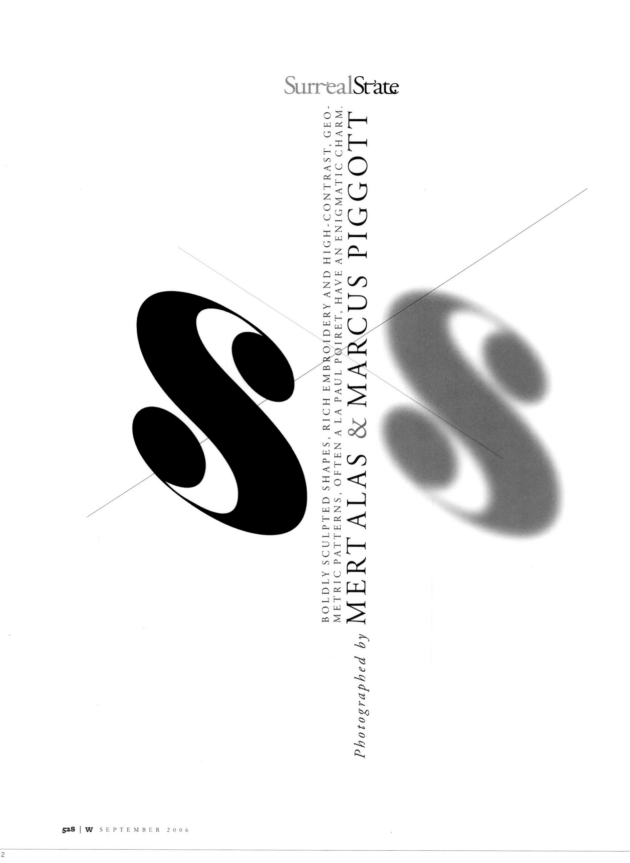

SurrealState

BOLDLY SCULPTED SHAPES, RICH EMBROIDERY AND HIGH-CONTRAST, GEO-
METRIC PATTERNS, OFTEN A LA PAUL POIRET, HAVE AN ENIGMATIC CHARM.

Photographed by MERT ALAS & MARCUS PIGGOTT

012. **W**

design director. Edward Leida. designer. Edward Leida. photographer. Mert Alas & Marcus Piggott
publisher. Condé Nast Publications Inc. issue. September 2006. category. Design: Spread

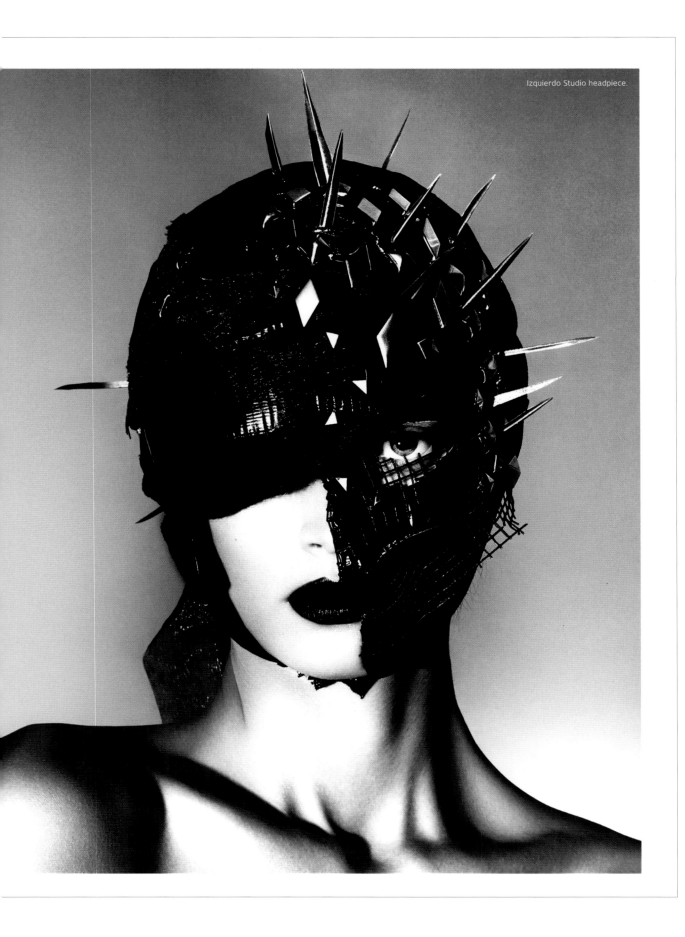

Izquierdo Studio headpiece.

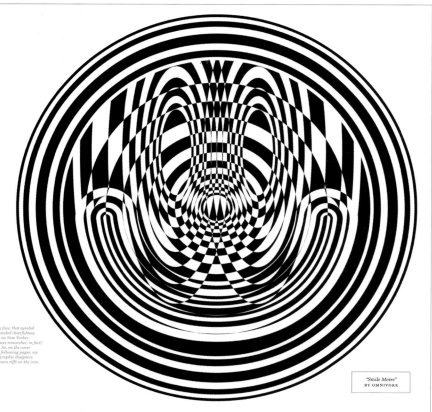

SOME
DARK THOUGHTS
ON
HAPPINESS

More and more psychologists
and researchers believe
they know what makes people happy.
But the question is, does a
New Yorker *want* to be happy?

BY *Jennifer Senior*

THEY SAY YOU CAN'T REALLY ASSIGN a number to happiness,
but mine, it turns out, is 2.88. That's not as bad as it sounds. I
was being graded on a scale of 1 to 5. My score was below average for my age, education level, gender, and occupation, sure, but at exactly the 50 percent
mark for my Zip Code. Liking my job probably
helped, being an atheist did not, and neither did
my own brain chemistry, which, in spite of my best efforts to improve it,
remains more acidic than I'd like. Unhappy thoughts can find surprisingly little resistance up there, as if they've found some wild river to run
along, while everything else piles up along the banks.

The test I took was something called the Authentic Happiness Inventory, and the man who designed it, Chris Peterson, is one of the first people I
meet at the Positive Psychology Center at the University of Pennsylvania.
Unlike many who study happiness for a living, he seems to embody it, though he tells me
that's a recent development. He offers me an impromptu tour of the place (walls of salmon
and plum and turquoise; tables piled high with complimentary granola bars), then wan-

*The smiley face, that symbol
of empty-headed cheerfulness,
is a visage no New Yorker
(or happiness researcher, in fact)
could love. So, on the cover
and in the following pages, six
New York graphic designers
offer their own riffs on the icon.*

"Smile Moiré"
BY OMNIVORE

013

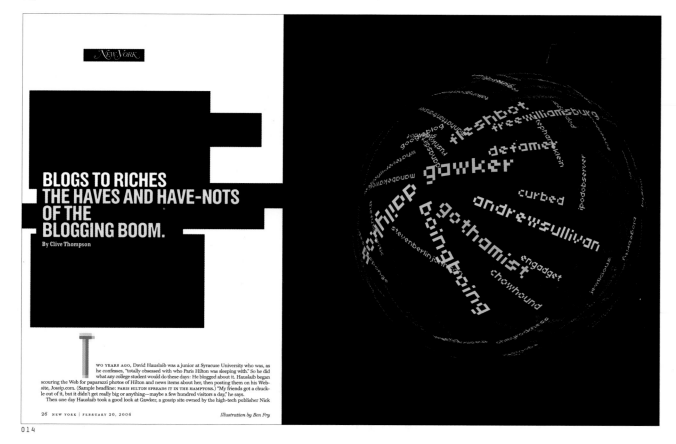

New York

BLOGS TO RICHES
THE HAVES AND HAVE-NOTS
OF THE
BLOGGING BOOM.

By Clive Thompson

TWO YEARS AGO, David Hauslaib was a junior at Syracuse University who was, as
he confesses, "totally obsessed with who Paris Hilton was sleeping with." So he did
what any college student would do these days: He blogged about it. Hauslaib began
scouring the Web for paparazzi photos of Hilton and news items about her, then posting them on his Website, Jossip.com. (Sample headline: PARIS HILTON SPREADS IT IN THE HAMPTONS.) "My friends got a chuckle out of it, but it didn't get really big or anything—maybe a few hundred visitors a day," he says.

Then one day Hauslaib took a good look at Gawker, a gossip site owned by the high-tech publisher Nick

Illustration by Ben Fry

014

013. **NEW YORK**

design director. Luke Hayman. art director. Chris Dixon. designer. Chris Dixon
illustrators. Michael Bierut, Rebecca Gimenez, Pentagram, Open NY,
Stephen Doyle, Knickerbocker, Omnivore. director of photography. Jody Quon
editor-in-chief. Adam Moss. publisher. New York Magazine Holdings. LLC
issue. July 17, 2006. category. Illustration: Story

014. **NEW YORK**

design director. Luke Hayman. art director. Chris Dixon. designer. Chris Dixon
illustrator. Ben Fry. director of photography. Jody Quon
photo editor. Lisa Corson. photographers. Phillip Toledano, Frank Schwere
editor-in-chief. Adam Moss. publisher. New York Magazine Holdings. LLC
issue. February 20, 2006. category. Design: Story

whiteheat

photography by horacio salinas
styling by beverley hyde
prop styling by molly findlay

015

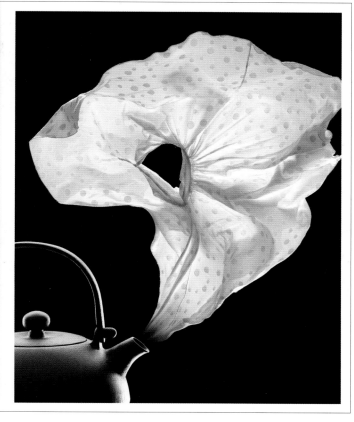

A Better Crystal Ball

personalized medicine promises a new
level of clarity with treatments tailored to one's genes
but it hinges on development
of exacting gene-based tests

BY MAYA PINES
PHOTOGRAPHS BY NOAH WEBB AND PAUL FETTERS

015. **CITY**

creative director. Fabrice Frere. art director. Adriana Jacoud
photo editor. Sarah Greenfield. photographer. Horacio Salinas
publisher. Spark Media. issue. April 2006
category. Photo: Spread

016. **HOWARD HUGHES MEDICAL INSTITUTE BULLETIN**

creative director. Hans Neubert. art director. Sarah Viñas
designer. Sarah Viñas. illustrators. Sarah Viñas, Jen Liao
studio. VSA Partners. publisher. Howard Hughes Medical Institute
issue. August 2006. category. Design: Spread

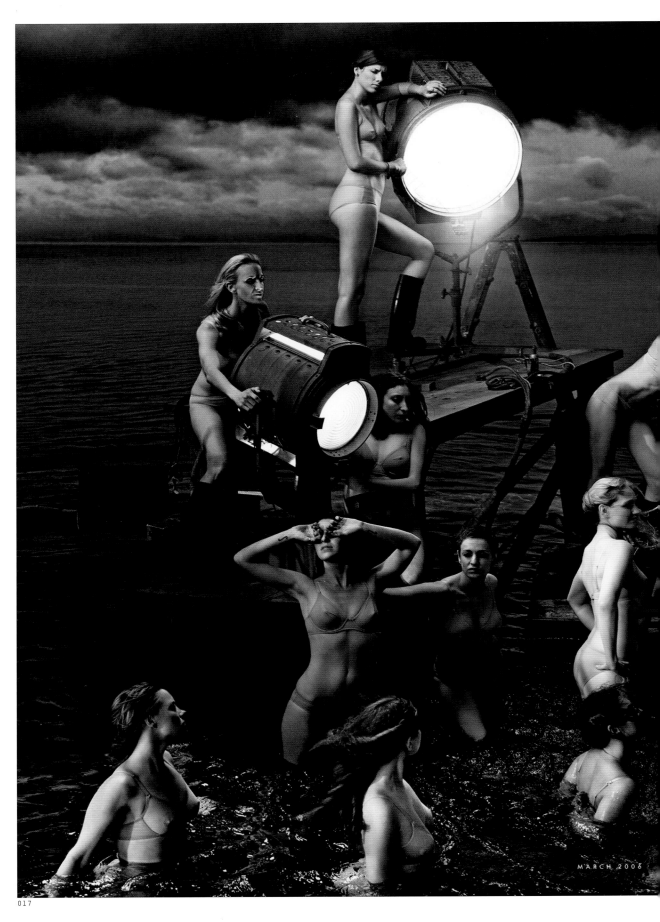

017

017. **VANITY FAIR**

design director. David Harris. art director. Julie Weiss. director of photography. Susan White. photographer. Annie Leibovitz
editor-in-chief. Graydon Carter. publisher. Condé Nast Publications Inc. issue. March 2006. category. Photo: Spread

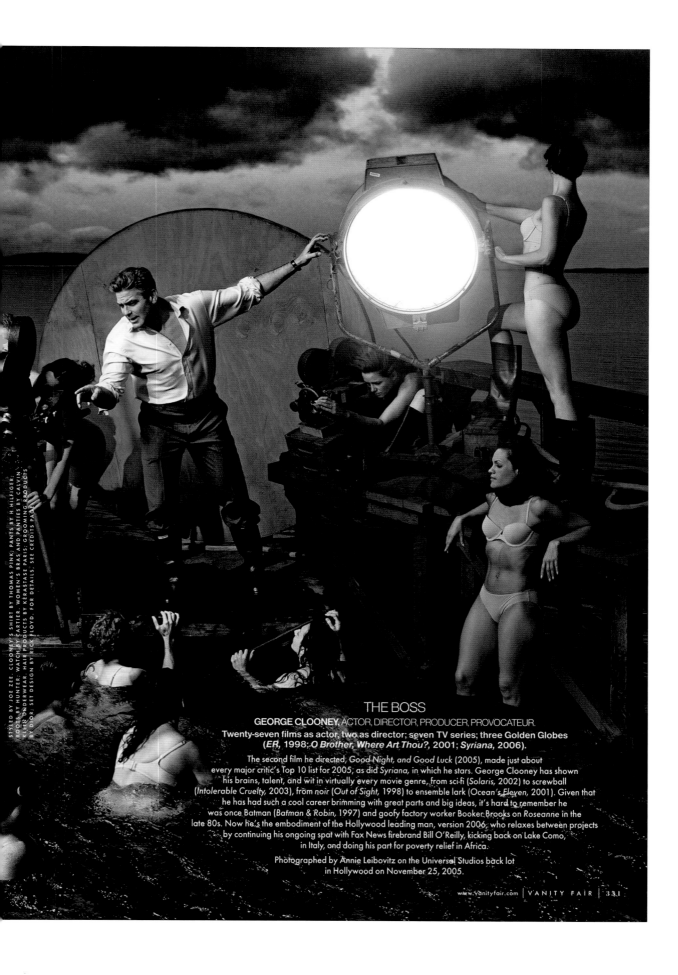

THE BOSS

GEORGE CLOONEY, ACTOR, DIRECTOR, PRODUCER, PROVOCATEUR.

**Twenty-seven films as actor, two as director; seven TV series; three Golden Globes
(*ER*, 1998; *O Brother, Where Art Thou?*, 2001; *Syriana*, 2006).**

The second film he directed, *Good Night, and Good Luck* (2005), made just about
every major critic's Top 10 list for 2005; as did *Syriana*, in which he stars. George Clooney has shown
his brains, talent, and wit in virtually every movie genre, from sci-fi (*Solaris*, 2002) to screwball
(*Intolerable Cruelty*, 2003), from noir (*Out of Sight*, 1998) to ensemble lark (*Ocean's Eleven*, 2001). Given that
he has had such a cool career brimming with great parts and big ideas, it's hard to remember he
was once Batman (*Batman & Robin*, 1997) and goofy factory worker Booker Brooks on *Roseanne* in the
late 80s. Now he's the embodiment of the Hollywood leading man, version 2006, who relaxes between projects
by continuing his ongoing spat with Fox News firebrand Bill O'Reilly, kicking back on Lake Como,
in Italy, and doing his part for poverty relief in Africa.

Photographed by Annie Leibovitz on the Universal Studios back lot
in Hollywood on November 25, 2005.

So fia's
PARIS

SOFIA COPPOLA SCOUTED THE CITY OF LIGHT TO
DIRECT HER LATEST FILM, 'MARIE ANTOINETTE.' IN BETWEEN, SHE INDULGED IN HER
FAVORITE FRENCH SPORT, SHOPPING. LYNN HIRSCHBERG TAGS ALONG.
Portrait by JEAN-BAPTISTE MONDINO **Photographs by** ANDREW DURHAM

CHANEL PARIS-NEW YORK COLLECTION DRESS. STYLED BY ALEXANDRA BERNARD AT MAREK & ASSOCIATES. HAIR BY ODILE GILBERT FOR ATELIER 68.
MAKEUP BY RÉGINE BEDOT AT MARIE-FRANCE THAVONEKHAM AGENCY.

018

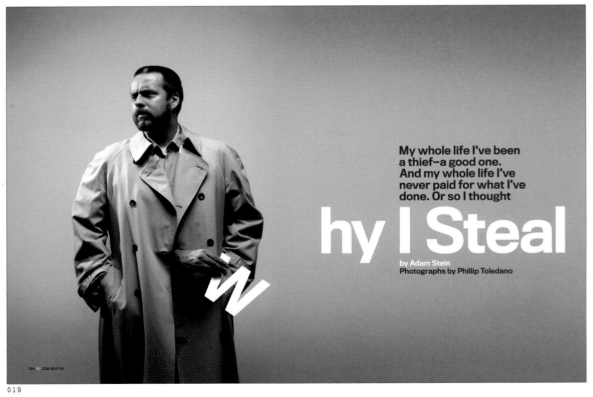

My whole life I've been
a thief—a good one.
And my whole life I've
never paid for what I've
done. Or so I thought

hy I Steal

by Adam Stein
Photographs by Phillip Toledano

019

018. **T. THE NY TIMES STYLE MAGAZINE**

creative director. Janet Froelich. senior art director. David Sebbah
art director. Christopher Martinez. designer. Christopher Martinez
director of photography. Kathy Ryan
senior photo editor. Judith Puckett-Rinella. photographers. Andrew Durham,
Jean-Baptiste Mondino. editor-in-chief. Stefano Tonchi. publisher. The New York
Times. issue. September 24, 2006. category. Design: Story

019. **GQ**

design director. Fred Woodward. art director. Ken DeLago
designer. Thomas Alberty. director of photography. Dora Somosi
photo editor. Justin O'Neill. photographer. Phillip Toledano
editor-in-chief. Jim Nelson. publisher. Condé Nast Publications Inc.
issue. March 2006. category. Design: Spread

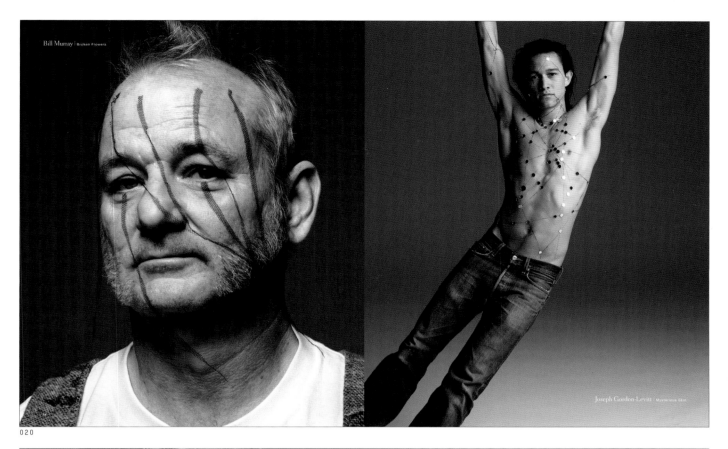

Bill Murray | Broken Flowers

Joseph Gordon-Levitt | Mysterious Skin

020

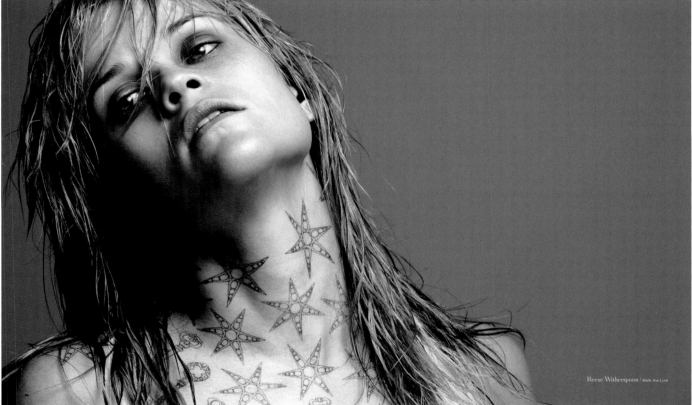

Reese Witherspoon | Walk the Line

020

020. **THE NEW YORK TIMES MAGAZINE**

creative director. Janet Froelich. art director. Arem Duplessis. designer. Cathy Gilmore-Barnes. director of photography. Kathy Ryan
photographers. Inez van Lamsweerde, Vinoodh Matadin. editor-in-chief. Gerald Marzorati. publisher. The New York Times. issue. February 19, 2006
category. Photo: Story

WILL FERRELL is the best _male model_ of his generation. He's a hero to _Small Children in Yemen_. He looks great in a _Kimono_. And he's awfully good at filling in the blanks of a classically clichéd celebrity profile

by JASON GAY _and Will Ferrell_

GQ . 146 . PHOTOGRAPHS BY MARK SELIGER

021

WILL FERRELL IS _half-cocked._ It's a painfully early morning at the _Bevonshire Lodge motel_, and when I knock on the door to Ferrell's room, he opens it dressed in only a _Kimono_ and a _Clippers hat_. His face resembles a _jigsaw puzzle_, and in the background I hear the television tuned to _The Rockford Files_ and see a half-empty bottle of _Laughing Clown malt liquor_.

"Sorry, man," he says as a _California condor_ chirps in the distance. "I didn't get home until _6 a.m._! We went out to the _airport Hilton_, and I thought I'd be in bed by midnight. But then _Gary Busey_ showed up and things just got crazy! We wound up at _Chuck Mangione's_ house, and I think I ate a _box of condoms_!"

Ferrell laughs. It's been more than _12_ years since we last met, and the 53-year-old actor has been on a remarkable ride. The first time I saw him, Ferrell was still a struggling _knife thrower_, trying to find his way in an uncompromising business. He was far from the _$80 million_-per-picture superstar he is today—the comic genius celebrated for his work in such films as _Old School_ and _Drowning Mona_. Back in the old days, Ferrell drove a _golf cart_. He ate his meals at _Ralphs_ supermarket, and his only dream was that one day he'd _get to design a line of throwing knives made out of shark cartilage._

"Let's eat some breakfast!" Ferrell announces. He calls out to his loyal assistant, who is sleeping under a hibiscus tree. "_Captain Greg! Captain Greg!_" he cries. A few minutes later, we're surrounded by a feast of _lobster, mango, and chili_. Ferrell inhales a bite. "Mmmmmm!" he says. "You like this recipe? _Jan-Michael Vincent_ gave it to me on the set of _Knight Hawk 4._ Fantastic!"

There are many things I want to ask

▪ NOTE TO READER: Will Ferrell filled in all the blanks for this story. He did a very _disturbing_ job.

148.GQ.COM.JUL.06

021

021. **GQ**
design director. Fred Woodward. designer. Ken DeLago
director of photography. Dora Somosi. photographer. Mark Seliger
editor-in-chief. Jim Nelson. publisher. Condé Nast Publications Inc.
issue. July 2006. category. Photo: Story

022. **GQ**
design director. Fred Woodward. designer. Anton Ioukhnovets
director of photography. Dora Somosi. photo editors. Justin O'Neill, Jesse Lee
photographer. Dan Forbes. editor-in-chief. Jim Nelson
publisher. Condé Nast Publications Inc. issue. October 2006
category. Design: Front/Back of Book

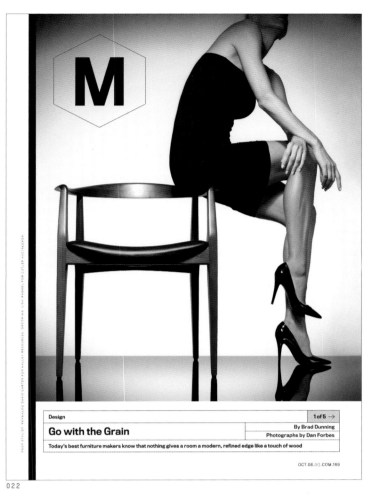

Design | 1 of 5 →

Go with the Grain

By Brad Dunning

Photographs by Dan Forbes

Today's best furniture makers know that nothing gives a room a modern, refined edge like a touch of wood

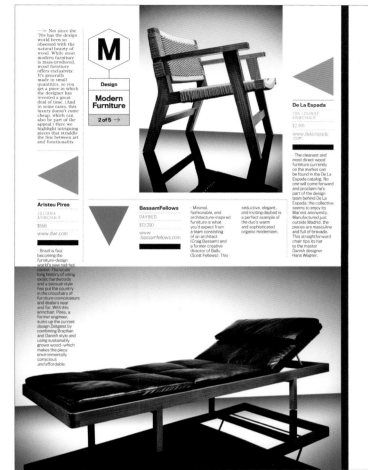

→ Not since the '70s has the design world been so obsessed with the natural beauty of wood. While most modern furniture is mass-produced, wood furniture offers exclusivity: It's generally made in small quantities, so you get a piece in which the designer has invested a great deal of time. (And in some cases, this luxury doesn't come cheap, which can also be part of the appeal.) Here we highlight intriguing pieces that straddle the line between art and functionality.

De La Espada

135 LOUNGE ARMCHAIR

$2,695

www.delaespada .com

· The cleanest and most direct wood furniture currently on the market can be found in the De La Espada catalog. No one will come forward and proclaim he's part of the design team behind De La Espada; the collective seems to enjoy its Marxist anonymity. Manufactured just outside Madrid, the pieces are masculine and full of bravado. This straightforward chair tips its hat to the master Danish designer Hans Wegner.

Aristeu Pires

JULIANA ARMCHAIR

$595

www.dwr.com

· Brazil is fast becoming the furniture-design world's new red-hot center. The locals' long history of using exotic hardwoods and a sensual style has put the country in the crosshairs of furniture connoisseurs and dealers near and far. With this armchair, Pires, a former engineer, sums up the current design Zeitgeist by combining Brazilian and Danish style and using sustainably grown wood—which makes the piece environmentally conscious and affordable.

BassamFellows

DAYBED

$13,200

www .bassamfellows.com

· Minimal, fashionable, and architecture-inspired furniture is what you'd expect from a team consisting of an architect (Craig Bassam) and a former creative director of Bally (Scott Fellows). This seductive, elegant, and inviting daybed is a perfect example of the duo's warm and sophisticated organic modernism.

John Houshmand

CONFERENCE COFFEE TABLE NO. 0026

$19,200

www .johnhoushmand .com

· Houshmand's work is a loose visual relative to that of the highly influential George Nakashima, whose massive midcentury pieces have skyrocketed in price in recent years. Houshmand treats barely fussed-over planks or stumps as works of art themselves, as if they were gifts from some god of the timberlands. His pieces are particularly striking when they're set off with a steel base, as in this simple but affective coffee table.

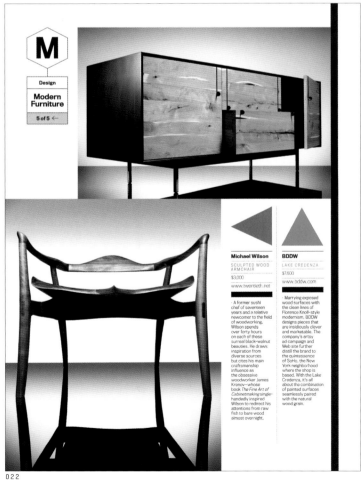

Michael Wilson

SCULPTED WOOD ARMCHAIR

$3,000

www.twentieth.net

· A former sushi chef of seventeen years and a relative newcomer to the field of woodworking, Wilson spends over forty hours on each of these surreal black-walnut beauties. He draws inspiration from diverse sources but cites his main craftsmanship influence as the obsessive woodworker James Krenov—whose book The Fine Art of Cabinetmaking single-handedly inspired Wilson to redirect his attentions from raw fish to bare wood almost overnight.

BDDW

LAKE CREDENZA

$7,600

www.bddw.com

· Marrying exposed wood surfaces with the clean lines of Florence Knoll–style modernism, BDDW designs pieces that are insidiously clever and marketable. The company's artsy ad campaign and Web site further distill the brand to the quintessence of SoHo, the New York neighborhood where the shop is based. With the Lake Credenza, it's all about the combination of painted surfaces seamlessly paired with the natural wood grain.

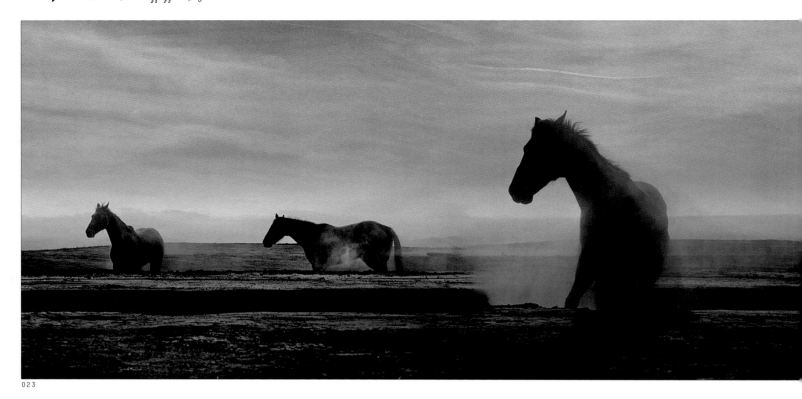

023

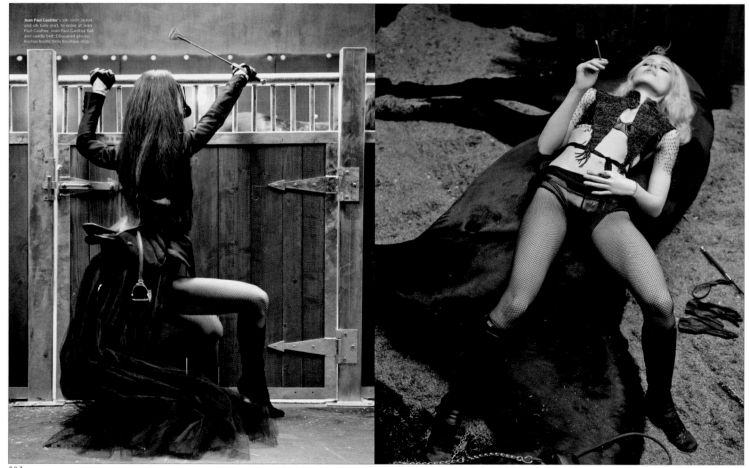

Jean Paul Gaultier's silk-satin jacket and silk-tulle skirt, to order at Jean Paul Gaultier; Jean Paul Gaultier hat and saddle belt; DSquared gloves; Rochas boots; Eros Boutique crop.

023

023. **W**

creative director. Dennis Freedman. design director. Edward Leida. designer. Edward Leida. photographer. Steven Klein
publisher. Condé Nast Publications Inc. issue. June 2006. category. Photo: Story + Design: Entire Issue

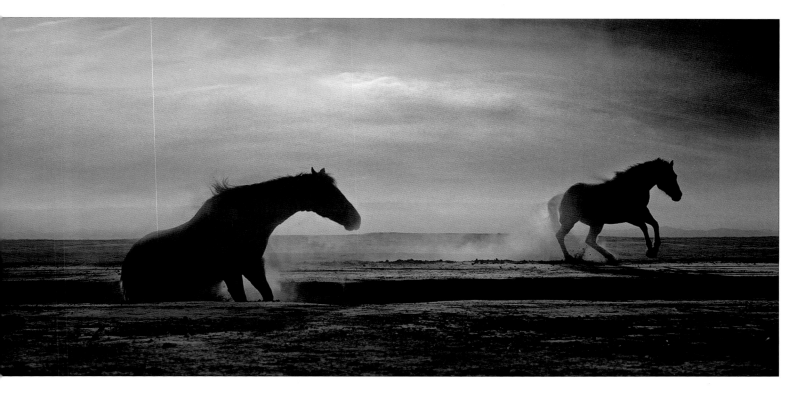

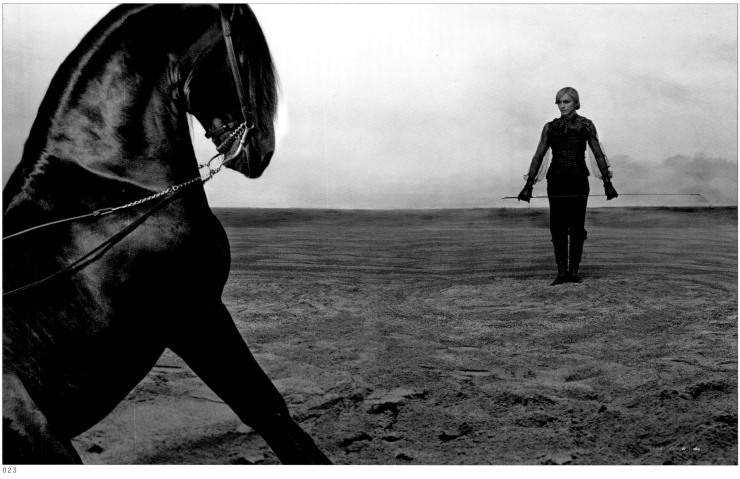

023

What If It's (**Sort of**) a Boy and (**Sort of**) a Girl?

For decades, doctors have operated on babies born with ambiguous genitalia. But there is a growing debate about the role physicians — and parents — should play in physically shaping children.

By Elizabeth Weil

Illustration by Christoph Niemann

48

024. **THE NEW YORK TIMES MAGAZINE**

creative director. Janet Froelich. art director. Arem Duplessis. designer. Nancy Harris Rouemy. illustrator. Christoph Niemann
editor-in-chief. Gerald Marzorati. publisher. The New York Times. issue. September 24, 2006. category. Illustration: Spread

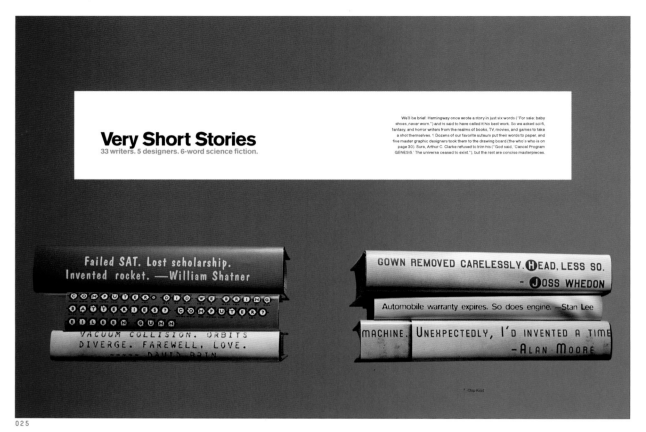

025

025

025. **WIRED**

creative director. Scott Dadich. design director. Bob Ciano. designers. Carl DeTorres, Allister Fein, Scott Dadich
illustrators. Chip Kidd, Frost Design, Tomato, Stephen Doyle, John Maeda. publisher. Condé Nast Publications, Inc.
issue. November 2006. category. Design: Story

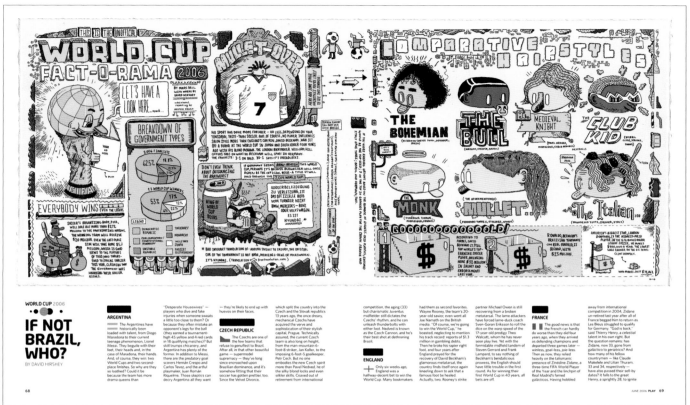

026

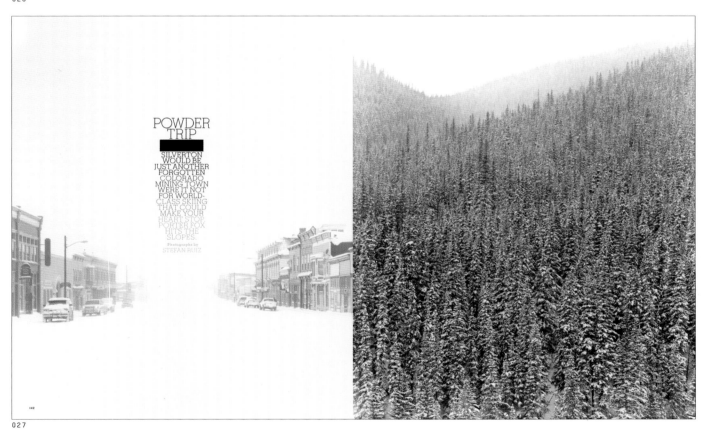

027

026. **PLAY, THE NY TIMES SPORT MAGAZINE**

creative director. Janet Froelich. art director. Christopher Martinez
designer. Guillermo Nagore. illustrator. Marc Bell
editor-in-chief. Mark Bryant. publisher. The New York Times
issue. June 2006. category. InfoGraphics: Story

027. **T, THE NY TIMES STYLE MAGAZINE**

creative director. Janet Froelich. art director. Christopher Martinez
designer. David Sebbah. director of photography. Kathy Ryan
photographer. Stefan Ruiz. senior art director. David Sebbah
senior photo editor. Judith Puckett-Rinella. editor-in-chief. Stefano Tonchi
publisher. The New York Times. issue. November 19, 2006
category. Design: Spread

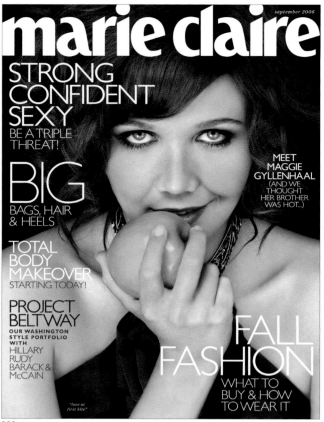

028

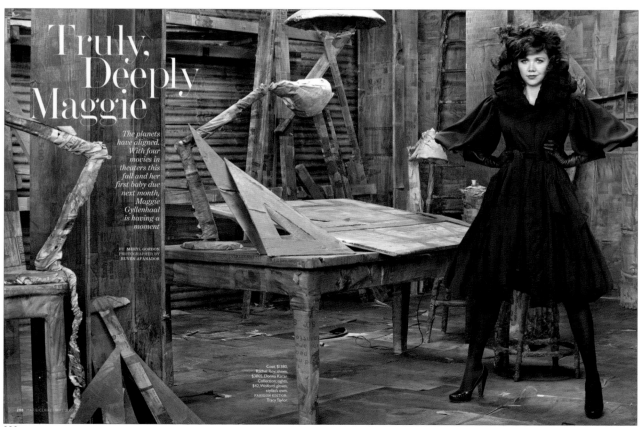

028

028. MARIE CLAIRE

creative director. Paul Martinez. art director. Jenny Leigh Thompson. designers. Paul Martinez, Jenny Leigh Thompson, Shannon Casey, Burgan Shealy, Greg Behar. director of photography. Alix Campbell. photo editors. Andrea Volbrecht, Melanie Chambers. photographers. Ruven Afanador, Jeff Harris, Geof Kern. art/photo assistant. Margo Didia. editor-in-chief. Joanna Coles. publisher. The Hearst Corporation-Magazines Division issue. September 2006. category. Design: Redesign

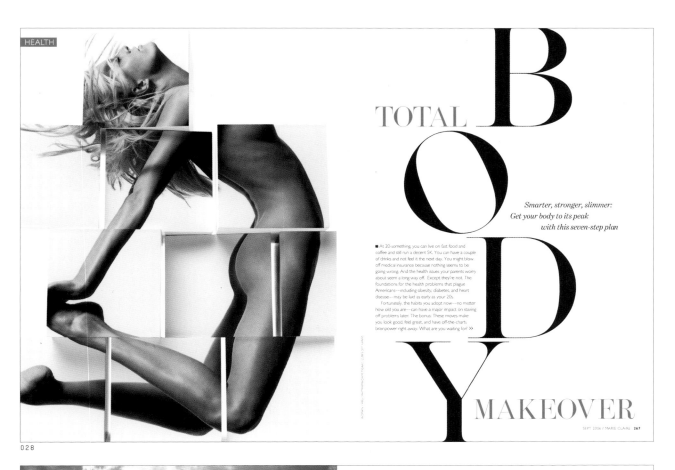

TOTAL BODY MAKEOVER

Smarter, stronger, slimmer:
Get your body to its peak
with this seven-step plan

■ At 20-something, you can live on fast food and coffee and still run a decent 5K. You can have a couple of drinks and not feel it the next day. You might blow off medical insurance because nothing seems to be going wrong. And the health issues your parents worry about seem a long way off. Except they're not. The foundations for the health problems that plague Americans—including obesity, diabetes, and heart disease—may be laid as early as your 20s.

Fortunately, the habits you adopt now—no matter how old you are—can have a major impact on staving off problems later. The bonus: These moves make you look good, feel great, and have off-the-charts brainpower right away. What are you waiting for! »

SEPT 2006 / MARIE CLAIRE **267**

028

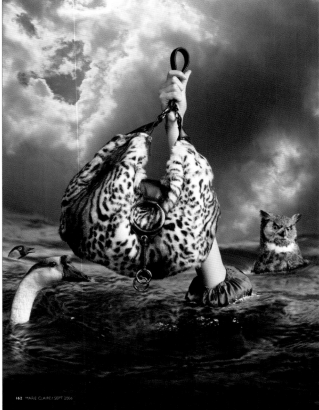

162 MARIE CLAIRE / SEPT 2006

THE SWIM (DON'T) SINK) GUIDE TO SHOPPING

Men just don't get it: Shopping is a sport. It takes stamina,
strategy, and sometimes a boatload of cash to get the right bag,
shoe, or dress. Five readers fess up on how to keep afloat

BY MAUREEN DEMPSEY
PHOTOGRAPHED BY GEOF KERN

MARIE CLAIRE / SEPT 2006 **163**

028

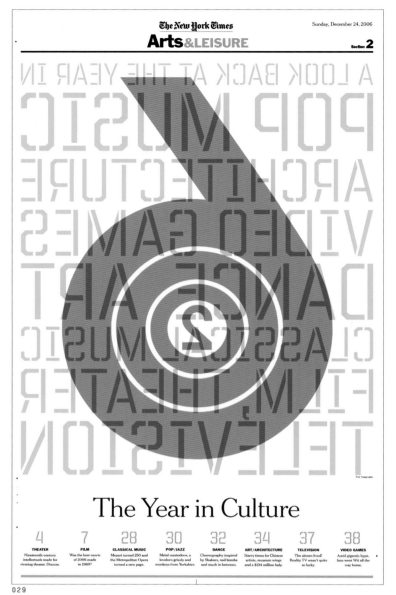

029

029. **THE NEW YORK TIMES**

design director. Tom Bodkin. art director. Paul Jean
typographers. Post Typography. publisher. The New York Times
issue. December 24, 2006. category. Design: Front Page, Newspaper

030

030

030. **THE NEW YORK TIMES**

designers. Shan Carter, Archie Tse, Baden Copeland, Jonathan Corum,
Graham Roberts, Mika Gröndahl. graphics director. Steve Duenes
deputy graphics editor. Matthew Ericson. publisher. The New York Times
category. Online: Graphics

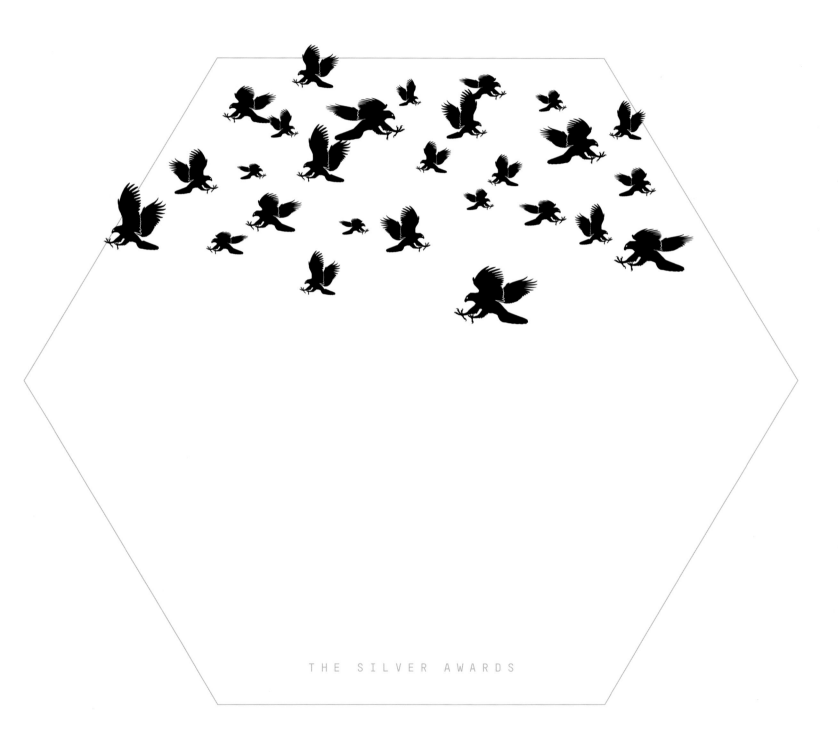

THE SILVER AWARDS

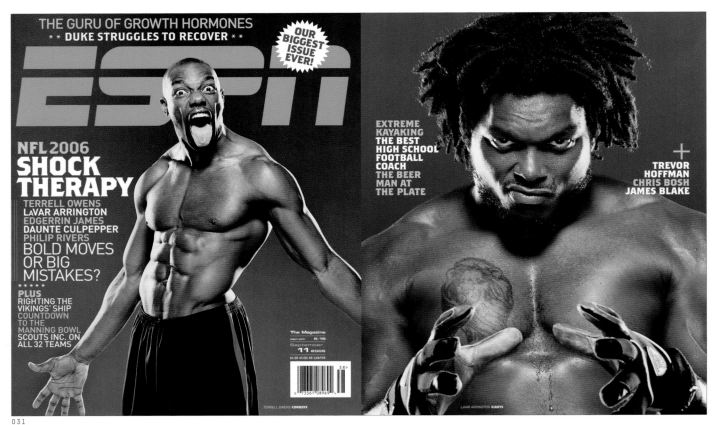

031

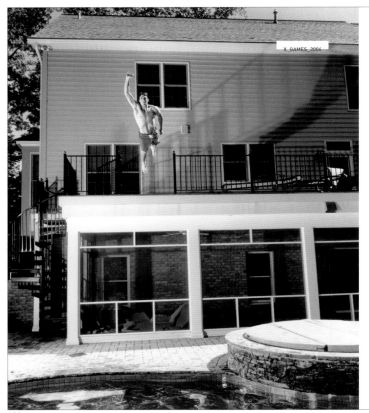

031

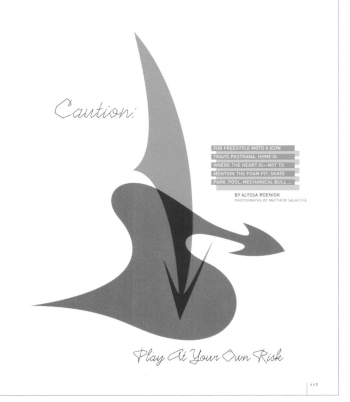

X_GAMES_2006

Caution:

FOR FREESTYLE MOTO X ICON
TRAVIS PASTRANA, HOME IS
WHERE THE HEART IS—NOT TO
MENTION THE FOAM PIT, SKATE
PARK, POOL, MECHANICAL BULL ...

BY ALYSSA ROENIGK
PHOTOGRAPHS BY MATTHEW SALACUSE

Play At Your Own Risk

117

THE NEW Rules

THE SPORTS GUY'S
NOT AFRAID
TO SAY IT:
FANTASY FOOTBALL
NEEDS FIXING.
AND (SURPRISE) HE'S
THE MAN TO FIX IT
★
BY BILL SIMMONS
ILLUSTRATION BY ZOHAR LAZAR

64

031

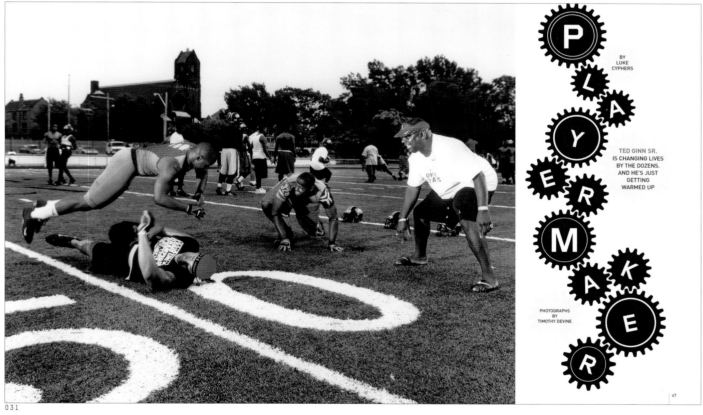

PLAYERMAKER

BY
LUKE
CYPHERS

TED GINN SR.
IS CHANGING LIVES
BY THE DOZENS.
AND HE'S JUST
GETTING
WARMED UP

PHOTOGRAPHS
BY
TIMOTHY DEVINE

67

031

031. **ESPN THE MAGAZINE**

creative director. Siung Tjia. art director. Robert Festino. designers. Jason Lancaster, Hitomi Sato, Kathie Scrobanovich, Yuko Miyake
illustrators. Zohar Lazar, Mario Zucca, Sam Weber, Jillian Tamaki, Marco Cibola, Jason Lee. director of photography. Catriona Ni Aolain
photo editors. Nancy Weisman, Jim Surber, Amy McNulty, Daniela Corticchia, Tricia Reed, Shawn Vale. photographers. Michael Muller, James Dimmock,
Adam Krause, Morad Bouchakour, Catherine Ledner, Chris Floyd, Justin Stephens, Matthew Salacuse, Sarah A. Friedman, Dan Chavkin, Timothy Devine,
Dana Lixenberg, Spencer Heyfron, David Barry, Robert Delahanty, Atiba Jefferson, Peter Yang, Greg Miller, Phil Mucci, Chris McPherson, Christopher Anderson,
Chris Stanford, Brian Smith, Fredrik Broden, Christian Lantry, David Barry, Matthew Mahon. editor-in-chief. Gary Hoenig. publisher. ESPN, Inc.
issue. July 31, 2006, September 11, 2006, September 25, 2006. category. Design: Magazine of the Year (+1 million circulation)

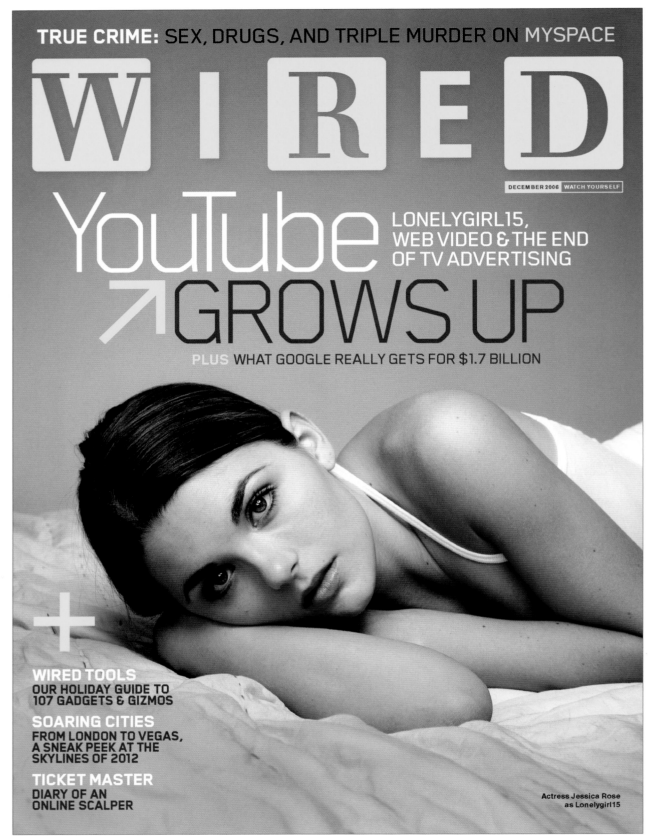

TRUE CRIME: SEX, DRUGS, AND TRIPLE MURDER ON MYSPACE

WIRED

DECEMBER 2006 | WATCH YOURSELF

YouTube GROWS UP

LONELYGIRL15,
WEB VIDEO & THE END
OF TV ADVERTISING

PLUS WHAT GOOGLE REALLY GETS FOR $1.7 BILLION

WIRED TOOLS
OUR HOLIDAY GUIDE TO
107 GADGETS & GIZMOS

SOARING CITIES
FROM LONDON TO VEGAS,
A SNEAK PEEK AT THE
SKYLINES OF 2012

TICKET MASTER
DIARY OF AN
ONLINE SCALPER

Actress Jessica Rose
as Lonelygirl15

032

032. **WIRED**

creative director. Scott Dadich. art directors. Maili Holiman, Jeremy LaCroix. designers. Carl DeTorres, Todd Kurnat, Victor Krummenacher illustrators. Oksana Badrak, Marian Bantjes, Bryan Christie, Michael Doret, Kevin Hand, Peter Hoey, James Jean, Jae Lee, Aaron Meshon, Christian Northeast, Noli Novak, David Plunkert, Matt Pyke, Paul Rogers, Quickhoney. director of photography. Matt Mowat. photo editors. Zana Woods, Carolyn Rauch. photographers. Darren Braun, David Clugston, Brent Humphreys, Jill Greenberg, Sian Kennedy, Michael Lewis, John Midgley, Stan Musilek, Nigel Parry, Steve Piexotto, Ed Hepburne Scott, Gregg Segal, Frank Schwere, Martin Timmerman, Robyn Twomey, Patrick Voigt, Ofer Wolfberger, Peter Yang. photo associate. Anna Alexander. photo producer. Amy Crilly contributing designers. Chip Kidd, Frost Design, Tomato, Stephen Doyle, John Maeda. publisher. Condé Nast Publications, Inc. issue. October 2006, November 2006, December 2006. category. Design: Magazine of the Year (500,000 — 1 million circulation) + Design: Entire Issue

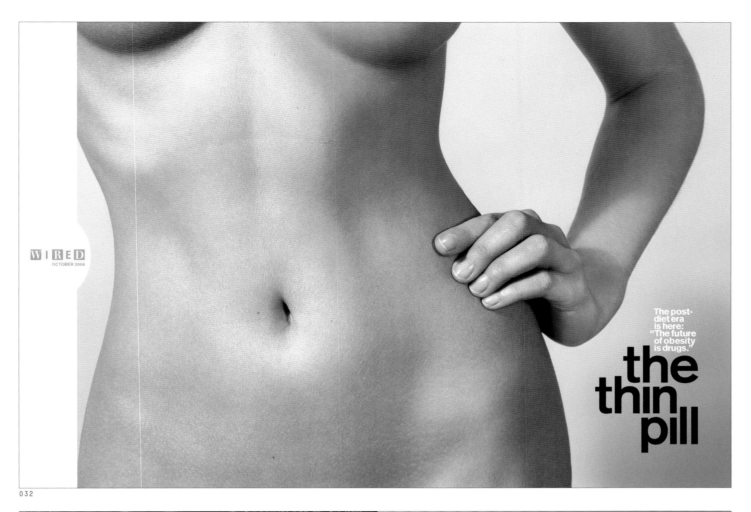

The post-diet era is here: "The future of obesity is drugs."

the thin pill

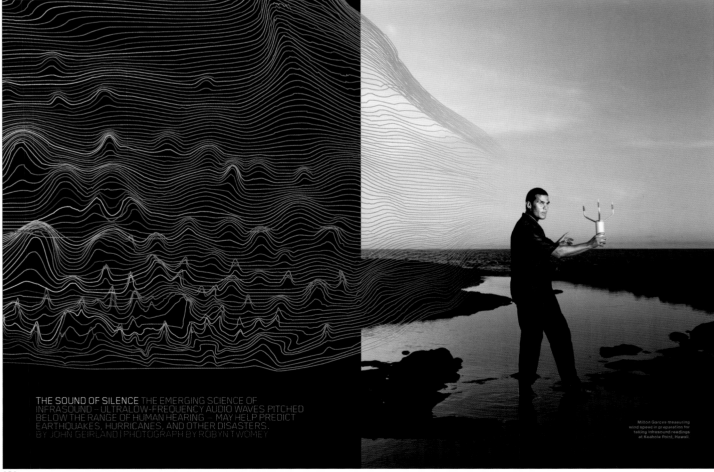

THE SOUND OF SILENCE THE EMERGING SCIENCE OF INFRASOUND – ULTRALOW-FREQUENCY AUDIO WAVES PITCHED BELOW THE RANGE OF HUMAN HEARING – MAY HELP PREDICT EARTHQUAKES, HURRICANES, AND OTHER DISASTERS. BY JOHN GEIRLAND | PHOTOGRAPH BY ROBYN TWOMEY

Milton Garces measuring wind speed in preparation for taking infrasound readings at Keahole Point, Hawaii.

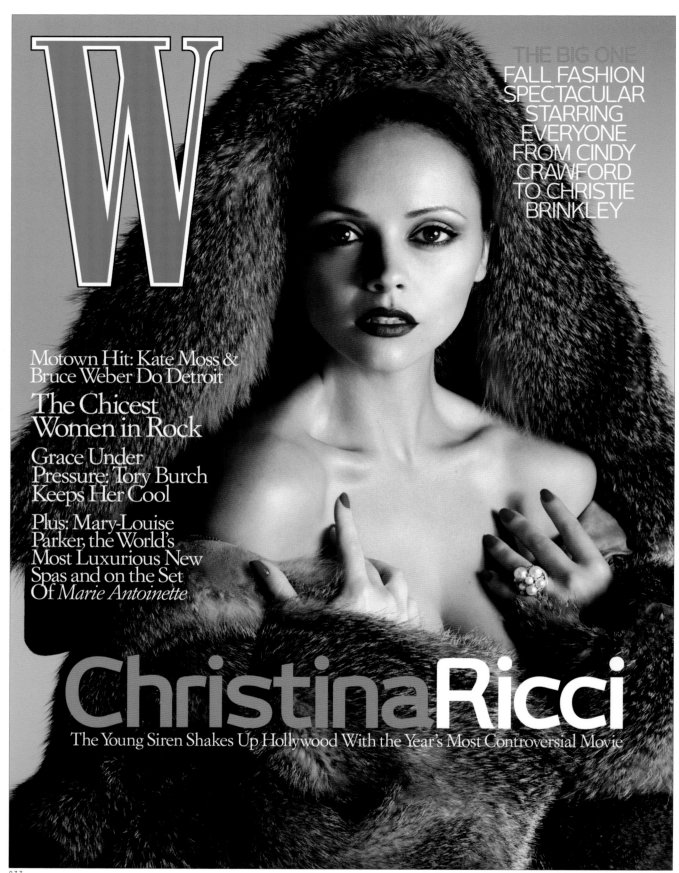

033. **W**

creative director. Dennis Freedman. design director. Edward Leida. art director. Nathalie Kirsheh. designers. Laura Konrad, Gina Maniscalco
photo editor. Nadia Vellam. photographers. Mario Sorrenti, Juergen Teller, Richard Prince, Brice Marden, Mert Alas & Marcus Piggot, Craig McDean, Fabien Baron,
Dean Kaufman, Bruce Weber, Stephen Shore. publisher. Condé Nast Publications Inc. issue. September 2006, November 2006, December 2006
category. Design: Magazine of the Year (under 500,000 circulation)

christina's world

The dark, sardonic 10-year-old who debuted in *Mermaids* is now a dark, sardonic 26-year-old—and still a Hollywood oddity. But with her searing turn in *Black Snake Moan*, Christina Ricci puts lightweight starlets to shame. **By Kevin West**

Photographed by Mert Alas & Marcus Piggott

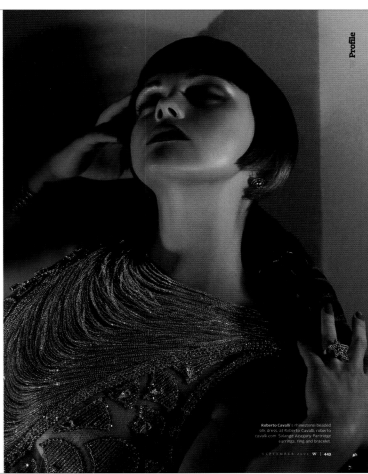

Roberto Cavalli's rhinestone-beaded silk dress, at Roberto Cavalli; roberto cavalli.com Solange Azagury-Partridge earrings, ring and bracelet.

SEPTEMBER 2006 W | 443

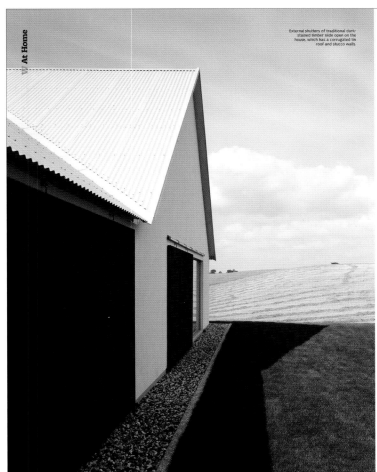

External shutters of traditional dark-stained timber slide open on the house, which has a corrugated tin roof and stucco walls.

PHOTOGRAPHED BY **FABIEN BARON**

Collaborating with architect John Pawson, über creative director Fabien Baron and his companion, Malin Ericson, have built a minimalist farmhouse in the remote and rustic reaches of southern Sweden for their summer holidays. **BY JAMES REGINATO**

barn o

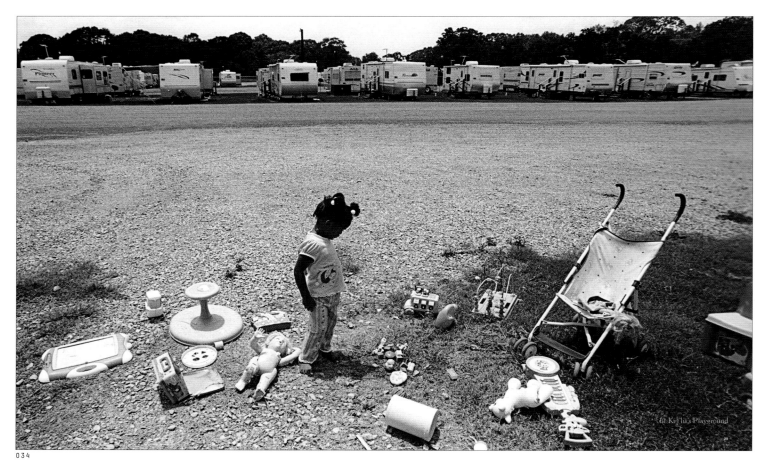
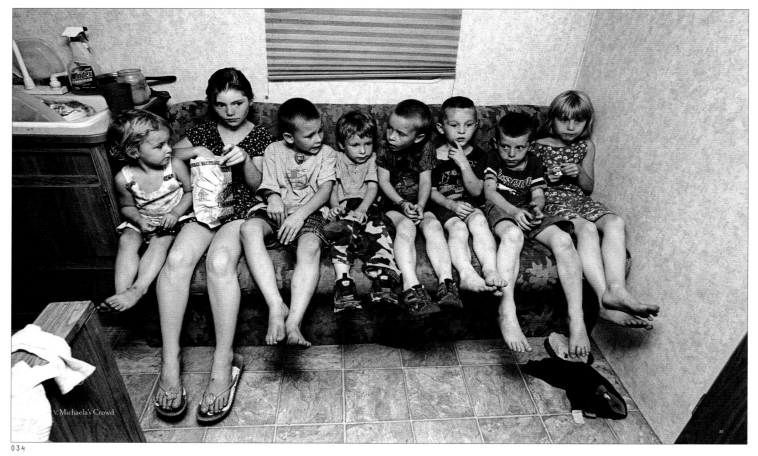

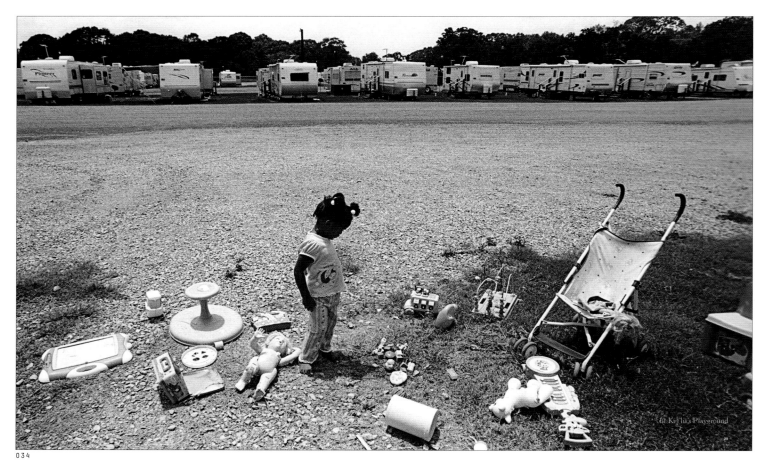

iii. Kellia's Playground

034

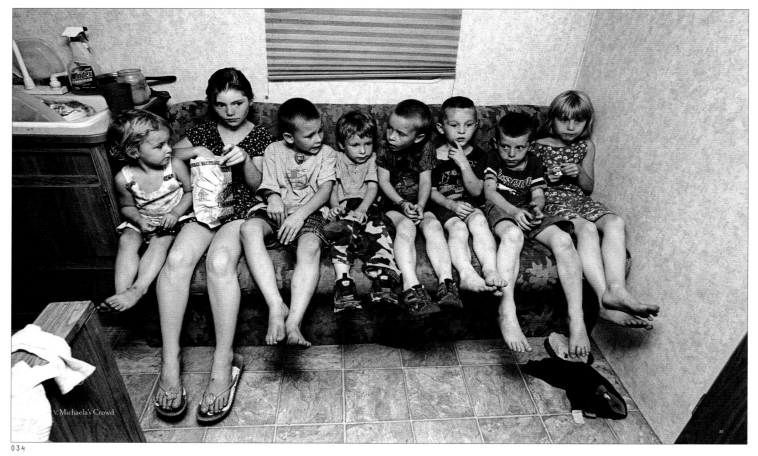

v. Michaela's Crowd

034

52

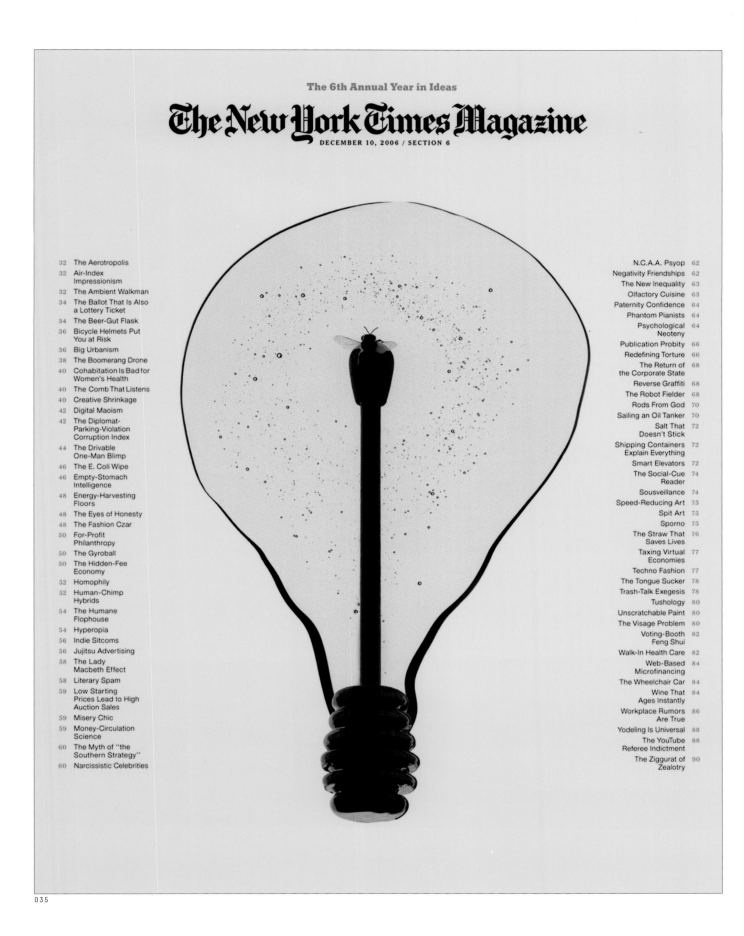

The 6th Annual Year in Ideas

The New York Times Magazine

DECEMBER 10, 2006 / SECTION 6

32 The Aerotropolis
32 Air-Index Impressionism
32 The Ambient Walkman
34 The Ballot That Is Also a Lottery Ticket
34 The Beer-Gut Flask
36 Bicycle Helmets Put You at Risk
36 Big Urbanism
38 The Boomerang Drone
40 Cohabitation Is Bad for Women's Health
40 The Comb That Listens
40 Creative Shrinkage
42 Digital Maoism
42 The Diplomat-Parking-Violation Corruption Index
44 The Drivable One-Man Blimp
46 The E. Coli Wipe
46 Empty-Stomach Intelligence
48 Energy-Harvesting Floors
48 The Eyes of Honesty
48 The Fashion Czar
50 For-Profit Philanthropy
50 The Gyroball
50 The Hidden-Fee Economy
52 Homophily
52 Human-Chimp Hybrids
54 The Humane Flophouse
54 Hyperopia
56 Indie Sitcoms
56 Jujitsu Advertising
58 The Lady Macbeth Effect
58 Literary Spam
59 Low Starting Prices Lead to High Auction Sales
59 Misery Chic
59 Money-Circulation Science
60 The Myth of "the Southern Strategy"
60 Narcissistic Celebrities

N.C.A.A. Psyop 62
Negativity Friendships 62
The New Inequality 63
Olfactory Cuisine 63
Paternity Confidence 64
Phantom Pianists 64
Psychological 64 Neoteny
Publication Probity 66
Redefining Torture 66
The Return of 68 the Corporate State
Reverse Graffiti 68
The Robot Fielder 68
Rods From God 70
Sailing an Oil Tanker 70
Salt That 72 Doesn't Stick
Shipping Containers 72 Explain Everything
Smart Elevators 72
The Social-Cue 74 Reader
Sousveillance 74
Speed-Reducing Art 75
Spit Art 75
Sporno 75
The Straw That 76 Saves Lives
Taxing Virtual 77 Economies
Techno Fashion 77
The Tongue Sucker 78
Trash-Talk Exegesis 78
Tushology 80
Unscratchable Paint 80
The Visage Problem 80
Voting-Booth 82 Feng Shui
Walk-In Health Care 82
Web-Based 84 Microfinancing
The Wheelchair Car 84
Wine That 84 Ages Instantly
Workplace Rumors 86 Are True
Yodeling Is Universal 88
The YouTube 88 Referee Indictment
The Ziggurat of 90 Zealotry

035

034. **THE NEW YORK TIMES MAGAZINE**

creative director. Janet Froelich. art director. Arem Duplessis
designer. Jeffrey Docherty. director of photography. Kathy Ryan
photographer. Brenda Ann Kenneally. editor-in-chief. Gerald Marzorati
publisher. The New York Times. issue. August 27, 2006
category. Photo: Story

035. **THE NEW YORK TIMES MAGAZINE**

creative director. Janet Froelich. art director. Arem Duplessis
designer. Gail Bichler. director of photography. Kathy Ryan
photographer. Horacio Salinas. editor-in-chief. Gerald Marzorati
publisher. The New York Times. issue. December 10, 2006
category. Design: Cover

036

036. **THE NEW YORK TIMES MAGAZINE**

creative director. Janet Froelich. art director. Arem Duplessis. designer. Leo Jung. director of photography. Kathy Ryan
editor-in-chief. Gerald Marzorati. publisher. The New York Times. issue. May 14, 2006. category. Design: Spread

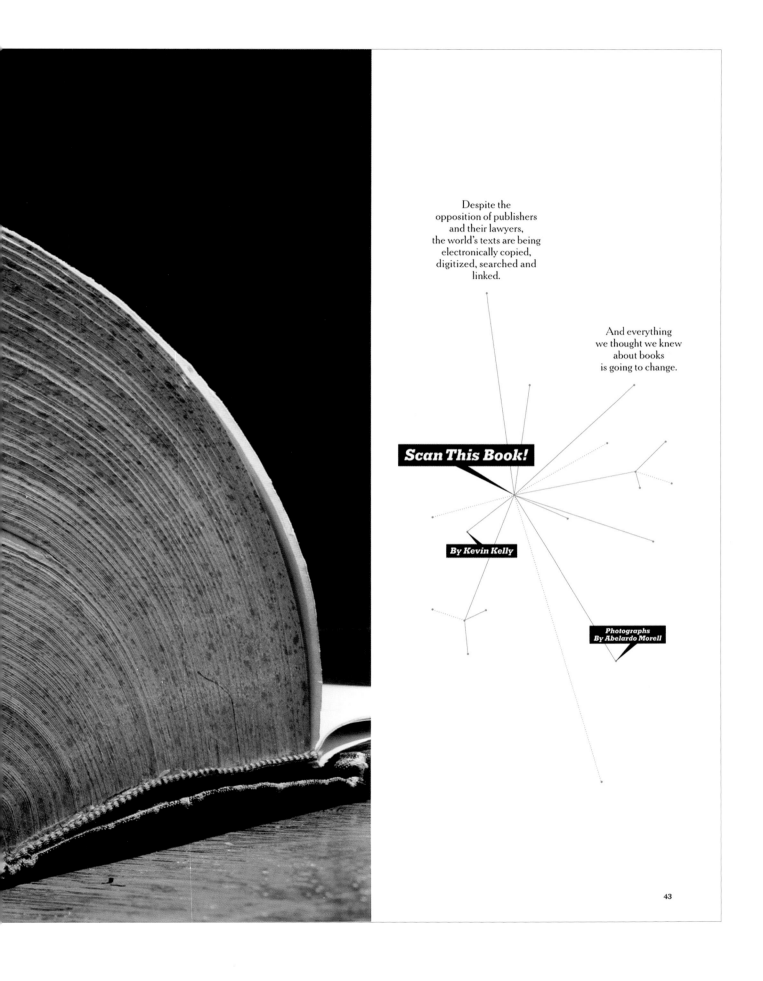

Despite the
opposition of publishers
and their lawyers,
the world's texts are being
electronically copied,
digitized, searched and
linked.

And everything
we thought we knew
about books
is going to change.

Scan This Book!

By Kevin Kelly

Photographs
By Abelardo Morell

43

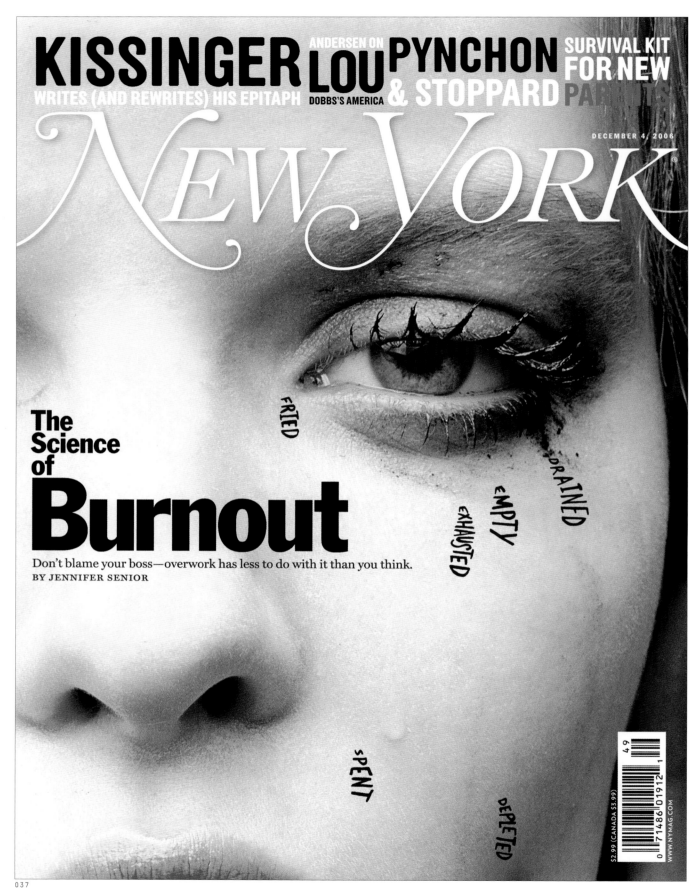

037. **NEW YORK**

design director. Luke Hayman. art director. Chris Dixon. designer. Luke Hayman. director of photography. Jody Quon
photo editors. Leana Alagia, Lea Golis, Alexandra Pollack. photographer. Stéphane Coutelle. typography. Joel Holland. editor-in-chief. Adam Moss
publisher. New York Magazine Holdings, LLC. issue. Decmber 4, 2006. category. Design: Cover

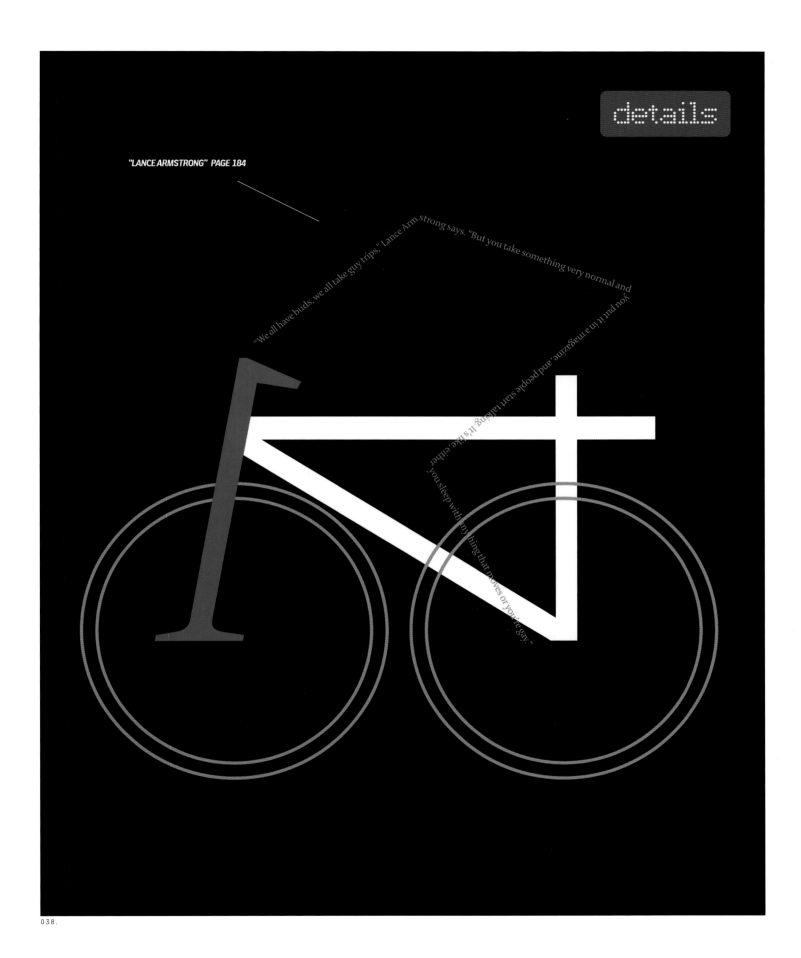

"LANCE ARMSTRONG" PAGE 184

"We all have buds, we all take guy trips," Lance Armstrong says. "But you take something very normal and you put it in a magazine, and people start talking, it's like, either you sleep with anything that moves or you're gay."

038.

038. **DETAILS**

creative director. Rockwell Harwood. art director. Andre Jointe. assistant art director. Robert Vargas. publisher. Condé Nast Publications
issue. November 2006. category. Design: Single Page

Blueprint

Perimeter
PERSONAL STYLE FROM EVERY ANGLE

Height: 15.16"

Diameter: 17.9"

Top

A Modern Twist

> Think of it as the Möbius stool. A Möbius strip has no beginning and no end, just as there's no end of uses for this stylish and sinuous Mushroom Stool by Tendo. Made of three interlocking pieces of lacquered steam-bent mahogany plywood, it can be a bedside table, an end table, a coffee table, an extra seat at the table.... **Mushroom Stool, $550,** Tortoise, 310-314-8448

039

039. **BLUEPRINT**

creative director. Eric A. Pike. design director. Deb Bishop. designers. Jennifer Merrill, Deb Bishop. director of photography. Heloise Goodman photo editors. Rebecca Donnelly, Mary Cahill, Sara McOsker. photographers. Jens Mortensen, Mark Lund, Karl Juengel. Stylist Shane Powers editor-in-chief. Rebecca Thuss. publisher. Martha Stewart Living Omnimedia. issue. Summer 2006. category. Design: Front/Back of Book

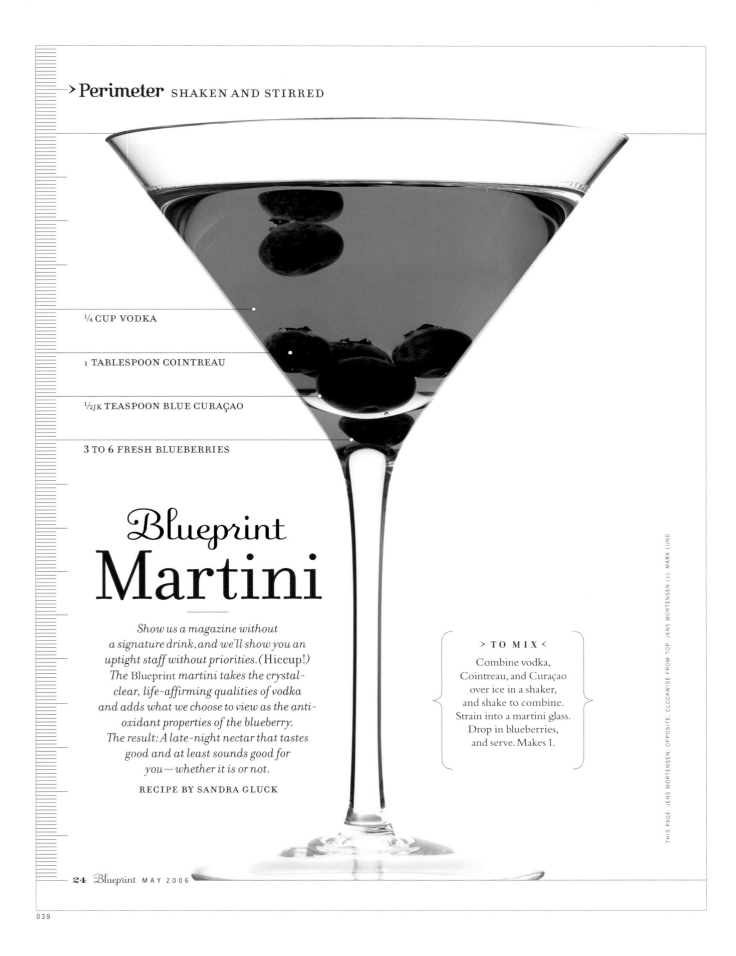

¼ CUP VODKA

1 TABLESPOON COINTREAU

½JK TEASPOON BLUE CURAÇAO

3 TO 6 FRESH BLUEBERRIES

Blueprint
Martini

Show us a magazine without
a signature drink, and we'll show you an
uptight staff without priorities. (Hiccup!)
The Blueprint martini takes the crystal-
clear, life-affirming qualities of vodka
and adds what we choose to view as the anti-
oxidant properties of the blueberry.
The result: A late-night nectar that tastes
good and at least sounds good for
you— whether it is or not.

RECIPE BY SANDRA GLUCK

> **TO MIX** <
Combine vodka,
Cointreau, and Curaçao
over ice in a shaker,
and shake to combine.
Strain into a martini glass.
Drop in blueberries,
and serve. Makes 1.

THIS PAGE: JENS MORTENSEN. OPPOSITE, CLOCKWISE FROM TOP: JENS MORTENSEN (2), MARK LUND

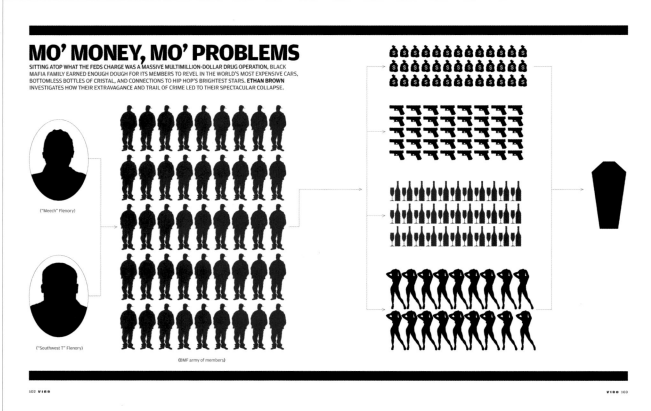

041

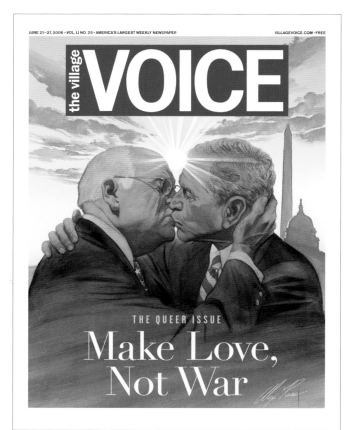

041

040. **VIBE**

design director. Florian Bachleda. designer. Neomi Assiabanha
editor-in-chief. Mimi Valdés. publisher. Vibe/Spin Ventures LLC
issue. May 2006. category. InfoGraphics: Spread

041. **THE VILLAGE VOICE**

art director. Ted Keller. designer. Ted Keller. illustrator. Alex Ross
publisher. Village Voice Media. issue. June 21, 2006
category. Design: Front Page, Newpaper

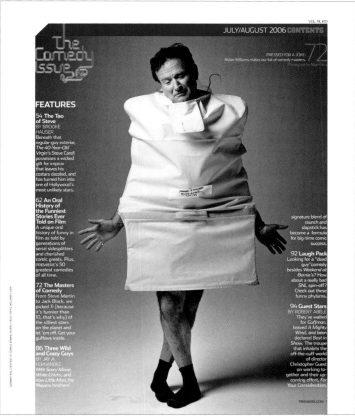

042

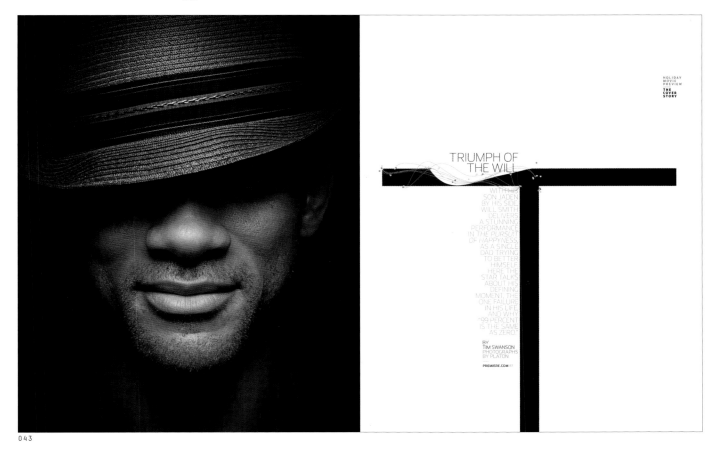

043

042. **PREMIERE**

art director. Dirk Barnett. designer. April Bell
director of photography. David Carthas. photographer. Nigel Parry
publisher. Hachette Filipacchi Media U.S. issue. July/August 2006
category. Photo: Single Page

043. **PREMIERE**

art director. Rob Hewitt. designer. Rob Hewitt
director of photography. David Carthas. photographer. Platon
publisher. Hachette Filipacchi Media U.S. issue. December 2006
category. Design: Spread

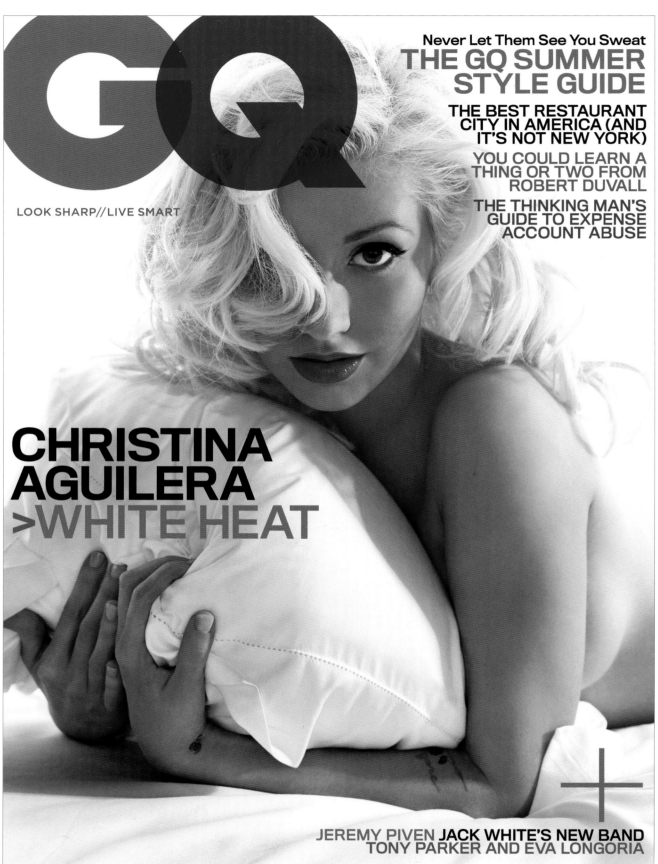

GQ

LOOK SHARP//LIVE SMART

Never Let Them See You Sweat
THE GQ SUMMER STYLE GUIDE
THE BEST RESTAURANT CITY IN AMERICA (AND IT'S NOT NEW YORK)
YOU COULD LEARN A THING OR TWO FROM ROBERT DUVALL
THE THINKING MAN'S GUIDE TO EXPENSE ACCOUNT ABUSE

CHRISTINA AGUILERA
>WHITE HEAT

JEREMY PIVEN **JACK WHITE'S NEW BAND**
TONY PARKER AND EVA LONGORIA

044

044. **GQ**

design director. Fred Woodward. art director. Ken DeLago. designers. Anton Ioukhnovets, Thomas Alberty, Michael Pangilinan, Drue Wagner, Eve Binder, Delgis Canahuate. director of photography. Dora Somosi. photo editors. Justin O'Neill, Jolanta Bielat, Jesse Lee photographer. Michael Thompson. senior photo editor. Krista Prestek. editor-in-chief. Jim Nelson. publisher. Condé Nast Publications Inc. issue. June 2006. category. Design: Entire Issue

045

045. **ESQUIRE**

design director. David Curcurito. art director. Darhil Crooks. associate art director. Colin Tunstall. designer. Derya Hanife Altan
director of photography. Nancy Jo Iacoi. photographer. Art Streiber. typography. Marion Deuchars. editor-in-chief. David Granger
publisher. The Hearst Corporation-Magazines Division. issue. December 2006. category. Design: Cover

046. **VIBE**

design director. Florian Bachleda. art director. Wyatt Mitchell. designers. Alice Alves, Neomi Assiabanha, Stravinski Pierre
director of photography. Leslie dela Vega. photo editors. Marian Barragan, EunJean Song, Charlotte Davis. editor-in-chief. Mimi Valdés
publisher. Vibe/Spin Ventures LLC. issue. September 2006. category. Design: Redesign + Cover + Entire Issue

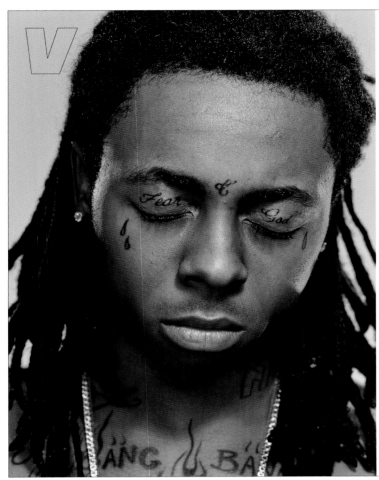

046

MUSIC
BOOKS
DVDS
FILMS
GAMES

BACKTALK

THE ROOTS
GAME THEORY
Def Jam
★★★★
BY THOMAS GOLIANOPOULOS

The Roots are mad as hell, and they're not gonna take it anymore. Between 9/11, the war on terror, Hurricane Katrina, stolen elections, steep gas prices, and illegal wiretaps, recent events have taken a toll *(CONTINUED ON NEXT PAGE)*

Illustration by **HIROSHI TANABE**

046

046

The New York Times Style Magazine SPRING 2006

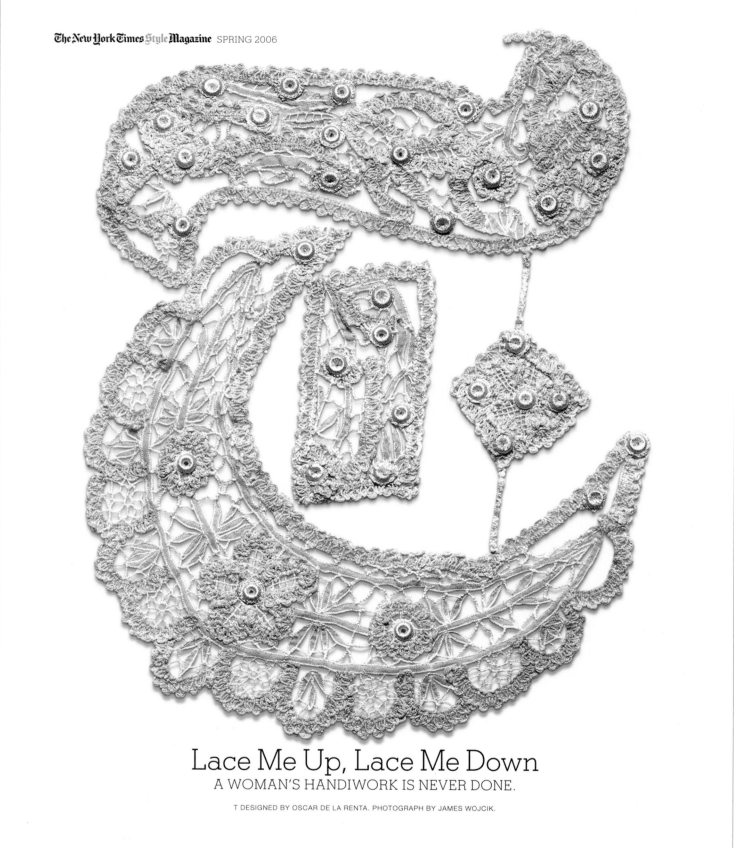

Lace Me Up, Lace Me Down
A WOMAN'S HANDIWORK IS NEVER DONE.

T DESIGNED BY OSCAR DE LA RENTA. PHOTOGRAPH BY JAMES WOJCIK.

047

047. **T, THE NY TIMES STYLE MAGAZINE**

creative director. Janet Froelich. art director. Christopher Martinez. designers. Janet Froelich, David Sebbah, Christopher Martinez, Elizabeth Spiridakis
director of photography. Kathy Ryan. photo editors. Scott Hall, Jennifer Pastore. photographers. Raymond Meier, Adam Fuss, Jean-Baptiste Mondino
senior art director. David Sebbah. senior photo editor. Judith Puckett-Rinella. editor-in-chief. Stefano Tonchi
publisher. The New York Times. issue. February 26, 2006. category. Design: Entire Issue

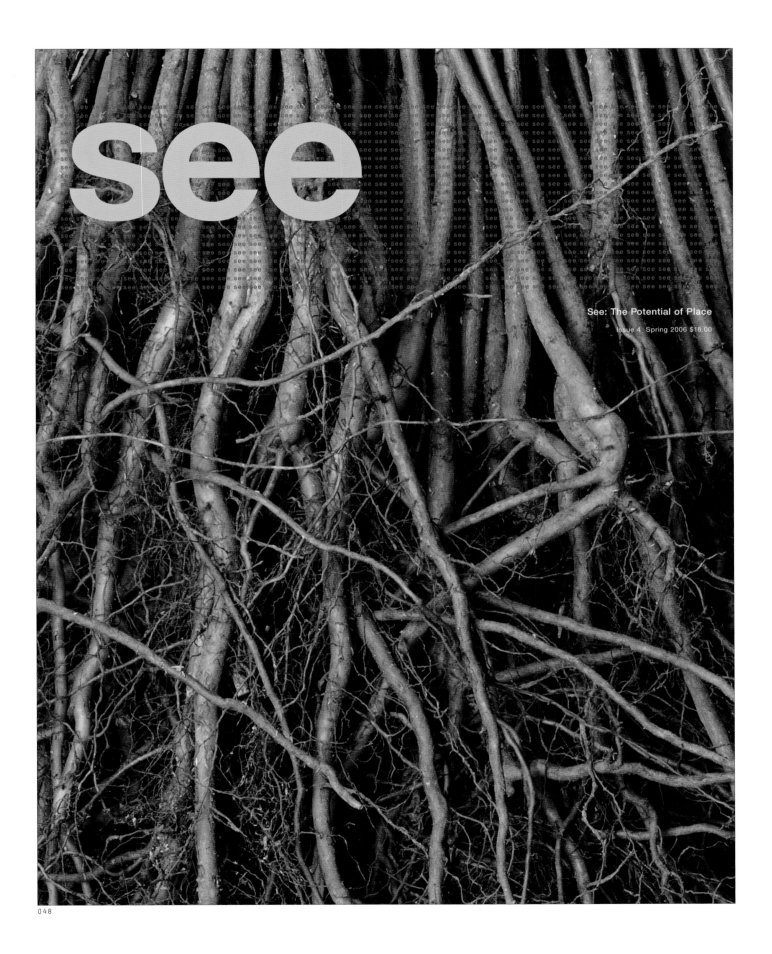

See: The Potential of Place

Issue 4 Spring 2006 $18.00

048. **SEE: THE POTENTIAL OF PLACE**

creative director. Bill Cahan. art directors. Bill Cahan, Todd Richards, Steve Frykholm. designers. Todd Richards, Erik Adams. illustrators. Blair Thornley, Brian Rea, Melanie Boone, Olaf Hajek, Sam Weber, Joseph Hart. photographers. Hans Gissinger, Nadar Kander, Michael Martin, Nathan Perkel, Andreas Vesalius, Joseph Hart, Dwight Eschliman, Nigel Young, Robert Canfield, Scott Wyatt, Tim Griffith. studio. Cahan & Associates. publisher. Herman Miller, Inc. client. Herman Miller. issue. May 2006. category. Design: Entire Issue

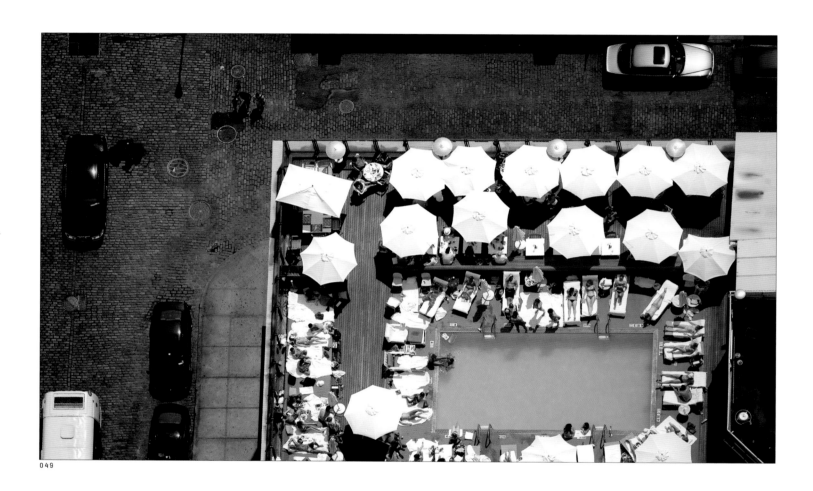

049

049. **NEW YORK**
design director. **Luke Hayman.** art director. **Chris Dixon**
director of photography. **Jody Quon.** photo editor. **Alexandra Pollack**
photographer. **Vincent Laforet.** editor-in-chief. **Adam Moss**
publisher. **New York Magazine Holdings, LLC.** issue. **July 3 - 10, 2006**
category. **Photo: Story**

050. **NEW YORK**
design director. **Luke Hayman.** art director. **Chris Dixon**
director of photography. **Jody Quon.** photo editor. **Alexandra Pollack**
photographer. **Mitchell Feinberg.** editor-in-chief. **Adam Moss**
publisher. **New York Magazine Holdings, LLC.** issue. **October 30, 2006**
category. **Photo: Single Page**

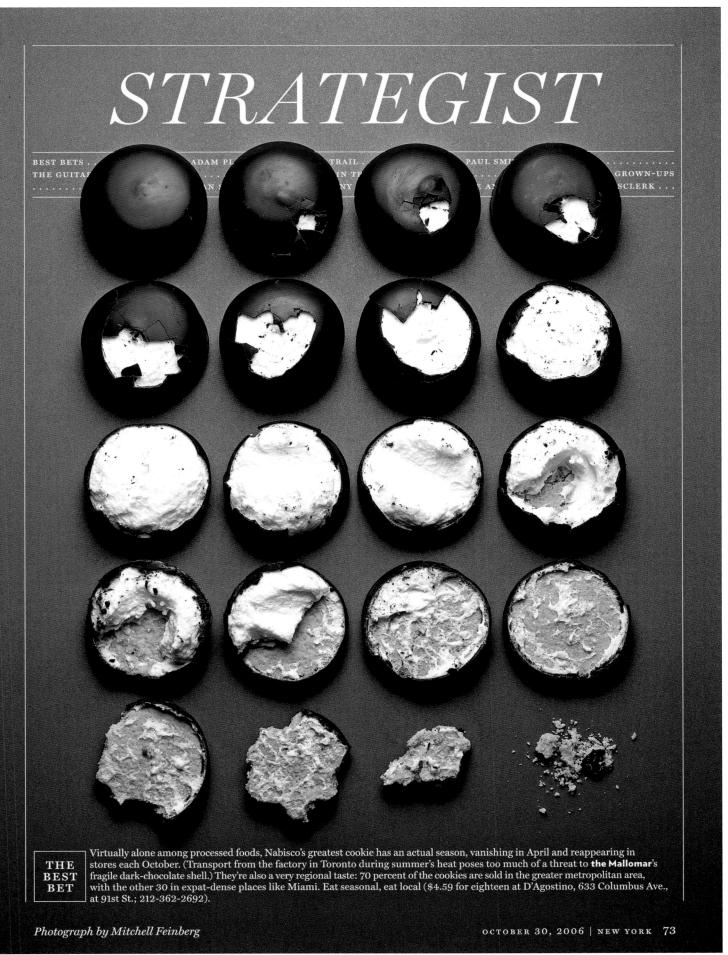

BEST BETS ADAM PL. TRAIL PAUL SMI.
THE GUITA. IN TH. GROWN-UPS
. AN NY E AN SCLERK . . .

THE BEST BET

Virtually alone among processed foods, Nabisco's greatest cookie has an actual season, vanishing in April and reappearing in stores each October. (Transport from the factory in Toronto during summer's heat poses too much of a threat to **the Mallomar**'s fragile dark-chocolate shell.) They're also a very regional taste: 70 percent of the cookies are sold in the greater metropolitan area, with the other 30 in expat-dense places like Miami. Eat seasonal, eat local ($4.59 for eighteen at D'Agostino, 633 Columbus Ave., at 91st St.; 212-362-2692).

Photograph by Mitchell Feinberg

OCTOBER 30, 2006 | NEW YORK **73**

The New York Times Magazine

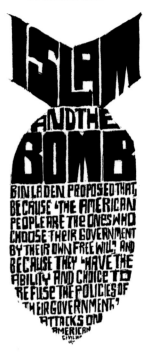

How to think — and not think — about the unspoken issue of the Second Nuclear Age.
By Noah Feldman

051

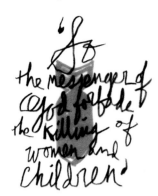

The New York Times Magazine

Interpret This For more than a thousand years, laws forbidding the killing of noncombatants held sway in the Muslim world. Suicide bombing has complicated the issue. Illustration by James Victore. (Page 50)

Back Story 10.29.06

Noah Feldman began studying Arabic as a teenager. "I'd gotten into history at Hebrew school," he told us last week, "and learned that Jewish thought and Islamic thought were intertwined. Also, Maimonides" — the medieval Jewish philosopher who grew up in Muslim-ruled Spain — "wrote in Arabic, and he told his students to read Islamic philosophy to get educated." Feldman went on to study Islamic philosophy and law in graduate school and law school — knowledge he draws upon in this week's cover article on Islam and nuclear proliferation. In his essay, Feldman, a contributing writer, makes reference not only to centuries-old texts but also to recent fatwas and Web postings — readings he approaches respectfully and judiciously. (He is a law professor at New York University.) "I was fascinated here, as I am generally, by how real-world politics affect and are affected by law, philosophy, religion," he said. "In short, I am interested in ideas."

Cover Story

50 **Islam, Terror and the Second Nuclear Age**
BY NOAH FELDMAN

If Iran gets the bomb, what will it do with it? Does Islamic law justify the use of weapons of mass destruction? Is there a Shiite urge for apocalypse? Is atomic warfare suicide bombing writ large?

44 **What He's Trying to Say** BY BEN WALLACE-WELLS

So far, Tony Snow seems to have becalmed the White House press corps. But it's not easy being the spokesman for an administration under siege.

58 **Taking the Fight to the Taliban** BY ELIZABETH RUBIN

The experience of American soldiers on the ground in Afghanistan shows what a counterinsurgency can, and cannot, do.

On the cover: Illustration by James Victore.

Continued on Page 6

4

051

If Iran gets the bomb, what will it do with it?

Is atomic warfare suicide bombing writ large?

Islam, Terror and the Second Nuclear Age

Does Islamic law justify the use of weapons of mass destruction?

Is there a Shiite urge for apocalypse?

By Noah Feldman
Illustrations by James Victore

50

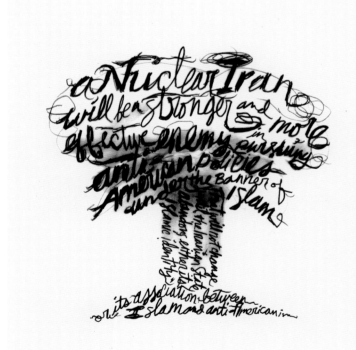

51

051

The New York Times Magazine / FEBRUARY 19, 2006

Iraq's Jordanian
Jihadis

How did the Middle East's most stable and modern Arab country give rise to Zarqawi
and a generation of border-crossing Islamist radicals?

By Nir Rosen

Jordan has long been thought of as the quiet country of the Middle East. People called it the
Hashemite Kingdom of Boredom and went there for a rest. King Hussein and his son, King
Abdullah II, who assumed the throne in February 1999, were friendly enough with the United
States, respectful toward Israel and measured advocates of modernization. As for the Islamist
stirrings that have roiled the region since the Iranian revolution of 1979, it was widely believed
that the king's domestic security service, the Mukhabarat, had infiltrated every group that
might think to stir unrest. But in truth Jordan had not been insulated from the radicalism
that has engulfed the Mideast in our time: in 1970 and '71, Jordan's Palestinians, who then,
as now, made up a majority of the country's population (today, 5.6 million), erupted, and

Abu Musab al-Zarqawi is the most violent Jordanian jihadi in Iraq, but he is not alone.

Illustration By Brian Rea

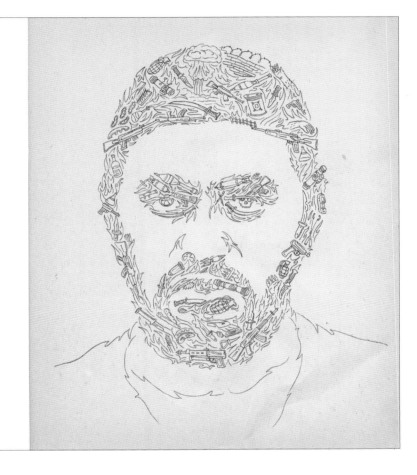

54

052

051. **THE NEW YORK TIMES MAGAZINE**

creative director. Janet Froelich. art director. Arem Duplessis
designer. Gail Bichler. illustrator. James Victore
editor-in-chief. Gerald Marzorati. publisher. The New York Times
issue. October 29, 2006. category. Illustration: Story

052. **THE NEW YORK TIMES MAGAZINE**

creative director. Janet Froelich. art director. Arem Duplessis
designer. Leo Jung. illustrator. Brian Rea
editor-in-chief. Gerald Marzorati. publisher. The New York Times
issue. February 19, 2006. category. Illustration: Spread

053

053

053. **PRINT**

art director. Kristina DiMatteo. designers. Kristina DiMatteo, Lindsay Ballant. photographer. Michael Schmelling
editor-in-chief. Joyce Rutter Kaye. publisher. F & W Publications. issue. November/December 2006. category. Design: Story

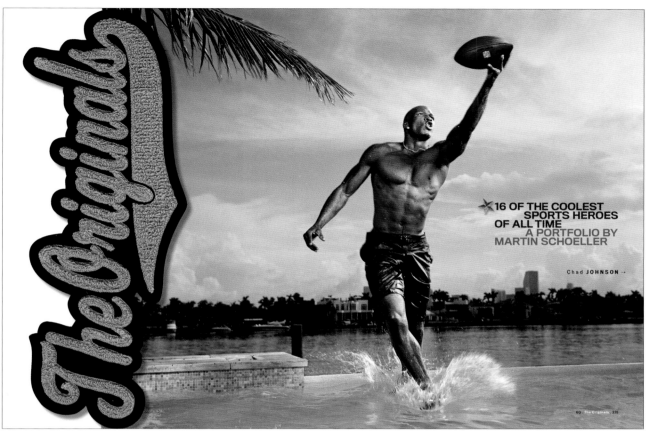

The Originals

★ **16 OF THE COOLEST SPORTS HEROES OF ALL TIME**
A PORTFOLIO BY MARTIN SCHOELLER

Chad JOHNSON →

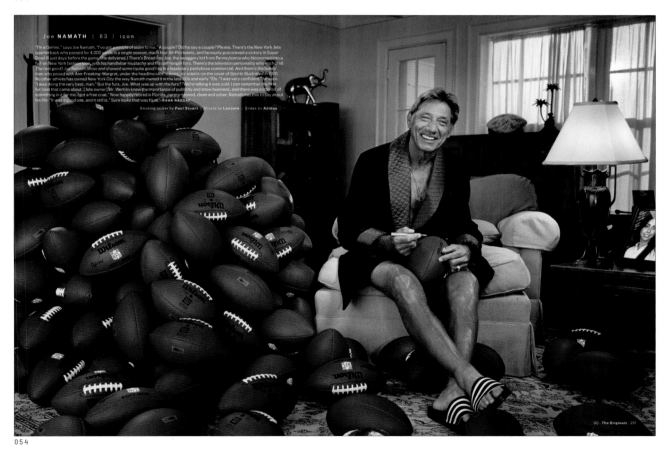

Joe **NAMATH** | 63 | icon

054. **GQ**

design director. Fred Woodward. designer. Ken DeLago. director of photography. Dora Somosi. photographer. Martin Schoeller
senior photo editor. Krista Prestek. editor-in-chief. Jim Nelson. publisher. Condé Nast Publications Inc. issue. November 2006
category. Photo: Story + Design: Story

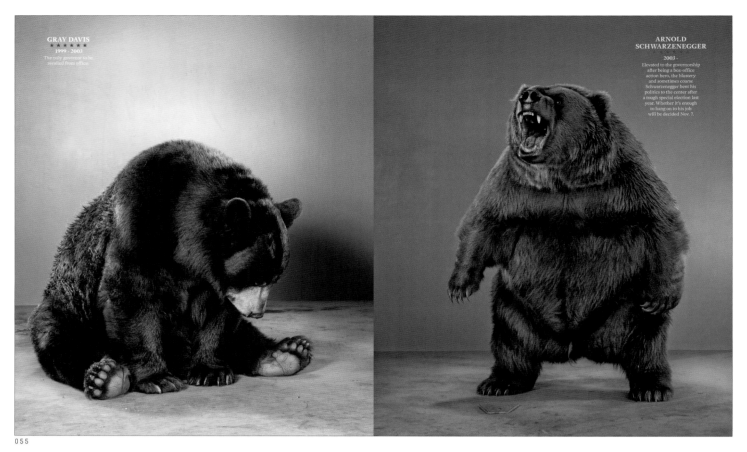

GRAY DAVIS
★ ★ ★ ★ ★ ★
1999 - 2003
The only governor to be
recalled from office.

ARNOLD
SCHWARZENEGGER
2003 -
Elevated to the governorship
after being a box-office
action hero, the blustery
and sometimes coarse
Schwarzenegger bent his
politics to the center after
a tough special election last
year. Whether it's enough
to hang on to his job
will be decided Nov. 7.

055

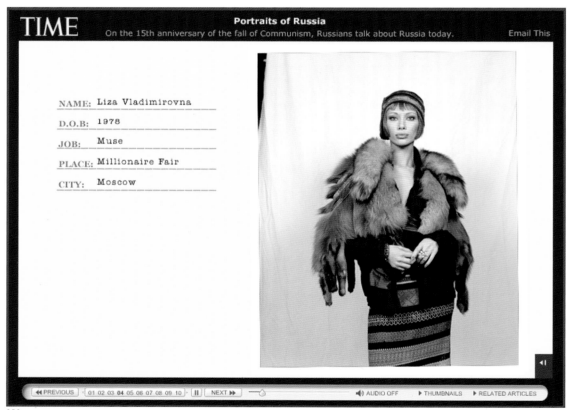

TIME

Portraits of Russia
On the 15th anniversary of the fall of Communism, Russians talk about Russia today.

Email This

NAME: Liza Vladimirovna

D.O.B: 1978

JOB: Muse

PLACE: Millionaire Fair

CITY: Moscow

◄◄ PREVIOUS · 01 02 03 04 05 06 07 08 09 10 · ❙❙ NEXT ►► ●—— 🔊 AUDIO OFF ► THUMBNAILS ► RELATED ARTICLES

056

055. **WEST / LOS ANGELES TIMES MAGAZINE**

creative director. Joseph Hutchinson. art director. Heidi Volpe
designers. Joseph Hutchinson, Heidi Volpe, Carol Wakano
photo editors. Heidi Volpe, Joseph Hutchinson. photographer. Jill Greenberg
publisher. Los Angeles Times. issue. October 29, 2006
category. Photo: Spread

056. **TIME.COM**

director of photography. Michele Stephenson. photo editors. Mark Rykoff,
Maria Buani. photographers. Jason Eskenazi, Valeri Nistratov
publisher. Time Inc. online address. www.time.com/tme/photoessays/2006/
portraits_of_russia/. issue. 2006. category. Online: Photography

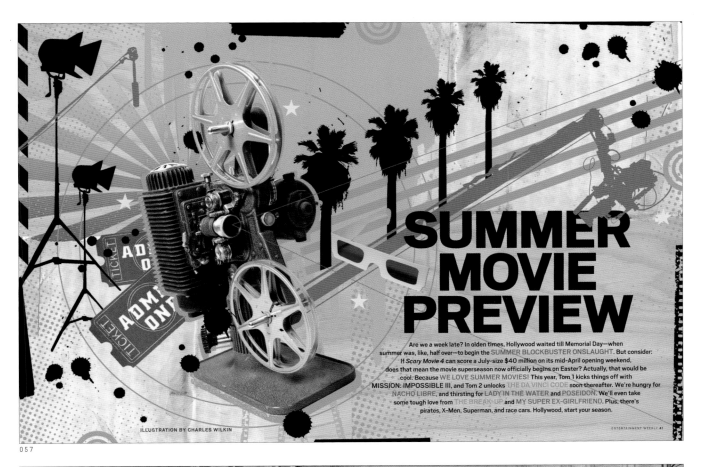

SUMMER MOVIE PREVIEW

Are we a week late? In olden times, Hollywood waited till Memorial Day—when summer was, like, half over—to begin the SUMMER BLOCKBUSTER ONSLAUGHT. But consider: If *Scary Movie 4* can score a July-size $40 million on its mid-April opening weekend, does that mean the movie superseason now officially begins on Easter? Actually, that would be cool. Because WE LOVE SUMMER MOVIES! This year, Tom 1 kicks things off with MISSION: IMPOSSIBLE III, and Tom 2 unlocks THE DA VINCI CODE soon thereafter. We're hungry for NACHO LIBRE, and thirsting for LADY IN THE WATER and POSEIDON. We'll even take some tough love from THE BREAK-UP and MY SUPER EX-GIRLFRIEND. Plus, there's pirates, X-Men, Superman, and race cars. Hollywood, start your season.

ILLUSTRATION BY CHARLES WILKIN

ENTERTAINMENT WEEKLY 41

057

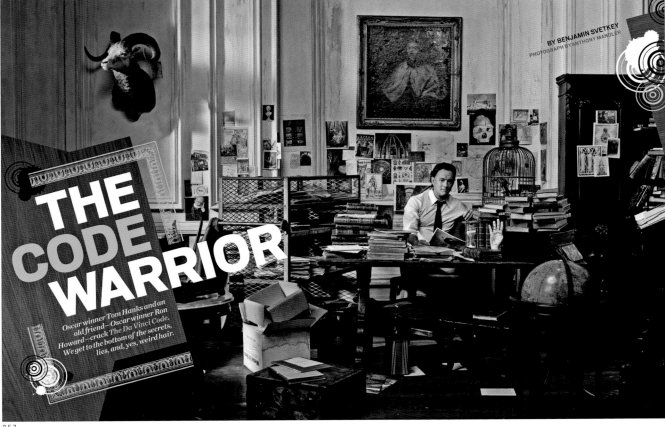

BY BENJAMIN SVETKEY
PHOTOGRAPH BY ANTHONY MANDLER

THE CODE WARRIOR

Oscar winner Tom Hanks and an old friend—Oscar winner Ron Howard—crack The Da Vinci Code. We get to the bottom of the secrets, lies, and, yes, weird hair.

057

057. **ENTERTAINMENT WEEKLY**

design director. Geraldine Hessler. art director. Brian Anstey. illustrator. Charles Wilkin. director of photography. Fiona McDonagh photo editor. Richard Maltz. photographers. Jesse Chehak, Anthony Mandler, Robert Maxwell, Brian Bowen Smith, Bryce Duffy, Gavin Bond managing editor. Rick Tetzeli. publisher. Time Inc. issue. April 28 - May 5, 2006. category. Design: Story

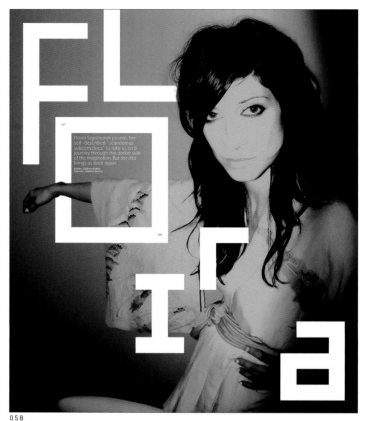

058

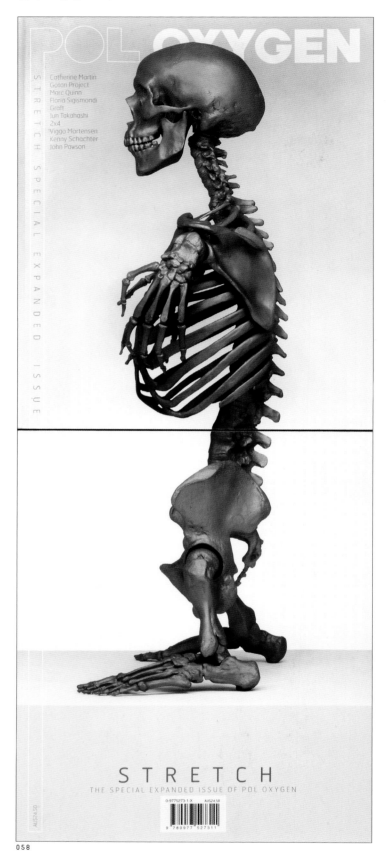

058

058

058. **POL OXYGEN**

creative director. Vince Frost. design director. Vince Frost. art directors. Anthony Donovan, Marcus Piper. photographers. Patrik Andersson, Clive Arrowsmith, Derek Henderson, Richard Kern, Kiyoshi Kuramitsu, James Muldowney, Cindy Palmano, Norman Reedus, Ricky Ridecos. studio. Frost Design. editor-in-chief. Jan Mackey. publisher. POL Publications. issue. November 2006. category. Design: Entire Issue

THE MERIT AWARDS

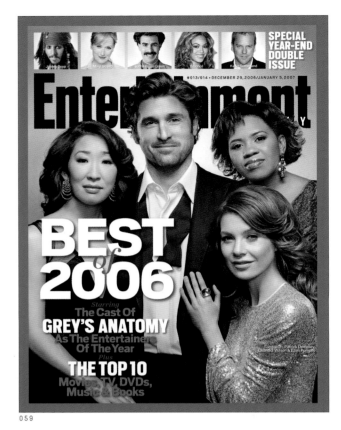

059

059

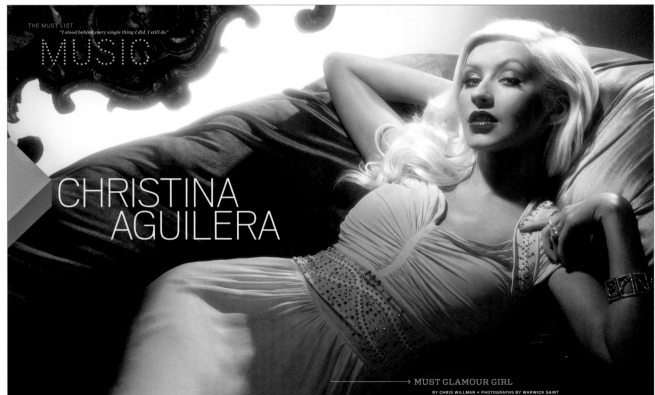

059

059. **ENTERTAINMENT WEEKLY**

design director. Geraldine Hessler. art director. Brian Anstey. designers. Jennie Chang, William Hooks, Jackie Dashevsky. illustrators. Todd Breland, Thomas Fuchs, Quickhoney, Jason Lee, Josh Cochran, Robert Risko, Sean McCabe, Yuko Shimizu, Kirsten Ulve, Jason Holley, Tavis Coburn, Sophie Toulouse, Tomer Hanuka, David Hughes. director of photography. Fiona McDonagh. photo editors. Audrey Landreth, Michael Kochman, Michelle Romero, Richard Maltz, Suzanne Regan, Freyda Tavin, Kristine Chin, Carrie Levitt, Samantha Xu, Melissa Roque. photographers. Ethan Hill, Bryce Duffy, Jake Chessum, Phil Knott, Justin Stephens, Jeff Riedel, Eric Ogden, Patrick Hoelck, Randall Slavin, Gavin Bond, Martin Schoeller, Hans Neleman, Michael Lewis, Dan Winters, Sheryl Nieds, Erin O'Brien, Robert D'Este, Michael Kelly, Alessandra Petlin, Alex Tehrani, Warwick Saint, Todd Oldham, James Dimmock, Robert Maxwell, Ruven Michael, Bruce Gilden. managing editor. Rick Tetzeli. publisher. Time Inc. issue. June 30 - July 7, 2006, October 13, 2006, December 29, 2006 - January 5, 2007. category. Design: Magazine of the Year

REAL SIMPLE
| life made easier |

Look great in less time
- get-ready strategies
- multipurpose products
- easy outfits

Organizing digital photos

The truth about sizing:
how to find clothes that fit

Spend, save, invest?
Your money questions
answered

Special pull-out
cookbook:
a month of dinners

plus the best:
corduroys
vacuums
frozen pizza

060

REAL SIMPLE
| life made easier |

Your holiday planner:
75 creative ideas for
a stress-free season

24 delicious (and easy)
Thanksgiving recipes

Tips to save on gifts,
decorating, and more

New ways to preserve
your family history

plus the best:
gloves
food processors
vanilla ice cream

060

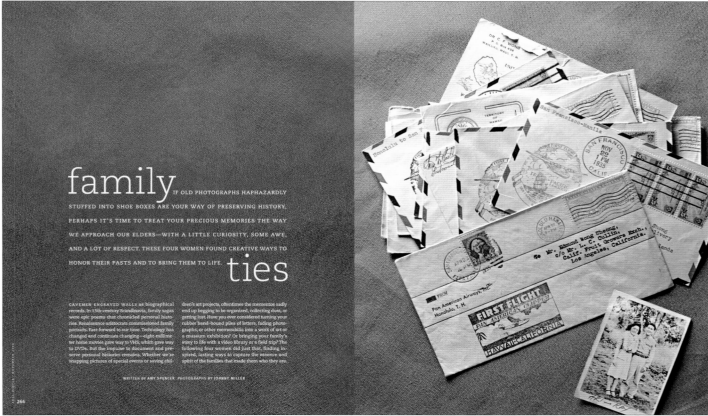

family
IF OLD PHOTOGRAPHS HAPHAZARDLY
STUFFED INTO SHOE BOXES ARE YOUR WAY OF PRESERVING HISTORY,
PERHAPS IT'S TIME TO TREAT YOUR PRECIOUS MEMORIES THE WAY
WE APPROACH OUR ELDERS—WITH A LITTLE CURIOSITY, SOME AWE,
AND A LOT OF RESPECT. THESE FOUR WOMEN FOUND CREATIVE WAYS TO
HONOR THEIR PASTS AND TO BRING THEM TO LIFE.
ties

CAVEMEN ENGRAVED WALLS as biographical records. In 13th-century Scandinavia, family sagas were epic poems that chronicled personal histories. Renaissance aristocrats commissioned family portraits. Fast-forward to our time. Technology has changed and continues changing—eight-millimeter home movies gave way to VHS, which gave way to DVDs. But the impulse to document and preserve personal histories remains. Whether we're snapping pictures of special events or saving children's art projects, oftentimes the mementos sadly end up begging to be organized, collecting dust, or getting lost. Have you ever considered turning your rubber band-bound piles of letters, fading photographs, or other memorabilia into a work of art or a museum exhibition? Or bringing your family's story to life with a video library or a field trip? The following four women did just that, finding inspired, lasting ways to capture the essence and spirit of the families that made them who they are.

WRITTEN BY AMY SPENCER PHOTOGRAPHS BY JOHNNY MILLER

264

060

060. **REAL SIMPLE**

creative director. Vanessa Holden. art directors. Ellene Wundrok, Philip Ficks. designers. Erin Whelan, Grace Kim, Nia Lawrence, Jessica Weit, Tracy Walsh illustrators. Carey Sookocheff, Matthew Sporzynski, Greg Clarke. director of photography. Naomi Nista. photo editors. Lauren Epstein, Susan McClennan Phear. Daisy Cajas. photographers. Anna Williams, Debra McClinton, Ellen Silverman, John Dolan, Marcus Nilsson, Monica Buck, Yunhee Kim, Annie Schlechter, Johnny Miller, Sang An, James Merrell, Victor Schrager, Gentl & Hyers, Nato Welton. publisher. Time Inc. issue. March 2006, September 2006, November 2006 category. Design: Magazine of the Year

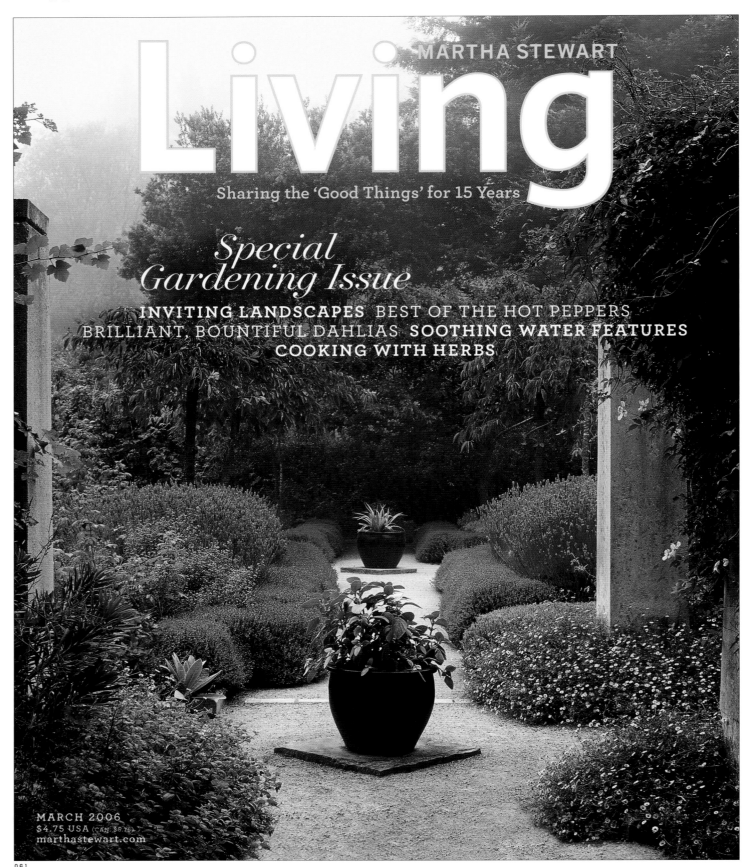

MARTHA STEWART

Living

Sharing the 'Good Things' for 15 Years

Special Gardening Issue

INVITING LANDSCAPES BEST OF THE HOT PEPPERS
BRILLIANT, BOUNTIFUL DAHLIAS **SOOTHING WATER FEATURES**
COOKING WITH HERBS

MARCH 2006
$4.75 USA (CAN $6.75)
marthastewart.com

061

061. **MARTHA STEWART LIVING**

creative director. Eric A. Pike. design director. James Dunlinson. art directors. Joele Cuyler, Mary Jane Callister, Matthew Axe, Cybele Grandjean, Amber Blakesley, Abbey Kuster-Prokell, Isabel Adbai, Stephen Johnson, Cameron King, Linsey Laidlaw. director of photography. Heloise Goodman. photo editors. Andrea Bakacs, Joni Noe. photographers. Sang An, Christopher Baker, Marion Brenner, Ngoc Minh Ngo, Helen Norman, William Abranowicz, Alastair Hendy, Hugh Stewart, James Wojcik, Hans Gissinger, Victoria Pearson, Eric Piasecki, Anna Williams. style director. Ayesha Patel. editor-in-chief. Margaret Roach
publisher. Martha Stewart Living Omnimedia. issue. March 2006, July 2006, December 2006. category. Design: Magazine of the Year

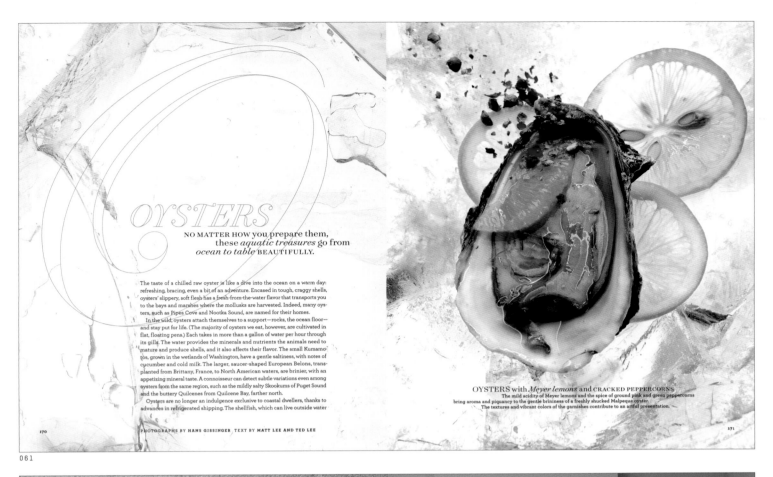

OYSTERS

NO MATTER HOW you prepare them, these *aquatic treasures* go from *ocean to table* BEAUTIFULLY.

The taste of a chilled raw oyster is like a dive into the ocean on a warm day: refreshing, bracing, even a bit of an adventure. Encased in tough, craggy shells, oysters' slippery, soft flesh has a fresh-from-the-water flavor that transports you to the bays and marshes where the mollusks are harvested. Indeed, many oysters, such as Pipes Cove and Nootka Sound, are named for their homes.

In the wild, oysters attach themselves to a support—rocks, the ocean floor—and stay put for life. (The majority of oysters we eat, however, are cultivated in flat, floating pens.) Each takes in more than a gallon of water per hour through its gills. The water provides the minerals and nutrients the animals need to mature and produce shells, and it also affects their flavor. The small Kumamotos, grown in the wetlands of Washington, have a gentle saltiness, with notes of cucumber and cold milk. The larger, saucer-shaped European Belons, transplanted from Brittany, France, to North American waters, are brinier, with an appetizing mineral taste. A connoisseur can detect subtle variations even among oysters from the same region, such as the mildly salty Skookums of Puget Sound and the buttery Quilcenes from Quilcene Bay, farther north.

Oysters are no longer an indulgence exclusive to coastal dwellers, thanks to advances in refrigerated shipping. The shellfish, which can live outside water

OYSTERS with *Meyer lemons* and CRACKED PEPPERCORNS
The mild acidity of Meyer lemons and the spice of ground pink and green peppercorns bring aroma and piquancy to the gentle brininess of a freshly shucked Malpeque oyster. The textures and vibrant colors of the garnishes contribute to an artful presentation.

170

171

PHOTOGRAPHS BY HANS GISSINGER TEXT BY MATT LEE AND TED LEE

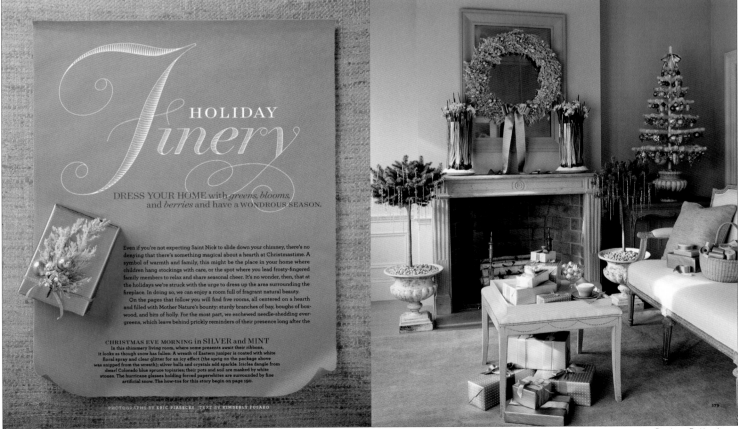

HOLIDAY *Finery*

DRESS YOUR HOME with *greens, blooms,* and *berries* and have a WONDROUS SEASON.

Even if you're not expecting Saint Nick to slide down your chimney, there's no denying that there's something magical about a hearth at Christmastime. A symbol of warmth and family, this might be the place in your home where children hang stockings with care, or the spot where you lead frosty-fingered family members to relax and share seasonal cheer. It's no wonder, then, that at the holidays we're struck with the urge to dress up the area surrounding the fireplace. In doing so, we can enjoy a room full of fragrant natural beauty.

On the pages that follow you will find five rooms, all centered on a hearth and filled with Mother Nature's bounty: sturdy branches of bay, boughs of boxwood, and bits of holly. For the most part, we eschewed needle-shedding evergreens, which leave behind prickly reminders of their presence long after the

CHRISTMAS EVE MORNING in SILVER and MINT
In this shimmery living room, where some presents await their ribbons, it looks as though snow has fallen. A wreath of Eastern juniper is coated with white floral spray and clear glitter for an icy effect (the sprig on the package above was snipped from the wreath); silver balls and crystals add sparkle. Icicles dangle from dwarf Colorado blue spruce topiaries; their pots and soil are masked by white stones. The hurricane glasses holding forced paperwhites are surrounded by fine artificial snow. The how-tos for this story begin on page 190.

PHOTOGRAPHS BY ERIC PIASECKI TEXT BY KIMBERLY FUSARO

179

+ Design: Entire Issue

81

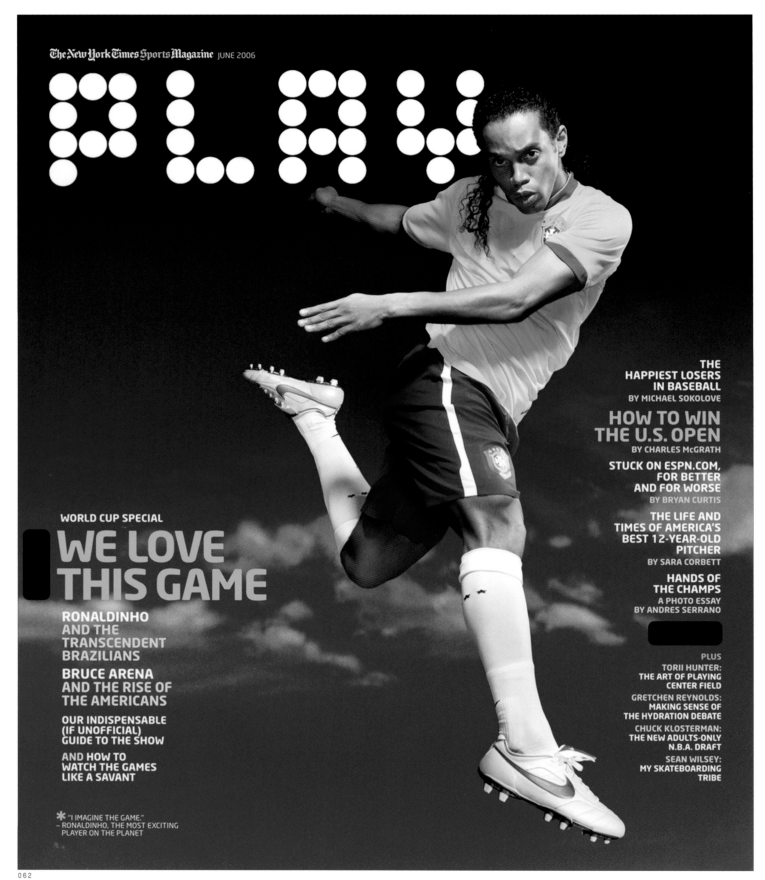

The New York Times Sports Magazine JUNE 2006

PLAY

THE
HAPPIEST LOSERS
IN BASEBALL
BY MICHAEL SOKOLOVE

**HOW TO WIN
THE U.S. OPEN**
BY CHARLES McGRATH

STUCK ON ESPN.COM,
FOR BETTER
AND FOR WORSE
BY BRYAN CURTIS

THE LIFE AND
TIMES OF AMERICA'S
BEST 12-YEAR-OLD
PITCHER
BY SARA CORBETT

HANDS OF
THE CHAMPS
A PHOTO ESSAY
BY ANDRES SERRANO

PLUS
TORII HUNTER:
THE ART OF PLAYING
CENTER FIELD

GRETCHEN REYNOLDS:
MAKING SENSE OF
THE HYDRATION DEBATE

CHUCK KLOSTERMAN:
THE NEW ADULTS-ONLY
N.B.A. DRAFT

SEAN WILSEY:
MY SKATEBOARDING
TRIBE

WORLD CUP SPECIAL

WE LOVE
THIS GAME

RONALDINHO
AND THE
TRANSCENDENT
BRAZILIANS

BRUCE ARENA
AND THE RISE OF
THE AMERICANS

OUR INDISPENSABLE
(IF UNOFFICIAL)
GUIDE TO THE SHOW

AND HOW TO
WATCH THE GAMES
LIKE A SAVANT

✳ "I IMAGINE THE GAME."
– RONALDINHO, THE MOST EXCITING
PLAYER ON THE PLANET

062

creative director. Janet Froelich. art directors. Dirk Barnett, Christopher Martinez. designers. Christopher Martinez, Dirk Barnett, Dragos Lemnei, Guillermo Nagore, Elizabeth Spiridakis. illustrators. Mark Bell, +ISM. director of photography. Kathy Ryan. photo editor. Kira Pollack. photographers. Finlay Mackay, Andrès Serrano, Christian Witkin, Vincent Laforet. editor-in-chief. Mark Bryant. publisher. The New York Times. issue. June 2006, September 2006, November 2006. category. Design: Magazine of the Year

AND GOD
CREATED
NOEL DEVINE

HE MAY BE THE
BEST HIGH-SCHOOL BACK
IN THE NATION,
GENETICALLY BLESSED,
A FULLY FORMED TALENT
WHO REDUCES
COLLEGE COACHES TO THE
LANGUAGE OF MIRACLES.
HIS SUCCESS SEEMS PREORDAINED. ALMOST.

BY ROBERT ANDREW POWELL **PHOTOGRAPHS BY FINLAY MacKAY**

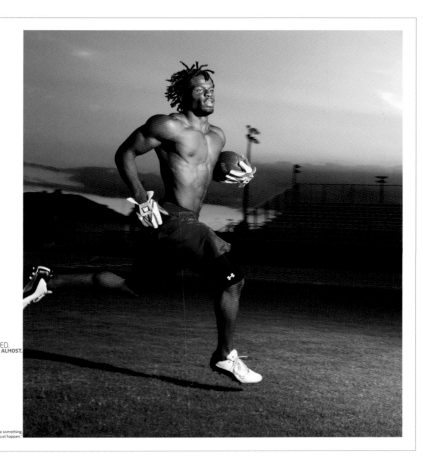

54 PLAY SEPTEMBER 2006

Going places "I think I have an angel on my shoulder. . . . There has to be something, because the moves and my runs, they just happen."

062

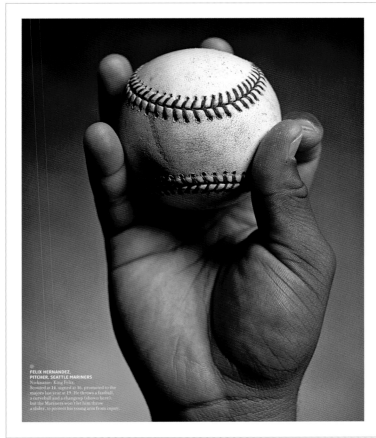

**FELIX HERNANDEZ,
PITCHER, SEATTLE MARINERS**
Nickname: King Felix.
Scouted at 14, signed at 16, promoted to the majors last year at 19. He throws a fastball, a curveball and a changeup (shown here), but the Mariners won't let him throw a slider, to protect his young arm from injury.

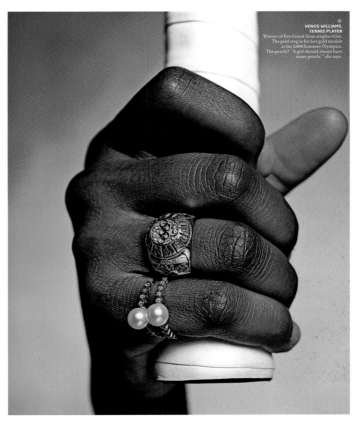

**VENUS WILLIAMS,
TENNIS PLAYER**
Winner of five Grand Slam singles titles. The gold ring is for her gold medals at the 2000 Summer Olympics. The pearls? "A girl should always have some pearls," she says.

062

THE NEW YORK ISSUE

The New York Times Magazine

SEPTEMBER 10, 2006 / SECTION 6

WHAT WAS, IS AND WILL BE
DOWNTOWN

★ **THE DIARIES AND NOTEBOOKS OF SUSAN SONTAG** (1958-67)
MAYOR BLOOMBERG'S LOWER-MANHATTAN JOURNEY BY JONATHAN MAHLER
THE TASTE OF FLAVORPILL BY CHIP BROWN
GROWING UP A VILLAGE COMMUNIST BY MICHAEL KIMMELMAN
WHEN DID IT BECOME COOL TO HANG OUT <u>OUTSIDE BOUTIQUES</u>? (SEE STYLE)

ALSO: A PHOTO PORTFOLIO OF NEW BOHEMIANS. THE CULTURE-DISTRICT CONUNDRUM. AND MORE …

063

063. THE NEW YORK TIMES MAGAZINE

creative director. Janet Froelich. art director. Arem Duplessis. designers. Jeff Glendenning, Gail Bichler, Cathy Gilmore-Barnes, Nancy Harris Rouemy, Leo Jung, Jeffrey Docherty, Jody Churchfield, Lucas Quigley. director of photography. Kathy Ryan. photo editors. Kira Pollack, Joanna Milter, Clinton Cargill, Leonor Mamanna, Luise Stauss. editor-in-chief. Gerald Marzorati. publisher. The New York Times. issue. March 5, 2006, September 10, 2006, December 10, 2006
category. Design: Magazine of the Year

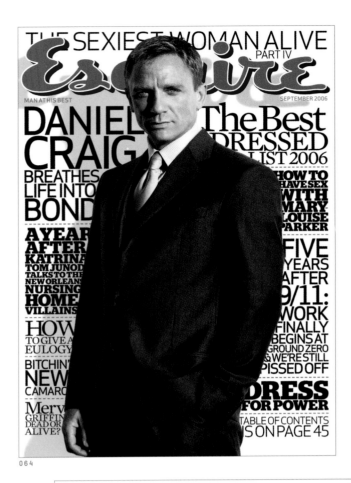

064

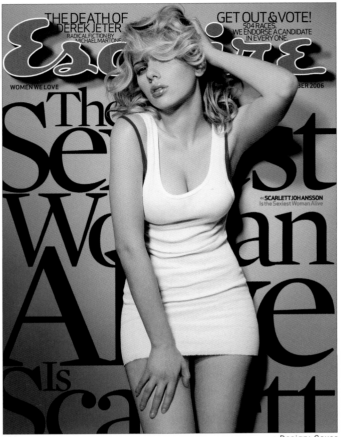

064

+ Design: Cover

064

064. **ESQUIRE**

design director. David Curcurito. art director. Darhil Crooks. designer. Derya Hanife Altan. illustrators. Andy Friedman, John Cuneo, Gary Taxali, Marion Duchars, Soogls, Joe McGee. director of photography. Nancy Jo Iacoi. photo editor. Michael Norseng. photographers. Sheryl Neilds, Art Streiber, Greg Williams, Darren Braun, Henry Leutwyler, Christian Witkin, Lee Crum, Jeff Lipsky, Sasha Beezubov, Andy Ryan. associate art director. Colin Tunstall. editor-in-chief. David Granger. publisher. The Hearst Corporation-Magazines Division. issue. September 2006, November 2006, December 2006. category. Design: Magazine of the Year

FOOD
everyday

from the kitchens of
MARTHA STEWART LIVING

ISSUE 82

SHOP SMART:
1 bag, 5 dinners
PLUS OUR BEST CHICKEN IDEAS EVER
AND FRESH STRAWBERRY DESSERTS

MAY 2006 www.everydayfoodmag.com

**roasted salmon
with lemon relish**
see recipe, page 83

065

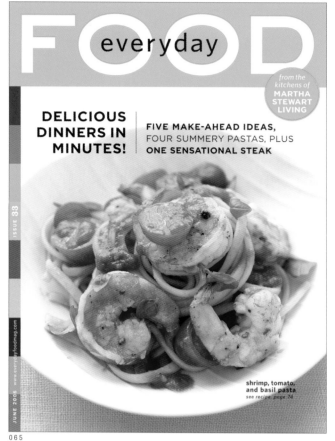

FOOD
everyday

from the kitchens of
MARTHA STEWART LIVING

ISSUE 83

DELICIOUS
DINNERS IN
MINUTES!

FIVE MAKE-AHEAD IDEAS,
FOUR SUMMERY PASTAS, PLUS
ONE SENSATIONAL STEAK

JUNE 2006 www.everydayfoodmag.com

**shrimp, tomato,
and basil pasta**
see recipe, page 74

065

WEEKEND DINNER

butterscotch banana splits

- 1 cup heavy cream
- 6 tablespoons butter
- ⅓ cup packed light-brown sugar
- 3 tablespoons light corn syrup
- 2 tablespoons granulated sugar
- 8 bananas, peeled and split lengthwise
- 2 pints chocolate ice cream (or your favorite)
- ½ cup salted peanuts, roughly chopped (optional)
- 8 maraschino cherries (optional)

1 Make butterscotch sauce: In a small saucepan, combine ⅓ cup cream, butter, brown sugar, and corn syrup. Bring to a boil over high heat; cook, stirring occasionally, until sugar has dissolved, 2 to 3 minutes. Let cool to room temperature. Sauce can also be made up to 1 week ahead; cover and refrigerate in an airtight container.

2 If sauce is refrigerated, place in microwave, before serving, for 30 seconds; stir. If still too thick, microwave for 15 seconds more, and stir again.

3 Whip the cream: In a large bowl, whisk remaining ⅔ cup cream and granulated sugar until soft peaks form.

4 Assemble: In each of eight shallow dishes, arrange 2 banana halves lengthwise. Place 2 scoops ice cream on bananas. Top with butterscotch sauce, whipped cream, and, if desired, peanuts and a cherry. Serves 8.

118

065

065. **EVERYDAY FOOD**

creative director. Eric A. Pike. design director. Scot Schy. art directors. William van Roden, Alberto Capolino. director of photography. Heloise Goodman senior photo editor. Andrea Bakacs. photographers. Jonathan Lovekin, José Manuel. stylists. Scot Schy, Cyd Raftus McDowell publisher. Martha Stewart Omnimedia. issue. May 2006, June 2006, July/August 2006. category. Design: Magazine of the Year

october 2006

marie claire

"the thrill is back"

FRESH
SPIRITED
SEXY

MORNING
AFTER
HAIR
(FLAUNT IT!)

WHAT TO
WEAR
TO WORK
NOW

**3 STORIES YOU
CAN'T IGNORE**
BREAST-
CANCER
DENIAL
MUSLIM
WOMEN TO
THE RESCUE
LAST CLINIC
STANDING

SARAH
JESSICA PARKER
WE'LL HAVE
WHAT SHE'S
HAVING...

BEAUTY
SPECIAL

GO ON,
FLIP US OVER

066

november 2006

marie claire

GELLAR
GROWS
UP (AND
SHE'S EVEN
MORE FAB)

SWALLOW
THIS: THE
NEW
BEAUTY
PILLS

CASH
TALK!
EARNING IT
BLOWING IT
SAVING IT

STOP
THE
PRESS!
STYLE
INSIDERS'
NEW
SECRET
HAUNTS

EXCLUSIVE:
AFTER ABU
GHRAIB:
LYNNDIE
ENGLAND'S
FIRST
JAILHOUSE
INTERVIEW

SEX, POWER
& ARAB TV!
(GOTTA TIVO)

*"the lady
is a vamp"*

ROCK
STAR
FASHION
WHAT TO WEAR NOW

066

+ Design: Cover

TRUE CRIME

On a Monday morning, Darren Mack knifed his wife, shot a judge, and booked it to a swinger's joint across the Mexican border. It's a story straight from a daytime soap opera— or, as it happens, from the hometown streets of writer Amanda Robb. An inside look at domestic homicide, Reno-style.

PHOTOGRAPHED BY TOD SEELIE/WPN

DEC 2006 / MARIE CLAIRE 117

066

066. **MARIE CLAIRE**

creative director. Paul Martinez. art director. Jenny Leigh Thompson. designers. Paul Martinez, Jenny Leigh Thompson, Shannon Casey, Burgan Shealy, Greg Behar
director of photography. Alix Campbell. photo editors. Andrea Volbrecht, Melanie Chambers. photographers. Ruven Afanador, Andrew Hetherinton, Neil Kirk,
Svend Lindbaek, Tod Seelie, James White, Troy Word. art/photo assistant. Margo Didia. editor-in-chief. Joanna Coles
publisher. The Hearst Corporation-Magazines Division. issue. September 2006, October 2006, November 2006. category. Design: Magazine of the Year

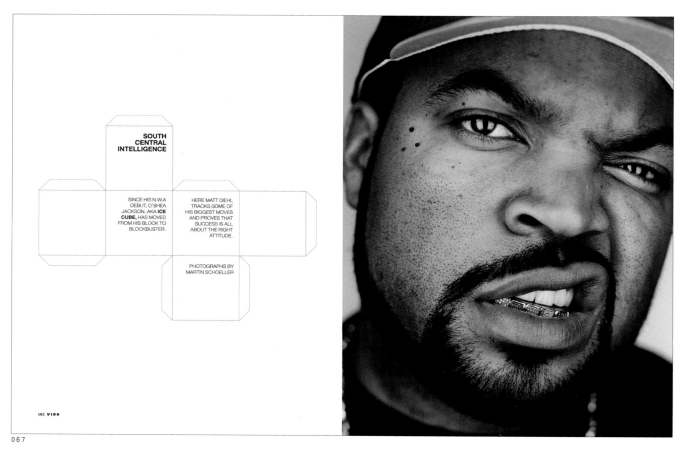

067

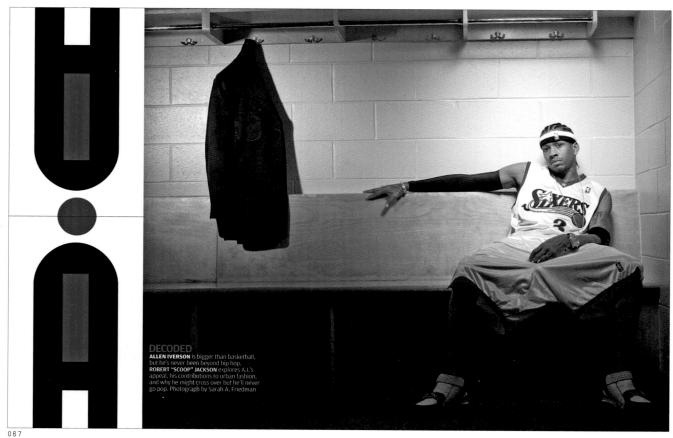

067

067. **VIBE**

design director. Florian Bachleda. art director. Wyatt Mitchell. designers. Alice Alves, Neomi Assiabanha, Stravinski Pierre
director of photography. Leslie dela Vega. photo editors. Marian Barragan, EunJean Song, Charlotte Davis. editor-in-chief. Mimi Valdés
publisher. Vibe/Spin Ventures LLC. issue. July 2006, August 2006, September 2006. category. Design: Magazine of the Year + Design: Spread

068

068

068. **33 THOUGHTS**

creative director. Jeremy Leslie. art director. James Crubb. studio. John Brown Publishing. publisher. John Brown
client. Boo Stoy Hayward. issue. Spring 2006, Summer 2006, Winter 2006. category. Design: Magazine of the Year

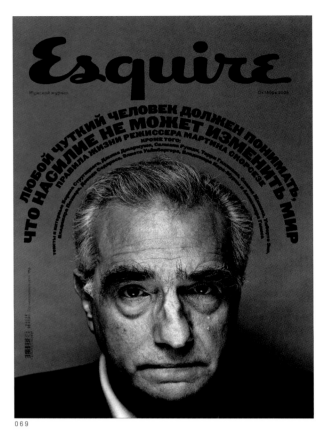

069

069

069

069. **ESQUIRE - RUSSIA**

art directors. Barbanel Dmitry, Maxim Nikandro. designers. Vladislav Borisov, Wyacheslav Fhitnikov. photo editor. Ekaterina Furtseva
publisher. Independent Media Sanoma Magzines. issue. May 2006, July/August 2006, October 2006. category. Design: Magazine of the Year

070

070

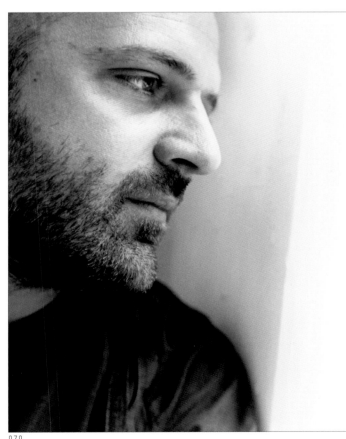

070

avantgarb

ONE OF FASHION'S QUIETEST ACHIEVERS, LONDON DESIGNER HUSSEIN CHALAYAN CREATES CLOTHING WITH A SCULPTURAL AESTHETIC, DRAWING FROM ARCHITECTURE, ENGINEERING AND EVEN POLITICS.

37 // SOCIAL FABRIC
WORDS // CAIA HAGEL
PORTRAIT // JULIAN ANDERSON

070. __POL OXYGEN__

creative directors. Marcus Piper, Vince Frost (Frost Design). art directors. Marcus Piper, Anthony Donovan. designers. Christian Schwarz, David Adjaye, Shane Currey illustrators. Arne Quinze, Vince Frost, Joshua Davis. photographers. Derek Henderson, James Muldowney, Clive Arrowsmith, Norman Reedus, Kiyoshi Kuramitsu, Ricky Ridecos, Jason Frank Rothenburg, Cindy Palmano, Richard Kerns, Tim Dewgeson, Julian Anderson, Edward Burtynsky, Thierry van Dorr, Lake Tajo, Jesper Brandt, Martin Mischkylnig, Gerrard Needham, Shin Toshihisa, Frank Bauer, Martin Parr. studio. Frost Design, Sydney. editor-in-chief. Jan Mackey publisher. POL Publications. issue. Issues 16, Issues 18, The Stretch Issue. category. Design: Magazine of the Year

VINO✚GASTRONOMIA
AÑO XXI / 4,50 € / CANARIAS 4,80 €

Armonías
TRES RECETAS
DE TRUFAS NEGRAS
EN BOCCONDIVINO

Harold McGee
ENTREVISTA CON EL GRAN
TEÓRICO DE LA QUÍMICA
GASTRONÓMICA

Catas
UVAS RECUPERADAS,
LOS NUEVOS 2005,
Y MUCHO TOKAJ

Quesos en el restaurante
CÓMO PRESENTAN EL
CLÁSICO PREPOSTRE LOS
MEJORES CHEFS ESPAÑOLES

mujeres
3 estrellas
DE EUGÉNIE BRAZIER
A CARME RUSCALLEDA,
TODAS LAS COCINERAS
QUE HAN ALCANZADO EL
OLIMPO GASTRONÓMICO

En busca de la uva perdida /
Triunfa la moda de recuperar
castas autóctonas olvidadas

071

VINO✚GASTRONOMIA
AÑO XXI / 4,50 € / CANARIAS 4,80€

Alberto Herráiz
LOCALIZAMOS EN PARÍS
AL MAYOR EXPERTO
EN GAZPACHO

Ymelda Moreno
HABLA LA MARQUESA
GOURMET QUE DIRIGE
LA GUÍA CAMPSA

Catas
BLANCOS Y TINTOS
PARA EL VERANO Y
LOS VINOS CANARIOS

Armonías
TRES RECETAS
DE CEVICHE
EN "LA GORDA"

LA OTRA CARA DE LA
fritura
EL CHEF DANI GARCÍA
REINVENTA LA TÉCNICA
ANDALUZA DE FREÍR
EL PESCADO

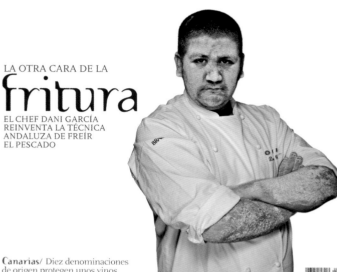

Canarias/ Diez denominaciones
de origen protegen unos vinos
originales y desconocidos

071

Texto/ Emma Sueiro / Fotografías / Fernando de Madariaga

LA COCINERA CATALANA CARME RUSCALLEDA HA CONSEGUIDO ESTE AÑO POR FIN
la tercera estrella
SIENDO LA PRIMERA MUJER ESPAÑOLA EN ALCANZAR EL OLIMPO GASTRONÓMICO

Ω VINO Y GASTRONOMIA

071

071. **VINO + GASTRONOMIA**

design director. Carmelo Caderot. art director. Carmelo Caderot. designer. Carmelo Caderot. director of photography. Carmelo Caderot
publisher. Vino y Gastronomía Comunicación. issue. Fritura Issue, Hermanos Issue, Mujeres Issue. category. Design: Magazine of the Year

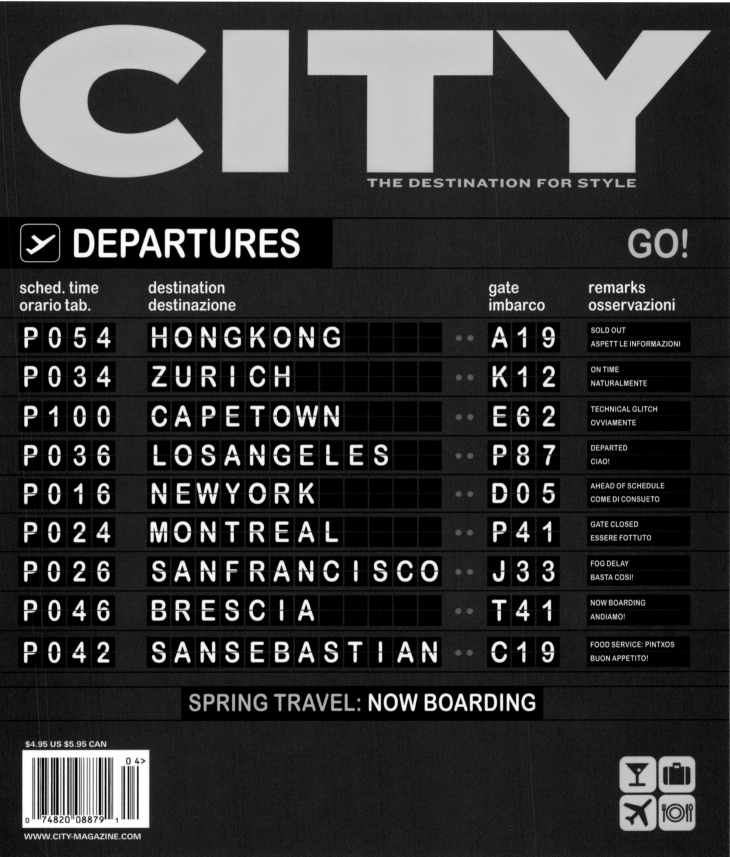

CITY

THE DESTINATION FOR STYLE

✈ DEPARTURES

GO!

sched. time orario tab.	destination destinazione		gate imbarco	remarks osservazioni
P054	HONGKONG	••	A19	SOLD OUT ASPETT LE INFORMAZIONI
P034	ZURICH	••	K12	ON TIME NATURALMENTE
P100	CAPETOWN	••	E62	TECHNICAL GLITCH OVVIAMENTE
P036	LOSANGELES	••	P87	DEPARTED CIAO!
P016	NEWYORK	••	D05	AHEAD OF SCHEDULE COME DI CONSUETO
P024	MONTREAL	••	P41	GATE CLOSED ESSERE FOTTUTO
P026	SANFRANCISCO	••	J33	FOG DELAY BASTA COSI!
P046	BRESCIA	••	T41	NOW BOARDING ANDIAMO!
P042	SANSEBASTIAN	••	C19	FOOD SERVICE: PINTXOS BUON APPETITO!

SPRING TRAVEL: NOW BOARDING

$4.95 US $5.95 CAN

0 74820 08879 1 04>

WWW.CITY-MAGAZINE.COM

072. **CITY**

creative director. Fabrice Frere. designer. Fabrice Frere. illustrator. Fabrice Frere. publisher. Spark Media
issue. April 2006. category. Design: Cover

073

074

075

076

077

078

073. **CITY**

creative director. Fabrice Frere
art director. Adriana Jacoud
designer. Fabrice Frere
illustrator. Gray Scott
photo editor. Sarah Greenfield
publisher. Spark Media
issue. September 2006
category. Design: Cover

076. **EGOISTA**

creative director. Patrícia Reis
design director. Henrique Cayette
designers. Filipa Gregório, Hugo Neves, Rita Salgveiro, Rodrigo Salas
producers. Francisco Ponciano, Cláudio Garrudo
studio. 004. publisher. Atelier 004
client. Estoril - Sol. issue. June 2006
category. Design: Cover

074. **CITY**

creative director. Fabrice Frere
art director. Adriana Jacoud
designer. Fabrice Frere
photo editor. Sarah Greenfield
photographer. Martyn Thompson
publisher. Spark Media
issue. October/November 2006
category. Design: Cover

077. **CAP & DESIGN**

art director. Fredrik Sundwall
designer. Fredrik Sundwall
photographer. Andreas Lind
studio. Manifestovision
publisher. IDG / Sweded
client. IDG. issue. April 2006
category. Design: Cover

075. **ESPN THE MAGAZINE**

creative director. Siung Tjia
designer. Siung Tjia
director of photography. Catriona Ni Aolain
photo editor. Joe Rodriquez
photographer. Brian Pellicone
publisher. ESPN, Inc.
issue. July 3, 2006
category. Design: Cover

078. **CITIGROUP PURSUITS**

creative director. Charlene Benson
design director. Alex Knowlton
art director. Kate Iltis
photo editor. Denise Bosco
photographer. Jim Bastardo
studio. Time Inc. Content Solutions
publisher. Time Inc. Content Solutions
client. Citigroup. issue. October 2006
category. Design: Cover

079

080

081

079. **AMERICAN THEATRE**

art director. Kitty Suen
illustrator. Jody Hewgill
editor-in-chief. Jim O'Quinn
issue. January 2006
category. Design: Cover

080. **BLUEPRINT**

creative director. Eric A. Pike
design director. Deb Bishop
director of photography. Heloise Goodman
photo editors. Rebecca Donnelly, Mary Cahill,
Sara McOsker
photographer. Chris Shipman
styled by. Shane Powers, Katie Hatch
editor-in-chief. Rebecca Thuss
publisher. Martha Stewart Living Omnimedia
issue. Summer 2006
category. Design: Cover

081. **BLAB**

creative director. Monte Beauchamp
designer. Jonathon Rosen
illustrator. Jonathon Rosen
studio. Jonathon Rosen Studio
publisher. Fantagraphics
issue. Fall 2006
category. Design: Cover

print

Print's Past, Present, Future

Soviet Children's Books

The Girls' Guide to Chick Lit

New Novels' Tricky Type

DESIGN CULTURE MEDIA
JUL/AUG 2006 US$12.95/CAN$15.95

082. **PRINT**

art director. Kristina DiMatteo. illustrator. Marian Bantjes. editor-in-chief. Joyce Rutter Kaye
publisher. F & W Publications. issue. July/August 2006. category. Design: Cover

METROPOLIS

LOUIS VUITTON trades traditional grandeur for a THEME-PARK take on luxury

ARCHITECTURE < CULTURE > DESIGN
March 2006

WILL IT PLAY IN PARIS?

WWW.METROPOLISMAG.COM
USA $5.95 ✦ CANADA $7.95

0 3>

0 74820 08756 5

083.

083. **METROPOLIS**

creative director. Criswell Lappin. art director. Nancy Nowacek. designer. Erich Nagler. photo editors. Bilyana Dimitrova, Magda Biernat
photographer. Jimmy Cohrssen. publisher. Bellerophon Publications. issue. March 2006. category. Design: Cover

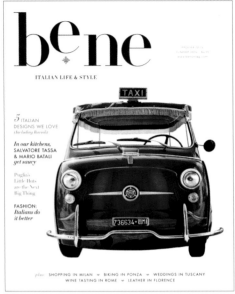

084

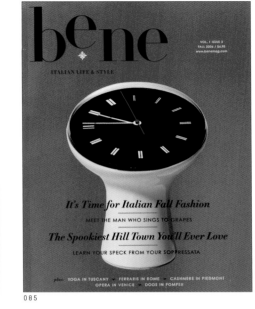

085

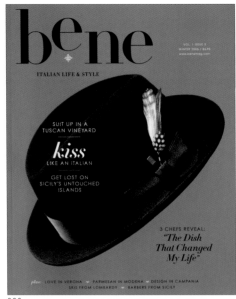

086

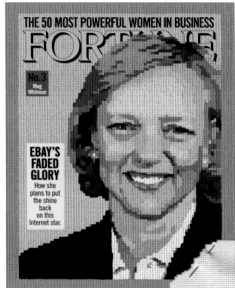

087

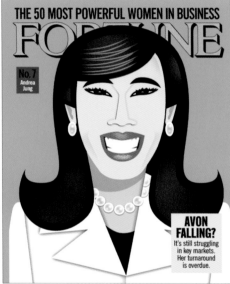

088

089

084. **BENE**

design director. Stella Bugbee
art director. Susan Baker
director of photography. Gemma Corsano
photographer. Matt Hupfel
publisher. Vinceri, LLC
issue. Summer 2006
category. Design: Cover

085. **BENE**

design director. Stella Bugbee
art director. Susan Baker
director of photography. Gemma Corsano
photographer. Chris Gentile
publisher. Vinceri, LLC
issue. Fall 2006
category. Design: Cover

086. **BENE**

design director. Stella Bugbee
art director. Susan Baker
director of photography. Gemma Corsano
publisher. Vinceri, LLC
issue. Winter 2006
category. Design: Cover

087. **FORTUNE**

design director. Robert Newman
art director. Renee Klein
illustrator. David Cowles
director of photography. Greg Pond
photo editor. Leslie dela Vega
publisher. Time Inc.
issue. October 16, 2006
category. Design: Cover

088. **FORTUNE**

design director. Robert Newman
art director. Renee Klein
illustrator. Robert Risko
director of photography. Greg Pond
photo editor. Leslie dela Vega
publisher. Time Inc.
issue. October 16, 2006
category. Design: Cover

089. **FORTUNE**

design director. Robert Newman
art director. Nai Lee Lum
illustrator. David McLimans
publisher. Time Inc.
issue. July 24, 2006
category. Design: Cover

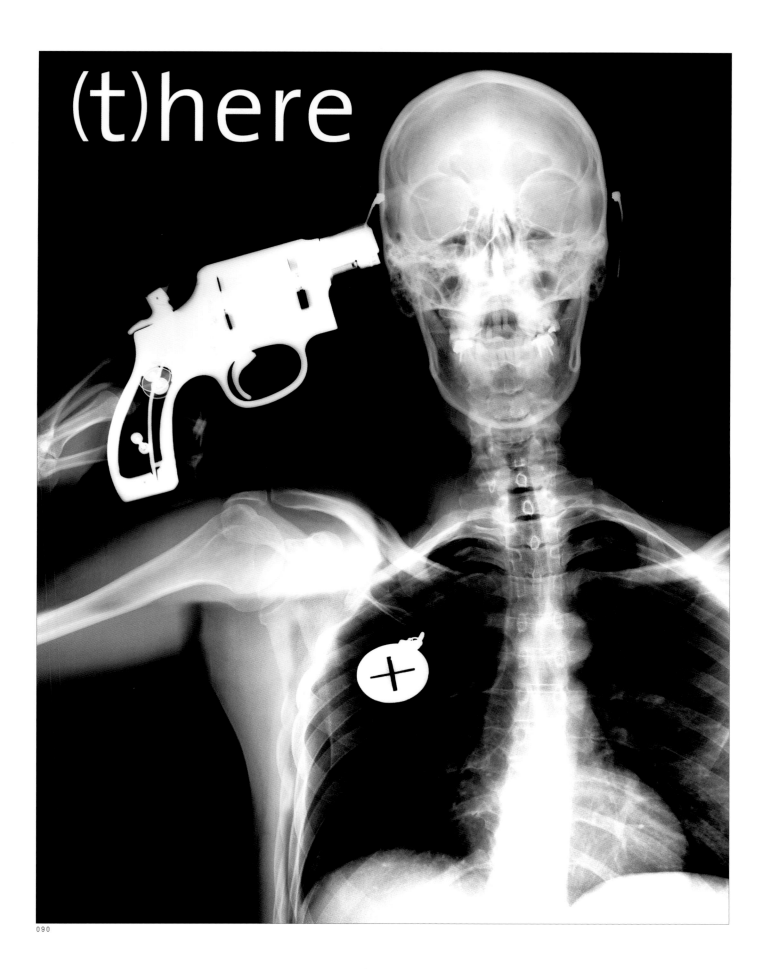

090

(T)HERE

creative director. Chris Wieliczko. design director. Jason Makowski. photographer. Hady Sy. publisher. There Media, Inc.
issue. September 2006. category. Design: Cover

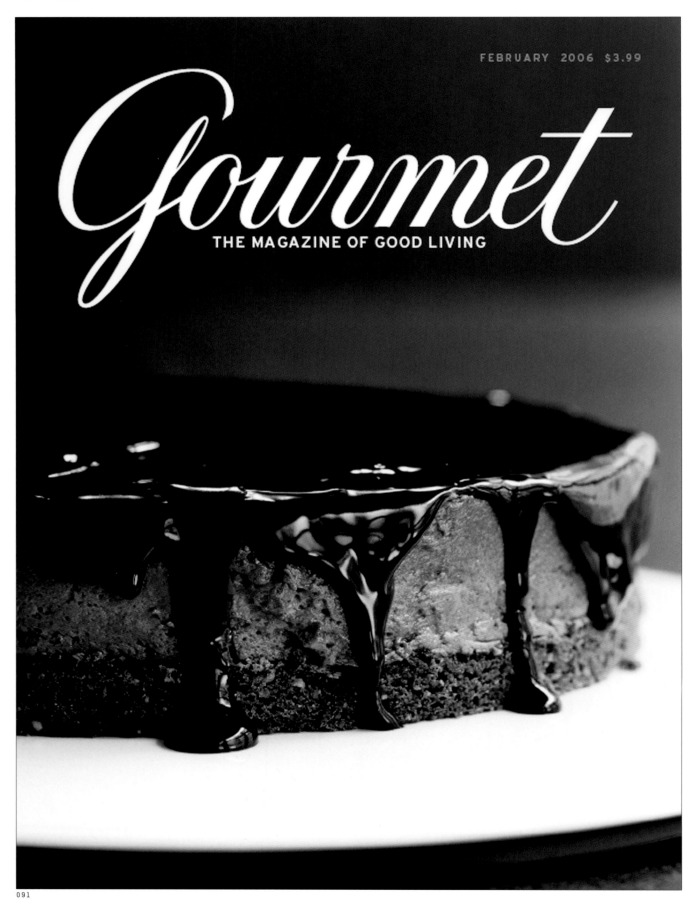

FEBRUARY 2006 $3.99

Gourmet

THE MAGAZINE OF GOOD LIVING

091

091. **GOURMET**

creative director. Richard Ferretti. art director. Erika Oliveira. designer. Richard Ferretti. photo editors. Amy Koblenzer, Megan Re photographer. Romulo Yanes. publisher. Condé Nast Publications, Inc. issue. February 2006. category. Design: Cover

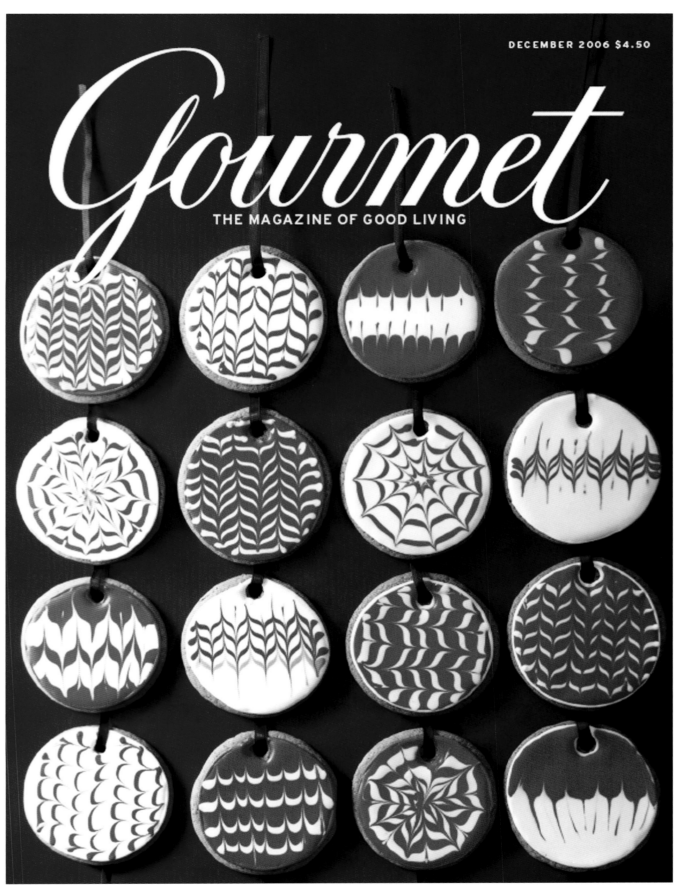

092. **GOURMET**

creative director. Richard Ferretti. art director. Erika Oliveira. designer. Richard Ferretti. photo editors. Amy Koblenzer, Megan Re
photographer. Romulo Yanes. publisher. Condé Nast Publications, Inc. issue. December 2006. category. Design: Cover

093

094

095

096

097

098

093. **TIME**

art director. Arthur Hochstein
director of photography. Michele Stephenson
photo editor. MaryAnne Golon
photographer. Ron Edmonds (AP)
publisher. Time Inc.
issue. November 6, 2006
category. Design: Cover

096. **THE NEW REPUBLIC**

creative directors. Joseph Heroun, Christine Car
illustrator. Andrio Abero
studio. Heroun + Co.
client. The New Republic
issues. November 20, 2006
category. Design: Cover

094. **TIME**

art director. Arthur Hochstein
director of photography. Michele Stephenson
photo editor. Mary Anne Golon
photographer. Weegee
publisher. Time Inc.
issue. October 16, 2006
category. Design: Cover

097. **GOOD**

creative director. Casey Capwell
design director. Scott Stowell
designers. Susan Barber, Rob Dileso, Gary Fogelson,
Serifcan Özcan, Nick Rock, Scott Stowell
illustrators. W+K 12, Tamara Shopsin, Peter Arkle,
Robin Cameron, Designs by Gary
photo editor. Joaquin Trujillo
photographers. Olivier Laude, Trujillo-Paumier,
Border Film Project. studio. Open
publisher. Good Magazine, LLC
client. Good Magazine
issue. September/October 2006
category. Design: Cover

095. **TIME**

art director. Arthur Hochstein
director of photography. Michele Stephenson
photo editor. Mary Anne Golon
publisher. Time Inc.
issue. November 20, 2006
category. Design: Cover

098. **PLAYBOY - GERMANY**

creative director. Wolfgang Buss
art director. Wolfgang Buss
designers. Gabriele Kessler, Moritz Röder
illustrator. Moritz Röder
director of photography. Parvin Nazemi
editor-in-chief. Stefan Schmortte
publisher. Burda. issue. July 2006
category. Design: Cover

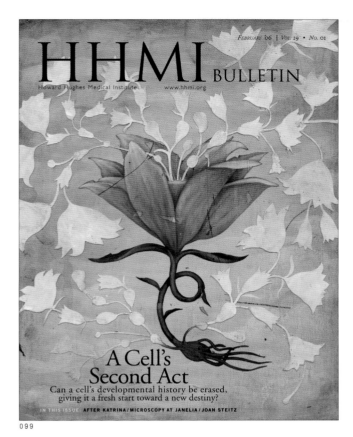

099

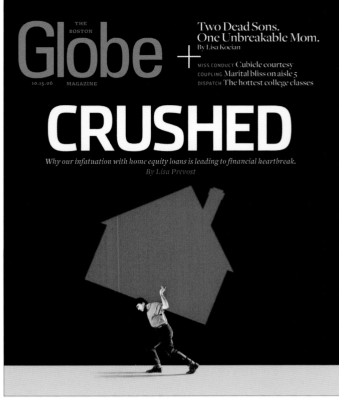

100

101

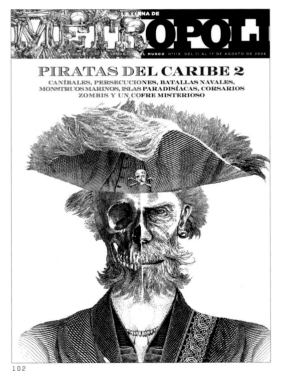

102

099. **HOWARD HUGHES MEDICAL INSTITUTE BULLETIN**

creative director. Hans Neubert. art director. Sarah Viñas
designer. Sarah Viñas. illustrator. Jason Holley
studio. VSA Partners. publisher. Howard Hughes Medical Institute
issue. February 2006. category. Design: Cover

101. **THE TRIDENT**

art director. Jimmy Ball. designer. Jimmy Ball
photographer. Jimmy Ball. editor-in-chief. Phyllis Grissom
publisher. Delta Delta Delta. issue. Winter 2006
category. Design: Cover

100. **THE BOSTON GLOBE MAGAZINE**

design director. Dan Zedek. art director. Brendan Stephens
designer. Brendan Stephens. illustrator. Josue Evilla
photographer. Stuart Redler (Getty). publisher. The New York Times
issue. October 15, 2006. category. Design: Cover

102. **METROPOLI**

design director. Carmelo Caderot. art director. Rodrigo Sanchez
designer. Rodrigo Sanchez. illustrator. Raul Arias
publisher. Unidad Editorial S.A. issue. August 11, 2006
category. Design: Cover

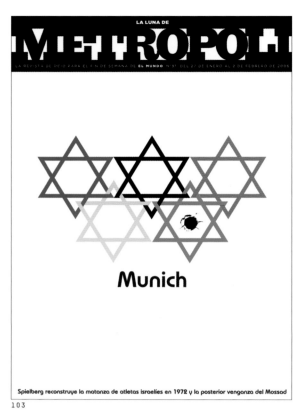

103

104

105

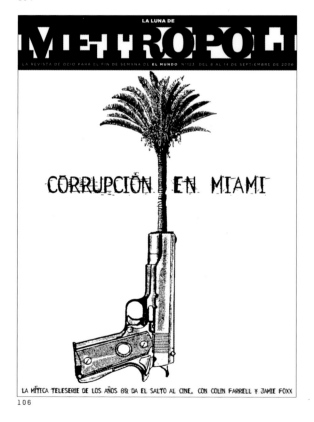

106

103. **LA LUNA DE METROPOLI**

design director. Carmelo Caderot. art director. Rodrigo Sanchez
designer. Rodrigo Sanchez. illustrator. Rodrigo Sanchez
publisher. Unidad Editorial S.A. issue. January 27, 2006
category. Design: Cover

105. **LA LUNA DE METROPOLI**

design director. Carmelo Caderot. art director. Rodrigo Sanchez
designer. Rodrigo Sanchez. illustrator. Rodrigo Sanchez
publisher. Unidad Editorial S.A. issue. November 24, 2006
category. Design: Cover

104. **LA LUNA DE METROPOLI**

design director. Carmelo Caderot. art director. Rodrigo Sanchez
designer. Rodrigo Sanchez. illustrator. Raúl Arias
publisher. Unidad Editorial S.A. issue. December 15, 2006
category. Design: Cover

106. **LA LUNA DE METROPOLI**

design director. Carmelo Caderot. art director. Rodrigo Sanchez
designer. Rodrigo Sanchez. illustrator. Raúl Arias
publisher. Unidad Editorial S.A. issue. September 8, 2006
category. Design: Cover

DIAGNOSIS: Did Scrooge Suffer From Lewy Body Dementia? (See Page 36)

The New York Times Magazine

DECEMBER 17, 2006 / SECTION 6

On Giving

What the superrich — and the rest of us — should
donate to reduce poverty, disease and death in the developing world.
A philosophical argument.

By Peter Singer

107. **THE NEW YORK TIMES MAGAZINE**

creative director. Janet Froelich. art director. Arem Duplessis. designer. Cathy Gilmore-Barnes. illustrator. Jeffrey Docherty
editor-in-chief. Gerald Marzorati. publisher. The New York Times. issue. December 17, 2006. category. Design: Cover

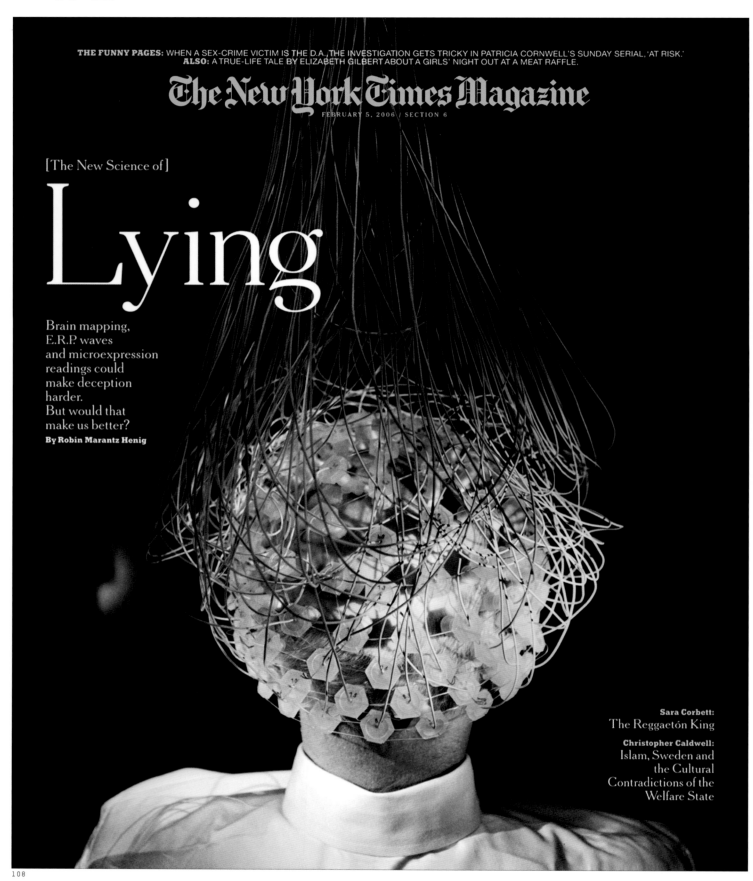

THE FUNNY PAGES: WHEN A SEX-CRIME VICTIM IS THE D.A., THE INVESTIGATION GETS TRICKY IN PATRICIA CORNWELL'S SUNDAY SERIAL, 'AT RISK.'
ALSO: A TRUE-LIFE TALE BY ELIZABETH GILBERT ABOUT A GIRLS' NIGHT OUT AT A MEAT RAFFLE.

The New York Times Magazine

FEBRUARY 5, 2006 / SECTION 6

[The New Science of]

Lying

Brain mapping,
E.R.P. waves
and microexpression
readings could
make deception
harder.
But would that
make us better?
By Robin Marantz Henig

Sara Corbett:
The Reggaetón King

Christopher Caldwell:
Islam, Sweden and
the Cultural
Contradictions of the
Welfare State

108

creative director. Janet Froelich. art director. Arem Duplessis. designer. Jeff Glendenning. director of photography. Kathy Ryan. photographer. Larry Fink
editor-in-chief. Gerald Marzorati. publisher. The New York Times. issue. February 5, 2006. category. Design: Cover

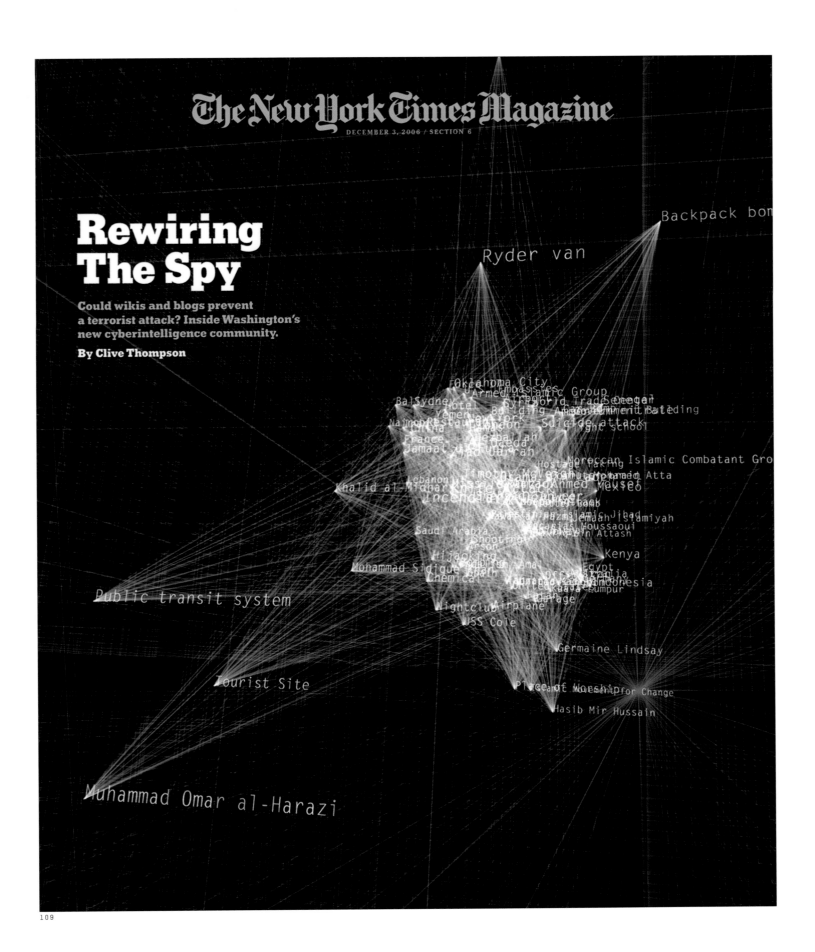

109. **THE NEW YORK TIMES MAGAZINE**

creative director. Janet Froelich. art director. Arem Duplessis. designer. Jeff Glendenning. illustrators. Lisa Strausfeld. James Nick Sears
editor-in-chief. Gerald Marzorati. publisher. The New York Times. issue. December 3, 2006. category. Design: Cover

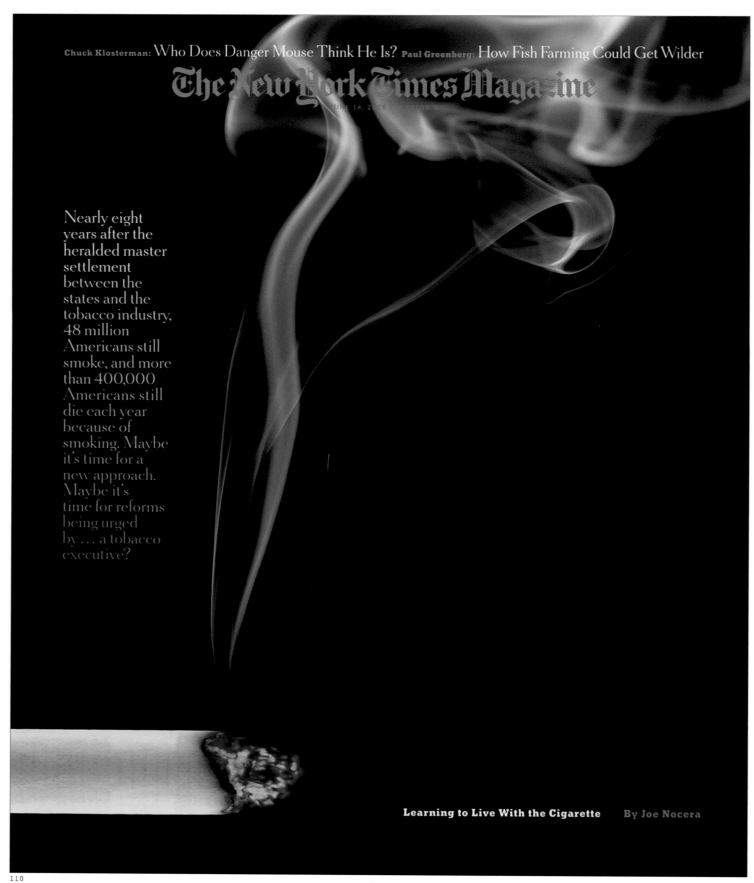

Chuck Klosterman: Who Does Danger Mouse Think He Is? Paul Greenberg: How Fish Farming Could Get Wilder

The New York Times Magazine

JUNE 18, 2006 / SECTION 6

Nearly eight years after the heralded master settlement between the states and the tobacco industry, 48 million Americans still smoke, and more than 400,000 Americans still die each year because of smoking. Maybe it's time for a new approach. Maybe it's time for reforms being urged by … a tobacco executive?

Learning to Live With the Cigarette By Joe Nocera

110

110. THE NEW YORK TIMES MAGAZINE

creative director. Janet Froelich. art director. Arem Duplessis. designer. Nancy Harris Rouemy. director of photography. Kathy Ryan. photographer. Andrew Bettles editor-in-chief. Gerald Marzorati. publisher. The New York Times. issue. June 18, 2006. category. Design: Cover

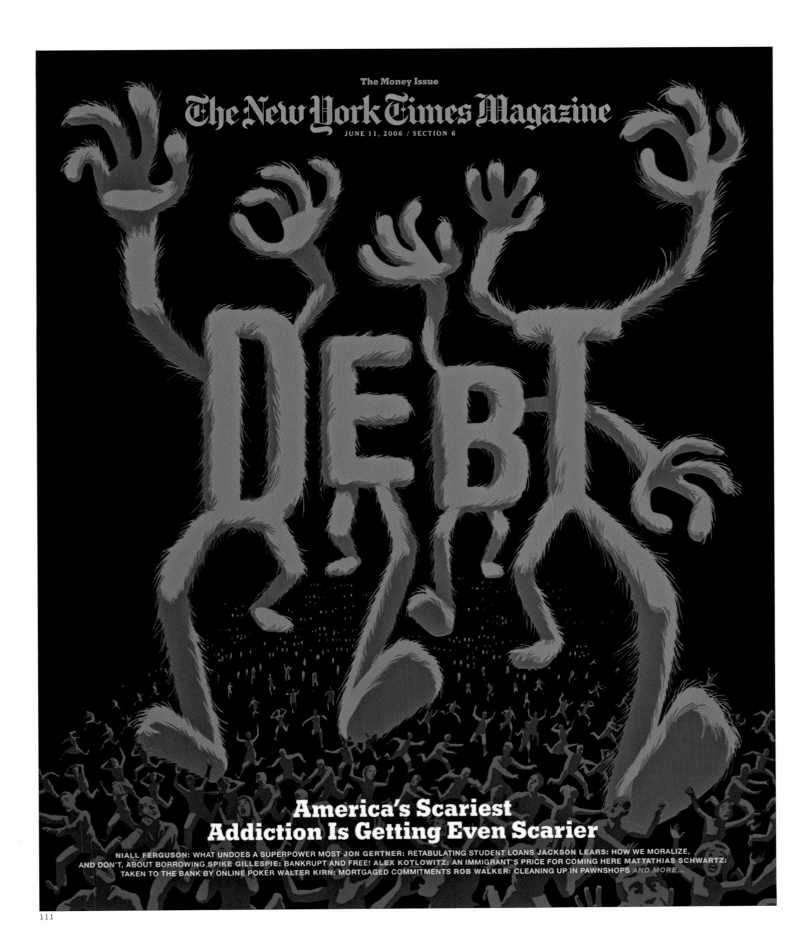

America's Scariest
Addiction Is Getting Even Scarier

NIALL FERGUSON: WHAT UNDOES A SUPERPOWER MOST JON GERTNER: RETABULATING STUDENT LOANS JACKSON LEARS: HOW WE MORALIZE, AND DON'T, ABOUT BORROWING SPIKE GILLESPIE: BANKRUPT AND FREE! ALEX KOTLOWITZ: AN IMMIGRANT'S PRICE FOR COMING HERE MATTATHIAS SCHWARTZ: TAKEN TO THE BANK BY ONLINE POKER WALTER KIRN: MORTGAGED COMMITMENTS ROB WALKER: CLEANING UP IN PAWNSHOPS *AND MORE...*

111

111. **THE NEW YORK TIMES MAGAZINE**

creative director. Janet Froelich. art director. Arem Duplessis. designer. Cathy Gilmore-Barnes. illustrator. Christoph Niemann
director of photography. Kathy Ryan. editor-in-chief. Gerald Marzorati. publisher. The New York Times. issue. June 11, 2006. category. Design: Cover

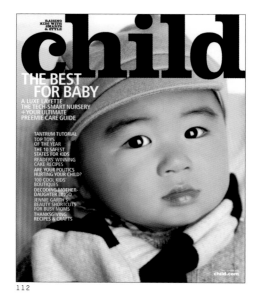

112

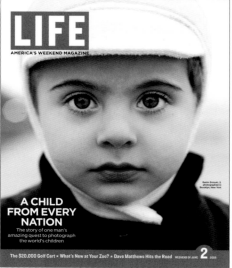

113

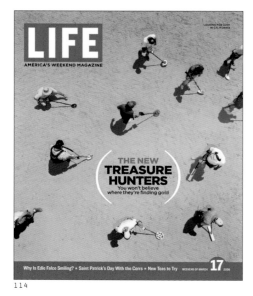

114

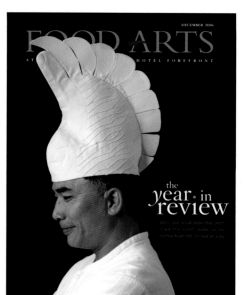

115

116

117

MARTHA STEWART

Living

Sharing the 'Good Things' for 15 Years

Île flottante with
a spun-sugar crown

Dreamy

DESSERTS as light as air
Carpets of colorful GROUND COVERS
Martha bakes her FAVORITE CAKES
Plus, 15 HOW-TOS everyone should know

Our 150th issue: A COLLECTOR'S EDITION

MAY 2006
$4.75 USA (CAN. $5.75)
marthastewart.com

118

118. **MARTHA STEWART LIVING**

creative director. Eric A. Pike. design director. James Dunlinson. art director. James Dunlinson. designer. Joele Cuyler
director of photography. Heloise Goodman. photo editors. Andrea Bakacs, Joni Noe. photographer. Christopher Baker. styled by. Ayesha Patel, Heidi Johannsen
editor-in-chief. Margaret Roach. publisher. Martha Stewart Living Omnimedia. issue. May 2006. category. Design: Cover

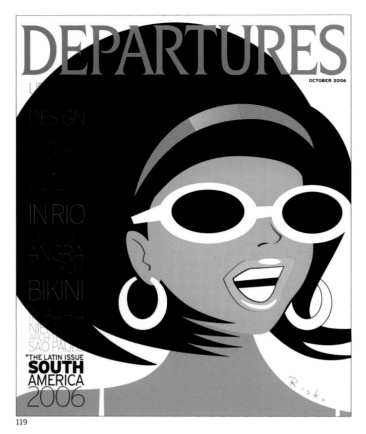

119

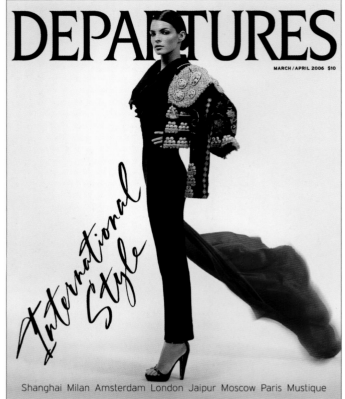

120

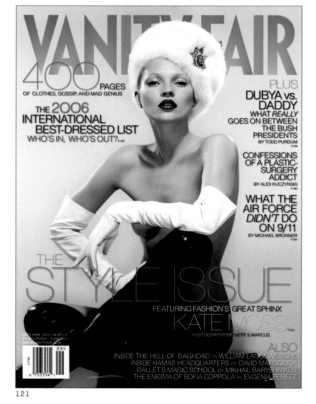

121

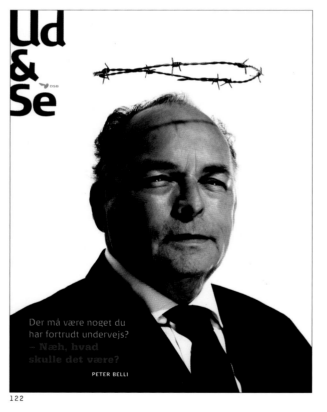

122

119. **DEPARTURES**

creative director. Bernard Scharf
art director. Adam Bookbinder
associate art director. Lou Corredor
illustrator. Robert Risko
director of photography. Jennifer Laski
photo editors. Jennifer Geaney, Brandon Perlman
publisher. American Express Publishing Co.
issue. October 2006
category. Design: Cover

120. **DEPARTURES**

creative director. Bernard Scharf
art director. Adam Bookbinder
associate art director. Lou Corredor
director of photography. Jennifer Laski
photo editors. Jennifer Geaney, Brandon Perlman
photographer. Alistair Taylor-Young
publisher. American Express Publishing Co.
issue. March/April 2006
category. Design: Cover

121. **VANITY FAIR**

design director. David Harris
art director. Julie Weiss
director of photography. Susan White
photographer. Mert Alas and Marcus Piggott
editor-in-chief. Graydon Carter
publisher. Condé Nast Publications Inc.
issue. September 2006
category. Design: Cover

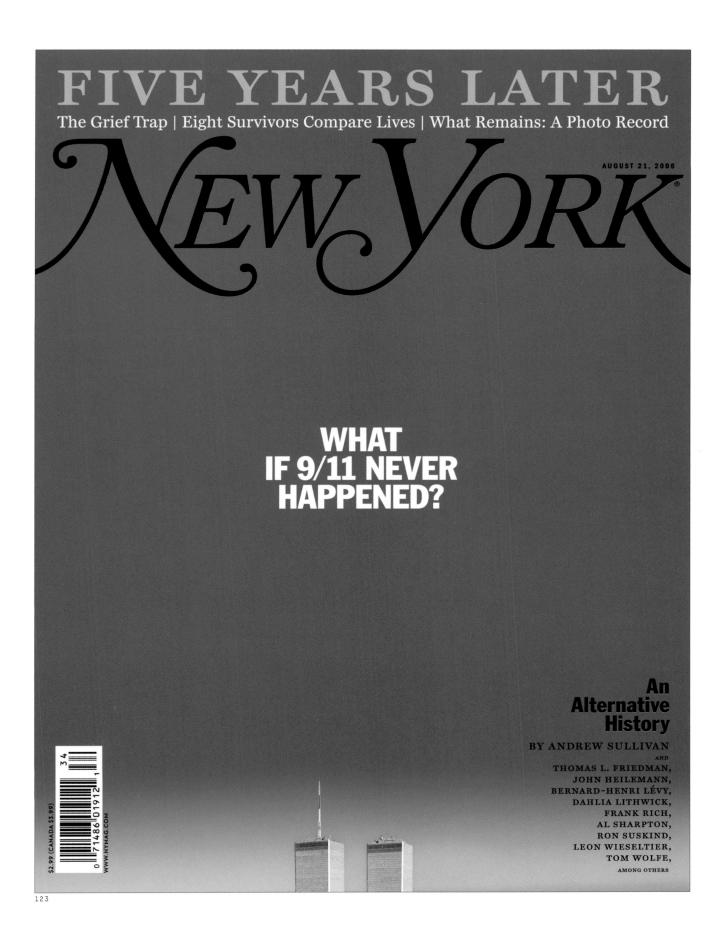

FIVE YEARS LATER

The Grief Trap | Eight Survivors Compare Lives | What Remains: A Photo Record

New York

AUGUST 21, 2006

WHAT IF 9/11 NEVER HAPPENED?

An Alternative History

BY ANDREW SULLIVAN

AND

THOMAS L. FRIEDMAN,
JOHN HEILEMANN,
BERNARD-HENRI LÉVY,
DAHLIA LITHWICK,
FRANK RICH,
AL SHARPTON,
RON SUSKIND,
LEON WIESELTIER,
TOM WOLFE,

AMONG OTHERS

$2.99 (CANADA $5.99)
WWW.NYMAG.COM

123

122. **UD & SE**

design director. Katinka Bukh. photographer. Per Morten Abrahamsen
publisher. DSB. issue. December 2006
category. Design: Cover

123. **NEW YORK**

design director. Luke Hayman. art director. Chris Dixon
designer. Luke Hayman. director of photography. Jody Quon. photographer.
Najlah Feanny (Corbis). editor-in-chief. Adam Moss
publisher. New York Magazine Holdings, LLC. issue. August 21, 2006
category. Design: Cover

124

125

126

127

128

129

124. **FOLK ART**

art director. Jeffrey Kibler
studio. The Magazine Group
publisher. American Folk Art Museum
client. American Folk Art Museum
issue. Spring/Summer 2006
category. Design: Cover

125. **IN**

art director. Renato Diaz
photo editor. Paula Fontaine
editor-in-chief. Paula Fontaine
publisher. Spafax Chile
issue. June 2006
category. Design: Cover

126. **PROTO**

creative director. Charlene Benson
design director. Alex Knowlton
art director. Lee Williams
designers. Alex Knowlton, Lee Williams
photo editor. Ann DeSaussure
photographer. Adri Berger (Getty)
studio. Time Inc. Content Solutions
publisher. Time Inc. Strategic Communications
client. Massachusetts General Hospital
issue. Spring 2006
category. Design: Cover

127. **NEWSWEEK**

creative director. Lynn Staley
design director. Bruce Ramsay
art director. Nurit Newman
director of photography. Simon Barnett
photographer. Craig Cutler
editor-in-chief. Jon Meacham
publisher. The Washington Post Co.
issue. November 13, 2006
category. Design: Cover

128. **TIME OUT NEW YORK**

art director. Matt Guemple
director of photography. Courtenay Kendall
photographer. Jeff Harris Studio
editor-in-chief. Brian Farnham
publisher. Time Out New York Partners, L.P.
issue. August 10-16, 2006
category. Design: Cover

129. **MANUFACTURA**

creative director. Guillermo Caballero
art director. Felipe Castro
photographer. Jean Paul Bergerault
editor-in-chief. David Luna
publisher. Grupo Editorial Expansión
issue. August 2006
category. Design: Cover

130

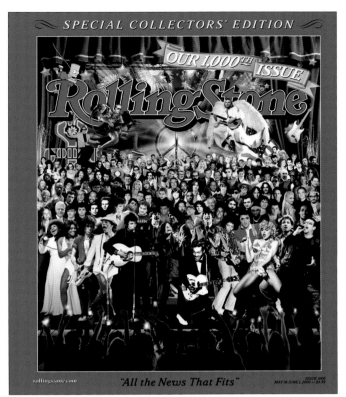

131

132

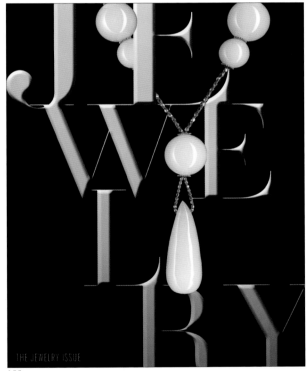

133

130. **PRINT**

art director. Kristina DiMatteo. designers. Kristina DiMatteo, Lindsay Ballant
photographer. Michael Schmelling. editor-in-chief. Joyce Rutter Kaye
publisher. F & W Publications. issue. November/December 2006
category. Design: Cover

132. **METROPOLIS**

creative director. Criswell Lappin. art director. Nancy Nowacek
designers. Michael Ian Kaye, Dylan Fracareta
photo editor. Bilyana Dimitrova. publisher. Bellerophon Publications
issue. September 2006. category. Design: Cover

131. **ROLLING STONE**

art director. Amid Capeci. designer. Martin Hoops
director of photography. Jodi Peckman. photo editor. Amelia Halverson
photographer. Michael Elins. publisher. Wenner Media
issue. May 18 - June 1, 2006. category. Design: Cover

133. **CENTURION**

creative director. Bernard Scharf. art director. Adam Bookbinder
director of photography. Jennifer Laski
photo editors. Jennifer Geaney, Brandon Perlman. photographer. Doug Rosa
associate art director. Lou Corredor. publisher. American Express Publishing
issue. Winter 2006. category. Design: Cover

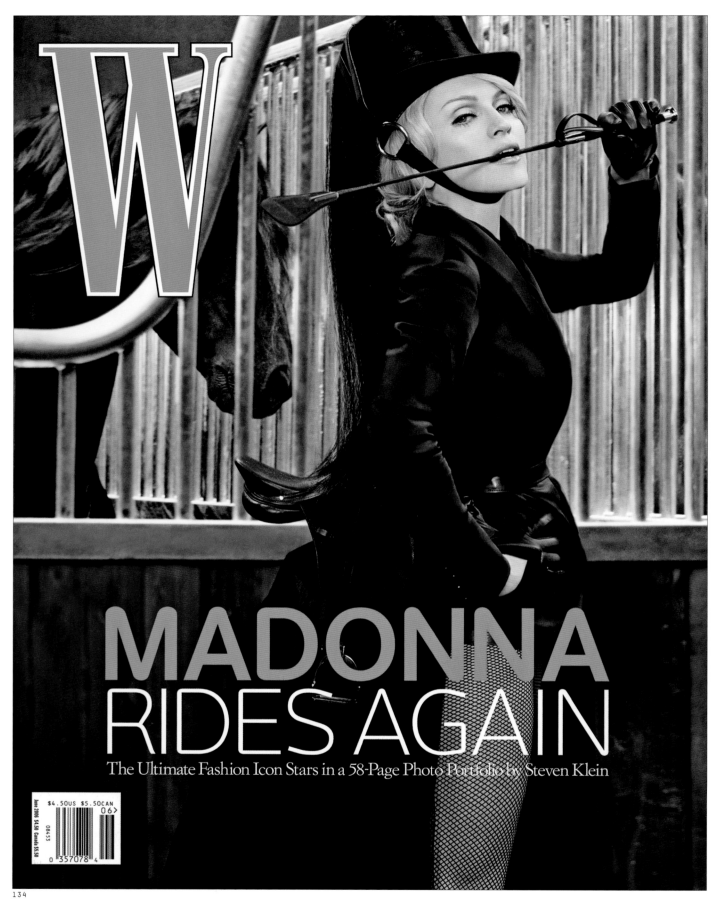

134.

134. **W**

design director. Edward Leida. art director. Nathalie Kirsheh. photographer. Steven Klein
publisher. Condé Nast Publications Inc. issue. June 2006. category. Design: Cover + Entire Issue

116

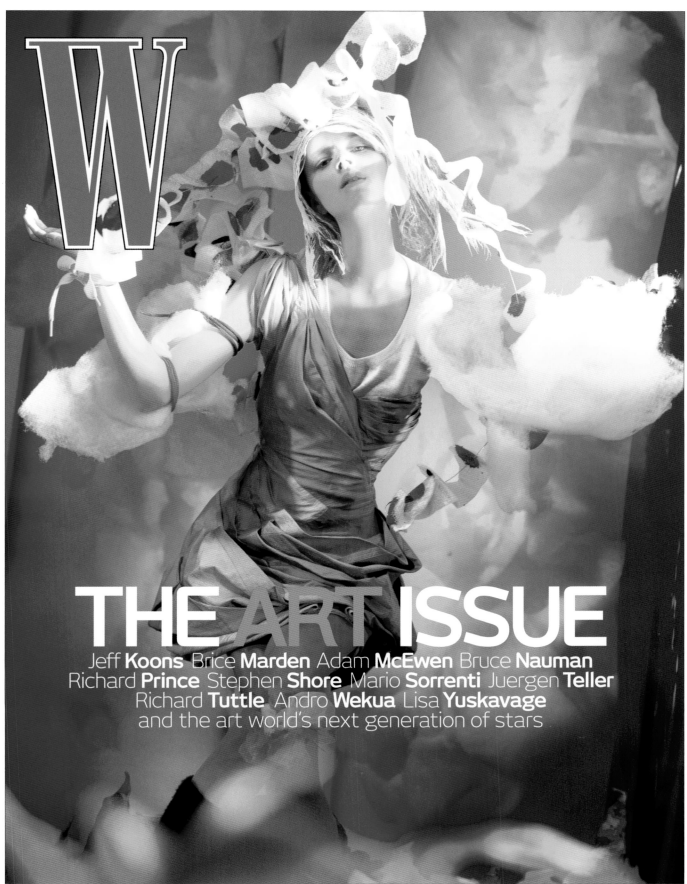

THE ART ISSUE

Jeff **Koons** Brice **Marden** Adam **McEwen** Bruce **Nauman**
Richard **Prince** Stephen **Shore** Mario **Sorrenti** Juergen **Teller**
Richard **Tuttle** Andro **Wekua** Lisa **Yuskavage**
and the art world's next generation of stars

135. **W**

design director. Edward Leida. art director. Nathalie Kirsheh. photographer. Mario Sorrenti
publisher. Condé Nast Publications Inc. issue. November 2006. category. Design: Cover

136

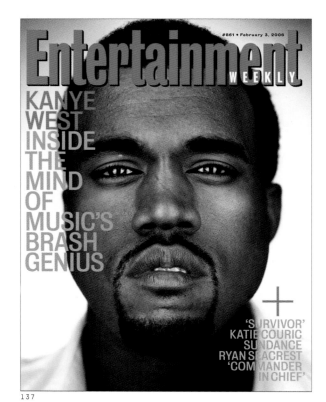

137

138

139

136. SOCIAL IMPACT

creative director. Eric Thoelke
art director. Karin Soukup
designer. Karin Soukup
illustrators. Brad Yeo (The iSpot), Dan Page
(The iSpot), Getty Images
photographers. Geoff Story
(Toky Branding + Design), iStock Photo
studio. Toky Branding + Design
editor-in-chief. Ellen Rostand
publisher. Washington University in St. Louis
client. George Warren Brown School of Social Work
at Washington University in St. Louis
issue. Spring 2006
category. Design: Cover

137. ENTERTAINMENT WEEKLY

design director. Geraldine Hessler
director of photography. Fiona McDonagh
photo editor. Audrey Landreth
photographer. Martin Schoeller
managing editor. Rick Tetzeli
publisher. Time Inc.
issue. February 3, 2006
category. Design: Cover

138. WIRED

creative director. Scott Dadich
designer. Scott Dadich
director of photography. Matt Mowat
photo editor. Carolyn Rauch
publisher. Condé Nast Publications, Inc.
issue. November 2006
category. Design: Cover

TIME

140

139. **CARL'S CARS**

creative director. Stéphanie Dumont. photographer. Nils Vik
publisher. Carl's Cars. issue. November 2006. category. Design: Cover

140. **TIME**

art director. Arthur Hochstein. illustrator. Tim O'Brien
director of photography. Michele Stephenson
photo editor. MaryAnne Golon. publisher. Time Inc.
issue. June 19, 2006. category. Design: Cover

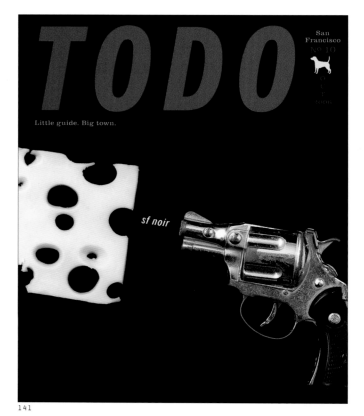

141.

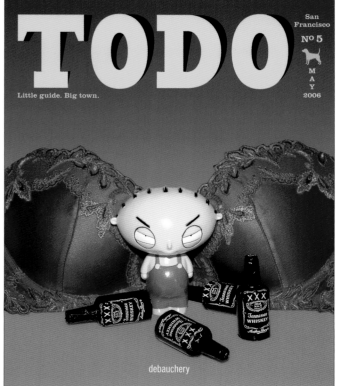

142.

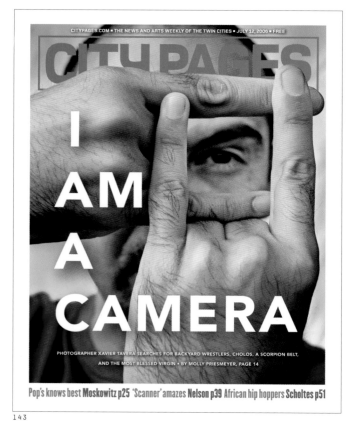

143.

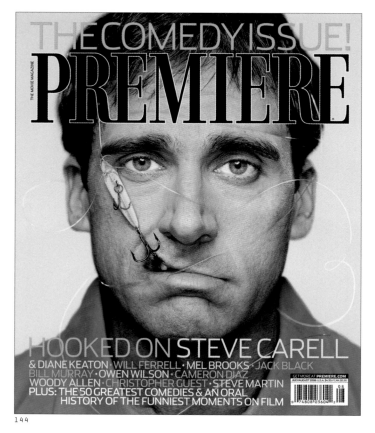

144.

141. TODO MONTHLY

creative director. Rhonda Rubinstein
designer. Rhonda Rubinstein
photographer. Daniel Furon
studio. Exbrook
publisher. Free Media Group
client. TODO Monthly
issue. October 2006
category. Design: Cover

142. TODO MONTHLY

creative director. Rhonda Rubinstein
designer. Rhonda Rubinstein
photographer. Daniel Furon
studio. Exbrook
publisher. Free Media Group
client. TODO Monthly
issue. May 2006
category. Design: Cover

143. CITY PAGES

art director. Nick Vlcek
photographer. Nick Vlcek
publisher. Village Voice Media
issue. July 12, 2006
category. Design: Cover

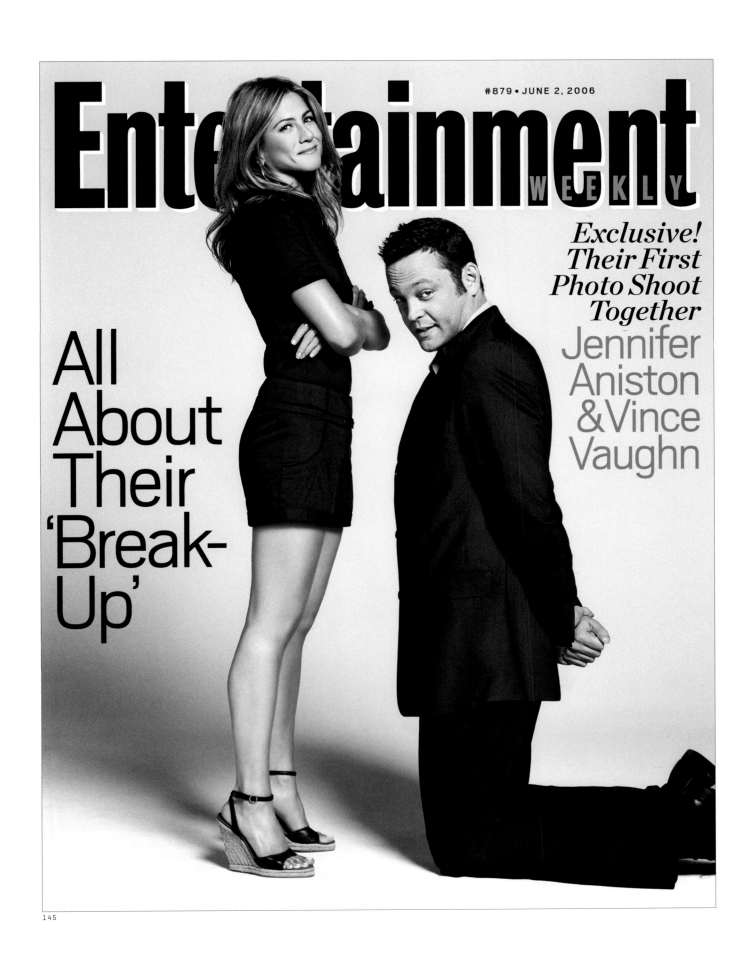

Entertainment

WEEKLY

#879 • JUNE 2, 2006

Exclusive!
Their First
Photo Shoot
Together

Jennifer
Aniston
&Vince
Vaughn

All
About
Their
'Break-
Up'

145

144. **PREMIERE**

art director. Dirk Barnett. designer. Dirk Barnett
director of photography. David Carthas. photographer. Martin Schoeller
publisher. Hachette Filipacchi Media U.S.
issue. July/August 2006. category. Design: Cover

145. **ENTERTAINMENT WEEKLY**

design director. Geraldine Hessler. director of photography. Fiona McDonagh
photographer. Gavin Bond. managing editor. Rick Tetzeli
publisher. Time Inc. issue. June 2, 2006. category. Design: Cover

A collaboration by Richard Tuttle & Mario Sorrenti

Creative Director: **Dennis Freedman** Fashion Editor: **Camilla Nickerson** Set Builder: **Philipp Haemmerle**
Hairstylist: **Julien d'Ys** Makeup Artist: **Linda Cantello** Choreographer: **Jock Soto**

146

146. **W**

design director. Edward Leida. art director. Nathalie Kirsheh. designer. Edward Leida. illustrator. Hubert Jocham
photographer. Mario Sorrenti. publisher. Condé Nast Publications Inc. issue. November 2006. category. Design: Spread

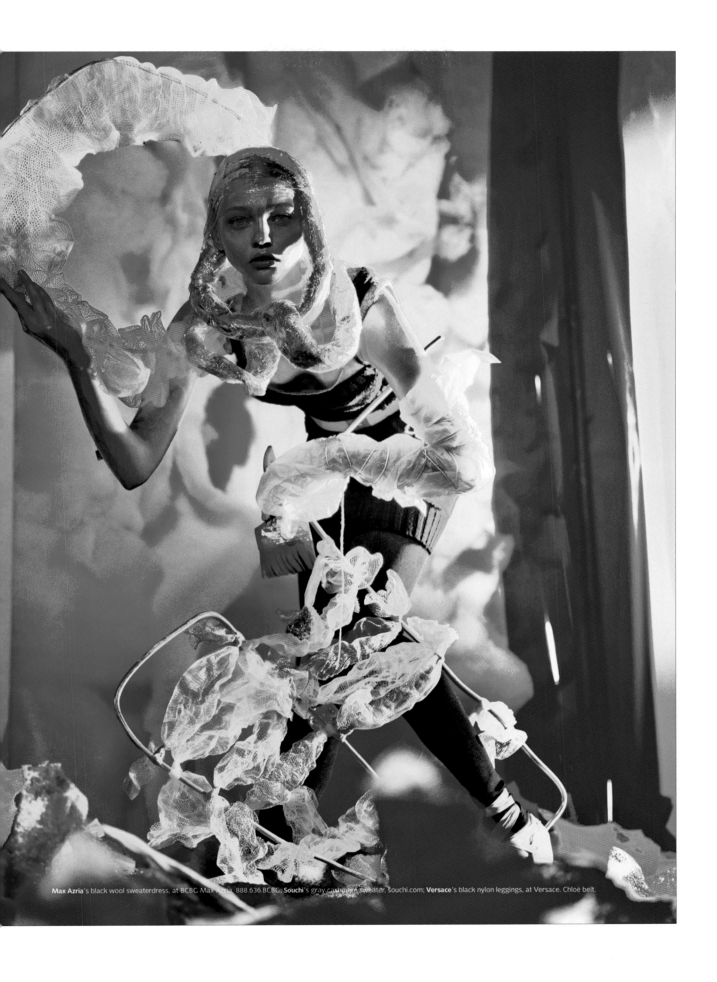

Max Azria's black wool sweaterdress, at BCBG Max Azria. 888.636.BCBG; Souchi's gray cashmere sweater, souchi.com; Versace's black nylon leggings, at Versace. Chloé belt.

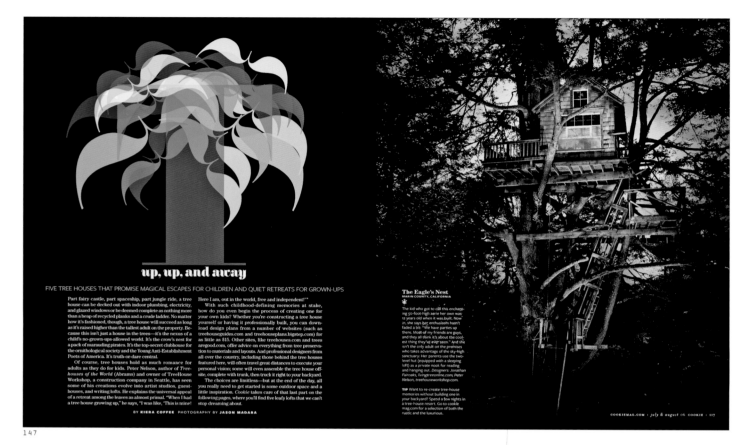

147

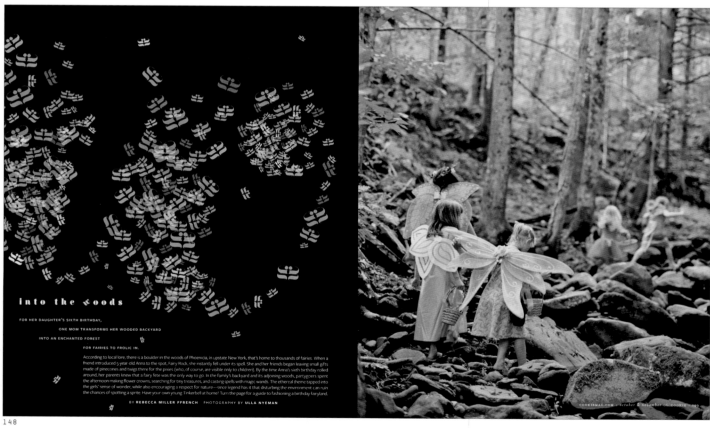

148

147. **COOKIE**

design director. Kirby Rodriguez. art director. Alex Grossman
designers. Nicolette Berthelot, Karla Lima. photo editor. Darrick Harris
photographer. Jason Madara. editor-in-chief. Pilar Guzmán
publisher. Condé Nast Publications Inc. issue. July/August 2006
category. Design: Spread

148. **COOKIE**

design director. Kirby Rodriguez. art director. Alex Grossman
designers. Nicolette Berthelot, Karla Lima. photo editor. Yolanda Edwards
photographer. Ulla Nyeman. editor-in-chief. Pilar Guzmán
publisher. Condé Nast Publications Inc. issues. October/November 2006
category. Design: Spread

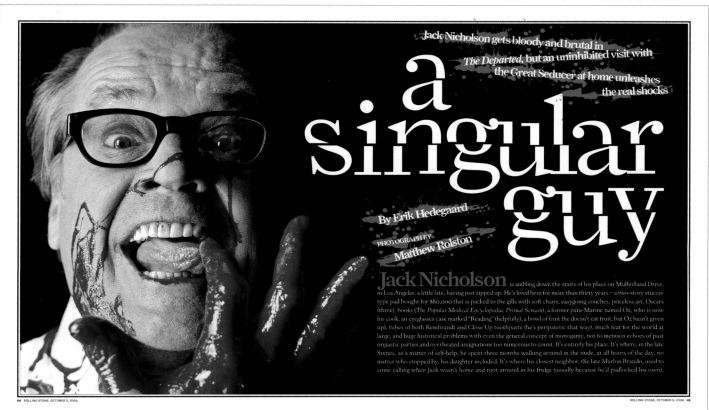

149

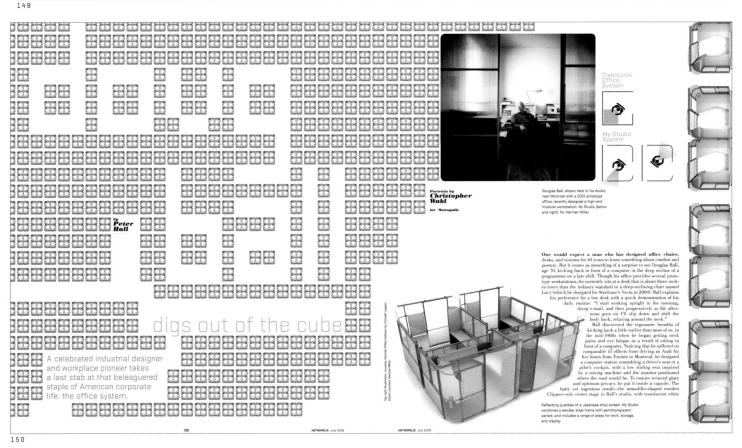

150

149. **ROLLING STONE**

art director. Amid Capeci. designer. Matthew Cooley
director of photography. Jodi Peckman. photo editor. Jodi Peckman
photographer. Matthew Rolston. publisher. Wenner Media
issue. October 5, 2006 RS 1010. category. Design: Spread

150. **METROPOLIS**

creative director. Criswell Lappin. art director. Nancy Nowacek
photo editor. Bilyana Dimitrova. photographer. Christopher Wahl
publisher. Bellerophon Publications. issue. July 2006
category. Design: Spread

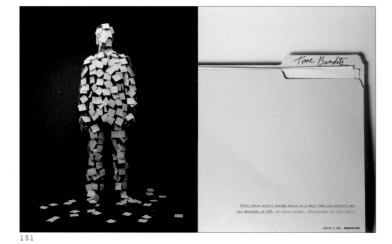

151

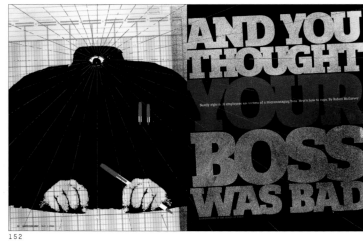

152

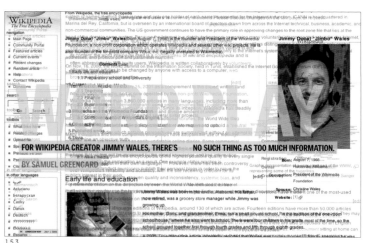

153

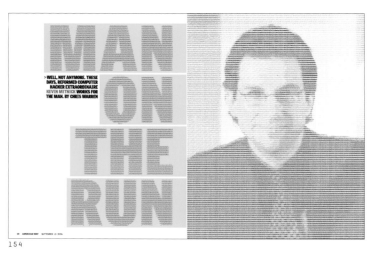

154

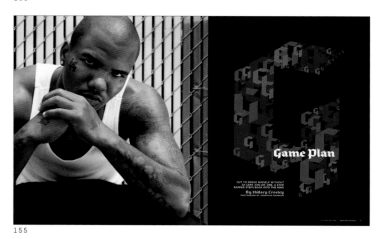

155

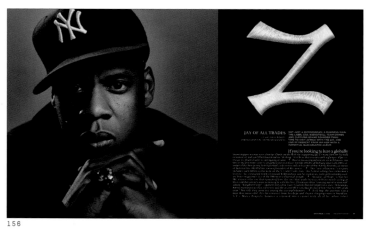

156

151. **AMERICAN WAY**

design director. J.R. Arebalo, Jr.
designer. Samuel Solomon
photographer. Tadd Myers
publisher. American Airlines Publishing
issue. January 15, 2006
category. Design: Spread

152. **AMERICAN WAY**

design director. J.R. Arebalo, Jr.
designer. Caleb Bennett
illustrator. The Heads of State
publisher. American Airlines Publishing
issue. May 1, 2006
category. Design: Spread

153. **AMERICAN WAY**

design director. J.R. Arebalo, Jr.
designer. Samuel Solomon
illustrator. Samuel Solomon
publisher. American Airlines Publishing
issue. July 1, 2006
category. Design: Spread

154. **AMERICAN WAY**

design director. J.R. Arebalo, Jr.
designer. Samuel Solomon
illustrator. Samuel Solomon
publisher. American Airlines Publishing
issue. September 15, 2006
category. Design: Spread

155. **BILLBOARD**

creative director. Josh Klenert
art director. Christine Bower
designers. Josh Klenert, Greg Grabowy
photo editor. Julie Mihaly
photographer. Jonathan Mannion
editor-in-chief. Scott McKenzie
publisher. VNU Business Media
issue. October 28, 2006
category. Design: Spread

156. **BILLBOARD**

creative director. Josh Klenert
art director. Christine Bower
designers. Greg Grabowy, Josh Klenert
photo editor. Julie Mihaly
photographer. Anthony Mandler
editor-in-chief. Scott McKenzie
publisher. VNU Business Media
issue. December 2, 2006
category. Design: Spread

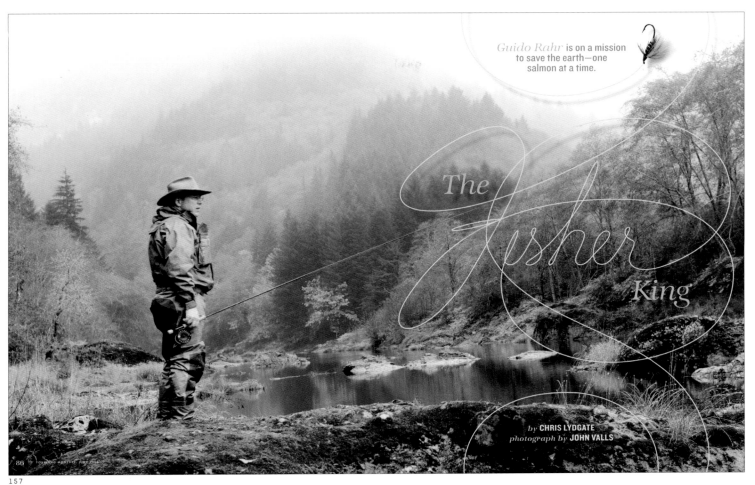

157.

157. **PORTLAND MONTHLY MAGAZINE**

art director. Pete Ivey
designer. Jason Blackheart
photographer. John Valls
publisher. Portland Monthly Inc.
issue. June 2006
category. Design: Spread

158.

158. **SCOTSMAN GUIDE**

design director. Deb Choat
art director. Rich Kim
illustrator. Keith Negley
editor-in-chief. Tony Stasiek
publisher. Scotsman Publishing, Inc.
issue. September 2006
category. Design: Spread

159.

159. **PHILADELPHIA STYLE MAGAZINE**

creative director. Todd Weinberger
art director. Samantha J. Bednarek
photo editor. Lina Watanabe
photographer. Shane McCauley
editor-in-chief. Sarah Schaffer
publisher. DLG Media Holdings, LLC
issue. December 2006
category. Design: Spread

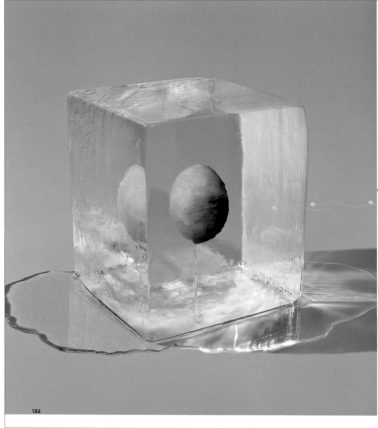

WHOSE EGG IS IT,
ANYWAY?

BY LOUISE FARR PHOTO ILLUSTRATION BY DARREN BRAUN

SHE'S DESPERATE TO BEAR A CHILD; HE REFUSES TO BE THE
FATHER. WHILE AUGUSTA AND RANDY ROMAN DUKE IT OUT IN
COURT, THREE EMBRYOS THEY CREATED TOGETHER ARE
ON ICE. WELCOME TO THE ___ STODY BATTLE OF THE FUTURE

Ten hours before Augusta Roman's in vitro fertilization appointment at the
Center of Reproductive Medicine, in Webster, Texas, her husband, Randy,
announced that he had changed his mind. It was April 19, 2002, and Augusta,
a registered nurse, had been resting in her nightgown on their floral-patterned
living room sofa, watching the evening news. She was tired but excited.
The next day was to be the culmination of nearly four years of temperature
monitoring and scheduled intimacy, unsuccessful artificial inseminations and
painful fallopian tube surgery.

At 40, Augusta believed that in vitro was her last chance to have the baby
she wanted so badly. Two days before, 13 eggs had been harvested from her
ovarian follicles. Combined in the lab with Randy's sperm, six of the eggs

132 133

160

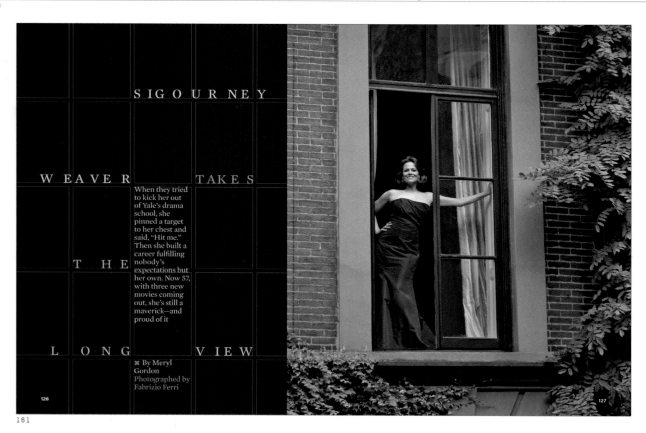

SIGOURNEY

WEAVER **TAKES**

When they tried
to kick her out
of Yale's drama
school, she
pinned a target
to her chest and
said, "Hit me."
Then she built a
career fulfilling
nobody's
expectations but
her own. Now 57,
with three new
movies coming
out, she's still a
maverick—and
proud of it

T H E

L O N G **VIEW**

✻ By Meryl
Gordon
Photographed by
Fabrizio Ferri

126 127

161

160. **MORE**

creative director. Maxine Davidowitz. art director. José G. Fernandez
designer. Ronald Sequeira, Jr. director of photography. Karen Frank
photo editor. Jenny Sargent. photographer. Darren Braun
editor-in-chief. Peggy Northrop. publisher. Meredith Corporation
issue. September 2006. category. Design: Spread

161. **MORE**

creative director. Maxine Davidowitz. art director. José G. Fernandez
designer. Maxine Davidowitz. director of photography. Karen Frank
photo editor. Jenny Sargent. photographer. Fabrizio Ferri
editor-in-chief. Peggy Northrop. publisher. Meredith Corporation
issue. October 2006. category. Design: Spread

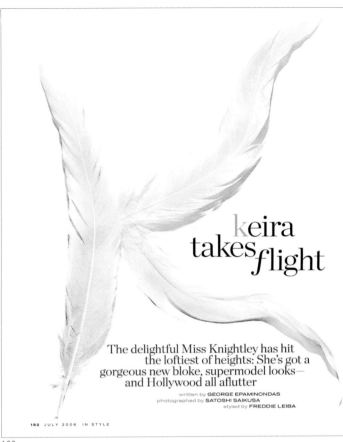

keira
takes *flight*

The delightful Miss Knightley has hit
the loftiest of heights: She's got a
gorgeous new bloke, supermodel looks—
and Hollywood all aflutter

written by **GEORGE EPAMINONDAS**
photographed by **SATOSHI SAIKUSA**
styled by **FREDDIE LEIBA**

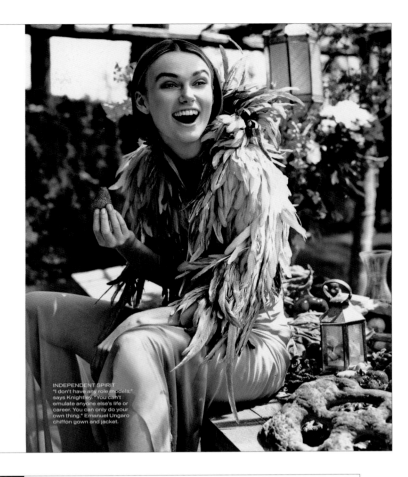

INDEPENDENT SPIRIT
"I don't have any role models,"
says Knightley. "You can't
emulate anyone else's life or
career. You can only do your
own thing." Emanuel Ungaro
chiffon gown and jacket.

162

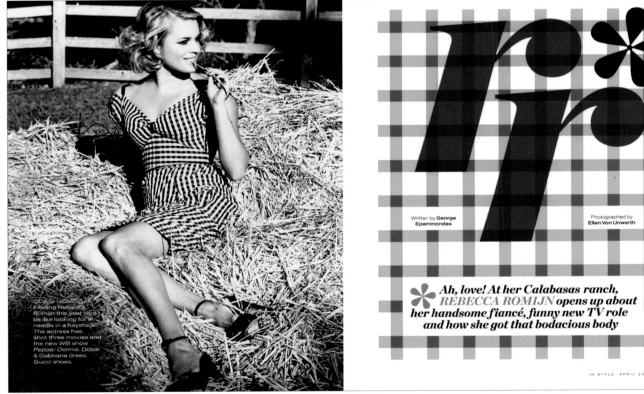

DOWN HOME
Finding Rebecca
Romijn this year won't
be like looking for a
needle in a haystack.
The actress has
shot three movies and
the new WB show
Pepper Dennis. Dolce
& Gabbana dress.
Gucci shoes.

163

Written by George
Epaminondas

Photographed by
Ellen Von Unwerth

*Ah, love! At her Calabasas ranch,
REBECCA ROMIJN opens up about
her handsome fiancé, funny new TV role
and how she got that bodacious body*

IN STYLE APRIL 2006 **163**

162. **INSTYLE**

creative director. John Korpics. director of photography. Bradley Young
photo editor. Nicole Hyatt. photographer. Satoshi Saikusa
publisher. Time Inc. issue. July 2006
category. Design: Spread

163. **INSTYLE**

creative director. John Korpics. director of photography. Bradley Young
photo editor. Nicole Hyatt. photographer. Ellen von Unwerth
publisher. Time Inc. issue. April 2006
category. Design: Spread

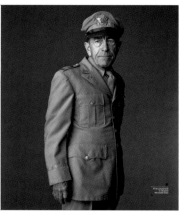

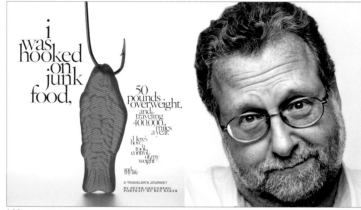

164

165

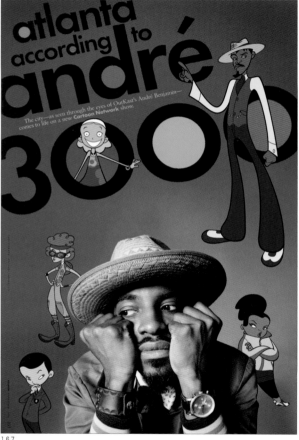

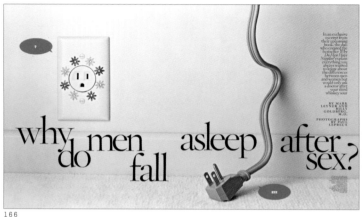

166

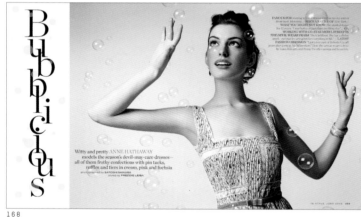

167

168

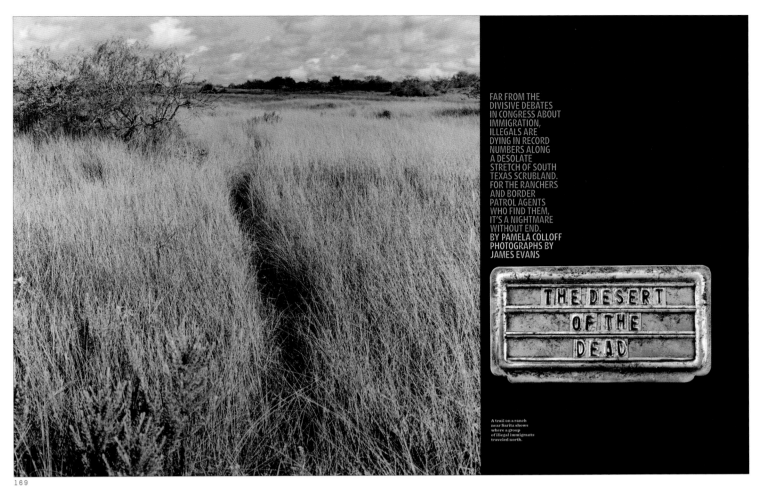

FAR FROM THE DIVISIVE DEBATES IN CONGRESS ABOUT IMMIGRATION, ILLEGALS ARE DYING IN RECORD NUMBERS ALONG A DESOLATE STRETCH OF SOUTH TEXAS SCRUBLAND. FOR THE RANCHERS AND BORDER PATROL AGENTS WHO FIND THEM, IT'S A NIGHTMARE WITHOUT END.
BY PAMELA COLLOFF
PHOTOGRAPHS BY JAMES EVANS

THE DESERT OF THE DEAD

A trail on a ranch near Sarita shows where a group of illegal immigrants traveled north.

169

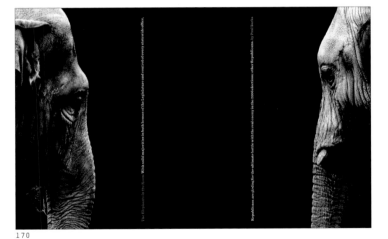

170

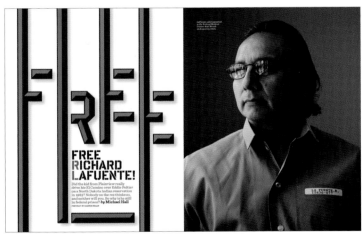

171

169. **TEXAS MONTHLY**

art director. TJ Tucker
designers. Rachel Wyatt, Andi Beierman
photo editor. Leslie Baldwin
photographer. James Evans
publisher. Emmis Communications Corp.
issue. November 2006
category. Design: Spread + Story

170. **TEXAS MONTHLY**

creative director. Scott Dadich
designers. Scott Dadich, TJ Tucker
photo editor. Leslie Baldwin
photographer. James F. Housel (Getty Images)
publisher. Emmis Communications Corp.
issue. January 2006
category. Design: Spread

171. **TEXAS MONTHLY**

art director. TJ Tucker
designers. Rachel Wyatt, Andi Beierman
photo editor. Leslie Baldwin
photographer. Darren Braun
publisher. Emmis Communications Corp.
issue. October 2006
category. Design: Spread

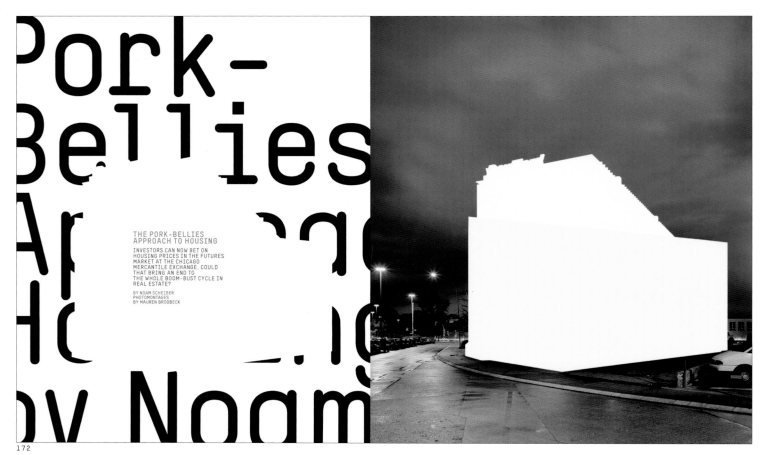

THE PORK-BELLIES
APPROACH TO HOUSING

INVESTORS CAN NOW BET ON
HOUSING PRICES IN THE FUTURES
MARKET AT THE CHICAGO
MERCANTILE EXCHANGE. COULD
THAT BRING AN END TO
THE WHOLE BOOM-BUST CYCLE IN
REAL ESTATE?

BY NOAM SCHEIBER
PHOTOMONTAGES
BY MAUREN BRODBECK

172

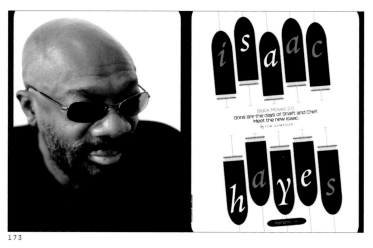

173

174

172. **KEY, THE NY TIMES REAL ESTATE MAGAZINE**

creative director. Janet Froelich
art directors. Arem Duplessis, Dirk Barnett
director of photography. Kathy Ryan
photo editor. Kira Pollack
photographer. Mauren Brodbeck
publisher. The New York Times
issue. September 10, 2006
category. Design: Spread

173. **MEMPHIS MAGAZINE**

creative director. Murry Keith
art director. Hudd Byard
designer. Hudd Byard
photographer. Andrea Zucker
publisher. Contemporary Media
issue. December 2006
category. Design: Spread

174. **MINNESOTA MONTHLY**

art director. Brian Johnson
photographer. Eric Moore
publisher. Greenspring Media Group
issue. March 2006
category. Design: Spread

MANHATTAN
ON THE
MOSKVA

AT THE
CENTER
OF
MOSCOW'S
BUILDING
BOOM
IS A
33-YEAR-OLD ADVENTURE-
SEEKING MULTIMILLIONAIRE WITH A
PET BOA CONSTRICTOR.
SERGEI POLONSKY MAY NOT BE A
VISIONARY, BUT HE KNOWS HOW TO
GET
THINGS
DONE.
BY
BRETT
FORREST

PHOTOGRAPHS
BY
HARF
ZIMMERMANN

The Federation Rising
When it's completed, the Federation Tower will
be the tallest skyscraper in Europe.

102

175

the view from the top

176

NO
VACANCY

It's a seller's market, and independent planners are finding it
a challenge to interest hotels in their clients' business

177

175. **KEY, THE NY TIMES REAL ESTATE MAGAZINE**

creative director. Janet Froelich
art directors. Arem Duplessis, Dirk Barnett
designer. Dirk Barnett
director of photography. Kathy Ryan
photo editor. Kira Pollack
photographer. Harf Zimmerman
publisher. The New York Times
issue. September 10, 2006
category. Design: Spread

176. **NYLON GUYS**

design director. Andrea Fella
art director. Alexander Chow
designer. Alexander Chow
director of photography. Stacey Mark
photographer. Kenneth Cappello
editor-in-chief. Marvin Scott Jarrett
publisher. Nylon LLC
issue. Fall 2006
category. Design: Spread

177. **PCMA CONVENE**

design director. Mitch Shostak
art director. Roger Greiner
illustrator. Ken Orvidas
studio. Shostak Studios
editor-in-chief. Michelle Russell
publisher. PCMA
client. PCMA
issue. September 2006
category. Design: Spread

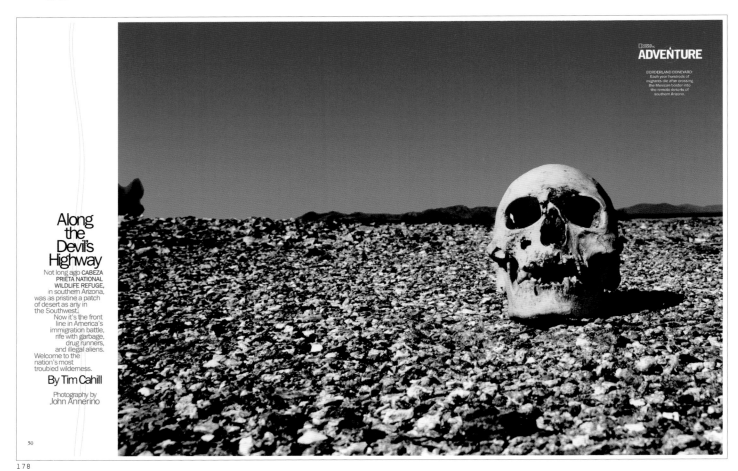

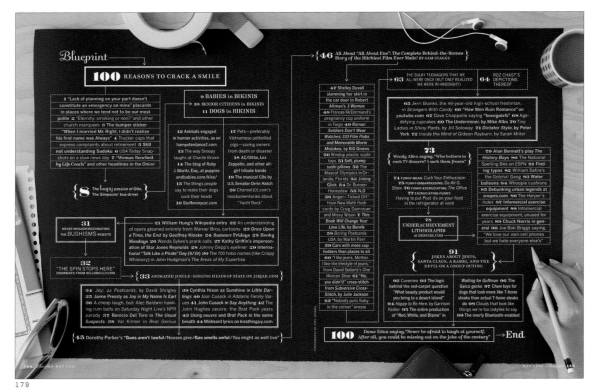

178. **NATIONAL GEOGRAPHIC ADVENTURE**

design director. Julie Curtis. art director. Rob Hewitt. designer. Rob Hewitt
director of photography. Sabine Meyer. photographer. John Annerino
publisher. National Geographic Society
issue. August 2006. category. Design: Spread

179. **BLUEPRINT**

creative director. Eric A. Pike. design director. Deb Bishop
designer. Cybele Grandjean. director of photography. Heloise Goodman
photo editors. Rebecca Donnelly, Sara McOsker, Mary Cahill
photographer. Karl Juengel. styled by. Kendra Smoot
editor-in-chief. Rebecca Thuss. publisher. Martha Stewart Living Omnimedia
issue. Summer 2006. category. Design: Spread

Lonely at the Top

A true story of one man's noble quest for solitude, wilderness, and a shred of lingering sanity

By Steve Friedman
Illustrations by John Cuneo

68 BACKPACKER 01/2006

180

THE LAST RUSTLER

RODDY DEAN PIPPIN WAS A POLITE YOUNG COWBOY WHO LOVED LOUIS L'AMOUR NOVELS AND DREAMED ABOUT LIFE ON THE OPEN RANGE. HE SAID HE WAS IN THE CATTLE BUSINESS—BUT HE ACTUALLY LED AN UNLIKELY GANG OF THIEVES WHO HIT COUNTLESS RANCHES ACROSS NORTH TEXAS. AND, JUST LIKE IN THE STORIES FROM THE OLD WEST, HE COULDN'T OUTRUN THE LAW FOREVER.
by Skip Hollandsworth

PHOTOGRAPHS BY JACK THOMPSON

181

180. **BACKPACKER**

art director. Matthew Bates. designer. Matthew Bates
illustrator. John Cuneo. publisher. Rodale Press
issue. April 2006. category. Design: Spread

181. **TEXAS MONTHLY**

creative director. Scott Dadich. designers. Scott Dadich, TJ Tucker
photo editor. Leslie Baldwin. photographers. Jack Thompson, Jeff Barton
publisher. Emmis Communications Corp. issue. May 2006
category. Design: Spread

SUMMER
MOVIE
PREVIEW

"I need to keep reinventing myself," says Bloom.

The Swashbuckling Adventures of Orlando Bloom

On the screen, Orlando Bloom plays a reluctant pirate. In life, he's an unassuming superstar. Despite a hefty bank account—thanks to such roles as the elftastic Legolas in the *Lord of the Rings* trilogy—and bragging rights to a place on every hottest, sexiest, most beautiful list out there, the only thing puffed up about Bloom is his pirate shirt. He speaks thoughtfully, with a soft British accent. Instead of arriving at LIFE's photo shoot with an entourage, he's accompanied solely by Sidi, the young mutt he rescued off of a street in Morocco a couple of years ago. With another high-seas romp, *Pirates of the*

By Matt Hendrickson
Cover & portraits by Rankin

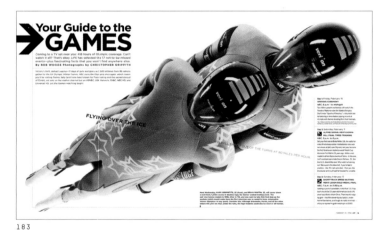

182. **LIFE**

creative director. Richard Baker
art director. Bess Wong
designer. Richard Baker
director of photography. George Pitts
photo editors. Katherine Schad, Tracy Doyle Bales, Caroline Smith
photographer. Rankin
publisher. Time Inc.
category. Design: Spread

183. **LIFE**

creative director. Richard Baker
art director. Bess Wong
designer. Bess Wong
director of photography. George Pitts
photo editors. Katherine Schad, Tracy Doyle Bales, Caroline Smith
photographer. Christopher Griffith
publisher. Time Inc.
issue. February 10, 2006
category. Design: Spread

184. **LIFE**

creative director. Richard Baker
art director. Bess Wong
designer. Bess Wong
director of photography. George Pitts
photo editors. Katherine Schad, Tracy Doyle Bales, Caroline Smith
photographer. Michael Edwards
publisher. Time Inc.
issue. March 24, 2006
category. Design: Spread

GIRL TROUBLE

TEENAGED ELLEN PAGE AMPS UP SUMMER'S FEAR
FACTOR AS AN X3 MUTANT AND A SCALPEL-WIELDING AVENGER.
IN HARD CANDY, GET READY TO SQUIRM.
BY TIM SWANSON PHOTOGRAPH BY TIERNEY GEARON

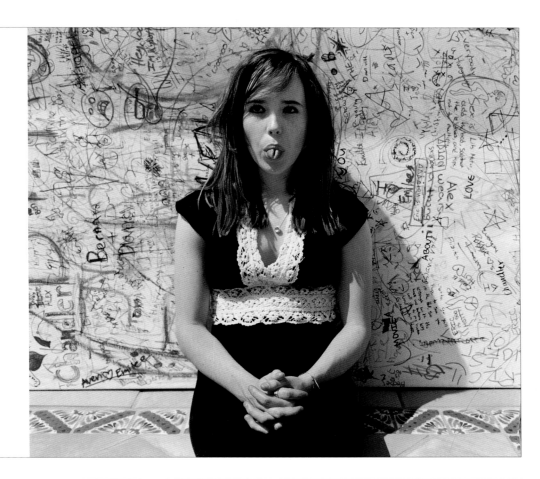

185

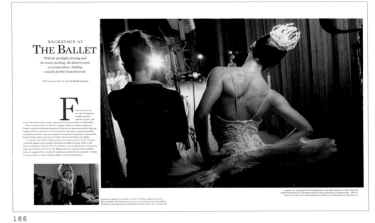

186

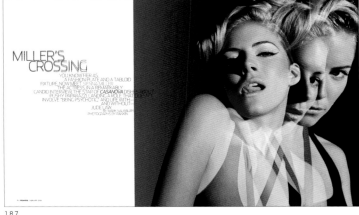

187

185. **PREMIERE**

art director. Dirk Barnett
designer. April Bell
director of photography. David Carthas
photographer. Tierney Gearon
publisher. Hachette Filipacchi Media U.S.
issue. May 2006
category. Design: Spread

186. **LIFE**

creative director. Richard Baker
art director. Bess Wong
designer. Jarred Ford
director of photography. George Pitts
photo editors. Katherine Schad, Tracy Doyle Bales,
Caroline Smith
photographer. Gleb Kosorukov
publisher. Time Inc.
issue. January 27, 2006
category. Design: Spread

187. **PREMIERE**

art director. Dirk Barnett
designer. Andre Jointe
director of photography. David Carthas
photographer. Rankin
publisher. Hachette Filipacchi Media U.S.
issues. February 2006
category. Design: Spread + Photo: Spread

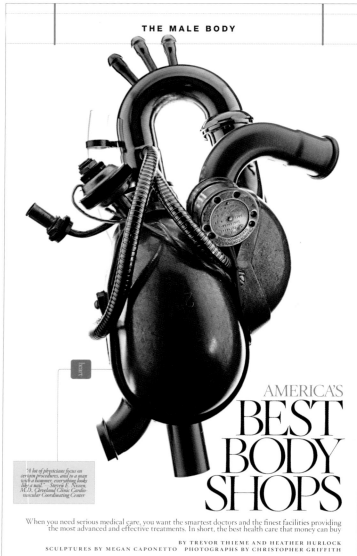

THE MALE BODY

AMERICA'S
BEST
BODY
SHOPS

When you need serious medical care, you want the smartest doctors and the finest facilities providing the most advanced and effective treatments. In short, the best health care that money can buy

BY TREVOR THIEME AND HEATHER HURLOCK
SCULPTURES BY MEGAN CAPONETTO PHOTOGRAPHS BY CHRISTOPHER GRIFFITH

188.

189.

190.

191.

BEST LIFE

188.

art director. Brandon Kavulla. designer. Brandon Kavulla
director of photography. Nell Murray. photographer. Christopher Griffith
publisher. Rodale. issue. March 2006. category. Design: Spread

190. **02138**

creative director. Patrick Mitchell. designer. Susannah Heesche
director of photography. Katharine MacIntyre. photographer. Lauren Greenfield
studio. PlutoMedia. publisher. Atlantic Media. issue. Premier Issue. 2006
category. Design: Spread

189. **BENEFITS SELLING**

creative director. Nancy Roy. art director. Joe Schlue
designer. Joe Schlue. director of photography. David Johnson
photographer. David Johnson. editor-in-chief. Denis Storey
publisher. Wiesner Publishing. issue. September 2006. category. Design: Spread

191. **AMERICAN AIRLINES NEXOS**

design director. Marco Rosales. designer. Marco Rosales
photographer. Douglas Menuez. publisher. American Airlines Publishing
issue. December 2006/January 2007. category. Design: Spread

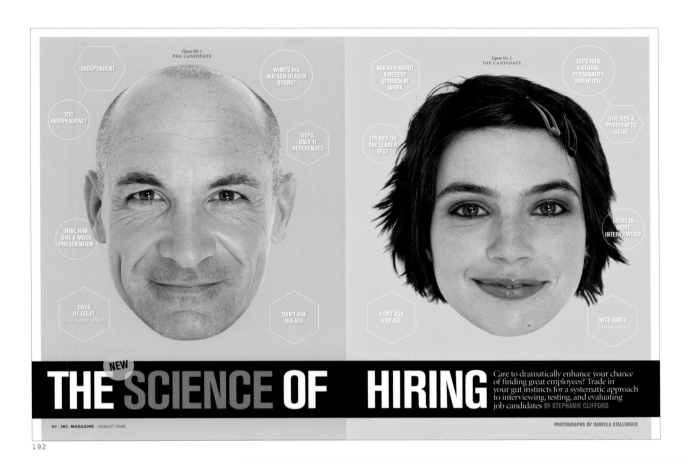

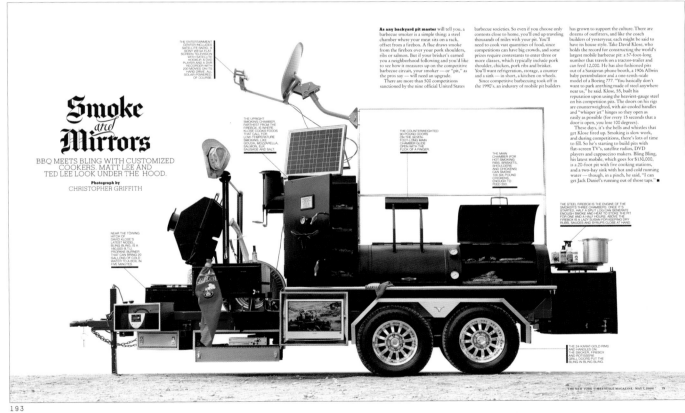

192. **INC.**

creative director. Blake Taylor. designer. David McKenna
director of photography. Alexandra Brez. photographer. Daniela Stallinger
publisher. Mansueto Ventures. issue. August 2006
category. Design: Spread

193. **T, THE NY TIMES STYLE MAGAZINE**

creative director. Janet Froelich. senior art director. David Sebbah
art director. Christopher Martinez. designers. Christopher Martinez,
David Sebbah. director of photography. Kathy Ryan
senior photo editor. Judith Puckett-Rinella. photographer. Christopher Griffith
editor-in-chief. Stefano Tonchi. publisher. The New York Times
issue. May 7, 2006. category. Design: Spread

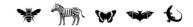

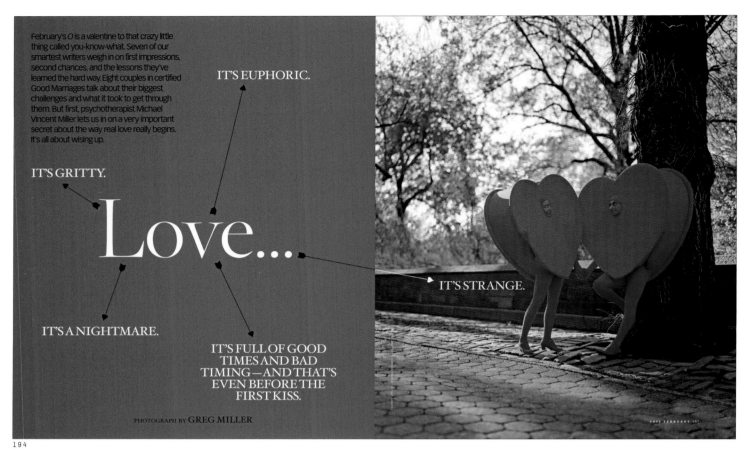

February's *O* is a valentine to that crazy little thing called you-know-what. Seven of our smartest writers weigh in on first impressions, second chances, and the lessons they've learned the hard way. Eight couples in certified Good Marriages talk about their biggest challenges and what it took to get through them. But first, psychotherapist Michael Vincent Miller lets us in on a very important secret about the way real love really begins. It's all about wising up.

IT'S EUPHORIC.

IT'S GRITTY.

Love...

IT'S STRANGE.

IT'S A NIGHTMARE.

IT'S FULL OF GOOD TIMES AND BAD TIMING—AND THAT'S EVEN BEFORE THE FIRST KISS.

PHOTOGRAPH BY GREG MILLER

194

195

194. **O, THE OPRAH MAGAZINE**

design director. Carla Frank. designer. Jana Meier
director of photography. Jennifer Crandall
publisher. The Hearst Corporation-Magazines Division. issue. February 2006
category. Design: Spread + Photo: Story

195. **CONDÉ NAST TRAVELER**

design director. Robert Best. art director. Kerry Robertson
publisher. Condé Nast Publications, Inc. issue. September 2006
category. Design: Spread + Design: Story

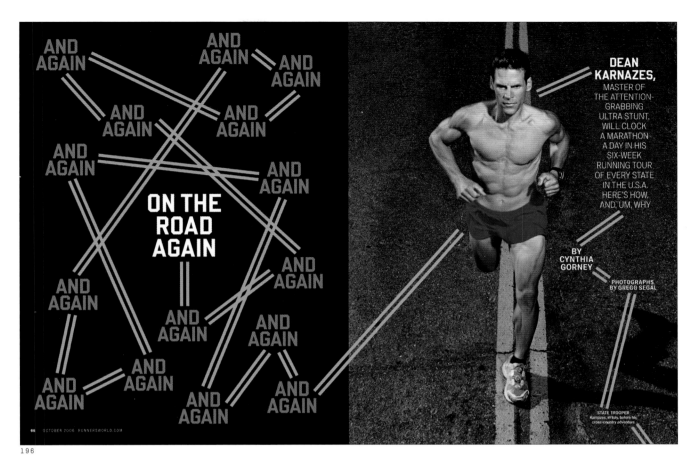

196

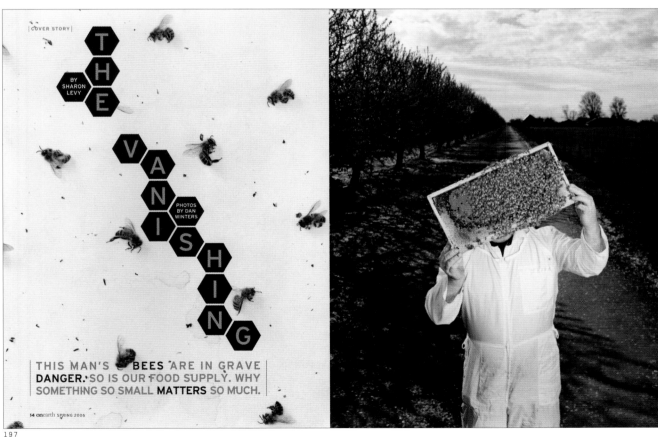

197

196. **RUNNER'S WORLD**

art director. Kory Kennedy. photo editor. Andrea Maurio
photographer. Gregg Segal. deputy art director. Elisa Yoch
assistant photo editor. Nick Galac. publisher. Rodale
issue. October 2006. category. Design: Spread

197. **ONEARTH**

art director. Gail Ghezzi. designer. Gail Ghezzi
photo editor. Gail Henry. photographer. Dan Winters
editor-in-chief. Douglas S. Barasch. publisher. NRDC
issue. Summer 2006. category. Design: Spread

198

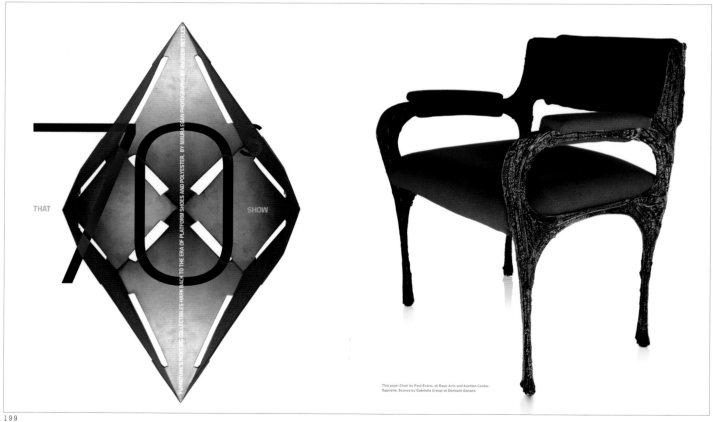

199

198. DETAILS

creative director. Rockwell Harwood. designer. Robert Vargas
director of photography. Liane Radel. photo editor. Hali Tara Feldman
photographer. Roger Deckker. deputy photo editor. Jessica Hafford
publisher. Condé Nast Publications. issue. September 2006
category. Design: Spread

199. DETAILS

creative director. Rockwell Harwood. designer. Robert Vargas
director of photography. Liane Radel. photographer. Andrew Bettles
publisher. Condé Nast Publications. issue. March 2006
category. Design: Spread

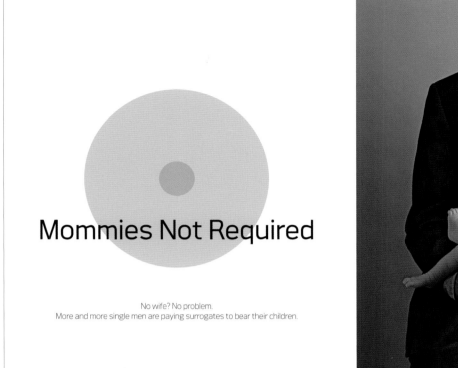

Mommies Not Required

No wife? No problem.
More and more single men are paying surrogates to bear their children.

BY KEVIN GRAY PHOTOGRAPHS BY MATTHEW DONALDSON

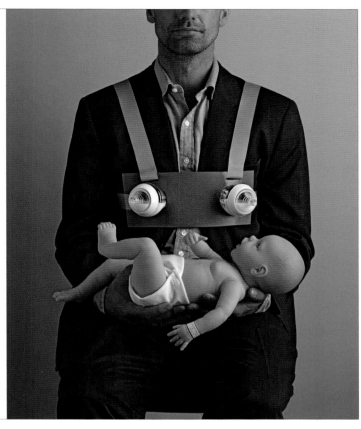

200

:-o

america's new bathroom wall

issive slut, searching

THANKS TO CRAIGSLIST, GETTING YOUR KINK ON HAS BECOME AS QUICK AND EASY AS BUYING A BIG MAC AND FRIES.

;)

e, and ready to strip off my

BY IAN DALY

:-#

234 DETAILS MARCH 2006

201

200. **DETAILS**

creative director. Rockwell Harwood. designer. Robert Vargas
director of photography. Liane Radel. photo editor. Hali Tara Feldman
deputy photo editor. Jessica Hafford. photographer. Matthew Donaldson
publisher. Condé Nast Publications. issue. August 2006
category. Design: Spread

201. **DETAILS**

creative director. Rockwell Harwood. designer. Robert Vargas
director of photography. Liane Radel. publisher. Condé Nast Publications
issue. March 2006. category. Design: Spread

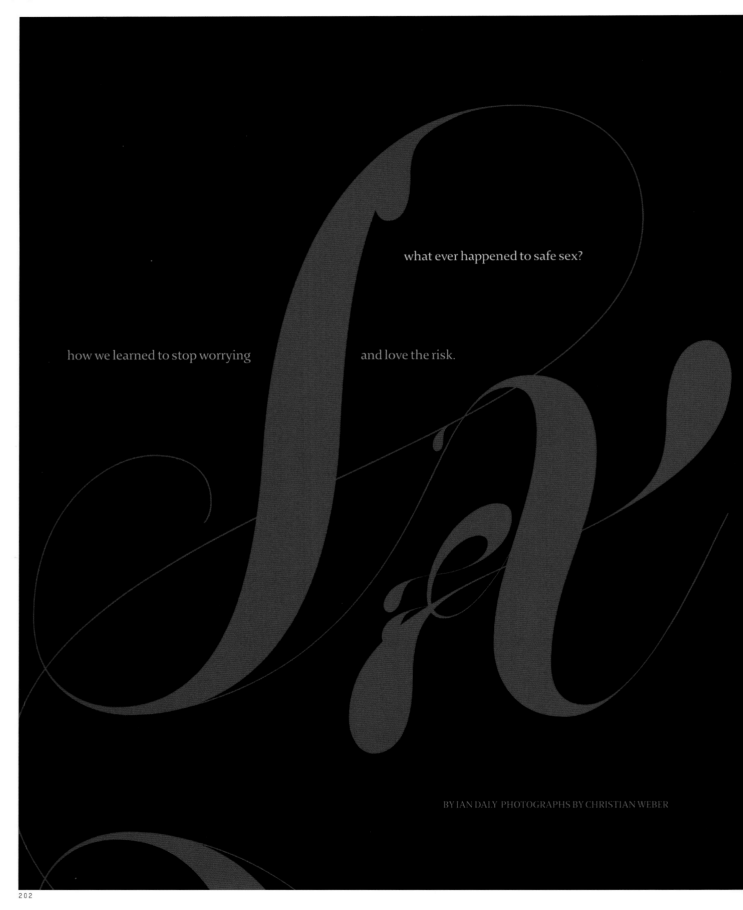

what ever happened to safe sex?

how we learned to stop worrying and love the risk.

BY IAN DALY PHOTOGRAPHS BY CHRISTIAN WEBER

202

202. **DETAILS**

creative director. Rockwell Harwood. art director. André Jointe. assistant art director. Robert Vargas. director of photography. Liane Radel photo editor. Hali Tara Feldman. photographer. Christian Weber. publisher. Condé Nast Publications. issue. October 2006. category. Design: Spread

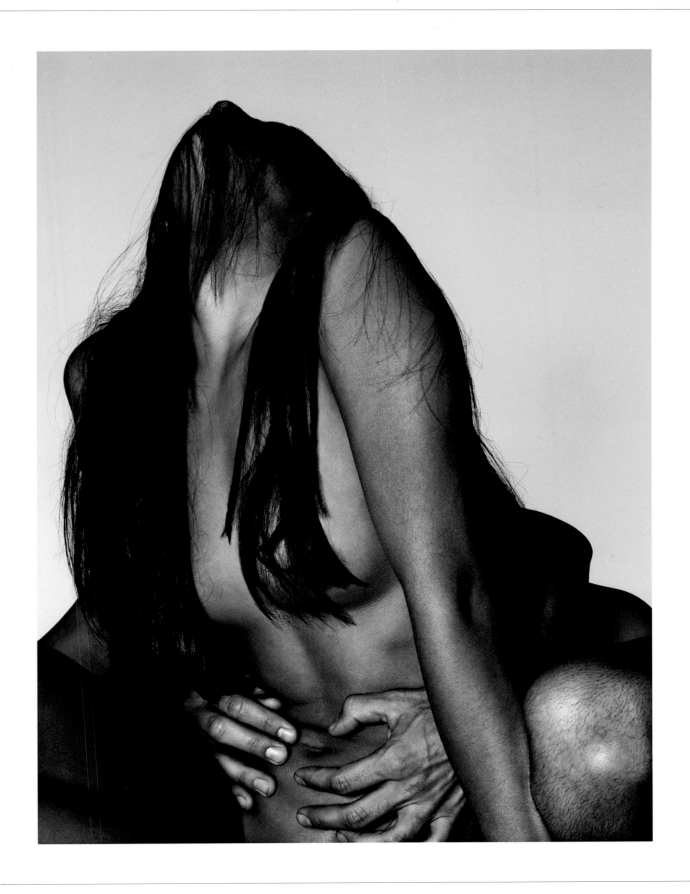

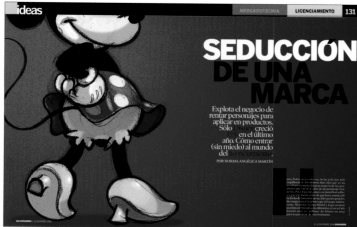

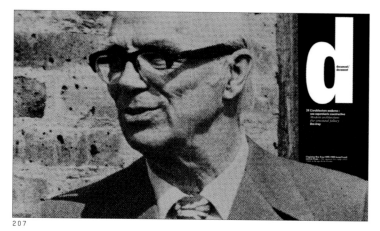

203. **DETAILS**

creative director. Rockwell Harwood
art director. André Jointe
assistant art director. Robert Vargas
publisher. Condé Nast Publications
issue. December 2006
category. Design: Spread

204. **EGOÍSTA**

creative director. Patrícia Reis
design director. Henrique Cayette
designers. Filipa Gregório, Hugo Neves,
Rita Salgueiro, Rodrigo Saias
producers. Francisco Ponciano, Cláudio Garrudo
studio. 004
publisher. Atelier 004
client. Estoril - Sol
issue. September 2006
category. Design: Spread

205. **EXPANSIÓN**

creative director. Guillermo Caballero
design director. Óscar Yañez
designer. Andrea Duran
illustrator. Luis Ledesma
EIC2. Barbara Anderson
editor-in-chief. Alberto Bello
publisher. Grupo Editorial Expansion
issue. March 2006
category. Design: Spread

206. **ELEGANT BRIDE**

creative director. Lou DiLorenzo
art director. Albert Toy
designer. Albert Toy
photo editor. Claudia Grimaldi
photographer. Michael Brandt
publisher. Condé Nast Publications Inc.
issue. Spring 2006
category. Design: Spread

207. **EAV**

design director. Susanna Shannon
designer. Catherine Houbart
photographer. Loren Leport
studio. Design Department
publisher. École d'architecture de Versailles
issue. January 2006
category. Design: Spread

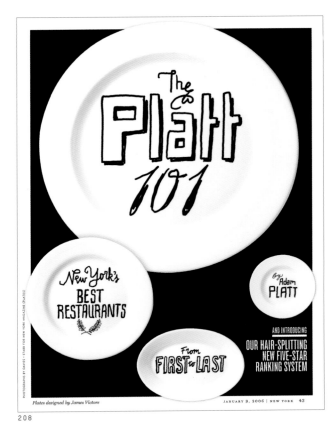

208

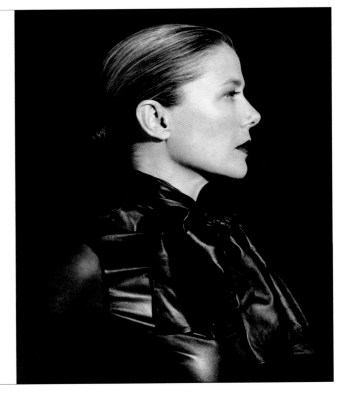

209

210

208. **NEW YORK**
design director. Luke Hayman
art director. Chris Dixon
designer. Randy Minor
illustrator. James Victore
director of photography. Jody Quon
photographer. Davies & Starr
editor-in-chief. Adam Moss
publisher. New York Magazine Holdings, LLC
issue. January 9, 2006
category. Design: Single Page

209. **NEW YORK**
design director. Luke Hayman
art director. Chris Dixon
designer. Chris Dixon
director of photography. Jody Quon
editor-in-chief. Adam Moss
publisher. New York Magazine Holdings, LLC
issues. May 15, 2006
category. Design: Single Page

210. **THE NEW YORK TIMES MAGAZINE**
creative director. Janet Froelich
art director. Arem Duplessis
designer. Nancy Harris Rouemy
director of photography. Kathy Ryan
photographers. Sofia Sanchez, Mauro Mongiello
editor-in-chief. Gerald Marzorati
publisher. The New York Times
issue. October 8, 2006
category. Design: Spread

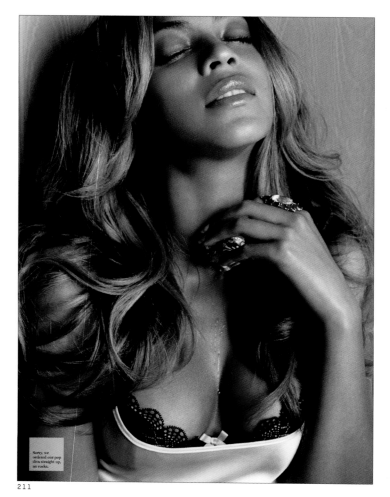

211.

212.

Mr. Faulkner Comes to Class

William Faulkner cultivated a public image
as a hard-drinking Southern gentleman
impatient with intellectual discussion
But the Faulkner who visited students reading
one of his greatest books *forty years ago*
was a more thoughtful and
complicated man.

By Robert Scholes
Illustration by Luke Best

213.

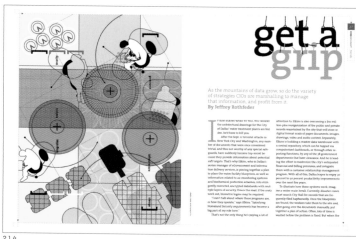

get a grip

As the mountains of data grow, so do the variety
of strategies CIOs are marshaling to manage
that information, and profit from it
By Jeffrey Rothfeder

214.

211. **BLENDER**

creative director. Andy Turnbull. designer. Andy Turnbull
illustrator. Billy Sorrentino. director of photography. Kristen Schaeffer
photographer. Cliff Watts. publisher. Dennis Publishing
issue. October 2006. category. Design: Spread

213. **BROWN ALUMNI MAGAZINE**

art director. Lisa Sergi. illustrator. Luke Best
publisher. Brown University. issue. May/June 2006
category. Design: Spread

212. **SPORTS ILLUSTRATED PRESENTS**

art director. Craig Gartner. designer. Karen Meneghin
publisher. Time Inc. issue. January 7, 2006
category. Design: Spread

214. **CIO INSIGHT**

art director. Aileen Hengeveld. designer. K-Hwa Park
illustrator. Mike Stones. editor-in-chief. Ellen Pearlman
publisher. Ziff Davis Media. issue. Spring 2006
category. Design: Spread

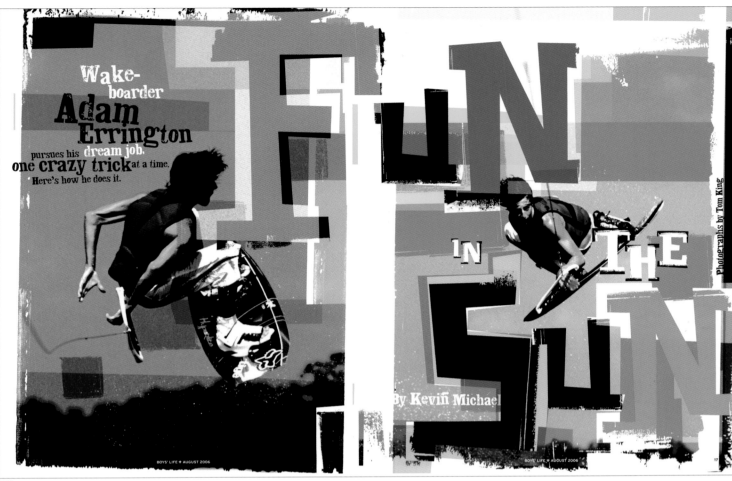

215

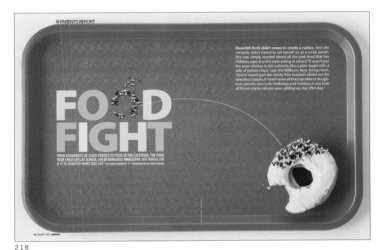

216

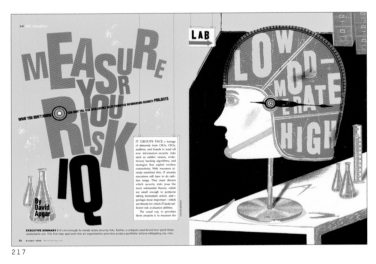

217

215. **BOYS' LIFE**

design director. Scott Feaster
designer. Kevin Hurley
illustrator. Kevin Hurley
director of photography. John R. Fulton, Jr.
photo editor. Olivia Ogren-Hrejsa
photographer. Tom King
publisher. Boy Scouts of America
issue. August 2006
category. Design: Spread

216. **PARENTS**

creative director. Jeffrey Saks
art director. Andrea Amadio
designer. Mairéad Liberace
director of photography. Clare Lissaman
photographer. David Prince
editor-in-chief. Sally Lee
publisher. Meredith
issue. January 2006
category. Design: Spread

217. **OPTIMIZE**

art director. Douglas Adams
designer. Douglas Adams
illustrator. Christian Northeast
publisher. CMP Media
issue. October 2006
category. Design: Spread

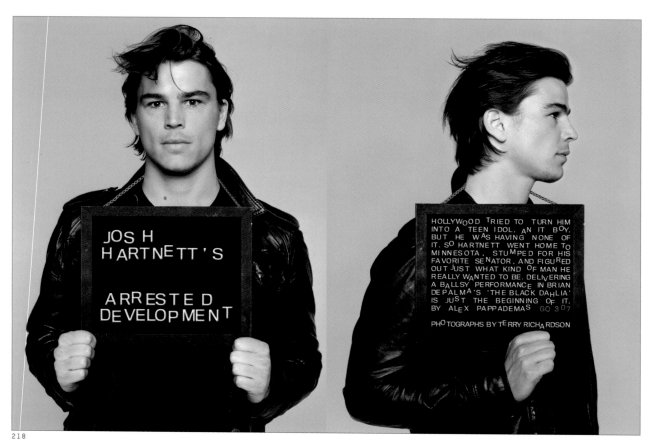

JOSH
HARTNETT'S

ARRESTED
DEVELOPMENT

HOLLYWOOD TRIED TO TURN HIM
INTO A TEEN IDOL, AN IT BOY,
BUT HE WAS HAVING NONE OF
IT. SO HARTNETT WENT HOME TO
MINNESOTA, STUMPED FOR HIS
FAVORITE SENATOR, AND FIGURED
OUT JUST WHAT KIND OF MAN HE
REALLY WANTED TO BE. DELIVERING
A BALLSY PERFORMANCE IN BRIAN
DEPALMA'S 'THE BLACK DAHLIA'
IS JUST THE BEGINNING OF IT.
BY ALEX PAPPADEMAS GQ 307

PHOTOGRAPHS BY TERRY RICHARDSON

218

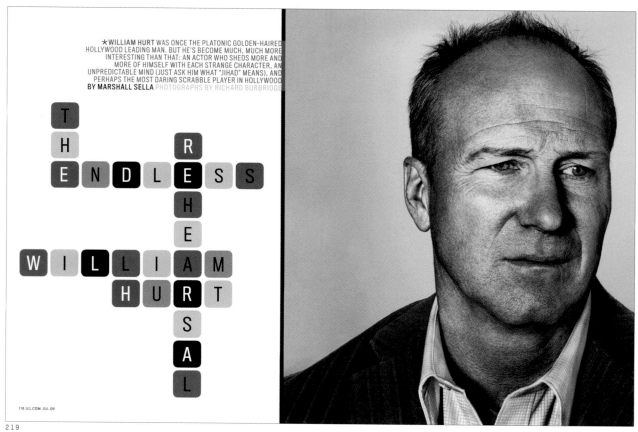

★WILLIAM HURT WAS ONCE THE PLATONIC GOLDEN-HAIRED
HOLLYWOOD LEADING MAN. BUT HE'S BECOME MUCH, MUCH MORE
INTERESTING THAN THAT: AN ACTOR WHO SHEDS MORE AND
MORE OF HIMSELF WITH EACH STRANGE CHARACTER, AN
UNPREDICTABLE MIND (JUST ASK HIM WHAT "JIHAD" MEANS), AND
PERHAPS THE MOST DARING SCRABBLE PLAYER IN HOLLYWOOD
BY MARSHALL SELLA PHOTOGRAPHS BY RICHARD BURBRIDGE

THE ENDLESS REHEARSAL WILLIAM HURT

118.GQ.COM.JUL.06

219

218. **GQ**

design director. Fred Woodward. designer. Ken DeLago
director of photography. Dora Somosi. senior photo editor. Krista Prestek
photographer. Terry Richardson. publisher. Condé Nast Publications Inc.
issue. October 2006. category. Design: Spread

219. **GQ**

design director. Fred Woodward. designer. Ken DeLago
director of photography. Dora Somosi. photographer. Richard Burbridge
publisher. Condé Nast Publications Inc. issue. July 2006
category. Design: Spread

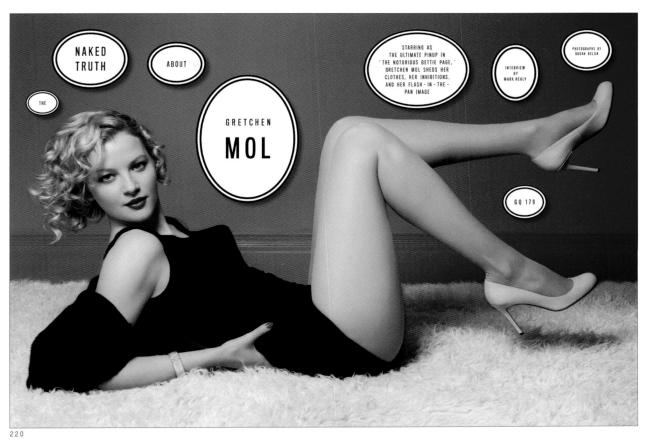

220

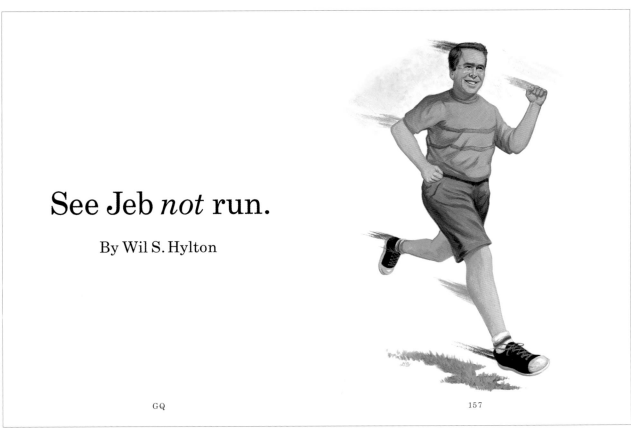

221

220. **GQ**

design director. Fred Woodward. designer. Ken DeLago
director of photography. Dora Somosi. senior photo editor. Krista Prestek
photographer. Dusan Reljin. publisher. Condé Nast Publications Inc.
issue. May 2006. category. Design: Spread

221. **GQ**

design director. Fred Woodward. designer. Anton Ioukhnovets
illustrator. David Brinley. editor-in-chief. Jim Nelson
publisher. Condé Nast Publications Inc. issue. May 2006
category. Design: Spread + Design: Story

The former <u>JON STEWART PROTÉGÉ</u> created an entire comic persona out of right-wing doublespeak, trampling the boundary between <u>PARODY AND POLITICS</u>. Which makes him the perfect spokesman for a political season in which everything is imploding.

PLUS COLBERT'S KEYS TO VICTORY, MIDTERM MUDSLINGING, AND KARL ROVE'S MOMENT OF TRUTH.

New York

STEPHEN COLBERT HAS AMERICA BY THE BALLOTS

By ADAM STERNBERGH

22

Photograph by Andrew Eccles

222. **NEW YORK**

design director. Luke Hayman. art director. Chris Dixon. designer. Chris Dixon. director of photography. Jody Quon photo editor. Amy Hoppy. photographer. Andrew Eccles. editor-in-chief. Adam Moss. publisher. New York Magazine Holdings, LLC issue. October 16, 2006. category. Design: Spread

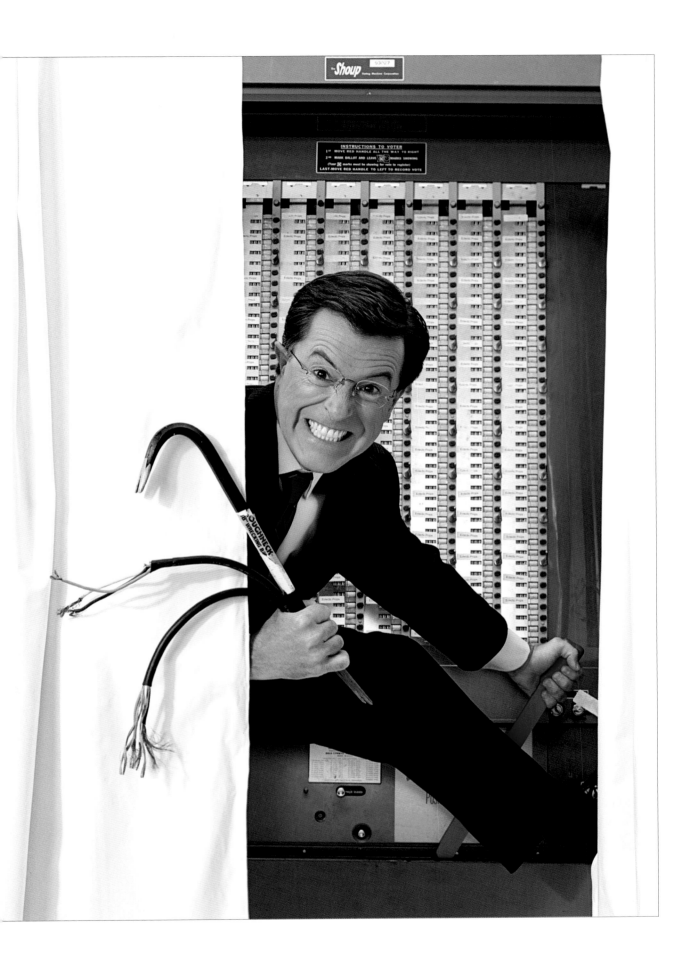

153

223

224

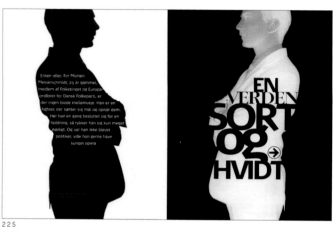

225

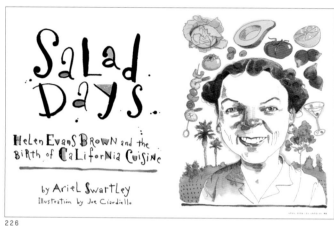

226

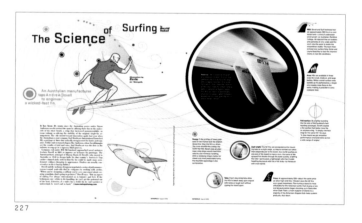

227

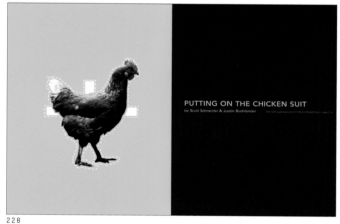

228

223. **CONTRIBUTE: NEW YORK**

design director. Mitch Shostak
art director. Susana Soares
illustrator. Dan Page
director of photography. Dan Demetriad
studio. Shostak Studios
editor-in-chief. Marcia Stepanek
publisher. Contribute Magazine, Inc.
client. Contribute: New York
issue. May/June 2006
category. Design: Spread + Illustration

224. **GUITAR LEGENDS**

design director. Andy Omel
designer. Andy Omel
photo editors. Jimmy Hubbard, Anna Dickson
photographer. Henry Goodwin
publisher. Future US
issue. Fall 2006
category. Design: Spread

225. **UD & SE**

design director. Katinka Bukh
photographer. Asger Carlsen
publisher. DSB
issue. April 2006
category. Design: Spread

226. **LOS ANGELES**

art director. Joe Kimberling
deputy art director. Lisa M. Lewis
designer. Lisa M. Lewis
illustrator. Joe Ciardiello
editor-in-chief. Kit Rachlis
publisher. Emmis
issue. April 2006
category. Design: Spread

227. **METROPOLIS**

creative director. Criswell Lappin
art director. Nancy Nowacek
illustrator. Feric
photo editor. Bilyana Dimitrova
publisher. Bellerophon Publications
issue. August 2006
category. Design: Spread

228. **MOVE! VOLUME 10**

creative director. Michael Schubert
design director. Lisa Gabbay
art director. Sal Catania
designer. Diana Yeo
illustrator. Diana Yeo
studio. Ruder Finn Design
publisher. Ruder Finn, Inc.
issue. April 2006
category. Design: Spread

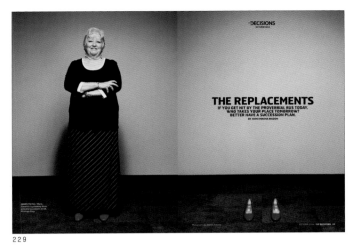

229

230

231

232

233

234

229. CIO DECISIONS

art director. Linda Koury
photographer. Dennis Kleiman
editor-in-chief. Anne McCrory
publisher. Techtarget
issue. October 2006
category. Design: Spread

230. WEALTH MANAGER

creative director. Laura Zavetz
designer. Laura Zavetz
publisher. Highline Media
issue. May 2006
category. Design: Spread

231. WINE SPECTATOR

art director. David Bayer
designer. Nicholas Rezabek
photo editor. Alexandra de Toth
photographer. Andrew McCaul
publisher. M. Shanken Communications Inc.
issue. May 15, 2006
category. Design: Spread

232. WEST / LOS ANGELES TIMES MAGAZINE

creative director. Joseph Hutchinson
art director. Heidi Volpe
designers. Joseph Hutchinson, Heidi Volpe,
Russell DeVita
photo editors. Heidi Volpe, Joseph Hutchinson
photographer. Nigel Cox
publisher. Los Angeles Times
category. Design: Single Page

233. UCLA MAGAZINE

design director. Charles Hess
designers. Susan Landesmann, Jamie Sholberg
director of photography. Charles Hess
photographer. Mark Berndt
studio. Chess Design
editor-in-chief. Jack Feuer
publisher. UCLA. client. UCLA
issue. July 2006
category. Design: Spread

234. TIME OUT NEW YORK KIDS

design director. Ron de la Peña
photo editor. Sarina Finkelstein
publisher. Time Out New York
issue. March/April 2006
category. Design: Single Page

235

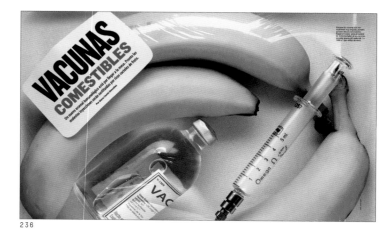

236

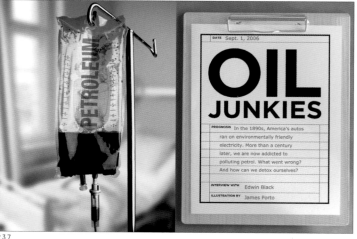

237

235. **PRINT**

art director. Kristina DiMatteo
designer. Kristina DiMatteo
photographer. Michael Heiko
editor-in-chief. Joyce Rutter Kaye
publisher. F & W Publications
issue. July/August 2006
category. Design: Story

236. **QUO**

creative director. Guillermo Caballero
art director. Fernando Bravo
designer. Alín Ponce de León
photo editors. Maximiliano Olvera, Luis Delfin
photographer. Jorge Garaiz
editor-in-chief. Carlos Pedroza
publisher. Grupo Editorial Expansión
issue. July 2006
category. Design: Spread

237. **REFORM JUDAISM**

art directors. Tim Baldwin, John Goryl
designer. Monica Alescio
photographer. James Porto
studio. B&G Design Studios
publisher. Union for Reform Judaism
client. Reform Judaism
issue. Fall 2006
category. Design: Spread

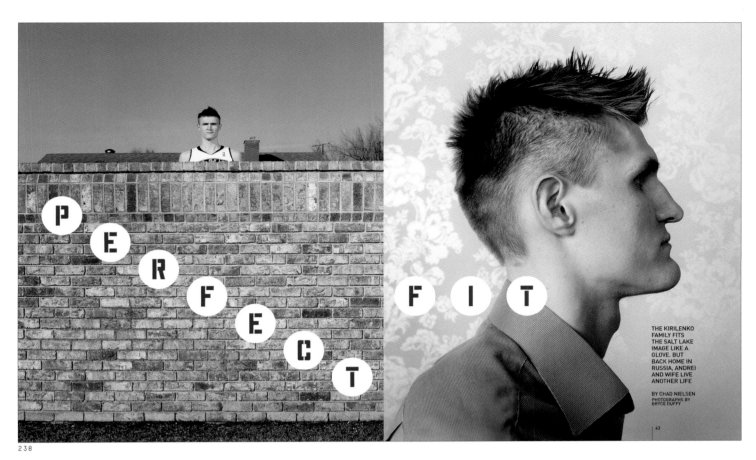

PERFECT

FIT

THE KIRILENKO
FAMILY FITS
THE SALT LAKE
IMAGE LIKE A
GLOVE. BUT
BACK HOME IN
RUSSIA, ANDREI
AND WIFE LIVE
ANOTHER LIFE

BY CHAD NIELSEN
PHOTOGRAPHS BY
BRYCE DUFFY

238

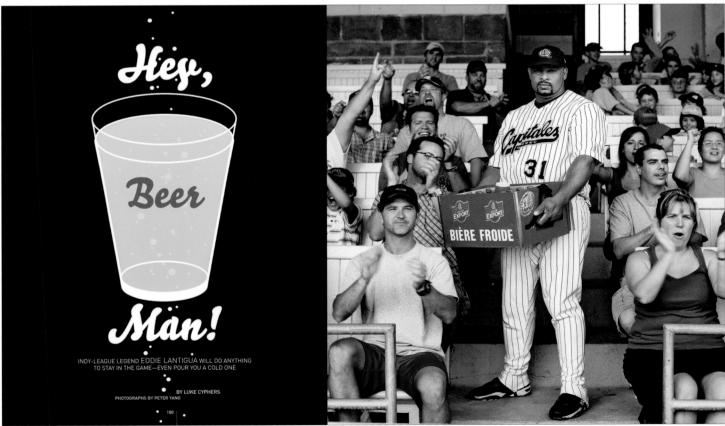

Hey,

Beer

Man!

INDY-LEAGUE LEGEND EDDIE LANTIGUA WILL DO ANYTHING
TO STAY IN THE GAME—EVEN POUR YOU A COLD ONE

BY LUKE CYPHERS
PHOTOGRAPHS BY PETER YANG

239

238. **ESPN THE MAGAZINE**

creative director. Siung Tjia. director of photography. Catriona Ni Aolain
photographer. Bryce Duffy. editor-in-chief. Gary Hoening
publisher. ESPN, Inc.. issues. September 5, 2006. category. Photo: Spread

239. **ESPN THE MAGAZINE**

creative director. Siung Tjia. designer. Siung Tjia
director of photography. Catriona Ni Aolain. photo editor. Catriona Ni Aolain
photographer. Peter Yang. publisher. ESPN, Inc.
issue. September 11, 2006. category. Design: Spread

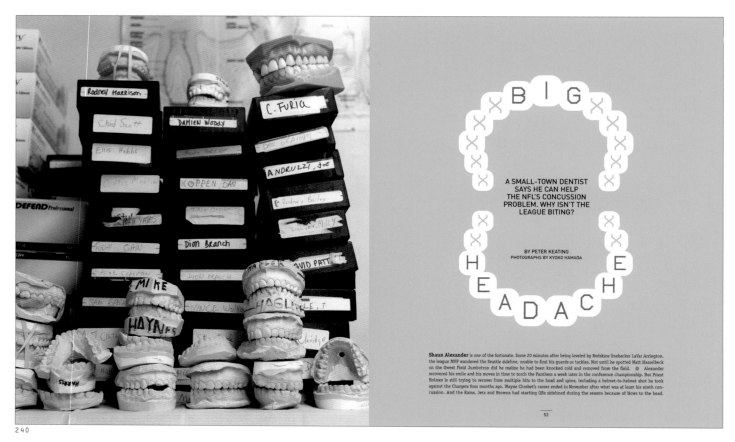

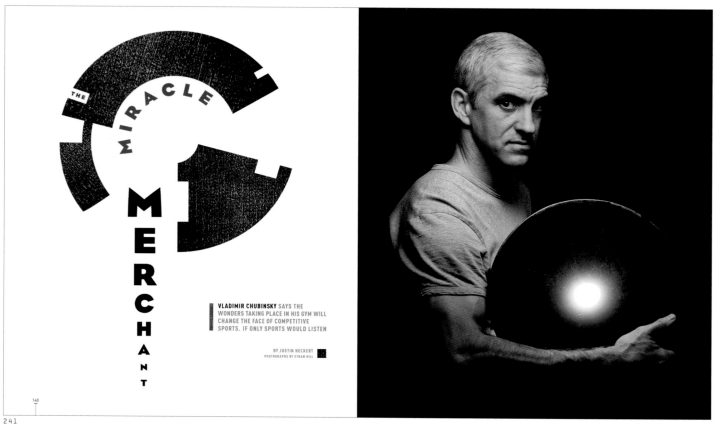

240. ESPN THE MAGAZINE

creative director. Siung Tjia. designer. Siung Tjia
director of photography. Catriona Ni Aolain. photo editor. Shawn Vale
photographer. Kyoko Hamada. publisher. ESPN, Inc.
issue. February 13, 2006. category. Design: Spread

241. ESPN THE MAGAZINE

creative director. Siung Tjia. designer. Jason Lancaster
director of photography. Catriona Ni Aolain. photo editor. Shawn Vale
photographer. Ethan Hill. publisher. ESPN, Inc.
issue. August 28, 2006. category. Design: Spread

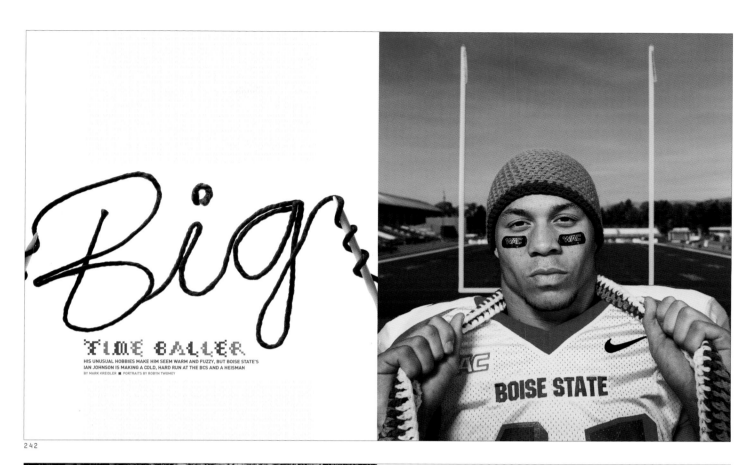

Big TIME BALLER

HIS UNUSUAL HOBBIES MAKE HIM SEEM WARM AND FUZZY, BUT BOISE STATE'S
IAN JOHNSON IS MAKING A COLD, HARD RUN AT THE BCS AND A HEISMAN
BY MARK KREIDLER ■ PORTRAITS BY ROBYN TWOMEY

242

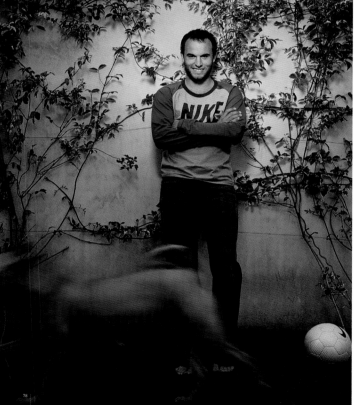

243

LANDON
DONOVAN HAS
BEEN CALLED
SOFT FOR
PLAYING IN THE
U.S. NOW HE
HAS A CHANCE
TO MAKE THE
WORLD PAY

BY
JEFF BRADLEY

PHOTOGRAPHS BY
ART STREIBER

home
SCHOOLED

242. **ESPN THE MAGAZINE**

creative director. Siung Tjia. designer. Jason Lancaster
director of photography. Catriona Ni Aolain. photo editor. Jennifer Aborn
photographer. Robyn Twomey. editor-in-chief. Gary Hoenig
publisher. ESPN, Inc. issue. November 20, 2006
category. Design: Spread

243. **ESPN THE MAGAZINE**

creative director. Siung Tjia. designer. Jason Lancaster
director of photography. Catriona Ni Aolain. photo editor. Nancy Weisman
photographer. Art Streiber. publisher. ESPN, Inc. issue. May 22, 2006
category. Design: Spread

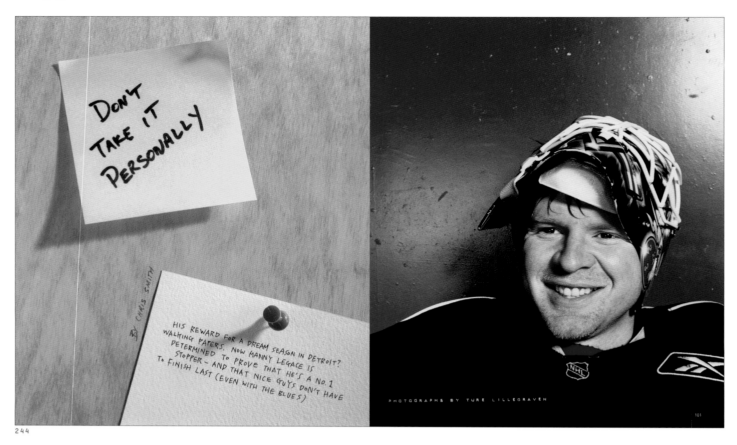

DON'T TAKE IT PERSONALLY

BY CHRIS SMITH

HIS REWARD FOR A DREAM SEASON IN DETROIT? WALKING PAPERS. NOW MANNY LEGACE IS DETERMINED TO PROVE THAT HE'S A NO. 1 STOPPER — AND THAT NICE GUYS DON'T HAVE TO FINISH LAST (EVEN WITH THE BLUES)

PHOTOGRAPHS BY TURE LILLEGRAVEN

101

244

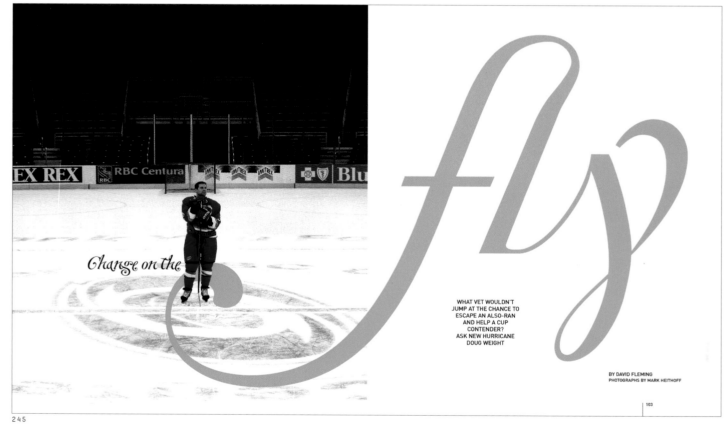

Change on the

fly

WHAT VET WOULDN'T JUMP AT THE CHANCE TO ESCAPE AN ALSO-RAN AND HELP A CUP CONTENDER? ASK NEW HURRICANE DOUG WEIGHT

BY DAVID FLEMING
PHOTOGRAPHS BY MARK HEITHOFF

103

245

244. **ESPN THE MAGAZINE**

creative director. Siung Tjia. designer. Hitomi Sato
director of photography. Catriona Ni Aolain. photo editor. Julie Claire
photographer. Ture Lillegraven. publisher. ESPN, Inc.
issue. December 18, 2006. category. Design: Spread

245. **ESPN THE MAGAZINE**

creative director. Siung Tjia. designer. Siung Tjia
director of photography. Catriona Ni Aolain. photo editor. Naomi Ben Shahar
photographer. Mark Heithoff. publisher. ESPN, Inc.
issue. April 10, 2006. category. Design: Spread

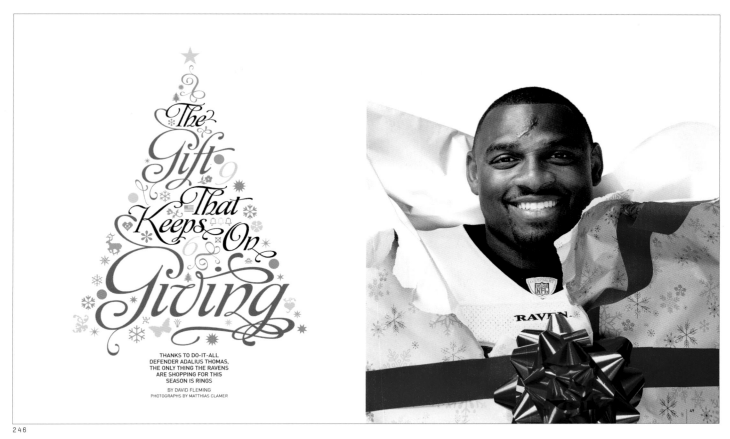

THE GIFT THAT KEEPS ON GIVING

THANKS TO DO-IT-ALL
DEFENDER ADALIUS THOMAS,
THE ONLY THING THE RAVENS
ARE SHOPPING FOR THIS
SEASON IS RINGS
BY DAVID FLEMING
PHOTOGRAPHS BY MATTHIAS CLAMER

246

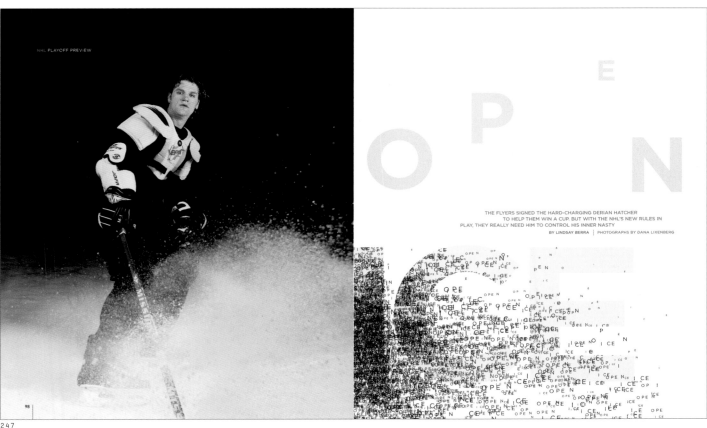

NHL PLAYOFF PREVIEW

OPEN

THE FLYERS SIGNED THE HARD-CHARGING DERIAN HATCHER
TO HELP THEM WIN A CUP. BUT WITH THE NHL'S NEW RULES IN
PLAY, THEY REALLY NEED HIM TO CONTROL HIS INNER NASTY

BY LINDSAY BERRA │ PHOTOGRAPHS BY DANA LIXENBERG

247

246. **ESPN THE MAGAZINE**

creative director. Siung Tjia. designer. Siung Tjia
director of photography. Catriona Ni Aolain. photo editors. Nancy Weisman,
Jim Surber. photographer. Matthias Clamer. publisher. ESPN, Inc.
issue. December 18, 2006. category. Design: Spread

247. **ESPN THE MAGAZINE**

creative director. Siung Tjia. designer. Jason Lancaster
director of photography. Catriona Ni Aolain. photo editor. Maisie Todd
photographer. Dana Lixenberg. editor-in-chief. Gary Hoenig
publisher. ESPN, Inc. issue. April 24, 2006
category. Design: Spread

248

249

250

251

252

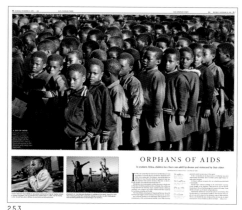
253

248. **HEMAWARE**

art director. Gregory Atkins
studio. The Magazine Group
publisher. National Hemophilia Foundation
client. National Hemophilia Foundation
issue. September/October 2006
category. Design: Spread

251. **HAWAII SKIN DIVER**

design director. Clifford Cheng
designer. Clifford Cheng
photographer. Terry Maas
studio. VOICE Design
publisher. Hawaii Skin Diver Publishing
issue. Fall 2006
category. Design: Spread

249. **JEWELRY W**

design director. Edward Leida
art director. Nathalie Kirsheh
designer. Laura Konrad
photo editor. Nadia Vellam
photographer. Mitchell Feinberg
publisher. Fairchild Publications
issue. Holiday 2006
category. Design: Spread

252. **ESPN THE MAGAZINE**

creative director. Siung Tjia
designer. Robert Festino
director of photography. Catriona Ni Aolain
photo editor. Axel Kessier
photographer. Bruce Bennett
publisher. ESPN, Inc.
issue. May 22, 2006
category. Design: Spread

250. **JAPAN+**

art director. Kevin Foley
designer. Kevin Foley
photo editor. Shinichi Okada
photographer. Tadashi okoshi
studio. KF Design
editor-in-chief. Cindy Allen
publisher. Jiji Gaho Sha, Inc.
client. Jiji Gaho Sha, Inc. issue. November 2006
category. Design: Spread

253. **LOS ANGELES TIMES**

creative director. Joseph Hutchinson
design director. Michael Whitley
designers. Michael Whitley, Joseph Hutchinson,
Kelli Sullivan
director of photography. Colin Crawford
photo editor. Mary Cooney
photographer. Carolyn Cole
publisher. Tribune Company
issue. November 27, 2006
category. Design: Single Page

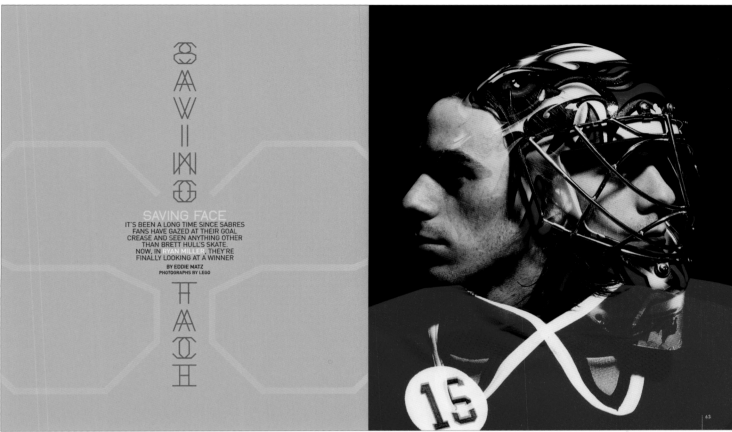

SAVING

SAVING FACE
IT'S BEEN A LONG TIME SINCE SABRES
FANS HAVE GAZED AT THEIR GOAL
CREASE AND SEEN ANYTHING OTHER
THAN BRETT HULL'S SKATE.
NOW, IN RYAN MILLER, THEY'RE
FINALLY LOOKING AT A WINNER
BY EDDIE MATZ
PHOTOGRAPHS BY LEGO

FACE

254.

255

A MATTER OF

FAT

256

254. **ESPN THE MAGAZINE**

creative director. Siung Tjia
designer. Siung Tjia
director of photography. Catriona Ni Aolain
photo editor. Amy McNulty
photographer. Lego
publisher. ESPN, Inc.
issue. March 27, 2006
category. Design: Spread

255. **ESPN THE MAGAZINE**

creative director. Siung Tjia
designer. Robert Festino
director of photography. Catriona Ni Aolain
photo editor. Catriona Ni Aolain
photographer. Gail Albert Halaban
publisher. ESPN, Inc.
issue. May 8 2006
category. Design: Spread

256. **WOMEN'S HEALTH**

art director. Andrea Dunham
designer. LanYin Bachelis
director of photography. Sarah Rozen
photo editor. Evie McKenna
publisher. Rodale
issue. July/August 2006
category. Design: Spread

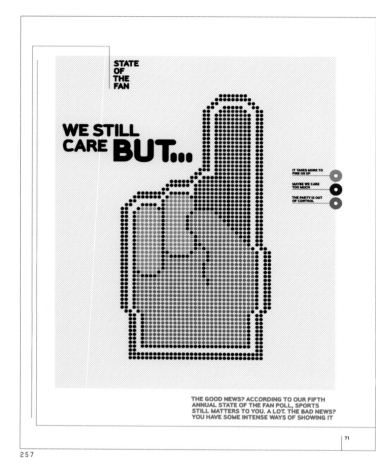

257

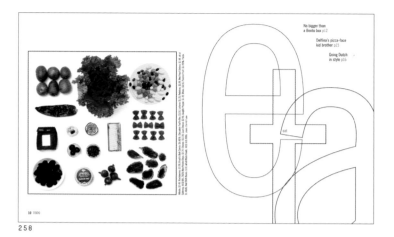

258

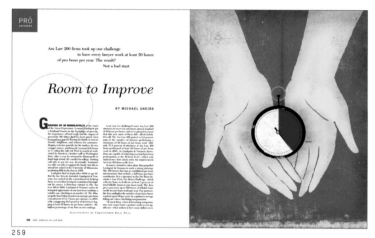

259

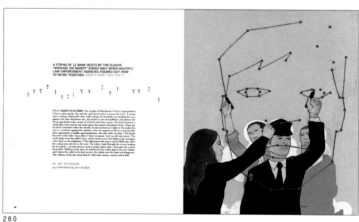

260

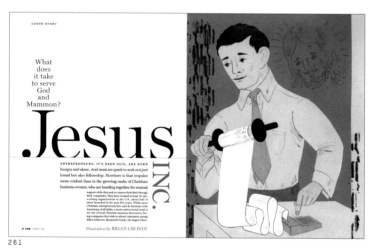

261

257. ESPN THE MAGAZINE

creative director. Siung Tjia
designer. Robert Festino
illustrator. +Ism
director of photography. Catriona Ni Aolain
publisher. ESPN, Inc.
issue. December 18, 2006
category. Design: Single Page

260. THE BOSTON GLOBE MAGAZINE

design director. Dan Zedek
art director. Brendan Stephens
designer. Emily Reid Kehe
illustrator. Elliott Golden
publisher. The New York Times
issue. May 7, 2006
category. Design: Spread

258. TODO MONTHLY

creative director. Rhonda Rubinstein
designer. Rhonda Rubinstein
photographer. Daniel Furon
studio. Exbrook
publisher. Free Media Group
client. TODO Monthly
issue. June 2006
category. Design: Spread

261. FORTUNE SMALL BUSINESS

art director. Scott A. Davis
designer. Michael Novak
illustrator. Brian Cronin
publisher. Time Inc.
issue. February 2006
category. Design: Spread + Illustration

259. THE AMERICAN LAWYER

art director. Joan Ferrell
designer. Joan Ferrell
illustrator. Christopher Silas Neal
editor-in-chief. Aric Press
publisher. American Lawyer Media
issue. July 2006
category. Design: Spread

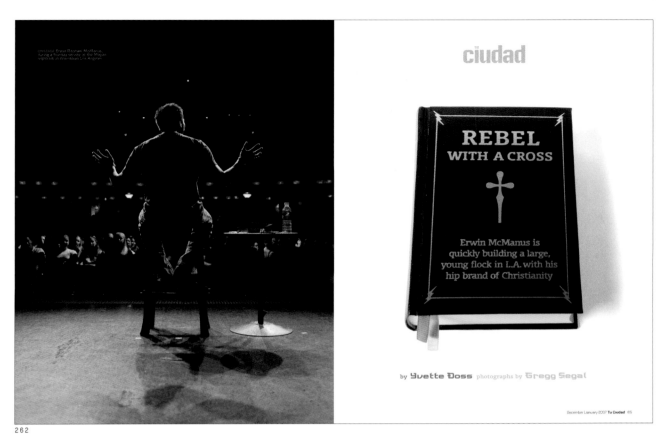

262

263

262. **TU CIUDAD**

art director. Tom O'Quinn. photo editor. Bailey Franklin
photographer. Gregg Segal. publisher. Emmis
issue. December 2006/January 2007. category. Design: Spread

263. **WIRED**

creative director. Scott Dadich. art director. Scott Dadich
designers. Todd Kurnat, Carl DeTorres. director of photography. Matt Mowat
photo editor. Carolyn Rauch. photographer. Martin Timmerman
publisher. Condé Nast Publications, Inc. issue. November 2006
category. Design: Spread

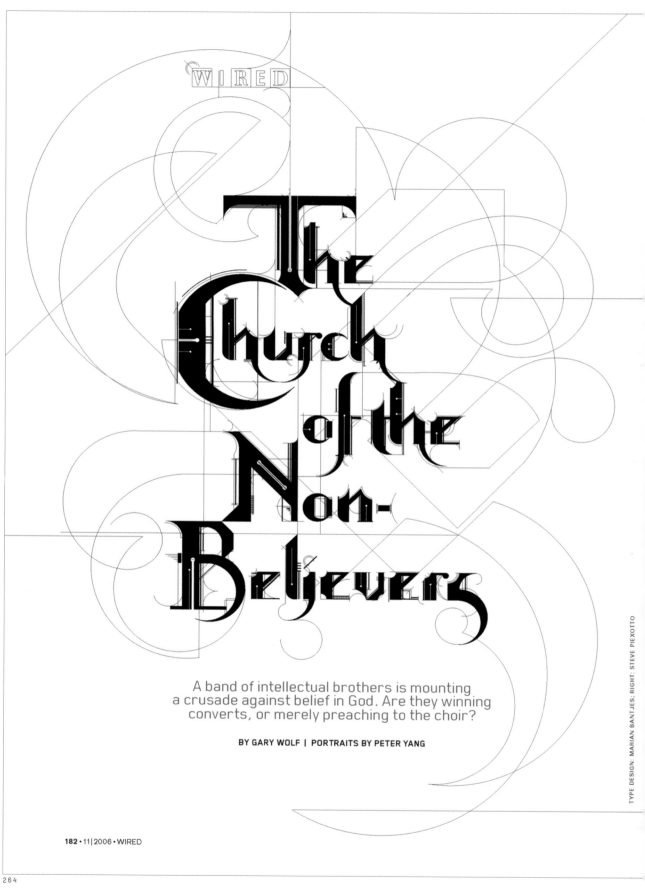

The Church of the Non-Believers

A band of intellectual brothers is mounting a crusade against belief in God. Are they winning converts, or merely preaching to the choir?

BY GARY WOLF | PORTRAITS BY PETER YANG

TYPE DESIGN: MARIAN BANTJES; RIGHT: STEVE PIEXOTTO

264. **WIRED**

creative director. Scott Dadich. art director. Maili Holiman. designers. Maili Holiman, Scott Dadich. illustrator. Marian Bantjes. director of photography. Matt Mowat. photo editor. Carolyn Rauch. photographer. Steve Piexotto. publisher. Condé Nast Publications, Inc. issue. November 2006. category. Design: Spread

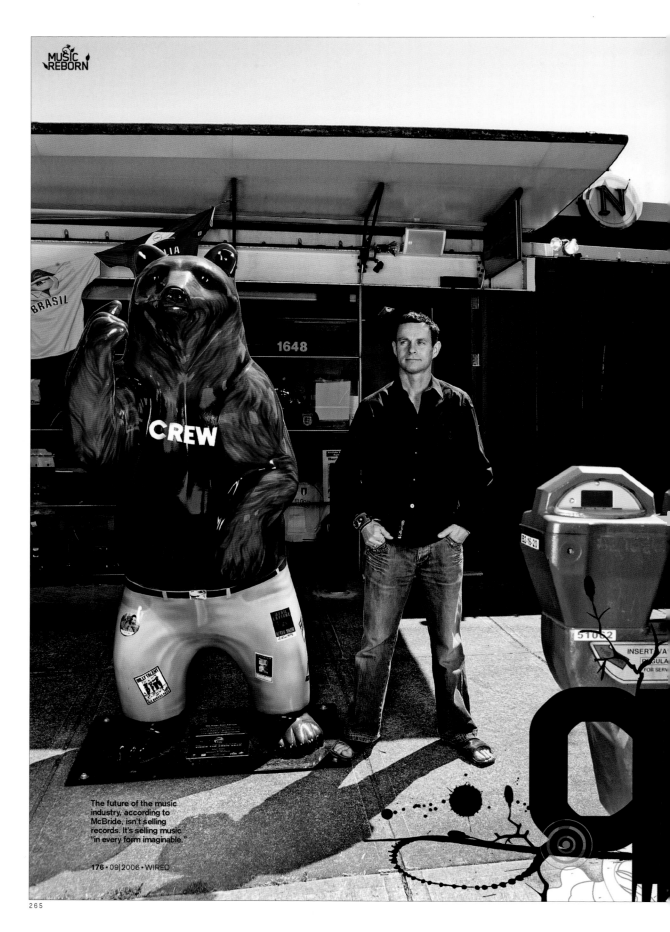

The future of the music industry, according to McBride, isn't selling records. It's selling music "in every form imaginable."

176 • 09|2006 • WIRED

265

265. **WIRED**

creative director. Scott Dadich. art director. Maili Holiman. designers. Maili Holiman, Todd Kurnat, Scott Dadich
illustrator. Vault 49. photo editor. Carolyn Rauch. photographer. Peter Yang. publisher. Condé Nast Publications, Inc.
issue. September 2006. category. Design: Spread

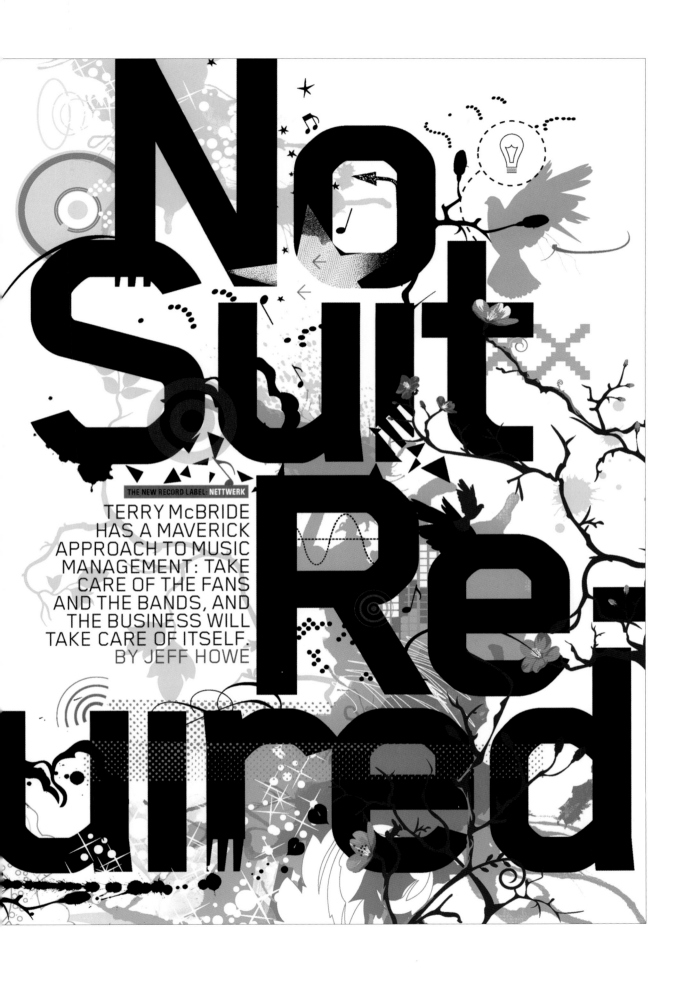

No Suit Required

TERRY McBRIDE HAS A MAVERICK APPROACH TO MUSIC MANAGEMENT: TAKE CARE OF THE FANS AND THE BANDS, AND THE BUSINESS WILL TAKE CARE OF ITSELF. BY JEFF HOWE

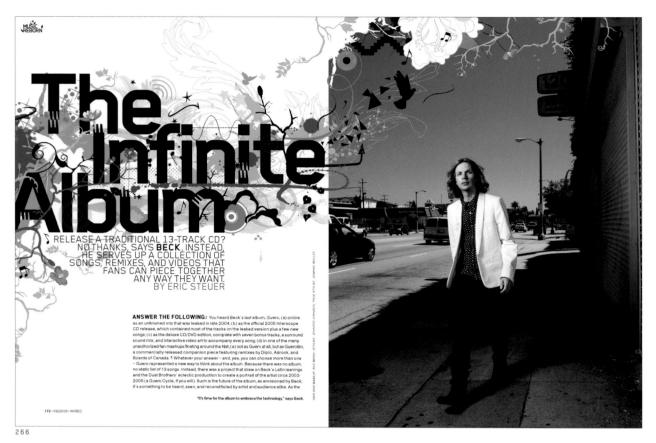

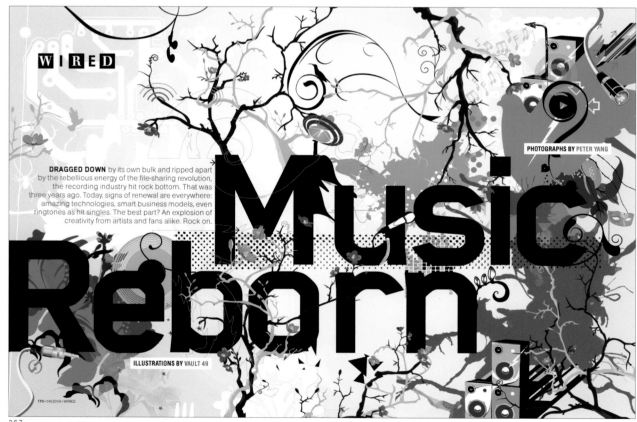

266.

266. **WIRED**

creative director. Scott Dadich. art director. Maili Holiman
designers. Maili Holiman, Todd Kurnat. illustrator. Vault 49
photo editor. Carolyn Rauch. photographer. Peter Yang
publisher. Condé Nast Publications, Inc. issue. September 2006
category. Design: Spread

267. **WIRED**

creative director. Scott Dadich. art director. Maili Holiman
designers. Maili Holiman, Todd Kurnat, Scott Dadich
illustrator. Vault 49. publisher. Condé Nast Publications, Inc.
issue. September 2006. category. Design: Spread + Story

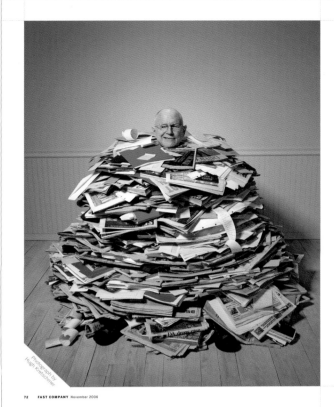

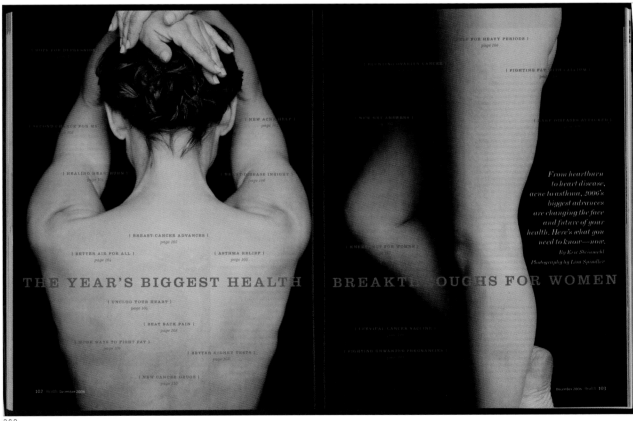

268. **FAST COMPANY**

art director. Dean Markadakis. designer. Dean Markadakis
director of photography. Meghan Hurley. photographer. Hugh Kretschmer
publisher. Mansueto Ventures, LLC. issue. November 2006
category. Design: Story

269. **HEALTH**

creative director. Myla Sorensen. associate art director. Kevin de Miranda
senior designer. Jenn McManus. photo editor. Michelle Hauf
photographer. Lisa Spindler. editor-in-chief. Doug Crichton
publisher. Southern Progress Corporation. issue. December 2006
category. Design: Story

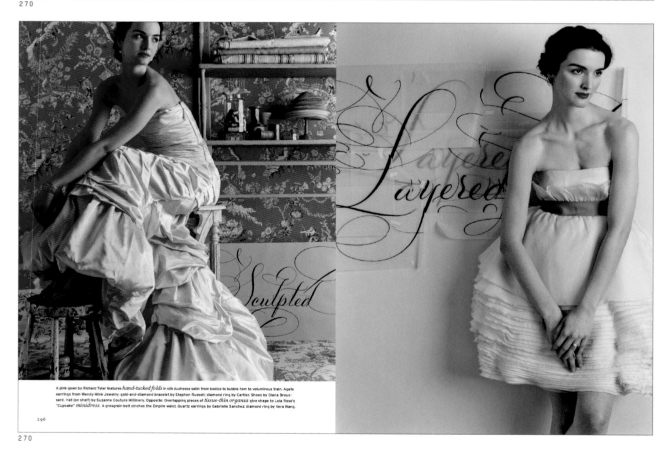

Bridal *silhouettes* have come in and out of fashion. The *curvy* ball gown gave way to a *slender* Empire shape; short, flirty skirts stepped aside for *flowing* A-lines. Now, it seems everything *old is new* again, and brides have so much to choose from. Try on many styles—today, what's *in fashion* is whatever makes you feel best.

in perfect

Shape

Fluid

Whisper-light chiffon *falls gracefully* in gathers on an Empire gown by Reem Acra. The high embroidered bodice is hand-beaded with crystals—a *regal detail* befitting this style's origin (Empress Josephine popularized the look during Napoleon's first empire). Floral diamond and white-gold wedding band by Rina Limor.

PHOTOGRAPHS BY *Patricia Heal* TEXT BY *Jill Gerston*

Layered

Sculpted

A pink gown by Richard Tyler features *hand-tucked folds* in silk duchesse satin from bodice to bubble hem to voluminous train. Agate earrings from Wendy Mink Jewelry; gold-and-diamond bracelet by Stephen Russell; diamond ring by Cartier. Shoes by Diana Broussard. Hat (on shelf) by Suzanne Couture Millinery. Opposite: Overlapping pieces of *tissue-thin organza* give shape to Lela Rose's "Cupcake" *minidress*. A grosgrain belt cinches the Empire waist. Quartz earrings by Gabrielle Sanchez; diamond ring by Vera Wang.

270

270. **MARTHA STEWART WEDDINGS**

creative director. Eric A. Pike. design director. Alexa Mulvihill. director of photography. Heloise Goodman. photo editor. Mary Cahill photographer. Patricia Heal. styled by. Theresa Canning Zast, Shana Faust, Charlyne Mattox. publisher. Martha Stewart Living Omnimedia issue. Summer 2006. category. Design: Story

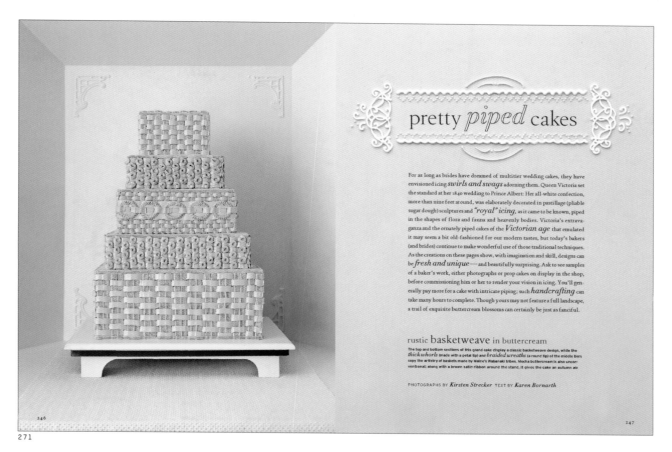

pretty *piped* cakes

For as long as brides have dreamed of multitier wedding cakes, they have envisioned icing *swirls and swags* adorning them. Queen Victoria set the standard at her 1840 wedding to Prince Albert: Her all-white confection, more than nine feet around, was elaborately decorated in pastillage (pliable sugar dough) sculptures and *"royal" icing*, as it came to be known, piped in the shapes of flora and fauna and heavenly bodies. Victoria's extravaganza and the ornately piped cakes of the *Victorian age* that emulated it may seem a bit old-fashioned for our modern tastes, but today's bakers (and brides) continue to make wonderful use of those traditional techniques. As the creations on these pages show, with imagination and skill, designs can be *fresh and unique*—and beautifully surprising. Ask to see samples of a baker's work, either photographs or prop cakes on display in the shop, before commissioning him or her to render your vision in icing. You'll generally pay more for a cake with intricate piping; such *handcrafting* can take many hours to complete. Though yours may not feature a full landscape, a trail of exquisite buttercream blossoms can certainly be just as fanciful.

rustic **basketweave** in buttercream

The top and bottom sections of this grand cake display a classic basketweave design, while the *thick whorls* made with a petal tip) and *braided wreaths* (a round tip) of the middle tiers copy the artistry of baskets made by Maine's Wabanaki tribes. Mocha buttercream is also unconventional; along with a brown satin ribbon around the stand, it gives the cake an autumn air.

PHOTOGRAPHS BY *Kirsten Strecker* TEXT BY *Karen Bornarth*

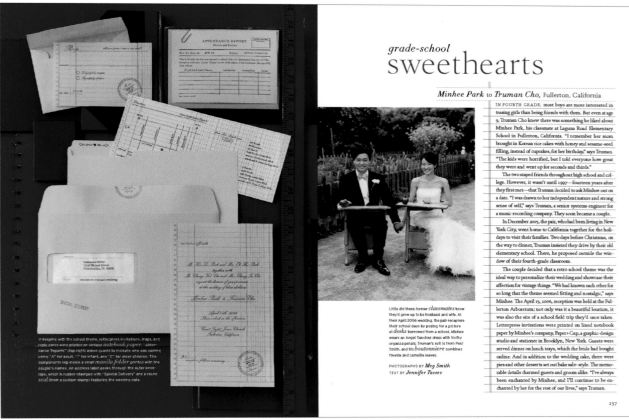

grade-school
sweethearts

Minhee Park to *Truman Cho*, Fullerton, California

IN FOURTH GRADE, most boys are more interested in teasing girls than being friends with them. But even at age 9, Truman Cho knew there was something he liked about Minhee Park, his classmate at Laguna Road Elementary School in Fullerton, California. "I remember her mom brought in Korean rice cakes with honey and sesame-seed filling, instead of cupcakes, for her birthday," says Truman. "The kids were horrified, but I told everyone how great they were and went up for seconds and thirds."

The two stayed friends throughout high school and college. However, it wasn't until 1997—fourteen years after they first met—that Truman decided to ask Minhee out on a date. "I was drawn to her independent nature and strong sense of self," says Truman, a senior systems engineer for a music-recording company. They soon became a couple.

In December 2005, the pair, who had been living in New York City, went home to California together for the holidays to visit their families. Two days before Christmas, on the way to dinner, Truman insisted they drive by their old elementary school. There, he proposed outside the window of their fourth-grade classroom.

The couple decided that a retro school theme was the ideal way to personalize their wedding and showcase their affection for vintage things. "We had known each other for so long that the theme seemed fitting and nostalgic," says Minhee. The April 15, 2006, reception was held at the Fullerton Arboretum; not only was it a beautiful location, it was also the site of a school field trip they'd once taken. Letterpress invitations were printed on lined notebook paper by Minhee's company, Paper+Cup, a graphic-design studio and stationer in Brooklyn, New York. Guests were served dinner on lunch trays, which the bride had bought online. And in addition to the wedding cake, there were pies and other desserts set out bake sale–style. The memorable details charmed guests and groom alike. "I've always been enchanted by Minhee, and I'll continue to be enchanted by her for the rest of our lives," says Truman.

Little did these former *classmates* know they'd grow up to be husband and wife. At their April 2006 wedding, the pair recapture their school days by posing for a picture at *desks* borrowed from a school. Minhee wears an Angel Sanchez dress with frothy organza petals; Truman's suit is from Paul Smith, and his *boutonniere* combines freesia and camellia leaves.

In keeping with the school theme, letterpress invitations, maps, and reply cards were printed on vintage *notebook paper*. "Attendance Reports" (top right) asked guests to indicate who was coming using "A" for adult, "I" for infant, and "C" for older children. The components slip inside a small *manila folder* printed with the couple's names. An address label peeks through the outer envelope, which is rubber-stamped with "Special Delivery" and a round *seal* (from a custom stamp) featuring the wedding date.

PHOTOGRAPHS BY *Meg Smith*
TEXT BY *Jennifer Tzeses*

271. **MARTHA STEWART WEDDINGS**

creative director. Eric A. Pike. design director. Alexa Mulvihill
art director. Jayme Smith. director of photography. Heloise Goodman
photo editor. Mary Cahill. photographer. Kirsten Strecker
styled by. Bergren Rameson. publisher. Martha Stewart Living Omnimedia
issue. Fall. category. Design: Story

272. **MARTHA STEWART WEDDINGS**

creative director. Eric A. Pike. design director. Alexa Mulvihill
art director. Jayme Smith. director of photography. Heloise Goodman
photo editor. Mary Cahill. photographer. Meg Smith
styled by. Theresa Canning Zast, Melissa Urdang
publisher. Martha Stewart Living Omnimedia. issue. Fall. category. Design: Story

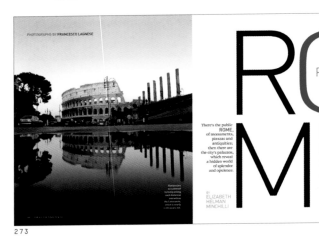

273

274

275

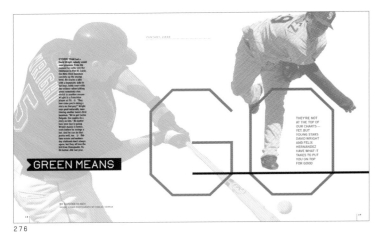

276

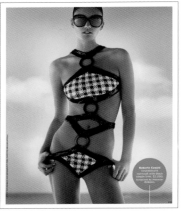

277

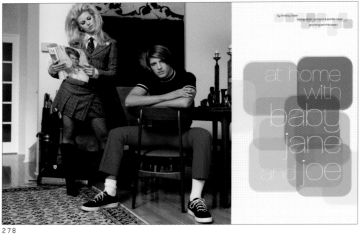

278

273. TOWN & COUNTRY TRAVEL

creative director. Mary Shanahan
art director. Matthew Lenning
director of photography. Casey Tierney
photo editor. Mara Hoberman
photographer. Francesco Lagnese
editor-in-chief. Pamela Fiori
publisher. The Hearst Corporation-Magazines Division
issue. Spring 2006. category. Design: Story

276. ESPN THE MAGAZINE

creative director. Siung Tjia
designer. Robert Festino
illustrator. Thomas Fuchs
director of photography. Catriona Ni Aolain
photo editor. Jim Surber
photographer. Carlos Serroa
editor-in-chief. Gary Hoenig
publisher. ESPN, Inc. category. Design: Story

274. SEED

creative director. Adam Bly
art director. Adam Billyeald
designers. Brian E. Smith, Jeffrey Docherty
editor-in-chief. Adam Bly
publisher. Seed Media Group
issue. August/September 2006
category. Design: Story

277. DEPARTURES

creative director. Bernard Scharf
art director. Adam Bookbinder
associate art director. Lou Corredor
director of photography. Jennifer Laski
photo editors. Jennifer Geaney, Brandon Perlman
photographer. Alistair Taylor-Young
publisher. American Express Publishing Co.
issue. July/August 2006. category. Design: Story

275. CARL'S CARS

creative director. Stephanie Dumont
art director. ATYPK
designer. ATYPK
publisher. Carl's Cars
category. Design: Story

278. DAY JOB

creative director. James Nixon
designer. Cameron Browning
photographer. Lindsay Lozon
publisher. Day Job Industries
issue. August 2006
category. Design: Story

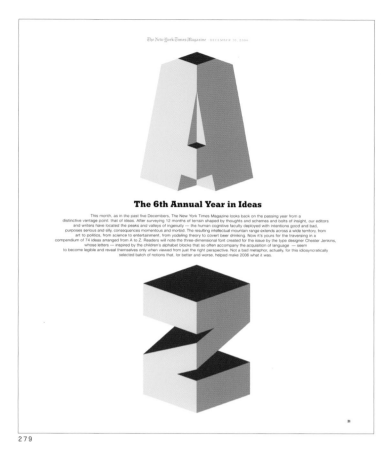

279

280

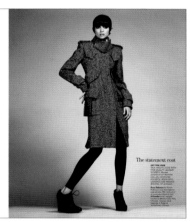

281

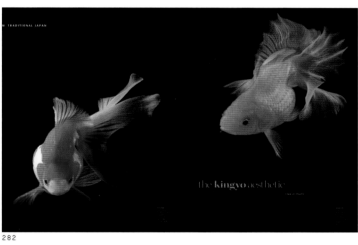

282

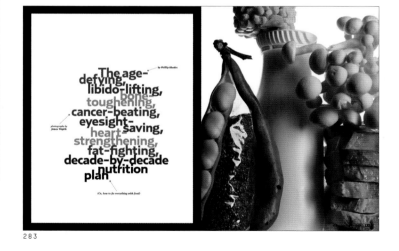

283

279. THE NEW YORK TIMES MAGAZINE

creative director. Janet Froelich
art director. Arem Duplessis
designer. Gail Bichler
director of photography. Kathy Ryan
photographer. Horacio Salinas
editor-in-chief. Gerald Marzorati
publisher. The New York Times
issue. December 10, 2006. category. Design: Story

282. JAPAN+

art director. Kevin Foley
designer. Kevin Foley
photo editor. Hisashi Kondo
photographer. Takahiro Sakuma
studio. KF Design
publisher/client. Jiji Gaho Sha, Inc.
issue. December 2006. category. Design: Story

280. DIALOGUE

creative director. Charlene Benson
design director. Chris Teoh
photo editor. Bess Hauser
photographer. Dan Forbes
studio. Time Inc. Content Solutions
publisher. Time Inc. Content Solutions
client. Metaldyne. issue. January 2006
category. Design: Story

283. MEN'S HEALTH

design director. George Karabotsos
designer. Matthew Lenning
director of photography. Marianne Butler
photo editor. Ernie Montiero
photographer. James Wojcik
publisher. Rodale Inc.
issue. March 2006. category. Design: Story

281. CHICAGO TRIBUNE MAGAZINE

art directors. David Syrek, Joseph Darrow
photographer. Kevin Sinclair
publisher. Chicago Tribune Company
issue. August 27, 2006
category. Design: Story

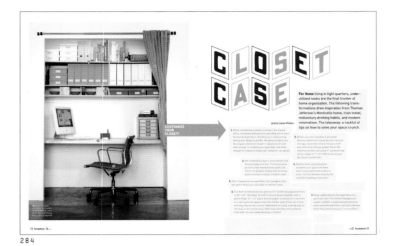

284

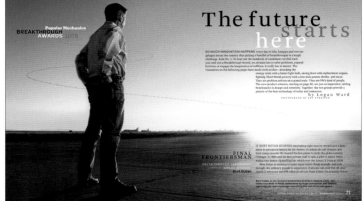

285

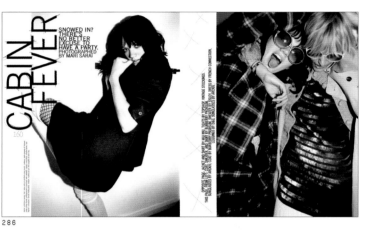

286

287

288

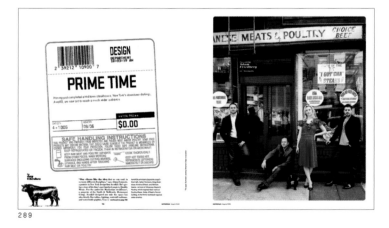

289

284. **READY MADE MAGAZINE**

art director. Eric Heiman
designers. Eric Heiman, Becky Eaton
director of photography. Howard Cao
photographers. Jason Madara, Micah Baird,
Kate Kelley, Cody Pickens. studio. Volume Inc.
editor-in-chief. Shoshana Berger
publisher. Wall Text Inc. client. Ready Made
Magazine. issue. October/November 2006
category. Design: Story

285. **POPULAR MECHANICS**

design director. Michael Lawton
art director. Peter Herbert
designers. Michael Friel, Agustin Chung
illustrators. Razro, Flying Chili, Blanddesigns
director of photography. Allyson Torrisi
photo editor. Alison Unterreiner
photographers. Art Streiber, Nathan Perkel,
Beth Perkins, Chad Hunt
publisher. The Hearst Corporation-Magazines Division
issue. November 2006. category. Design: Story

286. **NYLON**

art director. Michele Outland
designer. Michele Outland
director of photography. Stacey Mark
photographer. Mari Sarai
editor-in-chief. Marvin Scott Jarrett
publisher. Nylon LLC
issue. December 2006/January 2007
category. Design: Story

287. **METROPOLIS**

creative director. Criswell Lappin
art director. Nancy Nowacek
designer. Erich Nagler. illustrators. Tim Kucynda,
William Morrisey, Pure + Applied, mgmt. Design.
photo editors. Bilyana Dimitrova, Evelyn Dillworth.
photographers. Terry Adams, Patrick Rytikangas,
Evelyn Dillworth, Ralph Richter
publisher. Bellerophon Publications
issue. April 2006. category. Design: Story

288. **PREFIX PHOTO**

art directors. Claire Dawson, Fidel Peña,
Scott McLeod. designers. Claire Dawson, Fidel Peña
studio. Underline Studio
publisher. Prefix Institute of Contemporary Art
client. Prefix Institute of Contemporary Art
issue. November 2006
category. Design: Story

289. **METROPOLIS**

creative director. Criswell Lappin
art director. Nancy Nowacek
photo editor. Bilyana Dimitrova
photographers. Adam Friedburg, David Joseph
publisher. Bellerophon Publications
issue. August 2006
category. Design: Story

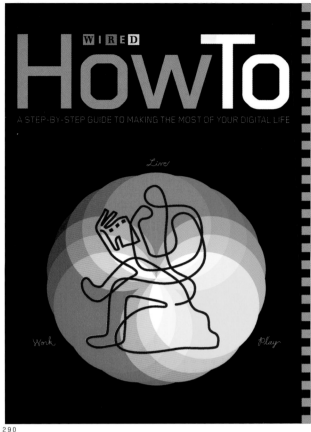

A STEP-BY-STEP GUIDE TO MAKING THE MOST OF YOUR DIGITAL LIFE

290

Photograph by JILL GREENBERG

Be an Expert on Anything
BY STEPHEN COLBERT

S

Stephen Colbert won't be taking the advice offered in this guide. He has dedicated his career to passing himself off as an expert on anything. Colbert honed this skill on *The Daily Show With Jon Stewart*, where he served as an analyst on everything from the Middle East to presidential gastronomy before gaining the title Senior Expert News Correspondent. He is a specialist in improv comedy, which he says "is partly about making people believe you know everything." On Comedy Central's hit show *The Colbert Report*, he goes beyond expertise into the arena of what he calls the anti-expert. "My show is an exercise in willfully ignorant, emotionally based, incurious passion about things. For instance, what gives Britannica the right to tell me that the Panama Canal was built in 1914? If I want to say 1941, that's my right." Don't even think about arguing with him.
– JOHN HOCKENBERRY

PICK A FIELD THAT CAN'T BE VERIFIED. Try something like string theory or God's will: "I speak to God. I'm sorry that you can't also." Security experts are in this category: They have security clearances, we don't. We can't question the expertise of the NSA because we are not in the NSA.

CHOOSE A SUBJECT THAT'S ACTUALLY SECRET. Dan Brown invented a secret subject for *The Da Vinci Code*, so now he is forever an expert on this secret subject that no one can challenge. Anybody who attacks the secret subject is, by definition, part of the cabal.

GET YOUR OWN ENTRY IN AN ENCYCLOPEDIA. In the media age, everybody was famous for 15 minutes. In the Wikipedia age, everybody can be an expert in five minutes. Special bonus: You can edit your own entry to make yourself seem even smarter.

USE THE WORD ZEITGEIST AS OFTEN AS POSSIBLE. Ideally, you want to find words that sound familiar but people don't really know their definitions: *zeitgeist, bildungsroman, doppelgänger* – better yet, anything Latin. But avoid *paradigm*. It's so 1994. If you say the word *paradigm*, everybody knows you're a poser.

BE SURE TO USE LOTS OF ABBREVIATIONS AND ACRONYMS. Someone who says the words *operations security* may be educated, but the person who uses the military abbreviation *Opsec* is clearly an expert. If I use the term *Gitmo*, that means I've actually been there. If you say, "We're going to Defcon 1," it means you probably have the launch codes. Real experts don't have time for extra syllables.

SPEAK FROM THE BALLS, NOT FROM THE DIAPHRAGM. In the expert game, you've got to have sack. That means speaking with confidence. In America, you've got to steer clear of nuance and ambivalence – and don't even contemplate doubt.

DON'T BE AFRAID TO MAKE THINGS UP. *Never* fear being exposed as a fraud. Experts make things up all the time. They're qualified to.

DON'T LIMIT YOURSELF TO CURRENT KNOWLEDGE. If you worry too much about being up-to-date, you miss out on vast territories of obsolete knowledge just waiting to be reclaimed. Think of leech-craft and all the lonely experts in the use of the little creatures, which are now experiencing a renaissance in health care.

GET AN HONORARY PHD. They work wonders. I have a doctorate in fine arts from Knox College in Illinois. All I did was give a speech, and now everybody has to call me Dr. Colbert.

MAKE A HABIT OF NAME-DROPPING. Say things like "I was talking to John Hockenberry yesterday for my story in *Wired*. Have you seen my cover?" I plan to use this issue of *Wired* to assert that I now know everything about wires.

BE FAMOUS. IT HELPS.

004 082006 • WIRED **HOW TO**

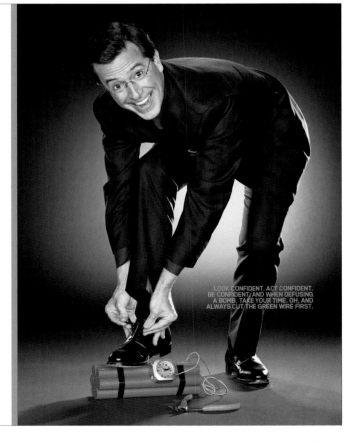

> LOOK CONFIDENT. ACT CONFIDENT. BE CONFIDENT. AND WHEN DEFUSING A BOMB, TAKE YOUR TIME. OH, AND ALWAYS CUT THE GREEN WIRE FIRST.

290

290. **WIRED**

creative director. Scott Dadich. art director. Jeremy LaCroix. designers. Scott Dadich, Carl DeTorres, Todd Kurnat
illustrators. Felix Sockwell, Jason Lee. photo editors. Carolyn Rauch, Amy Crilly. photographers. Jill Greenberg, Darren Braun,
Michael Muller, Justin Stephens, Gavin Bond. publisher. Condé Nast Publications, Inc. issue. August 2006. category. Design: Story

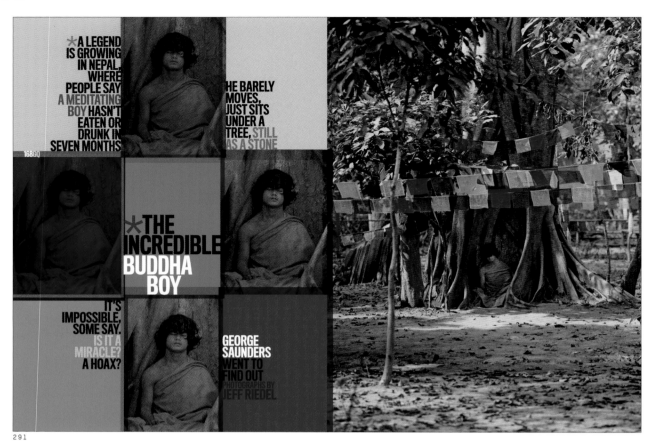

291

The Mail-Order Bride

After years of playing the field, photographer Steven Baillie was looking for a woman he could settle down with. He wanted a **postcard-perfect wife**: someone gorgeous, of course, who was caring and happy to serve her man—not as spoiled as the American women he knew. So he looked to South America and outsourced the search. Soon, he had more women than he could deal with. And they were beautiful, available, instantly committed to him. How could he have known it would end so badly? · · · **by John Bowe** · · · **Photographs by Steven Baillie**

292

291. **GQ**

design director. Fred Woodward. designer. Ken DeLago
director of photography. Dora Somosi. photo editor. Justin O'Neill
photographer. Jeff Riedel. publisher. Condé Nast Publications Inc.
issue. June 2006. category. Design: Story

292. **GQ**

design director. Fred Woodward. designer. Anton Ioukhnovets
director of photography. Dora Somosi. photo editor. Justin O'Neill
photographer. Steven Baillie. publisher. Condé Nast Publications Inc.
issue. April 2006. category. Design: Story

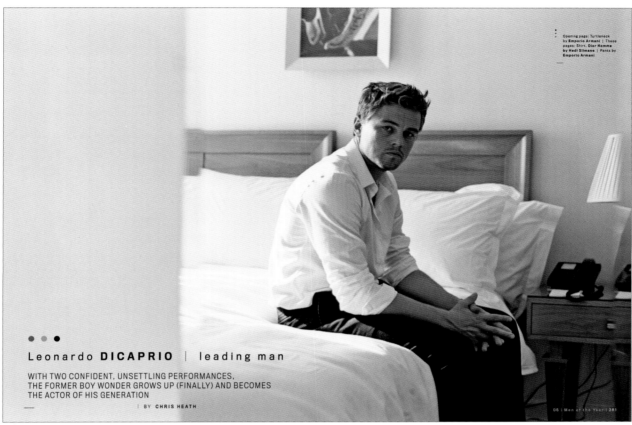

Opening page: Turtleneck
by Emporio Armani | These
pages: Shirt, Dior Homme
by Hedi Slimane | Pants by
Emporio Armani

• • •

Leonardo **DICAPRIO** | leading man

WITH TWO CONFIDENT, UNSETTLING PERFORMANCES,
THE FORMER BOY WONDER GROWS UP (FINALLY) AND BECOMES
THE ACTOR OF HIS GENERATION
—
| BY CHRIS HEATH

06 | Men of the Year | 281

293

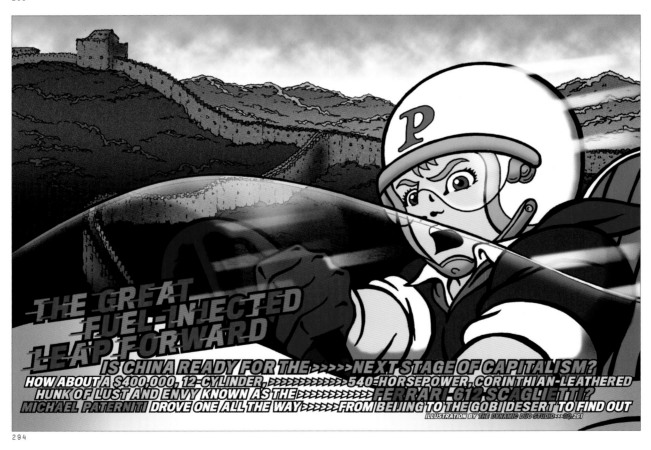

THE GREAT
FUEL-INJECTED
LEAP FORWARD

IS CHINA READY FOR THE >>>>> NEXT STAGE OF CAPITALISM?
HOW ABOUT A $400,000, 12-CYLINDER, >>>>>>>>>>> 540-HORSEPOWER, CORINTHIAN-LEATHERED
HUNK OF LUST AND ENVY KNOWN AS THE >>>>>>>>> FERRARI 612 SCAGLIETTI?
MICHAEL PATERNITI DROVE ONE ALL THE WAY >>>>> FROM BEIJING TO THE GOBI DESERT TO FIND OUT
ILLUSTRATION BY THE DYNAMIC DUO STUDIO >> GQ 261

294

293. **GQ**

design director. Fred Woodward. designer. Ken DeLago
director of photography. Dora Somosi. senior photo editor. Krista Prestek
photographer. Terry Richardson. publisher. Condé Nast Publications Inc.
issue. December 2006. category. Design: Story + Photo: Story

294. **GQ**

design director. Fred Woodward. illustrator. The Dynamic Duo Studio
director of photography. Dora Somosi. publisher. Condé Nast Publications Inc.
issue. March 2006. category. Design: Story

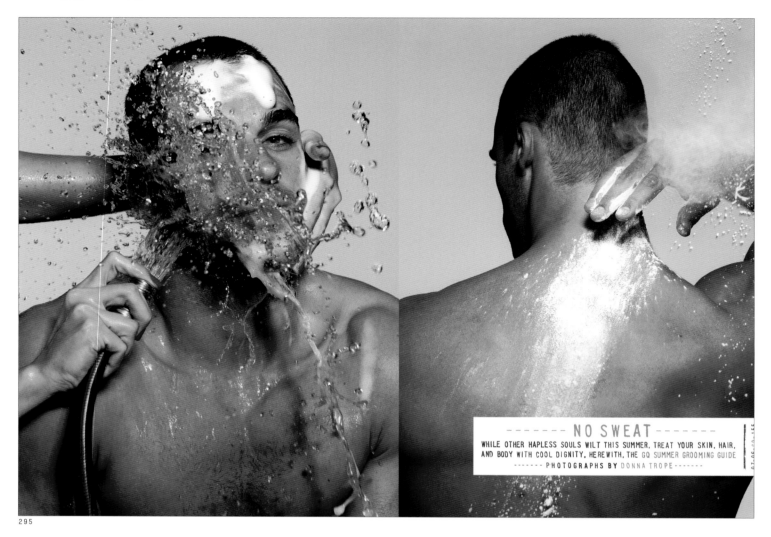

NO SWEAT
WHILE OTHER HAPLESS SOULS WILT THIS SUMMER, TREAT YOUR SKIN, HAIR,
AND BODY WITH COOL DIGNITY. HEREWITH, THE GQ SUMMER GROOMING GUIDE
PHOTOGRAPHS BY DONNA TROPE

295

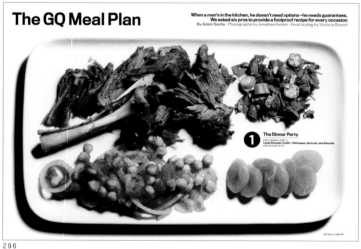

296

297

295. **GQ**

design director. Fred Woodward
designer. Anton Ioukhnovets
director of photography. Dora Somosi
photo editor. Justin O'Neill
photographer. Donna Trope
publisher. Condé Nast Publications Inc.
issue. July 2006
category. Design: Story

296. **GQ**

design director. Fred Woodward
designer. Anton Ioukhnovets
director of photography. Dora Somosi
photo editor. Justin O'Neill
photographer. Jonathan Kantor
publisher. Condé Nast Publications Inc.
issue. October 2006
category. Design: Story

297. **GQ**

design director. Fred Woodward
designer. Thomas Alberty
director of photography. Dora Somosi
photographers. Jessica Craig-Martin, Brian Finke,
Lisa Kereszi, Tom Schierlitz
publisher. Condé Nast Publications Inc.
issue. February 2006
category. Design: Story

298

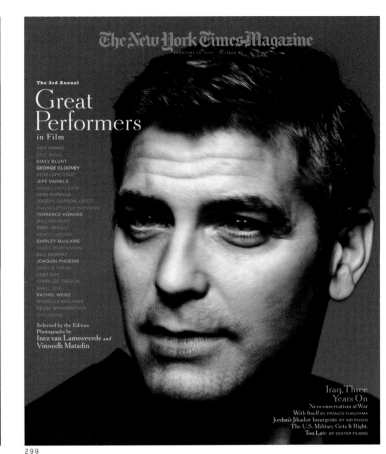

299

300

301

298. THE NEW YORK TIMES MAGAZINE

creative director. Janet Froelich
art director. Arem Duplessis
designers. Nancy Harris Rouemy, Gail Bichler,
Jeff Glendenning, Cathy Gilmore-Barnes, Leo Jung,
Jeffrey Docherty, Arem Duplessis
director of photography. Kathy Ryan
editor-in-chief. Gerald Marzorati
publisher. The New York Times
issue. December 31, 2006
category. Design: Entire Issue

299. THE NEW YORK TIMES MAGAZINE

creative director. Janet Froelich
art director. Arem Duplessis
designers. Cathy Gilmore-Barnes,
Jeff Glendenning, Leo Jung
director of photography. Kathy Ryan
editor-in-chief. Gerald Marzorati
publisher. The New York Times
issue. February 19, 2006
category. Design: Entire Issue

300. MARIE CLAIRE

creative director. Paul Martinez
art director. Jenny Leigh Thompson
designers. Shannon Casey, Burgan Shealy, Greg Behar
director of photography. Alix Campbell
photo editors. Andrea Volbrecht, Melanie Chambers
photographers. Ben Baker, Andrew Hetherington,
Sarah McColgan, James White
art/photo assistant. Margo Didia
publisher. The Hearst Corporation-Magazines Division
issue. November 2006
category. Design: Entire Issue

301. WIRED

creative director. Scott Dadich. art directors. Maili Holiman, Jeremy LaCroix
designers. Carl DeTorres, Todd Kurnat, Victor Krummenacher
illustrators. Oksana Badrak, Bryan Christie, Michael Doret, Kevin Hand, James Jean, David Plunkert, Matt Pyke
director of photography. Matt Mowat. photo editors. Zana Woods, Carolyn Rauch, Anna Alexander
photographers. Darren Braun, David Clugston, Jill Greenberg, Frank Schwere, Ed Hepburne Scott, Gregg Segal,
Patrick Voigt, Ofer Wolfberger, Peter Yang. publisher. Condé Nast Publications, Inc.
issue. December 2006. category. Design: Entire Issue

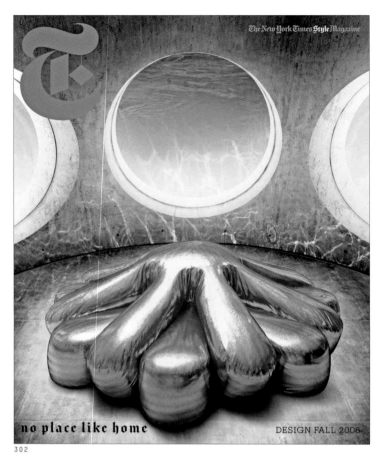

The New York Times Style Magazine

no place like home DESIGN FALL 2006

302

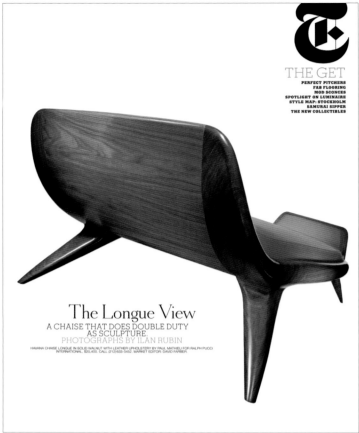

THE GET
PERFECT PITCHERS
FAB FLOORING
MOD SCONCES
SPOTLIGHT ON LUMINAIRE
STYLE MAP: STOCKHOLM
SAMURAI SIPPER
THE NEW COLLECTIBLES

The Longue View
A CHAISE THAT DOES DOUBLE DUTY
AS SCULPTURE.
PHOTOGRAPHS BY ILÁN RUBIN

HAVANA CHAISE LONGUE IN SOLID WALNUT WITH LEATHER UPHOLSTERY BY PAUL MATHIEU FOR RALPH PUCCI INTERNATIONAL, $20,400. CALL (212)633-0452. MARKET EDITOR: DAVID FARBER.

302

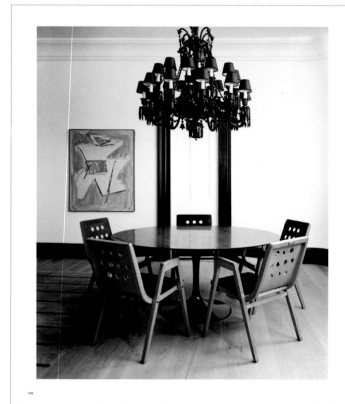

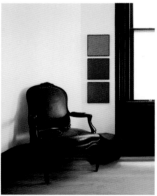

creative license
A PAIR OF NEW YORK ART DIRECTORS BRING
THEIR WORK HOME.

Text by ALIX BROWNE Photographs by GREG DELVES

302

302. **T, THE NY TIMES STYLE MAGAZINE**

creative director. Janet Froelich. senior art director. David Sebbah. art director. Christopher Martinez. director of photography. Kathy Ryan senior photo editor. Judith Puckett-Rinella. photo editors. Scott Hall, Jennifer Pastore. photographers. Raymond Meier, Ilán Rubin, Greg Delves editor. Pilar Viladas. editor-in-chief. Stefano Tonchi. publisher. The New York Times. issue. October 8, 2006. category. Design: Entire Issue

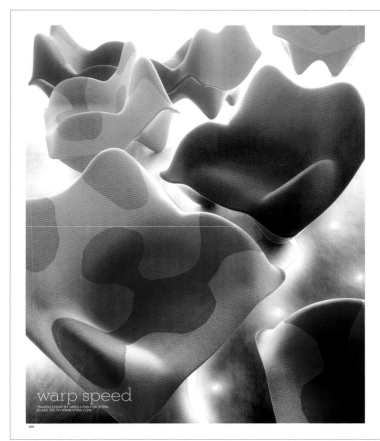

warp speed

RAVIOLI CHAIR BY GREG LYNN FOR VITRA. $3,650. GO TO WWW.VITRA.COM.

166

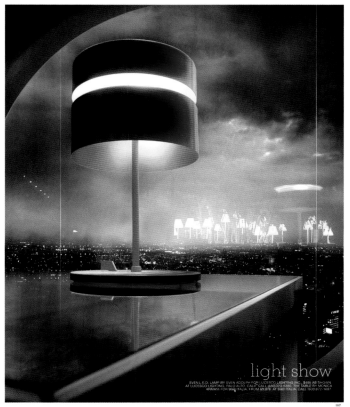

light show

SVEN L.E.D. LAMP BY SVEN ADOLPH FOR LUCEPLAN LIGHTING INC. $495 AS SHOWN. AT LUCEPLAN LIGHTING. PALO ALTO, CALIF. CALL (650) 373-6260. THE TABLE BY MONICA ARMANI FOR B&B ITALIA. FROM $7,976. AT B&B ITALIA. CALL (800) 872-1697.

167

303

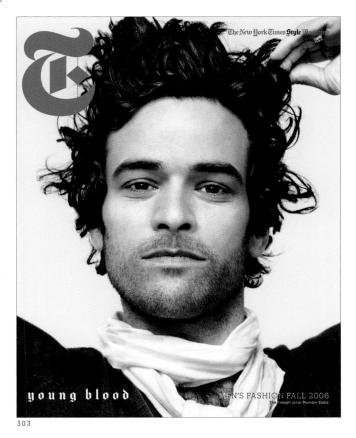

The New York Times Style Magazine

young blood

MEN'S FASHION FALL 2006
The French actor Romain Duris

303

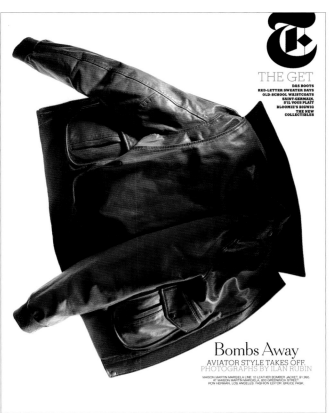

T
THE GET
DAS BOOTS
RED-LETTER SWEATER DAYS
OLD-SCHOOL WAISTCOATS
SAINT-GERMAIN,
S'IL VOUS PLAÎT
BLOOMIE'S BIGWIG
THE NEW
COLLECTIBLES

Bombs Away
AVIATOR STYLE TAKES OFF
PHOTOGRAPHS BY ILAN RUBIN

MAISON MARTIN MARGIELA LINE 10 LEATHER BOMBER JACKET, $1,990.
AT MAISON MARTIN MARGIELA, 803 GREENWICH STREET.
RON HERMAN, LOS ANGELES. FASHION EDITOR, BRUCE PASK.

303

303. **T, THE NY TIMES STYLE MAGAZINE**

creative director, Janet Froelich, senior art director, David Sebbah, art director, Christopher Martinez, designers, Janet Froelich, David Sebbah, Christopher Martinez, Elizabeth Spiridakis, Jody Churchfield, director of photography, Kathy Ryan, senior photo editor, Judith Puckett-Rinella photographers, Jean-Baptiste Mondino, Ilán Rubin, editor-in-chief, Stefano Tonchi, publisher, The New York Times, issue, September 17, 2006 category, Design: Entire Issue

304

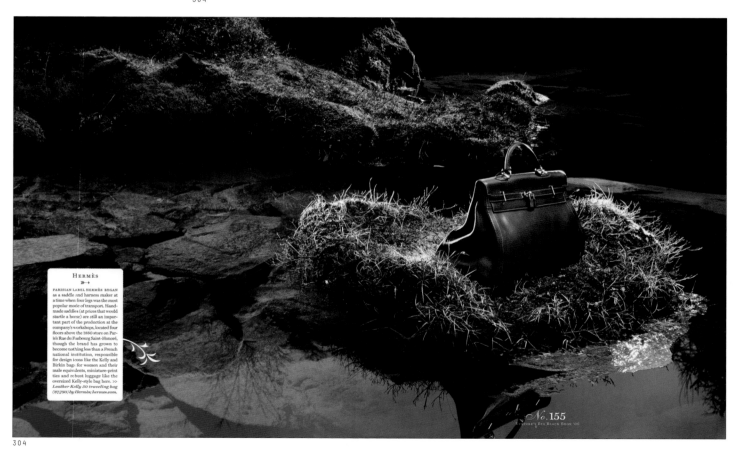

304

design director. David Curcurito. art director. Matthew Lenning. director of photography. Nancy Jo Iacoi. photo editor. Michael Norseng
photographers. Christopher Griffith, Julian Broad, Tim Simmons, Michael Muller. editor-in-chief. David Granger
publisher. The Hearst Corporation-Magazines Division. issue. Winter 2006. category. Design: Entire Issue

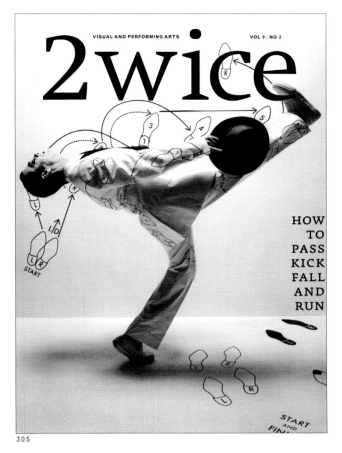

305

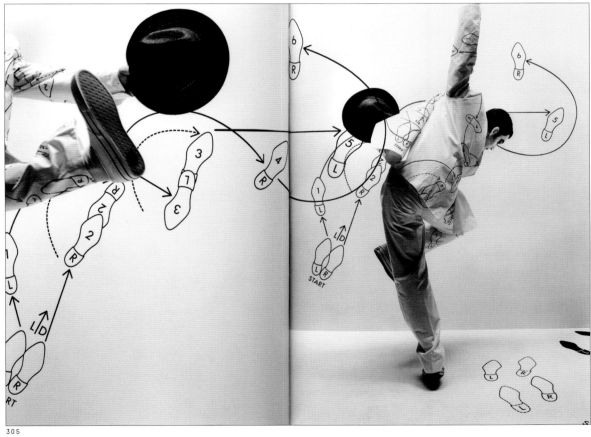

305

305. **2WICE**

art director. Abbott Miller. designers. Abbott Miller, Kristen Spilman. photographers. Jens Umbach, Katherine Wolkoff
studio. Pentagram Design, Inc. editor-in-chief. Patsy Tarr. client/publisher. 2wice Arts Foundation
issue. November 2006. category. Design: Entire Issue

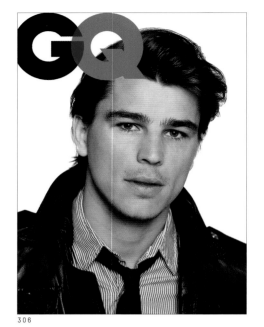

306

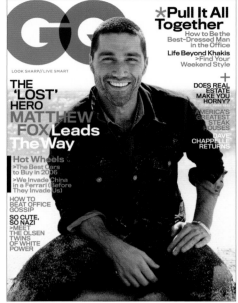

307

308

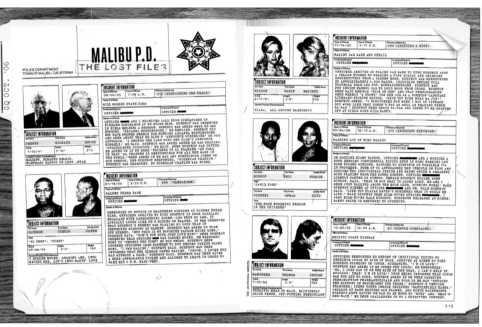

306

309

306. **GQ**

design director. Fred Woodward
art director. Ken DeLago
designers. Anton Ioukhnovets, Thomas Alberty,
Michael Pangilinan, Drue Wagner, Eve Binder,
Delgis Canahuate
illustrators. Jean-Philippe Delhomme,
John Ritter, Drew Friedman, James Kirkland,
Dynamic Duo, Tavis Coburn, John Ueland
director of photography. Dora Somosi
senior photo editor. Krista Prestek
photo editors. Justin O'Neill, Jolanta Bielat,
Jesse Lee. photographers. Peggy Sirota,
Nathaniel Goldberg, Fredericke Helwig. Steve Hiett,
Satoshi Saikusa, Tom Schierlitz, Martin Schoeller,
Mark Seliger, Carter Smith, Michael Thompson,
Ben Watts, Bruce Weber, Andrew Weir, Dan Winters
publisher. Condé Nast Publications Inc.
issue. March 2006. category. Design: Entire Issue

307. **GQ**

design director. Fred Woodward
art director. Ken DeLago.
designers. Anton Ioukhnovets, Thomas Alberty,
Michael Pangilinan, Drue Wagner, Eve Binder,
Delgis Canahuate
illustrators. Jean-Philippe Delhomme, John Ritter,
Zohar Lazar, Quickhoney, Seymour Chwast,
Sean McCabe, Knickerbocker Design, Ward Sutton,
Tavis Coburn, John Ueland
director of photography. Dora Somosi
senior photo editor. Krista Prestek
photo editors. Justin O'Neill, Jolanta Bielat,
Jesse Lee. photographers. Terry Richardson,
Richard Burbridge, Nathaniel Goldberg,
Fredericke Helwig, Steve Hiett, Brigitte Lacombe,
Satoshi Saikusa, Tom Schierlitz, Martin Schoeller,
Mark Seliger, Peggy Sirota, Carter Smith,
Michael Thompson, Ben Watts, Bruce Weber,
Dan Winters
publisher. Condé Nast Publications Inc.
issue. October 2006. category. Design: Entire Issue

308. **THE NEST**

art director. Liza Aelion
designers. Dawn Camner, Sophie Askew
illustrator. Jason O'Maley
photo editors. Dan Golden, Rebecca Kimmons
photographers. Antonis Achilleos, Jim Franco,
Ellen Silverman, Melanie Acevado
executive editor. Rosie Amodio
editor-in-chief. Carley Roney
publisher. The Knot
issue. Holiday 2006
category. Design: Entire Issue

309. **THIS OLD HOUSE**

design director. Amy Rosenfeld
art director. Hylah Hill
designers. John Taylor, Daisy Kim, Robert Hardin
illustrators. Jason Lee, Harry Bates, Tim Carroll
director of photography. Denise Sfraga
photo editor. Leah Vinluan
photographers. Anita Catero, Keller + Keller,
Eric Piasecki, John Lawton, Kolin Smith, Laura Moss.
Mark Weiss, Webb Chappell
publisher. Time Inc. issue. April 2006
category. Design: Entire Issue

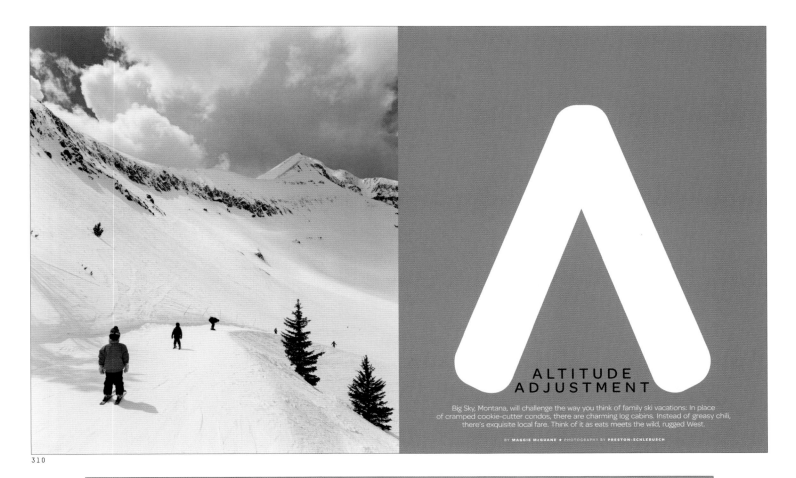

310

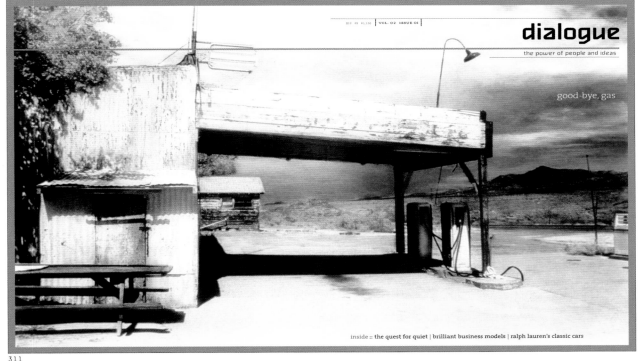

311

310. **COOKIE**

design director. Kirby Rodriguez. art director. Alex Grossman
designers. Nicolette Berthelot, Karla Lima. illustrators. Christopher Silas Neal,
Stina Persson, Brian Rea, Lisbeth Svarling, Mark Todd, Jesper Waldersten
photo editor. Darrick Harris. photographers. Zoe Adlersberg, Christopher Baker,
Graeme Boyle, Laura Gardner, Andrea Chu, Jack Coble, John Dolan, Dwight Eschliman,
Beth Galton, Matthew Hranek, Charles Masters, Ngoc Minh Ngo, Ethan Palmer,
Richard Pierce, Preston-Schlebusch, Horacio Salinas, Tamara Schlesinger, Peggy Sirota
editor-in-chief. Pilar Guzmán. publisher. Condé Nast Publications Inc.
issues. December 2006/January 2007. category. Design: Entire Issue

311. **DIALOGUE**

creative director. Charlene Benson. design director. Chris Teoh
photo editor. Bess Hauser. studio / publisher. Time Inc. Content Solutions
client. Metaldyne. issue. January 2006. category. Design: Entire Issue

312

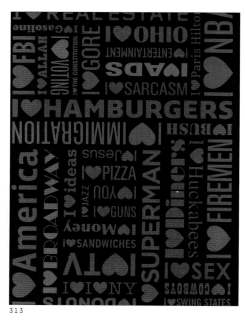

313

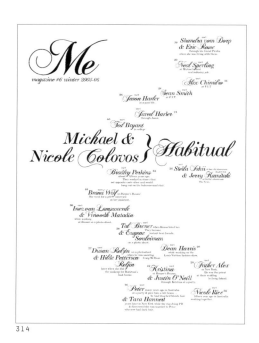

314

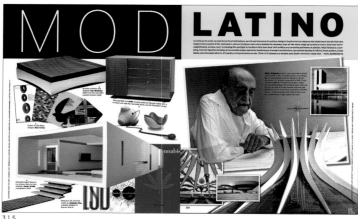

315

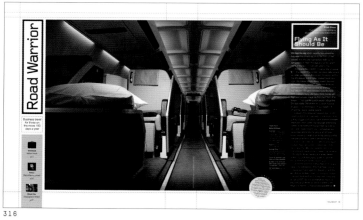

316

312. PROTO

creative director. Charlene Benson
design director. Alex Knowlton
art director. Lee Williams
photo editor. Ann DeSaussure
studio. Time Inc. Content Solutions
client. Massachusetts General Hospital
issue. Winter 2006.
category. Design: Entire Issue

313. GOOD

creative director. Casey Capwell
design director. Scott Stowell
designers. Susan Barber, Rob Dileso, Gary Fogelson,
Serifcan Özcan, Nick Rock, Scott Stowell
illustrators. W+K 12, Tamara Shopsin, Peter Arkle,
Robin Cameron, Designs by Gary
photo editor. Joaquin Trujillo
photographers. Olivier Laude, Trujillo-Paumier,
Border Film Project
studio. Open. publisher. Good Magazine, LLC.
issue. September/October 2006
category. Design: Entire Issue

314. ME MAGAZINE

creative director. Claudia Wu
photographers. Peter Hannert, Bootsy Holler,
Gil Sardenberg, Nikki Sargent, jarred Dean,
Tanya Hughes, marcelo Krasilcic, Terry Tsiolis
editor-in-chief. Claudia Wu
publisher. Me Magazine, Inc. issue. Winter 05-06
category. Design: Entire Issue

315. DEPARTURES

creative director. Bernard Scharf
art director. Adam Bookbinder
associate art director. Lou Corredor
illustrator. Robert Risko
director of photography. Jennifer Laski
photo editors. Jennifer Geaney, Brandon Perlman
photographers. Alistair Taylor-Young, Andrew Moore,
Robert Whitman, Alexandra Penney, Andrea Fazzari
publisher. American Express Publishing Co.
issue. October 2006. category. Design: Entire Issue

317

318

317

318

316. **DEALMAKER**

design director. Florian Bachleda
art directors. Clarendon Minges, Ted Keller
director of photography. Ian Spanier
studio. FB Design. publisher. Doubledown Media
issue. Fall 2006. category. Design: Entire Issue

317. **3X3.**

creative director. Charles Hively
art directors. Charles Hively, Sarah Munt
illustrators. Noah Woods, Viktor Koen,
Jody Hewgill, Etienne Delessert
photographers. Ash Steffy, Viktor Koen,
Balvis Rubess. publisher. 3x3 Magazine
issue. Fall/Winter 2006
category. Design: Entire Issue

318. **360**

creative director. Don Morris
design director. Josh Klenert
art directors. Philip Welsh, Jenny Knight,
André Mora. photographers. Joanna Van Mulder,
Erik Butler, Kurt Markus, James Merrell,
Francis Janisch. studio. Don Morris Design
editor-in-chief. Liz Buffa
publisher. American Express Publishing
issue. Summer 2006. category. Design: Entire Issue

fotografía Helena Gonçalves

{ ÉDEN

319

320

321

322

319. EGOÍSTA

creative director. Patrícia Reis
design director. Henrique Cayette
designers. Filipa Gregório, Hugo Neves,
Rita Salgueiro, Rodrigo Saias
producers. Francisco Ponciano, Cláudio Garrudo
publisher. Atelier 004. client. Estoril - Sol
issue. June 2006. category. Design: Entire Issue

320. EL MUNDO

design director. Carmelo Caderot
art director. Rodrigo Sanchez
designer. Rodrigo Sanchez
director of photography. Rodrigo Sanchez
publisher. Unidad Editorial S.A.
issue. December 17, 2006
category. Design: Entire Issue

321. REAL SIMPLE FOOD

creative director. Vanessa Holden
design director. Eva Spring
designer. Carolyn Veith Krienke
photo editors. Susan McClennan Phear,
Samantha Cassidy. photographers. Anna Williams,
Kirsten Strecker, Sang An, James Baigrie,
Monica Buck, Susie Cushner, Keate, Sara Remmington,
Charles Maraia, Brook Slezak. publisher. Time Inc.
issue. Fall 2006. category. Design: Entire Issue

322. REAL SIMPLE

creative director. Vanessa Holden
art directors. Ellene Wundrok, Philip Ficks
designers. Erin Whelan, Grace Kim, Tracy Walsh
illustrators. Matthew Sporzynski, Sophie Blackall,
Greg Clarke. photo editors. Naomi Nista,
Lauren Epstein, Susan McClennan Phear,
Annemarie Castro, Daisy Cajas
photographers. Yunhee Kim, William Meppem,
Quentin Bacon, Susie Cushner, Victor Schrager,
Beatrice DaCosta, Gentl & Hyers, James Merrell,
John Dolan, Mark Lund, Ngoc Minh Ngo,
Monica Buck, Nato Welton. publisher. Time Inc.
issue. March 2006. category. Design: Entire Issue

323

324

325

326

327

328

323. POPULAR MECHANICS

design director. Michael Lawton
art director. Peter Herbert
designers. Michael Friel, Agustin Chung
illustrators. Dogo, Lilah Anwen, Bland Design,
Razro, Head Case Design, Flying Chilli, Agustin Chung,
Translusczent, Loco Grafix, Eugene Thompson
director of photography. Allyson Torrisi
photo editor. Alison Unterreiner
photographers. Jens Mortensen, Art Streiber,
Beth Perkins, Tim Matsui, KC Armstrong,
Dennis Kleinman, Dan Saelinger, Gabriela Hasbun,
Chad Hunt, Nathan Perkel
publisher. The Hearst Corporation-Magazines Division
issue. November 2006, category. Design: Entire Issue

326. PERSPECTIVE

design director. Douglas Kelly
art director. Christian Campos
publisher. Imagination Publishing
client. International Interior Design Association
issue. Summer 2006, category. Design: Entire Issue

324. PEOPLE

creative director. Rina Migliaccio
art director. Greg Monfries
designer. Gloria Bang. illustrator. Chip Wass
director of photography. Chris Dougherty
photo editors. Christine Ramage, Lindsay Tyler
editor-in-chief. Martha Nelson
publisher. Time Inc. issue. Hollywood Oscar Daily
2006, category. Design: Entire Issue

327. NINTH LETTER

creative directors. Jennifer Gunji, Joseph Squier,
Nan Goggin. art director. Jennifer Gunji
designers. Sheila Cheng, Hye-Yeon Cho, Kelly Cree,
Nan Goggin, Charles Hannon, Austin Happel,
Blake Harvey, Troy Hayes, Jeffrey Jones, Borami Kang,
Adam Law, Gina Lee, Rob Mach, Jennifer Mahanay,
Cara McKinley, Clint Miceli, Becky Nasadowski,
Ho-Mui Wong. photographer. Troy Hayes
editor-in-chief. Jodee Stanley
publisher. University at Illinois at Urbana Champaign
client. UIUC Department of English
issue. Fall/Winter 2006
category. Design: Entire Issue

325. GREEN SOURCE

creative director. Mitch Shostak
design director. Anna Egger-Schlesinger
art director. Andrew Horton
designers. Clifford Rompf, Corey Kuepfer
illustrators. I-ni Chen, Jim Frazier
photographers. Maxwell Mackenzie, Mike Sinclair,
Tom Arban, Michael Shopenn, John Kormon
editorial director. Robert Ivy
executive editor. Nadav Malin
studio. Shostak Studios
publisher. McGraw-Hill Construction
client. McGraw-Hill Construction
issue. November 2006, category. Design: Entire Issue

328. CULTURE & TRAVEL

art director. Emily Crawford
illustrator. James Taylor
photo editor. Cory Jacobs
photographers. Mark Heithoff, Richard Barnes
associate art director. Sandra Garcia
publisher. LTB Media
issue. November/December 2006
category. Design: Entire Issue

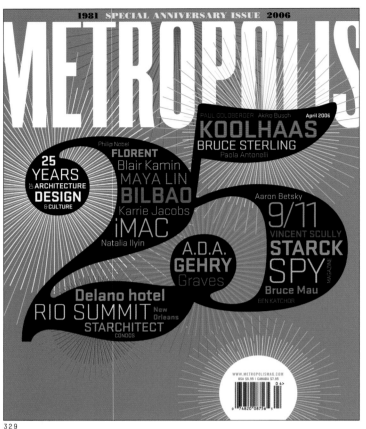

329

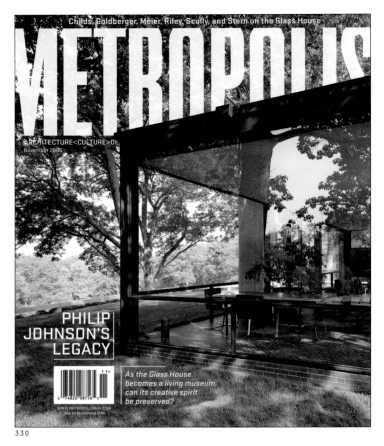

330

331

329. **METROPOLIS**

creative director. Criswell Lappin. art director. Nancy Nowacek
designer. Erich Nagler. illustrators. Danielle Aubert, For Office Use Only, Honest,
Natasha Jen, Leif Parsons, Steve Powers, Project Projects, Paul Sahre, Thumb,
Timorous Beasties, Tim Kucynda, William Morrisey, Pure + Applied, Ben Katchor,
Peter Arkle. photo editors. Bilyana Dimitrova, Magda Biernat, Evelyn Dillworth
photographers. Ralph Richter, Tony Law, Todd Hido, Tim Hursley, Julius Shulman,
David Allee, Kristine Larsen, Robert Polidori, Lara Swimmer, Sylvia Plachy,
Sean Hemmerle, Paul Warchol, Jimmy Cohrssen. publisher. Bellerophon Publications
issue. April 2006. category. Design: Entire Issue

330. **METROPOLIS**

creative director. Criswell Lappin. art director. Nancy Nowacek
designer. Erick Nagler. illustrators. Hiromi, Sugre, Matt Bouloutian,
Benoît Guillame. photo editors. Bilyana Dimitrova, Evelyn Dillworth
photographers. Paul Warchol, Sylvia Plachy, Eirik Johnson
publisher. Bellerophon Publications
issue. November 2006. category. Design: Entire Issue

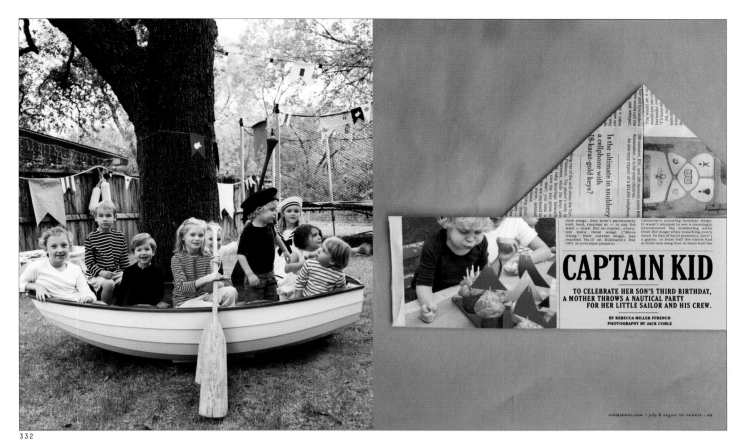

332

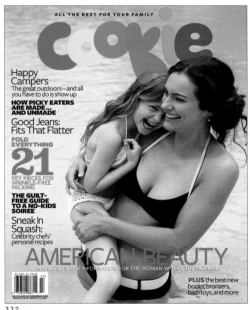

332

333

334

331. **PREMIERE**

art director. Rob Hewitt. designers. Andre Jointe, April Bell
illustrators. John Hendrix, Paul Willougby, Sean McCabe, Joshua Borouchou,
Jason Lee. director of photography. David Carthas. photo editors. Linda Liang,
Michele Ervin. photographers. Tierney Gearon, Rankin, Nick Haddow,
James Houston, Jeff Lipsky, David Strick. publisher. Hachette Filipacchi Media U.S
issue. September 2006. category. Design: Entire Issue

333. **COOKIE**

design director. Kirby Rodriguez. art director. Alex Grossman
designers. Nicolette Berthelot, Karla Lima. editor-in-chief. Pilar Guzmán
publisher. Condé Nast Publications Inc. issue. March/April 2006
category. Design: Entire Issue + Design: Spread

332. **COOKIE**

design director. Kirby Rodriguez. art director. Alex Grossman
designers. Nicolette Berthelot, Karla Lima. illustrators. Marc Alary,
Lovisa Burfitt, Lisbeth Svarling, Jesper Waldersten. photographers. Graeme Boyle,
Laura Gardner, Andrea Chu, Jack Coble, Kyoko Hamada, Blaise Hayward,
Matthew Hranek, Yunhee Kim, Keith Kleiner, Paola Kudacki, Jason Madara,
Charles Masters, Benoit Perverelli, Richard Pierce, Thirza Schaap,
Katherine Wolkoff. editor-in-chief. Pilar Guzmán
publisher. Condé Nast Publications Inc. issue. July/August 2006
category. Design: Entire Issue

334. **COOKIE**

design director. Kirby Rodriguez. art director. Alex Grossman
designers. Nicolette Berthelot, Karla Lima
illustrator. Studio Red at Rockwell Group. editor-in-chief. Pilar Guzmán
publisher. Condé Nast Publications Inc. issue. March/April 2006
category. Design: Entire Issue + Design: Spread

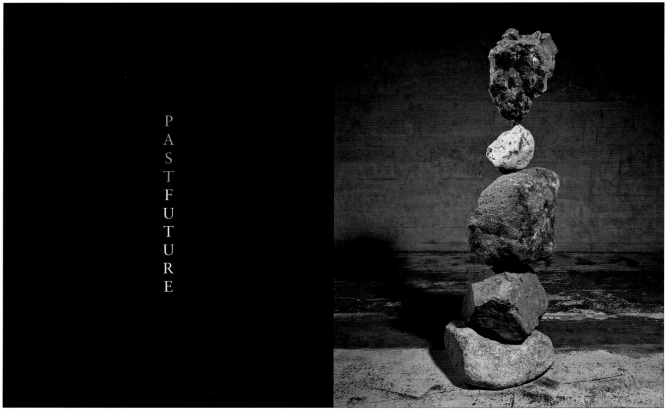

335

336

Left and previous page: Agent Provocateur boned corset. Erica lace panty with Loungewear Betty mesh boyshort. Right: Agent Provocateur sheer panty.

335. **SEE: THE POTENTIAL OF PLACE**

creative director. Bill Cahan. art directors. Bill Cahan, Todd Richards,
Steve Frykholm. designer. Todd Richards. illustrators. Artemio Rodriguez,
Joseph Hart, Brian Carter. photographers. Heimo Schmidt, Vivienne Flesher,
Robert Schlatter, Catherine Ledner, Andy Sacks, Colin Faulkner, Brian Carter
studio. Cahan & Associates. publisher. Herman Miller, Inc
issue. September 2006. category. Design: Entire Issue

336. **STEREOTYPE, THE MINI MAG**

creative director. Barbara Reyes. illustrators. Autumn Whitehurst, Ira Marcks,
Miryung Kim. director of photography. Leslie dela Vega
photographers. Leslie dela Vega, Colby Katz, Elizabeth young, Matthew Salacuse,
Kate + Camilla, Rebecca Greenfield, Steve Cohen. publisher. Stereotype
issue. 2006. category. Design: Entire Issue

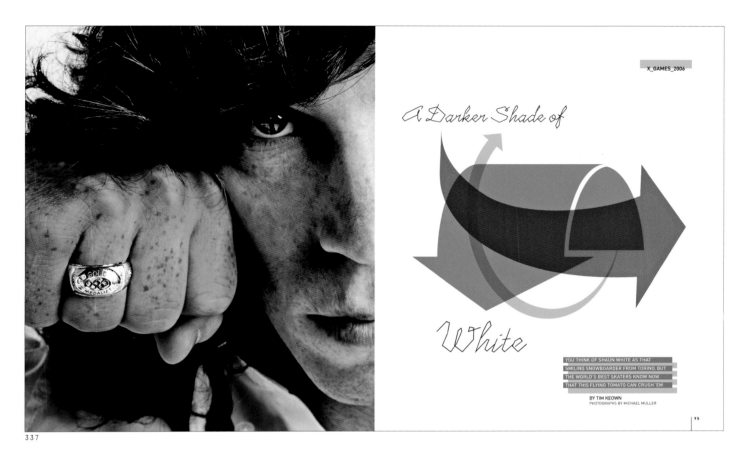

A Darker Shade of

White

YOU THINK OF SHAUN WHITE AS THAT
SMILING SNOWBOARDER FROM TORINO. BUT
THE WORLD'S BEST SKATERS KNOW NOW
THAT THIS FLYING TOMATO CAN CRUSH 'EM

BY TIM KEOWN
PHOTOGRAPHS BY MICHAEL MULLER

95

337

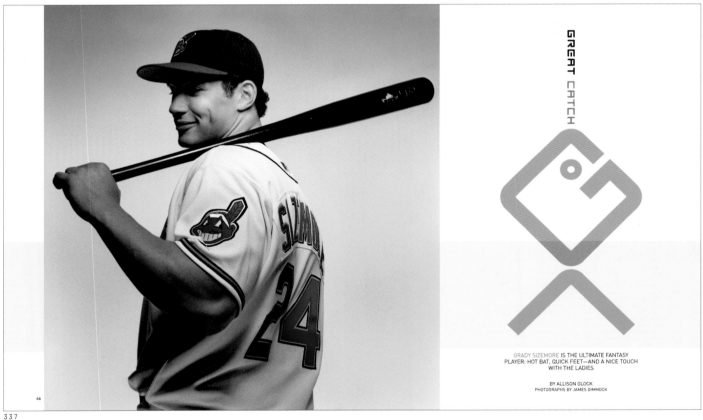

GREAT CATCH

GRADY SIZEMORE IS THE ULTIMATE FANTASY
PLAYER: HOT BAT, QUICK FEET—AND A NICE TOUCH
WITH THE LADIES

BY ALLISON GLOCK
PHOTOGRAPHS BY JAMES DIMMOCK

46

337

337. **ESPN THE MAGAZINE**

creative director. Siung Tjia. art director. Robert Festino. designers. Jason Lancaster, Hitomi Sato, Kathie Scrobanovich, Yuko Miyake
illustrator. Zohar Lazar. director of photography. Catriona Ni Aolain
photo editors. Nancy Weisman, Jim Surber, Amy McNulty, Daniela Corticchia, Tricia Reed, Shawn Vale
photographers. Michael Muller, James Dimmock, Adam Krause, Morad Bouchakour, Catherine Ledner, Chris Floyd, Justin Stephens, Matthew Salacues
editor-in-chief. Gary Hoenig. publisher. ESPN, Inc. issue. July 31, 2006. category. Design: Entire Issue

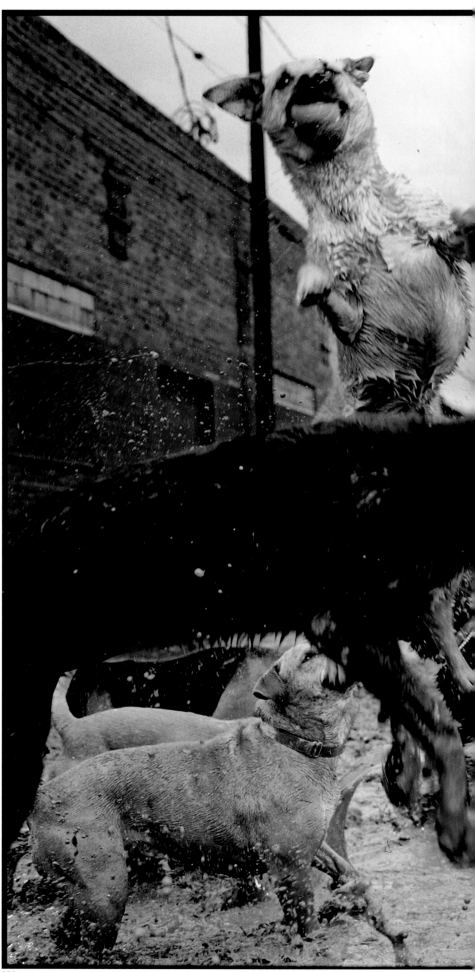

338. **THE NEW YORKER**

art director. Caroline Mailhot
director of photography. Elisabeth Biondi
photo editor. Natasha Lunn
photographer. Martin Schoeller
editor-in-chief. David Remnick
publisher. Condé Nast Publications Inc.
issue. May 22, 2006
category. Photo: Spread

338

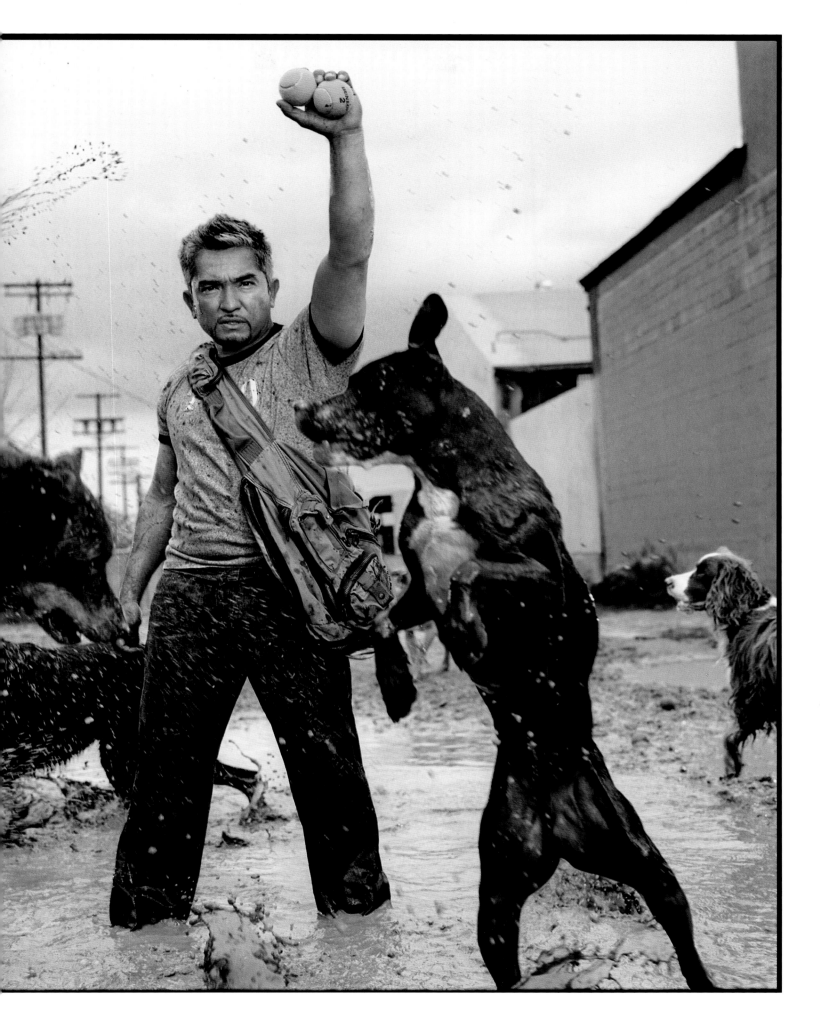

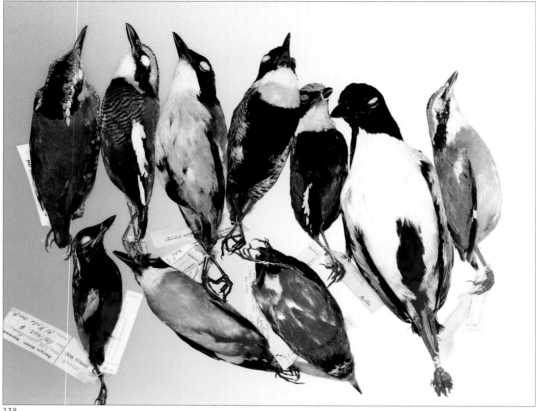

339

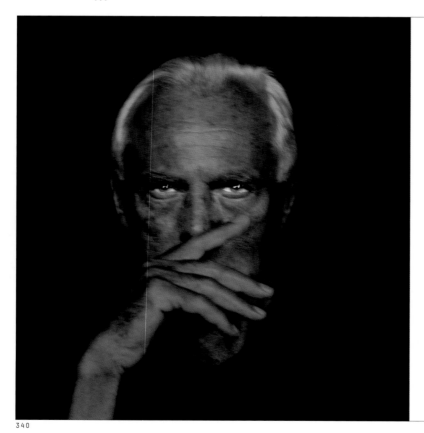

340.

WHAT MAKES GIORGIO RUN?
GIORGIO ARMANI IS THE WORLD'S RICHEST DESIGNER,
AND YET RETIREMENT IS NOT AN OPTION. ALICE RAWSTHORN
TRIES TO KEEP UP WITH THE HUMAN ENERGIZER.

W hen Bono edited a special issue of the British newspaper The Independent this summer, he sent a copy to Giorgio Armani with an inscription scrawled around the front page. "Señor Armani," it read. "You are an inspiration to me to not let go of detail and control of ideas and aesthetic. Only to God must we let go. A blessing ... Bono."

Addressing the most famous living Italian as a Spanish "señor" and not "signore" doesn't augur well for Bono's future as a control freak. But, for all his charming Irish blarney, Bono, the lead singer of U2, had one thing right: no one could ever accuse Giorgio Armani of letting go.

Take the scene backstage at the Emporio Armani men's show in Milan last June. The models lined up while Armani put the finishing touches to their makeup. They lined up again while he knotted neckties, adjusted the angle of hats, ruffled handkerchiefs in top pockets and fussed over buttons. Then he showed each one exactly how to pose. Once they'd hit the runway, Armani, a lithe 72 in his summer uniform of a tight navy blue T-shirt and baggy shorts, raced to the entrance, where he scrutinized the show on a plasma screen. Whenever he spotted something amiss, Armani pointed it out to a colleague, who sprinted off to correct it.

He isn't just like this at show time. "I've never met anyone whose attention to detail is so obsessive," notes Ron Frasch, the vice chairman of Saks Fifth Avenue. "He personally approves every necktie, every swatch of fabric. If you think of all the products his company puts out each year, that's incredible."

Famous photographers who arrive to take his portrait must do it Armani's way, right down to the lighting. Art directors

are told exactly how to produce his ads. Musicians arrive for fittings to discover that Armani himself will be doing the pinning. Before the opening of the Teatro Armani building in Milan, its architect, Tadao Ando, remembers Armani checking the angle and sightline of each of the 558 seats. Pauline Denyer, the wife of the fashion designer Paul Smith, reports a sighting of him sweeping the sidewalk outside one of his Milan boutiques. The furniture designer Mario Bellini, who has lived next door to Armani on Via Borgonuovo in Milan for more than 20 years, observes: "Our neighbors say that every morning he wakes up, runs down the street to look at the windows of his stores on Via Manzoni. He makes a mental note of everything that's wrong, and tells his staff."

That sort of dedication has paid off. After 30 years of extraordinary success, Giorgio Armani will go down in history as the man who defined the working wardrobe of the late-20th century and taught Hollywood how to dress. As the president, chief executive and sole shareholder of a company that generated 5 billion euros (about $6.4 billion) in retail sales last year, he is the world's wealthiest fashion designer, with a fortune estimated by Forbes at $4.5 billion. Ask a fashionista to name the most important designer working today, and she'll probably say Nicolas Ghesquière,

Portrait by NADAV KANDER

339. **THE NEW YORKER**

art director. Caroline Mailhot. director of photography. Elisabeth Biondi
photo editor. Elizabeth Culbert. photographer. Martin Schoeller
studio. Martin Schoeller Photography. editor-in-chief. David Remnick
publisher. Condé Nast Publications Inc.. issue. May 29, 2006
category. Photo: Spread

340. **T. THE NY TIMES STYLE MAGAZINE**

creative director. Janet Froelich. art director. Christopher Martinez
designer. Elizabeth Spiridakis. director of photography. Kathy Ryan
photographer. Nadav Kander. senior art director. David Sebbah
senior photo editor. Judith Puckett-Rinella. editor-in-chief. Stefano Tonchi
publisher. The New York Times. issue. September 17, 2006
category. Photo: Spread

Mitochondria
are doing
more than
just keeping
the cell's furnace
stoked.

The Powerhouse —and Sentinel —of the Cell

by Karen F. Schmidt

— LOOK UP "MITOCHONDRIA" IN ANY SCIENCE TEXT AND INVARIABLY THESE TUBULAR BAGS OF ENZYMES THAT FLOAT IN THE CELL'S INTERIOR ARE CALLED "THE POWER HOUSES OF THE CELL." OF COURSE, THE ROLE THEY PLAY AS CELLULAR FURNACES, converting nutrients and oxygen into energy, is immensely important. Every cell needs ATP—the chemical fuel generated by mitochondria—and some cells are particularly demanding: a muscle cell that pushes the leg into a sprint, a beta cell in the pancreas that synthesizes the hormone insulin, a brain cell that fires a signal to help create a thought. Each of these kinds of cells contains as many as 10,000 mitochondria, and it's no secret that those tiny organelles keep the home fires burning. • However, recent studies suggest that mitochondria do much more than generate energy. They are intimately involved in cell signaling, raising a red flag during times of cellular stress, such as when viruses invade or oxygen levels drop.

photograph by Mark Hooper

28 HHMI BULLETIN | May 2006

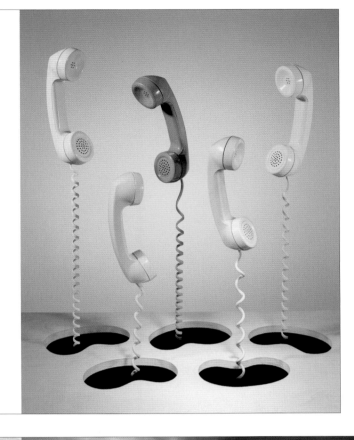

341

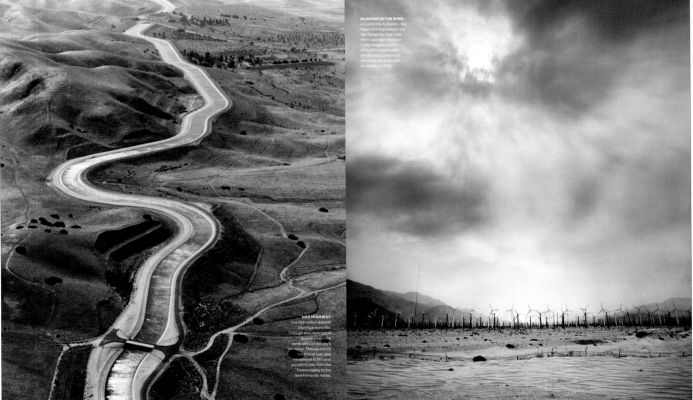

342

341. **HOWARD HUGHES MEDICAL INSTITUTE BULLETIN**

creative director. Hans Neubert. art director. Sarah Viñas
designer. Sarah Viñas. photo editor. Sarah Viñas. photographer. Mark Hooper
studio. VSA Partners. publisher. Howard Hughes Medical Institute
issue. May 2006. category. Photo: Spread

342. **WEST / LOS ANGELES TIMES MAGAZINE**

creative director. Joseph Hutchinson. art director. Heidi Volpe
designers. Heidi Volpe, Liz Hale. photo editors. Heidi Volpe, Joseph Hutchinson
photographer. Mark Hanauer. publisher. Los Angeles Times
category. Photo: Spread

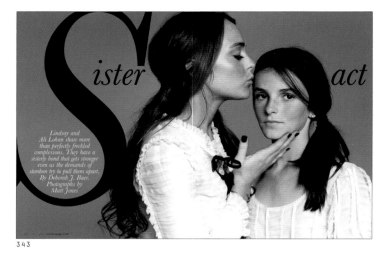

343

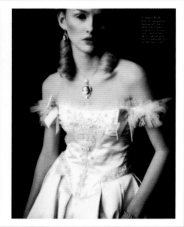

344

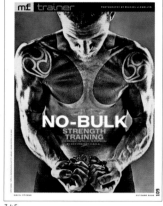

345

346

347

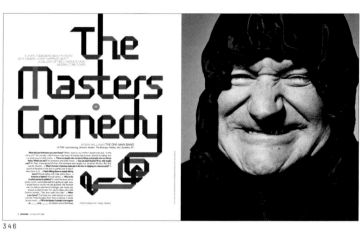

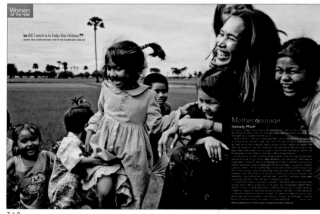

348

343. COSMOGIRL!

creative director. Jacqueline Azria-Palombo
design director. Kristin Fitzpatrick
designer. Kristin Fitzpatrick
director of photography. Georgia Paralemos
photographer. Matt Jones
editor-in-chief. Susan Schulz
publisher. The Hearst Corporation-Magazines Division
issue. November 2006. category. Photo: Spread

346. PREMIERE

art director. Dirk Barnett
designers. Dirk Barnett, Andre Jointe
director of photography. David Carthas
photographer. Nigel Parry
publisher. Hachette Filipacchi Media U.S.
issue. July/August 2006
category. Photo: Spread

344. MODERN BRIDE

creative director. Lou DiLorenzo
designer. Amy Jaffe
photo editor. Holly Watson
photographer. Alistair Taylor-Young
fashion editor. Juli Alvarez
publisher. Condé Nast Publications Inc.
issue. April/May 2006
category. Photo: Spread

347. INC.

creative director. Blake Taylor
designer. David McKenna
director of photography. Alexandra Brez
photo editor. Travis Ruse
photographer. Misty Keasler
publisher. Mansueto Ventures
issue. September 2006. category. Photo: Spread

345. MEN'S FITNESS

design director. John Seeger Gilman
designer. Ian Brown
director of photography. Monica Bradley
photo editor. Michelle Stark
photographer. Michael Llewellyn
publisher. American Media Inc.
issues. October 2006
category. Photo: Single Page

348. GLAMOUR

design director. Holland Utley
art director. Peter Hemme
designer. Amaya Taveras
director of photography. Suzanne Donaldson
photo editor. Stacey Deloreno
photographer. Norman Jean Roy
publisher. Condé Nast Publications Inc
issue. December 2006. category. Photo: Spread

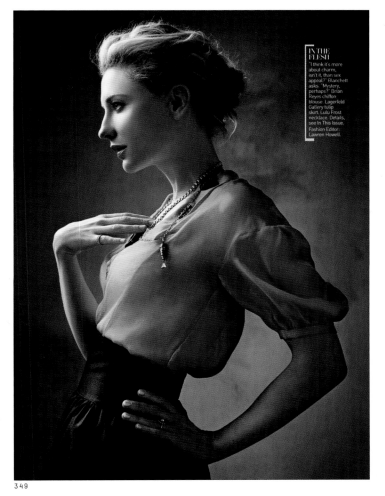

349

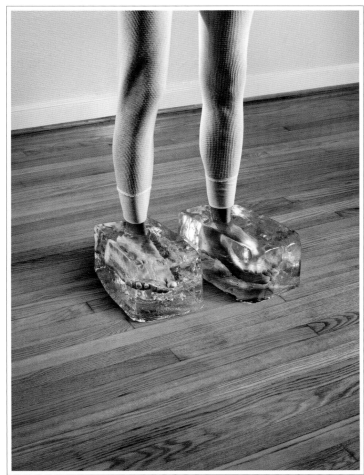

350

351

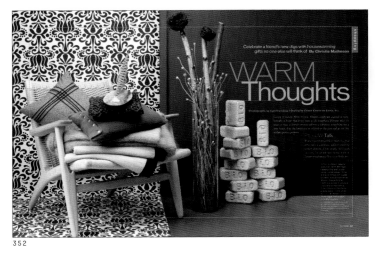

352

349. **MEN'S VOGUE**

creative director. Russell Labosky
director of photography. Ryan Cadiz
photographer. Norman Jean Roy
editor-in-chief. Jay Fielder
publisher. Condé Nast Publications Inc.
issue. Spring 2006
category. Photo: Single Page

351. **ELLE DÉCOR**

art director. Florentino Pamintuan
photo editor. Melissa LeBoeuf
publisher. Hachette Filipacchi Media U.S.
issue. June 2006
category. Photo: Spread

350. **SKI MAGAZINE**

creative director. Tom Brown Art + Design
art director. Nathan Sinclair
director of photography. Michelle Nihamin
photo editor. Tanya Dueri
photographer. Darren Braun
editor-in-chief. Kendall Hamilton
publisher. Time4. issue. November 2006
category. Photo: Single Page

352. **BOSTON MAGAZINE CONCIERGE**

creative director. Anne Bigler Amari
art director. Lori Pedrick
designer. Elizabeth DiFebo
photo editor. Monika Abercauph Naughton
photographer. Carl Tremblay
publisher. Metro Corp Publishing
issue. Fall 2006. category. Photo: Spread

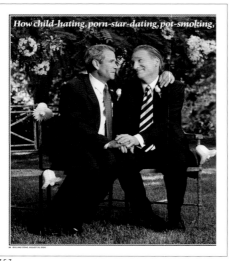

353

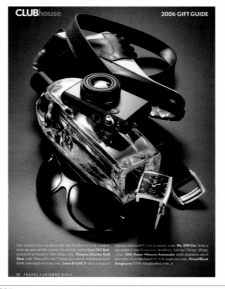

354

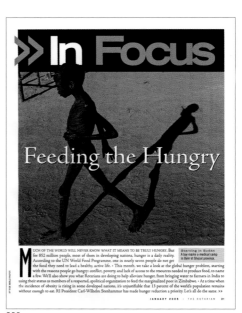

355

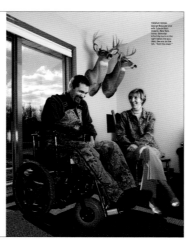

356

357

353. **ROLLING STONE**

art director. Amid Capeci
director of photography. Jodi Peckman
photo editor. Deborah Dragon
photographer. Robert Trachtenberg
publisher. Wenner Media
issue. August 24, 2006 RS 1007
category. Photo: Single Page

356. **FIELD & STREAM**

art director. Robert Perino
director of photography. Amy Berkley
photographer. Peter Yang
publisher. Time4 Media
issue. March 2006
category. Photo: Spread

354. **TRAVEL + LEISURE GOLF**

art directors. Paul Craven, Ian Doherty
designer. Ian Doherty
photo editors. Don Kinsella, Laurel Wassner
photographer. Nigel Cox
editor-in-chief. John Atwood
publisher. American Express Publishing Co.
issue. November/December 2006
category. Photo: Single Page

357. **PEOPLE**

creative director. Rina Migliaccio
designer. Greg Monfries
director of photography. Chris Dougherty
photo editor. Karen O'Donnell
photographer. Nina Berman
editor-in-chief. Larry Hackett
publisher. Time Inc.
issue. November 13, 2006
category. Photo: Spread + Photo: Story

355. **THE ROTARIAN**

creative director. Deborah A. Lawrence
designer. Ken Ovryn
publisher. Rotary International
issue. January 2006
category. Photo: Single Page

358. **THIS OLD HOUSE**

design director. Amy Rosenfeld
art director. Hylah Hill
designer. Amy Rosenfeld
director of photography. Denise Sfraga
photographer. David Prince
publisher. Time Inc.
issue. December 2006
category. Photo: Single Page

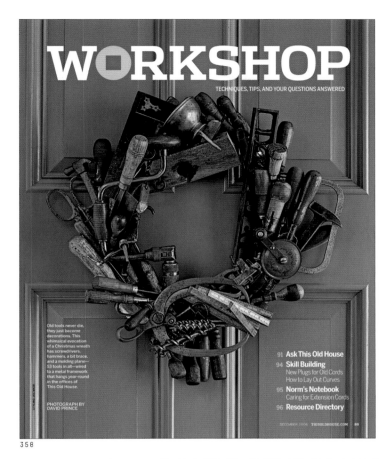

358

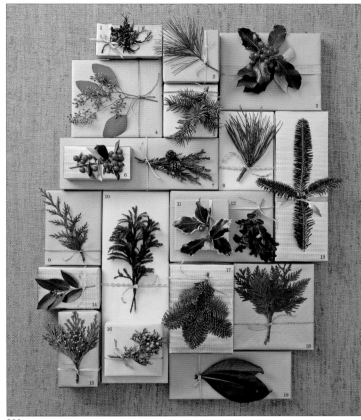

359

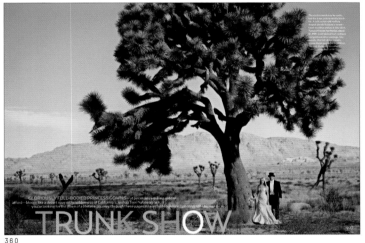

360

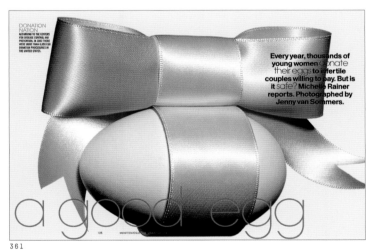

361

359. **MARTHA STEWART LIVING**

creative director. Eric A. Pike
design director. James Dunlinson
art director. Eric A. Pike
director of photography. Heloise Goodman
photo editors. Andrea Bakacs, Joni Noe
photographer. Eric Piasecki
styled by. Tony Bielaczyc, Melanio Gomez,
Marcie McGoldrick
editor-in-chief. Margaret Roach
publisher. Martha Stewart Living Omnimedia
issue. December 2006
category. Photo: Single Page

360. **BRIDES**

design director. Gretchen Smelter
art director. Donna Agajanian
designers. Ann Marie Mennillo, Gretchen Smelter
director of photography. Kristi Drago-Price
photo editor. Kristen Walsh
photographer. Jose Picayo
editor-in-chief. Millie Martini Bratten
publisher. Condé Nast Publications Inc.
issue. May/June 2006
category. Photo: Spread

361. **TEEN VOGUE**

creative director. Lina Kutsovskaya
art director. Kathleen McGowan
designers. Scott Williams, John Muñoz
director of photography. Zoë Bruns
photo editors. Mariel Osborn, Ashley Galloway,
Diana Son, Jennifer Kim
photographer. Jenny Van Sommers
editor-in-chief. Amy Astley
publisher. Condé Nast Publications Inc.
issue. February 2006
category. Photo: Spread

STRATEGIST

BEST BETS THE YOUNG FASHION DESIGN IN SEASON: SUN GOLD TOMATOES
. LAST-MINUTE LABOR DAY GETAWAYS. THAT BALD GUY'S CHOCOLATE,
REVIEWED . THE CHEAPEST APART PLAZA THE NEXT, NEXT SOHO

THE BEST BET The autumnal equinox takes place on September 23, which means by the end of next month the warm, rosy-toned sunlight now bathing New York will take on that crisp, pitiless blue quality—and your dinged-up walls will strike you as particularly drab. Instead of slapping on yet another coat of decorator's white (eggshell), call Carla Weisberg. She's primarily known for her surface designs for interiors—fabrics, wallpapers, rugs, and architectural elements—but she's also got a burgeoning **color-consulting** business. First, she interviews to determine likes and dislikes, how and when various rooms are used, and what kind of light (natural and unnatural) illuminates the home. Then she creates color cards— sometimes one for each room, or a palette with accents for different areas— that are tested and revised. It's up to the client to hire a painter, but for an additional fee, Weisberg will consult during that process as well. Start now and you'll have flawless walls for the holidays ($2,000 minimum fee for apartments under 2,500 square feet; 212-620-5276).

Photograph by Horacio Salinas

362. **NEW YORK**

design director. Luke Hayman. art director. Chris Dixon. director of photography. Jody Quon
photo editor. Alexandra Pollack. photographer. Horacio Salinas. editor-in-chief. Adam Moss
publisher. New York Magazine Holdings, LLC. issue. September 4-11, 2006. category. Photo: Single Page

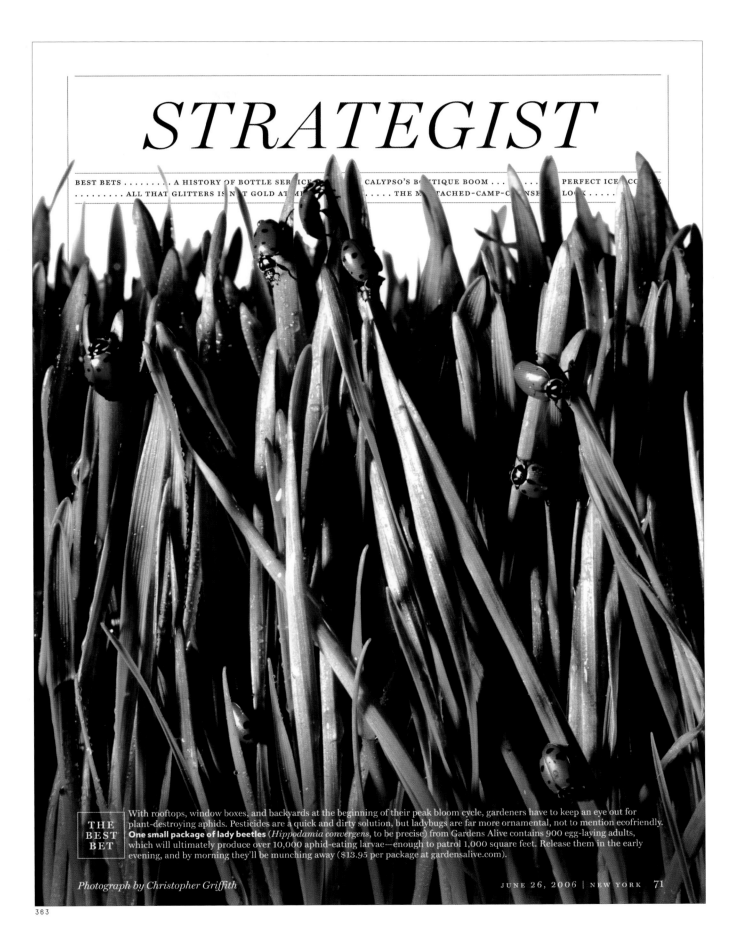

STRATEGIST

BEST BETS A HISTORY OF BOTTLE SERVICE CALYPSO'S BOUTIQUE BOOM PERFECT ICE ALL THAT GLITTERS IS NOT GOLD AT THE MUSTACHED-CAMP-COUNSELOR LOOK

THE BEST BET With rooftops, window boxes, and backyards at the beginning of their peak bloom cycle, gardeners have to keep an eye out for plant-destroying aphids. Pesticides are a quick and dirty solution, but ladybugs are far more ornamental, not to mention ecofriendly. **One small package of lady beetles** (*Hippodamia convergens*, to be precise) from Gardens Alive contains 900 egg-laying adults, which will ultimately produce over 10,000 aphid-eating larvae—enough to patrol 1,000 square feet. Release them in the early evening, and by morning they'll be munching away ($13.95 per package at gardensalive.com).

Photograph by Christopher Griffith

JUNE 26, 2006 | NEW YORK **71**

363

363. **NEW YORK**

design director. Luke Hayman. art director. Chris Dixon. director of photography. Jody Quon photo editor. Alexandra Pollack. photographer. Christopher Griffith. editor-in-chief. Adam Moss publisher. New York Magazine Holdings, LLC. issue. June 26, 2006. category. Photo: Single Page

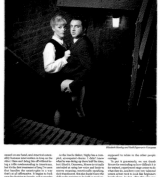 **And God Created Scarlett**

364

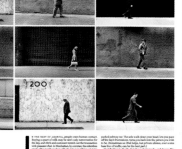 **To Have and to Hold**

365

366

367

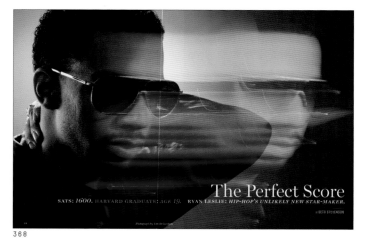 **The Perfect Score**

368

 THE ONCE AND FUTURE KISSINGER

369

364. NEW YORK

design director. Luke Hayman
art director. Chris Dixon
director of photography. Jody Quon
photo editor. Lea Golis
photographer. Andrew Eccles
editor-in-chief. Adam Moss
publisher. New York Magazine Holdings, LLC
issue. July 3-10, 2006. category. Photo: Spread

365. NEW YORK

design director. Luke Hayman
art director. Chris Dixon
director of photography. Jody Quon
photographer. Marilyn Minter
editor-in-chief. Adam Moss
publisher. New York Magazine Holdings, LLC
issue. August 28, 2006. category. Photo: Spread

366. NEW YORK

design director. Luke Hayman
art director. Chris Dixon
director of photography. Jody Quon
photo editor. Amy Hoppy
photographer. Amy Arbus
editor-in-chief. Adam Moss
publisher. New York Magazine Holdings, LLC
issue. December 11, 2006. category. Photo: Spread

367. NEW YORK

design director. Luke Hayman
art director. Chris Dixon
director of photography. Jody Quon
photographer. Gert Berliner
editor-in-chief. Adam Moss
publisher. New York Magazine Holdings, LLC
issue. December 25, 2006 - January 1, 2007
category. Photo: Spread

368. NEW YORK

design director. Luke Hayman
art director. Chris Dixon
director of photography. Jody Quon
photo editor. Leana Alagia
photographer. Tim Richardson
editor-in-chief. Adam Moss
publisher. New York Magazine Holdings, LLC
issue. November 20, 2006. category. Photo: Spread

369. NEW YORK

design director. Luke Hayman
art director. Chris Dixon
director of photography. Jody Quon
photo editor. Leano Alagia
photographer. Taryn Simon
editor-in-chief. Adam Moss
publisher. New York Magazine Holdings, LLC
issue. December 4, 2006. category. Photo: Spread

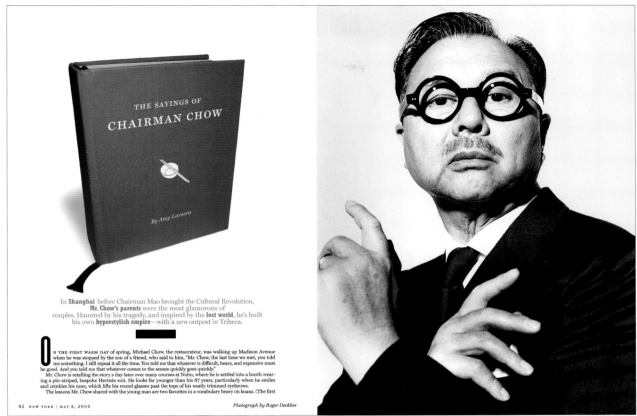

370

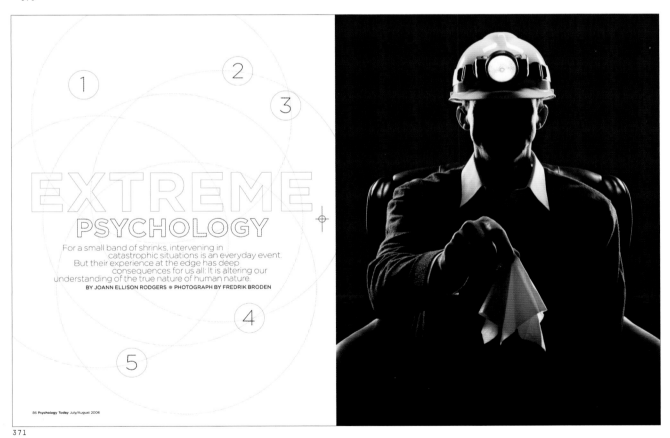

371

370. **NEW YORK**

design director. Luke Hayman. art director. Chris Dixon
director of photography. Jody Quon. photo editor. Amy Hoppy
photographer. Roger Deckker. editor-in-chief. Adam Moss
publisher. New York Magazine. Holdings, LLC. issue. May 8, 2006
category. Photo: Spread

371. **PSYCHOLOGY TODAY**

creative director. Edward Levine. photo editor. Claudia Stefezius
photographer. Fredrik Broden. studio. Levine Design, Inc
publisher. Sussex Publishers. client. Psychology Today
issue. July/August 2006. category. Photo: Spread

372

373

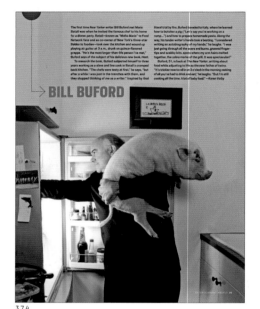

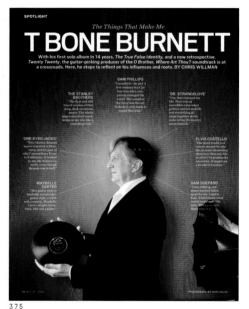

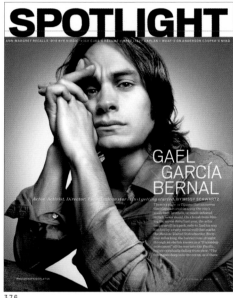

374

375

376

372. **CITY**

creative director. Fabrice Frere
art directors. Adriana Jacoud, Fabrice Frere
photo editor. Sarah Greenfield
photographer. Kenji Toma
publisher. Spark Media. issue. March 2006
category. Photo: Spread

374. **ENTERTAINMENT WEEKLY**

design director. Geraldine Hessler
designer. Jennie Chang
director of photography. Fiona McDonagh
photo editor. Freyda Tavin
photographer. Chris Buck
managing editor. Rick Tetzeli
publisher. Time Inc. issue. June 9, 2006
category. Photo: Single Page

373. **CITY**

creative director. Fabrice Frere
art directors. Adriana Jacoud, Fabrice Frere
photo editor. Sarah Greenfield
photographer. Tim Hogan
publisher. Spark Media. issue. May/June 2006
category. Photo: Single Page

375. **ENTERTAINMENT WEEKLY**

design director. Geraldine Hessler
designer. Evan Campisi
director of photography. Fiona McDonagh
photo editor. Carrie Levitt
photographer. Chris Buck
managing editor. Rick Tetzeli
publisher. Time Inc. issue. May 26, 2006
category. Photo: Single Page

376. **ENTERTAINMENT WEEKLY**

design director. Geraldine Hessler
designer. Evan Campisi
director of photography. Fiona McDonagh
photo editor. Carrie Levitt
photographer. Platon
managing editor. Rick Tetzeli
publisher. Time Inc. issue. June 2, 2006
category. Photo: Single Page

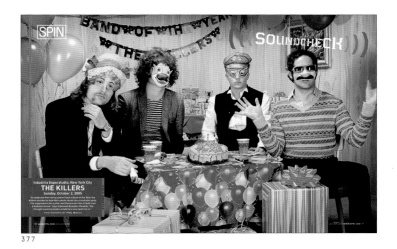

377

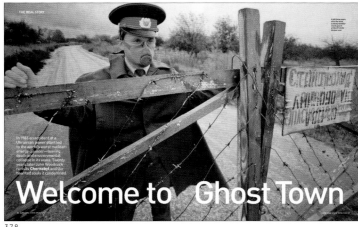

378

379

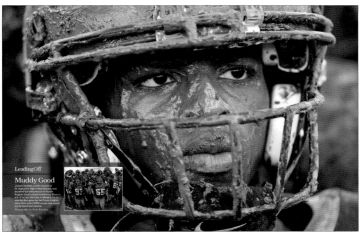

380

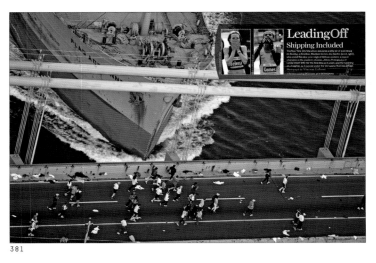

381

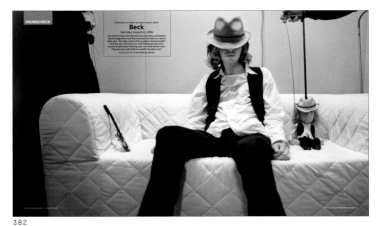

382

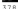

377. **SPIN**

design director. Kory Kennedy
art director. Devin Pedzwater
designer. Liz Macfarlane
director of photography. Kathleen Kemp
photo editors. Jennifer Santana, Bethany Mezick
photographer. Phil Mucci
publisher. Vibe/Spin Ventures LLC
issue. January 2006. category. Photo: Spread

378. **SPIN**

art director. Devin Pedzwater
designer. Liz Macfarlane
photo editors. Jennifer Santana, Bethany Mezick
photographer. Igor Krostin
publisher. Vibe/Spin Ventures LLC
issue. June 2006
category. Photo: Spread

379. **SPORTS ILLUSTRATED**

creative director. Steve Hoffman
art directors. Chris Hercik, Ed Truscio
director of photography. Steve Fine
photographer. Ron Jenkins (Ft. Worth Star-Telegram)
publisher. Time Inc.
issue. September 18, 2006
category. Photo: Spread

380. **SPORTS ILLUSTRATED**

creative director. Steve Hoffman
art directors. Chris Hercik, Ed Truscio
director of photography. Steve Fine
photographer. Bob Rosato
publisher. Time Inc. issue. September 4, 2006
category. Photo: Spread

381. **SPORTS ILLUSTRATED**

creative director. Steve Hoffman
art directors. Chris Hercik, Ed Truscio
director of photography. Steve Fine
photographer. Vincent LaForet
publisher. Time Inc. issue. November 13, 2006
category. Photo: Spread

382. **SPIN**

art director. Devin Pedzwater
designer. Liz Macfarlane
photo editors. Sabine Rogers, Bethany Mezick
photographer. Autumn DeWilde
publisher. Vibe/Spin Ventures LLC
issue. November 2006. category. Photo: Spread

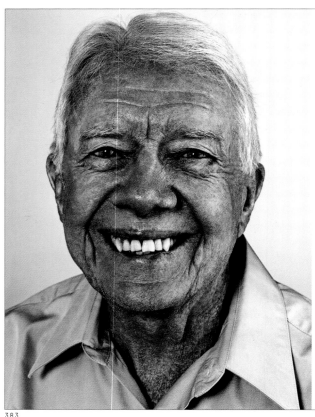

383

384

385

383. **GQ**

design director. Fred Woodward
designer. Anton Ioukhnovets
director of photography. Dora Somosi
photographer. Richard Burbridge
editor-in-chief. Jim Nelson
publisher. Condé Nast Publications Inc.
issue. January 2006. category. Photo: Spread

384. **MEN'S HEALTH**

design director. George Karabotsos
art director. Vikki Nestico. designer. Tim Leong
director of photography. Marianne Butler
photo editors. Ernie Monteiro. Vikram Tank.
John Toolan. photographer. David Arky
publisher. Rodale Inc. issue. January 2006
category. Photo: Single Page

385. **MEN'S HEALTH**

design director. George Karabotsos.
designer. Tim Leong
director of photography. Marianne Butler
photo editor. John Toolan
photographer. David Arky. publisher. Rodale Inc.
issue. May 2006. category. Photo: Single Page

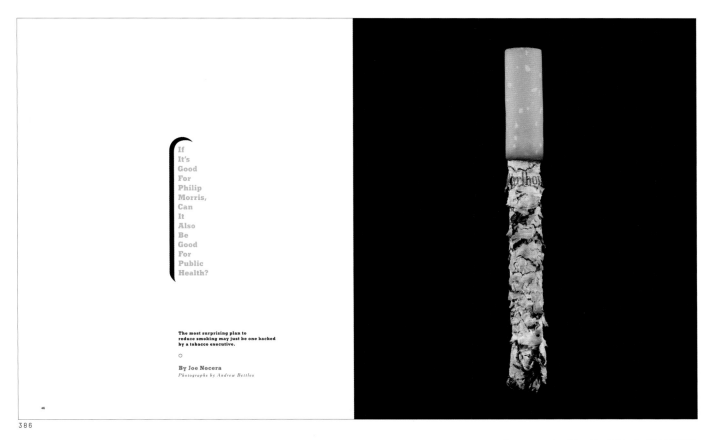

If It's Good For Philip Morris, Can It Also Be Good For Public Health?

The most surprising plan to reduce smoking may just be one backed by a tobacco executive.

○

By Joe Nocera
Photographs by Andrew Bettles

46

386

The New York Times Magazine · OCTOBER 22, 2006

To
Dance
Twyla Tharp choreographs Bob Dylan's music for Broadway. By ALEX WITCHEL. Photograph by Ruven Afanador

Beneath

the Diamond Skies

80

387

386. THE NEW YORK TIMES MAGAZINE

creative director. Janet Froelich. art director. Arem Duplessis
designer. Nancy Harris Rouemy. director of photography. Kathy Ryan
photographer. Andrew Bettles. editor-in-chief. Gerald Marzorati
publisher. The New York Times. issue. June 18, 2006. category. Photo: Spread

387. THE NEW YORK TIMES MAGAZINE

creative director. Janet Froelich. art director. Arem Duplessis
designer. Cathy Gilmore-Barnes. director of photography. Kathy Ryan
photographer. Ruven Afanador. editor-in-chief. Gerald Marzorati
publisher. The New York Times. issue. October 22, 2006. category. Photo: Spread

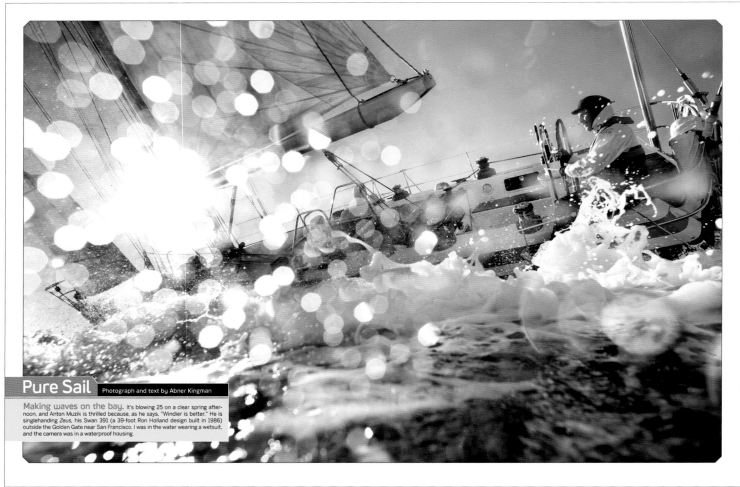

Pure Sail · Photograph and text by Abner Kingman

Making waves on the bay. It's blowing 25 on a clear spring afternoon, and Anton Muzik is thrilled because, as he says, "Windier is better." He is singlehanding *Zeus*, his Swan 391 (a 39-foot Ron Holland design built in 1986) outside the Golden Gate near San Francisco. I was in the water wearing a wetsuit, and the camera was in a waterproof housing.

388

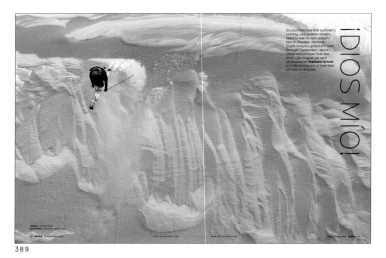

389

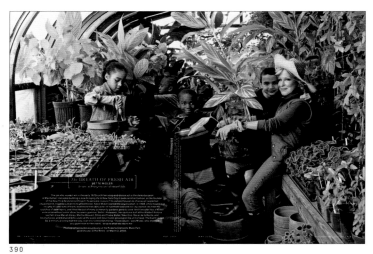

390

388. SAIL

design director. Paul Lee
designers. Ryan Jolley, Kate Berry
photo editor. Kate Berry
photographer. Abner Kingman
editor-in-chief. Peter Nielsen
publisher. Primedia. issue. June 2006
category. Photo: Spread

389. SKIING

art director. Dave Allen
photo editors. Julia Vandenoeuver, Sandra Gnandt
photographer. Matthew Scholl
assitant art director. Mark Lesh
editor-in-chief. Marc Peruzzi
publisher. Mountain Sports Media
issue. March/April 2006. category. Photo: Spread

390. VANITY FAIR

design director. David Harris
art director. Julie Weiss
director of photography. Susan White
photographer. Annie Leibovitz
editor-in-chief. Graydon Carter
publisher. Condé Nast Publications Inc.
issue. May 2006. category. Photo: Spread

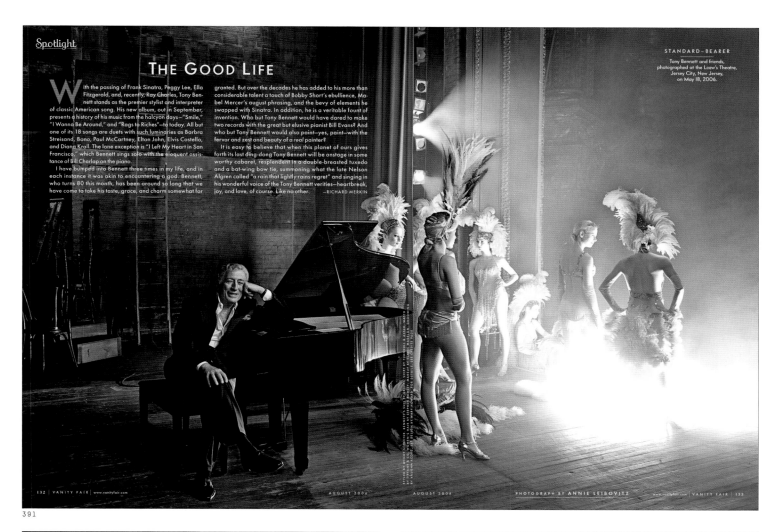

Spotlight

THE GOOD LIFE

With the passing of Frank Sinatra, Peggy Lee, Ella Fitzgerald, and, recently, Ray Charles, Tony Bennett stands as the premier stylist and interpreter of classic American song. His new album, out in September, presents a history of his music from the halcyon days—"Smile," "I Wanna Be Around," and "Rags to Riches"—to today. All but one of its 18 songs are duets with such luminaries as Barbra Streisand, Bono, Paul McCartney, Elton John, Elvis Costello, and Diana Krall. The lone exception is "I Left My Heart in San Francisco," which Bennett sings solo with the eloquent assistance of Bill Charlap on the piano.

I have bumped into Bennett three times in my life, and in each instance it was akin to encountering a god. Bennett, who turns 80 this month, has been around so long that we have come to take his taste, grace, and charm somewhat for granted. But over the decades he has added to his more than considerable talent a touch of Bobby Short's ebullience, Mabel Mercer's august phrasing, and the bevy of elements he swapped with Sinatra. In addition, he is a veritable fount of invention. Who but Tony Bennett would have dared to make two records with the great but elusive pianist Bill Evans? And who but Tony Bennett would also paint—yes, paint—with the fervor and zest and beauty of a real painter?

It is easy to believe that when this planet of ours gives forth its last ding-dong Tony Bennett will be onstage in some worthy cabaret, resplendent in a double-breasted tuxedo and a bat-wing bow tie, summoning what the late Nelson Algren called "a rain that lightly rains regret" and singing in his wonderful voice of the Tony Bennett verities—heartbreak, joy, and love, of course. Like no other. —RICHARD MERKIN

STANDARD-BEARER
Tony Bennett and friends, photographed at the Loew's Theatre, Jersey City, New Jersey, on May 18, 2006.

PHOTOGRAPH BY ANNIE LEIBOVITZ

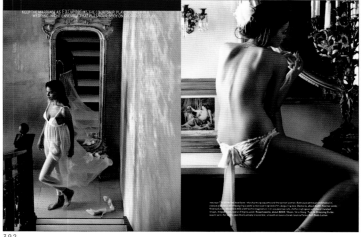

FATHERHOOD SPECIAL PART 2

The Mike Brady Method

BY BRENDAN HALPIN
PHOTOGRAPH BY PAUL LEPREUX

391. **VANITY FAIR**

design director. David Harris
art director. Julie Weiss
director of photography. Susan White
photographer. Annie Leibovitz
editor-in-chief. Graydon Carter
publisher. Condé Nast Publications Inc.
issue. August 2006. category. Photo: Spread

392. **BRIDES**

design director. Gretchen Smelter
art director/designer. Donna Agajanian
director of photography. Kristi Drago-Price
photo editor. Kristen Walsh
photographer. Debra McClinton
editor-in-chief. Millie Martini Bratten
publisher. Condé Nast Publications Inc
issue. March/April 2006. category. Photo: Spread

393. **BEST LIFE**

art director. Brandon Kavulla
designers. Brandon Kavulla, Dena Verdesca
director of photography. Nell Murray
photo editor. Jeanne Graves
photographer. Paul Lepreux. publisher. Rodale
issue. June 2006. category. Photo: Spread

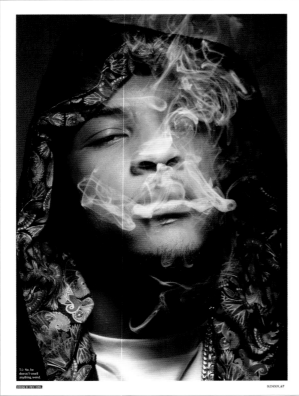

394

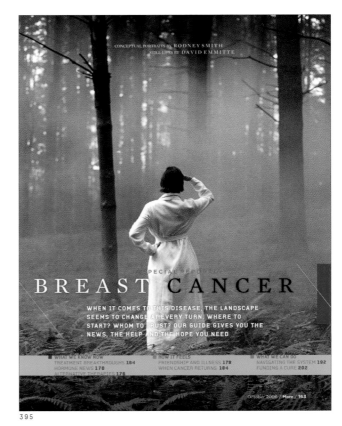

395

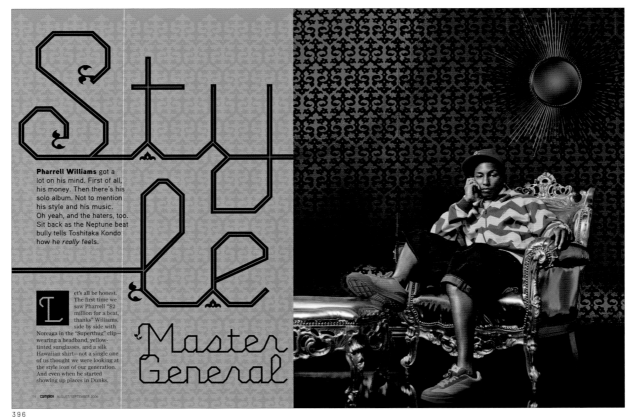

Pharrell Williams got a lot on his mind. First of all, his money. Then there's his solo album. Not to mention his style and his music. Oh yeah, and the haters, too. Sit back as the Neptune beat bully tells Toshitaka Kondo how he *really* feels.

Let's all be honest. The first time we saw Pharrell "$2 million for a beat, thanks" Williams, side by side with Noreaga in the "Superthug" clip—wearing a headband, yellow-tinted sunglasses, and a silk Hawaiian shirt—not a single one of us thought we were looking at the style icon of our generation. And even when he started showing up places in Dunks,

396

394. **BLENDER**

creative director. Andy Turnbull
art director. Andy Turnbull
director of photography. Kristen Schaeffer
photographer. Alexei Hay
publisher. Dennis Publishing. issue. July 2006
category. Photo: Single Page

395. **MORE**

creative director. Maxine Davidowitz
art director/designer. José G. Fernandez
director of photography. Karen Frank
photo editors. Jenny Sargent, Allison Chin
photographer. Rodney Smith
editor-in-chief. Peggy Northrop
publisher. Meredith Corporation
issue. October 2006. category. Photo: Single Page

396. **COMPLEX**

art director. Sean Bumgarner
designers. Jordan Hadley, Tim Leong
director of photography. Matt Doyle
photo editor. Tina Greenberg
photographer. Robert Maxwell
editor-in-chief. Richard Martin
publisher. Ecko. issue. August/September 2006
category. Photo: Spread

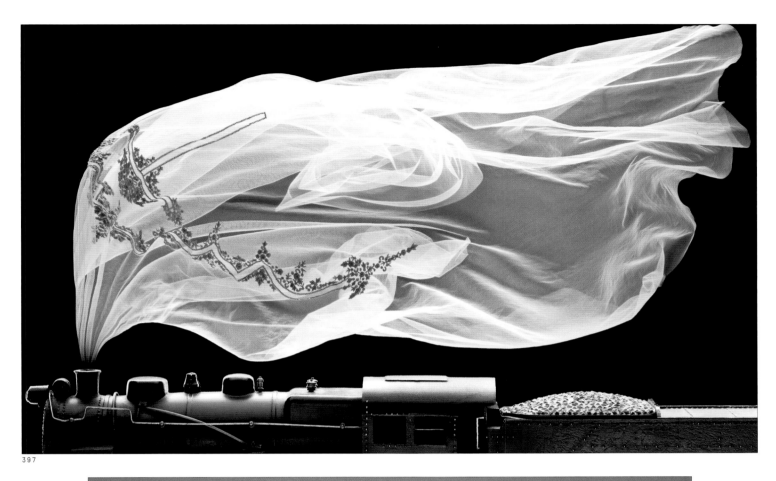

397

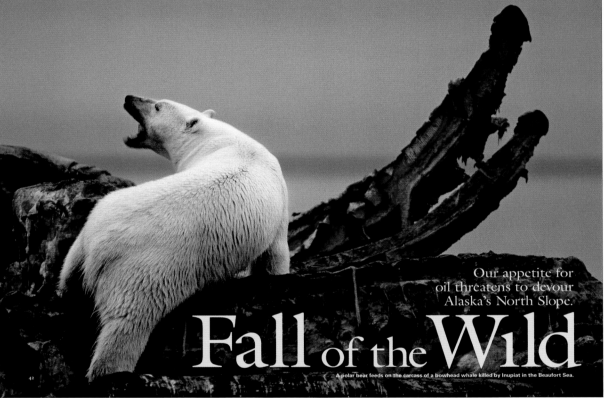

Our appetite for
oil threatens to devour
Alaska's North Slope.

Fall of the Wild

A polar bear feeds on the carcass of a bowhead whale killed by Inupiat in the Beaufort Sea.

398

397. **CITY**

creative director. Fabrice Frere. art director. Adriana Jacoud
photo editor. Sarah Greenfield. photographer. Horacio Salinas
publisher. Spark Media. issues. April 2006
category. Photo: Spread/Single Page

398. **NATIONAL GEOGRAPHIC**

design director. David Whitmore. art director. Elaine Bradley
director of photography. David Griffin. photo editor. Sarah Leen
photographer. Joel Sartore. publisher. National Geographic Society
issue. May 2006. category. Photo: Story

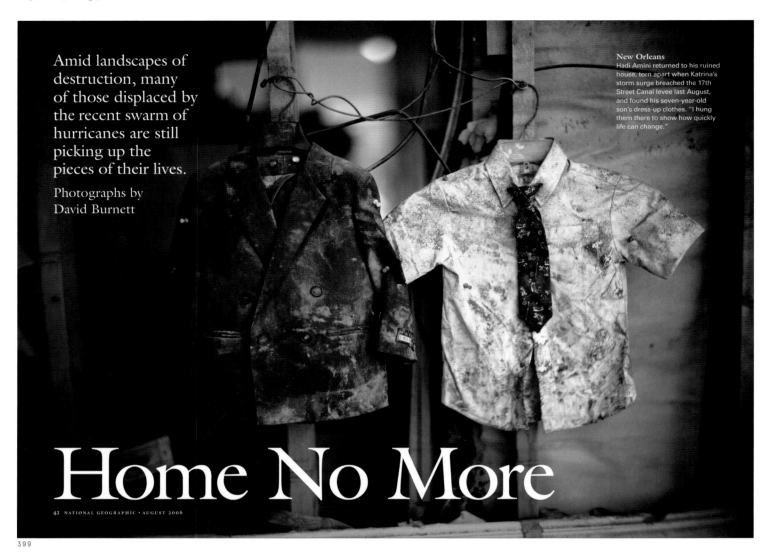

Amid landscapes of destruction, many of those displaced by the recent swarm of hurricanes are still picking up the pieces of their lives.

Photographs by David Burnett

New Orleans
Hadi Amini returned to his ruined house, torn apart when Katrina's storm surge breached the 17th Street Canal levee last August, and found his seven-year-old son's dress-up clothes. "I hung them there to show how quickly life can change."

Home No More

42 NATIONAL GEOGRAPHIC · AUGUST 2006

399

THE HEROES THE HEALING

MILITARY MEDICINE FROM THE FRONT LINES TO THE HOME FRONT

BY NEIL SHEA
PHOTOGRAPHS BY JAMES NACHTWEY

Through searing heat, American soldiers rush an injured comrade toward a medevac helicopter. Minutes before, a roadside bomb had blasted the soldier and two others on patrol along an empty road north of Baghdad. In Iraq, a battleground defined by relentless deserts, unpredictable bomb attacks, and vicious urban fighting, the military serves its soldiers with speed. The wounded are rescued quickly and propelled into a medical system that sweeps them from the front line to hospitals in the States faster than in any previous war. Once home, doctors, families, and communities help veterans rebuild their lives, one day at a time.

400

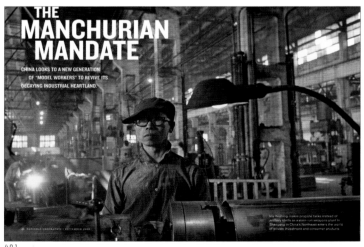

THE MANCHURIAN MANDATE

CHINA LOOKS TO A NEW GENERATION OF "MODEL WORKERS" TO REVIVE ITS DECAYING INDUSTRIAL HEARTLAND

401

399. **NATIONAL GEOGRAPHIC**

design director. David Whitmore
art director. Robert Gray
director of photography. David Griffin
photo editor. Kurt Mutcher
photographer. David Burnett
publisher. National Geographic Society
category. Photo: Story

400. **NATIONAL GEOGRAPHIC**

design director. David Whitmore
director of photography. David Griffin
photo editor. Kurt Mutchler
photographer. James Nachtwey
publisher. National Geographic Society
issue. December 2006
category. Photo: Story

401. **NATIONAL GEOGRAPHIC**

design director. David Whitmore
director of photography. David Griffin
photo editor. Sarah Leen
photographer. Fritz Hoffmann
publisher. National Geographic Society
issue. September 2006
category. Photo: Story

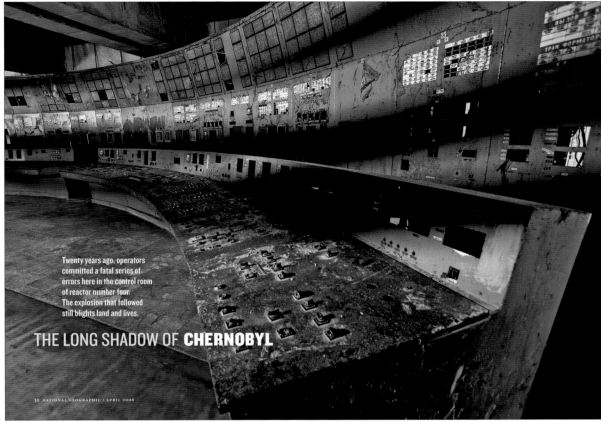

Twenty years ago, operators committed a fatal series of errors here in the control room of reactor number four. The explosion that followed still blights land and lives.

THE LONG SHADOW OF **CHERNOBYL**

32 NATIONAL GEOGRAPHIC • APRIL 2006

402

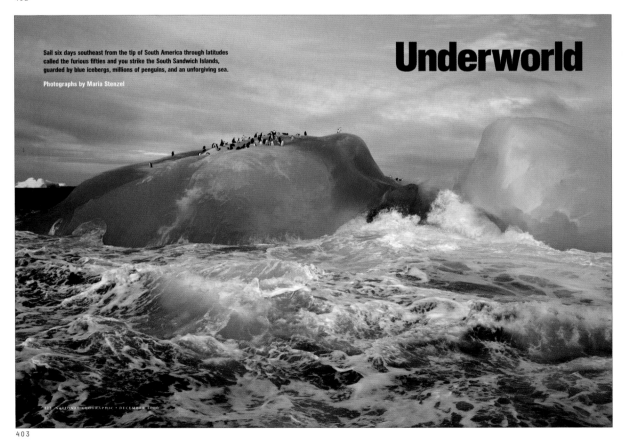

Sail six days southeast from the tip of South America through latitudes called the furious fifties and you strike the South Sandwich Islands, guarded by blue icebergs, millions of penguins, and an unforgiving sea.

Photographs by Maria Stenzel

Underworld

122 NATIONAL GEOGRAPHIC • DECEMBER 2000

403

402. **NATIONAL GEOGRAPHIC**

design director. David Whitmore. art director. David Whitmore
director of photography. David Griffin. photo editor. Kurt Mutchler
photographer. Gerd Ludwig. publisher. National Geographic Society
issues. April 2006. category. Photo: Story

403. **NATIONAL GEOGRAPHIC**

design director. David Whitmore
director of photography. David Griffin. photo editor. Sadie Quarrier
photographer. Maria Stenzel. publisher. National Geographic Society
issue. December 2006. category. Photo: Story

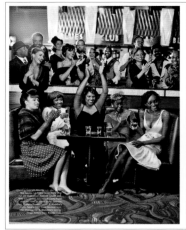
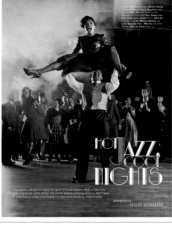

404

405

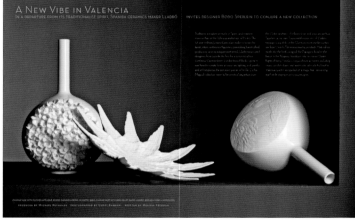

406

407

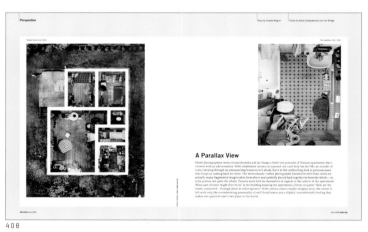

408

409

404. **ESSENCE**

creative director. Jean Griffin
art directors. Jean Griffin, Kyoko Kobayashi
director of photography. Laurie Kratochvil
photo editor. Amy Somlo
photographer. Anders Overgaard
publisher. Time Inc. issue. September 2006
category. Photo: Story

405. **CULTURE & TRAVEL**

art director. Emily Crawford
designer. Emily Crawford
photo editor. Cory Jacobs
photographer. Richard Barnes
publisher. LTB Media
issue. November/December 2006
category. Photo: Story

406. **HOUSE AND GARDEN**

creative director. Anthony Jazzar
art director. Trent Farmer
designer. Trent Farmer
photo editor. Lucy Gilmour
photographer. Coppi Barbieri
publisher. Condé Nast Publications, Inc.
issue. December 2006. category. Photo: Story

407. **HOUSE AND GARDEN**

creative director. Anthony Jazzar
art director. Trent Farmer
designer. Jennifer Madara
photo editor. Martha Maristany
photographer. François Dischinger
publisher. Condé Nast Publications, Inc.
issue. November 2006. category. Photo: Story

408. **DWELL**

creative director. Claudia Bruno
designers. Brendan Callahan, Emily CM Anderson
director of photography. Kate Stone
photo editors. Deborah Kozloff Hearey, Aya Brackett
photographers. Anita Grzeszykowska, Jan Smaga
publisher. Dwell LLC
issue. June 2006. category. Photo: Story

409. **ESSENCE**

creative director. Jean Griffin
art directors. Jean Griffin, Kyoko Kobayashi
photo editor. Amy Somlo
photographer. Tim Petersen
publisher. Time Inc.
issue. September 2006
category. Photo: Story

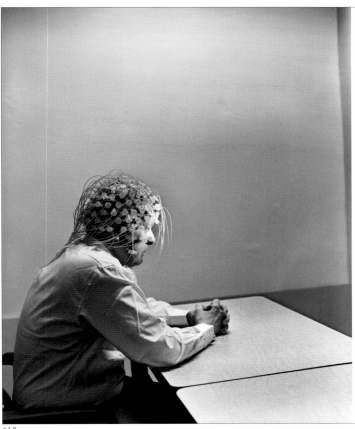

Looking for the Lie

Scientists are using brain imaging and other tools as new kinds of lie detectors. But trickier even than finding the source of deception might be navigating a world without it.

By Robin Marantz Henig

This refined version of the ordinary EEG has 128 electrodes rather than 12 and may be able to pinpoint when lying occurs in the brain.

Photographs by Larry Fink

47

410

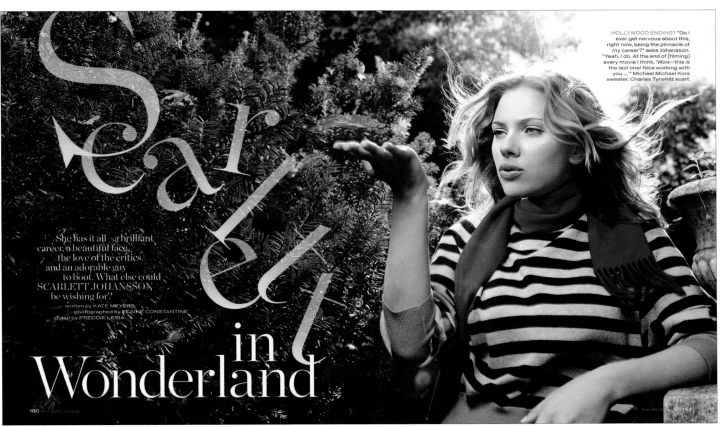

HOLLYWOOD ENDING? "Do I ever get nervous about this, right now, being the pinnacle of my career?" asks Johansson. "Yeah, I do. At the end of [filming] every movie I think, 'Wow—this is the last one! Nice working with you ..." Michael Michael Kors sweater. Charles Tyrwhitt scarf.

Scarlett in Wonderland

She has it all—a brilliant career, a beautiful face, the love of the critics and an adorable guy to boot. What else could SCARLETT JOHANSSON be wishing for?

written by KATE MEYERS
photographed by ELAINE CONSTANTINE
styled by FREDDIE LEIBA

411

410. **THE NEW YORK TIMES MAGAZINE**

creative director. Janet Froelich. art director. Arem Duplessis
designer. Jeff Glendenning. director of photography. Kathy Ryan
photographer. Larry Fink. editor-in-chief. Gerald Marzorati
wpublisher. The New York Times . issue. February 5, 20006. category. Photo: Story

411. **INSTYLE**

creative director. John Korpics. designer. Peter B. Cury
director of photography. Bradley Young. photo editor. Nicole Hyatt
photographer. Elaine Constantine. publisher. Time Inc.
issue. October 2006. category. Photo: Story

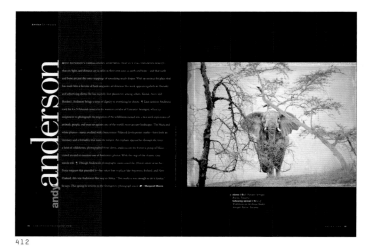

412

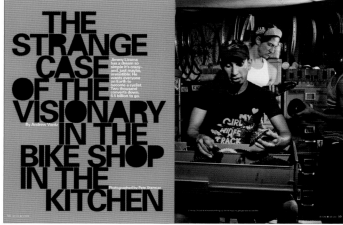

413

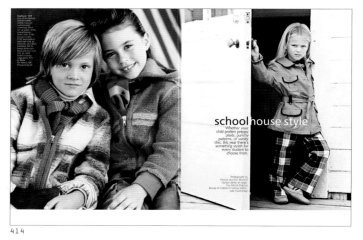

414

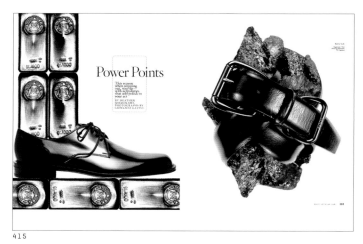

415

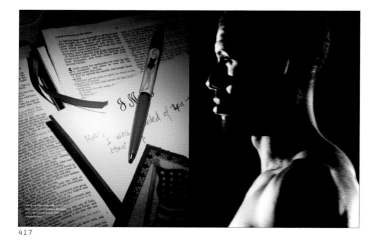

416

417

412. HEMISPHERES

design director. Jaimey Easler
art directors. Jody Mustain, Jennifer Swafford
designer. Jaimey Easler
photographer. Andy Anderson
publisher. Pace Communications. client. United
issue. May 2006. category. Photo: Story

413. BICYCLING

design director. David Speranza
designer. Susanne Bamberger
photo editor. Stacey Emenecker
photographer. Pete Starman
publisher. Rodale, Inc.
issue. May 2006. category. Photo: Story

414. CHILD

creative director. Daniel Chen
art director. Megan V. Henry
assistant art director. Janet Park
senior designer. Emma Taylor
director of photography. Ulrika Thunberg
photo editor. Melissa Malinowsky
photographers. Monica & Erik Skeisvoll
publisher. Meredith. issue. September 2006
category. Photo: Story

415. BEST LIFE

art director. Brandon Kavulla
designer. Dena Verdesca
photographer. Giovanni Gastel
fashion editor. Heather Shimokawa
publisher. Rodale. issue. December 2006
category. Photo: Story

416. BULLETIN OF THE ATOMIC SCIENTISTS

art director. Joy Olivia Miller
editor-in-chief. Mark Srauss
publisher. Bulletin of the Atomic Scientists
issue. July/August 2006
category. Photo: Story

417. CITY

creative director. Fabrice Frere
art director. Adriana Jacoud
designer. Fabrice Frere
photo editor. Sarah Greenfield
photographer. Kenji Toma
publisher. Spark Media
issue. March 2006. category. Photo: Story

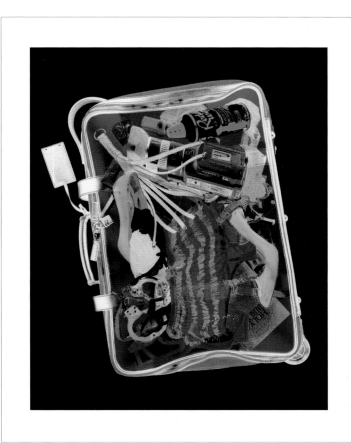

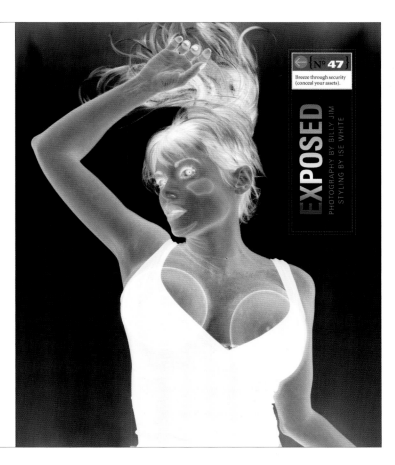

EXPOSED
PHOTOGRAPHY BY BILLY JIM
STYLING BY ISE WHITE

This page: Clockwise, from left: Polyurethane leather gym bag, $120, and nylon soccer socks, $6, both by **Adidas**; S2 sports radio armband, $40, by **Sony**; women's leather athletic shoes, $85, by **Gola**; graphite "Classic" racquet, from $120, by **Prince**. Opposite: Clockwise, from left: The "Baxter" monogram dog carrier, from $1,500, leash, from $240, and collar, from $190, all by **Louis Vuitton**. Opening page, left: Clockwise, from left: Knit and lace bra, $36, by **Eberjey**; patent-leather heels, $630, by Rene Caovilla; Jiggle Gel, $26, by **Benefit**, at Sephora; nylon stockings with embroidery details, $58, by **Chantal Thomass for Victoria's Secret**; high-definition video camcorder, $3,700, by **Sony**; "Cherry" lace ruffled underwear with garters, $85, and matching lace bra, $100, both by **Agent Provocateur**; rectangle open gold necklace, $1,188, by **Adina**. Opening page, right: Colored contacts, price on application, by **Fresh Look by Ciba Vision**; teeth whitener, $39, by **Crest Whitestrips**, at pharmacies nationwide; lipstick, $18, by **Make Up For Ever**, and self-tanning lotion, $23, by **Fake Bake**, both at Sephora; tank top, model's own.

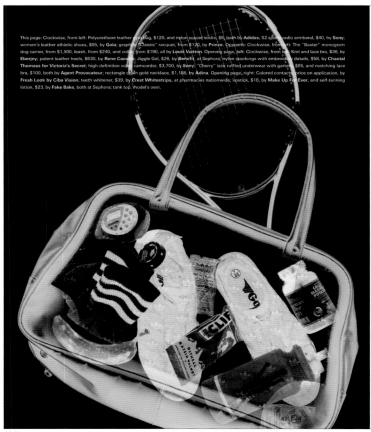

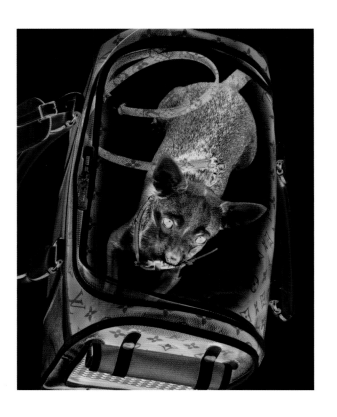

creative director. Fabrice Frere. art director. Adriana Jacoud. photo editor. Sarah Greenfield. photographer. Billy Jim
publisher. Spark Media. issue. October/November 2006. category. Photo: Story

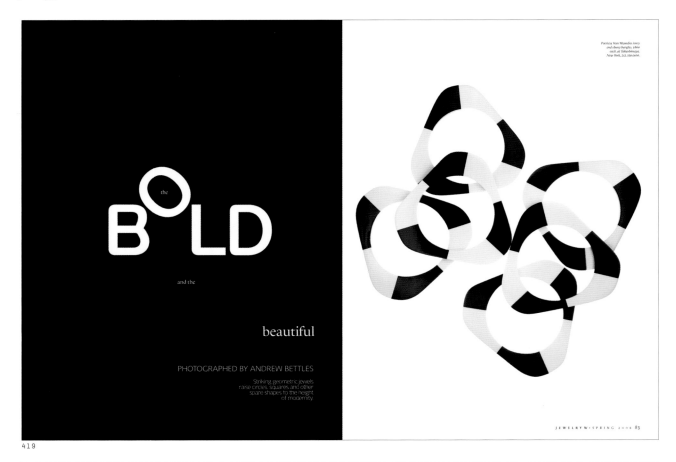

419

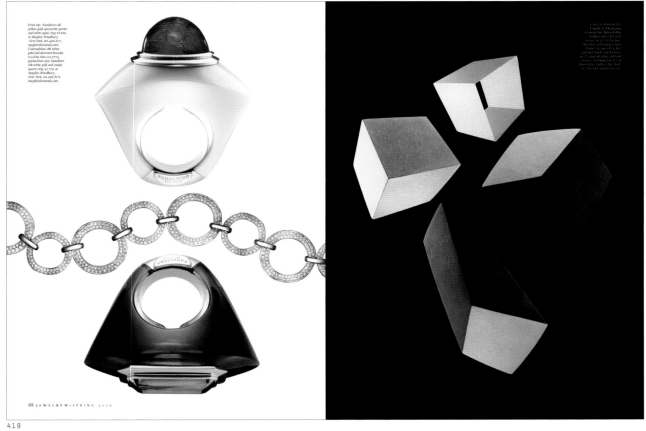

419

419. **JEWELRY W**

creative director. Dennis Freedman. design director. Edward Leida. art director. Nathalie Kirsheh
designer. Nathalie Kirsheh. photo editor. Nadia Vellum. photographer. Andrew Bettles
publisher. Fairchild Publications. issue. Spring 2006. category. Photo: Story

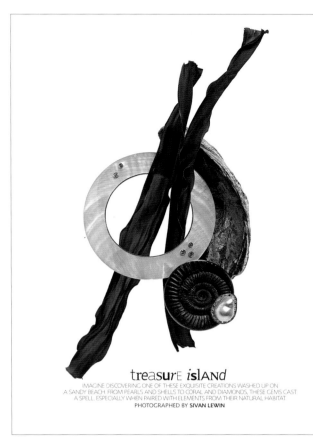

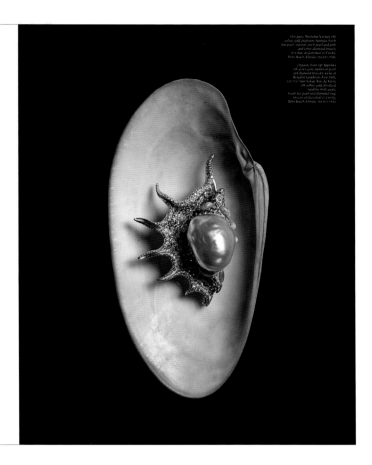

treasurE islANd

IMAGINE DISCOVERING ONE OF THESE EXQUISITE CREATIONS WASHED UP ON
A SANDY BEACH. FROM PEARLS AND SHELLS TO CORAL AND DIAMONDS, THESE GEMS CAST
A SPELL, ESPECIALLY WHEN PAIRED WITH ELEMENTS FROM THEIR NATURAL HABITAT.
PHOTOGRAPHED BY **SIVAN LEWIN**

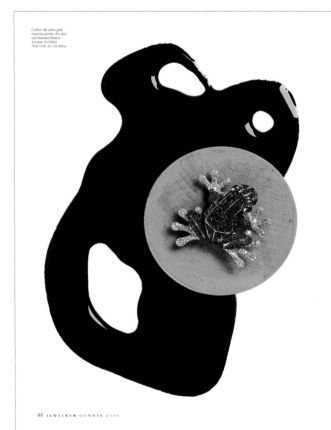

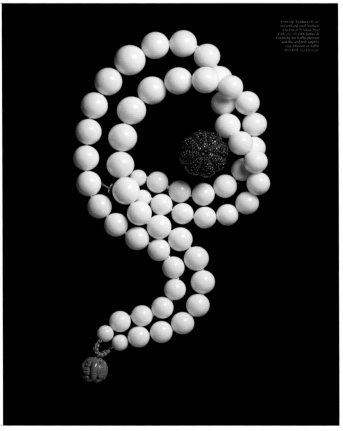

420. **JEWELRY W**

creative director. Dennis Freedman. design director. Edward Leida. art director. Nathalie Kirsheh
designer. Nathalie Kirsheh. photo editor. Nadia Vellam. photographer. Sivan Lewin
publisher. Fairchild Publications. issue. Summer 2006. category. Photo: Story

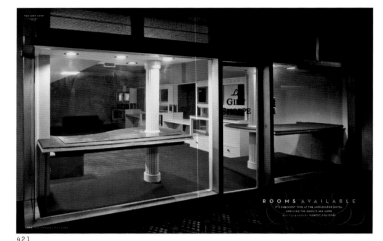

421.

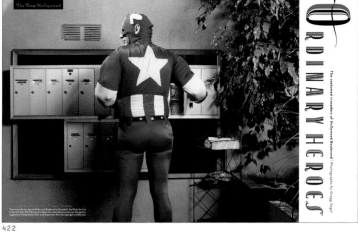

422.

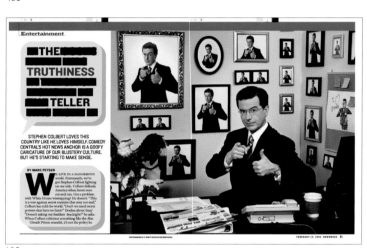

423.

424.

425.

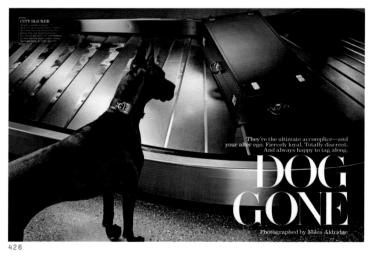

426.

421. LOS ANGELES

art director. Joe Kimberling
deputy art director. Lisa M. Lewis
photo editor. Kathleen Clark
photographer. Robert Polidori
editor-in-chief. Kit Rachlis
publisher. Emmis. issue. May 2006
category. Photo: Story

424. NEWSWEEK

creative director. Lynn Staley
art director. Dan Revitte
director of photography. Simon Barnett
photo editor. Paul Moakley
photographers. Craig Cutler, Ethan Hill (for
Newsweek). publisher. The Washington Post Co.
issue. May 15, 2006. category. Photo: Story

422. LOS ANGELES

art director. Joe Kimberling
deputy art director. Lisa M. Lewis
photo editor. Kathleen Clark
photographer. Gregg Segal
editor-in-chief. Kit Rachlis
publisher. Emmis. issue. June 2006
category. Photo: Story

425. NYLON

art director. Andrea Fella
designer. Andrea Fella
director of photography. Stacey Mark
photographer. Jason Nocito
editor-in-chief. Marvin Scott Jarrett
publisher. Nylon LLC
issue. March 2006. category. Photo: Story

423. NEWSWEEK

creative director. Lynn Staley
art director. Dan Revitte
director of photography. Simon Barnett
photo editor. Simon Barnett
photographer. F. Scott Schaefer
publisher. The Washington Post Co.
issue. February 13, 2006. category. Photo: Story

426. MEN'S VOGUE

creative director. Russell Labosky
director of photography. Ryan Cadiz
photographer. Miles Aldridge
editor-in-chief. Jay Fielder
publisher. Condé Nast Publications Inc.
issue. September/October 2006
category. Photo: Story

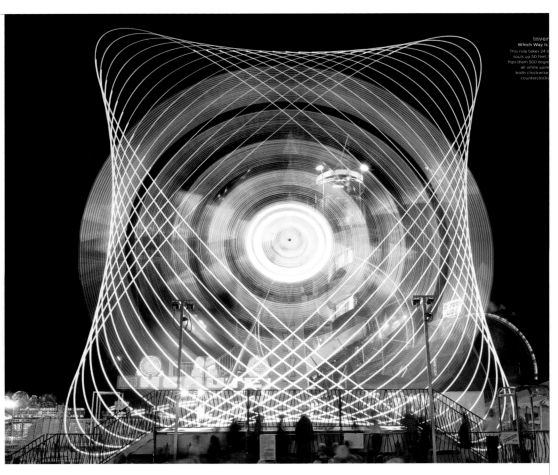

Go Ahead,
Take a Spin

When night falls at the
fairgrounds, there's always
time for one last thrill

BY GARRISON KEILLOR
PHOTOGRAPHS BY ROGER VAIL

The American state fair is a summer extravaganza that gives city people a chance to meet cows and pigs and sheep and to see what championship needlework looks like and to consume food at a rate that, if you maintained it for a year, you'd need to be carried around on a forklift. Along the way, you can purchase aluminum siding, encyclopedias, indoor-outdoor carpeting, and a vegetable slicer-dicer-juicer-blender that will julienne carrots or make a delicious raspberry-rutabaga nectar. But after a long day inspecting the Percherons and the champion potatoes and eating tacos and deep-fried cheese curds (two bags) and a Pronto Pup or two, a caramel apple, and a corn on the cob, when we're footsore and tired of crowds and the yap of barkers, I say, "Well, let's just go ride the

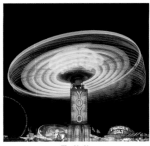

The Yo-Yo
One Serious Swing Set
Fairgoers who love to feel the wind in their hair and their feet in
the air flock to the Yo-Yo. Riders sit in individually
suspended swings, which spin at roughly a 45-degree angle.

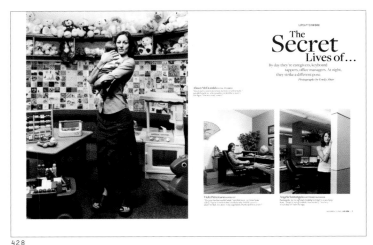

LIFEAFTERWORK

The
Secret
Lives of …

By day they're caregivers, keyboard
tappers, office managers. At night,
they strike a different pose.
Photographs by Emily Shur

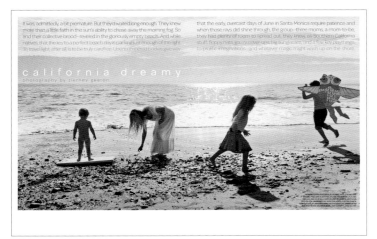

california dreamy
photography by tierney gearon

427. LIFE

creative director. Richard Baker
art director. Bess Wong
designers. Marina Drukman, Jarred Ford
director of photography. George Pitts
photo editors. Katherine Schad, Tracy Doyle Bales,
Caroline Smith. photographer. Roger Vail
publisher. Time Inc. issue. June 23, 2006
category. Photo: Story

428. LIFE

creative director. Richard Baker
art director. Bess Wong
designers. Marina Drukman, Jarred Ford
director of photography. George Pitts
photo editors. Katherine Schad, Tracy Doyle Bales,
Caroline Smith. photographer. Emily Shur
publisher. Time Inc. issue. November 3, 2007
category. Photo: Story

429. COOKIE

design director. Kirby Rodriguez
art director. Alex Grossman
designers. Nicolette Berthelot, Karla Lima
photo editor. Darrick Harris
photographer. Tierney Gearon
editor-in-chief. Pilar Guzmán
publisher. Condé Nast Publications Inc.
issue. May/June 2006. category. Photo: Story

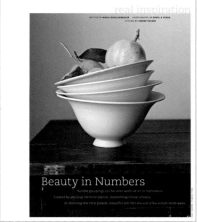

430

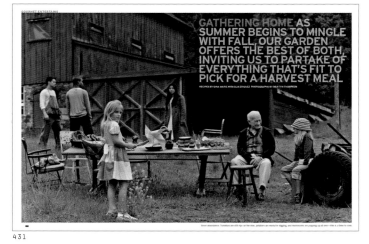

431

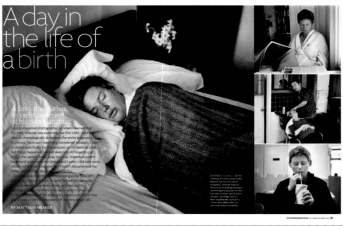

432

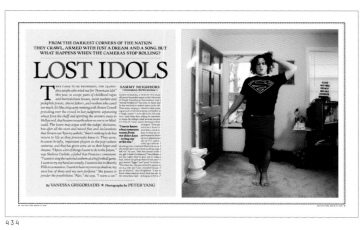

434

430. REAL SIMPLE

creative director. Vanessa Holden
director of photography. Naomi Nista
photo editor. Lauren Epstein
photographer. Gentl & Hyers
publisher. Time Inc. issue. March 2006
category. Photo: Story

433. GOURMET

creative director. Richard Ferretti
art director. Erika Oliveira
designer. Flavia Schepmans
photo editor. Amy Koblenzer
photographer. Jason Lowe
publisher. Condé Nast Publications, Inc.
issue. April 2006. category. Photo: Story

431. GOURMET

creative director. Richard Ferretti
art director. Erika Oliveira
designer. Erika Oliveira
photo editor. Amy Koblenzer
photographer. Martyn Thompson
publisher. Condé Nast Publications, Inc.
issue. September 2006. category. Photo: Story

434. ROLLING STONE

art director. Amid Capeci
director of photography. Jodi Peckman
photo editor. Deborah Dragon
photographer. Peter Yang
publisher. Wenner Media
issue. March 23, 2006 RS 996
category. Photo: Story

432. FIT PREGNANCY

art director. Stephanie K. Birdsong
director of photography. Beth Katz
photographer. Matthew Hranek
editor-in-chief. Peg Moline
publisher. Weider Publications, Inc.
issue. October/November 2006
category. Photo: Story

435. METROPOLIS

creative director. Criswell Lappin
art director. Nancy Nowacek
photo editors. Bilyana Dimitrova, Magda Biernat
photographers. Tony Law, Todd Hido, Tim Hursley,
Julius Shulman, David Allee, Kristine Larsen,
Robert Polidori, Lara Swimmer, Sylvia Plachy,
Paul Warchol, Sean Hemmerle, Jimmy Cohrssen
publisher. Bellerophon Publications
issue. April 2006. category. Photo: Story

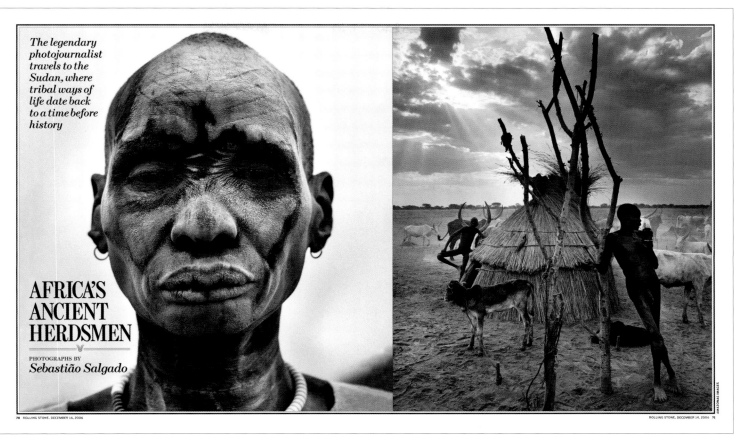

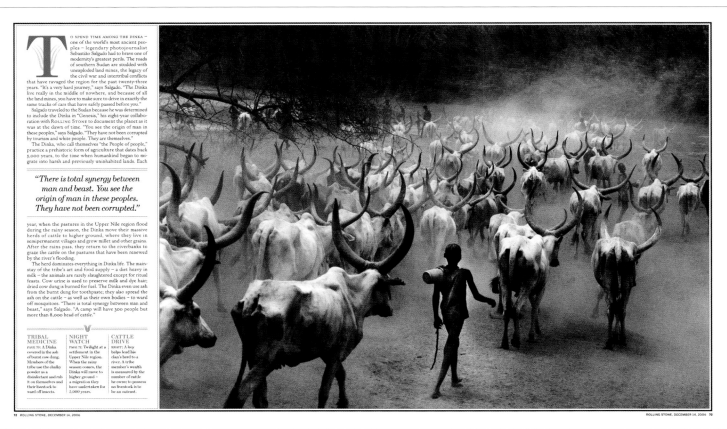

436. **ROLLING STONE**

art director. Amid Capeci. director of photography. Jodi Peckman. photographer. Sebastião Salgado publisher. Wenner Media. issue. December 14, 2006. category. Photo: Story

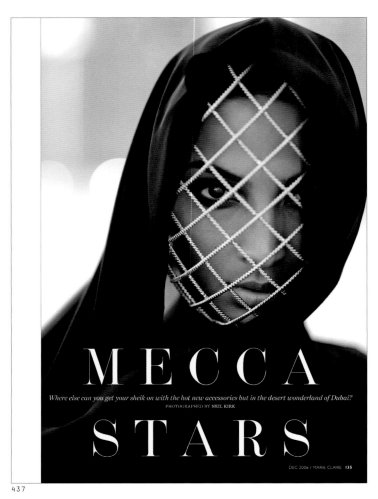

MECCA

Where else can you get your sheik on with the hot new accessories but in the desert wonderland of Dubai?
PHOTOGRAPHED BY NEIL KIRK

STARS

DEC 2006 / MARIE CLAIRE **135**

437

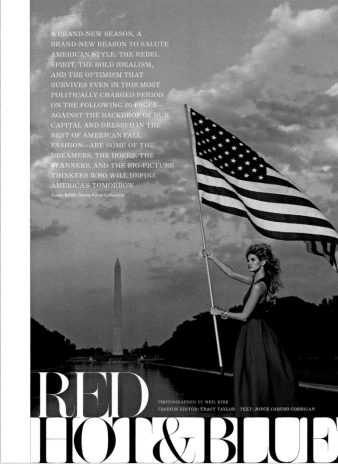

A BRAND-NEW SEASON, A
BRAND-NEW REASON TO SALUTE
AMERICAN STYLE: THE REBEL
SPIRIT, THE BOLD IDEALISM,
AND THE OPTIMISM THAT
SURVIVES EVEN IN THIS MOST
POLITICALLY CHARGED PERIOD.
ON THE FOLLOWING 20 PAGES—
AGAINST THE BACKDROP OF OUR
CAPITAL AND DRESSED IN THE
BEST OF AMERICAN FALL
FASHION—ARE SOME OF THE
DREAMERS, THE DOERS, THE
PLANNERS, AND THE BIG-PICTURE
THINKERS WHO WILL DEFINE
AMERICA'S TOMORROW

Gown, $4500, Donna Karan Collection

RED
HOT & BLUE

PHOTOGRAPHED BY NEIL KIRK
FASHION EDITOR: TRACY TAYLOR TEXT: JOYCE CARUSO CORRIGAN

438

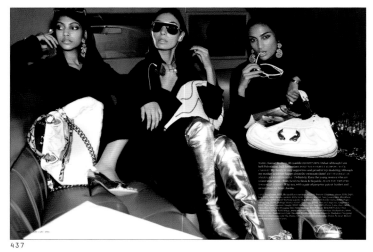

437

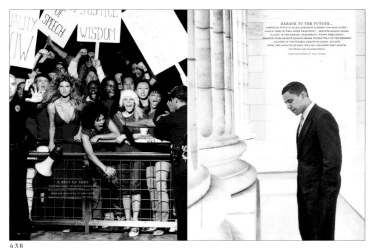

438

437. **MARIE CLAIRE**

creative director. Paul Martinez
art director. Jenny Leigh Thompson
designer. Paul Martinez
director of photography. Alix Campbell
photographer. Neil Kirk
fashion senior editor. Eric Nicholson
editor-in-chief. Joanna Coles
publisher. The Hearst Corporation-Magazines Division
issue. December 2006. category. Photo: Story

438. **MARIE CLAIRE**

creative director. Paul Martinez
art director. Jenny Leigh Thompson
designer. Paul Martinez
director of photography. Alix Campbell
photographers. Neil Kirk, Troy Word
fashion editor. Tracy Taylor
editor-in-chief. Joanna Coles
publisher. The Hearst Corporation-Magazines Division
issue. September 2006. category. Photo: Story

439. **MARIE CLAIRE**

creative director. Paul Martinez
art director. Jenny Leigh Thompson
designer. Paul Martinez
director of photography. Alix Campbell
photographer. Raphael Mazzucco
fashion director. Tracy Taylor
editor-in-chief. Joanna Coles
publisher. The Hearst Corporation-Magazines Division
issue. October 2006. category. Photo: Story

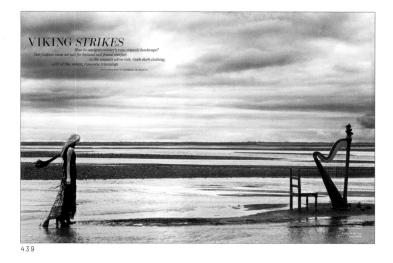

439

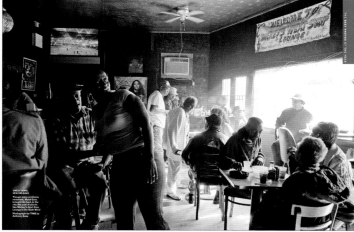

440

441

442

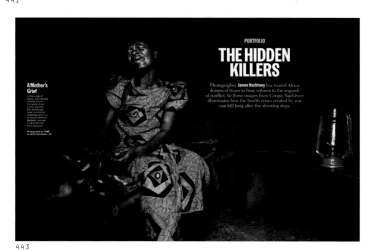

443

444

440. **TIME**

art director. Arthur Hochstein
deputy art director. Cynthia A. Hoffman
director of photography. Michele Stephenson
picture editor. MaryAnne Golon
associate Picture editor. Crary Pullen
photographers. Franco Pagetti, Farah Nosh,
Yuri Kozyrev, Brooks Kraft (Corbis),
Ghaith Abdul-Ahad (Getty), Thomas Dworzak
(Magnum), Shaul Schwarz (Getty), Alexandra Boulat
(VII), Robert Nickelsberg (Getty), Marcus Bleasdale,
Kadir Van Lohuizen (Agence VU), Christopher Morris
(VII), Anthony Suau, Lauren Greenfield (VII),
Andrew Kaufman. publisher. Time Inc
issue. December 18, 2006. category. Photo: Story

441. **TEXAS MONTHLY**

creative director. Scott Dadich
designers. Scott Dadich, TJ Tucker
photo editor. Leslie Baldwin
photographer. Dan Winters
publisher. Emmis Communications Corp.
issue. May 2006. category. Photo: Story

442. **CONDÉ NAST TRAVELER**

design director. Robert Best
art director. Kerry Robertson
director of photography. Kathleen Klech
photo editor. Esin Goknar
photographer. Brigitte LaCombe
editor-in-chief. Klara Glowczewska
publisher. Condé Nast Publications, Inc.
issue. March 2006. category. Photo: Story

443. **TIME**

art director. Arthur Hochstein
director of photography. Michele Stephenson
photographer. James Nachtwey (VII)
deputy art director. Cynthia A. Hoffman
picture editor. MaryAnne Golon
publisher. Time Inc. issue. June 5, 2006
category. Photo: Story

444. **INTERIOR DESIGN**

art director/designer. Claudia Marulanda
photographer. Ted Morrison
editor-in-chief. Cindy Allen
publisher. Reed Business Information
issue. October 2006. category. Photo: Story

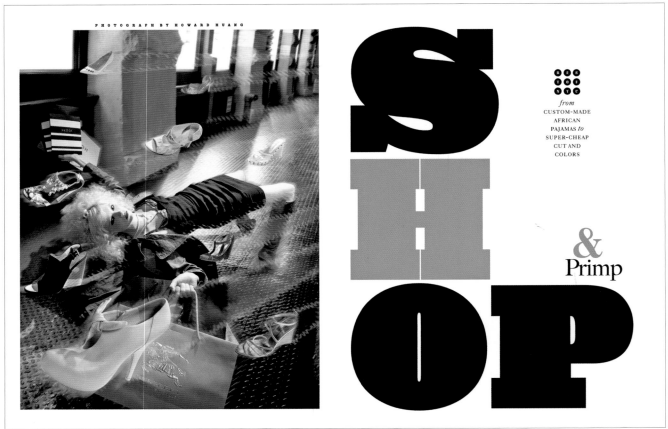

PHOTOGRAPH BY HOWARD HUANG

SHOP

from
CUSTOM-MADE
AFRICAN
PAJAMAS *to*
SUPER-CHEAP
CUT AND
COLORS

& Primp

445

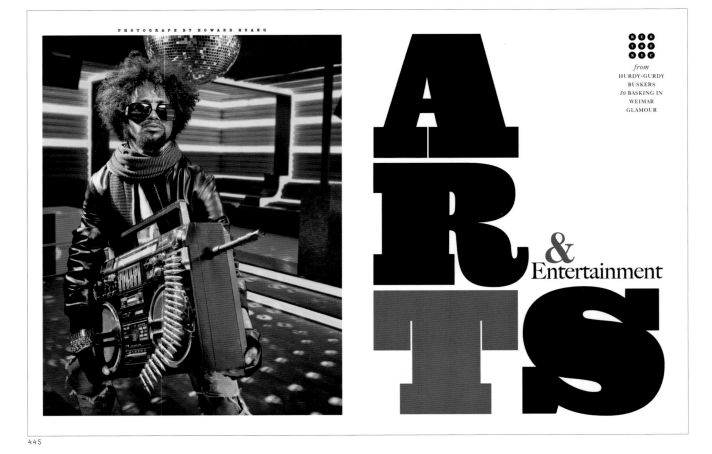

PHOTOGRAPH BY HOWARD HUANG

ARTS

from
HURDY-GURDY
BUSKERS
to BASKING IN
WEIMAR
GLAMOUR

& Entertainment

445

445. **THE VILLAGE VOICE**

art director. Ted Keller. designer. Ted Keller. photo editor. Staci Schwartz. photographer. Howard Huang
publisher. Village Voice Media. issue. October 18, 2006. category. Photo: Story

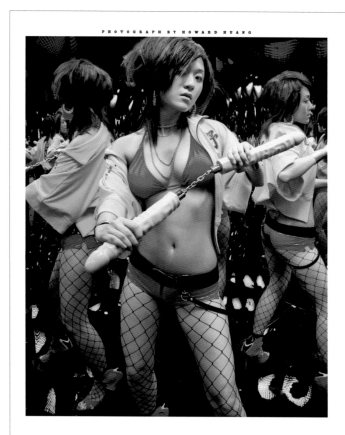

S E X

from HALF-NAKED GO-GO BOYS *to* FRIDAY-NIGHT TABLE TENNIS

& Sports

445

E A T S

from THE JUICIEST JERK *to* THE FREAKIEST FRIES

& Treats

445

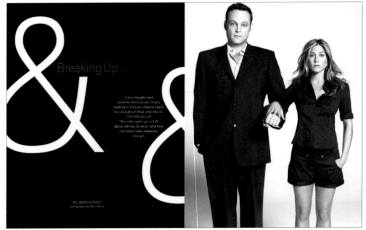

446

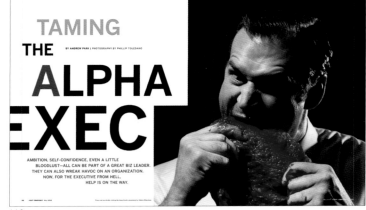

447

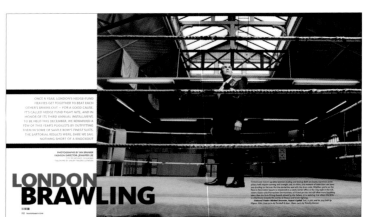

448

449

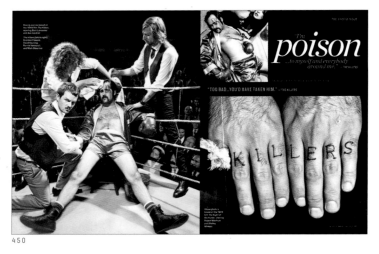

450

451

446. ENTERTAINMENT WEEKLY

design director. Geraldine Hessler
director of photography. Fiona McDonagh
photo editor. Fiona McDonagh
photographer. Gavin Bond
managing editor. Rick Tetzeli
publisher. Time Inc. issue. June 2, 2006
category. Photo: Story

447. ENTERTAINMENT WEEKLY

design director. Geraldine Hessler
art director. Brian Anstey
director of photography. Fiona McDonagh
photo editor. Richard Maltz
photographer. Henrik Knudsen, managing editor.
Rick Tetzeli, publisher. Time Inc. issue. October 13,
2006. category. Photo: Story

448. TRADER MONTHLY

design director. 1 Plus 1 Design
art director. Clarendon Minges
photographer. Ian Spanier
publisher. Doubledown Media
issue. October/November 2006
category. Photo: Story

449. FAST COMPANY

art director. Dean Markadakis
designer. Dean Markadakis
director of photography. Meghan Hurley
photographer. Phillip Toledano
publisher. Mansueto Ventures, LLC
issue. May 2006
category. Photo: Story

450. ENTERTAINMENT WEEKLY

design director. Geraldine Hessler
art director. Brian Anstey
director of photography. Fiona McDonagh
photo editor. Michele Romero
photographer. James Dimmock
managing editor. Rick Tetzeli. publisher. Time Inc.
issue. October 13, 2006. category. Photo: Story

451. TOPIC MAGAZINE

creative directors. Giampietro + Smith,
Stella Bugbee
director of photography. Gemma Hart Corsano
photographers. Allison Brown, KT Auletta,
Anna Sbiera-Paléologue, Tim Hout, Greg Halpern,
Jason Fulford, Albert Vecerka, Katherine Wolkoff,
Jem Cohen. publisher. Topic Magazine
issue. May 2006. category. Photo: Story

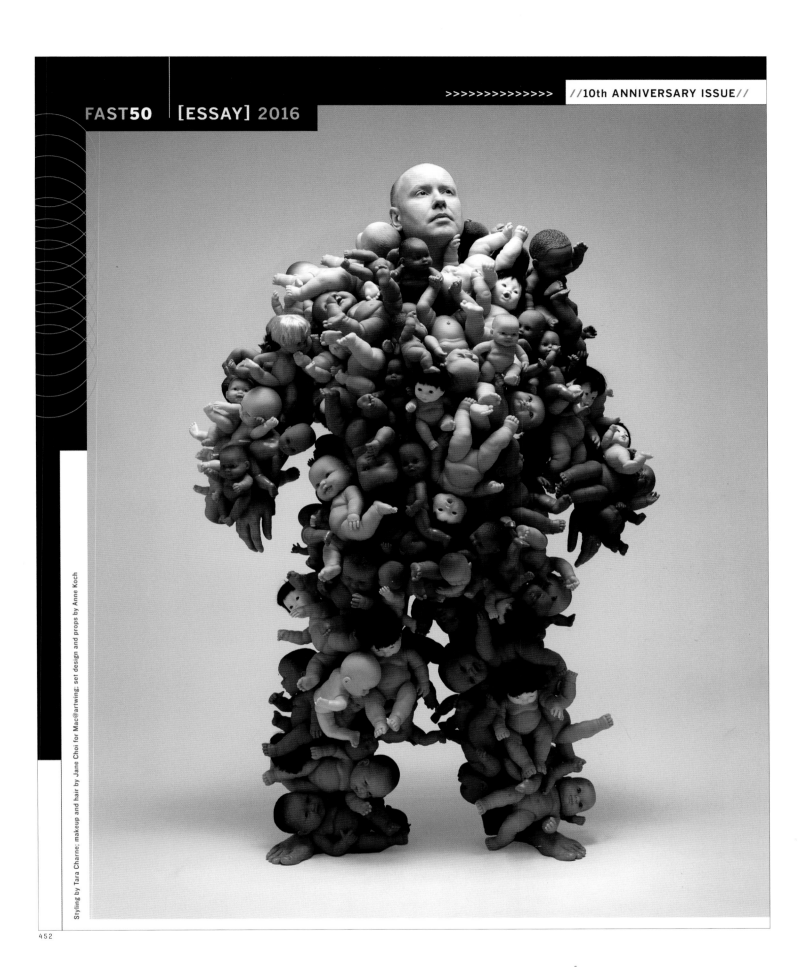

Styling by Tara Charne; makeup and hair by Jane Choi for Mac@artwing; set design and props by Anne Koch

452

452. **FAST COMPANY**

art director. Dean Markadakis. designer. Dean Markadakis. director of photography. Meghan Hurley
photographer. Phillip Toledano. publisher. Mansueto Ventures, LLC. issue. March 2006. category. Photo: Story

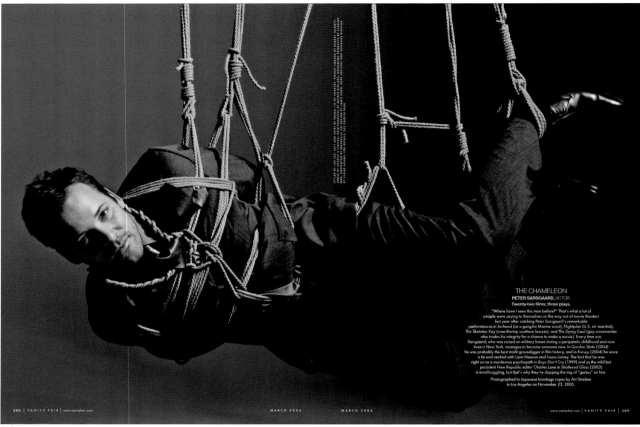

THE CHAMELEON
PETER SARSGAARD, ACTOR.
Twenty-two films; three plays.

"Where have I seen this man before?" That's what a lot of
people were saying to themselves on the way out of movie theaters
last year after catching Peter Sarsgaard's remarkable
performances in *Jarhead* (as a gung-ho Marine scout),
Flightplan (U.S. air marshal),
The Skeleton Key (over-the-top southern lawyer), and *The Dying Gaul* (gay screenwriter
who trades his integrity for a chance to make a movie). Every time out,
Sarsgaard, who was raised on military bases during a peripatetic childhood and now
lives in New York, manages to become someone new. In *Garden State* (2004)
he was probably the best misfit gravedigger in film history, and in *Kinsey* (2004) he wore
a tie and necked with Liam Neeson and Laura Linney. The fact that he was
right on as a murderous psychopath in *Boys Don't Cry* (1999) and as the mild but
persistent *New Republic* editor Charles Lane in *Shattered Glass* (2003)
is mind-boggling, but that's why they're slapping the tag of "genius" on him.
Photographed in Japanese bondage ropes by Art Streiber
in Los Angeles on November 23, 2005.

453

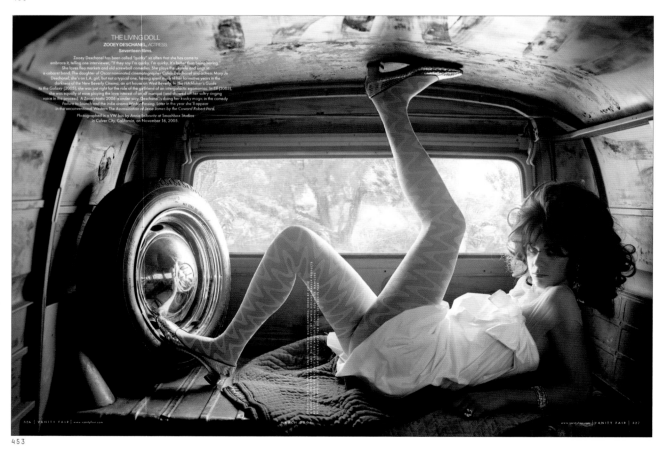

THE LIVING DOLL
ZOOEY DESCHANEL, ACTRESS.
Seventeen films.

Zooey Deschanel has been called "quirky" so often that she has come to
embrace it, telling one interviewer, "If they say I'm quirky, I'm quirky. It's better than being boring."
She loves flea markets and old screwball comedies. She plays the ukulele and sings in
a cabaret band. The daughter of Oscar-nominated cinematographer Caleb Deschanel and actress Mary Jo
Deschanel, she's an L.A. girl, but not a typical one, having spent much of her formative years in the
darkness of the New Beverly Cinema, an art house on West Beverly. In *The Hitchhiker's Guide
to the Galaxy* (2005), she was just right for the role of the girlfriend of an intergalactic egomaniac. In *Elf* (2003),
she was equally at ease playing the love interest of an elf manqué (and showed off her sultry singing
voice in the process). A Zooey-tastic 2006 is under way; Deschanel is doing her kooky magic in the comedy
Failure to Launch and the indie drama *Winter Passing*. Later in the year she'll appear
in the unconventional Western *The Assassination of Jesse James by the Coward Robert Ford*.
Photographed in a VW bus by Annie Leibovitz at Smashbox Studios
in Culver City, California, on November 16, 2005.

453

453. **VANITY FAIR**

design director. David Harris. art director. Julie Weiss. director of photography. Susan White. photographers. Annie Leibovitz,
Mert + Marcus, Mario Testino, Michael Thompson, Julian Broad, Alex Cayley, Nicholas Callaway, Ali Mahadavi, Terry Richardson, Nigel Parry,
Art Streiber, Sølve Sundsbø, Matthias Vriens. editor-in-chief. Graydon Carter. publisher. Condé Nast Publications Inc. category. Photo: Story

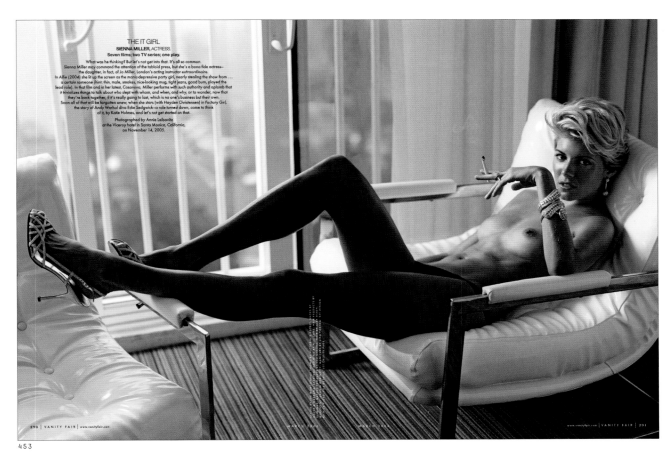

THE IT GIRL

SIENNA MILLER, ACTRESS.

Seven films; two TV series; one play.

*What was he thinking? But let's not get into that. It's all so common.
Sienna Miller may command the attention of the tabloid press, but she's a bona fide actress—
the daughter, in fact, of Jo Miller, London's acting instructor extraordinaire.
In Alfie (2004) she lit up the screen as the manic-depressive party girl, nearly stealing the show from . . .
a certain someone (hint: male, smokes, nice-looking mug, tight jeans, good bum, played the
lead role). In that film and in her latest, Casanova, Miller performs with such authority and aplomb that
it trivializes things to talk about who slept with whom, and when, and why, or to wonder, now that
they're back together, if it's really going to last, which is no one's business but their own.
Soon all of that will be forgotten anew, when she stars (with Hayden Christensen) in Factory Girl,
the story of Andy Warhol diva Edie Sedgwick—a role turned down, come to think
of it, by Katie Holmes, and let's not get started on that.*

Photographed by Annie Leibovitz
at the Viceroy hotel in Santa Monica, California,
on November 14, 2005.

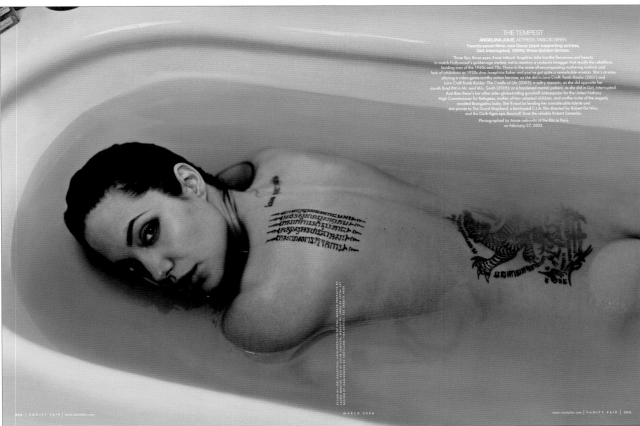

THE TEMPEST

ANGELINA JOLIE, ACTRESS. TABLOID SIREN.

**Twenty-seven films; one Oscar (best supporting actress,
Girl, Interrupted, 1999); three Golden Globes.**

*Those lips, those eyes, those tattoos! Angelina Jolie has the fierceness and beauty
to match Hollywood's golden-age starlets, not to mention a cocksure swagger that recalls the rebellious
leading men of the 1960s and 70s. Throw in the same all-encompassing mothering instincts and
lack of inhibitions as 1920s diva Josephine Baker and you've got quite a remarkable woman. She's at ease
playing a video-game-worthy action heroine, as she did in Lara Croft: Tomb Raider (2001) and
Lara Croft Tomb Raider: The Cradle of Life (2003); a sultry assassin, as she did opposite her
love(?) Brad Pitt in Mr. and Mrs. Smith (2005); or a hardened mental patient, as she did in Girl, Interrupted.
And then there's her other side—globe-trotting goodwill ambassador for the United Nations
High Commissioner for Refugees, mother of two adopted children, and mother-to-be of the eagerly
awaited Brangelina baby. She'll next be lending her considerable talents and
star power to The Good Shepherd, a fact-based C.I.A. film directed by Robert De Niro,
and the Dark Ages epic Beowulf, from the reliable Robert Zemeckis.*

Photographed by Annie Leibovitz at the Ritz in Paris
on February 27, 2005.

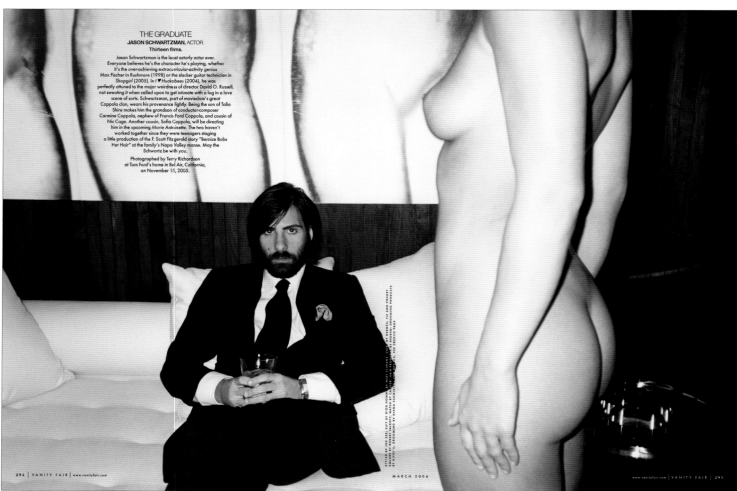

THE GRADUATE
JASON SCHWARTZMAN, ACTOR.
Thirteen films.

Jason Schwartzman is the least actorly actor ever. Everyone believes he's the character he's playing, whether it's the over-achieving extracurricular-activity genius Max Fischer in *Rushmore* (1998) or the slacker guitar technician in *Shopgirl* (2005). In *I ♥ Huckabees* (2004), he was perfectly attuned to the major weirdness of director David O. Russell, not sweating it when called upon to get intimate with a log in a love scene of sorts. Schwartzman, part of moviedom's great Coppola clan, wears his provenance lightly. Being the son of Talia Shire makes him the grandson of conductor-composer Carmine Coppola, nephew of Francis Ford Coppola, and cousin of Nic Cage. Another cousin, Sofia Coppola, will be directing him in the upcoming *Marie Antoinette*. The two haven't worked together since they were teenagers staging a little production of the F. Scott Fitzgerald story "Bernice Bobs Her Hair" at the family's Napa Valley manse. May the Schwartz be with you.

Photographed by Terry Richardson at Tom Ford's home in Bel Air, California, on November 15, 2005.

294 | VANITY FAIR | www.vanityfair.com

MARCH 2006

www.vanityfair.com | VANITY FAIR | 295

454

454

455

454. **VANITY FAIR**

design director. David Harris
art director. Julie Weiss
director of photography. Susan White
photographers. Annie Leibovitz, Mert + Marcus, Mario Testino, Michael Thompson, Julian Broad, Alex Cayley, Nicholas Callaway, Ali Mahadavi, Terry Richardson, Nigel Parry, Art Streiber, Sølve Sundsbø, Matthias Vriens
editor-in-chief. Graydon Carter
publisher. Condé Nast Publications Inc.
issue. March 2006
category. Photo: Story

455. **W**

creative director. Dennis Freedman
design director. Edward Leida
art director. Nathalie Kirsheh
designer. Edward Leida
photographer. David Sims
publisher. Condé Nast Publications Inc.
issue. January 2006
category. Photo: Story

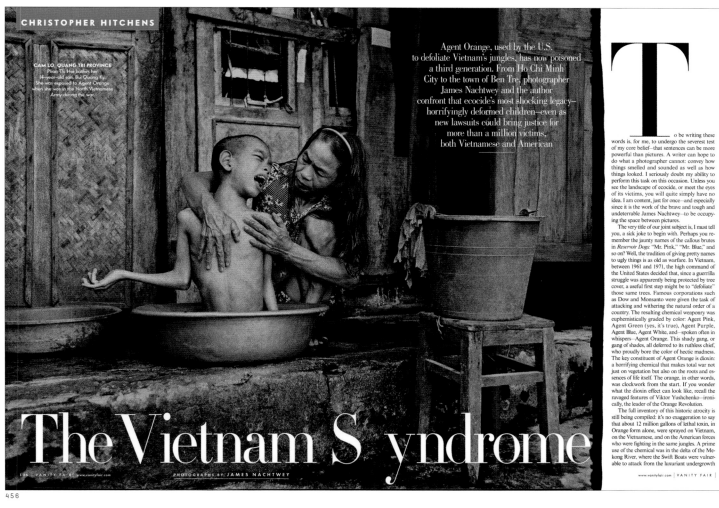

CAM LO, QUANG TRI PROVINCE
Phan Thi Hoi bathes her
14-year-old son, Bui Quang Ky.
She was exposed to Agent Orange
when she was in the North Vietnamese
Army during the war.

Agent Orange, used by the U.S.
to defoliate Vietnam's jungles, has now poisoned
a third generation. From Ho Chi Minh
City to the town of Ben Tre, photographer
James Nachtwey and the author
confront that ecocide's most shocking legacy—
horrifyingly deformed children—even as
new lawsuits could bring justice for
more than a million victims,
both Vietnamese and American

The Vietnam Syndrome

106 | VANITY FAIR | www.vanityfair.com PHOTOGRAPHS BY JAMES NACHTWEY www.vanityfair.com | VANITY FAIR | 107

To be writing these words is, for me, to undergo the severest test of my core belief—that sentences can be more powerful than pictures. A writer can hope to do what a photographer cannot: convey how things smelled and sounded as well as how things looked. I seriously doubt my ability to perform this task on this occasion. Unless you see the landscape of ecocide, or meet the eyes of its victims, you will quite simply have no idea. I am content, just for once—and especially since it is the work of the brave and tough and undeterrable James Nachtwey—to be occupying the space between pictures.

The very title of our joint subject is, I must tell you, a sick joke to begin with. Perhaps you remember the jaunty names of the callous brutes in *Reservoir Dogs*: "Mr. Pink," "Mr. Blue," and so on? Well, the tradition of giving pretty names to ugly things is as old as warfare. In Vietnam, between 1961 and 1971, the high command of the United States decided that, since a guerrilla struggle was apparently being protected by tree cover, a useful first step might be to "defoliate" those same trees. Famous corporations such as Dow and Monsanto were given the task of attacking and withering the natural order of a country. The resulting chemical weaponry was euphemistically graded by color: Agent Pink, Agent Green (yes, it's true), Agent Purple, Agent Blue, Agent White, and—spoken often in whispers—Agent Orange. This shady gang, or gang of shades, all deferred to its ruthless chief, who proudly bore the color of hectic madness. The key constituent of Agent Orange is dioxin: a horrifying chemical that makes total war not just on vegetation but also on the roots and essences of life itself. The orange, in other words, was clockwork from the start. If you wonder what the dioxin effect can look like, recall the ravaged features of Viktor Yushchenko—ironically, the leader of the Orange Revolution.

The full inventory of this historic atrocity is still being compiled: it's no exaggeration to say that about 12 million gallons of lethal toxin, in Orange form alone, were sprayed on Vietnam, on the Vietnamese, and on the American forces who were fighting in the same jungles. A prime use of the chemical was in the delta of the Mekong River, where the Swift Boats were vulnerable to attack from the luxuriant undergrowth

456.

[Style]

FLOWERS AS ART

No one gets it better than the Dutch. Just look at any Old Master still life. Hundreds of years later, Dutch breeders are still playing with the flower palette. In the U.S., a Dutch enclave in Carpinteria is passionate about growing Holland's latest art forms.

457.

this side of
paradise

Whether it's on the Côte d'Azur or the coast of Maine, living well is the best revenge in this season's sexy, nostalgic lingerie.

PHOTOGRAPHS BY DONNA DEMARI

458.

456. **VANITY FAIR**

design director. David Harris
art director. Julie Weiss
director of photography. Susan White
photographer. James Nachtwey
editor-in-chief. Graydon Carter
publisher. Condé Nast Publications Inc.
issue. August 2006
category. Photo: Story

457. **WEST / LOS ANGELES TIMES MAGAZINE**

creative director. Joseph Hutchinson
art director. Joseph Hutchinson
designer. Joseph Hutchinson
photo editors. Joseph Hutchinson, Carol Wakano
photographer. Jose Picayo
publisher. Los Angeles Times
category. Photo: Story

458. **WWD INTIMATES**

designer. Andrew Fylnn
photographer. Donna Demarí
group art director. Andrew Flynn
publisher. Condé Nast Publications Inc.
issue. July 2006
category. Photo: Story

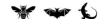

The Silent
BEAUTY

Seemingly too fragile, too real, too natural to survive the cutthroat fashion industry—let alone the vicious tabloid lashing she received last year—Kate Moss has not only become the blue-chip international supermodel but stayed true to herself. The secret of Moss's decade-long reign, writes A. A. GILL, may lie less in what she's done than in what she hasn't

———

T he British tabloid press, with its gander up, loins girded, helter-skelter, out on a celebrity fatwa, is a terrifying thing. A ululating bellow of vicious ill will and righteous cruelty. It's remorseless and relentless and borderline psychotic. It can obliterate the public and private lives of princesses and Cabinet ministers, football managers and children's-TV presenters. It's a force of human nature and nobody survives. Nobody, that is, except a slight, poised single mother with a sideways look. Nobody except Kate Moss.

She was snapped on a mobile phone, perhaps snorting what might have been cocaine with a rake pop boy. What followed made Osama's clippings book look like balanced joshing. It helped, of course, that it was Moss, and pretty girls not wearing much sell papers better than old men in suits. The press particularly went after the self-conscious and neurotic fashion companies that employed her. They meant business—to leave her with none.

So what did Kate do? What was her defense, her damage-limitation strategy, her self-preservation

PHOTOGRAPHS BY MERT ALAS AND MARCUS PIGGOTT • STYLED BY JOE McKENNA
DIRECTED BY MICHAEL ROBERTS

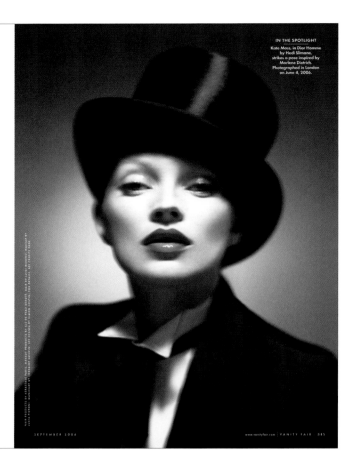

IN THE SPOTLIGHT
Kate Moss, in Dior Homme by Hedi Slimane, strikes a pose inspired by Marlene Dietrich. Photographed in London on June 4, 2006.

Her circle has REMAINED *protected, silent, and* CHARMED.

SCARLET TEMPTRESS
Moss channeling—and disrobing as—Dietrich in her role as Catherine the Great, from the 1934 film The Scarlet Empress. Coat, dress, and petticoat by Jean Paul Gaultier.

design director. David Harris. art director. Julie Weiss. director of photography. Susan White. photographers. Mert Alas. Marcus Piggott. editor-in-chief. Graydon Carter. publisher. Condé Nast Publications Inc. issue. September 2006. category. Photo: Story

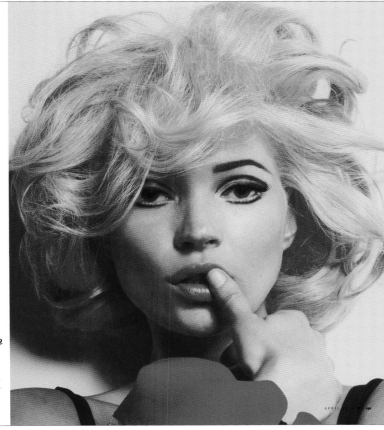

Performance

Iconic Kate Moss takes on another, very different icon,
with sultry poses, frilled dresses and tops,
and artfully ruffled blond hair.

Photographed by Mert Alas and Marcus Piggott

460

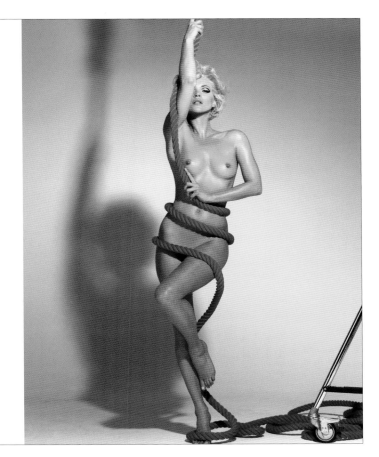

460

460. **W**

creative director. Dennis Freedman. design director. Edward Leida. art director. Nathalie Kirsheh. designer. Edward Leida
photographer. Mert Alas & Marcus Piggott. publisher. Condé Nast Publications Inc. issue. April 2006. category. Photo: Story

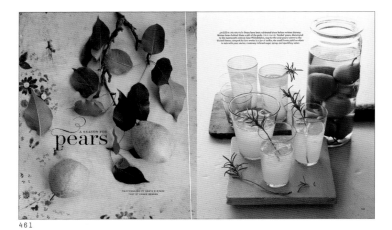

461

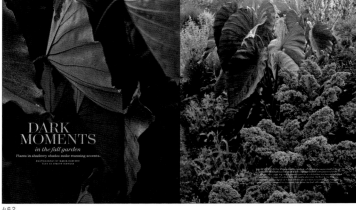

462

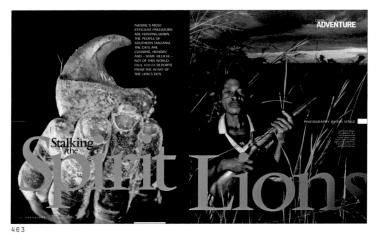

463

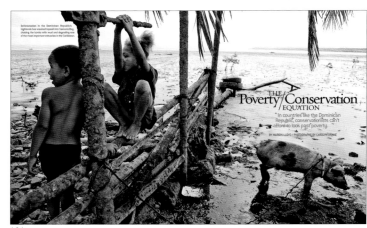

464

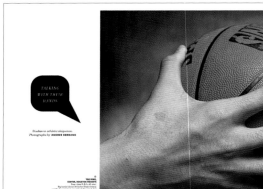

465

466

461. **MARTHA STEWART LIVING**

creative director. Eric A. Pike
design director. James Dunlinson
art director. Matthew Axe
director of photography. Heloise Goodman
photo editors. Andrea Bakacs, Joni Noe
photographer. Gentl + Hyers
styled by. Ayesha Patel, Lucinda Scala Quinn
editor-in-chief. Margaret Roach
publisher. Martha Stewart Living Omnimedia
issue. October 2006. category. Photo: Story

462. **MARTHA STEWART LIVING**

creative director. Eric A. Pike
design director. James Dunlinson
art director. Joele Cuyler
director of photography. Heloise Goodman
photo editors. Andrea Bakacs, Joni Noe
photographer. Maria Robledo
styled by. Tony Bielaczyc, Fritz Karch
editor-in-chief. Margaret Roach
publisher. Martha Stewart Living Omnimedia
issue. October 2006. category. Photo: Story

463. **NATIONAL GEOGRAPHIC ADVENTURE**

art director. Yvette Francis
designer. Marina Grinshpun
director of photography. Sabine Meyer
photographer. Ami Vitale
publisher. National Geographic Society
issue. October 2006
category. Photo: Story

464. **NATURE CONSERVANCY MAGAZINE**

art director. Sam Serebin
photo editor. Melissa Ryan
photographer. Carolyn Drake
editor-in-chief. Teresa Duran
issue. Summer 2006. category. Photo: Story

465. **PLAY, THE NY TIMES SPORT MAGAZINE**

creative director. Janet Froelich
art director/designer. Christopher Martinez
director of photography. Kathy Ryan
photo editor. Kira Pollack
photographer. Andres Serrano
editor-in-chief. Mark Bryant
publisher. The New York Times
issue. June 2006. category. Photo: Story

466. **WOMEN'S HEALTH**

art director. Andrea Dunham
designer. Andrea Dunham
director of photography. Sarah Rozen
photographer. Michael Muller
publisher. Rodale
issue. June 2006
category. Photo: Story

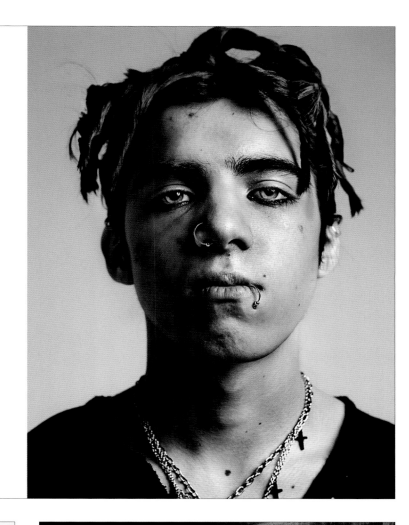

Bad Kids Inc.

New York

What's to be done about out-of-control teenagers? The man who gave us Citi Habitats has a plan to turn a parental self-help group into a company as popular and profitable as Weight Watchers.
BY DAVID AMSDEN

Photographs by Matt Hoyle

28

467

From **sauerkraut** to **schnitzel**, **Peking duck** to **pickles**, and **gnudi** to **cannoli**, our annual menu of the city's finest comestibles.

468

What the Butcher Knows

The best source of a beautiful cut is also the right person to tell you how to eat it.
BY MOLLY FRIEDMAN AND HELEN YUN

PHOTOGRAPHS BY HANS GISSINGER

FOOD

469

467. **NEW YORK**

design director. Luke Hayman
art director. Chris Dixon
director of photography. Jody Quon
photo editor. Amy Hoppy
photographer. Matt Hoyle
editor-in-chief. Adam Moss
publisher. New York Magazine Holdings, LLC
issue. January 9, 2006. category. Photo: Story

468. **NEW YORK**

design director. Luke Hayman
art director. Chris Dixon
director of photography. Jody Quon
photo editor. Alexandra Pollack
photographer. Horacio Salinas
editor-in-chief. Adam Moss
publisher. New York Magazine Holdings, LLC
issue. March 13, 20, 2006. category. Photo: Story

469. **NEW YORK**

design director. Luke Hayman
art director. Chris Dixon
director of photography. Jody Quon
photo editor. Leana Alagia
photographer. Hans Gissinger
editor-in-chief. Adam Moss
publisher. New York Magazine Holdings, LLC
issue. September 18, 2006. category. Photo: Story

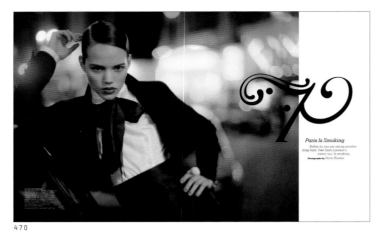

470

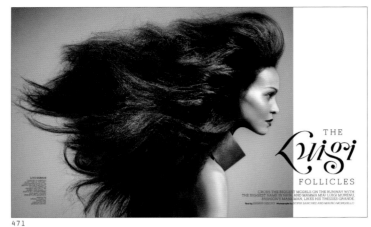

471

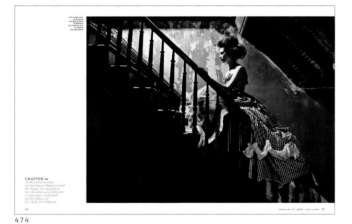

472

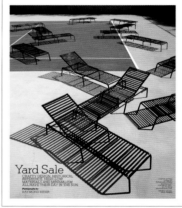

473

474

475

470. **T, THE NY TIMES STYLE MAGAZINE**

creative director. Janet Froelich
senior art director. David Sebbah
art director/designer. Christopher Martinez
director of photography. Kathy Ryan
senior photo editor. Judith Puckett-Rinella
photographer. Paolo Roversi
editor-in-chief. Stefano Tonchi
publisher. The New York Times
issue. August 27, 2006. category. Photo: Story

471. **T, THE NY TIMES STYLE MAGAZINE**

creative director. Janet Froelich
senior art director. David Sebbah
art director. Christopher Martinez
director of photography. Kathy Ryan
senior photo editor. Judith Puckett-Rinella
photographers. Sofia Sanchez, Mauro
Mongiello. editor-in-chief. Stefano Tonchi
publisher. The New York Times
issue. October 22, 2006. category. Photo: Story

472. **T, THE NY TIMES STYLE MAGAZINE**

creative director. Janet Froelich
senior art director. David Sebbah
art director/designer. Christopher Martinez
director of photography. Kathy Ryan
senior photo editor. Judith Puckett-Rinella
photographer. Ruven Afanador
editor-in-chief. Stefano Tonchi
publisher. The New York Times
issue. October 8, 2006. category. Photo: Story

473. **T, THE NY TIMES STYLE MAGAZINE**

creative director. Janet Froelich
senior art director. David Sebbah
art director/designer. Christopher Martinez
director of photography. Kathy Ryan
senior photo editor. Judith Puckett-Rinella
photographers. Sofia Sanchez, Mauro Mongiello
editor-in-chief. Stefano Tonchi
publisher. The New York Times
issue. August 27, 2006. category. Photo: Story

474. **NEW YORK**

design director. Luke Hayman
art director. Chris Dixon
director of photography. Jody Quon
photographer. Alex Majoli
editor-in-chief. Adam Moss
publisher. New York Magazine Holdings, LLC
issue. February 13, 2006
category. Photo: Story

475. **T, THE NY TIMES STYLE MAGAZINE**

creative director. Janet Froelich
senior art director. David Sebbah
art director. Christopher Martinez
director of photography. Kathy Ryan
senior photo editor. Judith Puckett-Rinella
photographer. Raymond Meier
editor-in-chief. Stefano Tonchi
publisher. The New York Times
issue. April 2, 2006. category. Photo: Story

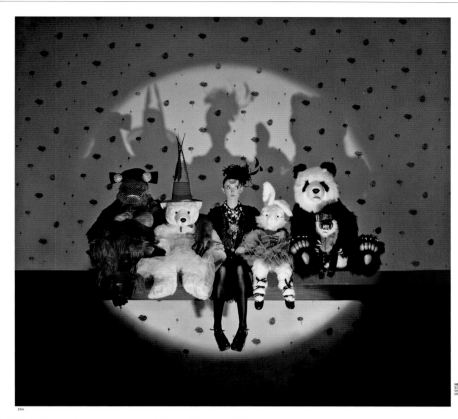

Anatomically Incorrect

With apologies to all who think it's naughty to consider women cuddly and cute.

Photographs by Jean-Paul Goude

HELLO, DOLLY THE MODEL AUDREY MARNAY, SURROUNDED BY HER FURRY FRIENDS, WEARS A CHANEL JACKET, $11,680, MATCHING SKIRT, $3,845, BLOUSE, $2,735, AND JEWELRY ALL AT SELECT CHANEL BOUTIQUES. LEAH C. COUTURE MILLINERY FEATHER HEADPIECE, WOLFORD HOSIERY, EMILIO PUCCI SHOES, ON TOYS, FROM LEFT: SUZANNE COUTURE MILLINERY MATADOR HAT WITH LEAH C. COUTURE MILLINERY NET; PHILIP TREACY HAT WITH FEATHERS. STUFFED ANIMALS FROM ANIMA. FASHION EDITOR: ANNE CHRISTENSEN.

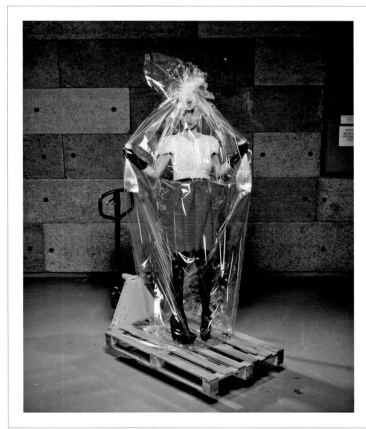

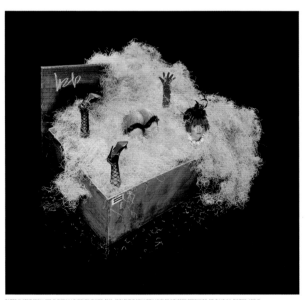

BABES IN ARMS FROM LEFT: CHRISTIAN LOUBOUTIN PUMPS, $565, AT BARNEYS NEW YORK. VINTAGE WOLFORD STOCKINGS. FIFI CHACHNIL PANTIES, ABOUT $140, AT AGENT PROVOCATEUR BOUTIQUES. LACRASIA GLOVE, $150 A PAIR. GO TO WWW.WEGLOVEYOU.COM. LEAH C. COUTURE MILLINERY HAIR ORNAMENT, $325, GO TO WWW.LEAHC.NET. LOUIS VUITTON NECKLACE, $1,280. GO TO WWW.LOUISVUITTON.COM. OPPOSITE: BALENCIAGA BY NICOLAS GHESQUIÈRE SILK BODICE AND HAND-PAINTED JACQUARD SKIRT, $101,370, AND ACCESSORIES, AT BALENCIAGA, 542 WEST 22ND STREET. FASHION ASSOCIATE: MELISSA VENTOSA. HAIR BY WARD AT FILOMENO. MAKEUP BY CRISTINE DUPUYS AT WWW.GREENAPPLEITALIA.COM. DIGITAL RETOUCHING BY JANVIER AND KILATO.

creative director. Janet Froelich. senior art director. David Sebbah. art director. Christopher Martinez. designer. David Sebbah
director of photography. Kathy Ryan. senior photo editor. Judith Puckett-Rinella. photographer. Jean-Paul Goude
editor-in-chief. Stefano Tonchi. publisher. The New York Times. issue. August 27, 2006. category. Photo: Story

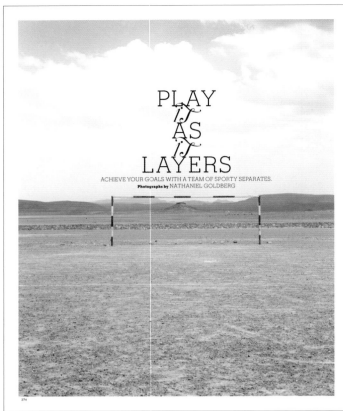

PLAY
it
AS
it
LAYERS

ACHIEVE YOUR GOALS WITH A TEAM OF SPORTY SEPARATES.
Photographs by NATHANIEL GOLDBERG

277

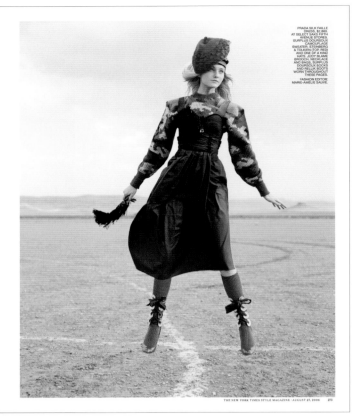

PRADA SILK FAILLE
DRESS, $2,860,
AT SELECT SAKS FIFTH
AVENUE STORES.
SURPLUS DOURSOUX
CAMOUFLAGE
SWEATER. STEINBERG
& TOLKIEN (TOP, RED)
AND ONE OF A KIND
HATS. JUDY BLAME
BROOCH. NECKLACE
AND BAGS. SURPLUS
DOURSOUX BOOTS
AND RELUX BOOTS
WORN THROUGHOUT
THESE PAGES.
FASHION EDITOR:
MARIE-AMÉLIE SAUVÉ.

THE NEW YORK TIMES STYLE MAGAZINE · AUGUST 27, 2006 275

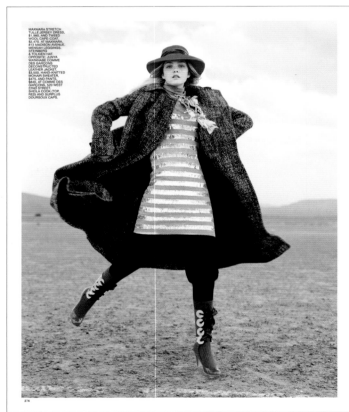

MAXMARA STRETCH
TULLE JERSEY DRESS,
$1,980, AND TWEED
WOOL CAPE-COAT,
$2,470, AT MAXMARA,
813 MADISON AVENUE.
MENUAH LEGGINGS.
STEINBERG
& TOLKIEN HAT.
OPPOSITE: JUNYA
WATANABE COMME
DES GARÇONS
DECONSTRUCTED
LEATHER JACKET,
$3,500, HAND-KNITTED
MOHAIR SWEATER,
$475, AND PANTS,
$840, AT COMME DES
GARÇONS, 520 WEST
22ND STREET.
SHEILA COOK (TOP,
RED) AND SURPLUS
DOURSOUX CAPS.

276

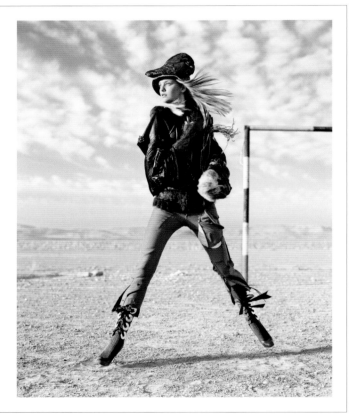

477. **T, THE NY TIMES STYLE MAGAZINE**

creative director. Janet Froelich. senior art director. David Sebbah
art director. Christopher Martinez. designer. Christopher Martinez
director of photography. Kathy Ryan
senior photo editor. Judith Puckett-Rinella. photographer. Nathaniel Goldberg
editor-in-chief. Stefano Tonchi. publisher. The New York Times
issue. August 27,2 006. category. Photo: Story

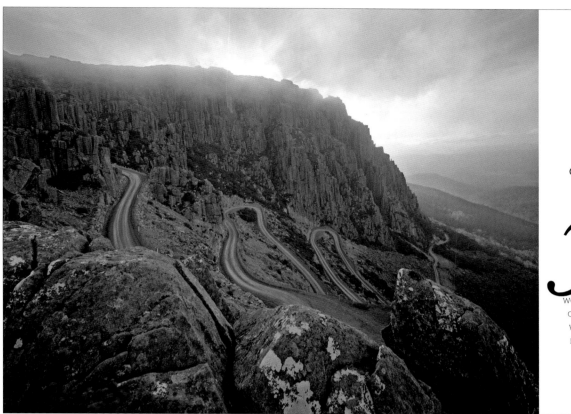

Out of This World

Ⓦ OOLLY WOMBATS, 3,000-YEAR-OLD PINES AND A RIVER CALLED STYX: TASMANIA IS A MYTHICAL PLACE, WONDROUS AND WEIRD. DARCY FREY HEADS TO THE BOTTOM OF THE PLANET.

Photographs by HARF ZIMMERMANN

478

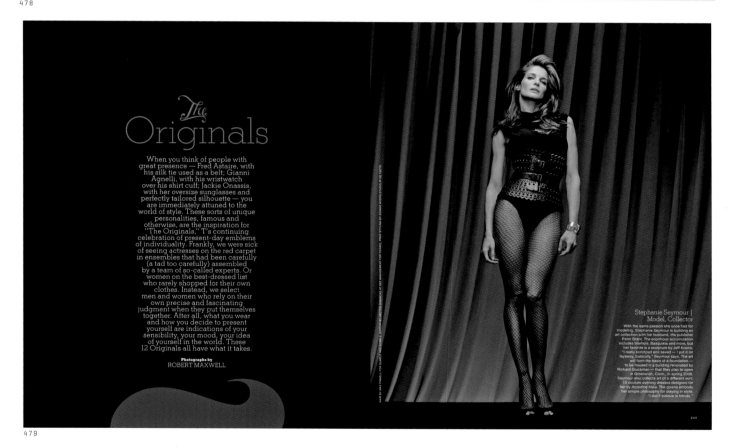

The Originals

When you think of people with great presence — Fred Astaire, with his silk tie used as a belt; Gianni Agnelli, with his wristwatch over his shirt cuff; Jackie Onassis, with her oversize sunglasses and perfectly tailored silhouette — you are immediately attuned to the world of style. These sorts of unique personalities, famous and otherwise, are the inspiration for "The Originals," T's continuing celebration of present-day emblems of individuality. Frankly, we were sick of seeing actresses on the red carpet in ensembles that had been carefully (a tad too carefully) assembled by a team of so-called experts. Or women on the best-dressed list who rarely shopped for their own clothes. Instead, we select men and women who rely on their own precise and fascinating judgment when they put themselves together. After all, what you wear and how you decide to present yourself are indications of your sensibility, your mood, your idea of yourself in the world. These 12 Originals all have what it takes.

Photographs by ROBERT MAXWELL

Stephanie Seymour | Model, Collector

With the same passion she once had for modeling, Stephanie Seymour is building an art collection with her husband, the publisher Peter Brant. The enormous accumulation includes Warhols, Basquiats and more, but her favorite is a sculpture by Jeff Koons. "I really scrimped and saved — I put it on layaway, basically," Seymour says. The art will form the basis of a foundation — to be housed in a building renovated by Richard Gluckman — that they plan to open in Greenwich, Conn., in spring 2008. Seymour also collects art of a different sort: 10 couture evening dresses designed for her by Azzedine Alaïa. The gowns embody her simple philosophy for staying in style: "I don't believe in trends."

479

478. **T. THE NY TIMES STYLE MAGAZINE**

creative director. Janet Froelich. senior art director. David Sebbah
art director. Christopher Martinez. designer. Christopher Martinez
director of photography. Kathy Ryan
senior photo editor. Judith Puckett-Rinella. photographer. Harf Zimmerman
editor-in-chief. Stefano Tonchi. publisher. The New York Times
issue. November 19, 2006. category. Photo: Story

479. **T. THE NY TIMES STYLE MAGAZINE**

creative director. Janet Froelich. senior art director. David Sebbah
art director. Christopher Martinez. director of photography. Kathy Ryan
senior photo editor. Judith Puckett-Rinella. photo editor. Jennifer Pastore
photographer. Robert Maxwell. editor-in-chief. Stefano Tonchi
publisher. The New York Times. issue. December 3, 2006. category. Photo: Story

Beyond the Pale

What makes a dress innocent? Is it the color, the cut, the little bunches of lace that embroider the yoke and suggest a small girl's birthday attire? Or perhaps it is the absence of flesh, as the artist Adam Fuss posits in these melancholy photographs reminiscent of his series "My Ghost." Taken without a camera, using light and light-sensitive paper, these photograms, as they are known, merely suggest the aura of sweetness. It is the wearer who provides the rest.

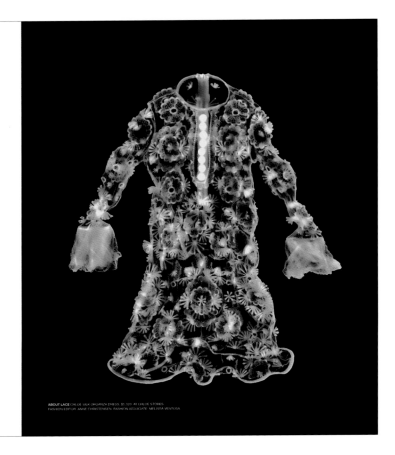

ABOUT LACE CHLOÉ SILK ORGANZA DRESS, $1,120. AT CHLOÉ STORES. FASHION EDITOR: ANNE CHRISTENSEN. FASHION ASSOCIATE: MELISSA VENTOSA.

480

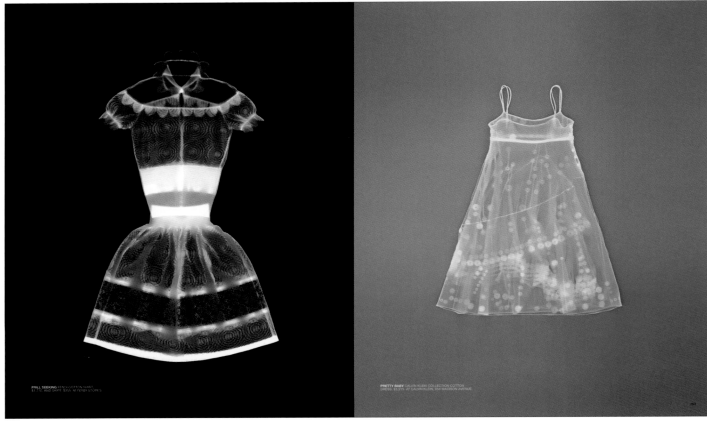

FRILL SEEKING FENDI COTTON SHIRT, $1,770. AND SKIRT, $355. AT FENDI STORES.

PRETTY BABY CALVIN KLEIN COLLECTION COTTON DRESS, $3,915. AT CALVIN KLEIN, 654 MADISON AVENUE.

480

480. **T, THE NY TIMES STYLE MAGAZINE**

creative director. Janet Froelich. art director. Christopher Martinez
designer. Christopher Martinez. director of photography. Kathy Ryan. photographer. Adam Fuss
fashion director. Ann Christenson. editor-in-chief. Stefano Tonchi
publisher. The New York Times. issue. February 26, 2006. category. Photo: Story

Style

Big

*F*oot

Lives!

Monster platforms and wedges make the world your stomping ground.
Photographs by Miles Aldridge Fashion editor: Elizabeth Stewart
Miu Miu lamé wedge sandal, $450. Similar styles available at select Miu Miu boutiques.

58

481

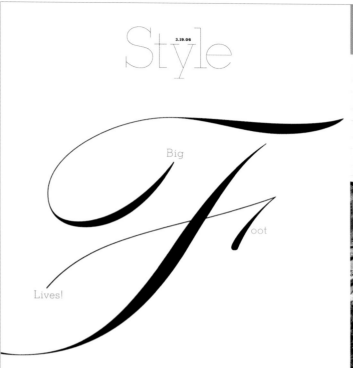

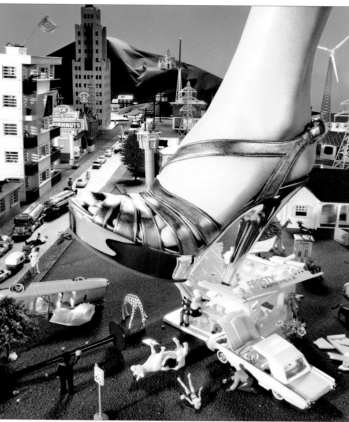

An Elephant Crackup?

Attacks by elephants on villages, people and other animals are on the rise. Some researchers are pointing to a species-wide trauma and the fraying of the fabric of pachyderm society.

By Charles Siebert
Photographs by Andres Serrano

42

482

481. **THE NEW YORK TIMES MAGAZINE**

creative director. Janet Froelich. art director. Arem Duplessis
designer. Nancy Harris Rouemy. photographer. Miles Aldridge
fashion editor. Elizabeth Stewart. editor-in-chief. Gerald Marzorati
publisher. The New York Times. issue. March 19, 2006. category. Photo: Story

482. **THE NEW YORK TIMES MAGAZINE**

creative director. Janet Froelich. art director. Arem Duplessis
designer. Cathy Gilmore-Barnes. director of photography. Kathy Ryan
photographer. Andres Serrano. editor-in-chief. Gerald Marzorati
publisher. The New York Times. issue. October 8, 2006. category. Photo: Story

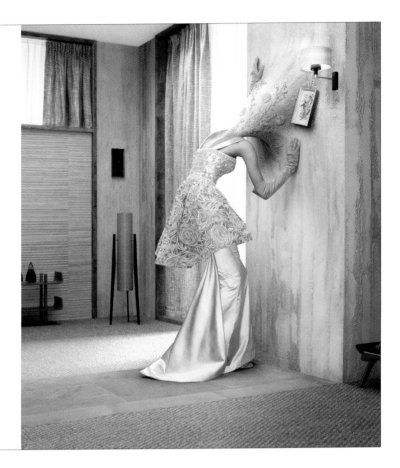

8.13.06 Style
COUTURE COLLECTIONS

GRAND ILLU SIONS

WEARING A DRESS THAT COSTS AS MUCH AS A HOUSE, A GIRL CAN'T BE BLAMED FOR LOSING HER HEAD.

Photographs by Erwin Olaf

VALENTINO HAUTE COUTURE COLLECTION DUCHESS
SATIN DRESS WITH PLEATED RUFFLES AND GLOVES AND SHOES.

FASHION EDITOR: ANNE CHRISTENSEN

40

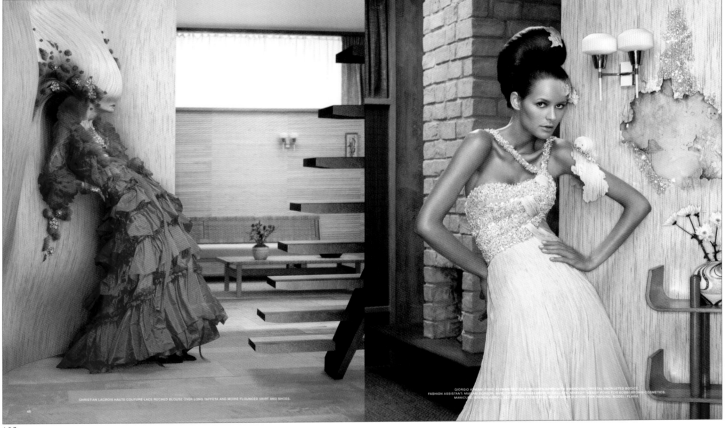

CHRISTIAN LACROIX HAUTE COUTURE LACE RUCHED BLOUSE OVER LONG TAFFETA AND MOIRE FLOUNCED SKIRT AND SHOES.

GIORGIO ARMANI PRIVE STRAPLESS SILK ORGANZA GOWN WITH SWAROVSKI CRYSTAL ENCRUSTED BODICE.
FASHION ASSISTANT: MARIAM BURSON, HAIR: CUTLER FOR REDKEN, MAKEUP: WENDY ROWE FOR BOBBI BROWN COSMETICS.
MANICURE: BRENDA ABRIE, SET DESIGN: FLORIA PRESS, MODEL: MARI SALLAT FOR TRUE MODELS, MODEL: PLAISIA.

483. **THE NEW YORK TIMES MAGAZINE**

creative director. Janet Froelich. art director. Arem Duplessis. designer. Nancy Harris Rouemy. photographer. Erwin Olaf. fashion editor. Anne Christensen
editor-in-chief. Gerald Marzorati. publisher. The New York Times. issue. August 13, 2006. category. Photo: Story

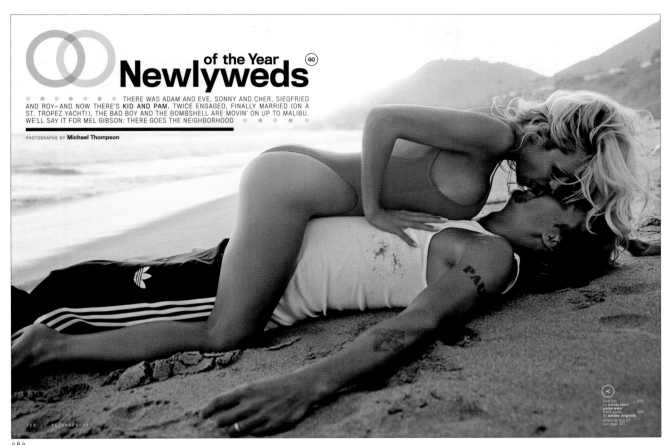

Newlyweds of the Year ^{GQ}

THERE WAS ADAM AND EVE, SONNY AND CHER, SIEGFRIED AND ROY—AND NOW THERE'S **KID AND PAM.** TWICE ENGAGED, FINALLY MARRIED (ON A ST. TROPEZ YACHT!), THE BAD BOY AND THE BOMBSHELL ARE MOVIN' ON UP TO MALIBU. WE'LL SAY IT FOR MEL GIBSON: THERE GOES THE NEIGHBORHOOD

PHOTOGRAPHS BY **Michael Thompson**

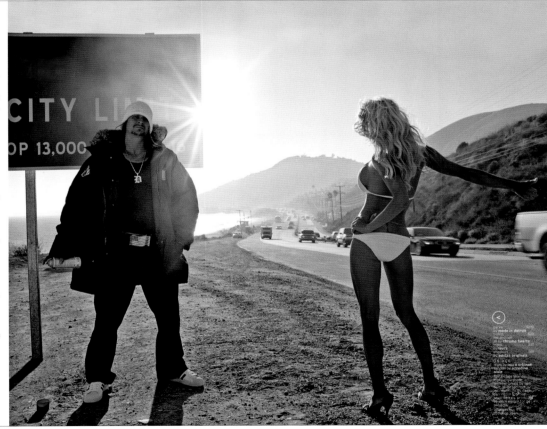

Is it true you sang a duet, "Sympathy for the Devil," at the wedding?
Kid What?
Pam "Sympathy for the Devil"? Oh no. That was the *afterparty.* And he was DJ'ing it and changing all the words, I think, as far as I remember—which is not a lot.
Kid I can't be held accountable for that unless somebody's got video.
Pam Video doesn't mean anything....

And, Kid, I heard you sang U2's "With or Without You" to your new bride.
Kid I wouldn't do that. That just takes the gay meter right to the end.
Pam That's enough with the *gay* word. That's not nice.
Kid It's a new word. All the kids are using it.
Pam No, they're not. As long as it's used in a positive context.

Who wrote the thank-you notes for all the wedding gifts?
Kid It's more like "you're welcome" notes. "You're welcome for the great party."

Where are you two living these days?
Pam We're bicoastal. Detroit and California.

Well, congratulations on being named GQ's Newlyweds of the Year.
Pam We've been trying to get this for a long time.
Kid There's a lot of responsibility that goes along with Couple of the Year. They just think it's a fun picture and everyone has a good laugh. But there's a lot of Couple of the Year charity things we're gonna be doing all year. It's pretty much a couple of hours a day for the whole three-six-five.
Pam Ask some serious questions.

Okay, Pam, you're known for your work in animal rights. Have you gotten Kid to change his ways?
Pam Working on it.
Kid Now I shoot the deer and she saves it.
Pam What did you say? That's divorce right there. You shoot anything, it's over. That's in writing.

Of course, before this time, you were engaged once before and broke it off....
Pam Yup. You have to bring that up, don't ya!

Was it hard to convince your friends that this time was for real?
Pam I think that's what you do. You have a great time together. You break up for a couple of years. Then you come back together. Then it's like you're really newlyweds and you're really excited to be together. And you live happily ever after. That's my theory. My advice.
Kid I'm not in charge of this relationship.—MICKEY RAPKIN

334 // DECEMBER 06

484. **GQ**

design director. Fred Woodward. designer. Anton Ioukhnovets. director of photography. Dora Somosi. senior photo editor. Krista Prestek photographer. Michael Thompson. publisher. Condé Nast Publications Inc. issue. December 2006. category. Photo: Story

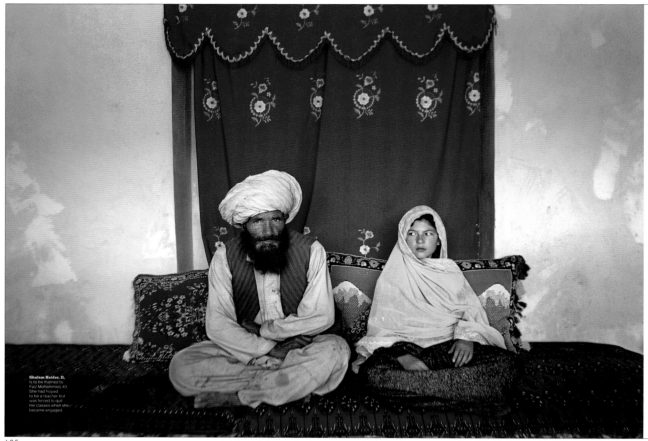

THE BRIDE PRICE

IN AFGHANISTAN, SOME DAUGHTERS SENT OFF TO BE MARRIED ARE JUST CHILDREN.

PHOTOGRAPHS BY STEPHANIE SINCLAIR

Text by Barry Bearak

IN MANY SOCIETIES, the term "child bride" calls to mind impetuous sweethearts, a ladder cautiously positioned beneath a bedroom window, a silent kiss in the moonlight and a young couple making an anxious getaway to a justice of the peace. But this is not a ready image the world over. In Afghanistan, a child bride is very often just that: a child, even a preteen, her innocence betrothed to someone older, even much, much older.

Rather than a willing union between a man and woman, marriage is frequently a

45

Ghulam Haider, 11, is to be married to Faiz Mohammed, 40. She had hoped to be a teacher but was forced to quit her classes when she became engaged.

485

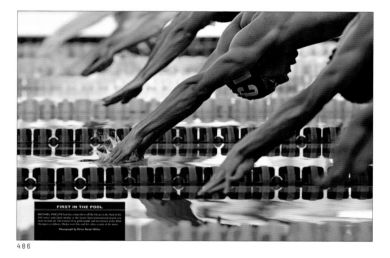

FIRST IN THE POOL

486

INVINCIBLE SPIRIT

486

485. **THE NEW YORK TIMES MAGAZINE**

creative director. Janet Froelich. art director. Arem Duplessis
designer. Jeffrey Docherty. illustrator. Stephanie Sinclair
director of photography. Kathy Ryan
editor-in-chief. Gerald Marzorati. publisher. The New York Times
issue. July 9, 2006. category. Photo: Story

486. **SPORTS ILLUSTRATED**

creative director. Steve Hoffman. art director. Eric Marguard
director of photography. Steve Fine. Peter Read Miller, Kim Jae-Huan,
Caroline Yang, Nic Bothman, Al Bello, Bernat Armague, Don Fernandez,
Micheal J. LeBrecht, Vladimir Sichov, Al Grillo, Odd Anderson, Gregg Newton
publisher. Time Inc. issue. December 25, 2006. category. Photo: Story

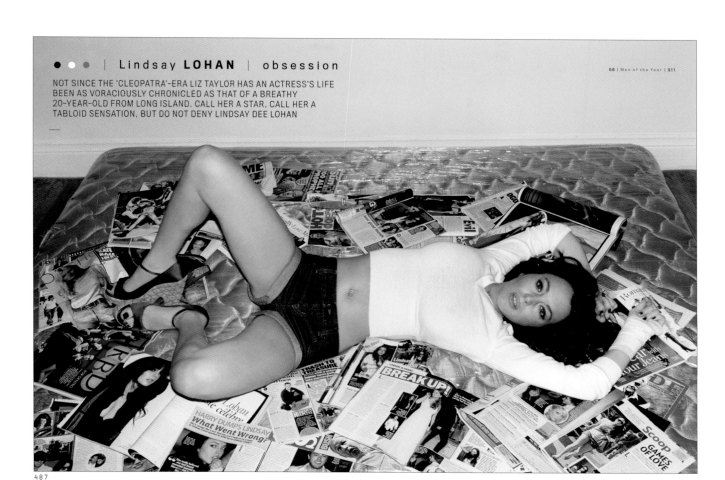

● ○ ● ○ | Lindsay **LOHAN** | obsession

NOT SINCE THE 'CLEOPATRA'-ERA LIZ TAYLOR HAS AN ACTRESS'S LIFE
BEEN AS VORACIOUSLY CHRONICLED AS THAT OF A BREATHY
20-YEAR-OLD FROM LONG ISLAND. CALL HER A STAR, CALL HER A
TABLOID SENSATION, BUT DO NOT DENY LINDSAY DEE LOHAN

487

Nawlins

FOTO CASPER BALSLEV
TEKST ANDREAS FUGL THØGERSEN

New Orleans
september 2005

ORKANEN KATRINA ramte 29. august 2005 den amerikanske
golfkyst. Et døgn senere brød de diger sammen, der skærmer New
Orleans mod søen Lake Pontchartrain, og byen blev lagt under vand.
Katrina kostede 1.836 mennesker livet, heraf mindst 1.200 alene i
New Orleans. I alt menes det, at orkanen er skyld i ødelæggelser for
81 milliarder dollar. Og så slog den luften ud af maven på Nawlins,
som de lokale udtaler navnet på byen, der længe har stået som et
pejlemærke i amerikansk kulturliv. Hjemsted for jazz, cajun, blues
og kreolsk livsstil. Men også en by, der efter Katrina fik stillet skarpt
på fattigdom og racisme. Efteråret 2005 tog fotograf Casper Balslev
til New Orleans for at dokumentere følgerne af katastrofen. De fleste
af de 490.000 indbyggere var evakuerede. Tilbage var ruiner, lig,
forrådnelse, smadrede veje, forladte biler og huse og en nådesløst
bagende sol. Og så stilheden. Selv fuglene var fløjet fra byen. Genop-
bygningen af New Orleans er stadig i gang, og kritikken af Bush-
regeringens indsats er vedholdende. Men i dagene efter vandmas-
sernes hærgen var der kun tabet. Netop det er skildret på de næste
sider i en stribe barske fotografier, der kan mærkes i maven. ⬛

⬛ Ud & Se DECEMBER 2006

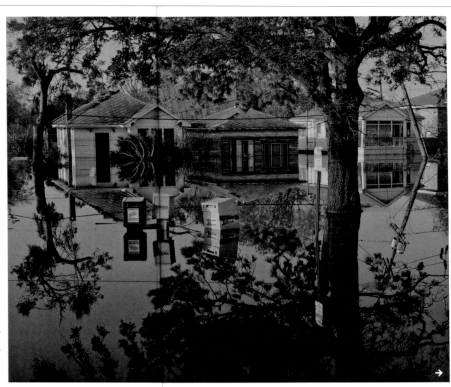

→

488

487. **GQ**

design director. Fred Woodward. designer. Ken DeLago
director of photography. Dora Somosi. senior photo editor. Krista Prestek
photographer. Terry Richardson. publisher. Condé Nast Publications Inc.
issue. December 2006. category. Photo: Story

488. **UD & SE**

design director. Katinka Bukh. photographer. Casper Balslev
publisher. DSB. category. Photo: Story

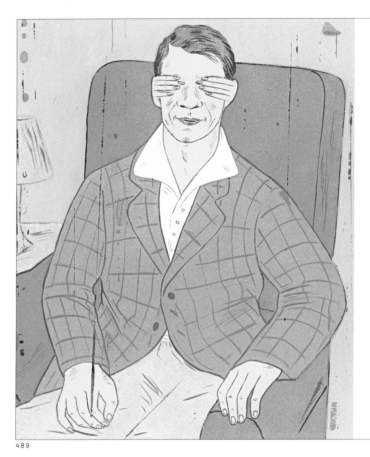

GUESS Ƨ'OHW BACK

OLD FLAMES STILL SMOLDER, ESPECIALLY WHEN THEY'RE EARLY LOVE AFFAIRS, WHICH LEAVE A PARTICULARLY VIVID MARK IN OUR MINDS. REAWAKENING SUCH A ROMANCE CAN BE AN INCENDIARY EXPERIENCE—INTENSELY PASSIONATE AND DANGEROUS TO TRIFLE WITH. **BY PAMELA WEINTRAUB • ILLUSTRATION BY BRIAN CRONIN**

July/August 2006 Psychology Today 79

489

An outbreak of paranoia sweeps our neurotic metropolis, as once calm New Yorkers try to convince **Mara Altman** that itty-bitty creatures have invaded their homes. So what if the exterminator says it's just lint?

Illustration by Bill Mayer

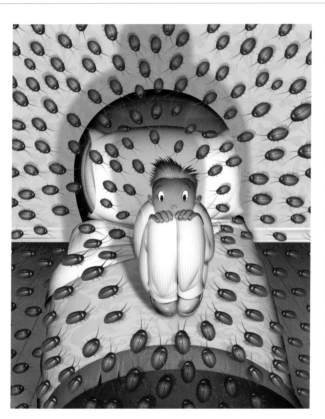

490

489. **PSYCHOLOGY TODAY**

creative director. Edward Levine. illustrator. Brian Cronin
studio. Levine Design, Inc. publisher. Sussex Publishers
client. Psychology Today. issue. July/August 2006
category. Illustration: Spread

490. **THE VILLAGE VOICE**

art director. Ted Keller. designer. Ted Keller
illustrator. Bill Mayer
publisher. Village Voice Media.
category. Illustration: Spread

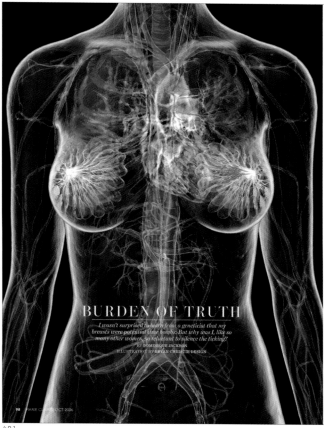

BURDEN OF TRUTH

I wasn't surprised to learn from a geneticist that my breasts were potential time bombs. But why was I, like so many other women, so reluctant to silence the ticking?
BY DOMINIQUE JACKSON
ILLUSTRATION BY BRYAN CHRISTIE DESIGN

x

x

FIRST PERSON

"SO, YOU SEE, surgery to remove the breast tissue would reduce your risk of developing cancer by 90 percent." She drew a wide circle two or three times around the number, written on a notepad now covered with scribbled statistics, and glanced up expectantly. She looked absurdly young. Could she really be a qualified genetic counselor? She wasn't even wearing a white coat. "But," I stammered, dazed and emotional after an hour detailing my entire family history, "what happens if I decide not to take the test?" She gave me a wry smile, and I thought I heard her sigh. "Well," she frowned. "Surely you understand it's cancer we're talking about here?"

As I walked back through the maze of hospital corridors, I felt a familiar indignation welling up. Who the hell was she to lecture me about this disease? I got into my car and, with the motor running, just sat there shaking in the driver's seat, railing at the smug counselor, at my defective genetic heritage, at all the aunts and ancestors who had handed it down to me. And then I began weeping for my mother.

Breast cancer has been the sinister thread running through my life for almost as long as I can remember—at least since I was 6 and my brother, Rory, was 3, when our parents explained that Mommy had found a bad lump and had to have an operation. When I was 12, she finally succumbed. For quite a while after that, the threat would lie dormant until I'd hear about a tragic celebrity struggle with the disease—Linda McCartney, Kylie Minogue—or some girlfriend's fund-raising effort. Every time, my mother's traumatic treatments would flash to mind: the five-inch rectangular burn on her back from experimental radiotherapy, the scar across her shaved head from when they removed her pituitary gland. But soon enough, I'd be back to nurturing the fantasy that breast cancer was something that happened to other people.

Yes, I went regularly for the ritual indignity of a mammogram. I made clumsy attempts to check my breasts after every period and felt. I had done my bit for the next 28 days. But then, in 2004, the beast jumped back to center stage. My cousin Sarah, six years younger than I am, found a lump while breast-feeding her new daughter.

It was an aggressive cancer, and the prognosis was not great. Her doctors had also identified a faulty gene—BRCA2—which meant that anyone in Sarah's family, including third-degree relatives like me, was also at risk.

There are a dozen close female cousins on Mom's side of the family, all aged between 38 and 48. At 44, I'm pretty much in the middle. The news put the family grapevine into overdrive: Michèle was definitely taking the test to see if she had the mutation; Jill wouldn't, but would make damn sure her daughters did. Even Chris, proud father of teenage girls, bravely went for a test himself: positive.

Me? I couldn't decide. On one hand, I have always presumed I'd inherited some genetic disposition from my mom. On the other, it was possible that I had somehow escaped scot-free: To date, of my eight cousins who have been tested, four are positive and four are negative.

Undoubtedly, breast cancer still claims too many victims; it killed my mother, and in a way, I believe it claimed my younger brother, too: Rory, a mama's boy if ever there was one, died 20 years after she did. Officially, it was from a combination of alcohol, anorexia, and HIV. But my dad and I knew better: It was slow suicide from grief. I hadn't managed to save Rory's life, but was I now being offered a chance to save my own?

Then one day, I was summoned by my cousin Amanda. Serene, doe-eyed Amanda, with the huge, cheerful husband and the two adorable daughters. She sat me down, opened a large envelope, and handed over some papers.

"BRCA2 Exon 16 sequencing—Analysis indicates heterozygous for familial mutation 7990–7992delATAinsTT. Relatives of Amanda are at risk. Molecular testing is available to them." I tried my usual spiel: "They keep a close eye on me because of Mom. I'm as aware as I can be. Honest." She wasn't buying it. She was seriously considering a preventive mastectomy. She, too, had lost her mother when she was little, and she had her girls to consider. Wouldn't I at least have another think about getting tested?

And that's how I ended up sitting opposite the teenage geneticist for my initial counseling session, discussing relative risk and frighteningly precise percentages. Stubborn I may be, but stupid I'm not. I can do the math. The counselor's preposterous balloons full of big numbers floated around in my head: If I have the gene, I have as high as an 85-percent chance of getting cancer; if I get my breasts removed, I cut my risk by 90 percent. She urged me to take the test.

I didn't make an appointment, but I did start to type the unthinkable—"prophylactic mastectomy"—into Google with obsessive frequency. I started to ask myself some tough questions: Would I continue to monitor my risk, take preventive drugs, or would I bite the bullet, take the test, and—if it came back positive for BRCA2—have the guts to go under the knife?

That would mean finally addressing the thorny issue of my breasts, after managing to ignore them for 30 years. They had been an embarrassment since the summer they appeared, as if by magic, on my bony rib cage. »

98 MARIE CLAIRE / OCT 2006

OCT 2006 / MARIE CLAIRE 99

491

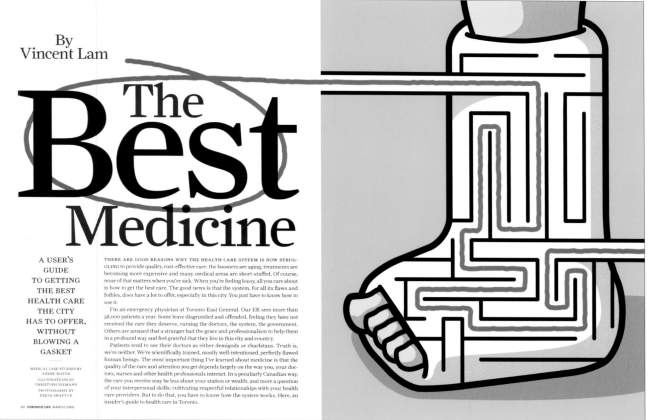

By
Vincent Lam

The Best Medicine

A USER'S
GUIDE
TO GETTING
THE BEST
HEALTH CARE
THE CITY
HAS TO OFFER,
WITHOUT
BLOWING A
GASKET

MEDICAL CASE STUDIES BY
ANDRE MAYER
ILLUSTRATIONS BY
CHRISTOPH NIEMANN
PHOTOGRAPHY BY
DEREK SHAPTON

40 TORONTO LIFE MARCH 2006

THERE ARE GOOD REASONS WHY THE HEALTH CARE SYSTEM IS NOW STRUGGLING to provide quality, cost-effective care: the boomers are aging, treatments are becoming more expensive and many medical areas are short-staffed. Of course, none of that matters when you're sick. When you're feeling lousy, all you care about is how to get the best care. The good news is that the system, for all its flaws and foibles, does have a lot to offer, especially in this city. You just have to know how to use it.

I'm an emergency physician at Toronto East General. Our ER sees more than 58,000 patients a year. Some leave disgruntled and offended, feeling they have not received the care they deserve, cursing the doctors, the system, the government. Others are amazed that a stranger had the grace and professionalism to help them in a profound way and feel grateful that they live in this city and country.

Patients tend to see their doctors as either demigods or charlatans. Truth is, we're neither. We're scientifically trained, mostly well-intentioned, perfectly flawed human beings. The most important thing I've learned about medicine is that the quality of the care and attention you get depends largely on the way you, your doctors, nurses and other health professionals interact. In a peculiarly Canadian way, the care you receive may be less about your station or wealth, and more a question of your interpersonal skills: cultivating respectful relationships with your health care providers. But to do that, you have to know how the system works. Here, an insider's guide to health care in Toronto.

492

491. **MARIE CLAIRE**

creative director. Paul Martinez. art director. Jenny Leigh Thompson designer. Burgan Shealy. illustrator. Bryan Christie Design. director of photography. Alix Campbell. editor-in-chief. Joanna Coles. publisher. The Hearst Corporation-Magazines Division. issue. October 2006. category. Illustration: Spread

492. **TORONTO LIFE**

art director. Carol Moskot. designer. Carol Moskot illustrator. Christoph Niemann. editor-in-chief. John Macfarlane publisher. St. Joseph Media. issue. March 2006 category. Illustration: Spread

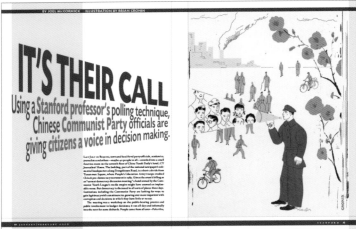

493

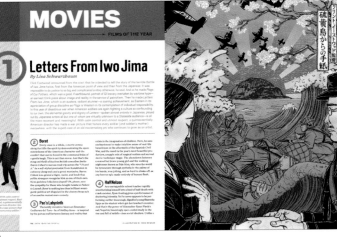

494

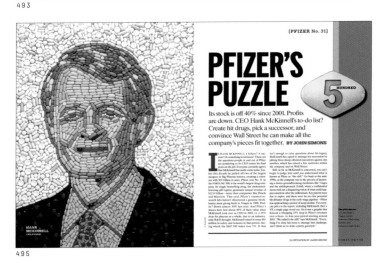

495

496

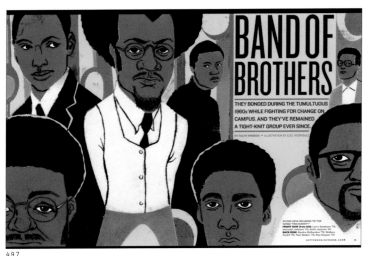

497

498

493. STANFORD MAGAZINE

creative director. Bambi Nicklen
art director. Amy Shroads
designer. Amy Shroads
illustrator. Brian Cronin
editor-in-chief. Kevin Cool
publisher. Stanford University
issue. January/February 2006
category. Illustration: Spread

494. ENTERTAINMENT WEEKLY

design director. Geraldine Hessler
art director. Brian Anstey
managing art director. Jennie Chang
illustrator. Yuko Shimizu
director of photography. Fiona McDonagh
managing editor. Rick Tetzeli
publisher. Time Inc.
issue. December 29, 2006
category. Illustration: Spread

495. FORTUNE

design director. Robert Newman
designer. Linda Rubes
illustrator. Jason Mecier
director of photography. Greg Pond
photo editor. Armin Harris
publisher. Time Inc.
issue. April 17, 2006
category. Illustration: Spread

496. FORTUNE

design director. Robert Newman
designer. Linda Rubes
illustrator. eBoy
publisher. Time Inc.
issue. May 15, 2006
category. Illustration: Spread

497. DARTMOUTH ALUMNI MAGAZINE

art director. Wendy McMillan
illustrator. Edel Rodriguez
publisher. Dartmouth College
issue. September/October 2006
category. Illustration: Spread

498. FAST COMPANY

art director. Dean Markadakis
designer. Henry Yung
illustrator. Eduard Recife
publisher. Mansueto Ventures, LLC
issue. October 2006
category. Illustration: Spread

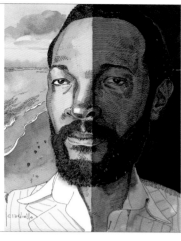
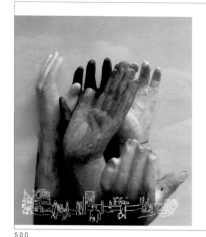

499

500

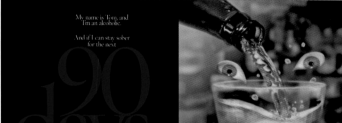

501

502

503

504

499. AMERICAN WAY

design director. J.R. Arebalo, Jr.
designer. Samuel Solomon
illustrator. Joe Ciardello
publisher. American Airlines Publishing
issue. June 15, 2006
category. Illustration: Spread

502. BOYS' LIFE

design director. Scott Feaster
designer. Kevin Hurley
illustrator. Red Nose Studio
publisher. Boy Scouts of America
issue. July 2006
category. Illustration: Spread

500. SMITH ALUMNAE QUARTERLY

design director. Ronn Campisi
art director. Ronn Campisi
illustrator. Polly Becker
studio. Ronn Campisi Design
publisher. Smith College
client. Smith College
issue. Winter 2006
category. Illustration: Spread

503. GOVERNING MAGAZINE

design director. Jandos Rothstein
art director. Bonnie Becker
illustrator. Jonathan Twingley
publisher. Congressional Quarterly, Inc.
issue. August 2006
category. Illustration: Spread

501. BEST LIFE

art director. Brandon Kavulla
designer. Brandon Kavulla
illustrator. Matt Mahurin
director of photography. Nell Murray
publisher. Rodale
issue. January 2006
category. Illustration: Spread

504. AMERICAN WAY

design director. J.R. Arebalo, Jr.
designer. Samuel Solomon
illustrator. eBoy
publisher. American Airlines Publishing
issue. November 15, 2006
category. Illustration: Spread

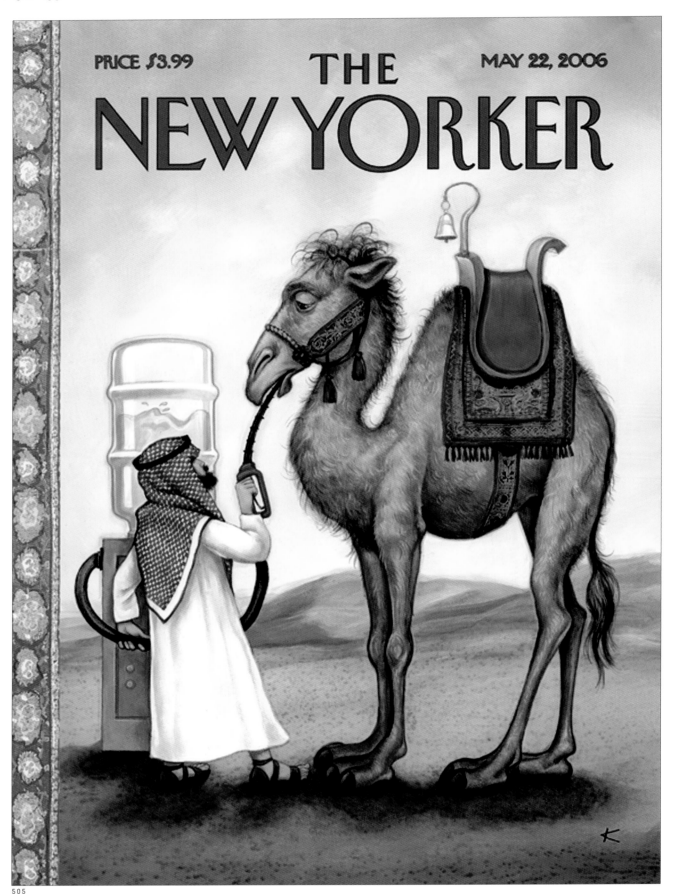

505

505. **THE NEW YORKER**

creative director. Françoise Mouly. illustrator. Anita Kunz. studio. Anita Kunz Illustrations
editor-in-chief. David Remnick. publisher. Condé Nast Publications Inc. issue. May 2006
category. Photo: Single Page

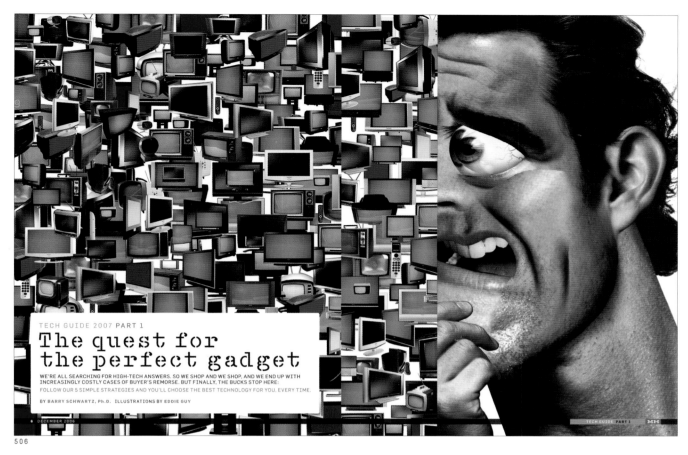

TECH GUIDE 2007 PART 1

The quest for the perfect gadget

WE'RE ALL SEARCHING FOR HIGH-TECH ANSWERS. SO WE SHOP AND WE SHOP, AND WE END UP WITH
INCREASINGLY COSTLY CASES OF BUYER'S REMORSE. BUT FINALLY, THE BUCKS STOP HERE:
FOLLOW OUR 5 SIMPLE STRATEGIES AND YOU'LL CHOOSE THE BEST TECHNOLOGY FOR YOU, EVERY TIME.

BY BARRY SCHWARTZ, Ph.D. ILLUSTRATIONS BY EDDIE GUY

6 DECEMBER 2006

theArts

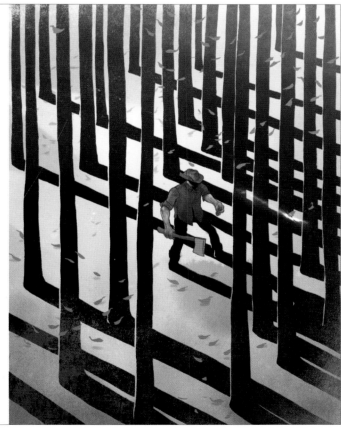

BOOKS

Memory the Monster

Terri Jentz revisits the scene of her violent attack
by Ariel Swartley

IN 1977, TERRI JENTZ WAS A 20-YEAR-OLD YALE STUDENT on an ambitious summer holiday. She and a roommate were riding a newly completed national bicycle trail from Oregon to the Atlantic coast. They were six days into the trip, camping in a small park just east of the Cascades, when a man in a pickup truck drove over their tent—the girls were asleep inside—then hacked the two women with an ax. Both survived. Jentz, who remained conscious enough to flag down help after the truck left, remembered their assailant as young, his cowboy shirt tucked meticulously into his jeans.

The "Cline Falls Incident" attracted national attention. Its pitting of liberated women against redneck wranglers could have been drawn from an Eagles song; its dusty desert hinterlands stood in popular imagination as a new American Gothic populated by Charlie Manson wanna-bes. Witnesses reported a number of vehicles in the park that evening—it was a local teen hangout—and there were clear tire tracks at the campsite, but no one was ever arrested for the crime.

Jentz assumed she'd put the inexplicable assault behind her. She finished college, worked in New York, and then, in her early thirties, moved to Los Angeles to become a screenwriter. But as she writes in her sprawling memoir, *Strange Piece of Paradise* (Farrar, Straus, and Giroux, 560 pages, $27), the restlessness didn't go away; and in 1992, she went back to central Oregon for the first time. The book's subtitle gives a sense of the wide swath she hoped to cover: "A

Return to the American West to Investigate My Attempted Murder—and Solve the Riddle of Myself." Jentz thinks that revisiting the place where the ugliness happened will lay some ghosts to rest. Instead—in the best traditions of both psychotherapy and mystery stories—it raises more.

In Jentz's telling, the ax attack cut across her life. On one side, she had an Ivy League student's breezy confidence; on the other, she was left with nightmares, damaged muscle, and an estranged relationship with the friend whose life she'd saved. Indeed, the woman appears in *Strange Piece of Paradise* under a pseudonym. Unconscious with a head wound when Jentz found her some yards from the tent, she had no memory of the attack that left her legally blind and never shared Jentz's interest in reliving it.

Jentz, meanwhile, gained the weird gratification of a notoriety she could choose to acknowledge or conceal. She found herself using the story as a litmus test of friendship, a cape to trail before a potential lover. If the result she really wanted—intimacy—seldom developed, no wonder. Her matter-of-fact recital and cool demeanor didn't seem much like openness. Still, she had no reason to think she was impaired. If she could talk about the trauma, pop psychology suggested, she must be okay.

Under the ministrations of television hosts and self-help books, confronting the past has taken on the formulaic rigidity of ancient myth. Memory is automatically a monster, and the remember must display her wounds. But from the moment Jentz places her first exploratory phone call, she finds herself in conflicting roles. As a victim, she requires consideration from the officials she talks to; as an investigator, she is regarded with suspicion. "Is it revenge you want?" a woman in Des-

130 LOS ANGELES MAY 2006 ILLUSTRATION BY SAM WEBER

506. **MEN'S HEALTH**

design director. George Karabotsos. art director. Joe Heroun
designer. Joe Heroun. illustrator. Eddie Guy. publisher. Rodale Inc.
issue. December 2006. category. Illustration: Spread

507. **LOS ANGELES**

art director. Joe Kimberling. designer. Lisa M. Lewis. illustrator. Sam Weber
deputy art director. Lisa M. Lewis. editor-in-chief. Kit Rachlis
publisher. Emmis. issue. May 2006. category. Illustration: Spread

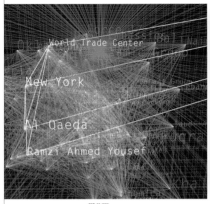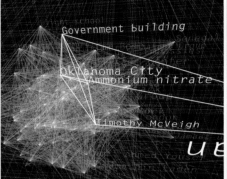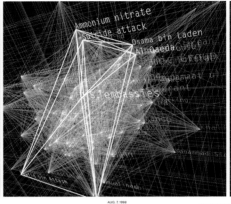

FEB. 26, 1993 APRIL 19, 1995 AUG. 7, 1998

These images represent terrorist attacks and some of the actors, weapons and targets linked to them. The physical relationship of the items suggests the level of connection.

Open-Source Spying

The nation's
intelligence
agencies are giving
their cold-war-era
computer systems
a makeover.

But will blogs and
wikis really
help spies uncover
terrorist plots?

By Clive Thompson

Illustrations by Lisa Strausfeld and James Nick Sears/Pentagram

54 55

 Aerotropolis, The In September, Bangkok witnessed the opening of the Suvarnabhumi Airport, which when finally completed will include virtually all the components of a major metropolis: shopping malls, office buildings, hotels, hospitals, an international business center, conference and exhibition spaces, warehouses and even a residential community. Traditionally, of course, airports have served cities, but in the past few years airports have started to become cities unto themselves, giving rise to a new urban form: the aerotropolis.

John Kasarda, a scholar of urban planning at the University of North Carolina, defines the term as more than a place for planes to come and go. It is a destination in its own right. The Changi Airport in Singapore, for example, contains cinemas, saunas and a swimming pool. In Dubai, the World Central International Airport and its environs, which are under construction, will contain office towers, hotels, a casino, a golf course, housing for workers and what promises to be one of the world's largest malls. (The price tag: $33 billion.)

Thanks to an increasing number of amenities that airports provide for both work and play, a growing number of travelers are doing business on the premises of the airport city. They can hold meetings and attend conferences by day and relax at restaurants and clubs by night, never once venturing into the old-fashioned "downtown." Certain industries even have an incentive to base their operations in airports: air-express companies, for instance, or manufacturers and distributors of lightweight products shipped on planes, like pharmaceuticals, microelectronics, medical instruments and fresh seafood.

"Access, access, access is replacing location, location, location as the most important commercial real estate principle," Kasarda says. No surprise, then, that the world's most expensive industrial real estate is adjacent to Heathrow Airport. STEPHEN MIHM

Air-Index Impressionism "Without the fog, London wouldn't be a beautiful city," the French painter Claude Monet wrote to his wife, Alice, during one of his long visits to England from France. Few Londoners would have agreed with his statement at the time, when the city was choked by the smog of the Industrial Revolution, but no one argues with the beauty of the colorful skies he began painting there between 1899 and 1901. Pollution has never looked quite as attractive as when seen through Monet's eyes.

Now there is evidence that Monet's atmospheric images of London were not Impressionist concoctions but a result of highly accurate observation. According to a paper published by two environmental scientists in August, the paintings (nearly 100 of which still exist) may "provide useful information in the analysis of the London fogs and air quality during this period" — a period before pollution levels were routinely recorded.

In their study, Jacob Baker and John E. Thornes of the University of Birmingham analyzed the position of the sun in 9 of the 19 paintings in Monet's "Houses of Parliament" series. There was "a perfect correlation," Thornes says, between the solar positions in the images, the actual solar positions derived from astronomical records and the dates on which Monet said, in letters to Alice, that he began the works. "We can date, almost to within 15 minutes, when he first put the sun onto certain images," Thornes says. Having found some quantitative information in the paintings, Baker and Thornes say they hope to find more. "We believe," Thornes says, "that we can basically deconstruct the images to work out how much smoke would have to be in the air to create that visibility and those colors in, say, February 1900."

Some art historians doubt the London paintings hold this much documentary evidence, pointing out, among other things, that Monet continued to work on many of the images after he returned to his studio in Giverny, France. "There's no question that Monet was astonishingly allegiant to what lay in front of him," the Monet scholar Paul Hayes Tucker says. "But at the same time, for example, he had a penchant for pinks. He always was trying to sneak pinks into pictures throughout his career."

Thornes concedes that "it's still just a hypothesis" but maintains that "we're fairly optimistic that we'll get something out of it." JOHN GLASSIE

Ambient Walkman, The The popularity of the iPod has given new urgency to an old criticism of the portable music player: namely, that it isolates the listener by tuning out the world around him. As one response to this problem, Noah Vawter, a graduate student at the M.I.T. Media Lab, has created a pair of headphones that tunes the listener back in.

The device, which Vawter calls Ambient Addition, consists of two headphones with transparent earpieces, each equipped with a microphone and a speaker. The microphones sample the background noise in the immediate vicinity — wind blowing through the trees, traffic, a cellphone conversation. Then, with the help of a small digital signal-processing chip, the headphones make music from these sounds. For instance, percussive sounds like footsteps and coughs are sequenced into a stuttering pat-

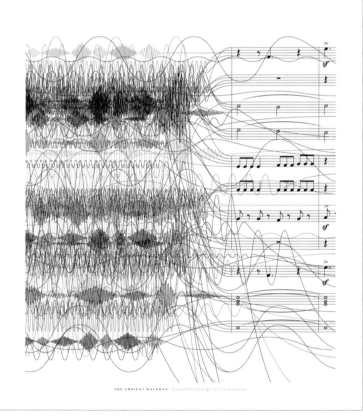

THE AMBIENT WALKMAN ILLUSTRATION BY JULIA HASTING

32

508. THE NEW YORK TIMES MAGAZINE

creative director. Janet Froelich. art director. Arem Duplessis
designer. Jeff Glendenning. illustrators. Lisa Strausfeld, James Nick Sears
editor-in-chief. Gerald Marzorati. publisher. The New York Times
issue. December 3, 2006. category. Illustration: Story

509. THE NEW YORK TIMES MAGAZINE

creative director. Janet Froelich. art director. Arem Duplessis
designer. Gail Bichler. illustrators. Julia Hasting, Santiago Piedrafita,
Deb Littlejohn. editor-in-chief. Gerald Marzorati. publisher. The New York Times
issue. December 10, 2006. category. Illustration: Story

Discrimination used to take aim at entire social groups. Now it is directed at the members of those groups who refuse to assimilate to the mainstream.

The Pressure to Cover

By Kenji Yoshino

When I began teaching at Yale Law School in 1998, a friend spoke to me frankly. "You'll have a better chance at tenure," he said, "if you're a homosexual professional than if you're a professional homosexual." Out of the closet for six years at the time, I knew what he meant. To be a "homosexual professional" was to be a professor of constitutional law who "happened" to be gay. To be a "professional homosexual" was to be a gay professor who made gay rights his work. Others echoed the sentiment in less elegant formulations. Be gay, my world seemed to say. Be openly gay, if you want. But don't flaunt.

I didn't experience the advice as antigay. The law school is a vigorously tolerant place, embedded in a university famous for its gay student population. (As the undergraduate jingle goes: "One in four, maybe more/One in three, maybe me/One in two, maybe you.") I took my colleague's words as generic counsel to leave my personal life at home. I could see that research related to one's identity — referred to in the academy as "mesearch" — could raise legitimate questions about scholarly objectivity.

I also saw others playing down their outsider identities to blend into the mainstream. Female colleagues confided that they would avoid references to their children at work, lest they be seen as mothers first and scholars second. Conservative students asked for advice about how open they could be about their politics without suffering repercussions at some imagined future confirmation hearing. A religious student said he feared coming out as a believer, as he thought his

Illustrations by Daniel Eatock

32

510

Most of us have tissue or blood samples on file somewhere, whether we know it or not.

Taking the Least of You

What we don't typically know is what research they are being used for and how much money is being made from them.

And science may want to keep things that way.

By Rebecca Skloot
Artworks by Marcel Dzama

38

511

510. **THE NEW YORK TIMES MAGAZINE**

creative director. Janet Froelich. art director. Arem Duplessis designers. Jody Churchfield, Gail Bichler. illustrator. Daniel Eatock editor-in-chief. Gerald Marzorati, publisher. The New York Times issue. January 15, 2006. category. Illustration: Spread

511. **THE NEW YORK TIMES MAGAZINE**

creative director. Janet Froelich. art director. Arem Duplessis designer. Jeff Glendenning. illustrator. Marcel Dzama editor-in-chief. Gerald Marzorati, publisher. The New York Times issue. April 16, 2006. category. Illustration: Story

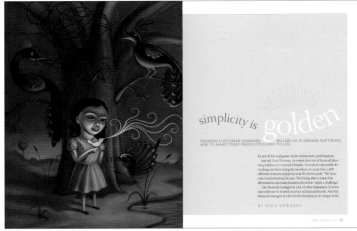

513

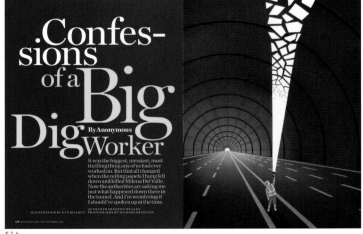

514

515

516

512

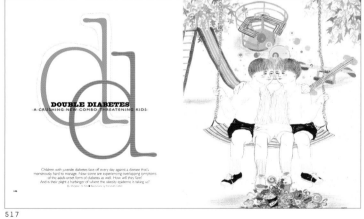

517

512. CONDÉ NAST TRAVELER

design director. Robert Best
art director. Kerry Robertson
illustrator. Kim Rosen
publisher. Condé Nast Publications, Inc.
issue. November 2006
category. Illustration: Single Page

513. CFO

design director. Robert Lesser
art director. Jenna Talbott
illustrator. Chris Buzelli
photo editor. Carol Lieb
publisher. CFO Publishing Corp
issue. January 2006
category. Illustration: Spread

514. BOSTON

art director. Robert Parsons
illustrator. Guy Billout
editor-in-chief. James Burnett
publisher. Metrocorp
issue. November 2006
category. Illustration: Spread

515. INC.

creative director. Blake Taylor
designer. Lou Vega
illustrator. Roderick Mills
publisher. Mansueto Ventures
issues. May 2006
category. Illustration: Single Page

516. MEN'S HEALTH

design director. George Karabotsos
art director. Joe Heroun
designer. Tim Leong
illustrator. Jason Holley
publisher. Rodale Inc.
issues. August 2006
category. Illustration: Single Page

517. CHILD

creative director. Daniel Chen
art director. Megan V. Henry
assistant art directors. Janet Park,
Jaclyn Steinberg. illustrator. Fernanda Cohen
director of photography. Ulrika Thunberg
photo editor. Melissa Malinowsky
publisher. Meredith. issues. October 2006
category. Illustration: Spread

518

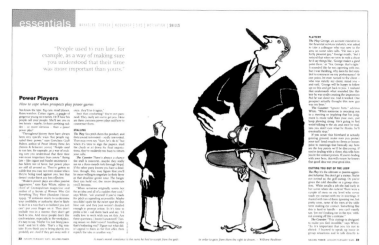

519

520

521

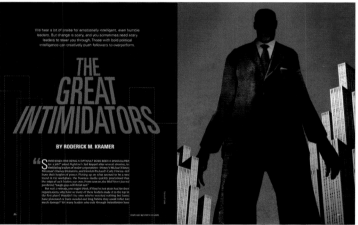

522

523

518. ANGELS ON EARTH

creative director. Francesca Messina
art director. Donald Partyka
designer. Donald Partyka
illustrator. Brian Cronin
publisher. Guideposts
issue. July/August 2006
category. Illustration: Spread

519. SELLING POWER

art director. Colleen Quinnell
designer. Tarver Harris
illustrator. Belle Mellor
publisher. Personal Selling Power
issue. January/February 2006
category. Illustration: Spread

520. DIABLO

art director. Tim J Luddy
illustrator. Anita Kunz
editor-in-chief. Susan Dowdney Safipour
publisher. Diablo Publications
issue. April 2006
category. Illustration: Spread

521. THE NEW YORK TIMES MAGAZINE

creative director. Janet Froelich
art director. Arem Duplessis
designer. Cathy Gilmore-Barnes
illustrator. David Foldvari
editor-in-chief. Gerald Marzorati
publisher. The New York Times
issue. June 11, 2006. category. Illustration: Spread

522. HARVARD BUSINESS REVIEW

art director. Karen Player
designer. Kaajal Asher
illustrator. Brian Stauffer
publisher. Harvard Business School Publishing
issue. February 2006
category. Illustration: Spread

523. BLOOMBERG MARKETS MAGAZINE

art director. John Genzo
designers. Kam Tai, Beth Mostello
illustrator. Steve Brodner
photo editor. Eric Godwin
deputy art director. Evelyn Good
publisher. Bloomberg L.P. issue. April 2006
category. Illustration: Spread / Story

524

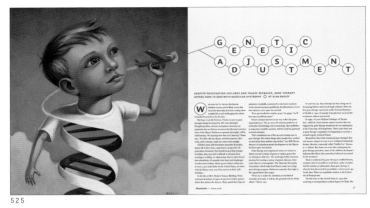

525

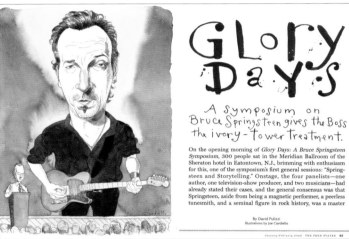

526

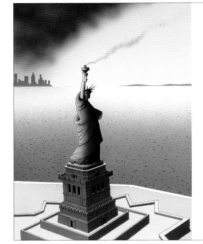

527

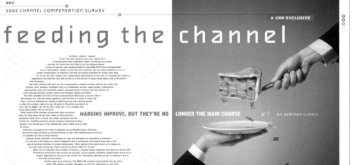

528

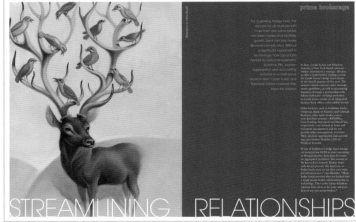

529

524. SEED

art director. Thomas Porostocky
designers. Kristopher Johns, Jong Woo Si
illustrator. Dylan Eastgaard
editor-in-chief. Adam Bly
publisher. Seed Media Group
issue. February/March 2006
category. Illustration: Spread + Design: Spread

525. ILLUMINATION MAGAZINE

art director. Blake Dinsdale
illustrator. Chris Buzelli
editor-in-chief. Charles E. Reineke
publisher. University of Missouri - Columbia
issue. Spring 2006
category. Illustration: Spread

526. THE PENN STATER

art director. Jonathan Ziegler
illustrator. Joe Ciardello
publisher. Penn State Alumni Association
issue. January/February 2006
category. Illustration: Spread + Design: Spread

527. READER'S DIGEST

design director. Hannu Laakso
art director. Dean Abatemarco
associate art director. Victoria Nightingale
designer. Victoria Nightingale
illustrator. Guy Billout
publisher. Reader's Digest Association
issue. January 2006. category. Illustration: Spread

528. CRN

art director. David Nicastro
designer. David Nicastro
director of photography. Kim Kullish
photographer. CJ Burton
publisher. CMP Media LLC
issue. June 26, 2006
category. Illustration: Spread

529. GLOBAL CUSTODIAN

creative director. SooJin Buzelli
designers. SooJin Buzelli, Maynard Kay
illustrator. Chris Buzelli
publisher. Asset International
issue. December 2006
category. Illustration: Spread

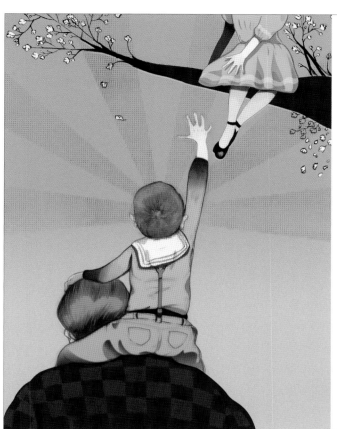

HERE COMES THE SON

THOUGHT **LEADER**

PAY ATTENTION TO HOW HE TREATS HIS MOTHER. IT'S A STATEMENT WOMEN OFTEN HEAR WHEN THEY WONDER ALOUD HOW A BOYFRIEND OR HUSBAND MIGHT BEHAVE TOWARD THEM IN THE LONG RUN. AND THERE'S APPARENT LOGIC IN THIS COMPARISON. A MAN'S MOTHER AND HIS WIFE ARE BOTH WOMEN; THUS, IT MIGHT SEEM, A MAN'S ATTITUDE TOWARD EACH SHOULD BE SIMILAR. BUT …

WHEN IT COMES TO MARRIAGE, MEN FOLLOW IN THEIR FATHERS' FOOTSTEPS, FOR BETTER OR FOR WORSE. SO NEIL CHETHIK DISCOVERED WHEN INTERVIEWING AMERICAN HUSBANDS FOR HIS NEW BOOK, *VOICEMALE*.

ILLUSTRATION BY MARCOS CHIN

FEBRUARY 2006 Sky **47**

530

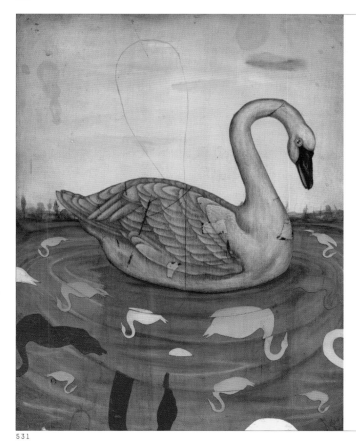

531

a

RESEARCHERS SET OUT TO UNDERSTAND NUCLEAR REPROGRAMMING
TO REVERT ADULT CELLS TO MEDICALLY USEFUL EMBRYONIC STEM CELLS
BY RICHARD SALTUS / ILLUSTRATION BY JASON HOLLEY

cell's

second act

February 2006 | HHMI BULLETIN **15**

530. **SKY**

art director. Ann Harvey. designer. Ann Harvey
illustrator. Marcos Chin. editor-in-chief. Duncan Christy
publisher. Pace Communications. issue. February 2006
category. Illustration: Spread

531. **HOWARD HUGHES MEDICAL INSTITUTE BULLETIN**

creative director. Hans Neubert. art director. Sarah Viñas
designer. Sarah Viñas. illustrator. Jason Holley
studio. VSA Partners. publisher. Howard Hughes Medical Institute
issue. February 2006. category. Illustration: Spread

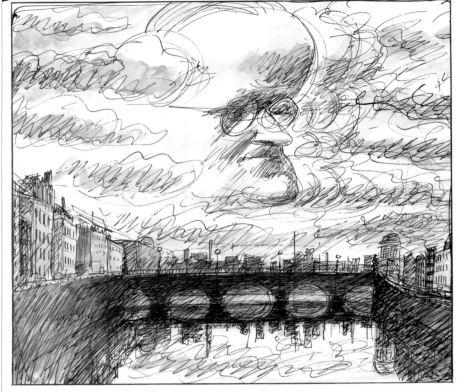

Dublin in Bloom

WHAT BETTER WAY TO CELEBRATE
"ULYSSES" AND THE GENIUS
OF JAMES JOYCE THAN WITH A PARTY.
AND WHAT BETTER DAY THAN JUNE 16,
WHEN THE NOVEL TAKES PLACE.
AND WHO BETTER TO LEND HIS NAME TO THE FESTIVITIES
THAN THE BOOK'S PROTAGONIST,
LEOPOLD BLOOM. *EDWARD SOREL*
JOINS THE JAMBOREE AND CAPTURES
THE SPIRIT OF BLOOMSDAY
IN HIS OWN INIMITABLE WORDS AND DRAWINGS

As the ghost of Joyce hovers over the River Liffey, 10,000 celebrants gather on O'Connell Street for Denny's Bloomsday Centenary Breakfast.

532

533

534

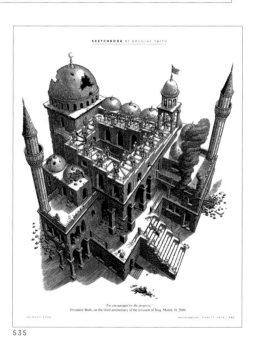

535

532. **CONDÉ NAST TRAVELER**

design director. Robert Best
art director. Kerry Robertson
illustrator. Edward Sorel
publisher. Condé Nast Publications, Inc.
issue. April 2006
category. Illustration: Story

533. **TIME**

art director. Arthur Hochstein
deputy art director. Cynthia Hoffman
illustrator. Hanoch Piven
director of photography. Michele Stephenson
photo editor. Mary Anne Golon
publisher. Time Inc. issue. October 23, 2006
category. Illustration: Single Page

534. **LITTLE BROWN BOOK**

creative director. Carol Pagliuco
art director. Christine Capuano
illustrator. Anja Kroencke
editor-in-chief. Liz Wallace
publisher. Rodale, Inc. client. Bloomingdales
issue. March/April 2006
category. Illustration: Single Page

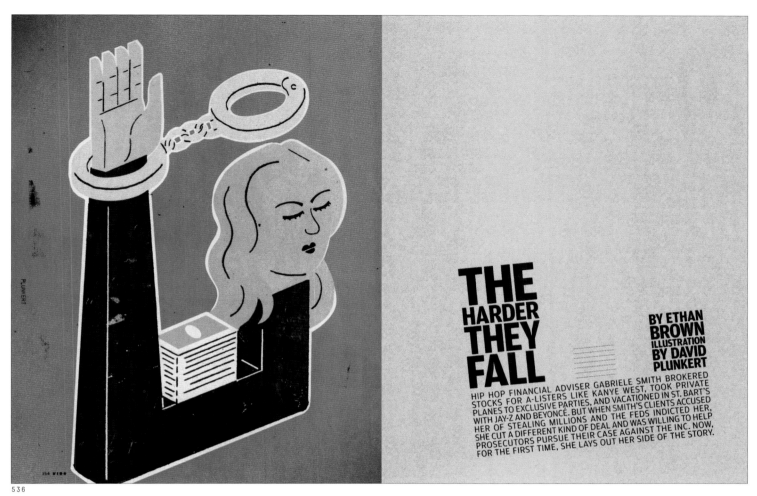

THE HARDER THEY FALL

BY ETHAN BROWN
ILLUSTRATION BY DAVID PLUNKERT

HIP HOP FINANCIAL ADVISER GABRIELE SMITH BROKERED STOCKS FOR A-LISTERS LIKE KANYE WEST, TOOK PRIVATE PLANES TO EXCLUSIVE PARTIES, AND VACATIONED IN ST. BART'S WITH JAY-Z AND BEYONCÉ. BUT WHEN SMITH'S CLIENTS ACCUSED HER OF STEALING MILLIONS AND THE FEDS INDICTED HER, SHE CUT A DIFFERENT KIND OF DEAL AND WAS WILLING TO HELP PROSECUTORS PURSUE THEIR CASE AGAINST THE INC. NOW, FOR THE FIRST TIME, SHE LAYS OUT HER SIDE OF THE STORY.

536

537

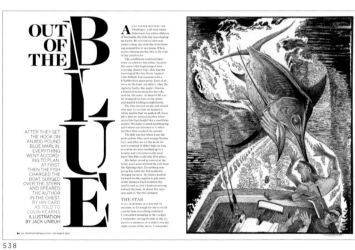

538

535. **VANITY FAIR**

design director. David Harris
art director. Julie Weiss
illustrator. Douglas Smith
editor-in-chief. Graydon Carter
publisher. Condé Nast Publications Inc.
issue. August 2006
category. Illustration: Single Page

536. **VIBE**

design director. Florian Bachleda
designer. Alice Alves
illustrator. David Plunkert
editor-in-chief. Mimi Valdés
publisher. Vibe/Spin Ventures LLC
issue. March 2006
category. Illustration: Spread

537. **REVOLVER**

design director. Andy Omel
art director. Josh Bernstein
illustrator. Arik Roper
director of photography. Rebecca Fain
editor-in-chief. Tom Beajour
publisher. Future US. issue. October 2006
category. Illustration: Spread

538. **SALT WATER SPORTSMAN**

art director. Elaine Ahn
illustrator. Jack Unruh
editor-in-chief. David Di Benedetto
publisher. Time4 Media
issue. November 2006
category. Illustration: Spread

539

540

541

539. **PREMIERE**

art director. Dirk Barnett
designer. April Bell
illustrator. Andrea Ventura
publisher. Hachette Filipacchi Media U.S.
issue. February 2006
category. Illustration: Spread

540. **COOKIE**

design director. Kirby Rodriguez
art director. Alex Grossman
designers. Nicolette Berthelot, Karla Lima
illustrator. Brian Cronin
editor-in-chief. Pilar Guzmán
publisher. Condé Nast Publications Inc.
issue. May/June 2006. category. Illustration: Spread

541. **HARVARD LAW BULLETIN**

design director. Ronn Campisi
art director. Ronn Campisi
illustrator. John Hersey
studio. Ronn Campisi Design
publisher. Harvard Law School
client. Harvard Law School
issue. Summer 2006. category. Illustration: Spread

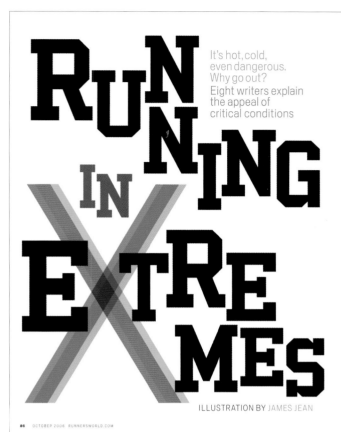

RUNNING IN EXTREMES

It's hot, cold, even dangerous. Why go out? Eight writers explain the appeal of critical conditions

ILLUSTRATION BY JAMES JEAN

86 OCTOBER 2006 RUNNERSWORLD.COM

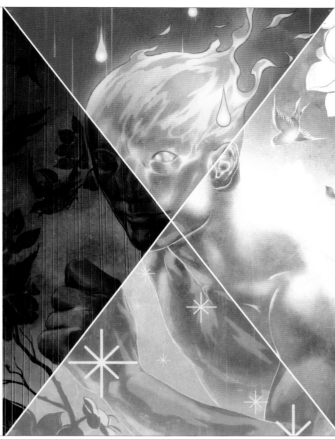

542

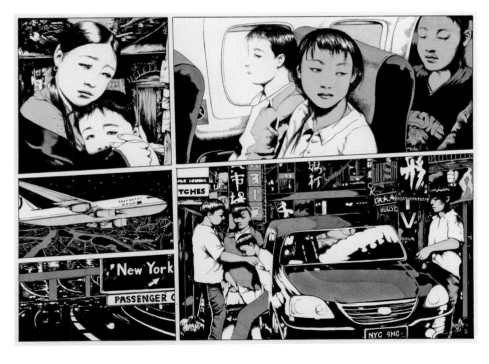

CHAPTER 6: THE IMMIGRANT

THE SMUGGLERS' DUE

DENG CHEN'S PARENTS SENT HIM TO AMERICA WHEN HE WAS **JUST 14** IN THE HOPE OF GIVING HIM A **BETTER** LIFE. HE SPENT THE NEXT **FOUR YEARS PAYING** FOR THEIR DECISION.

BY ALEX KOTLOWITZ

I WAS INTRODUCED to Deng Chen through an attorney who had helped him with some legal matters. Her specialty is trafficking, and when I told her I was doing some research on human smuggling and its victims, she cautioned me to be careful about using the word "victim" and, more to the point, not to confuse trafficking, which involves coercion, with smuggling, which is by choice. But then she told me about Chen, who at age 14 was sent by his parents to this country from China, by himself, with the assistance of smugglers; over the next four years, Chen worked to pay off a smuggling debt of $45,000, plus interest.

Deng Chen and I first got together this past winter in a room he was renting in Flushing, Queens. The third-floor apartment had been partitioned, so that every room, except the kitchen, was occupied; there were eight people living there, all Chinese, some documented, some not. On a later visit, the holders of the apartment's lease would chastise Chen for bringing a stranger there, but on this occasion no one was around, so we sat on the floor of his spartan room, leaned against his bed and talked for nearly five hours.

There was not much to distract us. On a desk in one corner sat a portable computer, a gift from an older woman who helped him along the way. His rather meager wardrobe fit on three small shelves, on top of which, beside a small bamboo plant, sat framed snapshots of his mother and father, whom he hadn't seen in eight years, and by his tele-

Illustrations By Vania Zouravliov

70 71

543


542. **RUNNER'S WORLD**

art director. Kory Kennedy. deputy art director. Elisa Yoch
illustrators. James Jean, David Hughes, Tomer Hanuka, Sam Weber,
Esther Pearl Watson, Jack Unruh, Justin Wood, Jeffrey Smith, Gina Triplett
photo editor. Andrea Maurio. assistant photo editor. Nick Galac
publisher. Rodale. issue. October 2006. category. Illustration: Story

543. **THE NEW YORK TIMES MAGAZINE**

creative director. Janet Froelich. art director. Arem Duplessis
designer. Leo Jung. illustrator. Vania Zouravliov
editor-in-chief. Gerald Marzorati. publisher. The New York Times
issue. June 11, 2006. category. Illustration: Story


My Satirical Self

× × × × × × × ×

How making fun of absolutely everything
is defining a generation.
By Wyatt Mason

Lately, my father has been angry. Seventy-nine, a vet-
eran of the U.S. Navy, a lifelong dues-paying member of three labor unions and now a collector of Social Se-
curity, my father, temperamentally a gentle person, is often filled with rage. The news does this to him, not
so much the stories of tsunamis or hurricanes or any instances of environmental malice that lawyers call
"acts of God." No, acts of God fill my godless, liberal father with melancholy, if not sorrow, over the inequi-
ty of the world, whereas it is the iniquity of the world, what you might call "acts of man," that are, these
days, driving him to distraction. My father's solution to such furies, dependable as the daily newspaper, to
the anger that sets upon him when he learns of the latest folly in the corridors of power, is to turn to the op-
ed pages. For our purposes here, it hardly matters who is writing, though, naturally, he has his favorites.
What matters to him is that every day, in those well-reasoned column inches, he finds a mirror for his rage.
Whereas, over the same period, his son has managed not to be angry, not in the least. Thirty-seven, a

Illustration by Andrew Rae

72

544. **THE NEW YORK TIMES MAGAZINE**

creative director. Janet Froelich. art director. Arem Duplessis. designer. Josef Reyes. illustrator. Andrew Rae
editor-in-chief. Gerald Marzorati. publisher. The New York Times. issue. September 17, 2006. category. Illustration: Spread

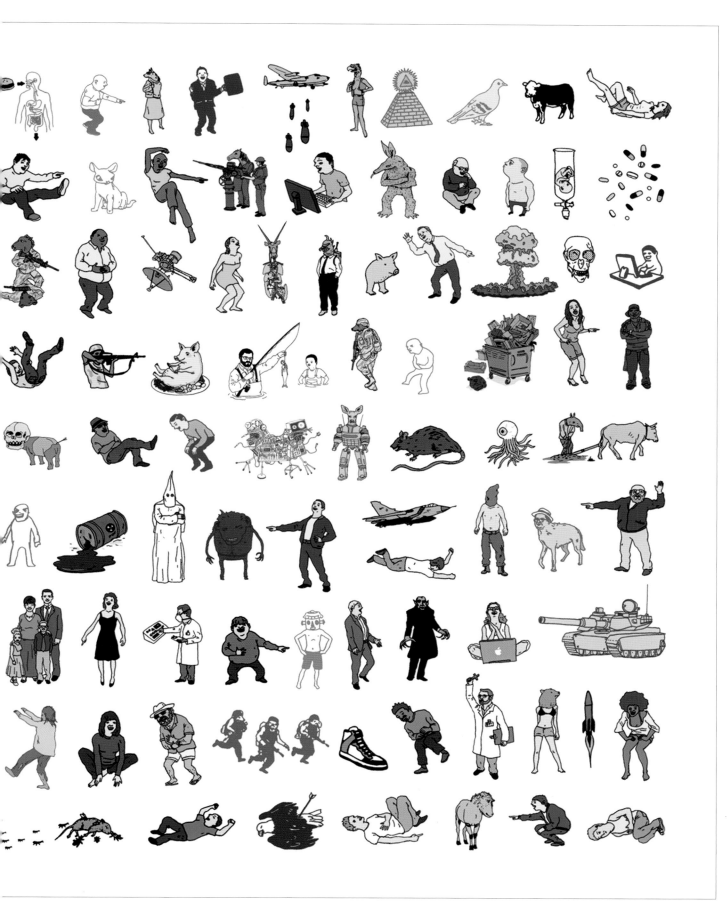

Cyber-Neologoliferation

In the age of
the Internet, the Oxford
English Dictionary is coming
face to face with the boundlessness of the English language.

By James Gleick

When I got to John Simpson and his band of lexicographers in Oxford earlier this fall, they were working on the P's. *Pletzel, plish, pod person, point-and-shoot, polyamorous* — these words were all new, one way or another. They had been plowing through the P's for two years but were almost done (except that they'll never be done), and the Q's will be "just a twinkle of an eye," Simpson said. He prizes patience and the long view. A pale, soft-spoken man of middle height and profound intellect, he is chief editor of the Oxford English Dictionary and sees himself as a steward of tradition dating back a century and a half. "Basically it's the same work as they used to do in the 19th century," he said. "When I started in 1976, we were still working very much on these index cards, everything was done on these index cards." He picked up a stack of 6-inch-by-4-inch slips and riffled through them. A thou-

Typography by Sam Winston

54

545. **THE NEW YORK TIMES MAGAZINE**

creative director. Janet Froelich. art director. Arem Duplessis. designer. Gail Bichler. illustrator. Sam Winston
editor-in-chief. Gerald Marzorati. publisher. The New York Times. issue. November 5, 2006. category. Illustration: Story

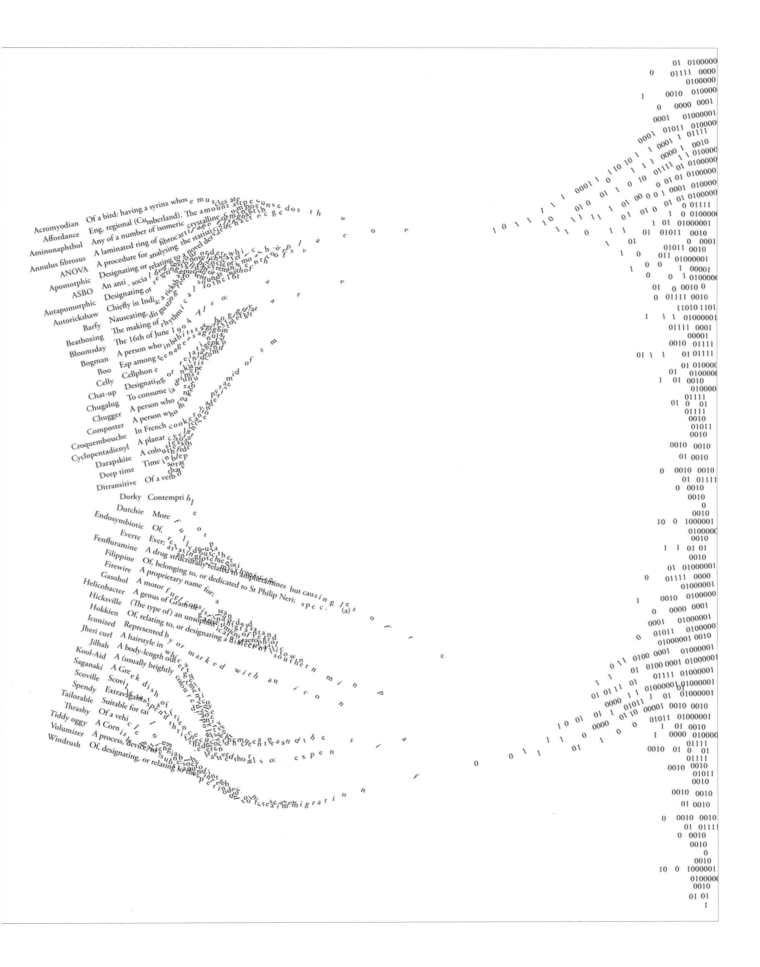

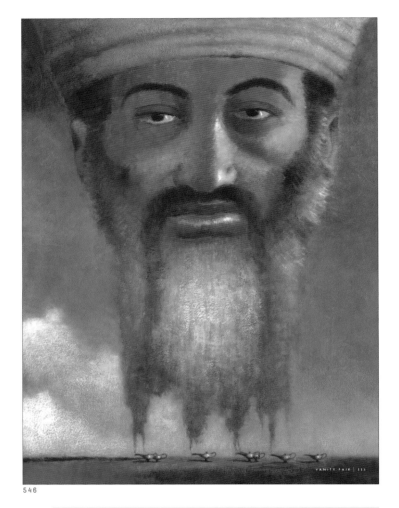

546

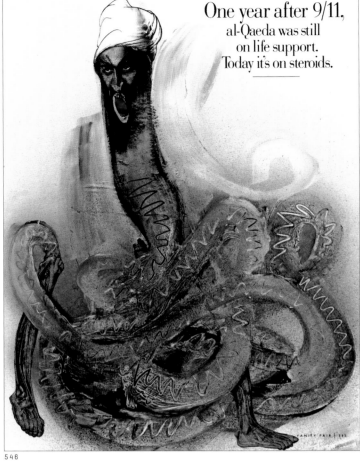

One year after 9/11,
al-Qaeda was still
on life support.
Today it's on steroids.

546

SPECIAL REPORT
CAREERS

07.17.06

Hot Skills, Cold Skills
Experts say the IT department of 2010 will be scouting the jobs. In four short years, a growing demand for IT skills to those with technology backgrounds who also know the business sector inside and out. PAGE 22

The World Gets Smaller Still
Savvy IT workers will turn globalization and a growing demand for IT skills to their advantage. Says Randy Carter, CIO at Cabot Corp., "It's ironic to see the industry change so quickly once again." PAGE 28

OPINION
IT Sweet Spots: 2010
What do Wayne Gretzky, Gebhard Leberecht von Blucher and Ross Perot have in common? They all have something illuminating to say about predicting the future, says columnist Thornton A. May. PAGE 42

The IT Profession:
2010

Here's a glimpse of what experts think the IT field will look like in four years — and some tips for getting prepared.

EDITOR'S NOTE

IN FOUR SHORT YEARS, the current class of college freshmen will be scouting for jobs. In four short years, a significant percentage of the working population will reach retirement age. In four short years, the makeup of the U.S. Congress and the White House will have changed. Four years can flit by in the blink of an eye, yet much is sure to happen in that time that will impact the IT field. Will you be ready?

We chose to thumb-tack this IT careers report on calendar year 2010. Experts predict major shifts in the IT profession by then: Boomer retirements will be in full swing, the next wave of college grads will be hitting the job market, and the line between IT departments and business units will be even more blurred. And then there's the expanding role of outsourcing, the ongoing H-1B-visa debates in Congress, and the unabating

merger and acquisition activity consolidating industries and IT staffs.

Our recent survey of 1,137 IT professionals shows a workforce worried about their future: Respondents cited outsourcing and the difficulty of keeping skills up to date as the two biggest threats to their jobs and careers. Yet they are willing to adapt to master that future: 91% said they would learn a new technical skill to help ensure prolonged employment.

Here's a certainty: IT workers will have to adapt to stay employed in 2010. Among other things, this special report aims to help you place your career bets, show you which skills will be hot and teach you how to turn globalization to your advantage.

So, will you be ready?

Ellen Fanning is special projects editor at Computerworld. She can be reached at ellen_fanning@computerworld.com.

547

COMPUTERWORLD July 17, 2006 www.computerworld.com

SPECIAL REPORT CAREERS

The IT worker of 2010 won't be a technology guru but rather a 'versatilist.'
By Stacy Collett

THE MOST sought-after corporate IT workers in 2010 may be those with no deep-seated technical skills at all. The nuts-and-bolts programming and easy-to-document support jobs will have all gone to third-party providers in the U.S. or abroad. Instead, IT departments will be populated with "versatilists" — those with a technology background who also know the business sector inside and out, can architect and carry out IT plans that will add business value, and can cultivate relationships both inside and outside the company.

That's the general consensus of three research groups that have studied the IT workforce landscape for 2010 — the year that marks the culmination of the decade of the versatile workforce. What's driving these changes? Several culprits include changes in consumer behavior, an increase in corporate mergers and acquisitions, outsourcing, the proliferation of mobile devices and growth in stored data.

What's more, the skills required to land these future technical roles will be honed outside of IT. Some of these skills will come from artistic talents, math excellence or even a knack for public speaking — producing a combination of skills not commonly seen in the IT realm.

On the edges of this new world, expertise in areas such as financial engineering, technology and mathematics will come together to form the next round of imaginative tools and technologies. Google Inc., eBay Inc. and Yahoo Inc. are already hiring math, financial analysis, engineering and technology gurus who will devise imaginative algorithms to fulfill users' online needs. And the National Academy of Sciences has identified a budding area of expertise that combines technology capabilities with artistic and creative skills, such as those found in computer gaming.

Hot Skills,
Cold Skills

547

546. **VANITY FAIR**

design director. David Harris. art director. Julie Weiss
illustrators. Brad Holland, Ralph Steadman, Mark Summers
editor-in-chief. Graydon Carter. publisher. Condé Nast Publications Inc.
issue. January 2006. category. Illustration: Story

547. **COMPUTERWORLD**

design director. Stephanie Faucher. designer. April O'Connor
illustrator. Melinda Beck. publisher. IDG
issue. July 17, 2006. category. Illustration: Story

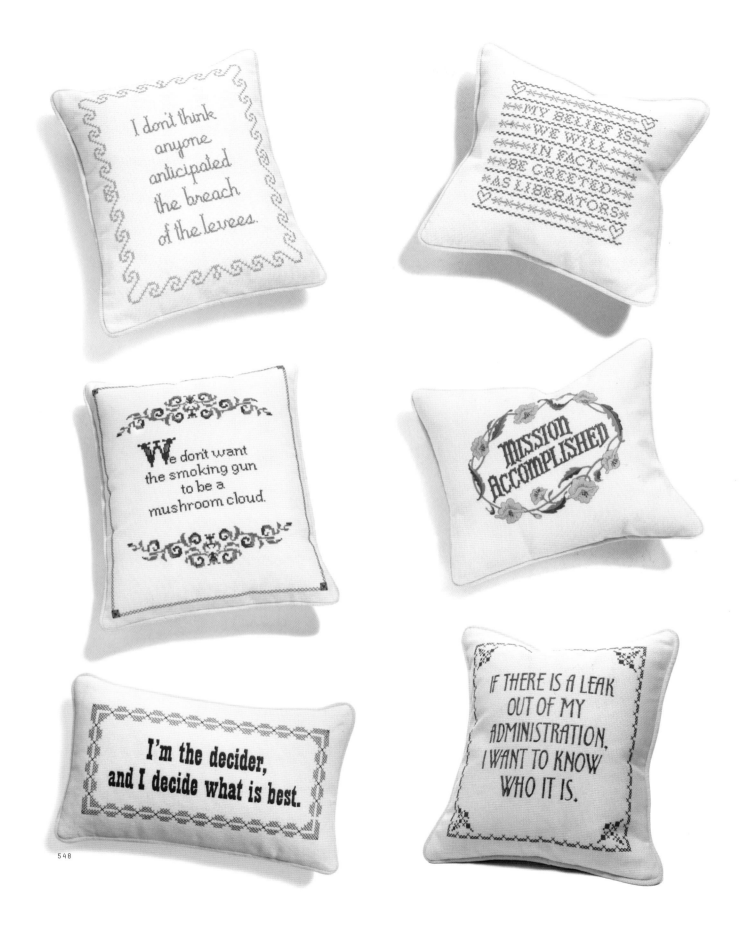

I don't think anyone anticipated the breach of the levees.

MY BELIEF IS WE WILL IN FACT, BE GREETED AS LIBERATORS

We don't want the smoking gun to be a mushroom cloud.

MISSION ACCOMPLISHED

I'm the decider, and I decide what is best.

IF THERE IS A LEAK OUT OF MY ADMINISTRATION, I WANT TO KNOW WHO IT IS.

548.

548. **VANITY FAIR**

design director. David Harris. art director. Julie Weiss. illustrator. Margaret Cusack editor-in-chief. Graydon Carter. publisher. Condé Nast Publications Inc. issue. July/August 2006. category. Illustration: Story

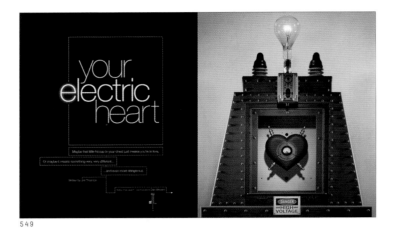

549

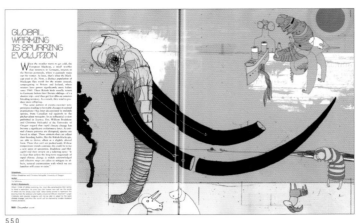

550

549

549

551

552

549. **BEST LIFE**

art director. Brandon Kavulla. designer. Brandon Kavulla
illustrators. Dan Winters, James Victore, Mirko Ilic
photo editor. Jeanne Graves. publisher. Rodale. issue. December 2006
category. Illustration: Story

551. **TOPIC MAGAZINE**

creative directors. Giampietro + Smith, Stella Bugbee
illustrator. Brian Rea. publisher. Topic Magazine
issue. December 2006. category. Illustration: Story

550. **SEED**

art director. Adam Billyeald. designers. Alice Cho, Jeffrey Docherty
illustrators. tra Selhtrow, Adam Billyeald, Sharon Molloy, Richard Sarson,
Marian Bantjes
editor-in-chief. Adam Bly. publisher. Seed Media Group
issue. December 2006/January 2007. category. Illustration: Story

552. **POSITIVE THINKING**

creative director. Francesca Messina. art director. Brendan Moran
designer. Glen Karpowich. illustrator. James Steinberg
publisher. Guideposts Publishing. issue. November/December 2006
category. Illustration: Story

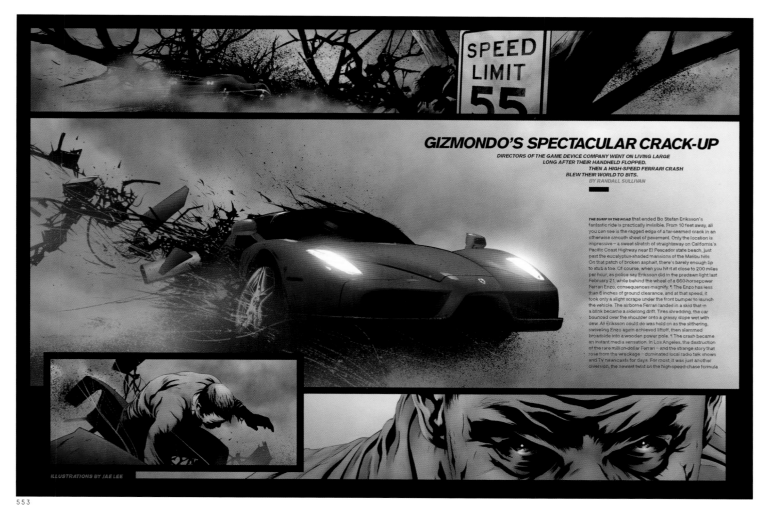

GIZMONDO'S SPECTACULAR CRACK-UP

**DIRECTORS OF THE GAME DEVICE COMPANY WENT ON LIVING LARGE
LONG AFTER THEIR HANDHELD FLOPPED.
THEN A HIGH-SPEED FERRARI CRASH
BLEW THEIR WORLD TO BITS.**
BY RANDALL SULLIVAN

THE BUMP IN THE ROAD that ended Bo Stefan Eriksson's
fantastic ride is practically invisible. From 10 feet away, all
you can see is the ragged edge of a tar-seamed crack in an
otherwise smooth sheet of pavement. Only the location is
impressive — a sweet stretch of straightaway on California's
Pacific Coast Highway near El Pescador state beach, just
past the eucalyptus-shaded mansions of the Malibu hills.
On that patch of broken asphalt, there's barely enough lip
to stub a toe. Of course, when you hit it at close to 200 miles
per hour, as police say Eriksson did in the predawn light last
February 21, while behind the wheel of a 660-horsepower
Ferrari Enzo, consequences magnify. ¶ The Enzo has less
than 6 inches of ground clearance, and at that speed, it
took only a slight scrape under the front bumper to launch
the vehicle. The airborne Ferrari landed in a skid that in
a blink became a sidelong drift. Tires shredding, the car
bounced over the shoulder onto a grassy slope wet with
dew. All Eriksson could do was hold on as the slithering,
swiveling Enzo again achieved liftoff, then slammed
broadside into a wooden power pole. ¶ The crash became
an instant media sensation. In Los Angeles, the destruction
of the rare million-dollar Ferrari — and the strange story that
rose from the wreckage — dominated local radio talk shows
and TV newscasts for days. For most, it was just another
diversion, the newest twist on the high-speed-chase formula

ILLUSTRATIONS BY JAE LEE

553

554

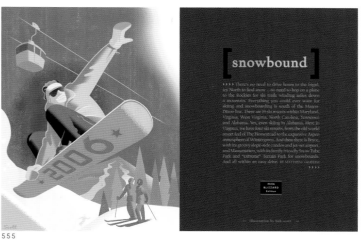

555

553. WIRED

creative director. Scott Dadich
art director. Jeremy LaCroix
designers. Jeremy LaCroix, Carl DeTorres
illustrator. Jae Lee
publisher. Condé Nast Publications, Inc.
issue. October 2006
category. Illustration: Story

554. CIO DECISIONS

art director. Linda Koury
illustrator. Serge Bloch
publisher. Techtarget
issue. December 2006
category. Illustration: Story

555. VIRGINIA LIVING MAGAZINE

art director. Tyler Darden
designer. Tyler Darden
illustrator. Bob Scott
publisher. Capefear Publishing
issue. February 2006
category. Illustration: Spread

Fifth Annual

MOViEs
for Grownups™

What is it with outsiders and misfits?
From Capote to Enron, from an
anguished intellectual to one
out-of-control ape, this year's winners
seem determined to chart their own
course, for better or for worse

By William R. Newcott • Illustrations by Roberto Parada

Best Movie for Grownups
Capote, directed by Bennett Miller

He stands there, an improbable man impeccably dressed, stark against the Midwest horizon. And to make matters worse, he has been told by his best friend to stay with the car. He's just too...well...*strange* to amble up to a Kansas farmhouse and ask to be let inside.

That's Truman Capote, the ultimate outsider, and this is the world into which he seemingly parachutes in *Capote*. It's a film with a meticulously narrow vision of a larger-than-life character, a guy who insists with a straight face, "I never lie," yet who lies with astonishing facility. The script, by Dan Futterman, is equally spare and majestic, like a Great Plains landscape. The Manhattan scenes crackle with cocktail banter and clinking glasses. The Heartland episodes unfold in some cinematic Central Time, full of measured words and thoughtful pauses. All crowned with one of the finest performances of this or any other year: Philip Seymour Hoffman, body and soul, as Truman Capote.

Thrilling in its composure, nail biting in its revelations, *Capote* is everything you could want in a movie for grownups. For the people of Holcomb, Kansas, the earth seemed to be coming off its axis when a local family was shotgunned to death in 1959. But when the flamboyant little man from New York City blew into town to write a story about the crime for *The New Yorker*, well, that just about tore it. Door by door Capote exposes his personal tragedies and insecurities to others—but only to disarm them into spilling their own secrets. "On the surface it's this elaborate story of a writer doing all

62 | **AARP** March&April 2006

Plains Dealer
As Capote,
Philip Seymour
Hoffman hits
the road.

PARADA

556

557

558

556. AARP THE MAGAZINE

design director. Courtney Murphy
deputy art director. Alanna Jacobs
designer. Courtney Murphy
illustrator. Roberto Parada
publisher. AARP Publications
issue. March/April 2006
category. Illustration: Story

557. CHICAGO TRIBUNE MAGAZINE

art directors. David Syrek, Joseph Darrow
illustrator. Nana Rausch
publisher. Chicago Tribune Company
issue. October 15, 2006
category. Illustration: Single Page

558. CHICAGO TRIBUNE MAGAZINE

art directors. David Syrek, Joseph Darrow
illustrator. Greg Clarke
publisher. Chicago Tribune Company
issue. November 19, 2006
category. Illustration: Single Page

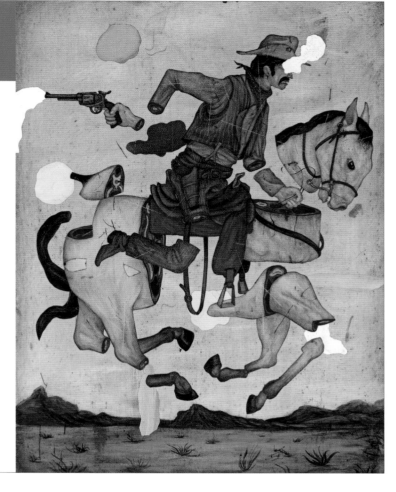

DVD
→ DISCS OF THE YEAR

① Sam Peckinpah's
Legendary Westerns
By Ken Tucker

This gathering of four very different Westerns directed by the late Peckinpah between 1962 and 1973 presents a wider, more inclusive vision of this genre than any other filmmaker's, and yes, I love John Ford and Howard Hawks, too. Peckinpah was so openhearted yet so cynical (he clearly loved the over-the-hill outlaws in his masterpiece *The Wild Bunch*, but knew their bad deeds doomed them to die grisly deaths), so celebratory yet so mournful (*Pat Garrett & Billy the Kid* is a bluesy folk elegy for the Old West and the Western itself, even without costar Bob Dylan's grandly dolorous soundtrack). Add the contemplative *Ride the High Country* and the boisterous *Ballad of Cable Hogue* and you get a fully imagined portrait not just of the West but of America, which Peckinpah, like so many great artists, saw as a place of endless opportunity and soul-crushing difficulty. The set has a stagecoach-full of extras and commentaries by some of the best Peckinpah analysts. But it also contains tremendously moving—and glowingly relevant—stories of friendship, romance, betrayal, confusion, despair, and elation... Well, you best get off your high horse, grab some grub, and gather round Sam Peckinpah's campfire.

"Sam Peckinpah was so openhearted yet so cynical, so celebratory yet so mournful."

② The Cary Grant Box Set
In a year that saw star-themed boxed sets go haywire—hey, who doesn't adore Jimmy Stewart, but did we really need a collection that includes *Firecreek* and *The Cheyenne Social Club*?—this was the classiest act from the movies' classiest male star. *The Cary Grant Box Set* is the crème de la Cary, from *His Girl Friday* (only the fastest, wittiest comedy ever filmed) to *Holiday* (only the most touching movie that Grant or costar Katharine Hepburn ever appeared in), plus three more worthies (*Only Angels Have Wings*, *The Talk of the Town*, *The Awful Truth*), all made between 1937 and 1942. Add shrewd comments from critic-historians David Thomson and Todd McCarthy and you've got a box of pure pleasure.

③ Pandora's Box
American actress Louise Brooks ascended into movie heaven as Lulu, the sensuous protagonist of G.W. Pabst's thrilling 1929 German silent film. Her ink-black hair cut with severe bangs, Lulu is irresistible to men, a wanton woman who knows exactly what she's doing...until she falls for Jack the Ripper. This superlative Criterion Collection package is half *Pandora*, half Louise: The second disc is given over to lengthy interviews and profiles of the charismatic actress; the small book enclosed includes the famous 1979 Kenneth Tynan *New Yorker* profile of Brooks that restored the then–nearly forgotten actress to prominence.

④ Reds 25th Anniversary Edition
For years, admirers of Warren Beatty's magisterial, sexy, knotty examination of journalist/American Communist John Reed have been awaiting its DVD release; it turns out that after 25 years, the movie has only increased in power and relevance. Beatty as Reed, Diane Keaton as his lover Louise Bryant (possibly her finest performance ever), and Jack Nicholson as Eugene O'Neill (back when Nicholson was still acting, not doing variations on Jack Nicholson the Oscar-Night Crazy Guy) all

112 2006 YEAR-END SPECIAL

ILLUSTRATION BY JASON HOLLEY

AROUND MY HOUSE ⊘

Any Tool Will Do
» That was pretty much my dad's home-repair motto. Of course, he knew child labor could accomplish a lot, too

BY CHUCK EICHTEN ILLUSTRATIONS BY SERGE BLOCH

Dad thought tools were like dinner utensils. If you have venison for dinner, you don't use your "venison utensils," you big baby.

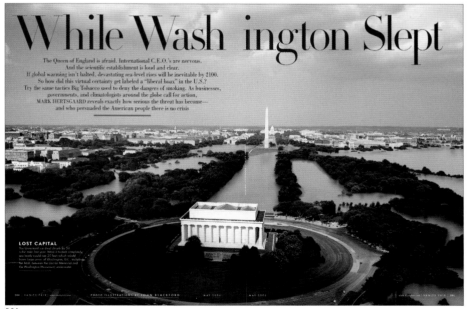

While Wash ington Slept

The Queen of England is afraid. International C.E.O.'s are nervous. And the scientific establishment is loud and clear. If global warming isn't halted, devastating sea-level rises will be inevitable by 2100. So how did this virtual certainty get labeled a "liberal hoax" in the U.S.? Try the same tactics Big Tobacco used to deny the dangers of smoking. As businesses, governments, and climatologists around the globe call for action, MARK HERTSGAARD reveals exactly how serious the threat has become— and who persuaded the American people there is no crisis

LOST CAPITAL

PHOTO ILLUSTRATIONS BY JOHN BLACKFORD

559. **ENTERTAINMENT WEEKLY**
design director. Geraldine Hessler
art director. Brian Anstey
managing art director. Jennie Chang
illustrators. Yuko Shimizu, Jason Holley, Tavis Coburn, Sophie Toulouse, Tomer Hanuka, David Hughes
director of photography. Fiona McDonagh
managing editor. Rick Tetzeli. publisher. Time Inc.
issue. Decmber 29, 2006 - January 5, 2007
category. Illustration: Story

560. **THIS OLD HOUSE**
design director. Amy Rosenfeld
art director. Hylah Hill
designer. Amy Rosenfeld
illustrator. Serge Bloch
director of photography. Denise Sfraga
publisher. Time Inc. issue. June 2006
category. Illustration: Story

561. **VANITY FAIR**
design director. David Harris
art director. Julie Weiss
illustrator. John Blackford
editor-in-chief. Graydon Carter
publisher. Condé Nast Publications Inc.
issue. May 2006
category. Illustration: Story

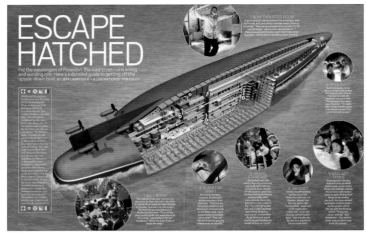

562

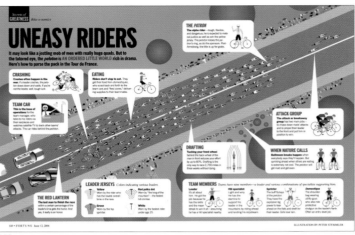

563

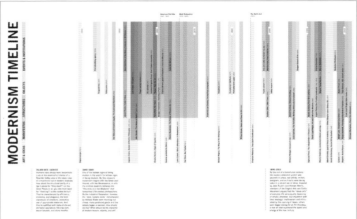

564

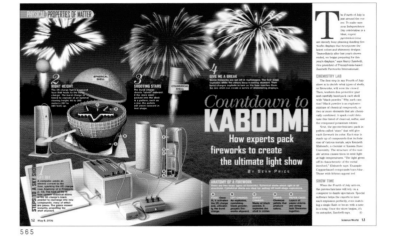

565

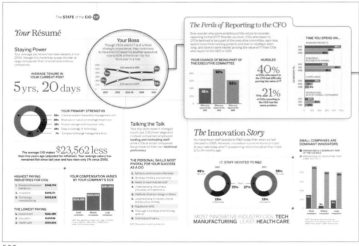

566

562. **ENTERTAINMENT WEEKLY**

design director. Geraldine Hessler
designer. Evan Campisi
illustrator. Dan Foley
director of photography. Fiona McDonagh
managing editor. Rick Tetzeli
publisher. Time Inc. issue. May 26, 2006
category. InfoGraphics: Spread

563. **FORTUNE**

design director. Robert Newman
art directors. John Tomanio, Linda Rubes
illustrator. Peter Stemmler
publisher. Time Inc.
issue. June 12, 2006
category. InfoGraphics: Spread

564. **DWELL**

creative director. Claudia Bruno
designers. Brendan Callahan, Emily CM Anderson
director of photography. Kate Stone
photo editors. Deborah Kozloff Hearey, Aya Brackett
publisher. Dwell LLC
issue. July/August 2006
category. InfoGraphics: Story

565. **SCIENCE WORLD**

creative director. Judith Christ-Lafond
art director. Felix Batcup
illustrator. Robert Kayganich
editor-in-chief. Patricia Janes
publisher. Scholastic, Inc.
issue. May 8, 2006
category. InfoGraphics: Story

566. **CIO MAGAZINE**

creative director. Mary Lester
art director. Matt Goebel
publisher. CXO Media
issue. December 15, 2006 / January 1, 2007
category. InfoGraphics: Story

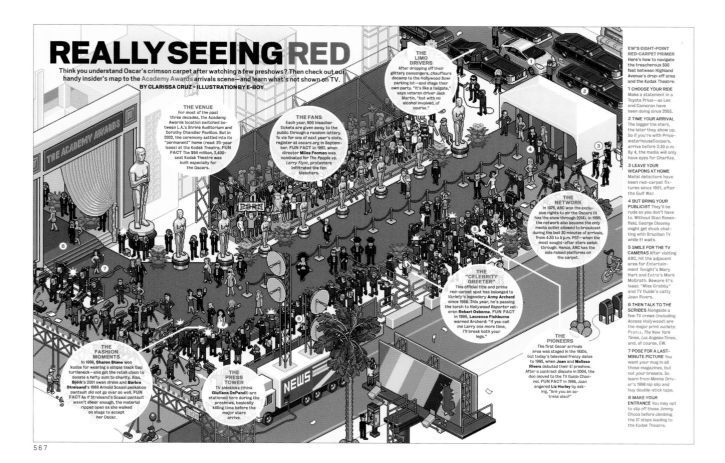

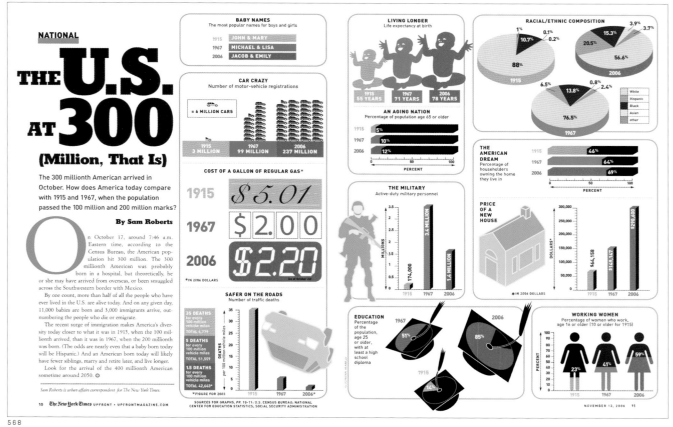

567. **ENTERTAINMENT WEEKLY**

design director. Geraldine Hessler. designers. William Hooks, Eric Paul
illustrator. Eboy. director of photography. Fiona McDonagh
managing editor. Rick Tetzeli. publisher. Time Inc.
category. InfoGraphics: Spread

568. **NEW YORK TIMES UPFRONT**

creative director. Judith Christ-Lafond. art director. Valerie Trucchia
illustrator. McKibillo. studio. Scholastic Inc. editor-in-chief. Elliott Rebhun
publisher. Scholastic Inc. issue. November 13, 2006
category. InfoGraphics: Spread

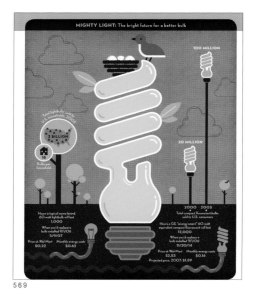

569

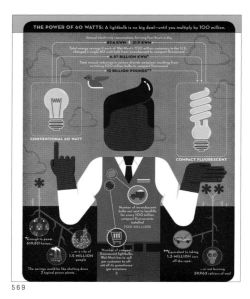

569

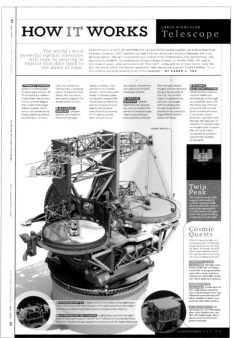

570

571

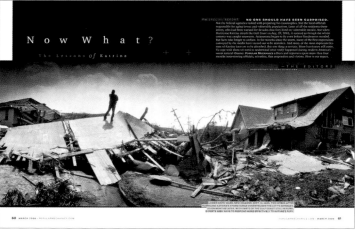

572

569. **FAST COMPANY**

art director. Dean Markadakis. designer. Lisa Kelsey
illustrator. Head Case Design
publisher. Mansueto Ventures, LLC
issue. September 2006. category. InfoGraphics: Story

571. **POPULAR MECHANICS**

design director. Michael Lawton. art director. Peter Herbert
designers. Michael Friel, Agustin Chung. illustrator. Headcase Design
director of photography. Allyson Torrisi. photo editor. Alison Unterreiner
publisher. The Hearst Corporation-Magazines Division
issue. May 2006. category. InfoGraphics: Story

570. **POPULAR MECHANICS**

design director. Michael Lawton. art director. Peter Herbert
designers. Michael Friel, Agustin Chung. director of photography. Allyson Torrisi
photo editor. Alison Unterreiner. photographer. Razro
publisher. The Hearst Corporation-Magazines Division. issue. May 2006
category. InfoGraphics: Single Page

572. **POPULAR MECHANICS**

design director. Michael Lawton. art director. Peter Herbert
designers. Michael Friel, Agustin Chung
illustrators. Bland Designs, Flying Chilli, Razro, Agustin Chung
director of photography. Allyson Torrisi. photo editor. Alison Unterreiner
photographer. Teru Kuwayama
publisher. The Hearst Corporation-Magazines Division
issue. March 2006. category. InfoGraphics: Story

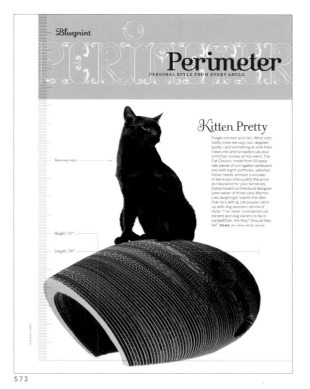

573

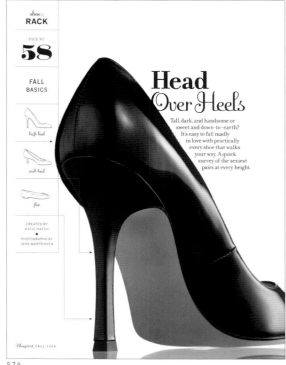

574

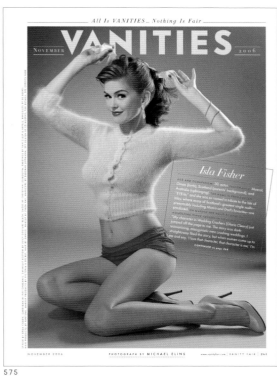

575

575

573. **BLUEPRINT**

creative director. Eric A. Pike
design director. Deb Bishop
art directors. Cybele Grandjean, Jennifer Merrill
designers. Gemma Comas, Karl Juengel,
Jens Mortensen
director of photography. Heloise Goodman
photo editors. Rebecca Donnelly, Sara McOsker
photographers. Karl Juengel, Jens Mortensen,
Gemma Comas. styled by. Brittany Williams,
Kendra Smoot. editor-in-chief. Sarah Humphreys
publisher. Martha Stewart Living Omnimedia
issue. Fall 2006. category. Design: Front/Back of Book

574. **BLUEPRINT**

creative director. Eric A. Pike
design director. Deb Bishop
art director. Jennifer Merrill
director of photography. Heloise Goodman
photo editors. Rebecca Donnelly, Sara McOsker
photographers. Karl Juengel, Jens Mortensen
styled by. Johannah Masters
editor-in-chief. Sarah Humphreys
publisher. Martha Stewart Living Omnimedia
issue. Fall 2006
category. Design: Front/Back of Book

575. **VANITY FAIR**

design director. David Harris
art director. Julie Weiss
designer. Angela Panichi
director of photography. Susan White
editor-in-chief. Graydon Carter
publisher. Condé Nast Publications Inc.
issue. November 2006
category. Design: Front/Back of Book

576

576

578

577

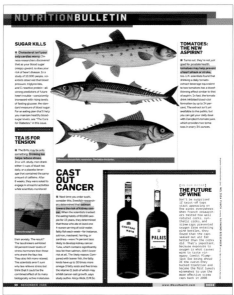

577

578

{CONTENTS}
VOLUME 2, NUMBER 6

CONTRIBUTORS

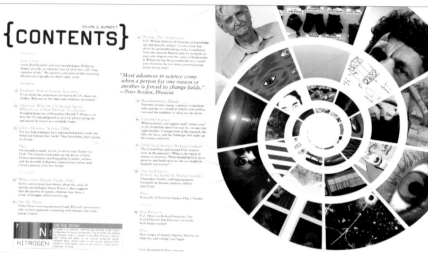

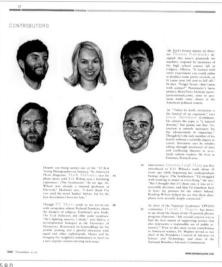

579

579

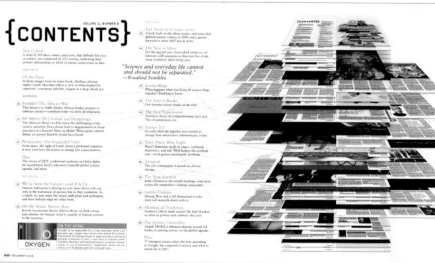

580

580

581

581

579. **SEED**

art director. Adam Billyeald
designers. Jeffrey Doherty, Brian E. Smith
illustrator. Bernd Schifferdecker
editor-in-chief. Adam Bly
publisher. Seed Media Group
issue. August/September 2006
category. Design: Front/Back of Book

580. **SEED**

art director. Adam Billyeald
designer. Brian E. Smith
illustrator. Bernd Schifferdecker
editor-in-chief. Adam Bly
publisher. Seed Media Group
issue. October/November 2006
category. Design: Front/Back of Book

581. **SEED**

art director. Adam Billyeald
designers. Alice Cho, Jeffrey Docherty
illustrator. Bernd Schifferdecker
editor-in-chief. Adam Bly
publisher. Seed Media Group
issue. December 2006/January 2007
category. Design: Front/Back of Book

582

582

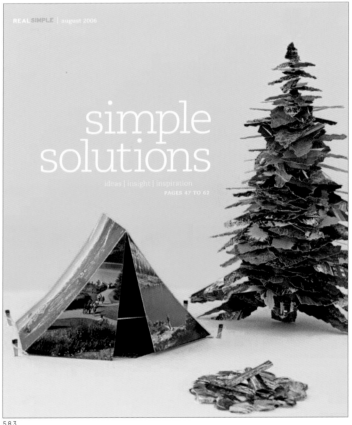

583

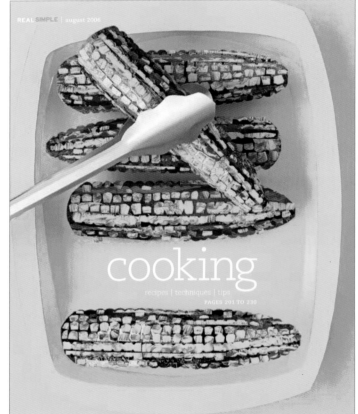

583

582. **REAL SIMPLE**

creative director. Vanessa Holden. design director. Eva Spring
illustrator. Matthew Sporzynski. director of photography. Naomi Nista
photo editor. Daisy Cajas. photographer. Monica Buck. publisher. Time Inc.
issue. July 2006. category. Design: Front/Back of Book

583. **REAL SIMPLE**

creative director. Vanessa Holden. design director. Eva Spring
illustrator. Matthew Sporzynski. director of photography. Naomi Nista
photo editor. Daisy Cajas. photographer. Monica Buck. publisher. Time Inc.
issue. August 2006. category. Design: Front/Back of Book

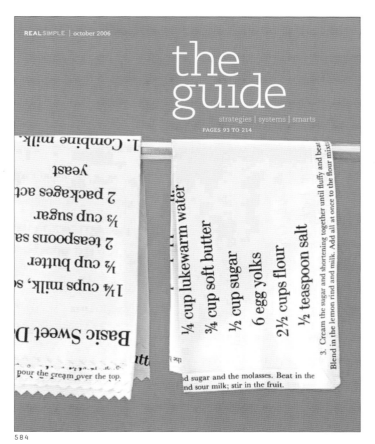

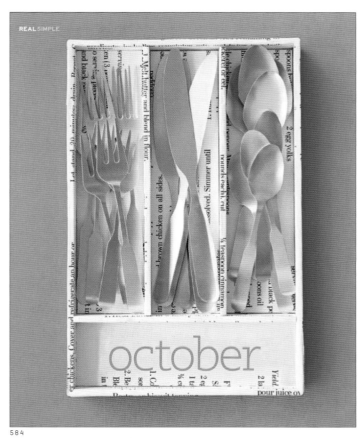

584. **REAL SIMPLE**

creative director. Vanessa Holden. design director. Eva Spring
illustrator. Matthew Sporzynski. director of photography. Naomi Nista
photo editor. Daisy Cajas. photographer. Monica Buck. publisher. Time Inc.
issue. October 2006. category. Design: Front/Back of Book

585. **REAL SIMPLE**

creative director. Vanessa Holden. design director. Eva Spring
illustrator. Matthew Sporzynski. director of photography. Naomi Nista
photo editor. Daisy Cajas. photographer. Monica Buck. publisher. Time Inc.
issue. November 2006. category. Design: Front/Back of Book

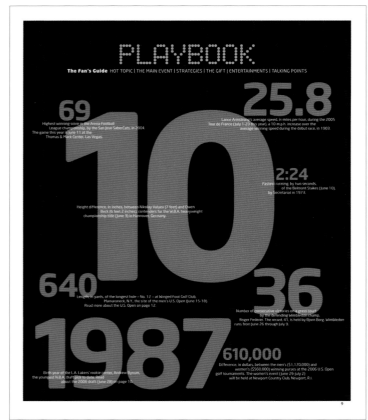

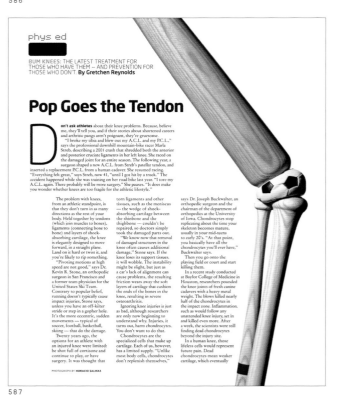

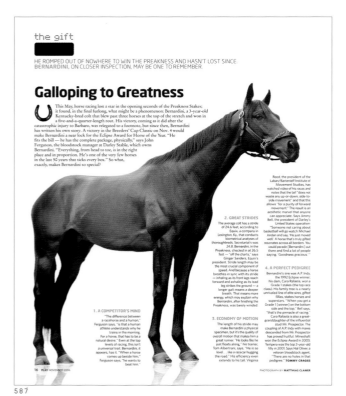

586. **PLAY, THE NY TIMES SPORT MAGAZINE**

creative director. Janet Froelich
art director. Christopher Martinez
designer. Dragos Lemnei
director of photography. Kathy Ryan
photo editor. Kira Pollack
editor-in-chief. Mark Bryant
publisher. The New York Times
issue. June 2006
category. Design: Front/Back of Book

587. **PLAY, THE NY TIMES SPORT MAGAZINE**

creative director. Janet Froelich
art director. Dirk Barnett. designer. Dragos Lemnei
director of photography. Kathy Ryan
photo editor. Kira Pollack
editor-in-chief. Mark Bryant
publisher. The New York Times
issue. November 2006
category. Design: Front/Back of Book

588. **BEST LIFE**

art director. Brandon Kavulla
designers. Brandon Kavulla, Heather Jones,
Dena Verdesca
director of photography. Nell Murray
photo editor. Jeanne Graves
photographer. Jens Mortensen
publisher. Rodale. issue. July 2006
category. Design: Front/Back of Book

588

588

588

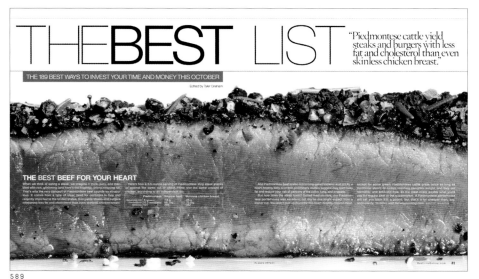

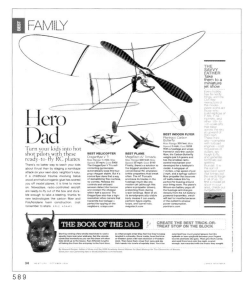

589

589

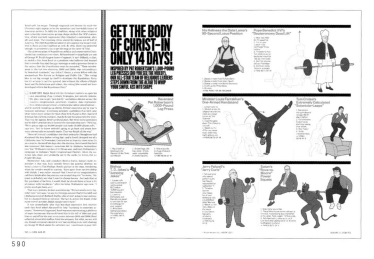

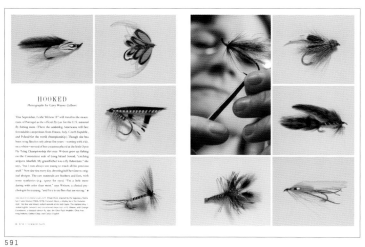

590

591

589. **BEST LIFE**

art director. Brandon Kavulla
designers. Brandon Kavulla, Heather Jones,
Dena Verdesca. illustrator. Richard Holiday
director of photography. William Nabers
photo editor. Jeanne Graves
photographers. Plamen Petkov, James Westman
publisher. Rodale. issue. October 2006
category. Design: Front/Back of Book

590. **GQ**

design director. Fred Woodward
designer. Thomas Alberty
illustrator. Jason Lee
publisher. Condé Nast Publications Inc.
issue. August 2006
category. Design: Front/Back of Book

591. **BOSTON COLLEGE MAGAZINE**

design director. Elizabeth Brandes
director of photography. Gary Wayne Gilbert
photographer. Gary Wayne Gilbert
editor-in-chief. Ben Birnbaum
publisher. Boston College
issue. Spring 2006
category. Design: Front/Back of Book

(SEX)

*URETHRA! I FOUND IT!

We'll assume you've heard of it, and that you have some vague idea where it's located, and that you've tried to minister to it. Adam Stein goes in search of the mysterious G-spot. His discoveries will marvel, amaze, and educate

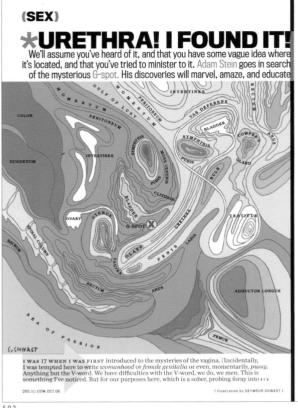

I WAS 17 WHEN I WAS FIRST introduced to the mysteries of the vagina. (Incidentally, I was tempted here to write *womanhood* or *female genitalia* or even, momentarily, *pussy.* Anything but the V-word. We have difficulties with the V-word, we do, we men. This is something I've noticed. But for our purposes here, which is a sober, probing foray into >>>

260.GQ.COM.OCT.06

(Illustration by SEYMOUR CHWAST)

592

(THE CRITIC)

With the man they cheered into the White House suddenly looking not so cheery, Fox News and other Bush boosters are now taking it on the chin. Tom Carson flings himself into the No Spin Zone, pores over 'The Colbert Report,' and finds a rabid new underdog in the making

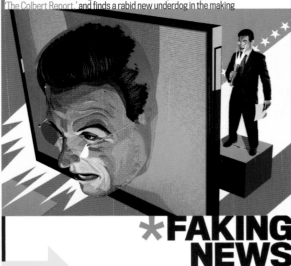

*FAKING NEWS

YEARS FROM NOW, before they grab their gas masks to head out for that 140-degree Christmas break in what's left of Vermont, your children may be puzzled to discover that Stephen Colbert's act on *The Colbert Report* originated as a parody of some guy they've never heard of. "Bill who?" they'll ask. "Dad, you mean that hairy old Times Square vagrant who's always hassling tourists at the David Blaine memorial is telling the *truth* about how important he used to be?" >>>

(Illustration by TAVIS COBURN)

AUG.06.GQ.COM.79

593

(THE CRITIC)

In 'The King,' Gael García Bernal plays a lusty sailor who lets loose on a preacher's family and upsets everybody's ideas about the Father, the Son, and the Holy Ghost—including yours by Tom Carson

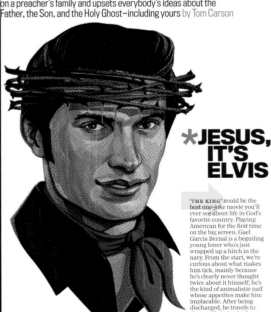

*JESUS, IT'S ELVIS

'THE KING' could be the best one-joke movie you'll ever see about life in God's favorite country. Playing American for the first time on the big screen, Gael García Bernal is a beguiling young loner who's just wrapped up a hitch in the navy. From the start, we're curious about what makes him tick, mainly because he's clearly never thought twice about it himself; he's the kind of animalistic naïf whose appetites make action implacable. After being discharged, he travels to Corpus Christi to look up pastor David Sandow >>>

(Illustration by TAVIS COBURN)

JUN.06.GQ.COM.105

594

(THE CRITIC)

Remember when sitcoms were dominated by cute singles and know-it-all yuppies? Now, TV's best comedies, like My Name Is Earl and The Office, celebrate trailer trash and hapless clock-watchers. And as Tom Carson explains, they've saved the art form

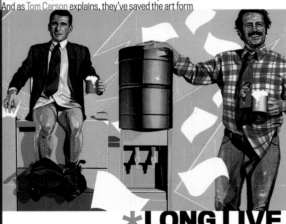

*LONG LIVE THE DEAD SITCOM

'MY NAME IS EARL' is the first sitcom in years that you can imagine Toby Keith and Kurt Vonnegut happily watching together, which just proves that TV with something for everybody ain't always so bad. It's a lot rarer than it should be for a series to combine so much real affection for American nonsense with this kind of sardonic slyness, so if your love of country could use a booster shot, you could do worse than tune in. You didn't really want to spend the rest of your sitcom life just watching interchangeable sets of college-educated simps swapping brand-name banter, now did you? >>>

(Illustration by TAVIS COBURN)

MAY.06.GQ.COM.103

595

592. **GQ**

design director. Fred Woodward
designer. Ken DeLago
illustrator. Seymour Chwast
publisher. Condé Nast Publications Inc.
issue. May 2006
category. Design: Front/Back of Book

593. **GQ**

design director. Fred Woodward
designer. Ken DeLago. illustrator. Tavis Coburn
director of photography. Dora Somosi
publisher. Condé Nast Publications Inc.
issue. August 2006
category. Design: Front/Back of Book

594. **GQ**

design director. Fred Woodward
designer. Ken DeLago
illustrator. Tavis Coburn
publisher. Condé Nast Publications Inc.
issue. June. 2006
category. Design: Front/Back of Book

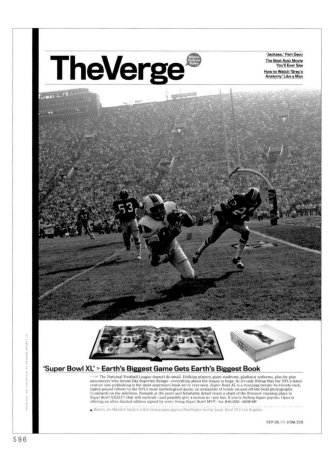

595. **GQ**

design director. Fred Woodward. designer. Ken DeLago
illustrator. Tavis Coburn. publisher. Condé Nast Publications Inc.
issue. May 2006. category. Design: Front/Back of Book

596. **GQ**

design director. Fred Woodward. designer. Thomas Alberty
illustrators. John Ritter, Jason Lee. director of photography. Dora Somosi
senior photo editor. Krista Prestek. photo editor. Jolanta Bielat
photographer. Wayne Maser. publisher. Condé Nast Publications Inc.
issue. September 2006. category. Design: Front/Back of Book

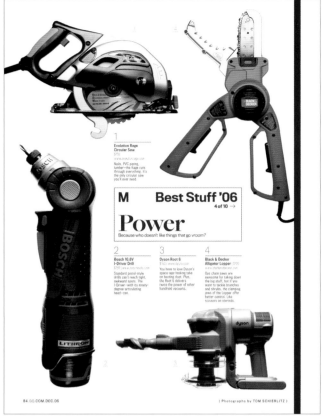

Manual
Look Sharp | Live Smart

GQ

Best Stuff
'06

The essential gear, gadgets, and accessories that will allow you to travel effortlessly, cook brilliantly, drive cleanly, and more

597

M **Best Stuff '06**
4 of 10 →

Power
Because who doesn't like things that go vroom?

597

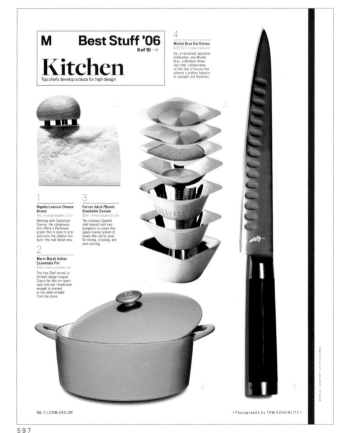

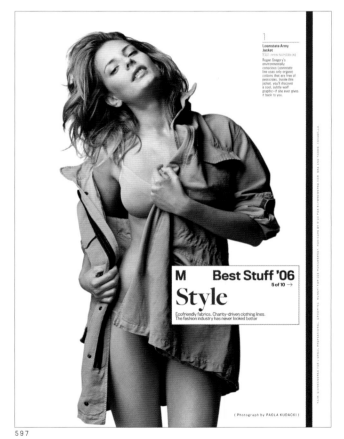

M **Best Stuff '06**
8 of 10 →

Kitchen
Top chefs develop a taste for high design

(Photographs by TOM SCHIERLITZ)

597

M **Best Stuff '06**
5 of 10 →

Style
Ecofriendly fabrics. Charity-driven clothing lines. The fashion industry has never looked better.

(Photograph by PAOLA KUDACKI)

597

597. **GQ**

design director. Fred Woodward. designer. Anton loukhnovets. illustrators. Knickerbocker Design, Nick Dewar
director of photography. Dora Somosi. photo editors. Justin O'Neill, Jesse Lee
photographers. Tom Schierlitz, Paloa Kudacki, Scott Schuman, Jason Nocito, Kenneth Capello, James Wojcik
publisher. Condé Nast Publications Inc. issue. December 2006. category. Design: Front/Back of Book

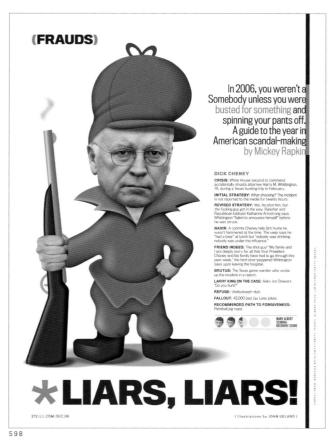

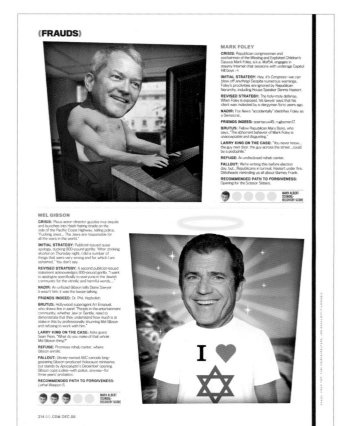

598

598

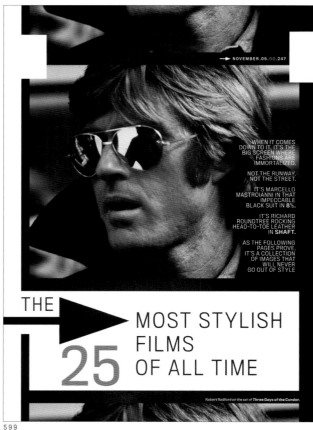

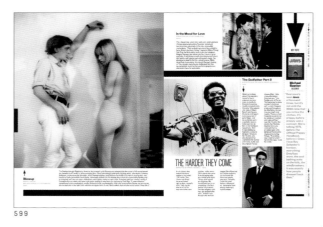

599

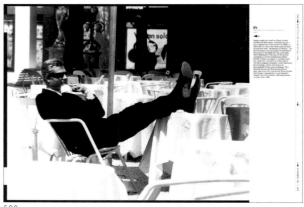

599

599

598. **GQ**

design director. Fred Woodward
art director. Ken DeLago. designer. Drue Wagner
illustrator. John Ueland. publisher. Condé Nast Publications Inc.
issue. December 2006. category. Design: Front/Back of Book

599. **GQ**

design director. Fred Woodward
designer. Thomas Alberty. director of photography. Dora Somosi
photo editor. Jolanta Bielat. publisher. Condé Nast Publications Inc.
issue. November 2006. category. Design: Front/Back of Book

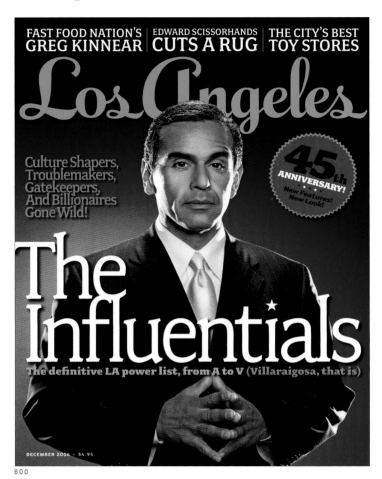

600

600

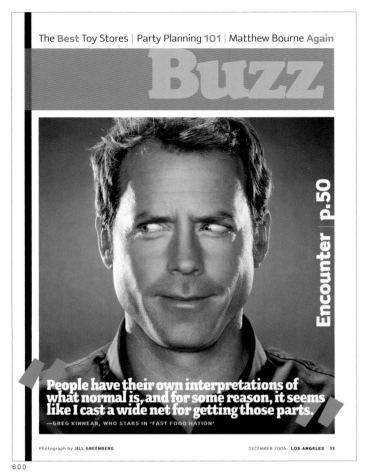

601

602

600. **LOS ANGELES**

art director. Joe Kimberling
designers. Lisa M. Lewis, Steven E. Banks, Debbie
Kim. illustrator. Peter Hoey
photo editor. Kathleen Clark
deputy art director. Lisa M. Lewis
editor-in-chief. Kit Rachlis. publisher. Emmis
issue. December 2006. category. Design: Redesign

601. **RADIO AND RECORDS**

creative director. Josh Klenert
design director. Anthony D'Elia
art directors. Ray Carlson, Chris Bonavita
designer. Kevin Limongelli
illustrator. Kun-Sung Chung. studio. Big Designs
Inc. editor-in-chief. Scott McKenzie
publisher. VNU Business Media
issue. August 11, 2006. category. Design: Redesign

602. **ARCCA**

design director. Bob Aufuldish
designers. Ragina Johnson
photographer. Eric R. Keune, AIA
studio. Aufuldish & Warinner
editor-in-chief. Tim Culvahouse
publisher. McGraw-Hill/AIACC
client. American Institute of Architects California
Council. issue. 2006.03. category. Design: Redesign

603

603

604

604

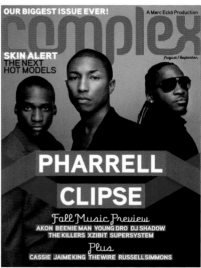

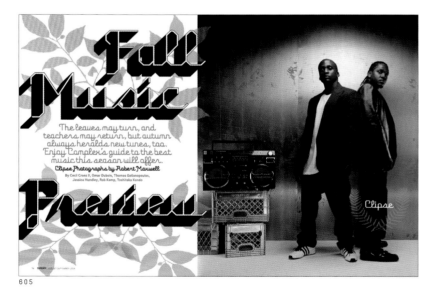

605

605

603. **VUELO**

creative director. Guillermo Caballero
art director. Roberto Gutiérrez
designers. José Blenda, Débora Martinez
photo editor. Ilán Rabchinskey
editor-in-chief. Rafael Lafarga
publisher. Grupo Editorial Expansión
issue. August 2006. category. Design: Redesign

604. **SCULPTURE**

art director. Eileen Schramm
photographers. Mark Wilson, Josh Nefsky
studio. Eileen Schramm visual communications
editor-in-chief. Glenn Harper
publisher. International Sculpture Center
client. Sculpture Magazine
issue. September 2006. category. Design: Redesign

605. **COMPLEX**

art director. Sean Bumgarner
designers. Jimmy Chung, Jordan Hadley, Tim Leong
director of photography. Matt Doyle
photo editor. Tina Greenberg
editor-in-chief. Richard Martin
publisher. Ecko. issue. August 2006
category. Design: Redesign

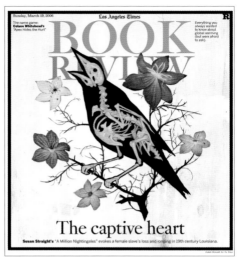

606

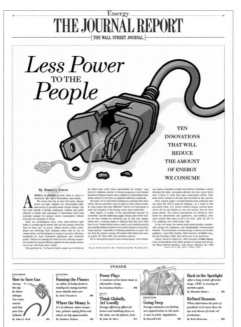

607

608

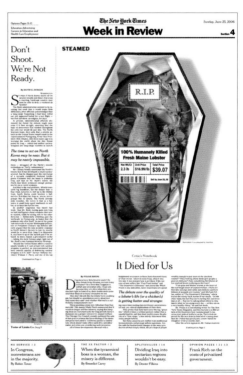

609

610

611

606. **LOS ANGELES TIMES BOOK REVIEW**

design director. Christian Potter-Drury
art director. Wesley Bausmith
designers. Wesley Bausmith, Carol Kaufman
illustrator. Jason Holley
publisher. Tribune Company
issue. March 19, 2006
category. Design: Front Page, Newspaper

609. **THE NEW YORK TIMES**

design director. Tom Bodkin
art director. Nicholas Blechmann
illustrator. Ji Lee
photographer. Daniel Root
publisher. The New York Times
issue. June 25, 2006
category. Design: Front Page, Newspaper

607. **THE WALL STREET JOURNAL**

art director. Orlie Kraus
illustrator. Christoph Niemann
publisher. Dow Jones & Co., Inc.
issue. October 16, 2006
category. Design: Front Page, Newspaper

610. **THE BOSTON GLOBE**

design director. Dan Zedek
art director. Greg Klee
designer. Greg Klee
publisher. The New York Times Co.
issue. January 22, 2006
category. Design: Front Page, Newspaper

608. **THE NEW YORK TIMES BOOK REVIEW**

design director. Tom Bodkin
art director. Nicholas Blechmann
illustrator. Abbott Miller
publisher. The New York Times
issue. November 26, 2006
category. Design: Front Page, Newspaper

611. **THE NEW YORK TIMES**

design director. Tom Bodkin
art director. Rodrigo Honeywell
illustrator. Rodrigo Corral
publisher. The New York Times
issue. May 14, 2006
category. Design: Front Page, Newspaper

612

614

613

615

612. **EW.COM**

creative director. Lisa Michurski
design director. Dmitry Paperny
lead visual designer. Jeffrey Jouppi
director of interaction design. Dixon Rohr
visual designer. Patricia Marroquin
lead interaction designer. Tobi Jo Langmo
interaction designer. Inbar Barak
managing editor. Jay Woodruff
project manager. Hooshere Bezdikian
publisher. Time Inc.
online address. www.ew.com. category. Online: Site
associated with a print publication

613. **DWELL**

creative director. Claudia Bruno
designer. Punchcut
photo editor. Kate Stone
online director. Perry Nelson
online editor. Christina Amini
developer. Clickability
publisher. Dwell LLC
online address. www.dwell.com
category. Online: Redesign

614. **TIME.COM**

director of photography. Michele Stephenson
photo editors. Mark Rykoff, Maria Bunai
photographer. Robert Nickelsberg (Getty)
publisher. Time Inc.
online address. www.time.com
issue. 2006. category. Online: Photography

615. **THE NEW YORK TIMES**

designers. Shan Carter, Aron Pilhofer,
Andy Lehren, Jeff Damens
graphics director. Steve Duenes
deputy graphics editor. Matthew Ericson
publisher. The New York Times
category. Online: Home Page Design

THE JUDGES

Fiona McDonagh
(Newsstand Co-Chair)
Director of Photography
Entertainment Weekly

Scott Dadich
Creative Director
Wired

Lance Pettiford
Art Director
The Washingtonian

George Karabotsos
(Newsstand Co-Chair)
Design Director
Men's Health

Wyatt Mitchell
Art Director
O, The Oprah Magazine

Michael Grossman
Editorial & Design
Consultant

Mitch Shostak
(Non-Newsstand Co-Chair)
Creative Director
Shostak Studios

Amid Capeci
Assistant Managing
Editor, Design
Newsweek

George Pitts
Director of Photography

Bruce Ramsay
Director of Covers
Newsweek

Dora Somosi
Director of Photography
GQ

TJ Tucker
Art Director
Texas Monthly

Deb Bishop
Design Director
Blueprint

Nathalie Kirsheh
Art Director
W

Rob Hewitt
Art Director

Jody Quon
Director of Photography
New York

Victor Williams
Art Director
Financial Week

David Whitmore
Senior Design Editor
National Geographic

Davia Smith
Art Director
Money

Maxine Davidowitz
Creative Director
More

Brandon Kavulla
Art Director
Best Life

Audrey Landreth
Deputy Director
of Photography
Entertainment Weekly

Jennifer Procopio
Art Director
InStyle

Peter Yates
Art Director

Brian Rea
Illustrator
& Art Director
Op-Ed Page
The New York Times

Gretchen Smelter
Design Director
Brides

Jonathan Hoefler
Hoefler & Frere-Jones

Lina Kutsovskaya
Art Director
Teen Vogue

Amy Rosenfeld
Design Director
This Old House

James Dunlinson
Design Director
Martha Stewart Living

Courtney Murphy,
Design Director
Good Housekeeping

Sharon Ludtke
Director of Design
Crushpad Winery

Stephen Scoble
Creative Director
Food & Wine

Jill Armus
Creative Director
Prevention

Paul Martinez
Design Director
Men's Journal

Brian Anstey
Art Director
Entertainment Weekly

photographs by **Mike McGregor**

Stacie McCormick
Director of Photography
Domino

Brian Johnson
Art Director
Minnesota Monthly

Mark Heflin
Director
American Illustration
& American Photography

Joe Kimberling
Art Director
Los Angeles Magazine

David Curcurito
Design Director
Esquire

Josh Klenert
Creative Director
Billboard

Robert Perino
Design Director
Fortune

Simon Barnett
Director of Photography
Newsweek

Laura Baer
Studio LB

Don Kinsella
Photo Edior
Travel & Leisure Golf

Robert Festino
Art Director
ESPN

Darren Ching
Creative Director
Photo District News

Jennifer Laski
Director of Photography
Departures

Bernard Scharf
Creative Director
Departures

Paul Schrynemakers
Creative Director
Rodale Interactive

Tim Davin
Art Director
Canadian Business Magazine

Kira Pollack
Photo Editor
The New York Times Magazine

Andrea Dunham
Design Director
Women's Health

Joan Ferrell
Art Director
American Lawyer Media

Linda Root
[Magazine of the Year Chair]
Principal
Studio Incubate

Brittain Stone
Director of Photography
US Weekly

Francesca Messina
Creative Director
Guideposts Publications

Michael Lawton
Design Director
Popular Mechanics

J.R. Arebalo, Jr.
Design Director
American Airlines
Publishing

Scott Davis
Art Director
Fortune Small Business

Casey Tierney
Director of Photography
Real Simple

John Walker
Creative Director
TV Guide

James Reyman
Principal
James Reyman Studio

Vanessa Holden
Art Director

Phil Bratter
Art Director

Volunteers (left to right): Abhilasha Sinha, Alice Alves, Angela Howard, Andre Jointe, Burgan Shealy, Delia Desai, Anthony Clarke, Laura Viola Maccarone, Eun Jean Song, Minal Nairi, Tim Leong, Sean Koo, Corliss Williams, Michael Friel, Christine Bower, Falguni Shah, Greg Grabowy, Maria Haddad, Sarah Crumb, Soni Khatri, Mike Ley, April Bell, Jenn McManus, Nancy Stamatopoulos [Volunteer Coordinator], Gina Maniscalco, Lisa Vosper, Belinda Hock, Demarcus McGaughey, Nia Lawrence, Clare Minges [Volunteer Coordinator], Thy Nguyen-huu, Grace Martinez, Lisa Kennedy, Will McDermott, Scott-Lee Cash [Volunteer Coordinator], Linda Rubes, Jenni Radosevich, Andrea Nasca

616. **LOU BEACH**
title. Prenatal
art director. Kelly Doe
publication.
The New York Times
publisher. The New York Times

619. **ISTVAN BANYAI**
title. Attention Shoppers
creative director. Blake Taylor
art director. Sarah Garcea
publication. Inc.
publisher. Mansueto Ventures

622. **BRIAN CRONIN**
title. Rolling the Dice on
China's Banks
art director. Nai Lee Lum
publication. Fortune
publisher. Time Inc.

617. **MONIKA AICHELE**
title. A Drink of Death
art director.
Nicholas Blechman
publication. The New York
Times Book Review
publisher. The New York Times

620. **HARRY CAMPBELL**
title. Spinach = Death
art director. Brian Rea
publication.
The New York Times
publisher. The New York Times

623. **JAMES BLAGDEN**
title. Buy an ID Card and
Forget About the Line
art director. Rodrigo Honeywell
publication/publisher.
The New York Times

618. **HARRY CAMPBELL**
title. Could You Please Die
Sometime in 2010?
art director. Davia Smith
publication. Money
publisher. Time Inc.

621. **JACK BLACK**
title. When Smart Shoppers
Buy Dumb Things
art director. Davia Smith
publication. Money
publisher. Time Inc.

624. **MARK ALARY**
title. First Course
art director. Nicholas Blechman
publication. The New York
Times Book Review
publisher. The New York Times

625. **RAYMOND BIESINGER**
title. Email To-Don't List
design director.
George Karabotsos
art director. Vikki Nestico
publication. Men's Health
publisher. Rodale Inc.

626. **BARRY BLITT**
title. Beat the Blahs
art director.
Robin Gilmore-Barnes
publication. Body + Soul
publisher. Body + Soul
Omnimedia

627. **KAREN CALDICOTT**
title. Jack Black
art director. Luke Hayman
publication. New York
publisher. New York Magazine
Holdings, LLC

628. **ANNA BHUSHAN**
title. Desperately
Seeking Susan
art director. Brian Rea
publication/publisher.
The New York Times

629. **CHRIS BUZELLI**
title. Your To-Don't List
design director.
George Karabotsos
art director. Vikki Nestico
publication. Men's Health
publisher. Rodale Inc.

630. **HARRY CAMPBELL**
title. Class Action / Benefit
Society Column
creative director. Mitch Shostak
art director. Susana Soares
publication. Contribute: New York
publisher. Contribute
Magazine, Inc.

631. **MONIKA AICHELE**
title. Discovery of a New Power
art director. Antonio DeLuca
publication. Walrus Magazine

632. **PAUL BLOW**
title. Who Are You at Work
art director. José Fernandez
publication. More
publisher. Meredith Corporation

633. **SERGE BLOCH**
title. Brain Workouts
art director. Arlene Lappen
publication. NRTA Live & Learn

634. **HARRY CAMPBELL**
title. Pensions: The Big Chill
art director. Davia Smith
publication. Money
publisher. Time Inc.

635. **STEVE BRODNER**
title. Happiness is a Warm iPod
art director. Ann Decker
publication. Fortune
publisher. Time Inc.

636. **MARCOS CHIN**

title. I Could Be Your Mama
art director. José Fernandez
publication. More
publisher. Meredith Corporation

637. **MARCOS CHIN**

title. Material World
art director. Lisa Thé
publication. Outside
publisher. Mariah Media, Inc.

638. **MARCOS CHIN**

title. Web Shopping Guide
art director. Marti Golon
publication. Time

639. **JEAN-PHILIPPE DELHOMME**

title. The Bleach Boys
design director.
Fred Woodward
publication. GQ
publisher. Condé Nast
Publications Inc.

640. **SELÇUK DEMIREL**

title. Faking It
art director.
Victoria Nightingale
publication. Reader's Digest
publisher. Reader's Digest
Association

641. **GREG CLARKE**

title. Roommate Rituals
art director. Cynthia Currie
publication. Kiplinger's
Personal Finance
publisher. Kiplinger
Washington Editors

642. **TAVIS COBURN**

title. When the Shark Bites
design director.
Fred Woodward
publication. GQ
publisher. Condé Nast
Publications Inc.

643. **JOSH COCHRAN**

title. Philanthropy / The
Business of Giving
art director. Alex Knowlton
publication. Citigroup Pursuits
publisher. Time Inc. Content
Solutions

644. **ERIK T. JOHNSON**

title. The Enemy
art director. Nicholas Blechman
publication. The New York
Times Book Review
publisher. The New York Times

645. **GILBERT FORD**

title. The Calculus of Drinking
art director. Lisa Sergi
publication. Brown Alumni
Magazine
publisher. Brown University

646. **GILBERT FORD**

title. The Drama of the
Gifted Parent
art director. Melissa Bluey
publication/publisher.
The Atlantic Monthly

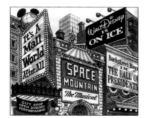

647. **CRAIG FRAZIER**

title. Mideast Peace
art director. Brian Rea
publication/publisher.
The New York Times

648. **SEAN KELLY**

title. Metropolitan Diary:
A Weekly Series
art director.
Michael Kolomatsky
publication/publisher.
The New York Times

649. **AARON GOODMAN**

title. The Good, the Bad, and
the Delicious
art directors. Gina Toole
Saunders, Tina-Lynn Cortez
publication. AARP Segunda
Juventud
publisher. AARP Publications

650. **JOHN HERSEY**

title. Unsafe at Any Speed
art director. Nicholas Blechman
publication. The New York
Times Book Review
publisher. The New York Times

651. **HEADCASE DESIGN**

title. Backup Tips: Keep
Your Data Backups Safe,
Simple and Fast
art director. Barbara Adamson
publication. PC World
publisher. International Data
Group

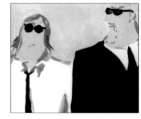

652. **JEAN-PHILIPPE DELHOMME**

title. Looks that Kill
design director.
Fred Woodward
publication. GQ
publisher. Condé Nast
Publications Inc.

653. **ANTON IOUKHNOVETS**

title. Breakout Performance
design director.
Fred Woodward
publication. GQ
publisher. Condé Nast
Publications Inc.

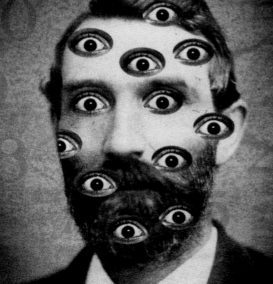

654. **THOMAS FUCHS**

title. Running for Seniors
art director. Kory Kennedy
publication. Runner's World
publisher. Rodale

655. **SARA FANELLI**

title. Bad Bosses
art director. Sonja Burri
publication. Chatelaine

656. **PAUL HOPPE**

title. The Brooklyn Issue
art director. Mike Weber
publication. New York Press

657. **LOU BEACH**

title. The Family That Couldn't Sleep
art director. Steven Heller
publication. The New York Times Book Review
publisher. The New York Times

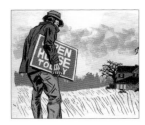

658. **ERIK T. JOHNSON**

title. Intimations
art director. Nicholas Blechman
publication. The New York
Times Book Review
publisher. The New York Times

659. **ZOHAR LAZAR**

title. Power Flowers
art director. Wendy Stoddart
publication. AARP The
Magazine
publisher. AARP Publications

660. **SEAN MCCABE**

title. Giving Circles
creative director. Mitch Shostak
art director. Susan Soares
publication. Contribute:
New York
publisher. Contribute
Magazine, Inc.

661. **LUBA LUKOVA**

title. How Angry Is Your City?
design director.
George Karabotsos
art director. Vikki Nestico
publication. Men's Health
publisher. Rodale Inc.

662. **ZOHAR LAZAR**

title. Hollywood's Secret List
design director.
Geraldine Hessler
publication. Entertainment
Weekly
publisher. Time Inc.

663. **LARS LEETARU**

title. The Office: The End
creative director. Blake Taylor
art director. Sarah Garcea
publication. Inc.
publisher. Mansueto Ventures

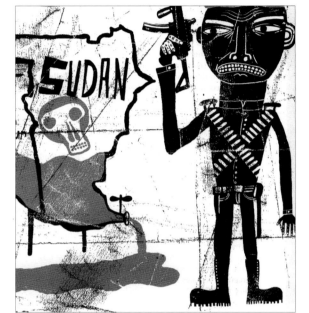

664. **MARK MATCHO**

title. Lab Rat: Save Face –
and Body
art director. Kory Kennedy
publication. Runner's World
publisher. Rodale

665. **JASON KERNEVICH,
DUSTIN SUMMERS**

title. Debugged
art director.
Nicholas Blechman
publication. The New York
Times Book Review
publisher. The New York Times

666. **CHRISTOPH NIEMANN**

title. Consumer Watch: Protect
Yourself Against Credit Fraud
art director. Barbara Adamson
publication. PC World
publisher. International Data
Group

667. **NATE WILLIAMS**

title. Barring Investments
in Sudan
art director. Cathy Gontarek
publication. The Pennsylvania
Gazette
distinctive merit

668. **NIALL MCCLELLAND**

title. Sideburns: How Long
Can You Go?
design director.
George Karabotsos
art director. Vikki Nestico
publication. Men's Health
publisher. Rodale Inc.

669. **ALEX NABAUM**

title. Less Power to Them
art director. Brian Wilson
publication. AARP The
Magazine
publisher. AARP Publications

670. **ALEX NABAUM**

title. The Cost of Free Money
art director. Brian Wilson
publication. AARP The
Magazine
publisher. AARP Publications

671. **ALEX NABAUM**

title. Power of Opposite
Thinking
creative director. Blake Taylor
art director. Lou Vega
publication. Inc.
publisher. Mansueto Ventures

672. **KEITH NEGLEY**

title. 4x4 – Road Trip
art director. Maria Bishirjian
publication. Replacement
Contractor
publisher. Hanley Wood

673. **CHRISTOPH NIEMANN**

title. Summer Reading Challenge
art director.
Victoria Nightingale
publication. Reader's Digest
publisher. Reader's Digest
Association

674. **CHRISTOPH NIEMANN**

title. Hassle-free PC: Use a
Sneaky Signature to Reduce Spam
art director. Barbara Adamson
publication. PC World
publisher. International Data
Group

675. **ZOHAR LAZAR**

title. Lighten Up
art director. Kory Kennedy
publication. Runner's World
publisher. Rodale

676. **HANOCH PIVEN**

title. Diary of an Eye Job
art director. José Fernandez
publication. More
publisher. Meredith Corporation

677. **KEN ORVIDAS**

title. The Voice of Authority
art director. José Fernandez
publication. More
publisher. Meredith Corporation

678. **JEFFREY SMITH**

title. October 2006
art director. Sarah Garcea
publication. Field & Stream
publisher. Time4 Media

679. **WALTER VASCONCELOS**

title. Topline
art director. Robert Lesser
publication. CFO Magazine
publisher. CFO Publishing

680. **DAVID PLUNKERT**
title. Data
creative director. Blake Taylor
art director. Lou Vega
publication. Inc.
publisher. Mansueto Ventures

681. **CHRISTIAN NORTHEAST**
title. For the Love of Poop
art director. Stephanie Birdsong
publication. Fit Pregnancy
publisher. Weider Publications, Inc.

682. **RODRIGO CORRAL**
title. Their Eyes Were Reading Smut
art director. Brian Rea
publication/publisher. The New York Times

683. **DAVID PLUNKERT**
title. Windows Tips: Vanquish Still More Windows Annoyances
art director. Beth Kamoroff
publication. PC World
publisher. International Data Group

684. **DAVID PLUNKERT**
title. What's the Best Pace for Your Long Runs?
art director. Kory Kennedy
publication. Runner's World
publisher. Rodale

685. **MIMI O.**
title. The End of Ingenuity
art director. Brian Rea
publication/publisher. The New York Times

686. **ADAM PALMER**
title. To Have & Have Not
art director. Nicholas Blechman
publication. The New York Times Book Review
publisher. The New York Times

687. **LEIF PARSONS**
title. Show Guns
art director. Cathy Gilmore-Barnes
publication. The New York Times Magazine
publisher. The New York Times

688. **LEIF PARSONS**
title. The Story of O's
art director. Cathy Gilmore-Barnes
publication. The New York Times Magazine
publisher. The New York Times

689. **CHRISTIAN NORTHEAST**
title. Geniuses Work
art director. Nicholas Blechman
publication. The New York Times Book Review
publisher. The New York Times

690. **DAVID PLUNKERT**
title. UMG Strongarms Microsoft for Royalties
creative director. Josh Klenert
art director. Greg Grabowy
publication. Billboard
publisher. VNU Business Media

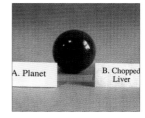

691. **PAUL SAHRE**
title. War of the Worlds
art director. Brian Rea
publication/publisher. The New York Times

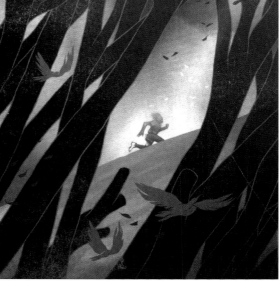

695. **SAM WEBER**
title. X: Darkness
art director. Kory Kennedy
publication. Runner's World
publisher. Rodale

692. **BRIAN REA**
title. Your Breakthrough Summer
design director. George Karabotsos
art director. Vikki Nestico
publication. Men's Health
publisher. Rodale Inc.

693. **STINA PERSSON**
title. Ask Mrs. Young
design director. Kirby Rodriguez
art director. Alex Grossman
publication. Cookie
publisher. Condé Nast Publications Inc.

694. **JASON LEE**
title. Get the Body of Christ - In Only 14 Days!
design director. Fred Woodward
publication. GQ
publisher. Condé Nast Publications Inc.

696. **PAUL SAHRE**
title. American Idol
art director. Nicholas Blechman
publication. The New York Times Book Review
publisher. The New York Times

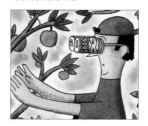

697. **MARC ROSENTHAL**
title. Food for Thought
art director. Ursula Rothfuss
publication. UCLA Magazine
publisher. UCLA

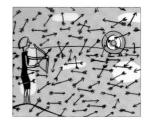

698. **MARC ROSENTHAL**
title. Cutting Through the Clutter
art director. Karen Berndt
publication. Event Magazine

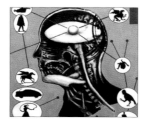

699. **JONATHON ROSEN**
title. Opinion
art director. Peter Buchanan-Smith
publication. Paper Magazine

700. **EDEL RODRIGUEZ**
title. A Vision of Cuba
publication. Time.com
publisher. Time Inc.

701. **DAVID PLUNKERT**
title. Poison Control
art director. Robert Perino
publication. Field & Stream
publisher. Time4 Media

702. **ALISON SEIFFER**

title. The Impostor Syndrome
creative director. Blake Taylor
art director. David McKenna
publication. Inc.
publisher. Mansueto Ventures

703. **JOON MO KANG**

title. Idols
art director. Nicholas Blechman
publication. The New York
Times Book Review
publisher. The New York Times

704. **GARY TAXALI**

title. Make Money on Ebay
art director. Marisa Fuoco
publication. Family Circle
publisher. Meredith

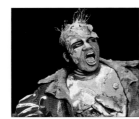

705. **LARA TOMLIN**

title. Grendel
art director. Max Bode
publication. The New Yorker
publisher. Condé Nast
Publications Inc.

706. **CHRISTIAN NORTHEAST**

title. Live Longer, Live Better
design director.
George Karabotsos
art director. Vikki Nestico
publication. Men's Health
publisher. Rodale Inc.

707. **JAMES VICTORE**

title. Rage Rules
design director.
George Karabotsos
art director. Vikki Nestico
publication. Men's Health
publisher. Rodale Inc.

708. **JAMES VICTORE**

title. Escape from the
Hospital: Feeling No Pain
design director.
George Karabotsos
art director. Vikki Nestico
publication. Men's Health
publisher. Rodale Inc.

709. **JAMES VICTORE**

title. Escape from the Hospital:
What Your Doctor Isn't Saying
design director.
George Karabotsos
art director. Vikki Nestico
publication. Men's Health
publisher. Rodale Inc.

710. **JASON HOLLEY**

title. 15 Things You Don't
Know About Your Penis
design director.
George Karabotsos
art director. Tim Leong
publication. Men's Health
publisher. Rodale Inc.
distinctive merit

711. **JAMES VICTORE**

title. Tame Your Terror
design director.
George Karabotsos
art director. Vikki Nestico
publication. Men's Health
publisher. Rodale Inc.

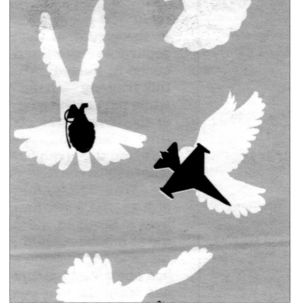

715. **JENNIFER DANIEL**

title. Old World Order
art director. Nicholas Blechman
publication. The New York
Times Book Review
publisher. The New York Times
distinctive merit

712. **WARD SCHUMAKER**

title. Biology of Healing
art director. Kelly Doe
publication/publisher.
The New York Times

713. **IAN DINGMAN**

title. The Deep
art director. Leo Jung
publication. The New York
Times Magazine
publisher. The New York Times
distinctive merit

714. **JESPER WALDERSTEN**

title. Spines
design director. Kirby Rodriguez
art director. Alex Grossman
publication. Cookie
publisher. Condé Nast
Publications Inc.

716. **LOVISA BURFITT**

title. Ask Mrs. Young
design director. Kirby Rodriguez
art director. Alex Grossman
publication. Cookie
publisher. Condé Nast
Publications Inc.
distinctive merit

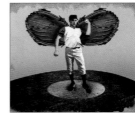

717. **PETER STEMMLER**

title. The Sex Position Playbook
design director.
George Karabotsos
art director. John Dixon
publication. Men's Health
publisher. Rodale Inc.

718. **ELLEN WEINSTEIN**

title. Only Human
creative director.
Francesca Messina
art director. Donald Partyka
publication. Angels on Earth
publisher. Guideposts

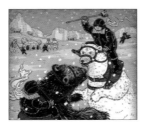

719. **YUKO SHIMIZU**

title. Clash of the Titans
art director. SooJin Buzelli
publication. Global Custodian
publisher. Asset International

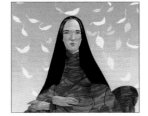

720. **SAM WEBER**

title. The New Eat Right Rules
art director. José Fernandez
publication. More
publisher. Meredith Corporation

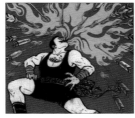

721. **YUKO SHIMIZU**

title. Fighting Fire with Fire
art director. SooJin Buzelli
publication. PLANSPONSOR

722. **GARY TAXALI**

title. A Quiz for Capitalists
art director. Ann Decker
publication. Fortune
publisher. Time Inc.

723. **JACK UNRUH**

title. Undressed to Kill
art director. Robert Perino
publication. Field & Stream
publisher. Time4 Media

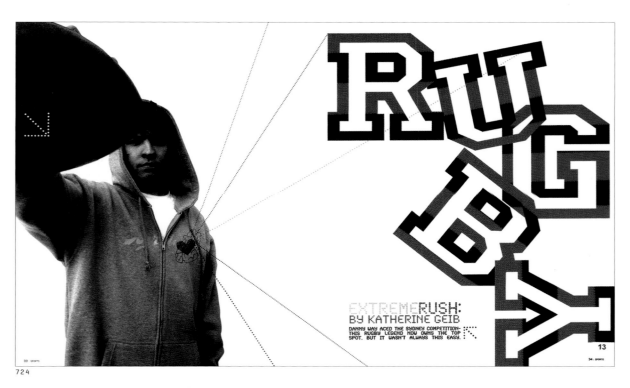

724

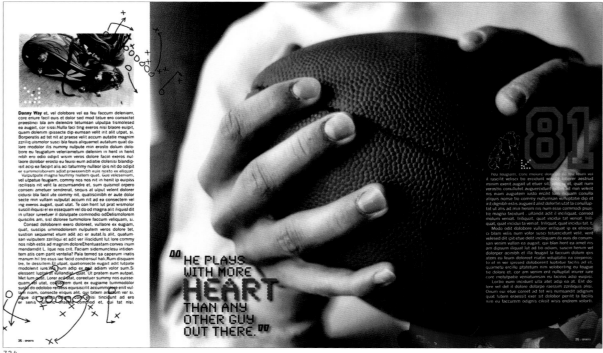

724

724. **ALLSION MCLEAN**

title. Rugby. school. Montana State University. instructor. Jeffrey Conger
category. Sports. award: First Place, the Adobe Scholarship in Honor of B.W. Honeycutt

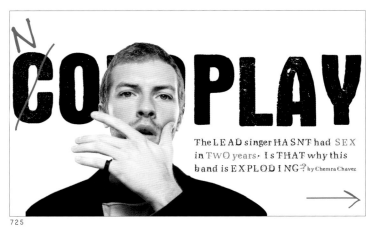

725

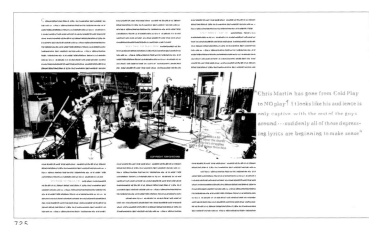

725

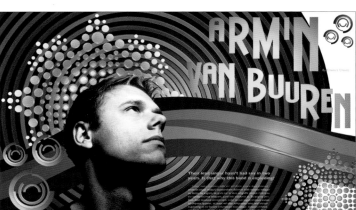

726

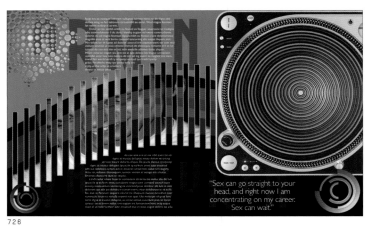

726

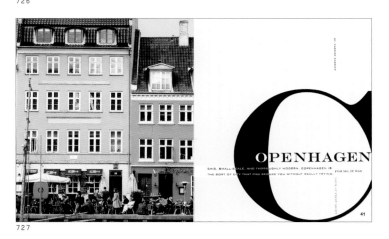

727

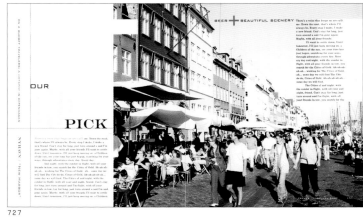

727

725. **MEGAN CUMMINS**

title. Coldplay
photographers. Elis Parrinder, Tom Sheehan
school. Savannah College of Art & Design
instructor. John Waters
category. Entertainment/Music
award. Second Place

726. **BEAU T.FOOR**

title. Armin Van Buren
school. Montana State University
instructor. Jeffrey Conger
category. Entertainment/Music
award. Third Place

727. **TINA NGUYEN**

title. Copenhagen
photographers. bloggingcopenhagen.net, colorado.
edu/gallery/copenhagen
school. School of Visual Arts, New York City
instructor. Mitch Shostak
category. Travel
award. First Honorable Mention

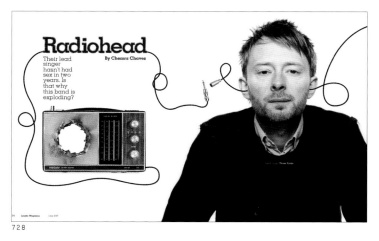

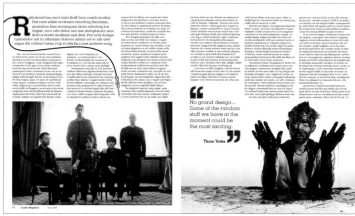

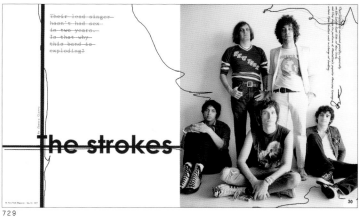

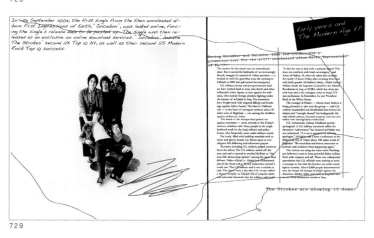

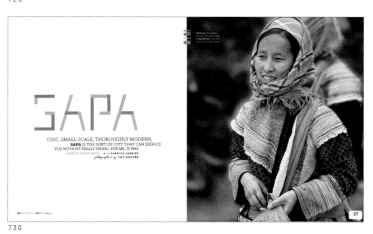

728

728

729

729

730

730

728. **WENJUN ZHAO**

title. Radiohead
photographers. Jason Evans, Capitol Records
school. The City College of New York, CUNY
instructor. Ina Saltz
category. Entertainment/Music
award. Second Honorable Mention

729. **SHIN-A KANG**

title. The Strokes
school. School of Visual Arts, New York City
instructor. Mitch Shostak
category. Entertainment/Music
award. Third Honorable Mention

730. **THY NGUYEN-HUU**

title. Sapa
school. Fashion Institute of Technology, New York City
instructor. Kingsley Parker
category. Travel
award. Fourth Honorable Mention

(t)here 99
+ISM 82-83, 164
004 94, 146, 190
02138 138
1 Plus 1 Design 232
2wice 185
2wice Arts Foundation 185
33 Thoughts 89
360 189
3x3 Magazine 189
3x3, The Magazine of Contemporary Illustration 189

A

Aaronson, Jennifer 16-18, 24
AARP Publications 276, 301, 302
AARP Segunda Juventud 301
AARP The Magazine 276, 302
Abatemarco, Dean 262
Abdul-Ahad (Getty), Ghaith 229
Abercauph Naughton, Monika 201
Abero, Andrio 102
Aborn, Jennifer 159
Abrahamsen, Per Morten 113
Abranowicz, William 80-81
Acevado, Melanie 186
Achilleos, Antonis 186
Adams, Douglas 149
Adams, Erik 67
Adams, Terry 176
Adamson, Barbara 301, 302
Adbai, Isabel 80-81
Adjaye, David 91
Adlersberg, Zoe 187
Aelion, Liza 186
Afanador, Ruven 42-43, 211, 242
Affanador, Ruven 87
Agajanian, Donna 203, 213
Ahn, Elaine 265
Aichele, Monika 300
Alagia, Leana 12-14, 56, 206, 241
Alary, Marc 193, 300
Alas, Mert 26, 50-51, 112, 234-235, 238, 239
Albert Halaban, Gail 163
Alberty, Thomas 8-11, 23, 32, 62, 180, 186, 287, 289, 291
Aldridge, Miles 224, 247
Alescio, Monica 156
Alexander, Anna 48-49, 181
Allee, David 12-14, 192, 226
Allen, Cindy 162, 229
Allen, Dave 212
Altan, Derya Hanife 63, 85
Alvarez, Juli 200
Alves, Alice 64-65, 88, 265, 282
Amadio, Andrea 149
American Airlines Nexos 138
American Airlines Publishing 126, 138, 255
American Express Publishing Co. 112, 115, 174, 188, 189, 202
American Folk Art Museum 114
American Institute of Architects California Council 292
American Lawyer Media 164
American Lawyer, The 164
American Media, Inc. 200
American Theatre 95
American Way 126, 255
Amini, Christina 295
Amodio, Rosie 186
An, Sang 79-81, 190
Anderson, Andy 220
Anderson, Barbara 146
Anderson, Christopher 46-47
Anderson, Emily CM 218, 278
Anderson, Julian 91
Anderson, Odd 250
Andersson, Patrik 76
Angels on Earth 261, 304
Anita Kunz Illustrations 256
Annerino, John 134
Anstey, Brian 25, 75, 78, 232, 254, 277
Anton, Emily 12-14
Anwen, Lilah 191
Arban, Tom 191
Arbus, Amy 206
arcCA 292
Arebalo, Jr., J.R. 126, 255
Arias, Raul 22, 103, 104
Arkle, Peter 102, 188, 192
Arky, David 210
Armague, Bernat 250
Armstrong, KC 191
Aroch, Guy 25
Arrowsmith, Clive 76, 91
Asher, Kaajal 261
Askew, Sophie 186
Asset International 262, 304
Assiabanha, Neomi 60, 64-65, 88, 282
Astley, Amy 203
Atelier 004 94, 146, 190
Atkins, Gregory 162, 217
Atlanta Magazine 130
Atlantic Media 138
Atlantic Monthly, The 301
Atwood, John 202
ATYPK 174
Aubert, Danielle 192
Aufuldish & Warinner 292
Aufuldish, Bob 292
Auletta, KT 232
Axe, Matthew 80-81, 240
Azria-Palombo, Jacqueline 200

B

B&G Design Studios 156
Bachelis, LanYin 163
Bachleda, Florian 60, 64-65, 88, 189, 265, 282

Backpacker 135
Bacon, Quentin 190
Badrak, Oksana 48-49, 181
Baigrie, James 190
Baillie, Steven 178
Baird, Micah 176
Bakacs, Andrea 80-81, 86, 111, 203, 240
Baker, Ben 130, 181
Baker, Christopher 80-81, 111, 187
Baker, Richard 110, 136, 225
Baker, Susan 98
Baldwin, Leslie 131, 135, 229
Baldwin, Tim 156
Ball, Jimmy 103
Ballant, Lindsay 72, 115
Balslev, Casper 251
Bamberger, Susanne 220
Bang, Gloria 191
Banks, Steven E. 292
Bantjes, Marian 48-49, 96, 166-167, 274
Banyai, Istvan 300
Barak, Inbar 295
Barasch, Douglas S. 141
Barber, Susan 102, 188
Barbieri, Coppi 218
Barnes, Richard 191, 218
Barnett, Dirk 20, 61, 82-83, 121, 132, 133, 137, 266, 286
Barnett, Simon 114, 224
Baron, Fabien 50-51
Barragan, Marian 64-65, 88
Barry, David 46-47
Barton, Jeff 135
Bastardo, Jim 94
Batcup, Felix 278
Bates, Harry 186
Bates, Matthew 135
Bauer, Frank 91
Bausmith, Wesley 294
Bayer, David 155
Beach, Lou 300, 301
Beajour, Tom 265
Beauchamp, Monte 95
Beck, Melinda 12-14, 24, 272
Becker, Bonnie 255
Becker, Polly 155
Bednarek, Samantha J. 12-14
Beezubov, Sasha 85
Behar, Greg 42-43, 87, 181
Beierman, Andi 131
Bell, April 41, 61, 82-83, 137, 193, 266
Bellerophon Publications 97, 115, 125, 154, 176, 192, 226
Bello, Al 250
Bello, Alberto 146
Bello, Roland 16-18, 24
Ben Shahar, Naomi 160
Bene 98
Benefits Selling 138
Bennett, Bruce 162
Bennett, Caleb 126
Benson, Charlene 94, 114, 175, 187, 188
Berger (Getty), Adri 114
Berger, Shoshana 176
Bergerault, Jean Paul 114
Berkley, Amy 202
Berliner, Gert 206
Berman, Nina 202
Berndt, Karen 303
Berndt, Mark 155
Bernstein, Josh 265
Berry, Kate 212
Berthelot, Nicolette 124, 187, 193, 225, 266
Best Life 138, 213, 220, 255, 274, 286, 287
Best, Luke 148
Best, Robert 140, 254, 260, 264
Bettles, Andrew 108, 142, 211, 222
Bezdikian, Hooshere 295
Bhushan, Anna 300
Bichler, Gail 53, 70, 84, 175, 181, 258, 259, 270-271
Bicycling 220
Bielaczyc, Tony 203, 240
Bielat, Jolanta 8-11, 23, 62, 186, 289, 291
Biernat, Magda 97, 192, 226
Bierut, Michael 28
Biesinger, Raymond 282, 300
Big Designs Inc. 292
Bigler Amari, Anne 201
Billard, Guy 260, 262
Billboard 126, 303
Billyeald, Adam 174, 274, 283
Binder, Eve 8-11, 23, 62, 186
Biondi, Elisabeth 196-198
Bird, Cass 12-14
Birdsong, Stephanie 226, 303
Birnbaum, Ben 287
Bishirjian, Maria 302
Bishop, Deb 16-18, 24, 58-59, 95, 134, 281
Blab 95
Black, Jack 300
Black, Kareem 293
Blackall, Sophie 190
Blackford, John 277
Blackheart, Jason 127
Blagden, James 300
Blakesley, Amber 80-81
Bland Design 176, 191, 280
Bleasdale, Marcus 229
Blechman, Nicholas 294, 300, 301, 302, 303, 304
Blecker, Olaf 21
Blenda, José 293
Blender 148, 214
Blitt, Barry 300
Bloch, Serge 275, 277, 300
bloggingcopenhagen.net 306
Bloomberg L.P. 261
Bloomberg Markets Magazine 261
Bloomingdales 264
Blow, Paul 300
Blueprint 16-18, 24, 58-59, 95, 134, 281
Bluey, Melissa 301
Bly, Adam 174, 262, 274, 283
Bode, Max 300
Bodkin, Tom 44, 294

Body + Soul 300
Body + Soul Omnimedia 300
Bonavita, Chris 292
Bond, Gavin 25, 75, 78, 121, 177, 232
Boo Stoy Hayward 89
Bookbinder, Adam 112, 115, 174, 188
Boone, Melanie 67
Border Film Project 102, 188
Borisov, Vladislav 90
Borouchou, Joshua 193
Bosco, Denise 94
Boston 260
Boston College 287
Boston College Magazine 287
Boston Globe Magazine, The 103, 164
Boston Globe, The 294
Boston Magazine Concierge 201
Bothman, Nic 250
Bouchakour, Morad 46-47, 195
Boulat (VII), Alexandra 229
Bouloutian, Matt 192
Bower, Christine 126
Boy Scouts of America 149, 255
Boyle, Graeme 187, 193
Boys' Life 149, 255
Brackett, Aya 218, 278
Bradley, Elaine 215
Bradley, Monica 200
Brandes, Elizabeth 287
Brandt, Jesper 91
Brandt, Michael 146
Braun, Darren 48-49, 85, 128, 131, 177, 181, 201
Bravo, Fernando 156
Breland, Tim 200
Brenner, Marion 80-81
Brez, Alexandra 139, 200
Brides 203, 213
Brinley, David 151
Broad, Julian 184, 234-235
Brodbeck, Mauren 132
Broden, Fredrik 46-47, 207
Brodner, Steve 261, 300
Brown Alumni Magazine 148, 301
Brown University 148, 301
Brown, Allison 232
Brown, Ian 200
Brown, Jeffrey Lamont 12-14
Browning, Cameron 174
Bruno, Claudia 218, 278, 295
Bruns, Zoë 203
Bryan Christie Design 253
Bryant, Mark 41, 82-83, 240, 266
Buani, Maria 74
Buchanan-Smith, Peter 303
Buck, Chris 208
Buck, Monica 79, 190, 284, 285
Buffa, Liz 189
Bugbee, Stella 98, 232, 274
Bukh, Katinka 113, 154, 251
Bulletin of the Atomic Scientists 220
Bumgarner, Sean 214, 293
Bunai, Maria 295
Burbridge, Richard 150, 186, 210
Burda 102
Burfitt, Lovisa 193, 304
Burgoyne, John 12-14
Burnett, David 216
Burnett, James 260
Burri, Sonja 301
Burton, CJ 262
Burtynsky, Edward 91
Bush, Christy 293
Buss, Wolfgang 102
Butler, Erik 189
Butler, Marianne 175, 210, 282
Buzelli, Chris 260, 262, 300
Buzelli, SooJin 262, 304
Byard, Hudd 132

C

Caballero, Guillermo 114, 146, 156, 293
Caderot, Carmelo 22, 92, 103, 104, 190
Cadiz, Ryan 201, 224
Cahan & Associates 67, 194
Cahan, Bill 67, 194
Cahill, Mary 16-18, 24, 58-59, 95, 134, 172, 173
Callaghan, Brendan 218, 278
Callaway, Nicholas 234-235
Callister, Mary Jane 80-81
Camner, Dawn 186
Campbell, Alix 42-43, 87, 181, 228, 253
Campbell, Harry 300
Campisi, Evan 208, 278
Campisi, Ronn 255, 266
Campos, Christian 191
Canahuate, Delgis 8-11, 23, 62, 186
Canfield, Robert 67
Canning Zast, Theresa 172, 173
Cao, Howard 176
Cap & Design 94
Capeci, Amid 155, 202, 226, 227
Capello, Kenneth 290
Capitol Records 307
Capolino, Alberto 86
Capossela, Eric 130
Cappello, Kenneth 133
Capuano, Christine 264
Capwell, Casey 102, 188
Car, Christine 102
Cargill, Clinton 84
Carl's Cars 119, 174
Carlsen, Asger 154
Carlson, Ray 292
Carroll, Tim 186
Carter, Brian 194
Carter, Graydon 30, 112, 212, 213, 234-235, 237, 238, 265, 272, 273, 277, 281

Carter, Shan 44, 295
Carthas, David 61, 121, 137, 193
Casey, Shannon 42-43, 87, 181
Cassidy, Samantha 190
Castro, Annemarie 190
Castro, Felipe 114
Catania, Sal 154
Catero, Anita 186
Cayette, Henrique 94, 146, 190
Cayley, Alex 234-235
Centurion 115
CFO Magazine 260, 302
CFO Publishing Corp 260, 302
Chambers, Melanie 42-43, 87, 181
Chang, Jennie 78, 208, 254, 277
Chappell, Webb 186
Charlebois, Myrabelle 110
Chatelaine 301
Chavkin, Dan 46-47
Chehak, Jesse 75
Chelbin, Michal 12-14
Chen, Daniel 110, 220, 260
Chen, I-ni 191
Cheng, Clifford 162
Cheng, Sheila 191
Chess Design 155
Chessum, Jake 12-14, 78
Chicago Tribune Company 175, 276
Chicago Tribune Magazine 175, 276
Child 110, 220, 260
Chin, Allison 214
Chin, Kristine 25, 78
Chin, Marcos 263, 301
Cho, Alice 274, 283
Cho, Hye-Yeon 191
Choat, Deb 127
Chow, Alexander 133
Christensen, Anne 246, 248
Christie, Bryan 48-49, 181
Christ-Lafond, Judith 278, 279
Christy, Duncan 263
Chu, Andrea 187, 193
Chung, Agustin 176, 191, 280
Chung, Jimmy 293
Chung, Kun-Sung 292
Churchfield, Jody 47, 84, 183, 259
Chwast, Seymour 186, 288
Ciano, Bob 40
Ciardiello, Joe 154, 255, 262
Cibola, Marco 46-47
CIO Decisions 155, 275
CIO Insight 148
CIO Magazine 278
Citigroup 94
Citigroup Pursuits 94, 301
City 29, 93, 94, 208, 215, 220, 221
City Pages 120
Claire, Julie 160
Clamer, Matthias 12-14, 161
Clark, Kathleen 224, 292
Clarke, Greg 79, 190, 276, 301
Clickability 295
Clugston, Duncan 48-49, 181
CMP Media LLC 149, 262
Coble, Jack 187, 193
Coburn, Tavis 78, 186, 277, 288, 289, 301
Cochran, Josh 78, 301
Cohen, Fernanda 260
Cohen, Jem 232
Cohrssen, Jimmy 97, 192, 226
Cole, Carolyn 162
Coles, Joanna 42-43, 87, 181, 228, 253
colorado.edu/gallery/copenhagen 306
Comas, Gemma 281
Complex 214, 293
Computerworld 272
Condé Nast Publications Inc. 8-11, 21, 23, 26, 30, 32, 34-37, 40, 48-51, 57, 62, 73, 100, 101, 112, 116-118, 122, 124, 140, 142-144, 146, 150, 151, 165-170, 177-181, 186, 193, 196-197, 198, 200, 201, 203, 310, 212, 213, 218, 224-226, 229, 234-239, 249, 251, 256, 260, 264-266, 272, 273, 275, 277, 281, 287, 288, 289, 290, 291, 301, 303, 304
Condé Nast Traveler 140, 229, 260, 264
Conger, Jeffrey 305, 306
Congressional Quarterly, Inc. 255
Constantine, Elaine 219
Contemporary Media 132
Contribute Magazine, Inc. 154, 300, 302
Contribute: New York 154, 300, 302
Cook Design 12-14
Cookie 124, 187, 193, 225, 266, 303, 304
Cool, Kevin 254
Cooley, Matthew 125
Cooney, Mary 162
Copeland, Baden 44
Corral, Rodrigo 294, 303
Corredor, Lou 112, 115, 174, 188
Corsano, Gemma 98, 232
Corson, Lisa 12-14, 28
Cortez, Tina-Lynn 301
Corticchia, Daniela 46-47, 195
Corum, Jonathan 44
CosmoGirl! 200
Coutelle, Stéphane 56
Cowles, David 98
Cox, Nigel 155, 202
Cox, Reuben 12-14
Craig-Martin, Jessica 180
Crandall, Jennifer 140
Craven, Paul 202
Crawford, Colin 162
Crawford, Emily 191, 218
Cree, Kelly 191
Crichton, Doug 171
Crilly, Amy 48-49, 177
CRN 262
Cronin, Brian 164, 252, 254, 261, 266, 300
Crooks, Darhil 63, 85
Crubb, James 89
Crum, Lee 85
Culbert, Elizabeth 198
Culture & Travel 191, 218
Culvahouse, Tim 292

Cummins, Megan 306
Cuneo, John 85, 135
Curcurito, David 63, 85, 184
Currey, Shane 91
Currie, Cynthia 301
Curtis, Julie 23, 134
Cury, Peter B. 130, 219
Cusack, Margaret 273
Cushner, Susie 190
Cutler, Craig 16-18, 24, 114, 224
Cuyler, Joele 80-81, 111, 240
CXO Media 278

D

D'Elia, Anthony 292
D'Este, Robert 78
DaCosta, Beatrice 190
Dadich, Scott 21, 40, 48-49, 118, 131, 135, 165-170, 177, 181, 229, 275
Damens, Jeff 295
Daniel, Jennifer 304
Darden, Tyler 275
Darrow, Joe 12-14
Darrow, Joseph 175, 276
Dartmouth Alumni Magazine 254
Dartmouth College 254
Dashevsky, Jackie 78
Davidowitz, Maxine 128, 214
Davies & Starr 12-14, 147
Davis, Charlotte 64-65, 88
Davis, Joshua 91
Davis, Mike 293
Davis, Scott A. 164
Dawson, Claire 176
Day Job 174
Day Job Industries 174
de la Peña, Ron 155
de Miranda, Kevin 171
de Toth, Alexandra 155
Dealmaker 189
Dean, Jarred 188
Decker, Ann 300, 304
Deckker, Roger 142, 207
dela Vega, Leslie 64-65, 88, 98, 282
DeLago, Ken 8-11, 32, 34, 62, 73, 150, 151, 178, 179, 186, 251, 288, 289, 291
Delahanty, Robert 46-47
Delessert, Etienne 189
Delfin, Luis 156
Delhomme, Jean-Philippe 186, 301
Deloreno, Stacey 200
Delta Delta Delta 103
DeLuca, Antonio 300
Delves, Greg 182
Demarí, Donna 237
Demetriad, Dan 154
Demirel, Selçuk 301
Dennis Publishing 148, 214
Departures 112, 174, 188
DeSaussure, Ann 114, 188
Design Department 146
Designs by Gary 102, 188
Details 57, 142-144, 146
DeTorres, Carl 40, 48-49, 165, 177, 181, 275
Deuchars, Marion 63
Devine, Timothy 46-47
DeVita, Russell 155
Dewar, Nick 290
Dewgeson, Tim 91
DeWilde, Autumn 209
Di Benedetto, David 265
Diablo 261
Diablo Publications 261
Dialogue 175, 187
Diamond, Ilana 12-14
Diaz, Renato 114
Dickson, Anna 154
Didia, Margo 42-43, 87, 181
DiFebo, Elizabeth 201
Dileso, Rob 102, 188
Dillworth, Evelyn 176, 192
DiLorenzo, Lou 146, 200
DiMatteo, Kristina 72, 96, 115, 156
Dimitrova, Bilyana 97, 115, 125, 154, 176, 192, 226
Dimmock, James 25, 46-47, 78, 195, 232
Dingman, Ian 304
Dinsdale, Blake 262
Dischinger, François 218
Dixon, Chris 12-14, 28, 56, 68, 69, 113, 147, 152-153, 204-207, 241, 242
Dixon, John 304
DLG Media Holdings, LLC 127
Dmitry, Barbanel 90
Docherty, Jeffrey 53, 84, 105, 174, 181, 250, 274, 283
Doe, Kelly 300, 304
Dogo 191
Doherty, Ian 202
Doherty, Jeffrey 283
Dolan, John 79, 187, 190
Don Morris Design 189
Donaldson, Matthew 143, 200
Donnelly, Rebecca 58-59, 95, 134, 281
Donovan, Anthony 76, 91
Doret, Michael 48-49, 181
Doubledown Media 189, 232
Dougherty, Chris 191, 202
Dow Jones & Co., Inc. 294
Doyle Bales, Tracy 110, 136, 137, 225
Doyle, Matt 214, 293
Doyle, Stephen 28, 40, 48-49
Dragon, Deborah 202, 226
Drago-Price, Kristi 203, 213
Drake, Carolyn 240
Drukman, Marina 110, 225
DSB 113, 154, 251
Duchars, Marion 85
Duenes, Steve 44, 295
Dueri, Tanya 201
Duffy, Bryce 75, 78 157
Dumont, Stéphanie 119, 174
Dunham, Andrea 163, 240

Dunlinson, James 80-81, 111, 203, 240
Duplessis, Arem 20, 33, 38, 53, 54, 70, 71, 84, 105-109, 132, 133, 147, 175, 181, 211, 219, 247, 248, 250, 258, 259, 261, 267-271
Duran, Andrea 146
Duran, Teresa 240
Durham, Andrew 32
Duvall, Wes 12-14
dwell 218, 278, 295
Dwell LLC 218, 278, 295
Dworzak (Magnum), Thomas 229
Dynamic Duo Studio, The 179
Dynamic Duo 186
Dzama, Marcel 259

 E

Easler, Jaimey 220
Eastgaard, Dylan 262
Eatock, Daniel 259
Eaton, Becky 176
Eav 146
eBoy 254, 255, 279
Eccles, Andrew 12-14, 152-153, 206
Ecko 214, 293
École d'architecture de Versailles 146
Edmonds (AP), Ron 102
Edwards, Yolanda 124
Edwards, Michael 12-14, 136
Egger-Schlesinger, Anna 191
Egoísta 94, 146, 190
Eileen Schramm visual communications 293
El Mundo 190
Elazegui, Kate 12-14
Elegant Bride 146
Elins, Michael 115
Elle Décor 201
Emenecker, Stacey 220
Emmis Communications Corp. 130, 131, 135, 154, 165, 224, 229, 257, 292
enRoute 110
Entertainment Weekly 25, 75, 78, 118, 121, 208, 232, 254, 277-279, 295, 302
Epstein, Lauren 79, 190, 226
Ericson, Matthew 44, 295
Ervin, Michele 193
Eschliman, Dwight 67, 187
Eskenazi, Jason 74
ESPN The Magazine 46-47, 94, 157-164, 174, 195
ESPN, Inc. 46-47, 94, 157-164, 174, 195
Esquire - Russia 90
Esquire 64, 218
Esquire's Big Black Book 184
Essence 218
Estoril - Sol 94, 146, 190
Etheridge, Annie 282,
Evans, James 131
Evans, Jason 307
Event Magazine 303
Everyday Food 86
Evilla, Josue 103
Exbrook 120, 164
Expansión 146

 F

F & W Publications 72, 96, 115, 156
Fain, Rebecca 265
Fairchild Publications 162, 222, 223
Family Circle 304
Fanelli, Sara 301
Fantagraphics 95
Farmer, Trent 218
Farnham, Brian 114
Fast Company 171, 232, 233, 254, 280
Faucher, Stephanie 272
Faulkner, Colin 194
Faust, Shana 172
Fazzari, Andrea 188
FB Design 189
Feanny (Corbis), Najlah 113
Feaster, Scott 149, 255
Fein, Allister 40
Feinberg, Mitchell 12-14, 69, 162
Feldman, Hali Tara 142-144
Fella, Andrea 133, 224
Feric 154
Fernandez, Don 250
Fernandez, José G. 128, 214, 300, 301, 302, 304
Ferrell, Joan 164
Ferretti, Richard 100, 101, 226
Ferri, Fabrizio 128
Festino, Robert 46-47, 162-164, 174, 195
Feuer, Jack 155
Fhitnikov, Wyacheslav 90
Ficks, Philip 79, 190
Field & Stream 202, 302, 303, 304
Fielder, Jay 201, 224
Fine, Steve 209, 250
Fink, Larry 106, 219
Finke, Brian 180
Finkelstein, Sarina 155
Fiori, Pamela 174
Fit Pregnancy 226, 303
Fitzpatrick, Kristin 200
Flegner, Cristina 110
Flesher, Vivienne 194
Floyd, Chris 46-47, 195
Flying Chilli 176, 191, 280
Flynn, Andrew 237
Fogelson, Gary 102, 188
Foldvari, David 261
Foley, Dan 224
Foley, Kevin 162, 175
Folk Art 110
Fontaine, Paula 114
Food Arts Magazine 110
Foor, Beau T. 306
For Office Use Only 192

Forbes, Dan 35, 175
Ford, Gilbert 301
Ford, Jarred 110, 137, 225
Fortune 98, 254, 278, 300, 304
Fortune Small Business 164
Fracareta, Dylan 115
Francis, Yvette 240
Franco, Jim 186
Frank, Carla 140
Frank, Karen 128, 214
Franklin, Bailey 165
Frazier, Craig 301
Frazier, Jim 191
Free Media Group 120, 164
Freedman, Dennis 36-37, 50-51, 222, 223, 236, 239
Frere, Fabrice 29, 93, 94, 208, 215, 220, 221
Friedburg, Adam 176
Friedman, Andy 85
Friedman, Drew 186
Friedman, Sarah A. 46-47
Friel, Michael 176, 191, 280
Froelich, Janet 20, 32, 33, 38, 41, 47, 53, 54, 66, 70, 71, 82-84, 105-109, 132, 133, 139, 147, 175, 181-183, 198, 211, 219, 240, 242-248, 250, 258, 259, 261, 267-271, 286
Frost Design 40, 48-49, 76, 91
Frost Design, Sydney 91
Frost, Vince 76, 91
Fry, Ben 12-14, 28
Frykholm, Steve 67, 194
Fuchs, Thomas 78, 174, 293, 301
Fulford, Jason 232
Fulton, Jr., John R. 149
Fuoco, Marisa 304
Furon, Daniel 120, 164
Furtseva, Ekaterina 191
Fuss, Adam 66, 246
Future US 154, 265
Flynn, Andrew 237

 G

Gabbay, Lisa 154
Galac, Nick 141, 267
Galligan, Mary 110
Galloway, Ashley 203
Galton, Beth 187
Garaiz, Jorge 156
Garcea, Sarah 300, 302
Garcia, Sandra 191
Gardner, Laura 187, 193
Garrudo, Cláudio 94, 146, 190
Gartner, Craig 148
Gastel, Giovanni 220
Geaney, Jennifer 112, 115, 174, 188
Gearon, Tierney 137, 193, 225
Gentile, Chris 98
Gentl & Hyers 16-18, 24, 79, 190, 226, 240
Genzo, John 261
George Warren Brown School of Social Work at Washington University in St. Louis 118
Getty Images 118
Ghezzi, Gail 141
Giampietro + Smith 232, 274
Gilbert, Gary Wayne 287
Gilden, Bruce 25
Gilman, John Seeger 200
Gilmore-Barnes, Cathy 33, 84, 105, 109, 181, 211, 247, 261, 303
Gilmore-Barnes, Robin 300
Gilmour, Lucy 218
Gimenez, Rebecca 218
Gissinger, Hans 67, 80-81, 241
Glamour 200
Glendenning, Jeff 84, 106, 107, 181, 219, 258, 259
Global Custodian 262, 304
Glowczewska, Klara 229
Gnandt, Sandra 212
Godwin, Eric 261
Goebel, Matt 278
Goggin, Nan 191
Goknar, Esin 162
Goldberg, Carin 20
Goldberg, Nathaniel 186, 244
Golden, Dan 186
Golden, Elliott 164
Goldfield, Danny 110
Golis, Lea 12-14, 56, 206
Golon, Marti 301
Golon, MaryAnne 102, 119, 229, 264
Gomez, Melanio 203
Gontarek, Cathy 302
Good 102, 188
Good Magazine, LLC 102, 188
Good, Evelyn 261
Goodman, Aaron 301
Goodman, Heloise 16-18, 24, 58-59, 80-81, 86, 95, 111, 134, 172, 173, 203, 240, 281
Goodwin, Henry 154
Goryl, John 156
Goude, Jean-Paul 243
Gourmet 100, 101, 226
Governing Magazine 255
GQ 8-11, 23, 32, 34, 35, 62, 73, 150, 151, 178, 179, 180, 186, 210, 249, 251, 287, 288-291, 301, 303
Grabowy, Greg 126, 303
Grandjean, Cybele 16-18, 24, 80-81, 134, 281
Granger, David 63, 85, 184
Graves, Jeanne 130, 213, 274, 286, 287
Gray, Robert 216
Green Source 191
Greenberg, Jill 48-49, 74, 177, 181
Greenberg, Tina 214, 293
Greenfield (VII), Lauren 138, 229
Greenfield, Sarah 29, 94, 208, 215, 220, 221
Greenspring Media Group 132
Gregório, Filipa 94, 146, 190
Greiner, Roger 133
Griffin, David 215-217
Griffin, Jean 218

Griffith, Christopher 136, 138, 139, 184, 205
Griffith, Tim 67
Grillo, Al 250
Grimaldi, Claudia 146
Grinshpun, Marina 240
Grissom, Phyllis 103
Gröndahl, Mika 44
Grossman, Alex 124, 187, 193, 225, 266, 303, 304
Grupo Editorial Expansion 146, 156, 293
Grzeszykowska, Anita 218
Guemple, Matt 114
Guillame, Benoît 192
Guideposts Publications 261, 274, 304
Guitar Legends 154
Gunji, Jennifer 191
Gutiérrez, Roberto 293
Guy, Eddie 257
Guzmán, Pilar 124, 187, 193, 225, 266

 H

Hachette Filipacchi Media U.S. 61, 121, 137, 193, 201, 266
Hackett, Larry 202
Haddow, Nick 193
Hadley, Jordan 214, 293
Hafford, Jessica 142, 143
Hajek, Olaf 67
Hale, Liz 199
Hall, Scott 47, 66, 182
Halpern, Greg 232
Halverson, Amelia 115
Hamada, Kyoko 158, 193
Hamilton, Kendall 201
Hanauer, Mark 199
Hand, Kevin 48-49, 181
Hanley Wood 302
Hannert, Peter 188
Hannon, Charles 191
Hansen, Lars 12-14
Hanuka, Tomer 78, 267, 277
Happel, Austin 191
Hardin, Robert 186
Harper, Glenn 293
Harris, Armin 254
Harris, Darrick 124, 187, 225
Harris, David 30, 112, 212, 213, 234-235, 237, 238, 265, 272, 273, 277, 281
Harris, Jeff 42-43
Harris, Tarver 261
Hart, Joseph 67, 194
Harvard Business Review 261
Harvard Business School Publishing 261
Harvard Law Bulletin 266
Harvard Law School 266
Harvey, Ann 263
Harvey, Blake 191
Harwood, Rockwell 57, 142, 143, 144, 146
Hasbun, Gabriela 191
Hasting, Julia 258
Hatch, Katie 16-18, 24, 95
Hauf, Michelle 171
Hauser, Bess 175, 187
Hawaii Skin Diver 162
Hawaii Skin Diver Publishing 162
Hay, Alexei 214
Hayes, Troy 191
Hayman, Luke 12-14, 28, 56, 68, 69, 113, 147, 152-153, 204-207, 241, 242, 300
Hayward, Blaise 193
Headcase Design 191, 280, 301
Heads of State, The 126
Heal, Patricia 172
Health 171
Hearst Corporation-Magazines Division, The 42-43, 63, 85, 87, 140, 174, 176, 181, 184, 191, 200, 228, 253, 280
Heesche, Susannah 138
Heiko, Michael 156
Heiman, Eric 176
Heithoff, Mark 12-14, 160, 191
Heller, Steven 301
Helwig, Fredericke 186
Hemaware 162
Hemisphere 220
Hemmel, Peter 200
Hemmerle, Sean 192, 226
Henderson, Derek 76, 91
Hendrix, John 193
Hendy, Alastair 80-81
Hengeveld, Aileen 148
Henry, Gail 141
Henry, Megan V. 110, 220, 260
Herbert, Peter 176, 191, 280
Hercik, Chris 209
Herman Miller 67, 194
Herman Miller, Inc. 67, 194
Heroun + Co. 102
Heroun, Joe 102, 257, 260, 282
Hersey, John 266, 301
Hess, Charles 155
Hessler, Geraldine 25, 75, 78, 118, 121, 208, 232, 254, 277, 278, 279, 302
Hetherington, Andrew 87, 181
Hewgill, Jody 95, 189
Hewitt, Rob 61, 134, 193
Heyfron, Spencer 46-47
Hido, Todd 192, 226
Hiett, Steve 186
Highline Media 155
Hill (for Newsweek), Ethan 224
Hill, Ethan 78, 158
Hill, Hylah 186, 202, 277
Hiromi 192
Hively, Charles 189
Hoberman, Mara 174
Hochstein, Arthur 102, 119, 229, 264
Hoelck, Patrick 25, 78
Hoenig, Gary 46-47, 157, 159, 161, 174, 195
Hoey, Peter 48-49, 292
Hoffman, Cynthia A. 229, 264
Hoffman, Steve 209, 250
Hoffmann, Fritz 216

Hogan, Tim 208
Holden, Vanessa 79, 190, 226, 284, 285
Holiday, Richard 287
Holiman, Maili 48-49, 166-170, 181
Holland, Brad 272
Holland, Joel 56
Holler, Bootsy 188
Holley, Jason 78, 103, 260, 263, 277, 294, 304
Honest 192
Honeywell, Rodrigo 294, 300
Hooks, William 78, 279
Hooper, Mark 199
Hoops, Martin 115
Hoppe, Paul 301
Hoppy, Amy 12-14, 152-153, 206, 207, 241
Horton, Andrew 191
Houbart, Catherine 146
House and Garden 218
Housel (Getty Images), James F. 131
Houston, James 193
Hout, Tim 232
Howard Hughes Medical Institute 29, 103, 199, 263
Howard Hughes Medical Institute Bulletin 29, 103, 199, 263
Hoyle, Matt 241
Hranek, Matthew 187, 193, 226
Huang, Howard 230-231
Hubbard, Jimmy 199
Hughes, David 78, 267, 277
Hughes, Tanya 188
Humphreys, Brent 16-18, 24, 48-49, 281
Hunt, Chad 176, 191
Hupfel, Matt 98
Hurley, Kevin 149, 255
Hurley, Meghan 171, 232
Hursley, Tim 192, 226
Hutchinson, Joseph 74, 155, 162, 199, 237
Hyatt, Nicole 129, 130, 219

 I

Iacoi, Nancy Jo 63, 85, 184
IDG / Sweded 94
IDG 94, 272
Ilic, Mirko 274
Illumination Magazine 262
Iltis, Kate 94
Imagination Publishing 191
IN 114
Inc. 139, 200, 260, 300, 302, 303, 304
Independent Media Sanoma Magzines 90
InStyle 129, 130, 219
Interior Design 229
International Data Group 301, 302, 303
International Interior Design Association 191
International Sculpture Center 293
Ioukhnovets, Anton 8-11, 23, 35, 62, 151, 178, 180, 186, 210, 249, 290, 301
Ippel, Erik 250
iStock Photo. 118
Ivey, Pete 127
Ivy, Robert 191

 J

Jackson, Alison 12-14
Jacobs, Alanna 276
Jacobs, Cory 191, 218
Jacoud, Adriana 29, 94, 208, 215, 220, 221
Jae-Huan, Kim 250
Jaffe, Amy 200
Janes, Patricia 278
Janisch, Francis 189
Japan+ 162, 175
Jarrett, Marvin Scott 133, 176, 224
Jazzar, Anthony 218
Jean, James 48-49, 181, 267
Jeff Harris Studio 114
Jefferson, Atiba 46-47
Jen, Natasha 192
Jenkins (Ft. Worth Star-Telegram), Ron 209
Jewelry W 162, 222, 223
Jiji Gaho Sha, Inc. 162, 175
Jim, Billy 221
Jocham, Hubert 122
Johannsen, Heidi 111
John Brown 89
John Brown Publishing 89
Johns, Kristopher 262
Johnson, Brian 132, 138
Johnson, Erik T. 192, 301, 302
Johnson, Ragina 192
Johnson, Stephen 80-81
Jointe, André 57, 137, 144, 146, 193
Jolley, Ryan 212
Jonathon Rosen Studio 95
Jones, Heather 130, 286, 287
Jones, Jeffrey 191
Jones, Matt 200
Jornal O Globo 110
Joseph, David 176
Jouppi, Jeffrey 295
Juengel, Karl 16-18, 24, 58-59, 134, 281
Jung, Leo 54, 71, 84, 181, 267, 304

 K

Kamoroff, Beth 303
Kander, Nadar 67, 198
Kang, Borami 191
Kang, Joon Mo 304
Kang, Shin-A 307
Kantor, Jonathan 180
Karabotsos, George 175, 210, 257, 260, 282, 300, 302, 303, 304
Karamarkos, Nancy 110

Karch, Fritz 240
Karpowich, Glen 274
Katcher, Ben 192
Katz, Beth 226
Kaufman, Andrew 229
Kaufman, Carol 294
Kaufman, Dean 50-51
Kavulla, Brandon 138, 213, 220, 255, 274, 286, 287
Kay, Maynard 262
Kaye, Michael Ian 115
Kayganich, Robert 278
Keasler, Misty 200
Keate 190
Keith, Murry 132
Keller + Keller 186
Keller, Ted 60, 189, 230-231, 252
Kelley, Kate 176
Kelly, Douglas 191
Kelly, Michael 78
Kelly, Sean 301
Kelsey, Lisa 180
Kemp, Kathleen 209
Kendall, Courtenay 114
Kenneally, Brenda Ann 53
Kennedy, Kory 141, 209, 267, 301, 302, 303
Kennedy, Sian 48-49
Kereszi, Lisa 180
Kern, Geof 42-43
Kern, Richard 76
Kernevich, Jason 302
Kerns, Richard 91
Kessler, Axel 162
Kessler, Gabriele 102
Keune, AIA, Eric R. 292
Key, The New York Times Real Estate Magazine 20, 132, 133
KF Design 162, 175
Kibler, Jeffrey 114
Kidd, Chip 40, 48-49
Kim, Daisy 186
Kim, Debbie 292
Kim, Grace 79, 190
Kim, Jennifer 203
Kim, Rich 127
Kim, Yunhee 79, 190, 193
Kimberling, Joe 154, 224, 257, 292
Kimmons, Rebecca 186
King, Cameron 80-81
King, Tom 149
Kingman, Abner 212
Kinsella, Don 202
Kiplinger Washington Editors 301
Kiplinger's Personal Finance 301
Kirk, Neil 87, 228
Kirkland, James 186
Kirsheh, Nathalie 50-51, 116, 117, 122, 162, 222, 223, 236, 239
Klech, Kathleen 229
Klee, Greg 294
Kleiman, Dennis 155
Klein, Renee 98
Klein, Steven 36-37, 116
Kleiner, Keith 193
Kleinman, Dennis 191
Klenert, Josh 126, 189, 292, 303
Knickerbocker Design 28, 186, 290
Knight, Jenny 189
Knot, The 186
Knott, Phil 78
Knowlton, Alex 94, 114, 188, 301
Knudsen, Henrik 25, 232
Kobayashi, Kyoko 218
Koblenzer, Amy 100, 101, 226
Kochman, Michael 25, 78
Koen, Viktor 189
Kolomatsky, Michael 301
Kondo, Hisashi 175
Konrad, Laura 50-51, 116, 162
Kormon, John 191
Korpics, John 129, 130, 219
Kosorukov, Gleb 137
Koury, Linda 155, 275
Kozloff Hearey, Deborah 218, 278
Kozyrev, Yuri 229
Kraft (Corbis), Brooks 229
Krasilcic, Marcelo 188
Kratochvil, Laurie 218
Kraus, Orlie 294
Krause, Adam 46-47, 195
Kretschmer, Hugh 171
Krienke, Carolyn Veith 190
Kroencke, Anja 264
Kromer, Wendy 173
Krostin, Igor 209
Krummenacher, Victor 48-49, 181
Kucynda, Tim 176, 192
Kudacki, Paloa 193, 290
Kuepfer, Corey 191
Kullish, Kim 262
Kunz, Anita 256, 261
Kuramitsu, Kiyoshi 76, 91
Kurnat, Todd 48-49, 165, 168-170, 177, 181
Kuster-Prokell, Abbey 80-81
Kutsovskaya, Lina 203
Kuwayama, Teru 280

 L

La Luna de Metropoli 22, 104
Laakso, Hannu 262
Labosky, Russell 201, 224
Lacombe, Brigitte 12-14, 186, 229
Lacroix, Jeremy 48-49, 177, 181, 275
Lafarga, Rafael 293
Laforet, Vincent 12-14, 68, 82-83, 209
Lagnese, Francesco 174
Laidlaw, Linsey 80-81
Lancaster, Jason 46-47, 158, 159, 161, 195
Landesman, Susan 155
Landreth, Audrey 25, 78, 118
Langmo, Tobi Jo 295
Lantry, Christian 46-47
Lappen, Arlene 300

Lappin, Criswell 97, 115, 125, 154, 176, 192, 226
Larsen, Kristine 192, 226
Laski, Jennifer 112, 115, 174, 188
Laude, Olivier 102, 188
Lavine, Michael 130
Law, Adam 191
Law, Tony 192, 226
Lawrence, Deborah A. 202
Lawrence, Nia 79
Lawton, John 186
Lawton, Michael 176, 191, 280
Lazar, Zohar 46-47, 186, 195, 302
LeBoeuf, Melissa 201
LeBrecht, Micheal J. 250
Leda 110
Ledesma, Luis 146
Ledner, Catherine 46-47, 194, 195
Lee, Gina 191
Lee, Jae 48-49, 275
Lee, Jason 12-14, 46-47, 78, 177, 186, 193, 287, 289, 303
Lee, Ji 294
Lee, Jesse 8-11, 23, 35, 62, 186, 290
Lee, Paul 212
Lee, Sally 149
Leen, Sarah 215, 216
Leetaru, Lars 302
Lego 163
Lehren, Andy 295
Leibovitz, Annie 30, 212, 213, 234-235
Leida, Edward 26, 36-37, 50-51, 116, 117, 122, 162, 222, 223, 236, 239
Lemnei, Dragos 82-83, 286
Lenning, Matthew 174, 175, 184
Leong, Tim 210, 214, 260, 293, 304
Leport, Loren 146
Lepreux, Paul 130, 213
Lesh, Mark 212
Leslie, Jeremy 89
Lesser, Robert 260, 302
Lester, Mary 278
Leutwyler, Henry 85
Levine Design, Inc. 207, 252
Levine, Edward 207, 252
Levitt, Carrie 25, 78, 208
Lewin, Sivan 223
Lewis, Lisa M. 154, 224, 257, 292
Lewis, Michael 48-49, 78
Li, Fanny 110
Liang, Linda 193
Liao, Jen 294
Liberace, Mairéad 149
Lieb, Carol 260
Lieberman, Rachael 25
Liebman, Jeremy 12-14
Life 110, 136, 136, 225
Lillegraven, Ture 160
Lima, Karla 124, 187, 193, 225, 266
Limongelli, Kevin 292
Lind, Andreas 94
Lindbaek, Svend 87
Lipsky, Jeff 85, 193
Lissaman, Clare 149
Little Brown Book 264
Littlejohn, Deb 258
Lixenberg, Dana 46-47, 161
Llewellyn, Michael 200
Loco Grafix 191
Lopez, Laleli 282
Lozon, Lindsay 174
LTB Media 191, 218
Luddy, Tim J 261
Ludwig, Gerd 217
Lukova, Luba 302
Lum, Nai Lee 98, 300
Luna, David 114
Lund, Mark 58-59, 190
Lunn, Natasha 196-197

M. Shanken Communications Inc. 110, 155
Maas, Terry 162
MacFarlane, John 253
Macfarlane, Liz 209
Mach, Rob 191
MacIntyre, Katharine 138
Mackay, Finlay 82-83
Mackenzie, Maxwell 191
Mackey, Jan 76, 91
Madara, Jason 124, 176, 193
Madara, Jennifer 25
Maeda, John 40, 48-49
Magazine Group, The 114, 162, 217
Mahadavi, Ali 234-235
Mahanay, Jennifer 191
Mahurin, Matt 255
Mailhot, Caroline 196-198
Majoli, Alex 242
Makowski, Jason 99
Malin, Nadav 191
Malinowsky, Melissa 110, 220, 260
Maltz, Richard 25, 75, 78, 232
Mamanna, Leonor 84
Mandler, Anthony 75, 126
Maniscalco, Gina 50-51, 116
Mannion, Jonathan 126
Mansueto Ventures 139, 171, 200, 232, 233, 254, 260, 280, 300, 302, 303, 304
Manufactura 114
Maraia, Charles 190
Marden, Brice 50-51
Marguard, Eric 250
Mariah Media, Inc. 301
Marie Claire 42-43, 87, 181, 228, 253
Maristany, Martha 218
Mark, Mary Ellen 130

Mark, Stacey 133, 176, 224
Markadakis, Dean 171, 232, 233, 254, 280
Markus, Kurt 189
Marroquin, Patricia 295
Martha Stewart Living 80-81, 111, 203, 240
Martha Stewart Living Omnimedia 16-18, 24, 58-59, 80-81, 86, 95, 111, 134, 172, 173, 203, 240, 281
Martha Stewart Weddings 172, 173
Martin, Michael 67, 293
Martin, Richard 214
Martinez, Christopher 32, 41, 47, 66, 82-83, 139, 182, 183, 198, 240, 242-246, 286
Martinez, Débora 293
Martinez, Paul 42-43, 87, 181, 228, 253
Martini Bratten, Millie 203, 213
Marulanda, Claudia 229
Marzorati, Gerald 33, 38, 53, 54, 70, 71, 84, 105-109, 147, 175, 181, 211, 219, 247, 248, 250, 258, 259, 261, 267-271
Maser, Wayne 289
Massachusetts General Hospital 114, 188
Masters, Charles 187, 193
Masters, Johannah 281
Matadin, Vinoodh 33
Matcho, Mark 302
Matsui, Tim 191
Mattox, Charlyne 172
Maurio, Andrea 141, 267
Maxwell, Robert 75, 78, 12-14, 214, 245, 293
Mayer, Bill 252
Mazzucco, Raphael 228
McCabe, Sean 12-14, 78, 186, 293, 302
McCaul, Andrew 155
McCauley, Shane 127
McClelland, Niall 302
McClennan Phear, Susan 190
McClinton, Debra 79, 213
McColgan, Sarah 181
McCrory, Anne 155
McDean, Craig 50-51
McDonagh, Fiona 25, 75, 78, 118, 121, 208, 232, 254, 277, 278, 279
McDowell, Cyd Raftus 86
McGee, Joe 85
McGoldrick, Marcie 203
McGowan, Kathleen 203
McGraw-Hill Construction 191
McGraw-Hill/AIACC 292
McKenna, David 139, 200, 304
McKenna, Evie 163
McKenzie, Scott 126, 292
McKibillo 279
McKinley, Cara 191
McLean, Allsion 305
McLeod, Scott 176
McLimans, David 98
McManus, Jenn 171
McMillan, Wendy 254
McNulty, Amy 46-47, 163, 195
McOsker, Sara 16-18, 24, 58-59, 95, 134, 281
McPherson, Chris 46-47
Me Magazine 188
Me Magazine, Inc. 188
Meacham, Jon 114
Mecier, Jason 254
Meier, Jana 140
Meier, Raymond 47, 66, 182, 242
Mellor, Belle 261
Memphis Magazine 132
Men's Fitness 200
Men's Health 175, 210, 257, 260, 282, 300, 302, 303, 304
Men's Vogue 201, 214
Méndez, Rebeca 12-14
Meneghin, Karen 148
Mennillo, Ann Marie 203
Menuez, Douglas 138
Meppem, William 19.
Meredith Corporation 110, 128, 149, 214, 220, 260, 300, 301, 302, 304
Meredith, David 16-18, 24
Mermelstein, Jeff 12-14
Merrell, James 79, 189, 190
Merrill, Jennifer 16-18, 24, 58-59, 191
Meshon, Aaron 48-49
Messina, Francesca 261, 274, 304
Metaldyne 175, 187
Metrocorp 201, 260
Metropoli 103
Metropolis 97, 115, 125, 154, 176, 192, 226
Meyer, Sabine 23, 134, 240
Mezick, Bethany 209
mgmt. Design 176
Miceli, Clint 191
Michael, Ruven 78
Michurski, Lisa 295
Midgley, John 48-49
Migliaccio, Rina 191, 202
Mihaly, Julie 126
Miller, Abbott 185, 294
Miller, Greg 46-47
Miller, Johnny 79
Miller, Joy Olivia 220
Miller, Peter Read 250
Mills, Roderick 260
Milter, Joanna 84
Minges, Clarendon 189, 232
Minnesota Monthly 132
Minor, Randy 12-14, 147
Minter, Marilyn 206
Minton, Jeff 25, 110
Mischkylnig, Martin 91
Mitchell, Patrick 138
Mitchell, Wyatt 64-65, 88, 282
Miyake, Yuko 46-47, 195
Moakley, Paul 224
Modern Bride 200
Mohr, Erik 110
Moline, Peg 226
Molloy, Sharon 274
Mondino, Jean-Baptiste 32, 47, 66, 183
Money 300
Monfries, Greg 191, 202

Mongiello, Mauro 147, 242
Monteiro, Ernie 175, 210
Moore, Andrew 188
Moore, Eric 132
Mora, André 189
Moran, Brendan 274
More 128, 214, 300, 301, 302, 304
Morlinghaus, Christoph 12-14
Morris (VII), Christopher 229
Morris, Don 189
Morrisey, William 176, 192
Morrison, Ted 229
Mortensen, Jens 16-18, 24, 58-59, 191, 281, 286
Moskot, Carol 253
Moss, Adam 12-14, 28, 56, 68, 69, 113, 147, 152-153, 204-207, 241, 242
Moss, Laura 186
Mostello, Beth 261
Mouly, Françoise 256
Mountain Sports Media 212
Move! Volume 10 154
Mowat, Matt 21, 48-49, 118, 165, 166-167, 181
Mucci, Phil 46-47, 209
Muldowney, James 76, 91
Muller, Michael 46-47, 177, 184, 195, 240
Mulvihill, Alexa 172, 173
Muñoz, John 203
Munt, Sarah 189
Murphy, Courtney 276
Murray, Nell 138, 213, 255, 286
Musilek, Stan 48-49
Mustain, Jody 220
Myers, Tadd 126

Nabaum, Alex 302
Nabers, William 130, 287
Nachtwey (VII), James 216, 229, 237
Nagler, Erich 97, 176, 192
Nagore, Guillermo 41, 82-83
Nasadowski, Becky 191
Nazemi, Parvin 102
Neal, Christopher Silas 187
Needham, Gerrard 91
Nefsky, Josh 293
Negley, Keith 127, 302
Neilds, Sheryl 85, 78
Nelson, Jim 8-11, 23, 32, 34, 35, 62, 73, 151, 210
Nelson, Martha 191
Nelson, Perry 295
Nest, The 186
Nestico, Vikki 210, 282, 300, 302, 304
Neubert, Hans 29, 103, 199, 263
Neves, Hugo 94, 146, 190
New Republic, The 102
New York 12-14, 28, 56, 68, 69, 113, 147, 152-153, 204-207, 241, 242, 300
New York Magazine Holdings, LLC 12-14, 28, 56, 68, 69, 113, 147, 152-153, 204-207, 241, 242, 300
New York Press 301
New York Times Book Review, The 294, 300, 301, 302, 303, 304
New York Times Company, The 20, 32, 33, 38, 41, 44, 47, 53, 54, 66, 70, 71, 82-83, 84, 103, 105-109, 132, 133, 139, 147, 166-175, 181-183, 198, 211, 219, 240, 242-248, 250, 258, 259, 261, 267-271, 286, 294, 295, 300, 301, 302, 303, 304
New York Times Magazine, The 33, 38, 53, 54, 70, 71, 84, 105-109, 147, 175, 181, 211, 219, 247, 248, 250, 258, 259, 261, 267-271, 303, 304
New York Times Upfront 279.
New York Times, The 300, 301, 302, 303, 304
New Yorker, The 196-198, 256
New Yorker, The 304
Newman, Nurit 114
Newman, Robert 98, 254, 278
Newsweek 114, 224
Newton, Gregg 250
Ngo, Ngoc Minh 80-81, 187, 190
Nguyen, Tina 306
Nguyen-Huu, Thy 307
Ni Aolain, Catriona 46-47, 94, 157-164, 174, 195
Nicastro, David 262
Nicholson, Eric 228
Nickelsberg (Getty), Robert 229, 295
Nicklen, Bambi 254
Nieds, Sheryl 78
Nielsen, Peter 212
Niemann, Christoph 38, 109, 253, 294, 302
Nightingale, Victoria 262, 301, 302
Nihamin, Michelle 201
Nikandro, Maxim 90
Nilsson, Marcus 79
Ninth Letter Literary and Arts Journal 191
Nista, Naomi 79, 190, 226, 284, 285
Nistratov, Valeri 74
Nixon, James 174
Nocito, Jason 224, 290, 293
Noe, Joni 80-81, 111, 203, 240
Norman, Helen 80-81
Norman, Page Marchese 16-18, 24
Norseng, Michael 85, 184
Northeast, Christian 48-49, 149, 303, 304
Northrop, Peggy 128, 214
Nosh, Farah 229
Novak, Michael 164
Novak, Noli 48-49

Nowacek, Nancy 97, 115, 125, 154, 176, 192, 226
NRDC 141
NRTA Live & Learn 300
Nyeman, Ulla 124
Nylon 176, 224
Nylon Guys 133
Nylon LLC 133, 176, 224

O, The Oprah Magazine 140
O., Mimi 303
O'Brien, Erin 78
O'Brien, Tim 119
O'Connor, April 272
O'Donnell, Karen 202
O'Maley, Jason 186
O'Neill, Justin 8-11, 23, 32, 35, 62, 178, 180, 186, 290
O'Quinn, Jim 95
O'Quinn, Tom 165
Ogden, Eric 25, 78
Ogren-Hrejsa, Olivia 149
Okada, Shinichi 162
Okoshi, Tadashi 162
Olaf, Erwin 248
Oldham, Todd 78
Oliveira, Erika 100, 101, 226
Olvera, Maximiliano 156
Omel, Andy 154, 265
Omnivore 28
OnEarth 141
Open 102, 188
Open NY 28
Optimize 149
Orvidas, Ken 133, 302
Osborn, Mariel 203
Outland, Michele 176
Outside 301
Overgaard, Anders 218
Ovryn, Ken 202
Özcan, Serifcan 102, 188

Pace Communications 220, 263
Page (The iSpot), Dan 118. 154
Pagetti, Franco 229
Pagliuco, Carol 264
Palmano, Cindy 76, 91
Palmer, Adam 303
Palmer, Ethan 187
Pamintuan, Florentino 201
Pangilinan, Michael 8-11, 23, 62, 186
Panichi, Angela 281
Paper Magazine 303
Paperny, Dmitry 295
Parada, Roberto 276
Paralemos, Georgia 200
Parents 149
Paris, Brad 12-14
Park, Janet 110, 220, 260
Park, K-Hwa 148
Parker, Kingsley 307
Parr, Martin 91
Parrinder, Elis 306
Parry, Nigel 48-49, 61, 200, 234-235
Parsons, Leif 192, 303
Parsons, Robert 260
Partyka, Donald 261, 304
Pastore, Jennifer 47, 66, 182, 245
Patel, Ayesha 80-81, 111, 240
Paul, Eric 279
PC World 301, 302, 303
PCMA 133
PCMA Convene 133
Pearlman, Ellen 148
Pearson, Victoria 80-81
Peckman, Jodi 115, 125, 202, 226, 227
Pedrick, Lori 201
Pedroza, Carlos 156
Pedzwater, Devin 209
Pellicone, Brian 94
Peña, Fidel 176
Penn State Alumni Association 262
Penn Stater, The 262
Penney, Alexandra 188
Pennsylvania Gazette, The 302
Pentagram Design, Inc. 28, 185
People 191, 202
Perino, Robert 202, 303, 304
Perkel, Nathan 67, 176, 191
Perkins, Beth 176, 191
Perlman, Brandon 112, 115, 175, 188
Personal Selling Power 261
Perspective 191
Persson, Stina 187, 303
Peruzzi, Marc 212
Perverelli, Benoit 193
Petersen, Tim 218
Peterson, Mark 12-14
Petkov, Plamen 287
Petlin, Alessandra 78
Philadelphia STYLE Magazine 127
Piasecki, Eric 80-81, 186, 203
Picayo, Jose 110, 203, 237
Pickens, Cody 176
Piedrafita, Santiago 258
Pierce, Richard 187, 193
Pierre, Stravinski 64-65, 88, 282
Piexotto, Steve 48-49, 166-167
Piggott, Marcus 26, 50-51, 112, 234-235, 238, 239
Pike, Eric A. 16-18, 24, 58-59, 80-81, 86, 95, 111, 134, 172, 173, 203, 240, 281
Pilhofer, Aron 295
Piper, Marcus 76, 91
Pitts, George 110, 136, 137, 225
Piven, Hanoch 264, 302

Plachy, Sylvia 192, 226
PLANSPONSOR 304
Platon 25, 61, 208
Play, The New York Times Sport Magazine 41, 82-83, 240, 286
Playboy - Germany 102
Player, Karen 261
Plunkett, David 48-49, 181, 265, 303
PlutoMedia 138
POL Oxygen 76, 91
POL Publications 76, 91
Polidori, Robert 192, 224, 226
Polifka, Alexandra 12-14, 56, 68, 69, 204, 205, 241
Pollack, Kira 82-84, 132, 133, 240, 286
Ponce de León, Alín 156
Ponciano, Francisco 94, 146, 190
Pond, Greg 98, 254
Popular Mechanics 176, 191, 280
Porostocky, Thomas 262
Portland Monthly Inc. 127
Portland Monthly Magazine 127
Porto, James 156
Positive Thinking 274
Post Typography 44
Potter-Drury, Christian 294
Powers, Shane 16-18, 24, 58-59, 95, 192
Prager, Alex 293
Prefix Institute of Contemporary Art 176
Prefix Photo 176
Premiere 61, 121, 137, 193, 200, 266
Press, Aric 164
Prestek, Krista 8-11, 23, 62, 73, 150, 151, 179, 186, 249, 251, 289
Preston-Schlebusch 187
Primedia 212
Prince, David 149, 202
Prince, Richard 50-51
Print 72, 96, 115, 156
Project Projects 192
Proto 114, 188
Psillos, Demetrios 12-14
Psychology Today 207, 252
Puckett-Rinella, Judith 32, 41, 47, 66, 139, 182, 183, 198, 242-245
Pullen, Crary 229
Punch, Melissa 282
Punchcut 295
Pure + Applied 176, 192
Pyke, Matt 48-49, 181

Quarrier, Sadie 217
Quickhoney 48-49, 78, 186
Quigley, Lucas 84
Quinnell, Colleen 261
Quinze, Arne 91
Quo 156
Quon, Jody 12-14, 28, 56, 68, 69, 113, 147, 152-153, 204-207, 241, 242

Rabchinskey, Ilán 293
Rachlis, Kit 154, 224, 257, 292
Radel, Liane 142, 143, 144
Radio and Records 292
Rae, Andrew 268-269
Ramage, Christine 191
Rameson, Bergren 173
Ramsay, Bruce 114
Rankin 136, 137, 193
Rauch, Carolyn 21, 48-49, 118, 165-170, 177, 181
Rausch, Nana 276
Razro 176, 191, 280
Re, Megan 100, 101
Rea, Brian 67, 71, 187, 274, 300, 301, 303
Reader's Digest 262, 301, 302
Reader's Digest Association 262, 301, 302
Ready Made Magazine 176
Real Simple 79, 190, 226, 284, 285
Real Simple Food 190
Rebhun, Elliott 279
Recife, Eduard 254
Red Nose Studio 255
Redler (Getty), Stuart 103
Reed Business Information 229
Reed, Tricia 46-47, 195
Reedus, Norman 76, 91
Reform Judaism 156
Regan, Suzanne 25, 78
Reid Kehe, Emily 164
Reineke, Charles E. 262
Reis, Patrícia 94, 146, 190
Reljin, Dusan 151
Remmington, Sara 190
Remnick, David 196-198, 256
Replacement Contractor 302
Revisto O Globo 110
Revitte, Dan 224
Revolver 265
Reyes, Josef 268-269
Rezabek, Nicholas 155
Richards, Todd 67, 194
Richardson, Terry 23, 150, 179, 186, 234-235, 251
Richardson, Tim 206
Richter, Mischa 293
Richter, Ralph 176, 192
Ridecos, Ricky 76, 91
Riedel, Jeff 25, 78, 178
Risko, Robert 78, 98, 112, 188
Ritter, John 186, 289
Roach, Margaret 80-81, 111, 203, 240
Roberts, Graham 44
Robertson, Kerry 140, 229, 260, 264
Robertson, Rebecca 16-18, 24
Robledo, Maria 240
Rock, Nick 102, 188

Rodale Inc. 135, 138, 141, 163, 175, 210, 213, 220, 240, 255, 257, 260, 264, 267, 274, 282, 286, 287, 300, 301, 302, 303, 304
Röder, Moritz 102
Rodriguez, Artemio 194
Rodriguez, Edel 254, 303
Rodriguez, Kirby 124, 187, 193, 225, 266, 303, 304
Rodriquez, Joe 94
Rogers, Paul 48-49
Rogers, Sabine 209
Rohr, Dixon 295
Rolling Stone 115, 125, 202, 226, 227
Rollins, Brent 293
Rolston, Matthew 125
Romero, Michele 25, 78, 232
Rompf, Clifford 191
Roney, Carley 186
Ronn Campisi Design 255, 266
Root, Daniel 294
Roper, Arik 265
Roque, Melissa 78
Rosa, Doug 115
Rosales, Marco 138
Rosato, Bob 209
Rosen, Jonathon 95. 303
Rosen, Kim 260
Rosenfeld, Amy 186, 202, 277
Rosenthal, Marc 303
Ross, Alex 60
Rostand, Ellen 118
Rotarian, The 202
Rotary International 202
Rothenburg, Jason Frank 91
Rothfuss, Ursula 303
Rothstein, Jandos 255
Rouemy, Nancy Harris 38, 84, 108, 147, 181. 211, 247, 248
Roversi, Paolo 47, 242
Roy, Nancy 138
Roy, Norman Jean 200, 201
Rozen, Sarah 163, 240
Rubes, Linda 254, 278
Rubess, Balvis 189
Rubin, Ilán 47, 182, 183
Rubinstein, Rhonda 120, 164
Ruder Finn Design 154
Ruder Finn, Inc. 154
Ruiz, Stefan 41
Runner's World 141, 267, 301, 302, 303
Ruse, Travis 200
Russell, Michelle 133
Rutter Kaye, Joyce 72, 96, 115, 156
Ryan, Andy 85
Ryan, Kathy 32, 33, 41, 47, 53, 54, 66, 82-83, 84, 106, 108, 109, 132, 133, 139, 147, 175, 181-183, 198, 211, 219, 240, 242-247, 250, 286
Ryan, Melissa 240
Rykoff, Mark 74, 295
Rytikangas, Patrick 176

S

Sacks, Andy 194
Saelinger, Dan 191
Safipour, Susan Dowdney 261
Sahre, Paul 192, 303
Saias, Rodrigo 146, 190
Saikusa, Satoshi 129, 130, 186
Sail 212
Saint, Warwick 78
Saks, Jeffrey 149
Sakuma, Takahiro 175
Salacues, Matthew 46-47, 195
Salas, Rodrigo 94
Salgado, Sebastião 227
Salgueiro, Rita 94, 146, 190
Salinas, Horacio 29, 53, 175, 187, 204, 215, 241
Salt Water Sportsman 265
Saltz, Ina 307
Sanchez, Hector 130
Sanchez, Rodrigo 22, 103, 104, 190
Sanchez, Sofia 147, 242
Santana, Jennifer 209
Sarai, Mari 176
Sardenberg, Gil 188
Sargent, Jenny 128, 214
Sargent, Nikki 188
Sarson, Richard 274
Sartore, Joel 215
Sato, Hitomi 46-47, 160, 195
Saunders, Gina Toole 301
Sbiera-Paléologue, Anna 232
Scala Quinn, Lucinda 240
Schaap, Thirza 193
Schad, Katherine 110, 136, 137, 225
Schaefer, F. Scott 224
Schaeffer, Kristen 148, 214
Schaffer, Sarah 127
Scharf, Bernard 112, 115, 174, 188
Schepmans, Flavia 226
Schierlitz, Tom 180, 186, 290
Schifferdecker, Bernd 283
Schlatter, Robert 194
Schlechter, Annie 79
Schlesinger, Tamara 187
Schlue, Joe 138
Schmelling, Michael 72, 115
Schmidt, Heimo 194
Schmortte, Stefan 102
Schoeller, Martin 25, 73, 78, 118, 121, 186, 196-198
Scholastic, Inc. 278, 279
Scholl, Matthew 212
Schrager, Victor 79, 190
Schramm, Eileen 293
Schubert, Michael 154
Schulz, Susan 110
Schumaker, Ward 304
Schuman, Scott 290
Schwartz, Staci 230-231
Schwarz, Shaul 229

Schwarz, Christian 91
Schwere, Frank 28, 48-49, 181
Schy, Scot 86
Science World 278
Scotsman Guide 127
Scotsman Publishing, Inc. 127
Scott, Bob 275
Scott, Ed Hepburne 48-49, 181
Scott, Gray 94
Scrobanovich, Kathie 46-47, 195
Sculpture 293
Sears, James Nick 107, 258
Sebbah, David 32, 41, 47, 66, 139, 182, 183, 198, 242-245
SEE: The Potential of Place 67, 194
Seed 174, 262, 274, 283
Seed Media Group 174, 262, 274, 283
Seelie, Tod 87
Segal, Gregg 48-49, 141, 165, 181, 224
Seiffer, Alison 304
Selby, Todd 12-14
Selhtrow, Tra 274
Seliger, Mark 34, 186
Selling Power 261
Sequeira, Jr., Ronald 128
Serebin, Sam 240
Sergi, Lisa 148, 301
Serrano, Andrès 82-83, 240, 247
Serrao, Carlos 12-14, 174
Sfraga, Denise 186, 202, 277
Shanahan, Mary 174
Shannon, Susanna 146
Shealy, Burgan 42-43, 87, 181, 253
Sheehan, Tom 306
Shelley, Noah 12-14
Sheppard, John 12-14
Shimizu, Yuko 78, 254, 277, 304
Shimokawa, Heather 220
Shipman, Chris 95
Sholberg, Jamie 155
Shopenn, Michael 191
Shopsin, Tamara 102, 188
Shore, Keith 293
Shore, Stephen 50-51
Shostak Studios, Inc. 133, 154, 191, 300
Shostak, Mitch 133, 154, 191, 300, 302, 306, 307
Shroads, Amy 254
Shulman, Julius 192, 226
Shur, Emily 25, 258
Si, Jong Woo 262
Sichov, Vladimir 250
Silas Neal, Christopher 164
Silverman, Ellen 79, 186
Simmons, Tim 184
Simon, Taryn 206
Sims, David 236
Sinclair, Kevin 175
Sinclair, Mike 191
Sinclair, Nathan 201
Sinclair, Stephanie 250
Sirota, Peggy 186, 187
Skeisvoll, Monica and Erik 220
Ski Magazine 201
Skiing 212
Sky 263
Slavin, Randall 78, 293
Sleboda, Christopher 12-14
Slezak, Brook 190
Smaga, Jan 218
Smelter, Gretchen 203, 213
Smith Alumnae Quarterly 255
Smith College 255
Smith, Brian 46-47
Smith, Brian Bowen 25, 75
Smith, Brian E. 174, 283
Smith, Caroline 110, 136, 137, 225
Smith, Carter 186
Smith, Davia 300
Smith, Douglas 265
Smith, Jayme 173
Smith, Jeffrey 267, 302
Smith, Kolin 186
Smith, Meg 173
Smith, Rodney 214
Smoot, Kendra 16-18, 24, 134, 281
Soares, Susan 154, 300, 302
Sobel, Shana 282
Social Impact 191
Sockwell, Felix 177
Solomon, Samuel 126, 255
Somlo, Amy 218
Somosi, Dora 8-11, 23, 32, 34, 35, 62, 73, 150, 151, 178, 179, 180, 186, 210, 249, 251, 288-291
Son, Diana 203
Song, EunJean 64-65, 88
Soogls 85
Sookocheff, Carey 79
Sorel, Edward 264
Sorensen, Myla 171
Sorrenti, Mario 117, 122
Sorrenti, Mario 50-51
Sorrentino, Billy 148
Soukup, Karin 177
Southern Progress Corporation 171
Spafax Canada 114
Spafax Chile 114
Spanier, Ian 189, 232
Spark Media 29, 93, 94, 208, 215, 220, 221
Speranza, David 220
Spilman, Kristen 185
Spin 209
Spindler, Lisa 171
Spiridakis, Elizabeth 47, 66, 82-83, 183, 198
Sports Illustrated 209, 250
Sports Illustrated Presents 148
Sporzynski, Matthew 79, 190, 284, 285
Spring, Eva 190, 284, 285
Squier, Joseph 191
Srauss, Mark 220
St. Jacques 113
St. Joseph Media 253
Staley, Lynn 114, 224
Stallinger, Daniela 139
Stanford Magazine 254

Stanford University 254
Stanford, Chris 46-47
Stanley, Jodee 191
Stark, Michelle 200
Starman, Pete 220
Stasiek, Tony 127
Stauffer, Brian 261
Stauss, Luise 84
Steadman, Ralph 272
Stefezius, Claudia 207
Steffy, Ash 189
Steinberg, Jaclyn 110, 260
Steinberg, James 274
Stemmler, Peter 278, 304
Stenzel, Maria 217
Stepanek, Marcia 154
Stephens, Brendan 103, 164
Stephens, Justin 46-47, 78, 177, 195
Stephenson, Michele 74, 102, 119, 229, 264, 295
Stewart, Elizabeth 247
Stewart, Hugh 80-81
Stoddart, Wendy 302
Stone, Kate 218, 278, 295
Stones, Mike 148
Storey, Denis 138
Story (Toky Branding + Design), Geoff 118
Stowell, Scott 102, 188
Strausfeld, Lisa 107, 258
Strecker, Kirsten 173, 190
Streiber, Art 63, 85, 159, 176, 191, 234-235
Strick, David 193
Studio Red at Rockwell Group 193
Suau, Anthony 229
Suen, Kitty 95
Sugre 192
Sullivan, Kelli 162
Summers, Dustin 302
Summers, Mark 272
Sundsbø, Sølve 234-235
Sundwall, Fredrik 94
Surber, Jim 46-47, 161, 174, 195
Sussex Publishers 207, 252
Sutton, Ward 186
Svarling, Lisbeth 187, 193
Swafford, Jennifer 220
Swimmer, Lara 192, 226
Sy, Hady 99
Syrek, David 175, 276

T

T, The New York Times Style Magazine 32, 41, 47, 66, 139, 182, 183, 198, 242-246
Taggart, Paul 23
Tai, Kam 261
Tajo, Lake 91
Takay 293
Talbott, Jenna 260
Tamaki, Jillian 46-47
Tank, Vikram 210, 282
Tarr, Patsy 185
Taveras, Amaya 200
Tavin, Freyda 25, 78, 208
Taxali, Gary 85, 304
Taylor, Blake 139, 260, 200, 300, 302-304
Taylor, Emma 220
Taylor, James 12-14, 191
Taylor, John 186
Taylor, Tracy 228
Taylor-Young, Alistair 112, 174, 188, 200
Techtarget 155, 275
Teen Vogue 203
Tehrani, Alex 78
Teller, Juergen 50-51
Teoh, Chris 175, 187
Testino, Mario 234-235
Tetzeli, Rick 25, 75, 78, 118, 121, 208, 232, 254, 277, 278, 279, 295
Texas Monthly 131, 135, 229
Thé, Lisa 301
There Media, Inc. 99
This Old House 186, 202, 277
Thoelke, Eric 118
Thompson, Eugene 191
Thompson, Jack 135
Thompson, Jenny Leigh 42-43, 87, 181, 228, 253
Thompson, Martyn 94, 226
Thompson, Michael 62, 186, 234-235, 249
Thornley, Blair 67
Thumb 192
Thunberg, Ulrika 110, 220, 260
Thuss, Rebecca 134
Thuss, Rebecca 58-59, 95
Tibbott, Natasha 16-18, 24
Tierney, Casey 174
TIME 102, 119, 229, 264, 301
Time Inc. 25, 74, 75, 78, 79, 98, 102, 110, 118, 119, 121, 129, 130, 136, 137, 148, 164, 186, 190, 191, 202, 208, 209, 218, 219, 225, 226, 229, 232, 250, 254, 264, 277-279, 284, 285, 295, 300-304
Time Inc. Content Solutions 94, 114, 175, 187, 188, 301
Time Out New York 114, 155
Time Out New York Kids 155
Time Out New York Partners, L.P. 114, 155
TIME.com 74, 295, 303
Time4 Media 201, 202, 265, 302-304
Timmerman, Martin 48-49, 165
Timorous Beasties 192
Tjia, Siung 46-47, 94, 157-164, 174, 195
Todd, Maisie 161
Todd, Mark 187
TODO Monthly 120, 164
Toky Branding + Design 118
Toledano, Phillip 28, 32, 232, 233
Tom Brown Art + Design 201
Toma, Kenji 208, 220
Tomanio, John 278
Tomato 40, 48-49

Tomlin, Lara 304
Tonchi, Stefano 32, 41, 47, 66, 139, 182, 183, 198, 242-246
Toolan, John 210
Topic Magazine 232, 274
Toronto Life 253
Torrisi, Allyson 176, 191, 280
Toshihisa, Shin 91
Toulouse, Sophie 78, 277
Town & Country Travel 174
Toy, Albert 146
Trachtenberg, Robert 202
Trader Monthly 232
Translusczent 191
Travel + Leisure Golf 202
Tremblay, Carl 201
Tribune Company 162, 294
Trident, The 103
Triplett, Gina 267
Trope, Donna 180
Trucchia, Valerie 279
Trujillo, Joaquin 102, 188
Trujillo-Paumier 102, 188
Truscio, Ed 209
Tse, Archie 44
Tsiolis, Terry 188
Tu Ciudad 165
Tucker, TJ 131, 135, 229
Tunstall, Colin 63, 85
Turell, Jimmy 293
Turnbull, Andy 148, 214
Twingley, Jonathan 255
Twomey, Robyn 48-49, 159
Tyler, Lindsay 191

U

UCLA 155, 303
UCLA Magazine 155, 303
UD & SE 113, 154, 251
Ueland, John 186, 291
UIUC Department of English 191
Ulve, Kirsten 78
Umans, Marty 110
Umbach, Jens 185
Underline Studio 176
Unidad Editorial S.A. 22, 103, 104, 190
Union for Reform Judaism 156
United 220
University at Illinois at Urbana Champaign 191
University of Missouri - Columbia 262
Unruh, Jack 265, 267, 302
Unterreiner, Alison 176, 191, 280
Urdang, Melissa 173
Utley, Holland 200
Uyttenbroek, Ellie 12-14

Vail, Roger 225
Valdés, Mimi 60, 64-65, 88, 265. 282
Vale, Shawn 46-47, 158, 195
Valls, John 127
van Dorr, Thierry 91
van Lamsweerde, Inez 33
Van Lohuizen (Agence VU), Kadir 229
Van Mulder, Joanna 189
van Roden, William 86
Van Sommers, Jenny 203
Vandenoeuver, Julia 212
Vang, Mikkel 16-18, 24
Vanity Fair 30, 112, 212, 213, 234-235, 237, 238, 265, 272, 273, 277, 281
Vargas, Robert 57, 142-144, 146
Vasconcelos, Walter 302
Vault 49 168-170
Vecerka, Albert 232
Vega, Lou 260, 302, 303
Vellam, Nadia 50-51, 116, 162, 222, 223
Ventura, Andrea 266
Verdesca, Dena 213, 220, 286, 287
Verslius, Ari 12-14
Vesalius, Andreas 67
VIBE 60, 64-65, 88, 265. 282
Vibe/Spin Ventures LLC 60, 64-65, 88, 209, 265, 282
Victore, James 70, 147, 274, 304
Vik, Nils 119
Viladas, Pilar 182
Village Voice Media 60, 120, 230-231, 252
Village Voice, The 60, 230-231, 252
Viñas, Sarah 29, 103, 199, 263
Vinceri, LLC 98
Vinluan, Leah 186
Vino + Gastronomia 92
Vino y Gastronomía Comunicación 92
Virginia Living Magazine 275
Vitale, Ami 240
Vlcek, Nick 120
VNU Business Media 126, 292, 303
VOICE Design 162
Voigt, Patrick 48-49, 181
Volbrecht, Andrea 42-43, 87, 181
Volpe, Heidi 74, 155, 199
Volume Inc. 176
von Unwerth, Ellen 129
Vriens, Matthias 234-235
VSA Partners 29, 103, 199, 263
Vuelo 293

W

W 26, 36-37, 50-51, 116, 117, 122, 236, 239
W+K 12 102, 188
Wagner, Drue 8-11, 23, 62, 186, 291
Wagner, Jelle 293
Wahl, Christopher 125
Wakano, Carol 74, 237
Waldersten, Jesper 187, 193, 304

Waldron, William 16-18, 24
Wall Street Journal, The 294
Wall Text Inc. 176
Wallace, Liz 264
Walrus Magazine 300
Walsh, Kristen 203, 213
Walsh, Tracy 79, 190
Warchol, Paul 192, 226
Washington Post Co., The 114, 224
Washington University in St. Louis 118
Wass, Chip 191
Wassner, Laurel 202
Watanabe, Lina 127
Waters, John 306
Watkinson, Mark 16-18, 24
Watson, Holly 200
Watts, Ben 186
Watts, Cliff 148
Wealth Manager 155
Weaver, Todd 293
Weber, Bruce 50-51, 186
Weber, Christian 144
Weber, Mike 301
Weber, Sam 46-47, 67, 257, 267, 303, 304
Weegee 102
Weider Publications, Inc. 226, 303
Weinberger, Todd 127
Weinstein, Ellen 304
Weir, Andrew 186
Weisman, Nancy 46-47, 159, 161, 195
Weiss, Julie 30, 112, 212, 213, 234-235, 237, 238, 265, 272, 273, 277, 281
Weiss, Mark 186
Weit, Jessica 79
Welsh, Philip 189
Welton, Nato 79, 190
Wenner Media 115, 125, 202, 226, 227
West / Los Angeles Times Magazine 74, 155, 199, 237
Westman, James 287
Whelan, Erin 79, 190
White, James 25, 87, 181
White, Susan 30, 112, 212, 213, 234-235, 237, 238, 281
Whitley, Michael 162
Whitman, Robert 189
Whitmore, David 215-217
Wieliczko, Chris 99
Wiesner Publishing 138
Wildman, Joshua 293
Wilkin, Charles 12-14, 75
Williams, Anna 79-81, 190
Williams, Brittany 281
Williams, Greg 85
Williams, Lee 114, 188
Williams, Nate 302
Williams, Scott 203
Willouby, Paul 193
Wilson, Brian 302
Wilson, Mark 293
Wine Spectator 155
Winston, Sam 270-271
Winters, Dan 78, 141, 186, 229, 274
Wired 21, 40, 48-49, 118, 165-170, 177, 181, 275
Witkin, Christian 82-83, 85
Wojcik, James 80-81, 175, 290
Wolfberger, Ofer 48-49, 181
Wolkoff, Katherine 185, 193, 232
Women's Health 163, 240
Wong, Bess 110, 136, 137, 225
Wong, Ho-Mui 191
Woo Si, Jong 262
Wood, Justin 267
Woodruff, Jay 295
Woods, Noah 189
Woods, Zana 48-49, 181
Woodward, Fred 8-11, 23, 32, 34, 35, 62, 73, 150, 151, 178, 179, 180, 186, 210, 249, 251, 287, 288, 289, 290, 291, 301, 303
Word, Troy 87, 228
Worrel, James 130
Wu, Claudia 188
Wundrok, Ellene 79, 190
WWD Intimates 237
Wyatt, Rachel 131
Wyatt, Scott 67

X

Xu, Samantha 25, 78

Y

Yanes, Romulo 100, 101
Yañez, Óscar 146
Yang, Caroline 250
Yang, Peter 46-49, 157, 168-169, 170, 181, 202, 226
Yeo (The iSpot), Brad 118
Yeo, Diana 157
Yoch, Elisa 141, 267
Young, Bradley 129, 130, 219
Young, Nigel 67
Yung, Henry 254

Z

Zavetz, Laura 155
Zedek, Dan 103, 164, 294
Zhao, Wenjun 307
Ziegler, Jonathan 262
Ziff Davis Media 148
Zimmerman, Harf 133, 245
Zouravliov, Vania 267
Zucca, Mario 46-47
Zucker, Andrea 132

PUB 42 was a momentous year of firsts for SPD: the first year a Director of Photography served as one of the co-chairs of the competition, the first year we held our judging over three days in generous space at FIT, The Fashion Institute of Technology in New York, and the first year we got to see George Karabotsos show off those shoulders in his dress onstage at the Gala. All in all, a GREAT year.

THE ANNUAL JUDGING would not be possible without the tremendous efforts of so many. George Karabotsos, Design Director, Men's Health, and Fiona McDonagh, Director of Photography, Entertainment Weekly, (Newsstand Co-Chairs), Mitch Shostak, Creative Director, Shostak Studios (Non-Newsstand Chair), Roger Black, President, Roger Black Studio (Online Chair) and Linda Root, Design Director, Studio Incubate (Magazine of the Year Chair) extend an enormous thank-you on behalf of SPD to all the judges and volunteers for a seamless weekend judging almost 7,000 entries at FIT on January 19-21, 2007.

MANY THANKS also to:
Mary Oleniczak and her staff in the FIT Facilities Office.

Henrik Knudsen and Julian Richards for the PUB 42 poster image and marquee '42' image.

Mike McGregor for the photographs of the judges during the Competition.

Elizabeth Neal for the Call for Entries Poster design, and design of the Gala Invitation.

Jason Lee for the Call for Entries entry forms.

Sharon Floyd and Getty Images for the vintage photographs at the Gala.

Tom Wagner for stage management and production on the night of the Gala, and Jon DeLouker for the Gala AV presentation.

Jan-Roman Potocki of Potocki Wódka for providing cocktails at the Gala.

Jane Hammer, for all her assistance to George and Fiona.

Laura White for the Gala Program design, and John McCarthy for the Gala Program production.

SCI Printing for printing of the Gala program.

Amerikom for printing the Call for Entries poster for the Student Competition.

David Rhodes and Richard Wilde of SVA, for providing free summer housing for the winners of the SPD Student Competition.

Courtney Spain and Joan Bodensteiner of Adobe.

For invaluable help and support in pre-production, Mike Ley.

An enormous thanks to Kurt Walters, for everything that's too much to list.

And most especially: to George Karabotsos and Fiona McDonagh.

Thank you for a wonderful year, and for making it look so easy.

SPOTS Chairs Emily Crawford and Brian Rea led the 20th Annual SPOTS competition this year, championing the little illustrations that say so much. From over 500 entries, the judges selected a class of illustrations that do an excellent job of improving the editorial message, from a wide spectrum of publications. Winners are featured in a visual index in this volume, and are celebrated more extensively in a very limited-edition book showcasing both the illustrations and smaller versions of the original editorial pages that featured the work.

Special thanks to the judges:
Peter Arkle, Illustrator
Barry Blitt, Illustrator
Kristina DiMatteo, Art Director, Print
Anita Kunz, Illustrator
Francesca Messina, Creative Director, Guideposts Publications
Chip Wass, Illustrator

THE STUDENT COMPETITION & THE ADOBE SCHOLARSHIP IN HONOR OF B.W. HONEYCUTT

Established in 1995, this competition honors the life and work of B.W. Honeycutt. It recognizes exceptional design by students with awards and three cash prizes: the Adobe Scholarship in Honor of B.W. Honeycutt, the first-place prize of $2500; second-place prize of $1000; and a third-place prize of $500. The top four winners also received summer internships at Fortune, Departures, Marie Claire and Men's Health, as well as copies of Adobe's Creative Suite Software. Chaired by Francesca Messina and Linda Root, this juried competition acknowledges the student designer and the teachers who develop their unique talents. In recognizing the promise of each student, Adobe affirms the creative possibilities inherent in the individual. Throughout its partnership with SPD, Adobe is helping shape the next generation of creative professionals. Together we are building the foundation that will sustain and further artistic accomplishments within the editorial design community.

Special thanks to the judges:
Susan Bogle, Design Director, Atlanta Home Magazine
Craig Gartner, Art Director, Sports Illustrated Presents
Gretchen Smelter, Design Director, Brides
Armin Vit, Designer, Pentagram
Fred Woodward, Design Director, GQ

The Society thanks its corporate partners for their ongoing support:
Adobe Systems, Inc.
The Heart Agency

SPD BOARD OF DIRECTORS

The Society of Publication Designers
17 East 47th Street, 6th Floor
New York, NY 10017
Tel: 212.223.3332
Fax: 212.223.5880
Email: mail@spd.org
www.spd.org

The SPD 42nd Publication Design Annual was designed and produced by Robert Priest and Grace Lee of Priest+Grace with help from Paloma Shutes

Nature studies by John Grimwade

First published in the United States of America by:
Rockport Publishers, Inc.
100 Cummings Center, Suite 406-L
Beverly, MA 01915
Tel: 978.282.9590
Fax: 978.283.2742